Arts of the City Victorious

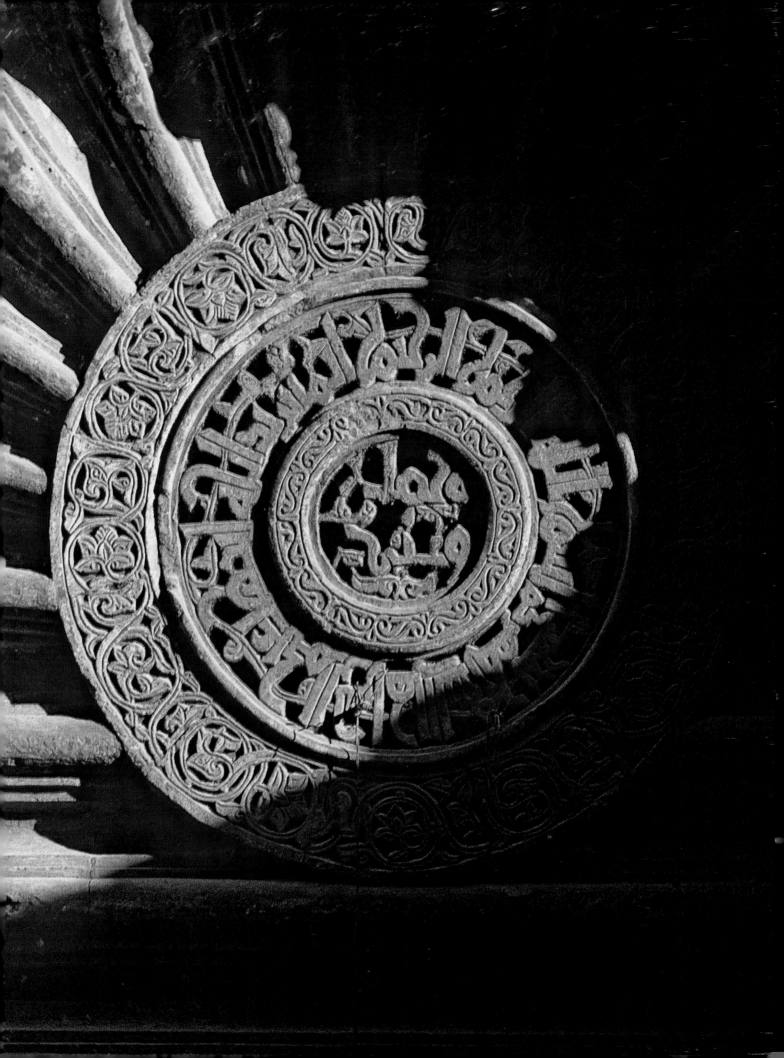

Arts of the City Victorious

Islamic Art and Architecture in Fatimid North Africa and Egypt

Jonathan M. Bloom

Yale University Press ~ New Haven and London

in association with

The Institute of Ismaili Studies

Designed by Sarah Faulks

Set in Bembo and Minion Tra, a font created by Decotype, Amsterdam,
for The Institute of Ismaili Studies

Printed in Singapore

Library of Congress Cataloging-in-Publication Data

Bloom, Jonathan (Jonathan M.)
Arts of the city victorious : Islamic art and architecture in Fatimid North Africa and Egypt / Jonathan M. Bloom.
p. cm.
Includes bibliographical references and index.
ISBN 978-0-300-13542-8 (cl : alk. paper)
1. Decorative arts, Fatimid–Africa, North. 2. Decorative arts, Fatimid–Egypt.
3. Architecture, Fatimid–Africa, North.
4. Architecture, Fatimid–Egypt. I. Title.

NK720.B58 2007
709.62´0902–dc22
2007032122

A catalogue record for this book is available from
The British Library

Endpapers: Linen and silk tiraz, twelfth century, Fatimid Egypt, detail, height (maximum): 40 cm, width: 31 cm.
Victoria and Albert Museum London, 1162–1900

Frontispiece: Cairo, Aqmar Mosque, detail of roundel over portal, 1125

Contents

Foreword by Robert Hillenbrand ix
Preface xiii

I An Introduction to Fatimid History and Fatimid Art 1

II Fatimid Art in North Africa 15

Fatimid Origins 15
Prelude in Syria 16
Arrival in North Africa 17
Mahdiyya 22
The Reign of al-Qa'im 33
The Reign of al-Mansur 35
Mansuriyya 37
Mansuriyya in the Mediterranean Context 40
Decorative Arts during the Reign
 of al-Mu'izz in North Africa 42

III Architecture in Egypt from 969 to the 1060s 51

The Arts in Egypt before the Fatimids 53
The Founding of Cairo 54
Architecture 59
Conclusion 85

IV The Decorative Arts from 969 to the 1060s 89

Egyptian Arts before the Fatimids 90
Textiles 91
Ceramics 93
Metalwares 97
Precious Metals 99
Rock Crystal and Glass 101
Woodwork 105

Ivory 107
Books and Paintings 109
Representation in Fatimid Art 113

V Architecture from the 1060s to 1171 117

The Historical Setting 118
Military Architecture 121
Palaces 129
Religious Architecture 129

VI The Decorative Arts from the 1060s to 1171 157

The Dispersal of the Fatimid Treasures 157
Coins 159
Textiles 159
Woodwork 162
Ceramics and Glass 167
Metalware 170
Books 170
Paintings 171

VII The Legacies of Fatimid Art 175

Cairo 176
Egyptian Islamic Art 181
North Africa 184
Sicily 189
Christian Europe 193
Conclusions 197

Appendix: The Fatimid Caliphs 200
Notes 201
Bibliography 220
Photograph credits 230
Index 231

THE INSTITUTE OF ISMAILI STUDIES

The Institute of Ismaili Studies was established in 1977 with the object of promoting scholarship and learning on Islam, in the historical as well as contemporary contexts, and a better understanding of its relationship with other societies and faiths.

The Institute's programmes encourage a perspective which is not confined to the theological and religious heritage of Islam, but seeks to explore the relationship of religious ideas to broader dimensions of society and culture. The programmes thus encourage an interdisciplinary approach to the materials of Islamic history and thought. Particular attention is also given to issues of modernity that arise as Muslims seek to relate their heritage to the contemporary situation.

Within the Islamic tradition, the Institute's programmes promote research on those areas which have, to date, received relatively little attention from scholars. These include the intellectual and literary expressions of Shiʻism in general, and Ismailism in particular.

In the context of Islamic societies, the Institute's programmes are informed by the full range and diversity of cultures in which Islam is practised today, from the Middle East, South and Central Asia, and Africa to the industrialized societies of the West, thus taking into consideration the variety of contexts which shape the ideals, beliefs and practices of the faith.

These objectives are realized through concrete programmes and activities organized and implemented by various departments of the Institute. The Institute also collaborates periodically, on a programme-specific basis, with other institutions of learning in the United Kingdom and abroad.

The Institute's academic publications fall into a number of interrelated categories:

1. Occasional papers or essays addressing broad themes of the relationship between religion and society, with special reference to Islam.
2. Monographs exploring specific aspects of Islamic faith and culture, or the contributions of individual Muslim thinkers or writers.
3. Editions or translations of significant primary or secondary texts.
4. Translations of poetic or literary texts which illustrate the rich heritage of spiritual, devotional and symbolic expressions in Muslim history.
5. Works on Ismaili history and thought, and the relationship of the Ismailis to other traditions, communities and schools of thought in Islam.
6. Proceedings of conferences and seminars sponsored by the Institute.
7. Bibliographical works and catalogues which document manuscripts, printed texts and other source materials.

This book falls into category two listed above.

In facilitating these and other publications, the Institute's sole aim is to encourage original research and analysis of relevant issues. While every effort is made to ensure that the publications are of a high academic standard, there is naturally bound to be a diversity of views, ideas and interpretations. As such, the opinions expressed in these publications must be understood as belonging to their authors alone.

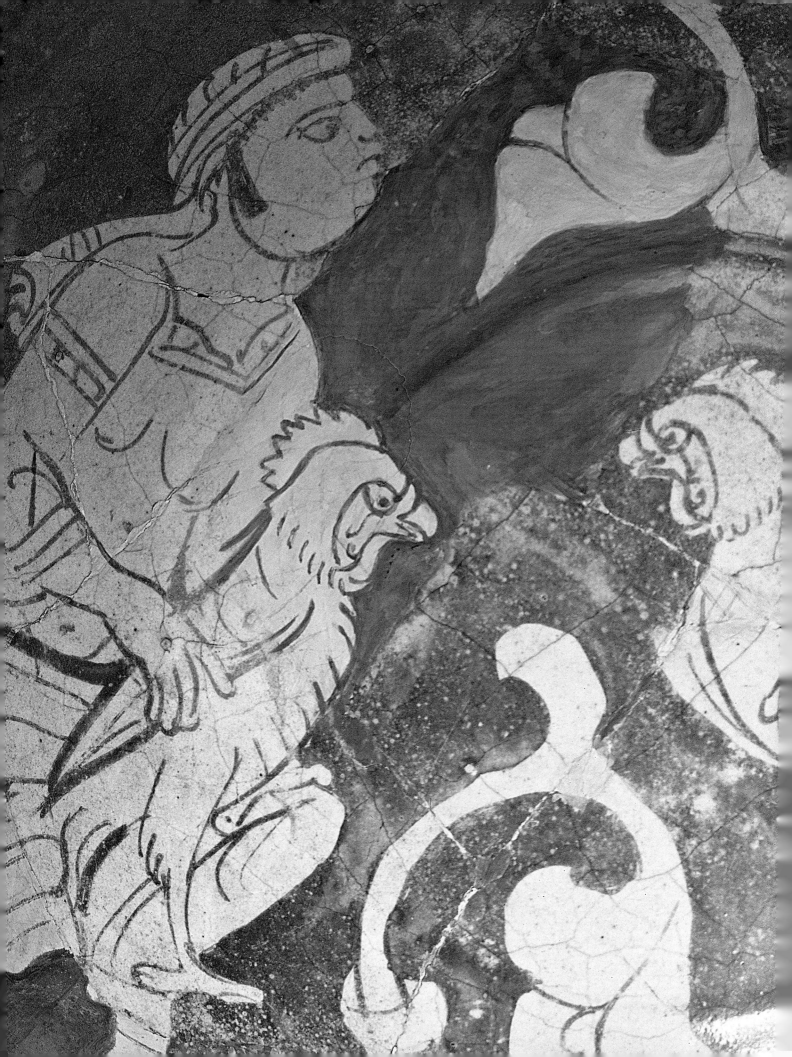

Foreword

Quite aside from its innate quality of profound scholarship and light, accessible, witty and elegant style, this is a book to welcome on three counts. First, it is that rarity in scholarly studies of Islamic art, a monographic and comprehensive treatment of all the arts of a single key dynasty. It is worth pointing out that such monographs on the art of the Umayyads, Abbasids, Saljuqs, Ilkhanids, Timurids, Safavids – I purposely omit the smaller dynasties scattered throughout the Islamic world – simply do not exist and, so far as I am aware, are not even in active preparation. In this respect, at least, the field of Islamic art is progressing at snail's pace. Thus the vital middle ground between the general survey, whether long or short, and the scholarly book or article on a discrete theme, medium, group of objects or individual artefact, remains ignored. That this should be so, given the geometric progression in the output of scholarship on Islamic art over the last generation, is nothing short of astonishing. Yet the need for such monographs is ever more urgent. The reason for their absence is not far to seek. They require intellectual daring, a solid familiarity with the historical context, and the capacity to see the wood as well as the trees. The combination of these gifts is all too rarely found.

Next, the book is thoroughly contextualized within the wider history of medieval Islamic art. Bloom ensures that Fatimid art is not presented in a vacuum but that it makes sense within its own time and place. Its debt to and interaction with the concurrent traditions of Muslim Spain and the Fertile Crescent, then under Abbasid rule, and even the lands further east, are prop-

erly factored into the discussion. Given the tendency in some earlier scholarship to present Fatimid art as a problem or as a curious phenomenon that is in some way extraneous to the mainstream of the evolution of Islamic art, this is a salutary and common-sense corrective. So too is Bloom's refusal to take the tempting but treacherous route of reading specific Ismaili symbolism into Fatimid art, of which more later. Bloom's unusual academic trajectory has been invaluable here. It has involved him for some two decades in the large-scale editing and writing of general works over the entire field of Islamic art, an experience deepened and widened still further by the mounting of ambitious exhibitions, again across the whole spectrum of Islamic art. He is therefore exceptionally well placed to write such a detailed monograph without getting lost in its innumerable by-ways.

Thirdly, the text is informed throughout by a perspective that Bloom has made very much his own over the years, namely the setting of Fatimid art within the Mediterranean and specifically the Christian world of the time. This is what distinguishes the art of the Islamic Mediterranean from Islamic art further east. He prefers to stress the international quality of much of the art of the Mediterranean basin – a unity of intention and expression that made little of gulfs of space or confessional differences – rather than to highlight the regional distinctiveness of, say, Muslim Spain or Sicily. He demonstrates that the Christian and Muslim worlds were not walled off from each other, but that on the contrary there was a permeable membrane between them, most particularly in the secular luxury

Facing page: earthenware bowl overglaze-painted in lustre, detail of Fig. 5

arts of the palace but also in religious art, in such details such as the use of dyed parchment or *muqarnas* ceilings.

So much for the general value of the book within the context of Islamic and medieval art. What of its worth as an account of the arts of Muslim Egypt from the tenth to the twelfth century? Here there is one obvious comparator – Contadini's *Fatimid Art at the Victoria and Albert Museum*, published less than ten years ago and a work of solid expertise, based on very close knowledge of one of the world's finest collections of the Fatimid minor arts. That was a major step forward at the time: an attempt to define the essential nature of Fatimid art by reference to the V&A collection, supplemented by other material. But it would be fair to say that Bloom's book in turn represents a quantum leap from that baseline, not least because it is considerably longer and can therefore cover much more ground. It is in no sense tied to or even biased towards any one collection; it covers a rather wider spectrum of the minor arts (taking in more Coptic material, bringing his uncommon expertise in the field of woodwork into play, and including coins); its historical infrastructure is very much fuller and extremely assured; it looks very closely at the origins of Fatimid art in North Africa; and – most important of all – it accords architecture its proper and primary place. All this is underpinned by a model scholarly apparatus of truly impressive depth and range. This is a scholar at the height of his powers. Typical of this approach is the final chapter ('The Legacies of Fatimid Art') which ventures into the subsequent Ayyubid period and beyond, and also into the art of non-Fatimid North Africa in Fatimid and later times, as well as into Christian Europe – a judicious and learned attempt to follow up many of the themes and motifs of Fatimid art in quite other contexts.

I had read most of this book very carefully at a rather earlier stage of its gestation and so can claim a particular familiarity with its text. It has gained substantially not only in length but also in stature in the interim. This is especially true of the non-architectural sections. Here he grapples successfully with questions of a kind that architecture does not pose. In no sense at all is this the book of Bloom's doctoral thesis – he is a very different scholar now than he was a quarter-century ago, with incomparably wider horizons – but it benefits hugely from the experience of preparing and writing that thesis all those years ago. He knows this subject inside out. He is totally at home with it. This sort of intimacy with one's material is not readily acquired in any other way. And

it gives his work the unmistakable stamp of authority without the concurrent myopia that is so often the price that must be paid. The strong emphasis on architecture in the thesis has been replaced by much wider sympathies, as shown by the illuminating discussions of textiles and lustreware, rock crystal and coins, and the parallel history of later Coptic art.

Professor Bloom deserves special praise on two other counts. The first is the way he has integrated history with art history throughout the book. So often, in any kind of survey of Islamic art, the historical section is treated perfunctorily and is shoved into an introduction; and you can almost hear the sigh of relief as the author moves on to what is of greater interest. Not here. There is a proper sense of changing historical circumstances – the tenth century is like neither the eleventh nor the twelfth, and to lump them together in a few platitudes about 'the Fatimid period' does violence to historical accuracy. Instead, the author not only deploys, with great assurance, a huge mass of historical information drawn from a variety of sources, some of them very unexpected and neglected (the footnotes give chapter and verse in appropriate detail), but also weaves this information seamlessly into his discussions of the works of art themselves. The context is thus very specific and constantly changing. This is where the book really gains from its author's saturation in the period over several decades. The layout of the work ensures that this approach is consistent throughout the text, for the chapters are for the most part arranged chronologically rather than thematically. This enables the reader to gauge the impact of current events on the art produced in a given period.

Equally praiseworthy is the decision to grasp the nettle of the impact of Shi'ism on Fatimid art. A lot of nonsense has been written about this, and on a uniformly slender evidential base. Professor Bloom has examined this issue minutely, and thus his conclusion that the particular Shi'i nature of the regime found no specific corresponding echo in the art that they produced is compelling. Given the current fashion for seeing symbolic meanings in so much Islamic art, this is a salutary conclusion. It is a curious relief to be able to appreciate Fatimid art straightforwardly as perhaps the quintessential expression of mid-medieval Islamic art, at least in the eleventh century, without having the picture muddied by cryptic, tendentious, half-baked and unsubstantiated references to religious symbolism.

The art of the Fatimids is a grand theme. This was, after all, a dynasty that claimed the universal Islamic

caliphate, that established itself at the junction of the eastern and western Islamic worlds, and was ambitious to expand in both directions. It drew sustenance from both sets of traditions, and fashioned a reputation for extravagant living that lasted for many generations and (as the work of al-Maqrizi shows) lost nothing in the retelling. For two brief centuries it astonished the Islamic world, dominated the Mediterranean and catapulted Egypt back to its ancient glory. It was the Fatimids who developed Cairo into a metropolis capable of replacing Baghdad when that city fell to the Mongols in 1258, and who thus laid the foundations for the later primacy of Egypt in the Near East, a primacy it still retains. Jonathan Bloom has risen to the challenge of this grand theme and written a book worthy of it.

Robert Hillenbrand
University of Edinburgh

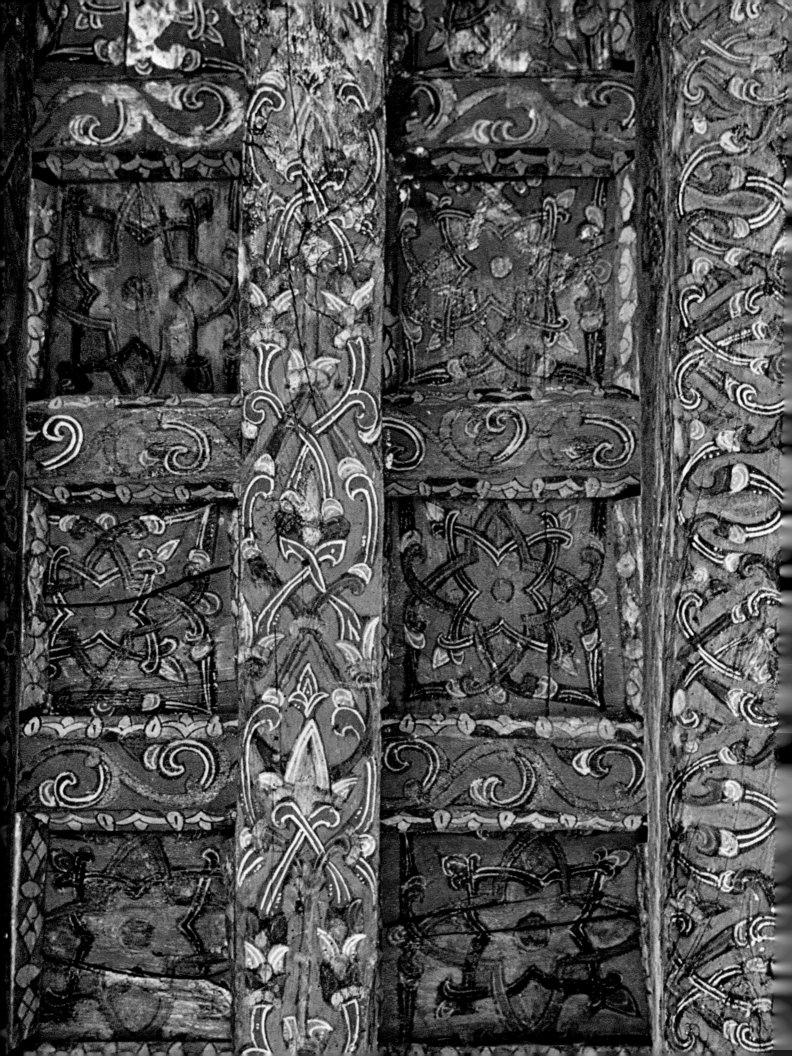

Preface

This baby can be said to have had a *very* long gestation. In January 1973, having applied to the University of Michigan to begin graduate study in the history of Islamic art later that year, I went off to Tunisia to work for a joint Tunisian–American project, the Corpus of Ancient Mosaics of Tunisia. During my six months there, I discovered that while Mediterranean springs were indeed a delight to all the senses, the Mediterranean winter – particularly as experienced in a thick-walled, open courtyard house in the *medina* of Tunis – left something to be desired. Every weekend soggy members of the team would wander off in an ancient Peugeot station wagon driven by Professor Margaret Alexander, the indefatigable director of the project, to visit not only all the ancient but also the Islamic sites of Tunisia and nearby Algeria. While working on the mosaics of El Djem later in the season, we would often drive across the coastal plain to Mahdia, the closest seaside town, for a fish dinner. Although I didn't know it at the time, it had been founded as al-Mahdiyya by the Fatimid caliphs, who ruled North Africa and Egypt from 909 to 1171. The trip was my first introduction to the art and architecture of North Africa, and it has remained a constant interest over the years.

Three years later, as a graduate student at Harvard University, I participated in a seminar directed by Professor Oleg Grabar on the art of the Fatimids and I presented an eminently forgettable report on the Fatimid palaces of Cairo. When it came time to choose a topic for my dissertation, therefore, I decided to combine my interests and write about the art and architecture of the Fatimids in North Africa and Egypt, not realizing what an immense topic that was. My gross naiveté was fortu-

nately ignored by the committee that awarded me a very generous Fulbright-Hayes Fellowship for Doctoral Dissertation Research Abroad, which allowed me to spend most of the academic year 1977–1978 travelling clockwise around the Mediterranean from Italy to Spain and France, with a final stop in Great Britain, investigating sites and visiting museum collections of Fatimid art. It was a truly memorable and transformative trip, and some of the images illustrating this volume were taken at that time. When I returned to Cambridge to write up the results of my work, I – and my adviser – began to realize what an immense task I had assigned myself. Anxious for me to complete my dissertation within the decade before he was scheduled to retire from teaching, Professor Grabar encouraged me to limit the scope of my work to the fourth century of the Hegira, roughly equivalent to the tenth century of the Common Era. The result was my dissertation, presented in 1980, thanks to a generous grant from the Mrs Giles R. Whiting Foundation.[1] It was a narrative history of early Fatimid art and architecture, combining references to extant buildings, texts and objects in a logical story that covered the period from the dynasty's founding in Tunisia in 909 to the reign of al-Hakim (996–1021) in Egypt.

Although I had completed a dissertation, I never felt that I had completed telling the story of Fatimid art to my own satisfaction. I published several articles based on chapters of my thesis in the 1980s, but the idea of a comprehensive and general book on Fatimid art remained in the back of my mind as I began my teaching career.[2] Concurrently I began investigating several other problems tangential to my work on Fatimid art, including the origin and date of the so-called 'Blue

Facing page: Kairouan, Great Mosque, painted wooden ceiling, detail of Fig. 152

Qur'an' and the history and meaning of the minaret, which eventually took my research in quite different directions.[3] I had less opportunity to follow my interests in the late 1980s and early 1990s, when I not only became the father of two wonderful children, but also had to spend most of my professional time either editing articles for *The Dictionary of Art* or writing chapters of *The Art and Architecture of Islam*.[4] These experiences, however, gave me a much broader perspective than I had ever had as a student on how Fatimid art fits in to the larger world of Islamic art.

With the completion of these projects in the mid-1990s, I then found myself working on a book about the history and impact of paper in the Islamic lands, a project that had interested me for quite a while but that had virtually nothing to do with the Fatimids, although I occasionally stuck my finger back into the pie.[5] Having completed that book in the late 1990s, I approached The Institute of Ismaili Studies in London about whether they would be interested in commissioning me to write a general book on the art and architecture of the Fatimids, from whom the present Nizari Ismaili spiritual leader, HH Prince Karim Aga Khan, traces his descent. The Institute's Head of Academic Research and Publications, Dr Farhad Daftary, eagerly accepted my proposal and encouraged me to write a short and accessible book as soon as possible, even sweetening the deal with the offer of a research trip to Egypt, which I hadn't visited for quite some time. Having written preliminary drafts of three chapters, I took the trip in the winter of 2000 and was finally able, despite the lingering effects of a sudden bout of pneumonia, to see the Mashhad al-Juyushi in the company of Professor Marianne Barrucand, as well as the Fatimid-era mausoleums and the tomb of the late Aga Khan III at Aswan.

When I returned from Egypt, however, my life and writing habits changed dramatically as my wife, Sheila Blair, and I were suddenly offered the opportunity of sharing the newly-established Norma Jean Calderwood University Professorship of Islamic and Asian Art at Boston College. It had just been established by Stanford Calderwood in honour of his wife, who had taught Islamic art at Boston College for many years and had been, coincidentally, one of my fellow students in Professor Grabar's Fatimid seminar twenty-odd years before! The extraordinarily generous support for research and travel provided to the Chair has made our professional lives immeasurably more productive and comfortable. Although I only teach half-time at Boston College, innumerable other projects and commitments – not the least of which has been the invitation to share the Hamad bin Khalifa Endowed Chair of Islamic Art at Virginia Commonwealth University – still made it difficult to pick up those three chapters where I had left off in the spring of 2000.

At regular intervals my dear friend and colleague Robert Hillenbrand gently nudged me to get back to the book, asking me how the project was going and encouraging me not to abandon it. When I told him that I had decided to give up the project, he refused to accept my decision and offered to read and comment on the shreds of typescript I had completed. 'Guilt is the gift that keeps on giving', our New Hampshire neighbour Jill Rodd regularly reminds me. Throughout all of this saga Sheila – who has had her own mammoth projects to complete – has been a steady and gentle beacon of direction and encouragement, most recently by selflessly taking on some of my teaching to allow me a bit of extra time to finish this book, in addition to reading large sections of the typescript as they came out of the printer. Although she was not an official member of the original Fatimid seminar of 1975 (she was preparing for her general exams), she has been with this project in every one of its myriad stages: from traipsing through the flea-infested back alleys of Cairo (only I got the fleas!) to driving across Algeria in a huge low-slung American sedan with the then American ambassador to visit the Qal'a of the Bani Hammad (she got car-sick!), typing the first drafts of the dissertation on an old Hermes manual typewriter in a steamy Cambridge attic and retyping the chapters on our first electric typewriter in a tiny town-house, writing the articles, forgetting about the Fatimids, deciding to write the book, deciding not to write the book, writing the book, discussing writing the book and finally finishing the book. I could not have done it without Robert's and Sheila's constant encouragement and support, and I thank them both deeply. At the invitation of Farhad Daftary, Robert has graciously agreed to write the Foreword to this book.

I trust that Farhad's enduring and generous patience will be sufficiently rewarded by the publication of this handsome volume. 'Better late than never', as the saying goes, although I am sure that at times he felt like 'never' was going to be the fate of this project. Indeed, I believe that at some point I finally screwed up the courage to tell him that I was dropping the project entirely, although he has had the extremely good taste never to acknowledge my decision! I am deeply honoured that he has chosen to make this book one of the Institute's publications celebrating the 50th anniversary of the Imamate of HH Prince Karim Aga Khan IV, who has been spiritual leader of the Nizari Ismaili community

since July 1957. Patricia Salazar at the Institute has calmly encouraged me to send her chapters as I finished writing and rewriting them, and her lively interest in the project has made my work immeasurably easier. It was decided to take the manuscript to a publisher experienced in producing handsome illustrated books, and I immediately suggested the London office of Yale University Press, which had published several of my earlier books. Gillian Malpass's enthusiasm for my manuscript has been deeply gratifying because her experience and wisdom are rare qualities in the world of academic publishing. How many authors have actually been entreated to *increase* the number of illustrations in their books? At the Press, Sarah Faulks has transmuted the dry text into the beautiful book you hold in your hands.

Over the years many friends and colleagues have helped – often unwittingly – while I have been writing this book by providing me with hospitality, conversation, references, offprints, etc. as well as by provoking reactions to their own ideas and publications. As they will see, I don't always agree with what they have said or written, but I'm quite sure the feelings are mutual. Indeed, as the reader will see, I don't always agree with what I myself have written in the past. I hope that differences of opinion will be accepted in the spirit of collegiality and goodwill in which they are offered. Among those I would particularly like to thank are: Eva Baer, Anna Balian, Marianne Barrucand, Adeane Bregman, Cécile Bresc, Stefano Carboni, Piet Collet, Anna Contadini, Anthony Cutler, Agnieszka Dobrowolska and Jaroslav Dobrowolski, Alison Gascoigne, Ernst Grube, Eva Hoffman, Marilyn Jenkins-Madina, David Knipp, Robert Mason, Mina Moraitou, Bernard O'Kane, Venetia Porter, Paula Sand-ers, Peter Sheehan, Eleanor Sims, Paul Walker, Nicholas Warner, Oliver Watson, Caroline Williams and Elaine Wright. In addition, the incomparable Interlibrary Loan Office at the Boston College Library has made the acquisition of obscure books and articles a breeze, often providing digital versions to my remote New Hampshire office in a matter of hours. The generous support funds for the Calderwood and bin Khalifa chairs have made it possible to take many of the pictures that illustrate this book as well as tweak certain aspects of the production.

Like the Fatimids, this book began in Tunisia and ended in Egypt. At the very last stages of writing this book Agnieszka Dobrowolska invited me to give my opinion of some Fatimid-era woodwork on the doors of the Fakahani mosque in Cairo. This, of course, necessitated a trip to Egypt where my family not only enjoyed the great hospitality of the Nederlands-Vlaams Instituut in Cairo but was also able to relax a bit along the shores of the Red Sea at Quseir, a port that flourished during the Fatimid era, while I reread the manuscript one final time.

Richmond, New Hampshire
December 2006

Since I submitted the manuscript for publication, several new books and articles related to the subjects discussed in this book have appeared, among them Cortese and Calderini, Knipp, Mulder, and Nicol. While I was unable to incorporate the new information they offer into my text, I've put references to their works in the bibliography.

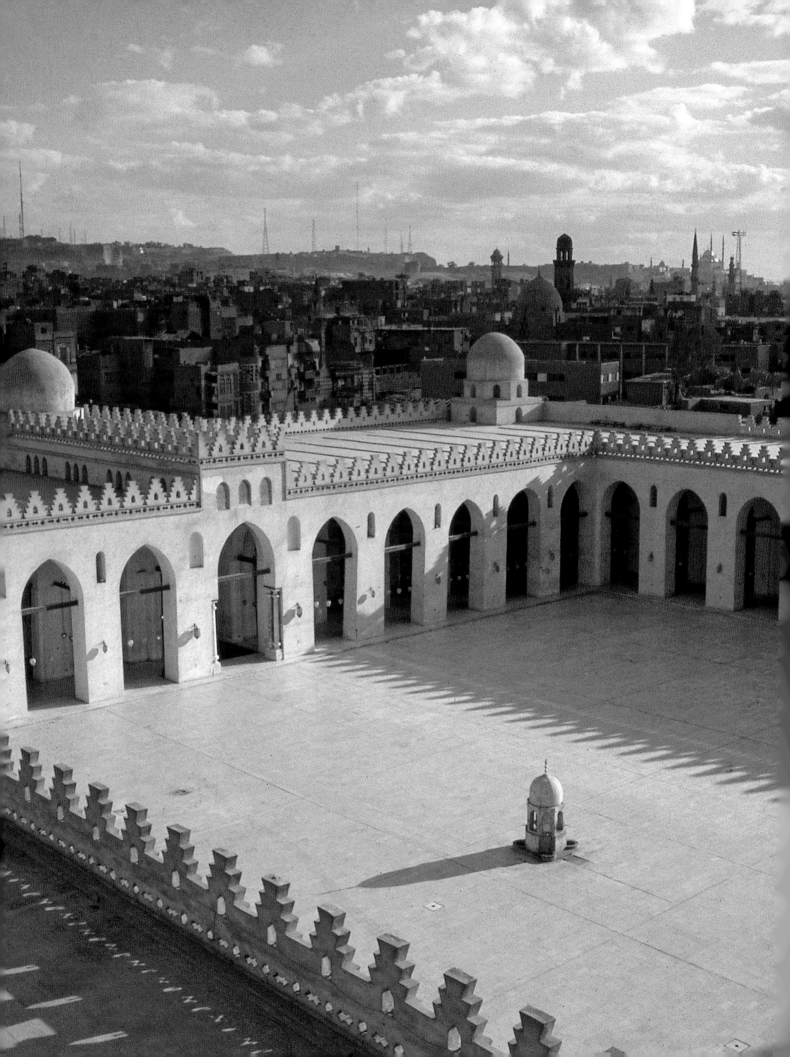

There is no doubt that the artists of Egypt under the Fātimis were skilled to a degree that found no parallel in the handicrafts of Europe. . . . This art may have succumbed for a while to the influence of the Mōsil school . . . and the Fātimy work may have owed much of its perfection to the teaching of Mesopotamian artists of a date earlier than any existing specimens; but it is impossible to overlook the existence of an ancient skill in arts of all kinds in Egypt itself, and to ascribe much of the merits of the Mamluk work to the traditions of the Fātimis.

Stanley Lane-Poole, *The Art of the Saracens in Egypt* (1886), pp. 163–4

Facing page: Cairo, Mosque of al-Hakim, detail of Fig. 45

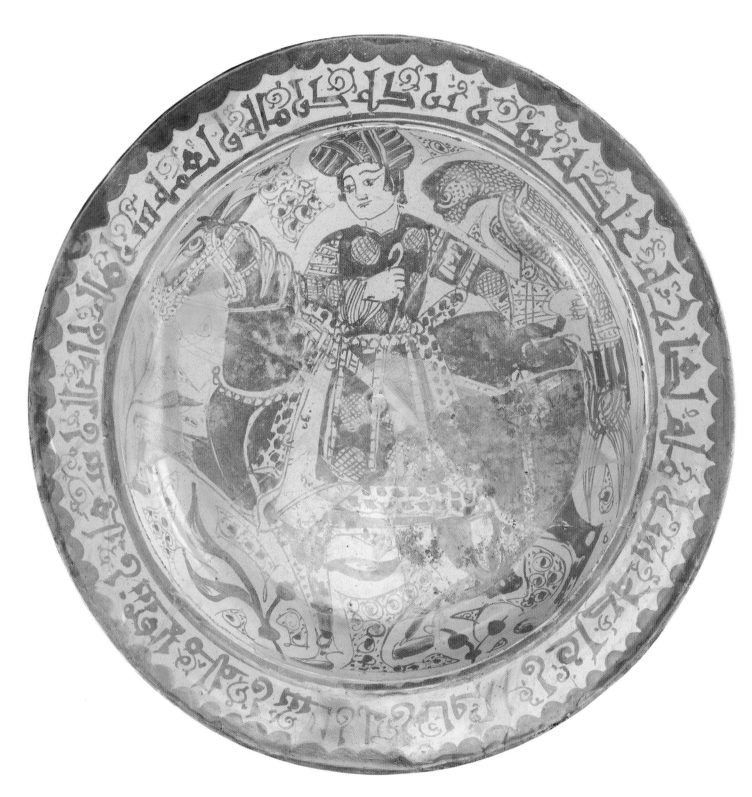

1 Earthenware plate overglaze-painted in lustre showing a mounted cavalier with anonymous good wishes on the rim. Early eleventh century(?), diameter: 38.3 cm (15⅛ in.). Washington, DC, Freer Gallery of Art, Smithsonian Institution, F1941.12

I

An Introduction to Fatimid History and Fatimid Art

This book is about the art and architecture of the Fatimid dynasty, rulers of North Africa and Egypt from 909 to 1171. In contrast to other periods of Islamic art, where our knowledge is fragmentary and its direction difficult to comprehend, Fatimid art and architecture seem to burst upon the scene in brilliant Technicolor, with new cities, great mosques and splendid palaces for the rulers filled with luxurious furnishings and a flourishing bourgeoisie that also enjoyed the same comforts of the good life (Fig. 1). Unlike many of their contemporaries, the Fatimids were Ismaili Shi'is who traced their descent from the Prophet Muhammad through his daughter Fatima (hence their name) and their seventh imam, a descendant of the Prophet, Isma'il. Espousing a messianic doctrine, they claimed that they, not the Abbasid caliphs of Baghdad nor the neo-Umayyad rulers of Córdoba, were the rightful rulers of the Islamic community and that their rule would bring about an era of peace, prosperity and righteousness. With the support of some allies among the Berbers, the indigenous population of North Africa, who were disaffected with the current regime, they established a beachhead in Ifriqiya, the region that now comprises Tunisia and eastern Algeria, in the early tenth century. They then attempted to expand their realm west to the Atlantic Ocean and the Iberian Peninsula and east to Egypt, Arabia and eventually Baghdad. Although they made no permanent conquests in the west, in 969 the Fatimid general Jawhar conquered Egypt and established a temporary camp there in anticipation of another move east in the very near future. Four years later, the fourth Fatimid caliph al-Mu'izz decided to move lock, stock and barrel from his capital in Tunisia to Egypt. He was

so confident that the North African episode had ended that he carried the remains of his ancestors in procession to Egypt. They were reburied in a special dynastic mausoleum within the new palace that his general had built for him in the now-permanent encampment, which was renamed *al-Qāhira* (the Victorious), whence the modern name Cairo (Fig. 2). At the same time, North Africa was largely forgotten and left to its own resources.

Once in Egypt, the Fatimid *Drang nach Osten* collapsed in Syria and Arabia, as other claimants also took advantage of faltering Abbasid power, thereby challenging dreams for a permanently Fatimid Syria. For the next two centuries, Egypt would remain the capital province of the Fatimid realm, while North Africa, Syria, Palestine and western Arabia would move in and more often out of the Fatimid orbit. Despite the realm's fluctuating fortunes, Cairo became the centre of a vast commercial universe that linked the Mediterranean basin to the Indian Ocean, connecting Byzantium and the rising Italian city-states in the north and west with the Islamic lands, tropical Africa and India to the south and east. Spices, silks, metals and ivory passed through Egyptian bazaars in return for timber, furs and slaves, while much of the profit stayed in Egypt, enriching both the merchants and the ruling elite. Although the Fatimids briefly occupied Baghdad and enjoyed hearing their name pronounced in the city's Friday sermon, the arrival there of the staunchly Sunni Seljuq Turks in the middle of the eleventh century began to revivify the fortunes of the moribund Abbasid caliphate and sent the Fatimid forces scampering back to Cairo. A series of internal crises in the middle of the eleventh century rocked the very foundations of the Fatimid state and the

1

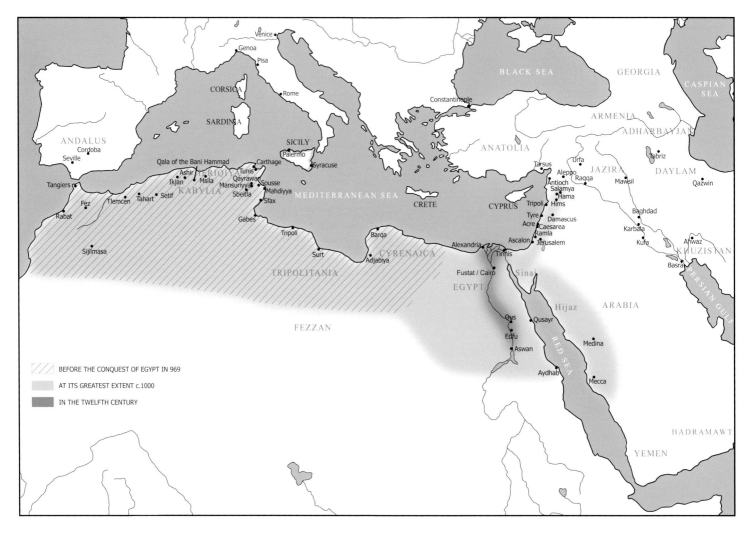

2 Map of North Africa and south-west Asia showing sites mentioned in the text as well as the Fatimid realm

Legend:
- //// BEFORE THE CONQUEST OF EGYPT IN 969
- AT ITS GREATEST EXTENT c.1000
- IN THE TWELFTH CENTURY

caliph was obliged to turn over most of his powers to a series of military viziers who ruled in fact if not in law for the next century.

The Fatimids had feared that the Seljuq *Drang nach Westen* would eventually bring them to the newly fortified gates of Cairo, but the European Crusaders' surprising capture of Jerusalem in July 1099 confused an already complex situation in the region. Instead of the Turks, the Crusaders steadily chipped away at Fatimid territory in the Levant so that by the middle of the twelfth century the Fatimids ruled little more than the Nile Valley itself. Following a complicated three-way game among the Fatimids, the Crusaders and the Zangid rulers of Syria, the young Salah al-Din, better known in the West as Saladin, became the last Fatimid vizier and then oversaw the demise of his erstwhile masters. After two centuries of Shi'i rule, Egyptians once again came to recognize the authority of the Sunni Abbasid caliph in Baghdad as the Fatimid centuries became the stuff of myth and legend.[1]

The bare outlines of the 262 years of Fatimid history are no preparation for the splendid art and architecture created under the dynasty's patronage and in Cairo's prosperous urban milieu. The Fatimids had inherited the provincial and relatively modest artistic traditions of their Aghlabid predecessors in North Africa, gradually transforming them as they took on larger and more important roles in the dramas played out in the central and western Mediterranean between the Byzantines and the neo-Umayyads of the Iberian Peninsula. But the North African prologue provides only a hint of the grand story of Fatimid art and architecture once they encountered the fertile ground of Egypt.

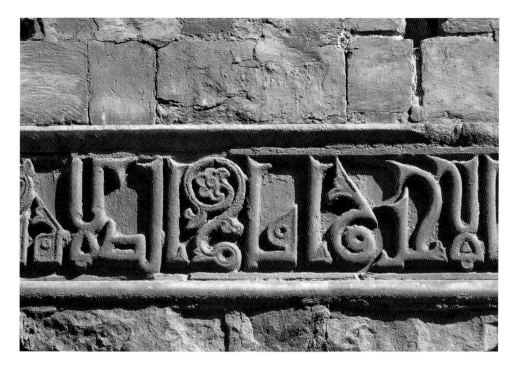

3 Floriated kufic inscription on the exterior of the west salient of the Hakim Mosque, 1013

Fatimid architecture and art in Egypt is characterized by the foundation of a new, walled capital city with magnificent palaces for the ruling caliphs and viziers, as well as large congregational mosques and smaller mosques for the general population. Shrines to descendants of the Prophet as well as mausolea for the remains of pious individuals proliferated as cemeteries appear to have taken on an increased importance in the religious life of the population. These commemorative buildings range in form from simple domed cubes to multi-roomed complexes with vestibules and auxiliary chambers. The explosive growth of Cairo encouraged builders to respond in new ways to urban pressures, whether by simultaneously orienting religious buildings to the street as well as to Mecca or by building mosques above shops let out to provide revenue to support the mosque. Stone, the traditional building material in North Africa and Egypt, reclaimed its dominance after several centuries when brick had been pre-eminent. Nevertheless carved plaster, the traditional medium for decorating brick walls, remained a major technique for embellishing interiors, and artisans excelled in creating elegant ensembles of vegetal, geometric and epigraphic ornament in stucco. The façades of buildings, particularly of mosques, seem to have become more important in this period, as the stones were carefully composed around magnificent portals often deeply and imagina-

tively carved with architectonic elements such as blind arcades, inscriptions and vegetal and geometric ornament. Fatimid architectural decoration is characterized, above all, by the extensive use of inscriptions, typically written in an elegant floriated kufic script, in which the angular forms of the letters are embellished with additional curvilinear stems, leaves and flowers (Fig. 3). Carved, painted and joined wood also plays a prominent role in Fatimid architectural decoration, whether as decorated planks serving as cornices and covering beams, carved panels set into doors or highly crafted furnishings including portable mihrabs and minbars.

Artisans of the Fatimid period also excelled in what we today call the decorative arts, which traditionally play an enormous role in the artistic production of Islamic societies. Textiles, of course, were the major medium and Egypt was – for better and often for worse – the centre of medieval linen production, for the focus on growing flax for cash instead of wheat for food led to repeated famines over the course of the period.[2] Nevertheless, gossamer Fatimid linens were decorated with tapestry-woven bands of epigraphic and lively figural ornament in colourful wool and silk, sometimes with the addition of gold-wrapped threads. The ruler gave such cloths seasonally to his courtiers, many of whom eventually used them as burial shrouds. The aridity of

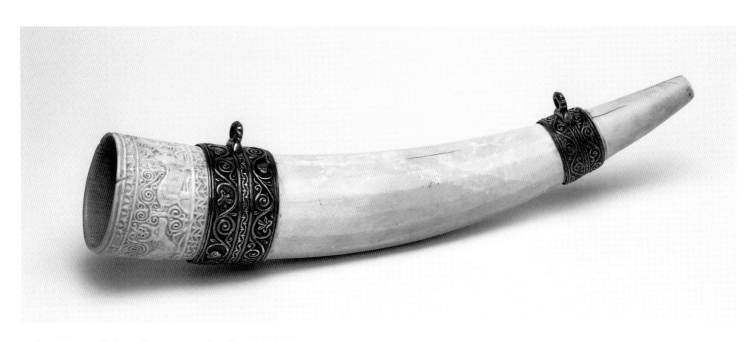

4 Carved ivory oliphant, Egypt, *c.*1000. London, British Museum OA+1302

the Egyptian climate explains why so many of these buried textiles have been preserved, but other weaving techniques that produced all-over patterns were also used, although fewer of these types of textiles have survived. Artisans carved ivories (Fig. 4) and rock crystals with exquisite precision and glass-blowers and potters decorated their finest wares with iridescent lustre designs. Smiths worked in a variety of metals and techniques, ranging from granulated gold and silver decorated with niello to cast or hammered and chased alloys of copper.

In addition to this wide range of media, Fatimid art is notable because many works show a predilection for lively, often naturalistic figural ornament depicting humans and animals engaged in a variety of activities, from wrestling to drinking, hunting to riding (Fig. 5). The widespread use of figural ornament, normally rare in Islamic art, has made Fatimid art particularly popular in the West and scholars have spilled a great deal of ink trying to explain what exactly these figures are doing and what they mean.[3]

For this and other reasons the arts of the Fatimid period seem to defy most of the conventions of Islamic art in medieval times. Since the revelation of Islam in the seventh century, the general trend in the visual arts had been away from figural representation. Muslims preferred vegetal, epigraphic and geometric ornament, especially for their public and religious art, and what figural ornament persisted became increasingly abstract.

Although the Fatimids produced no figural religious art, their secular art apparently ignores this trend, so scholars have consequently wondered why: did it have something to do with when and where the Fatimids appeared, who they were or what they believed?

The Umayyads, the first Islamic dynasty, had created their art in the context of late-antique Syria, where Mediterranean artistic traditions were strong, but the Abbasid dynasty had made their capitals in Mesopotamia, looking unwaveringly towards Iran and Central Asia for artistic inspiration. Whereas Umayyad art can be seen as the brilliant last gasp of late-antique artistic traditions in the Mediterranean region, Abbasid art is the first original visual expression of the new civilization of Islam. Abbasid models were widely emulated throughout the Muslim world, as the prestige of Abbasid capitals at Baghdad, Raqqa and Samarra radiated across Eurasia and North Africa. The Mediterranean focus of Fatimid art is not a return to Umayyad precedent, for the Fatimids would have considered anything identifiably Umayyad to be contemptible, but rather the realization of a geopolitical imperative long attested by history, in which the relative artistic vacuum in Egypt since the eclipse of Romanism was finally filled by the presence of able and willing patrons and artists. Did Coptic, or indigenous Christian, communities in Egypt preserve these artistic traditions through the first three centuries of Islamic rule and bring them to the attention of Fatimid era artists (Fig. 6)?

4

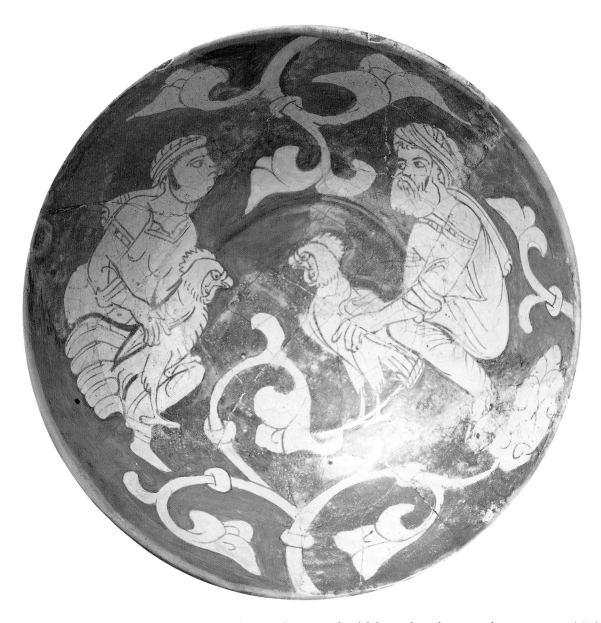

5 Earthenware bowl overglaze-painted in lustre with a scene of cockfighting, eleventh century, diameter: 23.7 cm (9⅓ in.).
Ham, Surrey, Keir Collection, no. 88

Furthermore, in a period dominated not only by the increased role of Iran and Central Asia in the emerging Islamic culture but also by the actual movement of large numbers of Central Asian Turks into south-west Asia, the eastward expansion of a North African Fatimid culture to Egypt and Syria was an unusual movement from west to centre that threatened the very heartland of the Abbasid empire and its Islamic culture. While the role of the Central Asian Turks in the development of medieval Islamic societies has long been studied, the role of North African Berbers is much more poorly understood.[4] What role might they have played in the formation of a distinctive Fatimid art?

Finally, the Fatimids were the most prominent and successful dynasty of what has been called the 'Shi'i century', when Shi'is ruled most of the former Abbasid lands: in addition to the Fatimids in Algeria and Tunisia, Sicily, Egypt, southern Syria and western Arabia, their sometime allies, the Ismaili Qarmatis, controlled eastern Arabia. Meanwhile, the Zaydi Buyids (or Buwayhids) ruled most of Iraq and Iran, the Hamdanids ruled northern Syria and several lesser Shi'i dynasties ruled parts of northern Syria and northern and southern Iraq. Apart from the Buyids, the Fatimids were the only Shi'i dynasty to play a major role in the arts until the advent of the Safavids in sixteenth-century Iran.[5] In

5

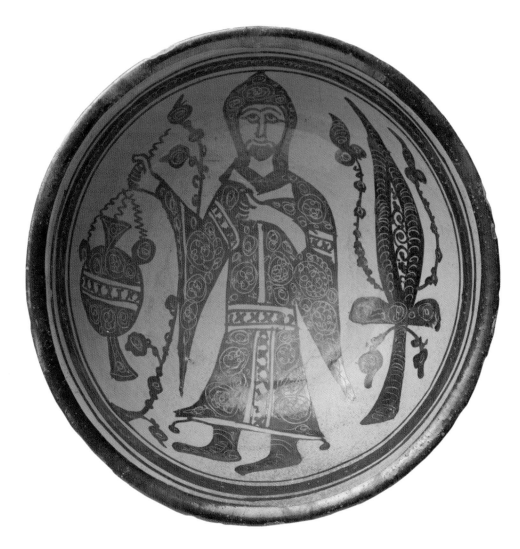

6 Two views of a deep fritware bowl with depiction of a Coptic priest, inscribed twice on the exterior with the word or name *sa'd*, second half of eleventh century, diameter: 23.5 cm (9¼ in.). London, Victoria and Albert Museum, C.49-1952, purchased with the assistance of The Art Fund and the Bryan Bequest

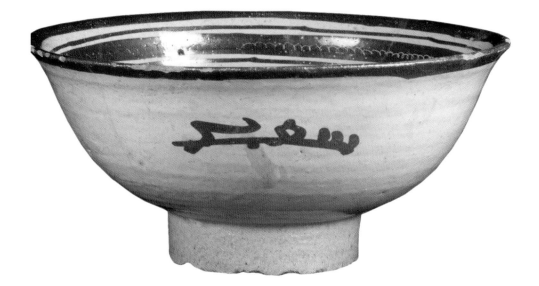

the face of the Seljuqs' militant Sunnism, Shi'i successes would soon crumble everywhere in the Central Islamic lands except in Egypt, which managed to hang on for another century, although at no time did the majority of the Egyptian population adopt Ismaili beliefs. The eleventh and twelfth centuries under the Seljuqs were a period of extraordinary artistic creativity in the eastern Islamic lands, as many new techniques and ideas, ranging from madrasas to muqarnas, new scripts to arabesque and geometric decoration, were developed and refined.[6] How much of that filtered – or was able to filter – into the Fatimid realm?

It is tempting to view the art of the Fatimids as a dynastic art, in much the same way that such later dynasties as the Timurids, the Safavids, the Ottomans or the Mughals created dynastic styles of art by which they distinguished themselves from their contemporaries. As we shall see, there are several reasons why this may not be the best way of looking at Fatimid art. First, only one portion of what survives – early congregational mosques, figural woodwork, tiraz textiles and rock crystals, for example – was indubitably commissioned by and for the rulers. Other examples, including even the walls and gates of Cairo, smaller mosques and a few ceramics and metalwares, are known to have been ordered by or for the powerful viziers and the upper echelons of the court. Still other pieces, including the vast majority of the lustre ceramics that 'characterize' Fatimid art, were anonymous products presumably made for the market. So from the perspective of patronage, what we today call Fatimid art reflects a broad range of tastes from the court to the bourgeoisie.

Second, there is little evidence that the Fatimids or their contemporaries thought much about styles, in dynastic or any other terms. As they sat in their palaces or paraded around the city in elaborate processions, Fatimid rulers – like contemporary rulers everywhere – probably thought more about the material wealth their art represented rather than about any stylistic or symbolic meaning it might have. Fatimid art is, as we shall see, a continuation and intensification of techniques and styles that had already been developed in Egypt or practised elsewhere and brought to Cairo by artisans in search of good jobs and high pay. Many of the characteristic features of Fatimid art, such as the use of public inscriptions in kufic script, are used elsewhere or in Egypt by the Fatimids' successors; conversely, many of the developments said to distinguish the arts of the Fatimids' contemporaries, such as the use of cursive writing and geometry, are also found in Fatimid art – if one only cares to look.

Some scholars have attempted to detect a distinctly Shi'i, indeed Ismaili, quality to Fatimid art, whether in the concentric circles that decorate their coins (see Fig. 23) or in the repeated niches that decorate their buildings, but it is difficult, if not impossible, to argue that such meanings were held consistently over time. One can easily imagine that some designs, such as the seven-point stars on the cenotaph of al-Husayn (see Fig. 136), might have been intended to subtly remind the viewer of the seven imams of the Ismaili line, but the six- and eight-point stars in other designs have no such meaning and are simply there for their visual delight. Although Ismaili adepts were trained at seeing the hidden meanings behind outward appearances, such meanings would have been lost to virtually all other eyes since so few adopted the Ismaili beliefs of the rulers. After the fall of the Fatimids, some individuals carefully excised phrases from some inscriptions they found particularly offensive, presumably because of their Shi'i content (Fig. 7). I know of no cases, however, where any pictorial or graphic expression was similarly defaced because its content was thought to be too obviously Ismaili.

Finally, even if the Fatimids had wanted to create a dynastic style in the relatively small region they ruled, they didn't yet have the means to ensure the consistency of artistic expression from one medium to another, for the idea of doing preliminary drawings on a relatively inexpensive and disposable medium like paper was just beginning to take root at that time. The period of Fatimid rule in Egypt coincides with the period in which paper replaced papyrus, the traditional writing material of Egypt for nearly four thousand years, and parchment, the material on which the Qur'an was copied. Visitors to Egypt at the beginning of the period still mention papyrus as a writing material. By the end of the Fatimid period, papyrus seems to have become a curiosity used for amulets and charms. Paper, which could be made virtually everywhere from almost any plant material, became the preferred medium for general writing and eventually even for copying the Qur'an. After the introduction of paper to the Islamic lands, paper-mills were successively established in Samarqand, Baghdad, Damascus and Egypt. While authors quickly took advantage of the new medium, it would be several centuries, however, before paper became common and cheap enough for artists and artisans to use it as a throwaway medium on which to work out their designs before transferring them to a more durable – and more expensive – surface. The process is just beginning to be understood. Although virtually no

7 Kufic inscription on the exterior of the Great Mosque of Sfax recording its reconstruction in 980–1; at a later date the inscription was carefully defaced, presumably to remove sentiments deemed offensive

books from the Fatimid period have survived, the rubbish-heaps of Cairo have preserved innumerable paper fragments on which this transformation was written – and drawn.[7]

Why the Fatimids? Although some surviving artifacts and buildings from the Fatimid period can indeed be beautiful and even exquisite, they are rarely like Persian miniatures or Oriental carpets whose sheer beauty speaks directly to a viewer, whatever his or her background. Many more of them are mere fragments and demand leaps of imagination to make them come together and come alive. Although a few artists' names have been identified, it is far too early to be able to delineate the oeuvre, let alone the career, of a particular individual talent. Instead, the art of this period is interesting and exciting because of its context: it was produced in the first period in the history of Islamic art when the surviving monuments are reinforced by a rich array of medieval sources that help us understand the shape of a long-past time in ways that are rare for other periods. Certainly written sources can help us understand the artistic monuments of Umayyad Syria and Abbasid Iraq, but the monumental record is very fragmentary and the texts are few in number and limited in quality.

Thanks to the increasing availability of paper, however, the Fatimid period was a period of substantial literary activity; nevertheless few sources have survived from this period in their original form.[8] Some of them were lost or destroyed in the transition from one dynasty to another; others are Ismaili sources that were long hidden and are only recently coming to light. Probably the most important source for the period remains the work of Taqi al-Din Ahmad b. ʿAli al-Maqrizi (1364–1442), the Mamluk historian who traced the history of his native city and its founding dynasty in several encyclopedic books. A student of the great Ibn Khaldun, al-Maqrizi may have been the first historian to understand that the history of space – a city, a building – can reveal as much as any text or document. To that end, he attempted to reconstruct the vanished Fatimid city by tracing its walls and streets and enumerating its mosques and palaces in his massive book, *Exhortations and Instructions on the Districts and Antiquities*, usually known as the *Khiṭaṭ* ('Districts' – like all Arabic titles, it sounds much better in the original language as *al-Mawāʿiẓ waʾl-iʿtibār bi-dhikr al-khiṭaṭ waʾl-athār*).[9] Al-Maqrizi also wrote a chronicle of Fatimid history from its origins to the end of the dynasty, *Admonitions of the Orthodox*, usually known as the *Ittiʿāẓ* ('Admonitions').[10]

8

In both these books he gathered together many sources, some extant or partly extant today but many more long vanished, that date either from the Fatimid period itself or from shortly thereafter. Al-Maqrizi's interest in the visual world is unique and his writings provide an invaluable companion to understanding virtually every aspect of Fatimid art. Nevertheless, it should always be remembered that al-Maqrizi lived between three and five centuries *after* the events he chronicled, so he can hardly be considered a contemporary source.

One of the contemporary sources al-Maqrizi repeatedly cites in regard to the fabulous treasures that the troops looted from the Fatimid palace in the middle of the eleventh century is the *Book of Treasures and Curiosities*, written in Arabic by an anonymous eyewitness to the events in question. Long thought to have been lost, the manuscript was discovered in the 1950s in the Gedik Ahmet Paşa Library at Afyonkarahısar in Turkey and subsequently published in an Arabic edition and translated into English.[11] Other sources cited by al-Maqrizi, as well as the first draft of his *Khiṭaṭ*, are slowly being discovered in dusty libraries, but rarely are they as concerned with the material and visual world as the *Book of Treasures*. Several eyewitness accounts of Fatimid North Africa and Egypt by geographers have also survived, including *The Best Divisions for Knowledge of the Regions* written *c*.985, just after the foundation of Cairo, by the Jerusalem native al-Maqdisi (sometimes called al-Muqaddasi).[12] Dating from the middle of the eleventh century is the Persian Ismaili Nasir-i Khusraw, whose *Book of Travels* recounts his visit to Cairo during the long reign of al-Mustansir.[13]

Perhaps the most important source to be studied in recent years is the collection of some 300,000 documents, most of them on paper, discovered in the nineteenth century in a storeroom (known in Hebrew as a *geniza*) of the Palestinian Synagogue in Fustat (Old Cairo). Dating largely from the mid-tenth to the mid-thirteenth centuries, the Geniza documents include bills of exchange, orders of payment, trousseau lists, contracts, letters, deeds, etc. put aside for eventual burial because medieval Jews believed that any piece of writing that possibly contained the name of God should be treated with great respect. Although the documents pertain specifically to the Jewish community of Cairo and their trading partners from southern Europe to western India, much information about medieval commercial society – whether Jewish, Muslim or Christian – in the Mediterranean basin has been extrapolated in a series of books and studies by the late S. D. Goitein and many others.[14] Trousseau-lists and wills, for

example, provide unparalleled information about material culture in the period.[15] Sources such as these establish the contexts in which to look at and better understand the architecture and arts of the Fatimid period.

This book is intended to be read not only by students and historians of Islamic art and Islam but also by general readers, particularly those interested in the history and culture of the Ismailis, a world-wide community of Muslims who revere as their spiritual leader the Aga Khan, direct descendant of the Prophet Muhammad and all the Fatimid imam-caliphs through the caliph al-Mustansir (*r*.1036–1094). I have therefore conceived of it principally as a narrative to be read, not as a reference work for scholars to consult in the hope of finding a mention of every known example of everything. I believe that historians have a responsibility to present readers not only with analysis but also with synthesis, in other words, 'the larger picture'. To that end I have tried to provide some generalizations and look at how the arts of the Fatimid period relate and compare synchronically with the arts elsewhere in the Muslim world and diachronically with the arts of other periods in Egypt. Although I acknowledge that the subject of this book may, in the larger scheme of things, be considered somewhat rarefied, I have tried to steer a judicious course between presenting my ideas in a clear and straightforward manner and referencing the extensive scholarly literature – and controversies – that can qualify virtually every statement one attempts to make about Fatimid art. Many of the issues I deal with in these pages remain undecided and the subject of lively scholarly debate, yet many, if not most, readers will be happy to ignore some of the finer points that are discussed or referenced in the endnotes. I have also used a simplified system of transcribing names and words from Arabic, except in italicized text and the endnotes. The subscript dots and macrons so beloved of scholars are arcane mysteries to all others. I have also used Common Era dates throughout.

Following this introduction, I present the history of Fatimid art and architecture in three broad periods and six chapters: the Fatimids in North Africa from the foundation of the dynasty in 909 to the expedition to Egypt in 969 (Chapter 2); the Fatimids in Egypt from the foundation of Cairo to the crises of the 1060s (Chapters 3 and 4); and finally the Fatimids in Egypt from Badr al-Jamali's restoration of power to the end of the dynasty in 1171 (Chapters 5 and 6). While I treat all the arts of the North African period together in Chapter 2, I deal with each of the Egyptian periods in

two chapters, one devoted to architecture and the other devoted to the decorative arts. Occasionally coverage overlaps slightly, especially in the discussion of wood-work which can be considered as either architectural fittings or independent furnishings. A final chapter (Chapter 7) summarizes the legacies of Fatimid art in Egypt and elsewhere from the fall of the dynasty to recent times.

No work of this type can be done without standing on the shoulders of past (and far greater) scholars. Some of the greatest orientalists have studied various aspects of Fatimid history and art for well over a century, thanks to the publication of such seminal texts as Ibn al-Athir's continuation of al-Tabari's *History* (Leiden, 1851–76), al-Maqrizi's *Districts* (Bulaq, 1853) or Nasir-i Khusraw's *Travels* (Paris, 1881). Even before then, interest in the Fatimids had been spurred by the French orientalist Silvestre de Sacy's *Exposé de la religion des Druzes* (Paris, 1838), which concerned the beliefs of the followers of the Fatimid propagandist al-Darazi who claimed the divinity of the imam-caliph al-Hakim. De Sacy's *Druzes* were 'atheistic revolutionaries who drew upon Shi'ite political fanaticism and a mixture of Greek and Persian philosophy'.[16] Later in the century, the German orientalist Ferdinand Wüstenfeld composed the first history of the dynasty in a European language.[17] Although he based his work on Arabic sources, they were all Sunni; Ismaili sources have only become accessible to scholars in the twentieth century, although to my knowledge the new information they provide has not yet had a particularly great relevance to the visual arts.[18]

The publication of primary texts and secondary sources in the nineteenth century began to pique the interest of other scholars anxious not only to relate extant works of art to texts but also to imagine – like al-Maqrizi had done centuries before – what had been lost over the intervening years. In the late 1880s, for example, the French scholar Paul Ravaisse used al-Maqrizi's text to trace the outlines of the long-vanished Fatimid palaces on the plan of present-day Cairo (Fig. 8), the results of which he published in 1889–90.[19] He was soon followed by the Swiss scholar Max van Berchem, who was particularly interested in inscriptions and a cascade of scholarship on the Fatimid period soon followed.[20] During the first half of the twentieth century, the French scholar Gaston Wiet (1887–1971) not only continued van Berchem's work on inscriptions, but also wrote on several specific examples of Fatimid art, many of which might initially have crossed his desk after 1926 when King Fu'ad appointed him Director of Cairo's Museum of Arab Art.[21]

Despite the centuries of renovation and rebuilding of Cairo's urban core, a few Fatimid buildings continued to poke through the dense fabric in better or worse condition to also provoke the curiosity of scholars. They debated such questions as whether the arches of the al-Azhar mosque were 'Persian' in inspiration or whether the dome over the entrance to the prayer-hall had 'Sicilian' or 'Coptic' influence.[22] At roughly the same time, such scholars as Stanley Lane-Poole realized that the sherds of lustre ceramics he observed in the rubbish-heaps to the east of Fustat (Old Cairo) after high winds had blown away the dust probably dated to the Fatimid period, because the site had been burned and abandoned in 1168 at the very end of the Fatimid period.[23] Unfortunately, Fustat's proximity to the burgeoning capital meant not only that its ruins continued to provide building materials (as well as fertilizer for local farmers) but also that it continued to serve as a dump for the capital's refuse, so the stratigraphy of the site can be very confusing indeed.

Most archaeologists working in Egypt at the time tended to focus on recovering artefacts from the Pharaonic period and ignoring anything that lay above, but a few intrepid individuals evinced some curiosity about Islamic finds. In 1877–8, excavations in the Fayyum produced more than 100,000 documents of which some 20,000 were on paper and dated between the ninth and the fourteenth centuries. They were acquired by Archduke Ranier of Austria in 1884.[24] Perhaps inspired by Lane-Poole's report, in the winter of 1896 the Swedish scholar and dealer F. R. Martin excavated and removed several thousand ceramic fragments from Fustat.[25] Although the Egyptian Committee for the Conservation of Monuments of Arab Art had been founded in 1881, official excavation at the site was only begun in 1912 by the newly established Museum of Arab Art. Ali Bahgat, who directed the excavation until about 1924, collected thousands of objects, some of considerable value, for the Museum, but he kept no record of what was found where. Modern archaeology, focusing less on the recovery of artefacts and more on the comprehensive examination of the material remains of the past, began at the site in 1964 as Cairo's town planners eyed Fustat's ruins as potential open space for modern construction.[26] Since then, new large-scale scientific excavations and rescue missions have been undertaken by the Egyptian Antiquities Department and the American Research Centre in Egypt (ARCE), directed by Professor George Scanlon of the American University in Cairo.[27] Although they have not produced many spectacular finds, they have provided extraordi-

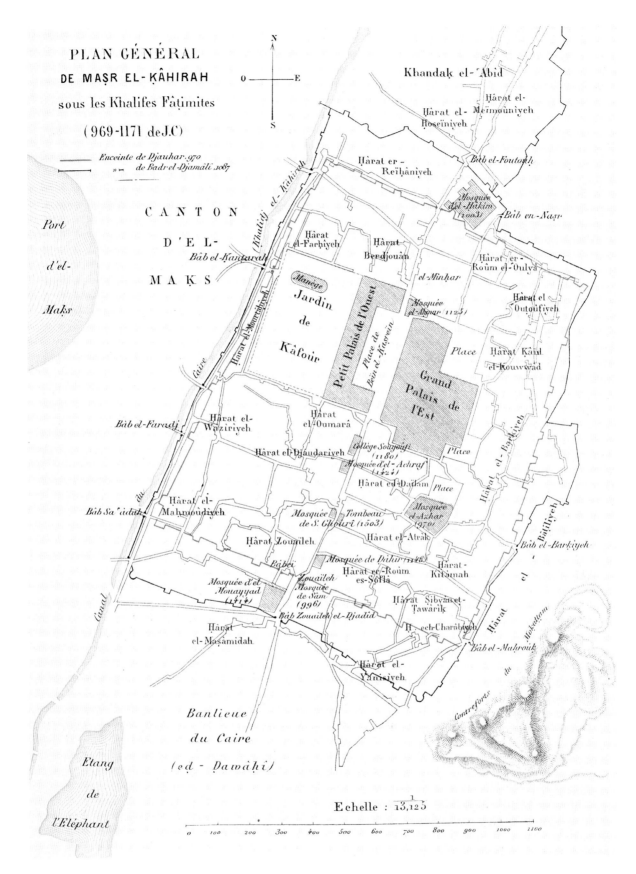

PLAN GÉNÉRAL
DE MAṢR EL-ḲÂHIRAH
sous les Khalifes Fâṭimites
(969-1171 de J.C)

———— Enceinte de Djauhar .970
» — de Badr el-Djamâli .1087

N
O — E
S

Khandaḳ el-ʿAbid

Ḥàrat el-Meïmoûniyeh
Ḥàrat el-Hoseïniyeh
Ḥàrat er-Reïhâniyeh
Bàb el-Foutoûḥ

Mosquée d'el-Hàkim (1003)
Bâb en-Naṣr

CANTON
D'EL-
MAḲS

Port
d'el-
Maḳs

(Khalidj el-Ḳâhirah)
Bâb el-Ḳantarah

Ḥàrat el-Farḥiyeh
Ḥàrat Berdjouàn
el-Minḥar
Mosquée el-Aḳmar (1125)
Ḥàrat er-Roûm el-Oulyâ
Ḥàrat el Outoûfiyeh

Manège
Jardin
de
Ḳàfour

Petit Palais de l'Ouest
Place de Baïn el-Ḳaṣrein
Grand Palais de l'Est
Place
Ḥàrat Ḳàid el-Kouwwad

Ḥàrat el-Mouraḥḥyeh

Ḥàrat el-Waziriyeh
Bâb el-Faradj

Ḥàrat el-Oumarâ
Ḥàrat el-Djaudariyeh
Collège Soujoûṭi (1180)
Mosquée d'el-Achraf (1424)
Ḥàrat ed-Daïlam
Place
Ḥàrat el-Barḳiyeh

Bâb Saʿàdah
Ḥàrat el-Mahmoûdiyeh

Mosquée de Sʿ Ghoûri (1503)
Tombeau
Mosquée el-Azhar (970)

Ḥàrat Zouaïleh
Ḥàrat el-Atrak
Bàb el-Barḳiyeh

Mosquée de Dahir (1148)
Ḥàrat er-Roûm es-Sôflâ
Ḥàrat el-Kitâmah
Bâb el-Bâtiliyeh

Bàbei
Zouaïleh
Mosquée d'el-Monayyad (1414)
Mosquée de Sâm (996)
Bâb Zouaïleh el-Djadîd
Ḥàrat Sibyaïet-Ṭawârik
H. ech-Charâbiyeh
Bàb el-Mahroûk

Ḥàrat el-Maṣàmidah
Ḥàrat el-Yanisiyeh

Banlieue
du Caire
(eḍ-Dawâḥi)

Étang
de
l'Éléphant

Echelle : 1/13,125

0 100 200 300 400 500 600 700 800 900 1000 1100

8 Plan of Cairo in the Fatimid period by Paul Ravaisse (1889) based on information provided by the fifteenth-century historian al-Maqrizi

narily detailed and nuanced information about the realities of daily life in Fatimid-era Egypt.

While the majority of Fatimid architecture was built in Egypt and remains there, there are still important sites in Tunisia and Algeria, with some comparable material in Sicily. Most of the North African material remains very poorly published since the end of the colonial period.[28] Many pieces of woodwork and ceramics – or at least the fragments discovered in excavations – also remain in Egypt, yet large collections of ceramics, many presumably excavated unofficially in Egypt, are housed in other countries, for example at the Benaki Museum in Athens.[29] Paradoxically, complete works in rock crystal, ivory and glass are more often found in European church treasuries and museums than in the land of their manufacture.

Previous books and shorter works on Fatimid art and architecture have tended to study Fatimid art by dividing it by medium – rock crystal, textiles, ceramics, glass, etc. – or by milieu – the palace and the royal city, religious life, daily life and the spread of Fatimid art.[30] Some scholars have focused on particular aspects of Fatimid art, whether individual media, such as painting, ceramics or woodwork, the royal treasures or monumental inscriptions.[31] The French scholar Marius Canard, following in the work of the Russian K. A. Inostrantsev (1876–1941), studied Fatimid ceremonial, a subject that has recently evolved into the study of Fatimid performance.[32] Some other research has dealt specifically with the history of Cairo, whether generally or particularly in the Fatimid period.[33] For the study of Fatimid architecture, nothing can or will ever compare with K. A. C. Creswell's magisterial *The Muslim Architecture of Egypt*, published in 1952, of which the first volume is a series of monographs on Fatimid architectural monuments, ranging from great mosques to small tombs and excavated houses. While his studies are marvels of careful measurement and observation, Creswell would have been the first to admit that he had little interest in interpretation and meaning, so many subsequent architectural historians have dealt with individual buildings or groups of buildings and their meanings, whether overt or hidden.[34] In short, there is no lack of work on virtually all aspects of Fatimid art, yet there has been as yet no comprehensive overview to which an interested reader can turn.[35]

For example, the most readily accessible introduction to the art and architecture of the period in English, *Islamic Art and Architecture: 600–1250*, by the late Richard Ettinghausen, Oleg Grabar and Marilyn Jenkins-Madina, deals uneasily with the subject because of the way they divided their book into periods before and after 1000 and central, western and eastern regional sections.[36] They were uneasy with Fatimid art, which straddles almost all these categories and placed most, but not all of it, under the rubric of Medieval Islamic Art of the Central Islamic Lands, i.e. Part Two, Chapter 6, Part I. 'To these organizational divisions we made one partial exception. The rich and brilliant period of the Fatimids (909–1171) could not, we felt, be cut into separate temporal or regional components in order to fit into our broad order of Islamic history. It belongs to the Muslim west as well as to the area of the central lands and it flourished during a period covered by both of our broad categories. We ended by putting most of its art in the Medieval Islamic section and in the central lands for reasons that will be explained in due course, but some early Fatimid objects are discussed under western Islamic lands in the earlier period. This is, no doubt, a shaky accommodation to a reluctant history.'[37]

This book proposes to treat all of the arts of the Fatimid period, whether North African or Egyptian or even Syrian, whether art or architecture, as a unified whole. Rather than deal thematically with my subject, I have chosen to organize my material chronologically, with a decided emphasis on securely dated examples. The Fatimids ruled for 262 years, of which 202 were in Egypt alone. Over the course of those years a lot of water flowed down the Nile and there is every reason to believe that Fatimid art in the tenth century was different from that in the twelfth, just as American art in the eighteenth century is different from that in the twentieth. Museum labels and catalogues routinely describe something as 'Egypt, eleventh-twelfth centuries', which actually covers a lot of time. Isn't there some way of making such attributions more precise? Focusing on dated or datable examples has allowed me to establish a scaffold from which to suspend undated examples, but in general I have left that second task to others. I have also tried to include representative examples of all forms of art, ranging from monumental buildings to delicate ivories and have tried to write only about examples that I can illustrate. Given the limited patience of readers and publishers, I have had to limit my discussions so that some well-known pieces in major collections will not be found here. It is very easy to say that something 'looks' Fatimid; it is more difficult to prove that it is.

My approach is, I will be the first to admit, a rather old-fashioned one, but it was very successful in *The Art and Architecture of Islam: 1250–1800*, a book I co-authored over a decade ago.[38] I have tried to look critically at my sources, both medieval and modern, and will readily admit that I find some – but certainly not all – of my earlier arguments about some aspects of Fatimid architecture difficult to maintain today. I have also tried to be as sceptical as I can be without being nihilistic. Interpretations change as new discoveries are made and we learn more about our subject. No doubt were I to write this book again several decades from now, I might reach some very different conclusions, but this one has already taken quite enough time to finish.

II

Fatimid Art in North Africa

The glorious art of the Fatimid dynasty had the most inauspicious beginnings. Nothing in the early history of the movement in Iraq or Syria would suggest an unusual interest in the visual arts, but as the Fatimid rulers in North Africa transformed their revolutionary movement into a political state and laid their plans for expansion to other regions of the Muslim world, their attitude changed. Indeed, the rulers increasingly used the visual arts to bolster their claims to legitimacy in the eyes of not only their subjects but also their rivals in the Mediterranean basin, particularly the neo-Umayyad rulers of Spain and the Byzantine emperors of Constantinople. Such a change suggests that the Fatimids' entry onto the larger stage of international diplomacy turned their attention to art, rather than any inherent sense that their mission could be expressed in visual terms. Before 969, when the Fatimids conquered Egypt from their base in North Africa, they had amassed great wealth from the surplus agricultural production of North Africa and their control of the lucrative trans-Saharan trade, yet they were ultimately limited in their artistic achievements by the meagre artistic resources available to them then and there. Despite the interest and importance of this early period for setting the stage for the Fatimid achievement, only after the conquest of Egypt did the various elements come together to allow the creation of a brilliant era of visual art.

Fatimid Origins

All Shi'is believe that the leadership of the Muslim community was transferred from the Prophet Muhammad through his daughter Fatima and son-in-law 'Ali, the fourth caliph, to their descendants. Following the death of Muhammad's great-great-great grandson, the Shi'i imam (leader) Ja'far al-Sadiq, in 765, the Shi'a were divided over the succession, because Ja'far's son Isma'il, who he had already designated as his heir, was not present at the time of his father's death; he had either predeceased him or had disappeared. Some of Isma'il's followers denied his death and expected his return as a Messiah (*al-mahdī*, 'right/just guide'), while others transferred their allegiance to either Isma'il's son Muhammad or Ja'far's sons 'Abd Allah and Musa. Shi'i doctrine has at its centre the idea of the *mahdī* or 'the one who appears' (*al-qā'im*) as a redeemer-like figure in the body of a descendant of the Prophet Muhammad who will restore true Islam and 'fill the earth with justice and righteousness.'

The origins of the Fatimid dynasty in Iraq and Syria are murky indeed.[1] Like all Shi'is, they claimed descent from the Prophet Muhammad through his daughter Fatima, yet the exact line of descent was never very clear. In recent decades specialists in Ismaili and Fatimid history have laboriously strung together snippets of information culled from a bewildering variety of later and distant sources to create a coherent and detailed narrative of the origin of the Fatimids.[2] Other scholars, however, have questioned whether it is appropriate to accept these later sources at face value, for the information they convey may very well have been coloured by later authors' desire to foster a particular interpretation of the distant events in question.[3] Despite all the scholarship the story remains confusing and many aspects are still conjectural. The combination of heterodox religious beliefs combined with a certain

Facing page: parchment folio from the Blue Qur'an

amount of cloak-and-dagger theatricality has extraordinary resonance for modern ears.

The religious doctrine known today as Ismailism – they called themselves the followers of 'the true religion' or 'the Truth' – evolved in the middle of the ninth century in the Iranian province of Khuzistan. 'Abd Allah ('the Elder'), a prosperous merchant, began teaching the doctrine in the bustling commercial town of 'Askar Mukram, located on the Karun River north of al-Ahwaz. So long as the *mahdī* remained in hiding, a deputy was needed to prepare for his return and 'Abd Allah assumed that role. Accompanied by his disciples, he was forced to flee to Basra in southern Iraq, where he was accepted as a member of the 'Aqil family (descendants of 'Ali's brother 'Aqil) of the Hashim clan and continued his teaching and preaching, gathering a community of followers. Fearful of persecution, 'Abd Allah was then forced to flee to the town of Salamya (also known as Salamiyya), located some 30 kilometres south east of Hama in Syria. At this time, the Abbasids were recolonizing this region and 'Abd Allah was able to establish himself in a house near the market in the guise of 'a merchant from Basra.' He was buried in the town and his grave is still revered.[4]

Towards the end of the ninth century, 'Abd Allah's grandson, Abu'l-Shalaghlagh, expanded the Ismaili mission beyond Syria. An Iraqi clandestine group was founded in 875 or 878; a propagandist-missionary (Arab. *dāʿī*) was active in Yemen in 881 or 882; two years later another one sailed from there to Sind (now in Pakistan) and in 893 the first mission was established in present-day Algeria. Abu'l-Shalaghlagh died without a male heir and subsequently his nephew Saʿid ibn al-Husayn (b. 31 July 874), who would eventually assume the name and messianic title 'Abd Allah ('the Younger') *al-mahdī*, succeeded to the leadership of the Ismailis. Some confusion arises not only because there were two 'Abd Allahs but also because later non-Ismaili authors invariably referred to this second figure by the diminutive – and pejorative – name 'Ubayd Allah ('the little slave of God'), which is how he is usually known to history.

Differences of opinion about the succession to 'Abd Allah al-Akbar, who died at Salamya sometime after 874, as well as about the nature of the Ismaili mission led to a major split into two rival factions. The first faction comprised the loyalists, followers of Saʿid ibn al-Husayn, who recognized continuity in the imamate. Instead of claiming, as had his predecessor, that he was merely the agent of the absent imam Muhammad ibn Ismaʿil, Saʿid claimed that the imamate had actively continued in his family all along. The loyalist camp

included the bulk of the Ismailis in Yemen, as well as the Ismaili communities founded in Egypt, North Africa and Sind. A second dissident group rejected this claim, believing that the absent imam Muhammad ibn Ismaʿil would himself eventually return as the *mahdī*. They became known as the Qaramita (the plural form of Qarmati) or Qarmathians, after one of their original leaders in Iraq, the missionary Hamdan Qarmat, who had been actively propagandizing in the region near Kufa.[5] The dissident communities were concentrated in Iraq, Bahrayn, Iran and Central Asia. The Qarmatis would later seriously challenge the authority of 'Abd Allah's descendants in Egypt and Syria.

Prelude in Syria

The secret and revolutionary nature of the early Ismaili cause, as well as its decentralized quality, would have militated against any form of ostentatious display, yet several incidents in accounts of this period reveal the earliest, somewhat ambivalent, attitudes of the Fatimid leaders towards material culture. Salamya, located at the crossroads between routes via Rusafa, Raqqa and the Euphrates to Iraq and the eastern Islamic lands and via Hims and Damascus to Arabia, Egypt and the western Islamic lands, was the centre of a vast but secret movement directed by a man posing as a wealthy merchant. He acquired several houses and eventually built himself a great town house that served as the secret centre of the Ismaili mission.[6] The missionaries of the far-flung Ismaili communities could come and go as they pleased under the guise of commercial travellers, meanwhile bringing their leader tribute of money, textiles and 'all sorts of curiosities and exotica', including myrobalan, musk, amber, gems and weapons ornamented with carnelian. Such luxurious accoutrements would have only enhanced the image of a successful merchant the Ismaili leader wished to project.[7]

Although the Ismaili missionaries must have strived to conceal their identities while propagating their revolutionary message in the small and isolated communities where they worked, they, like their leader, lived in constant fear of discovery by Abbasid authorities. Ismaili missionaries, like other revolutionaries over the course of Islamic history, built fortified refuges for their followers. Each was called a 'place of emigration' (*dār al-hijra*), a name that consciously asked the Ismaili community to recall the Prophet Muhammad's emigration from Mecca to Medina and his founding of his community of believers in 622. For example, around 890 or

892, Ismaili missionaries in the Sawad of Kufa chose an Aramaean village named Mahtamabad and heaped up 'a great many stones and built a well-fortified wall, eight cubits thick, all around the village. Behind it they placed a large moat. All this took place in the shortest time.' Within the wall they built a large structure, where men, women and children were brought.[8] Similar houses of emigration were also established in such other centres of Ismaili activity as Yemen and North Africa, but there is no evidence that these activists yet built anything as substantial – or public – as a mosque.

Although the Ismailis wanted to replace the Abbasid caliphs with the righteous descendants of Muhammad ibn Isma'il, it remains unclear exactly when, where and how the leadership thought this was to be done. Was their idea to create a series of isolated 'cells' that would remain relatively independent until it was deemed appropriate to reveal themselves, or was it to sow Ismaili 'seeds' in isolated communities throughout the Islamic lands, which would slowly grow and expand, eventually merging with the next adjacent community and taking over everywhere? The leadership surely attempted to control and orchestrate the activities of the isolated Ismaili communities through the secret workings of their propagandists, but it must have been extremely difficult to do this while maintaining a low public profile.

All this changed in the autumn of 903, when Zikrawayh ibn Mihrawayh, an Iraqi missionary from the loyalist faction, prematurely established the first state of the (as yet unnamed) *mahdī* in several cities along the Orontes River in Syria. The leader announced his claim by arrogating the traditional symbols of sovereignty that the Umayyad and Abbasid caliphs had used for centuries, namely invoking the ruler's name in the Friday sermon and placing it on coins. The Friday sermon read in the mosques under Zikrawayh's control concluded with an invocation to the 'Successor, the rightly-guided Heir, the Lord of the Age, the Commander of the Faithful, the *mahdī*.' Similarly, Zikrawayh is said to have struck coins in the name of the *mahdī*. According to literary sources the obverse (front) bore Qur'an 17:81, 'And say: the truth has come and falsehood and deception have disappeared' and the reverse, the *shahāda* or profession of faith, 'There is no god but God', followed by Qur'an 42:23, 'Say: I ask for no reward from you other than friendship, as is customary among kin.' The coins were probably struck at Hims, as no other local mints are known to have operated in Syria at this time.[9]

None of these coins is known to have survived, so it is impossible to discuss their visual characteristics. Nev-

ertheless, their texts would have made them quite distinguishable from the standard Abbasid issues of this era, which were remarkably uniform in content.[10] On the obverse, in addition to the ruler's name and that of his designated heir, standard Abbasid dinars and dirhams carried the *shahāda* surrounded by the Qur'anic verse, 'God's is the command, past and future; and on that day the believers shall rejoice in the victory granted with God's help' (30:4–5). In contrast, Zikrawayh's coins bore Qur'anic verses invoked to make specific ideological points in favour of the new regime.[11] This selective use of Qur'anic inscriptions would become a defining feature of later Fatimid art; the early appearance of this practice in Syria, however, indicates that it was neither an Egyptian phenomenon nor a Fatimid one; instead it should be linked to a pan-Islamic development in monumental epigraphy during the late ninth and tenth centuries.[12]

Arrival in North Africa

Towards the end of the ninth century, two brothers, Abu'l-'Abbas and Abu 'Abd Allah, were recruited to the Ismaili cause in Kufa and when their teacher transferred to Egypt, they received permission to follow him there. Abu'l-'Abbas, the elder brother, served as a courier between Egypt and the central command in Salamya, while the younger, Abu 'Abd Allah, was sent to the Yemen. From there, Abu 'Abd Allah went to Mecca, where he met some Kutama Berbers who had come on the pilgrimage from the region of Constantine in present-day Algeria. The Kutama, one of the great Berber confederations of North Africa, had lived in the region between the Aures mountains and the Mediterranean Sea since Roman times when they were known as the *Ucutumani*.[13] Abu 'Abd Allah accompanied them as far as Egypt, where he claimed to want to establish himself as a schoolteacher. The Berbers, however, who appear to have already been exposed to Shi'i beliefs in North Africa, pressed him to continue home with them and teach there. He did so, establishing himself at the Kutama citadel of Ikjan in the region of Algeria now known as Lesser Kabylia.[14] This region, along with neighbouring Tunisia, was known in medieval times as the province of Ifriqiya, an Arabicized form of the Latin name, *Africa Proconsularis*. The province was ruled for the Abbasid caliphs by the oppressive Aghlabid dynasty of governors (r.800–909). Under their rule, Ifriqiya had been an outpost of Abbasid authority and its capital Kairouan had become a bastion of Maliki Sunnism. In

the past, opposition to Aghlabid rule in Ifriqiya had tended to coalesce around the neo-Umayyad dynasty in the far west, whose ancestors the Abbasids had decimated and who continued to be sworn enemies of the dynasty that had replaced it everywhere but in al-Andalus.[15]

Meanwhile, the untimely public campaign in Syria threatened to compromise the Fatimid leader's safety, so he quickly escaped from Salamya accompanied only by his son, the chief missionary and a few attendants. Pursued by the Abbasid authorities, who were determined to capture them and nip this rebellion in the bud, the small group of revolutionaries took advantage of Salamya's central location and escaped first to Ramla in Palestine and then to Fustat, the capital of Egypt, where they were welcomed by the local representative of the Ismaili mission. This individual, known in the sources as Abu ʿAli, was none other than the missionary Hamdan Qarmat, who had rejoined the mainstream cause. His presence in Egypt at this early date suggests that the Ismailis were already planning to take Egypt.[16] Disguised as a merchant, the Fatimid leader remained in Egypt about a year, as he watched events unfold in Syria. Publicly he intended to move on to Yemen, which had long been a loyal centre of Ismaili activity, but he surprised his travelling companions by abandoning the idea of establishing himself in southern Arabia and instead joined a merchant caravan travelling towards the Maghrib, where the missionary Abu ʿAbd Allah was active.[17]

At Tripoli, the last town before the Aghlabid frontier, the imam began to fear his capture by the Aghlabid authorities, so he sent Abu ʿAbd Allah's brother Abu'l-ʿAbbas ahead as a scout. The Aghlabid governor, who was concerned about increased Ismaili activity in his domains, arrested Abu'l-ʿAbbas as a spy. The Ismaili leader attempted to rendezvous with Abu ʿAbd Allah at Ikjan, but the imam was forced to change his plans and join another caravan. It skirted not only the Aghlabid territories in Ifriqiya but also those of the Zanata Berbers in central Algeria (who were ruled by the Rustamids of Tahart, who espoused the secessionist Khariji doctrine that rejected all caliphal authority). It also had to avoid those lands in northern Morocco controlled by the Idrisids of Fez (also Kharijis) and by the neo-Umayyads of Spain, who adhered to Sunni doctrine, although they were no friends of either the Abbasids of Baghdad or their Aghlabid lieutenants in Kairouan. Instead, ʿAbd Allah headed across the northern Sahara directly for the commercial entrepôt of Sijilmasa, located in the Tafilalt oasis of south-eastern Morocco, just about as far as possible from where he wanted to be in the Kutama lands in the northeast. Sijilmasa, a bustling but remote centre of trans-Saharan commerce, was ruled by the Banu Midrar, a Berber family that had long espoused Khariji beliefs.

Arriving in Sijilmasa, the refugee Ismaili leader rented a fine house and resided there unnoticed for nearly five years (905–9), while Abu ʿAbd Allah continued his missionary work among the Kutama Berbers of Ifriqiya, transforming their loose tribal confederation into a disciplined army that could topple the Aghlabid state. The Aghlabid amir meanwhile waged a propaganda war against the Ismaili insurgents, accusing them of un-Islamic practices, such as destroying mosques and abolishing the five daily prayers. Sitting on his throne under the parade pavilion (qubbat al-ʿard) in his palace at Raqqada, a suburb of Kairouan, the amir distributed bounties of gold to win the loyalty of his subjects and flaunted his connection with his overlord in Baghdad, the Abbasid caliph al-Muktafi, who had, he claimed, sent him a caravan bearing magnificent robes of honour, banners and – most importantly – weapons to use against the rebels.

Nevertheless, after a century of the Aghlabid amirs' high living, gold would have won more loyalty among the hostile population than fancy gewgaws. The rebels successfully chipped away at the Aghlabid domains, first securing a base in the Kutama lands in eastern Algeria from which they began attacking the major towns of Ifriqiya. Just in the nick of time, the last Aghlabid amir, Ziyadat Allah III, escaped from his palace at Raqqada and fled to Egypt. On 1 Rajab 296 (25 March 909) the missionary Abu ʿAbd Allah entered Raqqada and received a congratulatory delegation of notables from Kairouan. Although thankful for the support of his Kutama helpers, he wisely guaranteed a general amnesty and safe-conduct for all the people of Kairouan. Like Zikrawayh in Syria, Abu ʿAbd Allah immediately removed the name of the hated Abbasid caliph from the coinage and Friday sermon, replacing it with that of the (still-as-yet unnamed) mahdī, who was waiting patiently incognito in Sijilmasa. Abu ʿAbd Allah's brother, who had been freed from the Aghlabid prison, led public disputations in the congregational mosque with the Maliki jurists of Kairouan on the finer points of Ismaili theology; meanwhile Abu ʿAbd Allah set off with his army to Sijilmasa to rescue the imam, who had been put under house arrest by the local Midrarid amir when he learned the stranger's true identity. Moving west, the Ismaili army secured control of all of North Africa, toppling first the Rustamid rulers of Tahart and then arriv-

ing at Sijilmasa, where Abu 'Abd Allah showed sufficient force to compel the amir to release his prisoner.

Until this moment, the leader of the Ismaili movement had actually played a minor public role compared to his missionaries, who had done all the ostensible work. This was now to change. Al-Mahdi's chamberlain, Ja'far ibn 'Ali, who wrote an autobiography several decades later, vividly described the scene of his master's triumph in Sijilmasa. The Mahdi sat on a throne in the middle of a tent and said to his servant, 'Give me the two splendid garments which I have been keeping especially in such-and-such a trunk.' He brought them out and the Mahdi donned one of them and gave the other to his son Abu'l-Qasim. Then al-Mahdi said, 'And now the clothing and swords, which I have been keeping for these here!' He first clothed the missionary Abu 'Abd Allah with his own hand, wound a turban around his head and girded him with a sword, then clothed his chamberlain Ja'far with a double garment, the underlayer made of *dabīqī* linen, with matching turban, trousers and slippers and girded him with a sword. He similarly clothed and girded four other attendants.[18]

If this story is true, the Mahdi must have acquired all this finery before embarking on his long journey, because these garments do not seem to be the kinds of goods that would have been readily available in remote Sijilmasa. If it isn't – which seems more likely as it has the ring of history reviewed through rose-coloured spectacles – it still reflects an early Fatimid state of affairs and shows how important rich textiles and clothing were for the Fatimids. The Mahdi seems to have been a completely unwarlike figure; indeed, all his life he presented himself only as a successful merchant. Even when he became caliph, he never took part in a single military campaign.[19] In contrast to the missionary Abu 'Abd Allah, who lived ascetically and wore coarse garments, already in Sijilmasa before his public recognition the Mahdi's appearance and demeanor are said to have raised concerns amongst several of his companions. Around him 'they found silk and brocade clothing, gold and silver vessels, Greek eunuchs and indications of the use of alcohol. In their Berber simplicity, they disapproved of all this . . .'. Even Abu 'Abd Allah himself showed signs of becoming increasingly disturbed by the Mahdi's apparent love of worldly pomp and remonstrated with him about the negative effect his conduct would have on the Kutama.[20] On a larger scale, the contrast in style between the Mahdi's ostentatious display and Abu 'Abd Allah's revolutionary puritanism represent two very different approaches to the task of government. It may also have signalled the growing antagonism between the two men that would eventually lead to the missionary's demise.[21]

In October 909 the Mahdi set off on the three-month journey across North Africa to Kairouan, entering the former Aghlabid capital of Raqqada on 4 January 910, where he was acclaimed as ruler by the Kutama Berbers and the notables of the city. He made his triumphal entrance wearing a garment of dark silk with matching turban, riding on a red steed; behind him his son Abu'l-Qasim wore bright red silk and a matching turban while riding a dun-coloured horse. Before them rode Abu 'Abd Allah on a red-brown steed, wearing a mulberry-coloured garment and white linen shawl, turban and Alexandrian kerchief; in his hand he held a handkerchief with which he wiped the sweat and dust from his face.[22]

From these accounts the Mahdi appears to have been something of a clothes-horse, but this would have been by no means unusual in the mercantile world in which he lived and promulgated his message. On the one hand, the Mahdi's love of textiles may have been personal affectation; his taste may also have been born from his long 'cover' as a merchant. On the other, he was not alone in his passion for cloth. Textiles played a central role in medieval Islamic society, occupying a position comparable to that played by the heavy industries of modern times, and the production of and trade in fibres, dyes, mordants and finished textiles were the fuel that drove medieval Islamic economies. Textiles were widely seen as signs of status and marks of wealth. Rulers regularly gave them to their clients, and brides listed them in their trousseaux.[23] In short, the Mahdi seems to have been playing the role of someone between a rich merchant and a prince, which was exactly what he was.

Arriving in Kairouan, the Mahdi installed himself in the Aghlabids' Palace of the Patio (*qaṣr al-ṣaḥn*) in Kairouan, which Abu 'Abd Allah was forced to vacate. Although archaeologists have brought to light only tantalizing fragments to confirm the fulsome textual accounts of the splendid Aghlabid capital, at that time the palaces of Aghlabid Kairouan were surely the most luxurious and well-appointed structures standing anywhere between Fustat and Córdoba. Abu'l-Qasim, al-Mahdi's son, received his own 'palace' – perhaps no more than separate quarters – thereby establishing a practice of generationally separate residences that al-Mahdi's successors would follow for many years.[24] The following day, the name of the hitherto unnamed *mahdī*, 'Abd Allah Abu Muhammad, was finally revealed to the public in the sermon pronounced in the

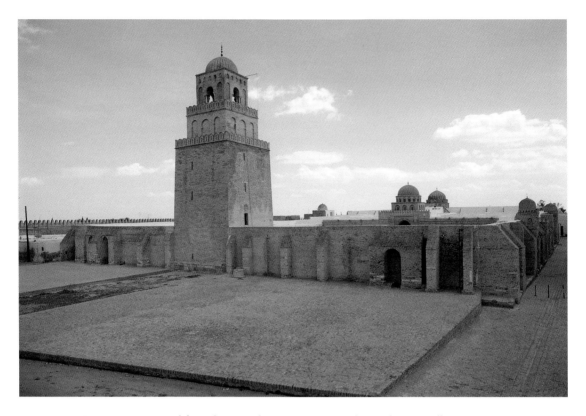

9 Kairouan, Great Mosque viewed from the west, showing minaret on the north-west wall

congregational mosque of Kairouan and his full titles – 'the imam rightly guided by God' and 'the commander of the faithful' – were specified, leaving no doubt that he was directly challenging the Abbasids' right to rule over the community of Muslims.

The Mahdi and his successors would face a veritable host of problems, including but not limited to the transformation of their revolutionary movement into a state, the consolidation of their power in North Africa, the persistent hostility of the Maliki ulema of Kairouan, the often turbulent relations with the Byzantines over control of Sicily (which the Fatimids inherited from the Aghlabids) and the continued animosity of rival claimants to the caliphate – not only the Abbasids in Baghdad but also the neo-Umayyads in Córdoba. The Abbasids were a long and safe distance away in the east, but the neo-Umayyads – especially under the able rule of 'Abd al-Rahman III (r.912–961) – constituted a real and present danger in the west. In this fluid and difficult situation, there was much need for good diplomacy and little place for such extraneous activities as the patronage of art and architecture.

Thus, just as the Mahdi and his son moved into the recently vacated Aghlabid palaces of Raqqada, so the early Fatimids inherited the artistic traditions of the Agh-

labid rulers of North Africa. Initially they added little to this inheritance. The Great Mosque of Kairouan (Fig. 9) had been built and enlarged under Aghlabid patronage several times in the ninth century and these changes had made it the most significant monument of Islamic architecture between the Nile and the Atlantic. Its structure combined a local Ifriqiyan tradition of building with fine stone masonry – a technique that went back to Roman times – with a hypostyle (many-columned) plan inspired by the metropolitan styles of Abbasid Baghdad and Samarra. A massive three-storied stone minaret, at that time the tallest structure in all of northern Africa, was a particularly strong symbol of the Aghlabids' dependence on their Abbasid overlords.[25] The mosque's luxurious furnishing with a carved teakwood minbar and imported glazed tiles decorated with lustre painting also reflected the latest techniques and styles of Abbasid Mesopotamia.[26] In the other major cities of the Aghlabid realm, such as Tunis, Sousse and Sfax, patrons had erected somewhat less ambitious or sophisticated buildings as well as a series of severely practical ribāṭs, or fortified monasteries, along the Mediterranean coast at such localities as Sousse and Monastir.[27] Given the Aghlabids' energetic architectural patronage over the course of the previous century, the Fatimids would have had no imme-

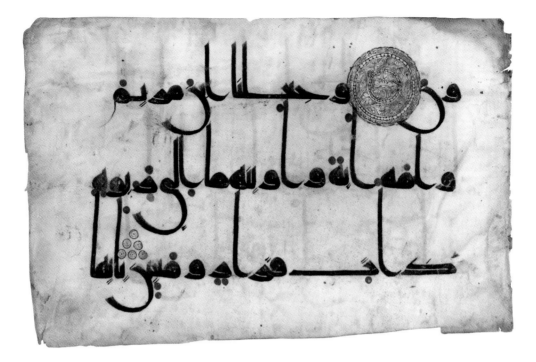

10 Page from a manuscript of the Qur'an copied on parchment, perhaps at Kairouan, ninth century (?),
20 × 31 cm (7¾ × 12¼ in.). Kuwait, Dar al-Athar al-Islamiyya LNS2 CA(a)

diate need to commission new buildings, although the requisite expertise to build them was surely present among the region's inhabitants.

Kairouan was the Aghlabids' official capital city, but in the middle of the ninth century, they – along with their household, their army and their administrators – had abandoned the city proper for suburban palace-cities which they had established following Abbasid precedent in Iraq. The first of these palaces was al-ʿAbbasiyya, the second was Raqqada, founded by Ibrahim II in 876. Its Palace of the Pool (Qaṣr al-baḥr) contained an artificial lake whose remains can still be seen, although the site has not yet been properly excavated or published.[28] With the removal of the rulers to the suburbs, the city itself was left in the hands of the ulema, who were primarily followers of the conservative Maliki school associated with the city of Medina, although a substantial minority of them were Hanafis associated with the legal teachings of Kufa.[29] Perhaps as a consequence of its status as a centre of religious scholarship, Kairouan is also believed to have become a centre for the production of Qur'an manuscripts in the ninth century, for a large cache of ancient Qur'an manuscripts copied on parchment in angular kufic scripts and bound in tooled leather cases was kept for centuries in the city's congregational mosque (Fig. 10). It is unlikely, however, that all these

ancient manuscripts were actually copied in the city and the distinctive characteristics of specifically Aghlabid manuscripts have yet to be distinguished.[30]

It is equally difficult to characterize other aspects of Aghlabid artistic life. Scholars have been unable to agree, for example, on whether the exquisite carved panels of teak on the ninth-century minbar in the Great Mosque of Kairouan are Mesopotamian or North African work.[31] Later local accounts suggest that the panels were carved locally of wood that had been imported to decorate the amir's palace, but the panels' stylistic affinities are closer to known Mesopotamian examples than to local examples of wood carving. Similarly the mihrab in Kairouan's congregational mosque is surrounded with a set of tiles overglaze-painted with lustre, an expensive technique developed in Mesopotamia that seems to have been kept something of a trade secret. The extent to which the local tiles may have inspired local potters has remained a matter of lively dispute until recently, when petrographic analysis determined them all to be imported.[32] In sum, a sufficiently rich picture of Aghlabid-period art may have survived the centuries, but the surviving evidence indicates neither that the visual culture of the Aghlabids was the most splendid or sophisticated of its time nor that the visual arts played a major role in late Aghlabid court life.

21

Mahdiyya

The Mahdi must have imagined that his sojourn in Ifriqiya was only temporary. Egypt and Spain, not to mention Syria and Iraq, he must have thought, would recognize his authority as quickly and easily as had the Yemen and North Africa, and he could soon move from his temporary and peripheral quarters to a more central location from which to rule the Islamic lands. Therefore he would have been content at the outset to make do with the Aghlabid administrative and residential facilities in and near Kairouan. Two years later, however, in 912, he began travelling along the Ifriqiyan coast looking for an appropriate site on which build a new administrative centre.[33] Something must have happened during that time to make him change his mind.

The difficulties of transforming a clandestine revolutionary movement into a functioning state must have been far greater and more time-consuming than the Mahdi had initially imagined. Many of the Berbers were Kharijis, sworn enemies of the Shi'is and many of the North African Arabs were equally hostile Maliki Sunnis. The new regime found support among the Kutama Berbers and the non-Maliki Arabs, some of whom were Shi'is and some Sunnis of the Hanafi school. Only a minority of the population ever became Ismailis and so Fatimid rule took on quite different political and religious aspects. It is likely that the overwhelming majority of people who lived under Fatimid rule accepted their government with the same degree of enthusiasm – or resignation – they had accorded prior rulers like the Aghlabids.[34]

For the Ismailis, the situation was quite different, for they held a special position within the population at large. For them, the caliph was the infallible representative of God on earth. Whatever the caliph decreed was divine law and his interpretation of all matters whether religious or secular was unquestionably true. The establishment of the Fatimid state surely brought about the rule of the righteous, but it also gained an additional dimension in providing continuing access to divine guidance in the person of the imam. The Ismailis' core mission was to increase the number of adherents within the state and propagate the state abroad.[35]

Ismailis may have imagined that the advent of the Mahdi would usher in a new messianic era and their Kutama allies surely anticipated that they in particular would inherit the Aghlabids' power and prerogatives. The ruler meanwhile had to keep competing factions in check without entirely alienating the mass of Kairouan's population.[36] The establishment of a new dynastic seat

would not only create a refuge and redoubt against the regime's foes but it could also be seen to fulfil, in some way, the dynasty's messianic promise.[37] Al-Mahdiyya ('[The city] of the Mahdi'), or so the foundation was called, was conceived on a time-tested practical and symbolic model. Not only was it a *dar al-hijra*, or place of emigration and refuge, much like the early refuges that Fatimid missionaries had built in hostile environments, but it also stood in the long tradition of other first constructions in Islamic history. These ranged from the Prophet's house-mosque in Medina to the series of early administrative centres the Abbasids had constructed in Iraq that culminated in the Round City of Baghdad.[38] The Mahdi would surely have been familiar with the traditions associated with his ancestor's building in Medina, but it is unknown whether he knew – or even cared about – what the hated Abbasids had built in Iraq.

The site the Mahdi eventually selected for his new city was a rocky peninsula shaped like the head of a spear which points eastwards into the Mediterranean about halfway between the Tunisian cities of Sousse and Sfax. The start of construction, which entailed the massive fortification of the peninsula, was delayed until 916, following his son Abu'l-Qasim's first and abortive campaign to conquer Egypt. The new capital was officially inaugurated five years later on 20 February 921, the date having been pushed forward as a result of heavy rains at Kairouan; the Mahdi, his son and the court were forced to move into their residences even though the buildings were not yet finished. The mosque was probably completed about this time and we know from historical sources that there was also a *musalla*, or festival prayer ground, just outside the city walls. By the following year the port facilities – such as the dockyard mentioned in the texts that corresponds to the excavated harbour still visible at the site today – must have been functioning because naval expeditions had already returned to Mahdiyya from the Calabrian coast.[39] Some modern authors imagine the city to have been constructed as a restricted enclave for the Fatimid elite, carrying 'to an extreme the physical isolation of the Muslim ruler from the Muslim community.'[40] Nevertheless there must have been such 'ordinary' facilities as shops and markets, because we know that merchants were forced to leave the city during the rebellion of Abu Yazid in May 945. This view is confirmed by the geographer, merchant and Fatimid missionary Ibn Hawqal, who visited the city a few years later. He said that Mahdiyya had 'many palaces, fine residences and houses, baths and caravanserais'. Virtually none of this remains today.

The capital city of the Roman province of *Africa Proconsularis* had been Carthage, situated on the Mediterranean coast just north of modern Tunis. Its location, less than a hundred miles from Sicily, offered easy maritime access not only to Rome, but also to the eastern and western halves of the Mediterranean basin. In the seventh century Muslim conquerors had turned their backs on the Mediterranean and created the inland city of Kairouan (from Arabic *qayrawān*, 'garrison camp') to be the capital of the province of Ifriqiya. Whereas the old capital had been linked by the sea lanes to the port of Rome and the rest of the empire, the new Muslim capital was linked by caravan routes to Egypt in the east, the rest of North Africa to the west and across the Sahara to the south. Throughout the ninth century, the Aghlabid governors had maintained their capital at or near Kairouan, but as their Mediterranean fleet became an increasingly significant instrument of foreign policy, particularly after they conquered Sicily, such coastal cities as Sousse (the ancient Hadrumetum) and Sfax (formerly Taparura) revived in importance. As the Mahdi inherited not only the Aghlabids' fleet but also their territories in Sicily, a new capital on the Mediterranean coast would have been ideally suited to help extend Fatimid authority from one end of the Mediterranean to the other – and beyond.

Virtually an island, the Mahdiyya peninsula projects about a mile (1400 metres) into the Mediterranean and is linked to the mainland only by a narrow isthmus, originally less than 200 metres across, although subsequent development has made it much wider. Unlike many other favourable sites along the Ifriqiyan coast, this one may not have been occupied in pre-Islamic times, perhaps because there was no ready supply of drinking water. The Roman settlement of Gummi, known to the Arabs as Jumma, lay somewhat inland and a harbour basin (*cothon*) and some graves had been hewn out of the rock there, presumably by Phoenecian traders.[41] The Fatimids, however, excavated cisterns for the storage of rainwater in the rocky peninsula.

Access to the peninsula from the mainland was controlled by a massive rampart which the Mahdi ordered built across the isthmus. Protected by an advance wall some 40 metres away, the main wall appears to have had polygonal towers at either end where it met the sea wall, as well as regularly spaced projecting towers and an elaborate gate with iron fittings in the centre. The gate (Fig. 11), now known as *al-Saqīfa al-kahla* ('the dark vestibule') because of the long vault on its interior, controlled entry to the city by means of an enormous iron-clad door, although it is not clear how much of the present structure goes back to Fatimid times and how many of the fabulous stories about this gate are only legends.[42] An extensive suburb called Zawila (after a district in the Libyan Fezzan) developed on the mainland outside the city walls. The peninsula's long sea front was fortified with a stone wall, approximately 8.3 metres thick and reinforced with approximately 110 towers spaced every 20 metres. Two larger towers in the southern sea wall controlled access (by means of an iron chain which could be raised or lowered at will) to the rectangular port that had been excavated within the enceinte, much like the ancient ports of Carthage, Utica or Hadrumetum (Sousse). A shipyard or arsenal (*dār al-ṣinaʿa*) was also located along this side of the peninsula.[43] This massive public works project must have taken several thousand labourers several years to finish. Although the massive wall and gate may have isolated the Mahdi and his entourage from the majority of his subjects who lived outside, the mighty fortress also served to strengthen the ruler's cause.[44]

Very little of all this splendour remains – apart from some bits of the walls and gates, the mosque, the foundations of the palace and a few chance finds (Fig. 12a). Yet even these show that all the forms and techniques used at the site derive entirely from the local artistic vocabulary, indicating on the one hand that the Mahdi relied on a local workforce, which is to have been expected, and on the other that he had no preconceived notion of what form his new foundation should take. The centrepieces of the city, as in all contemporary Muslim towns, would have been the mosque and the ruler's residence, which together represented religious and civil authority. But unlike Islamic foundations up to and including Baghdad, where the ruler's palace stood adjacent to the mosque, at Mahdiyya the mosque and the rulers' palaces were quite separate structures.

The mosque of Mahdiyya, which is the most important Fatimid monument to survive in North Africa, was built on an irregular site on the southern shore of the peninsula, a site made flat by the construction of an extensive terrace to support the prayer hall. The collapse of part of the terrace in medieval times led to the repeated repair and rebuilding of the mosque. In the 1960s the structure was extensively reconstructed to what was then believed to be its original Fatimid aspect. The building now measures approximately 75 × 55 metres and consists of a roughly square courtyard preceding a hypostyle prayer hall (Fig. 12b). On the north three entrances provide access to the court, which is surrounded by arcades supported on columns. On the south, the rectangular prayer hall has eight rows of

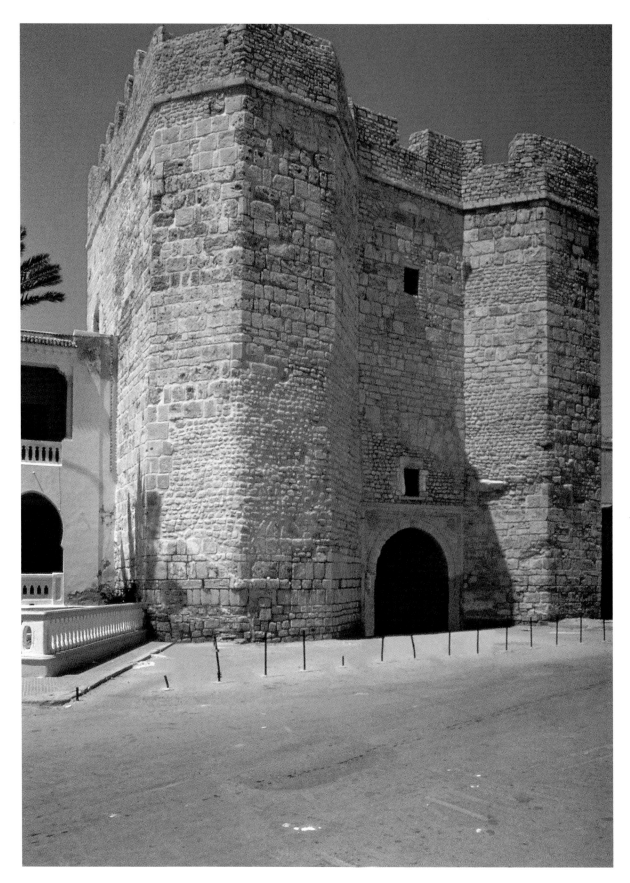

11 Mahdiyya, al-Saqifa al-Kahla, tenth century with later additions

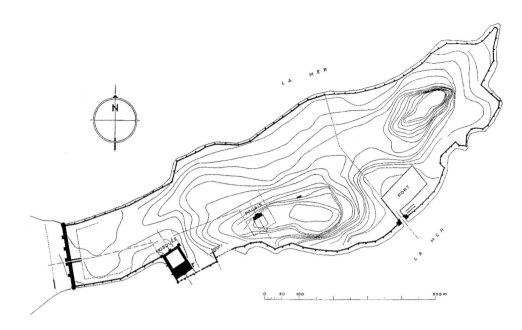

12a (LEFT)
Mahdiyya, plan of
the site, showing
location of walls,
gate, harbour, palace
and mosque. After
Lézine, *Mahdia*

12b (BELOW)
Mahdiyya, plan of
the mosque as
reconstructed to its
presumed tenth-
century state. After
Lézine, *Mahdia*

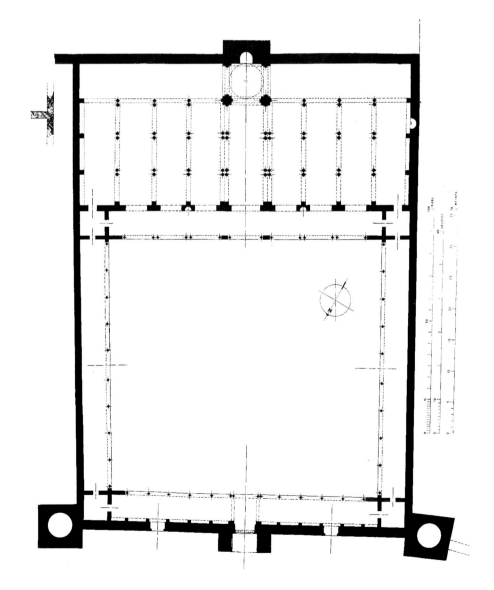

columns supporting arches that support a flat roof, presumably originally built of wood, with an elegant stone dome covering the bay in front of the mihrab.[45]

The bare stone walls glimmering in the Mediterranean sun give the mosque a much plainer aspect than it probably once had, but there is no way to recover the mosque's original decoration, whatever it might have been. In its parti, or general plan, the building is a reduced version of the nearby congregational mosque of Kairouan, with colonnades perpendicular to the qibla wall, double colonnades along the axial aisle and a so-called T-plan formed by a wide axial aisle intersecting another aisle running along the qibla wall. (This last aspect of the plan is the most conjectural.) The most notable feature of the Kairouan mosque, its massive three-story tower minaret standing astride the courtyard wall opposite the qibla (see Fig. 9), was not reproduced at Mahdiyya. In its place stands a monumental portal, with a large central arched opening framed by two stories of smaller blind niches on either side (Fig. 13). This portal was flanked by lesser entrances and projecting bastions at the corners, said to be the first example of a 'composed mosque façade' in Islamic architecture.[46] The bastions, once thought to have supported minarets, actually housed above-ground cisterns to collect rainwater from the roof for ablution.[47]

Given the pre-eminent role of the Kairouan mosque as a model for most features of the mosque at Mahdiyya, it is indeed odd that its massive minaret was replaced by a projecting portal, an otherwise unusual feature in contemporary Islamic architecture. At this time few mosques anywhere had fancy doorways. The projecting stone block with its central arched opening flanked by two stories of shallow niches was doubtlessly inspired by a Roman triumphal arch, probably the one at nearby Sbeitla (ancient Sufetula) (Fig. 14), which had been constructed as a freestanding structure during the reign of Antonius Pius (138–161), but which had been incorporated into the city's defences during the Byzantine period. By Fatimid times it would have been perceived not as a freestanding structure but as a portal projecting from a wall. The portal of the Mahdiyya mosque therefore stands in the same relationship to the wall of the mosque as did the Roman arch in the Fatimid era. Scholars such as Alexandre Lézine have suggested that the choice of a Roman triumphal arch as a model for the portal at Mahdiyya was inspired by a Fatimid passion for ceremonies, a custom that became particularly apparent in the dynasty's later years in Egypt. From this triumphal node, the argument goes, the rest of Mahdiyya would have been laid out in triumphal avenues and plazas that would have provided a fitting stage for the imagined ceremonies.[48] Yet at this early date there is evidence neither for such planning nor for elaborate Fatimid ceremonial and so another explanation must be sought.

Why would the Fatimids, who had followed the Kairouan model so closely in all other aspects, have replaced the tower with a portal? It is often thought that minarets, or towers attached to mosques, go back to the early years of Islam, but the Abbasids were the first regularly to attach towers to congregational mosques in the ninth century and most Sunni Muslims considered the single minaret, usually located opposite the qibla, to be an appropriate place from which to give the call to prayer. They also understood the minaret to signify the new status of the congregational mosque as a centre of the Sunni ulema under Abbasid patronage.[49] As the minaret's introduction clearly postdated the Prophet, however, a significant number of Muslims rejected this innovation and Shi'is in particular maintained that the call to prayer should be given only from the doorway or roof of the mosque, as a tradition going back to 'Ali maintained. Thus, it is not surprising that the Mahdi rejected the idea of adding a tower to his mosque. But why replace it with a monumental portal?

In general, most mosques built by the Umayyads and Abbasids did not have fancy portals, although their palaces always did, because the palace doorway was an important place where those who could enter were separated from those who could not. Mosques, by contrast, were meant to welcome all believers. In the ninth and tenth centuries, however, a few mosques – the Masjid al-Haram in Mecca, the Great Mosque of Córdoba and the mosque of Mahdiyya, for example – are known to have had one or more elaborate portals. Some scholars have understood this development as a transfer of motifs from the palace to the mosque, but one explanation does not seem to fit all the known cases. For the mosque of Mahdiyya, the simplest explanation may be that a long blank façade like that found on the mosque at nearby Sousse (Fig. 15) – or at faraway Samarra – was considered ugly and dull. An appropriate model was readily and locally available by combining Sbeitla's Roman arch with the arrangement already found on the façade of the nearby ribat at Sousse, where a massive if undecorated portal projected from the main block of the building (Fig. 16).[50] It might also have pleased the Mahdi to know that Ismaili worshippers seeing the portal might have recalled the famous tradition of the Prophet reported by the Shi'a, 'I am the city of knowledge and 'Ali is its gate', but there is no indication – in

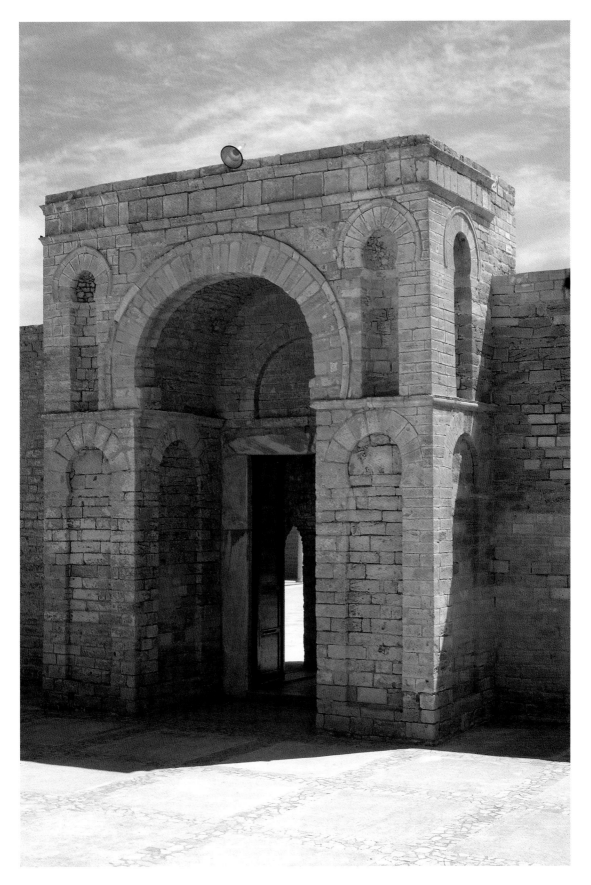

13 Mahdiyya, mosque, portal, completed 921

14 (RIGHT) Sbeitla,
Arch of Antonius Pius

15 (BELOW) Sousse,
Great Mosque, general
view showing
undecorated façade,
850

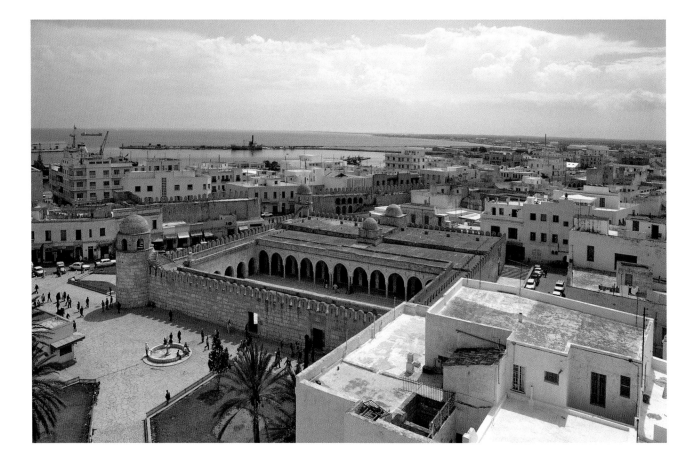

the form of an inscription, for example – that this meaning was explicit for this mosque. As in most Islamic art, meanings were left ambiguous, but the perennial popularity of the monumental projecting portal in subsequent Fatimid mosques speaks strongly in favour of such an interpretation.

The absence of monumental inscriptions on this portal is another surprising feature, although the blank entablature on the architrave across the top of the portal block would have provided a perfect setting for one, either carved into the stone or as a series of affixed stone panels. Aghlabid buildings in Ifriqiya regularly bore inscriptions in this location, as on the exterior of the Mosque of Bu Fatata at Sousse (838–41) or the so-called Mosque of the Three Doors at Kairouan (866) (Fig. 17).[51] By the early tenth century Arabic inscriptions had become a standard feature of Islamic architectural decoration from Spain to Central Asia. The importance of monumental writing for the early Fatimids is confirmed by the Maghribi historian Ibn 'Idhari, who said that upon assuming power the Mahdi had ordered the names of his predecessors erased from 'mosques, cisterns, forts and bridges' and replaced with his own, thereby effecting a symbolic occupation of the land.[52] Other Fatimid period buildings in Ifriqiya are known to have had inscriptions, although none survives unaltered

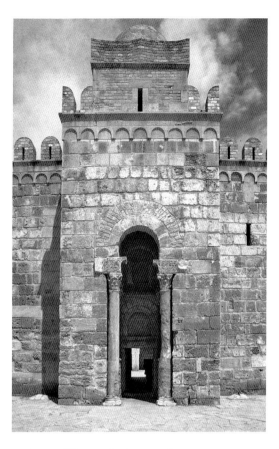

16 Sousse, Ribat, projecting portal, 821

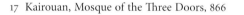

17 Kairouan, Mosque of the Three Doors, 866

29

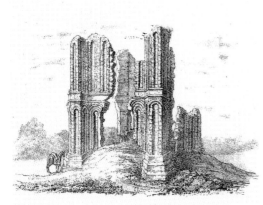

Ruines de Bordj-el-Arif. (Tunisie.)
dessiné par M. Ch. Tissot.

N. EST.

EST SUD.

Inscriptions de Bordj-el-Arif.

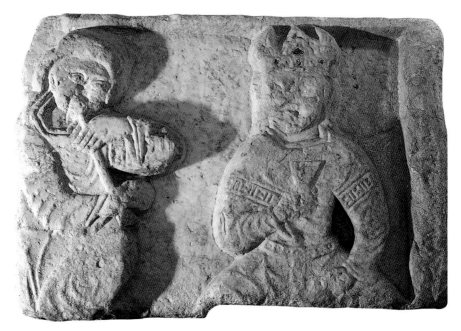

19 (ABOVE) Marble relief with seated figure and musician, found at Mahdiyya, tenth century. Tunis, Bardo Museum

18 (LEFT) Borj al-'Arif, a now destroyed monument of the tenth (?) century, drawn by Charles Tissot in the 1850s

in situ. A detached marble fragment in Tunis (see Fig. 24 below), for example, bears a beautiful floriated kufic inscription whose text would have been particularly appropriate to a portal, but it is thought that the fragment came from a building nearer Kairouan. After Sunnis regained control of Ifriqiya, many Fatimid-era inscriptions were effaced to remove offending Shi'i phrases, such as the one recording the renovation of the congregational mosque at Sfax in 988 (see Fig. 7).[53] Finally, the enigmatic Fatimid-period building known as the Borj al-'Arif, which was destroyed in the nineteenth century, was decorated with tall narrow niches crowned by an inscription in kufic script (Fig. 18).[54] In short, it is quite possible, even likely, that the Mahdiyya portal was once decorated with a carved inscription band of which no trace remains. Similarly, it is quite possible that inscriptions were used on the interior of the mosque as well, but the total reconstruction of the mosque in modern times means that it is impossible to say one way or the other.

Palaces were the other major construction behind Mahdiyya's city walls, but even less of them remains. The written sources indicate that there were two palaces, one for the Mahdi and another for his son Abu'l-Qasim, and they faced each other across an open space. One palace, presumably the Mahdi's, is known to

have had a Great Hall (*īwān al-kabīr*) for receptions. Many years ago archaeologists discovered the lower walls of a structure near the mosque that they identified as the entrance complex to al-Qa'im's palace and several columns and capitals used in the later houses of Mahdiyya are thought to date from the Fatimid period.[55] The masonry of the entrance complex was said to be careful and well-done and glazed ceramic star-and-cross tiles have also been found at the site. Although these remains could not predate the Fatimid occupation of the site, it is highly unlikely, however, that they belong to the original Fatimid phase of decoration, as star-and-cross tiles – quite apart from glazed ones – are unknown from such an early date anywhere, and the site continued to be occupied well into the Zirid period and later, when tile revetments became increasingly common in North Africa.[56]

Similarly a small (53 × 35 centimetres; 21 × 14 inches) fragmentary marble relief of a seated figure wearing a crown with triangular projections and holding a cup with a flutist entertaining him on the left (Fig. 19) was found many years ago at Mahdiyya.[57] Both figures wear long-sleeved garments with geometric armbands, presumably representing inscribed *ṭirāz*, or embroidered or woven bands. The face of the crowned figure has been mutilated, while that of the musician still has large and

bulging almond-shaped eyes. Holes in the crown were encrusted with lead that may have once held coloured stones. Borders on the right and top indicate these were the edges of the composition, while the rough edges at the bottom and left indicate that the original slab would have been somewhat larger.

The figures have often been compared to the figures of entertainers carved in the wooden beams of the Fatimid palaces in Cairo about a century later (see Chapter 4), but no comparable figural sculpture is known from North Africa, let alone from the Fatimid period there, although literary sources report that the main gate of Mahdiyya was decorated with two figures of lions. Some scholars have seen Mesopotamian 'influence' in this relief, particularly in the details of the crown, which is of a type quite unknown in North Africa, while others have discerned traces of the very distant African past. In the absence of any further evidence – such as scientific analysis of the marble – or of comparable material, one can only assign the relief generally to the period when Mahdiyya flourished in the tenth or eleventh century. We cannot specify whether it was made locally or imported from some point further east – or west. Its purpose remains equally enigmatic, although it seems likely that it would have been inset in a wall as part of some decorative programme. The selective mutilation suggests not wanton iconoclasm but that the crowned figure was particularly objectionable.

In contrast, a large (60 metres square) geometric mosaic pavement discovered at the site (Fig. 20) probably does date from sometime in the early Fatimid period. The design is a complicated geometric interlace of straight and curved lines formed of squares, circles, squares with curved sides, lobed squares, inscribed squares and polygonal stars, filled with palmettes and floral motifs worked in white, black and reddish brown stone tesserae. Composed of thousands of small cubes of stone, the pavement clearly demonstrates that local artisans had preserved ancient techniques for centuries, for in late antiquity mosaicists had decorated the villas of the North African gentry with an amazing variety of extraordinarily fine and detailed geometric and representational floor mosaics. In Byzantine times the pavements had become less ambitious in design and scale, but North African artisans continued to make such pavements into Islamic times, as the mosaic pavement discovered in the Aghlabid ruins of Raqqada shows.[58]

While some of the geometric designs of the Mahdiyya pavement reflect a continuation of the archaizing geom-

20 Detail of mosaic pavement (covering 58 m²) made of multi-coloured limestone tesserae discovered at Mahdiyya. Raqqada, Museum of Islamic Art

etry of the Raqqada pavement at a lower level of workmanship, other elements, particularly the calyx motifs used as fillers, point to the new type of ornament that Mesopotamian artisans had developed during the ninth century. It is as yet unclear by what means North African artisans learned of such developments. The Mahdiyya pavement shows that by the mid-tenth century North African artisans, while still preserving local techniques of decoration, were becoming aware of contemporary artistic developments elsewhere in the Muslim lands. Taken together, the relative modesty of these remains suggests that Mahdiyya should not be imagined as a stupendously luxurious palace city but as a secure administrative and military centre for the new rulers of Ifriqiya who wanted to live with a modicum of comfort.

An anonymous poem composed on the completion of Mahdiyya hyperbolically compares the new foundation to Mecca:

Congratulations, O magnanimous prince, for
 your arrival on which time smiles.

You have established a camp in a hospitable land
 which the glorious envoys have secured for
 you.

If indeed the sanctuary and the precincts are
 exalted, its ossuary shrines are equally exalted.

31

A residence has arisen in the land of the west: in
 it praying and fasting will be acceptable.
It is Mahdiyya, the sacred and protected, just like
 the sacred places in Tihama,
As if your footprints make it the Maqam Ibrahim
 where there is no maqam.
As the pilgrim kisses the Sacred Corner, we kiss
 the court of your palace.
If indeed time and dominion grow old, their
 foundations, when tested, are but rubble,
To you, O Mahdi, dominion is itself a servant,
 which time itself serves.
The world is yours and your progeny's: wherever
 you are in it you will always be imams.[59]

The poet's imagery is enthusiastic and hyperbolic in anticipation of a generous reward; it was easier to write poetry about the new era than to actually bring it about, and the poem should not should be read so literally as to mean that Fatimid ceremonial began with members of the court kissing the palace's courtyard.[60]

Mahdiyya's monumental buildings as well as the repeated military campaigns must have cost the Mahdi significant sums of money. Most Islamic regimes raised revenues from a combination of tolls and dues, as well as land taxes on state property and alms taxes on the property of Muslims. While the latter were based in Islamic law, the former were tainted with illegality and the Fatimid regime, which is reported to have required a fifth of all income in tribute to the imam, would have been doubly tainted, particularly in the view of Kairouan's Maliki ulema.[61] According to the geographer Ibn Hawqal, who was in Ifriqiya a few years later in 947–51, the annual revenues of the Fatimid treasury amounted to a relatively modest seven or eight hundred thousand dinars, or approximately twice the revenues collected at Sijilmasa. This low figure is perhaps an indication of Fatimid insistence on avoiding excessive taxation. Levies on trade were particularly profitable, as Ifriqiya was situated at the crossroads of the Mediterranean at a point where as many as six trade cycles overlapped: overland trade to the south, east and west and maritime trade to the north, west and east.[62]

The creation of a walled city on the Tunisian coast as the first Fatimid capital is therefore a logical product of historical circumstances and local traditions. While much has been made of the Fatimids' desire to distance themselves from the hostile Sunni atmosphere of Kairouan in the location and defensive design of the new capital, the important roles of the navy and maritime commerce in early Fatimid times should not be underrated. To see the foundation of Mahdiyya as merely a defensive response to the hostility of Kairouan's ulema underestimates the Mahdi's global aspirations for his new regime. These are clearly voiced in a poem composed to celebrate the inauguration of the new city, which specifically expresses the impermanence of this 'camp in a hospitable land' before the expected conquest of the remaining lands of Islam.[63] Nevertheless, far from suggesting, as some modern scholars have done, that this was 'first and foremost a palace city' restricted only to Fatimid courtiers and administrators, contemporary witnesses such as Ibn Hawqal indicate that Mahdiyya was like other contemporary cities in the Muslim world with the usual and necessary complement of urban functions.[64]

Construction of Mahdiyya had started following the failure of the first Fatimid assault on Egypt in 914–15. A second attack launched in 920 also ended the following year in a Fatimid defeat.[65] Although neither campaign was successful, the Abbasids were dealt a particular blow by forcing them to divert the substantial revenues of Egypt and Syria in their defence. Meanwhile, the Qarmatis of Bahrayn, erstwhile allies of the Fatimids, renewed attacks on Abbasid Iraq and Arabia. At the beginning of 930, under the leadership of their imam Abu Tahir al-Jannabi, the Qarmatis entered Mecca and attacked the pilgrims, killing many and plundering their goods. They looted the Kaaba, carrying off its treasures, devotional articles and ex-voto gifts. The *kiswa*, or cloth covering the Kaaba, was detached and the rebels went away with treasures including the pearl known as 'the Orphan' which weighted 14 mithqals (about 65 grams) and relics including the ear pendants of Mary, the horn of Abraham's ram and the staff of Moses, both covered with gold and encrusted with precious stones. In addition they took a gold cane with a golden cover, seventeen chandeliers decorated with silver and three silver mihrabs, not quite six feet high, which had been placed in front of the Kaaba. The Black Stone was removed and loaded onto a camel and taken off to the Qarmati capital al-Hasa' in Bahrayn. Only the Kaaba's golden waterspout escaped their greed.[66] The sack cost the Abbasid caliphs much prestige as well as money and left their capital at Baghdad wide open for attack, which came, neither from the distant Fatimids nor from the nearby Qarmatis of Bahrayn – who began frittering away their energies over internal conflicts – but from yet another Shi'i group waiting in the wings: the Buyids, warlords from the plain of Gilan along the Caspian coast.[67]

The Reign of al-Qa'im

The Mahdi died in 934 and was succeeded by his son who took the regnal name *al-Qā'im bi-amr Allah*, 'He who Arises at God's Command'. While his father was alive he had led major military expeditions to the west and east; after his father's death al-Qa'im remained largely secluded in grief but continued, as best he could, his father's policies of internal consolidation and expansion.[68] To that end he supported the Sanhaja Berber chief Ziri ibn Manad, whose ancestral lands lay at the southern edge of the Jebel Lakhdar, the mountains running across the northern edge of the great plain stretching south to the Sahara. According to the fourteenth-century historian al-Nuwayri, al-Qa'im provided Ziri with an able architect and gave him iron and other building materials with which to build his palace at Ashir, but this story is unconfirmable, as only the lower walls and a very few fragments of decoration survived into the twentieth century at the site, located about 95 miles (150 kilometres) south of Algiers.[69]

Begun in 935–6 during the reign of al-Qa'im, but 'enlarged and strengthened' by Ziri ibn Manad during the latter years of the reign of his successor al-Mansur, the building consists of a walled enclosure measuring 72 × 40 metres with a single entrance projecting on the south side (Fig. 21).[70] The whole construction is meticulously planned and laid out and the principal façade is faced with fine ashlar, indicating that high standards of construction were attainable when desired, although most of the interior was built of roughly-cut stone. The building is laid out in three tracts: the central tract consists of an entrance complex comprising a series of rooms leading to a large square court, a large T-shaped reception room opposite, which must have been the principal reception room and three long and narrow rooms on either side of the court. Passages alongside the rooms lead to pairs of smaller self-contained suites at either end of the building; each consists of a square court surrounded by four long rooms, of which the one opposite the entrance has a slightly projecting bay, smaller-scale versions of the T-shaped reception room in the central tract. The walls seem to have been covered with plaster which was then carved in patterns, but very little of the decoration remains. The court façade of the entrance complex was lined with an arcade of eleven columns and the wall opposite, the façade of the reception room, was decorated with stone panels carved with a design of intersecting arches (Fig. 22).[71]

Ashir's remote location and the similarities in plan between its entrance and the ruined entrance discovered at Mahdiyya suggested to some scholars that Ashir reflects the lost Fatimid art of Mahdiyya and this interpretation is bolstered by the late story about the 'able architect'. Indeed, some have used these similarities to reconstruct the palaces at Mahdiyya based on Ashir. Other scholars have seen the presence of Umayyad Syrian or even Abbasid Mesopotamian elements in the metrology and design of Ashir, although it is quite unclear how such ideas would have been transported to remote North Africa at this time.[72] In a world long before pictures and paper, architectural ideas were largely transmitted by memory and gesture, so it is much more likely that whatever similarities exist between the entrance complex at Mahdiyya and the palace at Ashir reflect a common source. One should

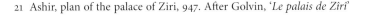

21 Ashir, plan of the palace of Ziri, 947. After Golvin, '*Le palais de Ziri*'

22 Ashir, stone fragments carved with intersecting arched decoration

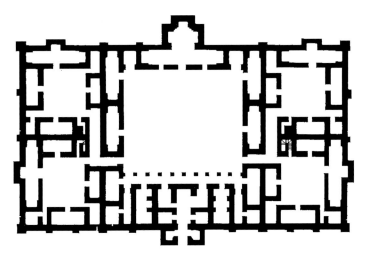

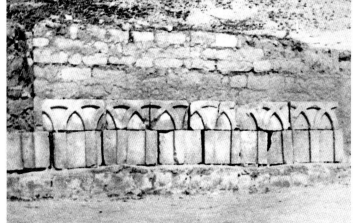

remember that the architecture of late antiquity was as much a heritage of the North African provinces as it was of Syria.

Similarly, the arrangement of narrow rooms around the courts at Ashir, particularly the T-shaped room opposite the entrance, has been linked by some to the plans of the houses of Fustat. Again, the connection seems tenuous, for the long, narrow rooms respond not to some preconceived plan but rather to the materials available for construction – stone or rammed earth for walls and relatively short timbers for roofs. The only means available to contemporary builders to make high-prestige spaces broader – without using roof trusses or vaults which seem not to have been available – was to multiply them into hypostyle halls, as in contemporary mosques, or by adding projecting bays, as at Ashir. This disposition of long rooms would continue to characterize residential architecture in North Africa and Spain for many centuries.

Perhaps the most unusual feature at Ashir is the decorative motif of intersecting arches, which is entirely unknown in the earlier art of North Africa. Intersecting arches immediately suggest artistic connections with Spain, where this motif became relatively common, but no one has yet explained how these connections might have been effected. Rather than looking for Fatimid sources to the east, it may be more profitable to look to the west, with which this region had long associations. The old Roman city of Tiaret, which lay slightly to the west of Ashir, had been developed in the ninth century by the Ibadi Rustamids under the name of Tahart as a major commercial entrepôt for east–west trade with Spain; despite doctrinal differences between the Rustamids and the neo-Umayyads, it had allied itself with distant Córdoba to ensure its independence from the nearby Aghlabids, and it is possible that merchants and craftsmen might have introduced Andalusian motifs to Tahart before it was destroyed by the Fatimids. In 925 the future al-Qa'im founded the city of Msila somewhat east of Ashir and placed it under the command of the Andalusian 'Ali b. Hamdun.[73] Such links may help explain the presence of typical Iberian motifs in the middle of North Africa.

After the Fatimids destroyed the Ibadi principality of Tahart, Ibadi Khariji merchants established the oasis city of Sedrata (Sadrata) near Wargla in the Algerian Sahara, although Tahart itself continued to survive for some decades.[74] To judge from the fragmentary remains of carved stucco found decorating some of the ruins at Sedrata, local artisans developed a distinct style based on geometricized vegetal ornament before the site was abandoned in the second half of the thirteenth century.[75] Scholars have compared its ornament to that found at roughly contemporary Islamic sites such as Córdoba, Samarra and Nishapur, but it seems much more likely that the style of decoration had a local origin in the shallow drilled decoration typical of provincial Byzantine stone decoration from North Africa.[76]

The material finds at Ashir were even more meagre: only a few rather poor ceramics were discovered at the site. Their paucity and poverty suggests that metropolitan Fatimid material culture – whatever it might have been – did not penetrate this region very deeply, if at all, and casts doubt on how much Ashir should be thought to be a reflection of Mahdiyya. The careful construction of Ashir, like at Tahart before it and the far more splendid Qal'a of the Bani Hammad (see Chapter 7) afterwards, indicates the continuing economic and political importance of the central Maghrib. Because control of this region remained so essential for Fatimid policy, Fatimid allies in this region were granted significant funds to spend on impressive construction, but the penetration of metropolitan material culture – whether Fatimid or otherwise – seems to have been minimal at best.

Despite al-Qa'im's efforts to win the Berbers' support, the new dynasty faced its most serious challenge yet in the revolt of Abu Yazid. Abu Yazid Makhlad ibn Kaydad was an Ibadi Khariji of Zanata Berber descent, who nearly brought about the new dynasty's downfall. Although the bulk of the Ifriqiyan population did not support Abu Yazid's Khariji views and as a Khariji Abu Yazid would have been as opposed to the Sunni majority as he was to the new Fatimid rulers, he was still able to channel a variety of regional, tribal and religious conflicts to support a revolt against Fatimid rule beginning in 943. He quickly conquered several North African cities and was even supported at first by the Malikis of Kairouan, who – despite deep doctrinal differences with his Khariji beliefs – saw an ally in their enemy's enemy. The most dangerous moment of the rebellion came in 946, when Abu Yazid besieged Mahdiyya itself, just as the Fatimid imam-caliph al-Qa'im died on 17 May. Keeping al-Qa'im's death secret for over a year, his thirty-two-year-old son Abu Tahir Isma'il forced Abu Yazid to withdraw to Kairouan, whose population eventually excluded him from the city. Abu Tahir eventually defeated Abu Yazid on 19 August 947 near the site of the future Qal'at Bani Hammad in Algeria and assumed the appropriate regnal name of *al-Manṣūr bi'llāh* (the Aided by God; the Victorious).[77]

The Reign of al-Mansur

Several new trends in the arts can be discerned beginning with the reign of al-Mansur (946–953).[78] His mother Karima had been a slave-concubine of the last Aghlabid amir who had been received by the future al-Qa'im as his share of the spoils of conquest. The first of the dynasty to be born in North Africa, al-Mansur thought of himself as much an Ifriqiyan Arab as an easterner. He is known to have been fascinated by the antique ruins he saw, such as the *jedar*s, or tumulus graves, of Berber princes from the fifth century CE at Jebel Lakhdar, 80 miles south of Tahart. While visiting this site, al-Mansur was interested enough to find someone able to read a stone inscribed in Latin (*bi-rūmiyya*), and although the text was read inaccurately and incompletely, he attempted to gain access – however partial – to the earlier history of the land he ruled.[79] Like his contemporary in Iran, the Buyid ruler 'Adud al-Dawla (*r.*944–983), who found a mobed to read the Achaemenid inscriptions at Persepolis and left his own inscription there,[80] al-Mansur was deeply interested in the past, trying to find roots – whether real or imagined. He never lost interest in Roman ruins, having a tombstone translated at Setif, the ancient Sitifis, visiting the ruins of ancient Sufetula, whose triumphal arch may have provided the model for the portal at Mahdiyya and camping in the Roman theatre at Sousse, the ancient Hadrumetum.

Al-Mansur was accompanied on many of these trips, whose principal purpose was to quell any lingering Khariji resistance in North Africa, by his son Ma'add (the future caliph al-Mu'izz), who came to share his father's interest in antiquity.[81] The two made a side-trip from Tunis to see the ruins of Carthage – 'among the most astonishing buildings of the ancients', according to the Fatimid author Qadi al-Nu'man – where they spent several days,[82] and visited the great Roman aqueduct that connected the springs of Mount Zaghouan to Carthage, a distance of 132 kilometres. Some of the 17-kilometre-long arcade of gigantic pillars still remains standing over the Oued Miliane depression. The future al-Mu'izz thought afterwards that he would have restored this aqueduct had any buildings at Carthage needed water.[83]

Al-Mansur seems to have learned from his confrontation with Abu Yazid that Fatimid control over the Maghrib would remain precarious without a continual display of overwhelming force as well as a milder policy towards their non-Shi'i subjects.[84] To that end, al-Mansur embarked on a course of public display and

ceremony that his predecessors had tried only tentatively. Confronting Abu Yazid on the battlefield of Kairouan in August 946, the prince stood out beneath a splendiferous umbrella, which betokened the presence of God's appointed. Somehow, he had also acquired Dhu al-Fiqar, the fabulous double-edged sword of his ancestor 'Ali b. Abi Talib.[85] Like his grandfather, al-Mansur wore magnificent clothes, but there was method in his display. He knew that he also had to play the part of a ruler. At the final battle against Abu Yazid in the Hodna mountains in March 947, the prince led the assault wearing red and gold.[86] After defeating Abu Yazid, al-Mansur returned to Kairouan on 13 January 948 and made his triumphal entrance wearing quince-coloured brocade.[87]

Sources for this period provide the first evidence for a concerted policy of royal gift-giving between the Fatimid caliphs and their subjects. During the Abu Yazid crisis the prince received money, horses, camels and other animals in tribute from his subjects and provided his supporters with food and clothing. He bought – and maintained – the loyalty of important Berber chiefs, such as Maksin ibn Sa'd and Ziri ibn Manad, with gifts of cloth, gold, silver, curios and treasures 'to captivate their souls'. He also sent Ziri robes of honour, perfumes and 'kingly curios *(tarā'if al-mulūkiyya)* of incalculable price and indescribable beauty', as well as pure-bred horses whose saddles and bridles were heavy with gold and silver. The ruler himself amassed the most precious things to be found in his realm and the finest treasures of every kind.[88]

Contemporary sources also provide the first evidence for Fatimid royal workshops during the reign of al-Mansur, although they may have been established already during al-Qa'im's reign or even earlier. The most important was the textile workshop, where textiles were woven and embroidered with the ruler's name. In many regions of the Islamic world the manufacture and presentation of inscribed cloth (*ṭirāz*) became an important symbol of sovereignty, as rulers regularly gave courtiers lengths of inscribed cloth which they then made into garments. One of the very earliest tiraz textiles to survive, probably woven in the reign of the Umayyad Marwan II (*r.*774–750), was woven in the factory of Ifriqiya, indicating that state textile factories had been established in the region at an early date.[89] From his earliest appearance, the Mahdi had shown an unusual interest in fine textiles and garments; the eunuch Jawdhar, who had entered the Mahdi's service, oversaw his and his successors' stores of textiles and clothing, which must have grown significantly once the looms

23 Dinar of al-Muʿizz struck at al-Mansuriyya in 342 CE. American Numismatic Society 1917.215.29

of Ifriqiya and Sicily came under Fatimid control.[90] Al-Mansur eventually freed Jawdhar and elevated him in rank, ordering that his name was to be embroidered on the cloth, even specifying the text to be inscribed. Jawdhar stated that the cloth was made 'to honour and to augment (the caliph's) importance . . . He enjoyed the products of his slaves, often exclaiming as we watched over them, "Their works are splendid gardens!"'[91] No Fatimid textiles from this early date are known to have survived.

In contrast, coins, which were another traditional sign of sovereignty in the Muslim world, were more durable and many early Fatimid examples survive. As soon as the Fatimids had seized control in Kairouan, they began issuing coins with a new and revolutionary message, but the die-cutters initially followed Aghlabid and Abbasid prototypes, inscribing the Qur'anic verses in a single circular border. Such continuity occurred not only because the missionary Abu ʿAbd Allah and the Mahdi employed the same craftsmen to carve their dies as their Aghlabid predecessors had but also because coinage is especially conservative, since people do not readily accept unfamiliar coins. Thus, the value of Fatimid coins was initially assured by their fineness and their weight, not their new design.[92] Scholars and collectors have focused their attention on Fatimid gold

coins; the Fatimids also struck both *waraq* (alloyed) and *nuqra* (pure) silver dirhams, but they did not issue copper coins.[93]

Al-Qa'im, once the dynasty had been in power for more than a couple of decades, felt secure enough to abandon the traditional Abbasid coinage used by his father, adopting new legends and a more refined calligraphic style, in which the earlier letters with beadlike, globular terminals were replaced by wedge-shaped letters closer to calligraphic norms.[94] In one coin the final *yāʾ* of *mahdī* ends in a delightful floriated terminal, revealing a degree of the diecutter's playfulness. The new design also doubled the border, making it wider at the expense of the central field, but as some Umayyad and Abbasid coins also exhibit this feature, this feature is not in itself distinctive of Fatimid coins alone. The Khariji Abu Yazid briefly struck dinars in the same style as al-Qa'im,[95] once again reaffirming the conservative nature of coin design. Once al-Mansur publicly announced his succession to the imamate, however, he did not merely replace his father's name on the coinage but had the coins redesigned so that the circular borders came to dominate the field. In the first issues text was removed from the inner band of the border, leaving a blank ring to surround the central legends on both the obverse and reverse (Fig. 23).[96] It is difficult for modern eyes to appreciate quite how revolutionary these changes would have been to a population that had had more than two centuries of familiarity with coinage of the standard Islamic epigraphic types.

Coins with the new design were first struck in al-Mansur's name in May 948, nearly a year after Abu Yazid's defeat. The coins of al-Mansur, like those of his predecessors, included Qur'anic phrases (e.g. 6:115: 'The words of your Lord are perfectly true and just; none can alter His words, for He is all-hearing and all-knowing') without an explicitly Shiʿi message, but those of his successor al-Muʿizz introduced strongly Shiʿi slogans, increased the number of borders and eventually eliminated the central field in favour of a single dot.[97] With great variation in the number and content of the circular bands and the presence or absence of a central field, the concentric arrangement remained characteristic of most Fatimid coins struck in North Africa, Egypt, Syria and Arabia for another two centuries.[98]

It is difficult to provide an explicit motive for these changes in design. Striking gold coins was an essential element of caliphal prestige. The Fatimids had begun striking gold coins at Raqqada in 909; the neo-Umayyads of al-Andalus, who had previously only struck silver, began striking gold twenty years later in

929 when 'Abd al-Rahman III assumed the title of caliph, presumably in response to the proclamation of the Fatimid caliphate nearby. The gold for Fatimid coins came from tropical west Africa, a region to which North Africa was linked by extensive caravan routes across the Sahara, and both rival caliphates, the neo-Umayyad and Fatimid, wanted this gold. The Fatimids were obliged to stare down not only the neo-Umayyads and the Abbasids but also smaller rivals, like the Ikhshidids of Egypt, who minted gold coins in the Abbasids' name. The dinars al-Mu'izz issued not only spelled out the dynasty's doctrine but were virtually pure gold, making them much more attractive than their rivals' coins. In the words of Michael Brett, al-Mu'izz's 'ideological purpose created a demand which elicited a supply'.[99] The new design, therefore, explicitly proclaimed their finer quality.

Irene Bierman has conflated this gradual and somewhat inconsistent transformation of Fatimid coinage into a single event during the reign of al-Mu'izz and mistakenly concluded that the introduction of a concentric design on coins was intended to 'emblematize' Ismaili rule and ideology. She likened the concentric circles of the coins to the concentric districts of a city or the concentric circles of power around the ruler, but such an extreme interpretation is quite unfounded in the facts.[100] Although it is conceivable that some contemporary might have drawn such a parallel, it is equally possible that someone else could have interpreted the concentric rings as symbolizing the succession to the Mahdi, since in contrast to Christian or Buddhist iconography, no specific text makes a particular interpretation more correct than another. Furthermore, such a graphic interpretation implies that a three-dimensional entity such as a city could have been conceptualized as a two-dimensional representation (i.e. a plan), yet there is little, if any, evidence for such visual sophistication at this time and place. Coinage, it should be remembered, is an inherently conservative medium and great symbolic changes are more likely to have been ventured in other media.

A clue to the contemporary meaning of the new coins is more accurately revealed by the memoirs of the eunuch Jawdhar, chamberlain to the first Fatimid caliphs, who referred to this new type of dinar as the *manṣūrī*, after the ruler who first struck them. The caliph sent the first thousand examples to his loyal servant, whom he had freed and elevated in rank. In the accompanying letter, al-Mansur wrote that Jawdhar should accept this money as a benediction, for 'no riches are purer than the money which I offer'. The gift was not only tangible wealth but also a symbol of the esteem in which the ruler held Jawdhar.

Mansuriyya

In the autumn of 946, just before setting out in the final pursuit of Abu Yazid, the prince ordered the building of a new palace city on the site of his camp a short distance south west of Kairouan. It was to be called *al-Ṣabra*, the city of Fortitude and Endurance, and *al-Manṣūriyya*, the city of the Conqueror.[101] According to the late tenth-century geographer (and Fatimid sympathizer) al-Maqdisi, the city

> is rounded like a cup and there is not another place like it. The ruler's house is in the centre of the city, just as in Baghdad and water runs through the middle of it. Very well populated, it has excellent markets within which stands the congregational mosque of the ruler. The width of the [city] wall is twelve cubits and it is separated from the buildings of the city, for between them and it is a space the width of a road. The merchants go back and forth between the capital and Sabra mounted on Egyptian asses. The gates of the town are: *Bāb al-Futūḥ* (Gate of Triumphs), *Bāb Zawīla* (Gate of the Zawila Tribe) and *Bāb Wādī al-Qassārīn* (Gate of the Valley of the Fullers); they are all reinforced with iron. The walls are of baked brick jointed with lime.[102]

To judge from al-Maqdisi's account, the Fatimid caliph al-Mansur had taken the Round City of Baghdad, which had been founded nearly two centuries earlier by the Abbasid caliph of the same name, as his model. The parallels are indeed striking. But al-Maqdisi, whose Fatimid sympathies are clear in the favourable comparison, should not be read too literally: by the tenth century, little, if anything, was left of Baghdad's fabled Round City. The Fatimid ruler had never seen it and the imitation was nothing more than generic, based on a faint impression of a faraway fabled place. Verbal descriptions would have sufficed to indicate that it had a mosque and palace in the centre surrounded by shops and houses, all enclosed within a circular wall. At the same time, it is also quite likely that the Fatimid al-Mansur would have consciously avoided emulating *anything* done by an Abbasid, whose dynasty he had sworn to overthrow.

Although the new capital returned the seat of power to the suburbs of Kairouan, the site represented a break

with the immediate past and shows how far the Fatimids had come in three decades: whereas his grandfather the Mahdi had constructed his capital city away from Kairouan on a peninsula protected by the Mediterranean and strong walls as a secure refuge, al-Mansur built al-Mansuriyya on the plain near Kairouan to provide a luxurious setting for royal pomp and splendour and to generate wealth to support and expand the Fatimid state. The location alone reveals the Fatimids' new sense of self-confidence following the defeat of Abu Yazid.

The walls and gates were constructed first and the splendid palaces, gardens and mosque begun only after Mansur had polished off Abu Yazid. When al-Mansur arrived at the site in January 948, he conducted the midday prayer in his palace, as the mosque – which one source says was called *al-Azhar*, 'luminous', 'resplendent' or 'brilliant' – was not yet completed.[103] Mansur and his successor al-Mu'izz made their capital there from 949 to 973, building 'lofty and splendid structures having marvellous plantings and tamed waters.' Meanwhile, the old residences at Mahdiyya were used to warehouse royal relatives whose presence at Mansuriyya was unwanted and inconvenient and some of these folk remained in these 'gilded cages' until the dynasty moved to Egypt.[104] The new palaces at Mansuriyya bore grandiose names such as the Camphor Audience-Hall, the Crown Room, the Myrtle Audience-Hall, the Silver Room and Khwarnaq (the name of a famous Sasanian palace) that reverberated with faint echoes of the Abbasids' palaces at Samarra.[105] The multiplicity of names suggests that there were several campaigns of construction as the rulers' needs evolved and changed. One should not therefore imagine the palace as a single building but as an agglomeration of structures.

Again, it is often said that Mansuriyya, like Mahdiyya, was another restricted palace-city for the ruler and his court. Yet it is clear that not only courtiers and slave soldiers were settled in al-Mansuriyya; al-Mansur also had the families of 14,000 Kutama supporters transplanted there, a number – even if inflated – that presupposes the existence of a full panoply of urban functions to service them.[106] Al-Maqdisi mentions markets and 'people going back and forth' to Kairouan. Abu 'Ubayd al-Bakri, a usually reliable source of the eleventh century, said that al-Mu'izz transferred the markets of Kairouan to al-Mansuriyya and at each of the city's gates 26,000 silver dirhams were collected daily as tolls on goods entering the city.[107] A ruler would have been ill-advised to keep merchants out when their activities provided such enormous revenues.

The internal chronology of Mansuriyya is difficult to establish, for although al-Mansur founded it, his son al-Mu'izz built some of the magnificent palaces at the site. Qadi al-Nu'man, for example, reported that al-Mu'izz ordered some colossal antique columns transported from Sousse to Mansuriyya to be erected in the Great Hall, a feat that was considered impossible. Al-Nu'man feared that if the undertaking failed, it might severely damage the caliph's prestige. But it was successful and the fragments of colossal columns, with a diameter of over one metre, may still be seen at the site.[108] Al-Mansur built a palace facing a large pool, in the midst of which was another palace connected to the first by a footbridge. Al-Mu'izz expanded the waterworks by realizing his father's and grandfather's plans to bring water from the distant spring of Ayn Ayyub by constructing an aqueduct modelled on the Roman one that serviced Carthage.[109] Continued occupation made the history of the site even more confusing, for following al-Mu'izz's departure for Egypt in 973, his Zirid lieutenants continued to rule from Mansuriyya for another eighty-five years, adding new buildings and remodelling older ones.

Aerial reconnaissance of the site of Sabra/Mansuriyya in 1947 revealed a huge, roughly circular enclosure approximately 750 metres in diameter representing the line of the city walls, in which several large circular and rectangular depressions can be identified as the remains of the pools that formed the centrepiece of each palace.[110] Virtually nothing else has survived, for after the site was abandoned, the residents of Kairouan used it as a quarry for building materials, especially bricks, and that which wasn't carried away by men was washed away by repeated floods of the Oued Zroud. French and Tunisian archaeologists have excavated the mounds of debris – containing fragments of pottery, glass, carved plaster, marble and glazed tile – sporadically since 1921 and systematically since 1972, but the detailed results of their findings have never been published methodically and available information remains sparse but intriguing.[111] The remains of one residence revealed a series of rectangular rooms arranged in an elaborate T-plan opening onto a courtyard. The walls, constructed of sun-dried bricks, are reported to have been rendered with plaster which was painted or carved with geometric, floral, epigraphic and figural motifs, although only fragments are said to have survived.[112] Most scholars have related the fragmentary plan of this building to a 'Mesopotamian' prototype, but it also shares features with the plan of suites of rooms found at the contemporary palace of Madinat al-Zahra, outside Córdoba in Spain, suggesting that such comparisons are virtually meaningless. We

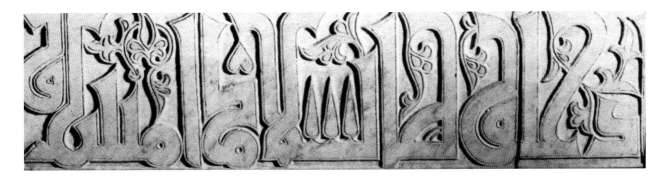

24 Kufic inscription on white marble found in the fourteenth-century Zawiya al-Gharaniyya, presumably from al-Mansuriyya. Tenth century, 140 × 38 cm. Raqqada, Museum of Islamic Art

know so little about residential architecture in this period that it seems premature to talk about 'influences' flying all over the map. It has also been suggested that a fragment of a white marble inscription written in an elegant floriated kufic script discovered in the fourteenth-century Zawiya al-Gharyaniyya in Kairouan (Fig. 24) came from one of the monumental gates of al-Mansuriyya. The incomplete text reads 'Enter it in peace, forbearing [from fear]', which would be appropriate to a portal, but the inscription could just as easily date from the period of Zirid occupation of the site, which lasted well into the eleventh century.[113]

Fortunately, court poetry helps to fill in the void. For example, a poem by the Fatimid court poet 'Ali ibn Muhammad al-Iyadi praises Sabra's Khawarnaq palace in the period:

> Now that glory has become great and the great
> one rules over the stars, a porticoed pavilion
> spreads,
> He built a dome for dominion in the midst of a
> garden which is a delight to the eye,
> In well-laid-out squares, whose courtyards are
> verdant, whose birds are eloquent,
> Surrounding an enormous palace among palaces,
> as if you could see the very sea gushing in its
> corners.
> It has a pool for water filling its vast space across
> which eyes race and flit.
> The rivulets which gush into it lie like polished
> swords on the ground.
> In the midst of its waters an audience hall stands
> like Khawarnaq amidst the Euphrates' flood,
> As if the purity of its waters – and its beauty –
> were as smooth as glass of azure hue.
> If night unrolls the figure of its stars over it, you
> would see Blacks burned by fire,

> And if the sun grazes it, it appears like a beautiful
> bejewelled sword on the diadem of al-Mu'izz.
> The secluded balconies around it were virgins
> wearing girdled gowns.
> The foam dissolves on the face of its waters as does
> the rain on parched soil.[114]

In sharp contrast to the earlier poem about Mahdiyya, which said more about Fatimid aspirations than about the city's physical aspects, this poem is a frank encomium about physical pleasure and delight. From the poem we learn that the focus of this palace was a huge pool fed by multiple water channels and surrounded by arcaded porticoes. In sharp contrast to the Mahdi's residences at Mahdiyya, which appear to have been rather straightforward and utilitarian structures, those of his grandson at Mansuriyya were meant to delight and impress in the tradition of the earlier Aghlabid suburban palaces at al-'Abbasiyya and al-Raqqada near Kairouan. Whereas the Mahdi had worried about security and providing sufficient water to his city, his grandson and great-grandson made pleasure and the extravagant display of water a central feature of his palaces. Fatimid palatine architecture had embarked on a new course.

Nevertheless, the palaces at Mansuriyya also continued local traditions. For example, the idea of a large palace designed around the ostentatious display of water can be traced to the Aghlabid Qasr al-Bahr (Lake Palace) at Raqqada and the extensive system of Aghlabid waterworks was itself built on earlier Roman remains.[115] Elaborate waterworks were not, it would seem, part of the Umayyad and Abbasid palace traditions, although they became common under the neo-Umayyads of al-Andalus. According to the geographer al-Bakri, the Mahdi is supposed to have remarked that he saw two things in Ifriqiya of which he had never seen the like in the east (i.e. Iraq, Syria or Egypt): the great

Aghlabid reservoir at Kairouan and the Lake Palace at Raqqada.[116] (The Aghlabid reservoir still survives and it remains impressive.) Nevertheless the Mahdi had not chosen to build such a palace for himself. His grandson's desire to create a vast palace organized around a massive pleasure pool in the centre of a triumphal showpiece of a city speaks not only of greater security and increased resources but also of a new taste for ostentatious display.

Mahdiyya's walls had been essential to its role as a fortress and stronghold, but those of Mansuriyya reflect a different sense of pomp and majesty with which the Fatimid caliph began to surround himself following the triumphant defeat of Abu Yazid. Instead of security, the caliph's primary concern must have been, like many other medieval Muslim potentates, to construct high walls to contain a theme park for his private pleasure. While some of these new ideas may have come from local traditions, they indicate that the Fatimids, whether through their own experience or through that of their advisers and associates, were also casting their net over a far wider area.

Mansuriyya in the Mediterranean Context

Scholars have usually interpreted the creation of Mansuriyya in purely local terms as the second in a series of Fatimid foundations that would eventually culminate in the establishment of their permanent capital in Egypt. But the change in tone from Mahdiyya, a practical base from which the Fatimids expected to conquer the world, to Mansuriyya, a luxurious setting in which they would project their power and satisfy their pleasures, cannot be explained merely in local terms. It was also a response to contemporary developments in the western Mediterranean, particularly to events transpiring in the far north-west corner of North Africa and across the straits of Gibraltar on the Iberian peninsula.

The Fatimids held a big grudge against the Abbasids, who had usurped their claim to rule, but they held an even greater one against the Umayyads. They believed that Mu'awiya, the first Umayyad caliph, had usurped power from 'Ali, the Prophet's son-in-law and progenitor of the Fatimid line, and neo-Umayyad descendants continued to rule as amirs in the Iberian peninsula. In 929, the neo-Umayyad amir 'Abd al-Rahman III had declared himself *amir al-mu'minin* (Commander of the Faithful) or caliph, taking the regnal name *al-Nāṣir* (the Helper or Protector). This act was equally a matter of domestic and foreign policy, for it was directed not only at the Muslims of al-Andalus but also the Abbasids, the

Byzantines and especially the Fatimids. For nearly two hundred years the neo-Umayyad rulers of Spain had felt no need to declare themselves caliphs. But then the Fatimids came on the scene and once it transpired that the world could cope with two rival caliphates, there was no reason that there could not be three.

Neo-Umayyad and Fatimid territorial ambitions first came into conflict in north-west Africa: by 921 the Fatimids had already attacked Fez, which the neo-Umayyads saw as being in their sphere of influence, and over the following decades the local Berber chiefs continuously switched allegiances back and forth as the balance of power in the region shifted.[117] The Fatimid prince Isma'il's choice of the regnal name *al-Manṣūr* had made perfect sense in the context of Abu Yazid's revolt; it also was a riposte to his neo-Umayyad rival, 'Abd al-Rahman, who had chosen the name *al-Nāṣir*; both names are derived from the same Arabic verb *n-ṣ-r*, 'to help, aid, assist, render victorious'.

In 936, exactly a decade before al-Mansur began construction of the new Fatimid capital outside Kairouan, 'Abd al-Rahman III, the neo-Umayyad ruler of Spain, had begun building Madinat al-Zahra', a self-sufficient palace-city conceived on a monumental and urban scale with its own mosques, baths, markets and urban administration, on the hills to the west of Córdoba. Called both a city and a palace in the sources, Madinat al-Zahra' had its own city manager, police chief, judge and congregational mosque. Madinat al-Zahra' combined a local tradition of country estates with a 'new eastern concept of palatial magnificence and complexity using rich materials for highly theatrical effects'.[118] Observers agreed that it was 'the utmost of splendour and magnificence . . . and that nothing of its kind had ever before been built in Islam. Those who entered it from faraway places and of different social ranks . . . judged that they had never seen or heard of anything like it, nor imagined the existence of such a thing'.[119] A new type of urban centre in which aesthetic innovations serving the apparatus of sovereignty outweighed other considerations, it seems that Madinat al-Zahra', far more than Baghdad, was the model that inspired the Fatimid al-Mansur to build al-Mansuriyya.[120]

'Abd al-Rahman III had amassed expensive foreign materials for his new palace-city because their acquisition brought prestige to him and his works. For example, he had over one thousand ancient columns brought from Ifriqiya, most of them from the ruins of Carthage; others, of pink and grey marble – some of them can still be seen today – were brought from the ruins of a church near Sfax. We can hardly suppose that

the Tunisian coast was the closest source for these materials or that this expropriation of materials took place with the consent of the Fatimid caliph; his Andalusian rival must have taken advantage of the disruption caused by Abu Yazid's revolt to procure the costly spolia.[121] Al-Mansur's subsequent decision to pillage materials from pre-Islamic sites in North Africa for his own palace-city takes on new meaning in this context, for in this manner al-Mansur could be understood, like his rival, to be attempting to acquire prestige from the possession and reuse of ancient remains. Furthermore, al-Mansur's island palace connected by a footbridge to a larger palace is uncannily reminiscent of Madinat al-Zahra', where a similar effect was created for the pavilion in the midst of the Upper Garden. Facing the so-called Salón Rico, it was surrounded by pools so that from inside it appeared to be floating.[122]

Al-Mansur could have learned about 'Abd al-Rahman's plans for Madinat al-Zahra' either from Umayyad agents active in North Africa or through such figures as his secretary, a certain Abu Ja'far Muhammad ibn Ahmad al-Baghdadi, who had previously served both the Mahdi and al-Qa'im. As his name indicates, Abu Ja'far Muhammad was originally from Baghdad and had arrived at Sijilmasa around the same time as the Mahdi, where the two had become acquainted. The Mahdi's first secretary had been Abu'l-Yusr al-Baghdadi, a learned man of letters who had composed a series of books on Qur'an and Sunna. From his own residence at the court of Córdoba and at the Aghlabid court in Kairouan, Abu'l-Yusr had gained experience in foreign politics. He made himself available to the new regime and served it until his death in January 911. The Mahdi then appointed the intelligent, worldly and cultivated Abu Ja'far Muhammad as adviser and secretary, even sending him to Córdoba, where he acted as a Fatimid missionary, agent and spy, all the while becoming well known in Córdoban literary circles.[123] Other individuals like these men must have travelled between the courts and may have provided the cultural conduit.

Madinat al-Zahra' covered only 11 hectares (27 acres), while Sabra-Mansuriyya, to judge from the aerial photograph, was four times larger, covering about 44 hectares (110 acres). Nevertheless, the parallels are striking. Both were suburban foundations containing residences for the caliph, his retinue and his followers, along with a mosque, workshops and the mint. The palaces of Mansuriyya, like those of Madinat al-Zahra', had gardens and lavish displays of water, also provisioned by the reuse of originally Roman aqueducts.[124] Mansuriyya, like Madinat al-Zahra', had conspicuous displays of antique materials such as the

columns al-Mu'izz had brought from Sousse. Both were unusually complex foundations intended to express dynastic authority and personal power.[125]

The differences between Mansuriyya and the old capital at Mahdiyya are equally striking. Mahdiyya had the practical aspect of a fortress and retreat; despite its encircling walls, Mansuriyya was principally designed for the luxurious pleasures of a prince. Mahdiyya had been a public manifestation of the righteousness of the new order; Mansuriyya was a manifestation of the prince's power through the conspicuous display of the limitless resources he had available to devote to his private pleasures. No longer did the ruler see himself simply as a wealthy merchant who was also the rightful imam, heir to the spiritual and temporal authority of the Prophet. Now he announced himself to be a successful warrior, restorer of the tottering regime he had inherited from his dying father and heir to the royal traditions of ages past, an equal to all the kings of this world.

In 952–3 the Byzantine emperor Constantine VII sent a monk-ambassador to the court of al-Mansur bearing precious gifts. This was not the first contact between the Fatimids and Christian powers. Some twenty-five years earlier, the Mahdi may have entered into an alliance with the Bulgarian ruler Symeon (d.927) against their common Constantinopolitan enemy, and in the wake of many raids against southern Italy, the Byzantine emperor Romanus Lecapenus (r.920–944) sent an embassy to Mahdiyya to negotiate a truce.[126] The embassy, which arrived in 931 or 932, brought presents and offered renewed payment of tribute in exchange for the security of Calabria and Apulia. This truce raised the international prestige of the Fatimids considerably, for not only had the Emperor given diplomatic recognition to the new dynasty, but he had also meekly offered to pay tribute once again.[127]

Constantine's embassy of 952–3 was sent to renew that truce, bearing tribute of 'gold and silver vessels inlaid with jewels, brocades, silk, nard and other precious items'. According to one Fatimid chronicler, the Byzantine envoy was struck by the majesty of the Fatimid sovereign and the pomp with which he surrounded himself, 'finding it unequalled even in his own land'. This is, of course, very difficult to accept at face value, since this was the period in which Byzantine court ceremonial was at its height.[128] According to Fatimid sources, al-Mansur wished to send the ambassador home with appropriate gifts to the emperor. He asked his chamberlain Jawdhar (who was now in charge of all the treasuries) to collect gifts that would be even finer and of greater value than those he had received from the emperor:

25 Parchment folio with text of Q 25:48–54 from the Blue Qur'an, tenth century. The Aga Khan Trust for Culture

> I know how much you desire that there not be any-
> thing beautiful in this world except that it be ours and
> in our treasuries and I imagine that this leads you to
> be miserly and refuse to send things to the Christians
> as you have been ordered to do. Do not be like this,
> for the treasures of the world remain in the world and
> we accumulate them only to rival our enemies in
> splendour, show the nobility of our sentiments, the
> greatness of our soul and the generosity of our hearts
> in the gift of things of which one is envious and about
> which everyone is selfish.[129]

Al-Mansur's pious platitudes about the transitory nature of worldly goods do not conceal his shrewd understanding of the symbolic role of fine gifts to project the greatness and power of the Fatimid caliph and show his equality with the world's great rulers. Whereas his father and grandfather had couched their claims primarily in religious and philosophical terms, avoiding the wider context in favour of a narrowly Islamic one, al-Mansur was creating an aura of splendour to affirm and enhance his position as a major player in the Mediterranean arena.

These diplomatic exchanges had one final episode: in 964, the Byzantine emperor Nicephorus Phocas sent an armada to Reggio in Calabria under the command of Nicetas, an elderly patrician and the emperor's young nephew, Manuel Phocas. The army crossed into Sicily and was annihilated in 965; after Manuel was killed, Nicetas attempted to return home, but his fleet was destroyed in the straits of Messina and Nicetas was captured by the Fatimids. He spent two years in com-

fortable imprisonment at the Fatimid court while al-Mansur's successor made preparations for his campaign to conquer Egypt.[130]

Decorative Arts during the Reign of al-Muʿizz in North Africa

In March 953 al-Mansur died at the age of forty after a reign of less than six years. His son Maʿadd acceded to the throne as *al-Muʿizz li-Dīn Allāh* ('He who Glorifies God's Religion') at the age of twenty-two.[131] Although his father had restored royal authority by ending Abu Yazid's revolt, the young ruler had still to pacify the territory he had inherited, extend his hegemony over it and realize the imperialistic aims of his predecessors. This exceptional ruler devoted himself entirely to this programme for nearly twenty years, until January 973, when he left North Africa for Egypt, which his general Jawhar had conquered three years earlier. Although al-Muʿizz spent only the last three years of his life in Egypt, vainly trying to continue his dynasty's eastward expansion into Syria, his greatest contribution was the nurturing of the mature Fatimid state. It was characterized by a rigorous administrative and financial organization, solid political and religious institutions and a brilliant intellectual and artistic life, all of which would be fully realized in the new capital established on the banks of the Nile.

The Fatimids' willingness to place themselves on the larger diplomatic stage, whose cast included the neo-Umayyads of Spain and the Byzantines, explains their new interest in the production of luxury art during the reigns of al-Mansur and particularly al-Muʿizz. Nothing of comparable quality can be ascribed to an earlier period. Among the most important pieces of evidence for this new interest are two of the earliest works of Fatimid art known to survive: an undated manuscript of the Qur'an on blue-dyed parchment and a small ivory box made for al-Muʿizz in Mansuriyya. A third example, a large map of the world embroidered in gold on silk, is known only through texts.

The Qur'an manuscript, which European scholars have known about for nearly a century, is unique, for the parchment pages are readily identified by their indigo colour and the fifteen lines of angular gold script in a text block measuring approximately 19 × 29 centimetres (7.5 x 11.5 inches) (Fig. 25).[132] On the basis of the surviving pages of this 'Blue Qur'an', the original manuscript must have comprised over six hundred leaves which would have been divided in seven volumes

26 Two pages with Q 23:43–61 from a Qur'an manuscript copied on parchment at Palermo in 982-3. 17.6 × 25 cm (7 × 9⅞ in. [each page]); London, Nour Foundation, QUR 261, folios 8b–9a

with about ninety leaves in each. Over the years, the Blue Qur'an has been ascribed to places as far apart as early ninth-century Khurasan and late tenth-century Spain – and recently even Sicily[133] – but scholarly consensus points to North Africa in the mid-tenth century. A catalogue of Kairouan's mosque library indicates that the manuscript was there (and more or less complete) in the late thirteenth century. The continued presence of the Blue Qur'an in Tunisia seems to have inspired later patrons to commission similarly coloured manuscripts, including a five-volume copy of the Qur'an written in gold and silver on tinted paper in the early fifteenth century.[134] At some later date – perhaps as early as the sixteenth century – some parts of the manuscript were removed, possibly to Istanbul or even further east.

Circumstantial evidence also supports the Maghribi origin of the Blue Qur'an. The verses are counted using a distinctive variant form of *abjad*, or alphabetic numeration, which was followed only in the western Islamic lands. By the mid or late tenth century in the eastern and central Islamic lands, paper was becoming popular for manuscripts of the Qur'an, but parchment continued to be preferred in the Maghrib far longer than elsewhere. Along with paper came the development of new more fluid scripts better suited to the medium. For example, a manuscript (Fig. 26) copied on parchment in 982-3 at *Madīnat Siqilliyya* (Palermo), which was then under Fatimid control, shows the wide diffusion of new scripts in the tenth century, of which some would eventually evolve into the distinctive Maghribi script used in North Africa by the early eleventh century.[135] It is likely

that the Blue Qur'an was made somewhat earlier, although perhaps not so early as the rather plain script might suggest, for there are indications that it may be consciously archaizing rather than simply old.[136] The blind rulings found on the pages of the Blue Qur'an, for example, are otherwise unknown in early parchment manuscripts of the Qur'an.[137] There is no particular reason to believe that the Aghlabid rulers of Ifriqiya would have commissioned such a manuscript in the ninth century, but, as we shall see, there is every reason to believe that the Fatimids commissioned it in the middle of the tenth.

The unusual colour scheme – gold writing on royal blue – is a colour combination that has had luxurious and even royal connotations for centuries, long before the rise of Islam. The mosaic inscriptions on the Dome of the Rock in Jerusalem, for example, were written in gold on a blue ground, but the Fatimids in Tunisia could hardly have been inspired by – or wanted to emulate – the great works of Umayyad art. Rather, the colour combination must have been inspired by something closer in time and space. A likely possibility is a Byzantine imperial manuscript or document, of which some were written in silver and gold on parchment dyed purple or blue. True purple made from murex, the rare dye made from the glands of a Mediterranean mollusc, was initially used at several Mediterranean sites – including some in Tunisia – for dyeing textiles and documents, but from the seventh century it was used mostly at Constantinople, where it continued to be used at least until the eleventh century.[138] The marriage certificate of the Holy Roman Emperor Otto II and the Byzantine

27 Ivory box made for al-Mu'izz at Mansuriyya between 953 and 973. Madrid, Archaeological Museum

princess Theophano was written *c.*970 in gold on purple-dyed parchment and Byzantine embassies are known to have presented 'sky-blue' documents to the neo-Umayyads in Spain; there is no reason to doubt that Byzantine embassies to the Fatimids would have brought similar documents.[139] As Arabic did not semantically distinguish between the colours blue and purple, the Fatimids would not have been primed to see that the deep purple obtained from murex was significantly different from – or more desirable than – the deep blue obtained from indigo.

One can only speculate about the manuscript's ultimate purpose. There is no reason to think that it was made for the Great Mosque of Kairouan in which it was later kept, for the Fatimids had no great love for the city and its Maliki ulema. Events suggest that they thought of Ifriqiya as merely a way-station on their path to reclaim the Muslim world. One could imagine therefore that the manuscript was made as a gift, perhaps for the Byzantine emperor, who might be expected to appreciate its imperial connotations, even if he could not read the script. Stories about the libraries the Fatimids later maintained in Egypt suggest that multiple copies of such luxury manuscripts may have been produced, although no other is known to survive.

The second example of North African Fatimid luxury art to survive is an ivory box (Fig. 27).[140] Measuring 42 × 24 × 20 centimetres (16.5 × 9.4 × 7.8 inches), each side of the box is a rectangular ivory plaque held between four corner posts which stand on bulbous feet. Two of the posts extend above the lid, itself composed of two ivory plaques, to end in bulbous turned finials. The bottom of the box consists of three long strips of ivory, with corners cut out to fit around the posts. The top of the lid has similar cutouts in the rear corners to allow for the finials. The box is now held together with iron hinges and clamps, but these are clearly later additions, as they have nothing to do with – and often obscure – the original decoration. All four sides of the box are painted along the edges of the plaques and corner posts with an undulating stem from which emerge half-palmette leaves nestled in the bends. The border of the lid is inscribed in an elegant angular script:

In the name of God, the Merciful, the Compassionate. Help from God and speedy victory (Qur'an 61:13) for God's servant and His friend, Ma'add Abi Tamim, the Imam al-Mu'izz [li-din Allah], Commander of the Believers – God's blessings upon him and on his good ancestors and pure descendants. Among the things that was ordered to be made in Mansuriyya the Pleasing (to God). The work of A[hma]d al-Khurasani.

The lid is further embellished on the inner edge of the inscription with an elongated fret design painted with four-petalled rosettes in the corners. The decoration is done in brown and greenish-black paint; the inscription is reserved against a dark ground.

28 Ivory box carved and painted with friezes of griffins, tenth or eleventh century, 19 × 41 × 23 cm (7½ × 16⅛ × 9 in.). Mantua, Museo Diocesano Francesco Gonzaga

While the artisan is otherwise unknown, the names of al-Mu'izz and Mansuriyya indicate that the Madrid box must have been made in North Africa in the two decades between the caliph's accession in 952 and his departure for Egypt in 973; the particular Qur'anic verse chosen suggests a date in the mid-960s, when preparations were being made for the conquest of Egypt, for the verse was also inscribed on the silk map made in 964. The choice of material is significant: ivory – the hardest organic material known, yet one relatively easy to work – was an extremely expensive material, for virtually all supplies of ivory used in the medieval Mediterranean lands were imported by caravan across the Sahara from tropical Africa, whether via Egypt, Tunisia or Morocco.

Apart from an extraordinarily similar, but uninscribed, box decorated with friezes of griffins painted red and green on a gilded ground (Fig. 28), which may also date to this time and place, no other ivories are known from tenth-century North Africa.[141] Many ivory boxes, however, were made from the middle of the tenth century both at Córdoba in Spain for the Fatimids' neo-Umayyad rivals and in Constantinople for their

Byzantine ones.[142] It would not have been surprising for the Fatimids to have wanted ivory boxes as well. Neo-Umayyad boxes seem to have been made exclusively for internal consumption at the court, while the Byzantine ones were made for patrons ranging from the emperors to the wealthy bourgeoisie. The Mansuriyya box is comparable in size to a splendid carved box now in Pamplona (24 × 38 × 24 centimetres; 9.5 × 15 × 9.5 inches), yet unlike the ivory boxes of Spain – in which the carved plaques are held together with tiny pins or nails – Ahmad al-Khurasani's box is pathetically unsophisticated. The panels are simply painted, not elaborately carved and they are joined together with heavy corner posts rather than fixed directly to each other.

Contemporary Byzantine boxes have carved ivory or bone plaques and strips affixed to wooden cores. On most, prefabricated strips of rosette decoration enclose small panels of mythological or circus scenes.[143] Although the Fatimid casket has only painted decoration, the organization in panels and bands is actually closer to Byzantine models than to neo-Umayyad ones. The painted technique is, however, similar to that found

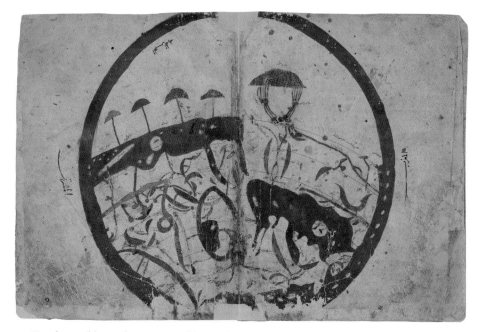

29 Circular world map from a copy of the *Book of Curiosities*, twelfth–thirteenth century, probably after an eleventh-century original. 32.4 × 24.5 cm (12¾ × 9⅝ in. [each page]). Oxford, Bodleian Library, MS. Arab. c. 90, fols 27b–28a. South is at the top, the Mediterranean sea is the blue body of water on the lower right and the Indian Ocean is the blue body of water on the upper left

on a group of ivory boxes attributed to Sicily in the eleventh and twelfth centuries.[144]

Since there is no evidence that any of the neo-Umayyad caskets ever left Spain before modern times, one may imagine therefore that al-Mu'izz's box might have been made to imitate a Byzantine ivory box, perhaps one that had arrived at the Fatimid court with one of the Byzantine embassies. The undulating palmette vine borders on the North African box find a ready equivalent in the rosettes of Byzantine ones, but the Byzantine figural scenes may have been deemed inappropriate for the specific use – whatever it might have been – to which this box might have been put. The use of painted decoration suggests the artist's unfamiliarity with the traditional technique of carving ivory, which best exploits the material's special qualities. It also suggests that the primary function of this box was not to hold something but to display relatively large slabs of an extremely expensive material, an aim which lavish painting would foil. Although the Mu'izz casket is the only sure example to survive, it shows that even before the conquest of Egypt, Fatimid court workers in North Africa were interested in producing expensive and showy goods, if not yet capable of the finest craftsmanship. How this box ended up in Spain is not known.

Related to these two extant works of art is a world map that was made in North Africa at this time, transported to Egypt in the 970s and recorded for posterity when the royal treasuries were looted in the mid-eleventh century. Housed in the treasury of rugs and furnishings in the Fatimid palace in Cairo, it was woven of blue silk and portrayed the earth's climes, mountains, seas, cities, rivers and roads. Representations of Mecca and Medina, the two Holy Cities, were particularly prominent. Every detail was identified in writing of gold, silver or silk. Across the bottom, the legend read, 'Among the things ordered by al-Mu'izz li-Din Allah, longing for God's Sanctuary (i.e. Mecca) and proclaiming the landmarks of His Messenger, in the year 353 [964].' It is reported to have cost 22,000 dinars to make.[145]

One can imagine that this map was a large woven version of the typical 'Balkhi school' map that contemporary geographers had used to illustrate their writings, where the Arabian peninsula, including Mecca and Medina, was at the centre, with the Mediterranean Sea and Indian Ocean as equivalent bodies of water on either side (Fig. 29).[146] Such a map was the equivalent in the Muslim world of the so-called T-O maps of medieval Christendom, where the known world was represented by a circle (O) which was divided into three parts by a T, with Jerusalem at the centre. Perhaps the most famous example of this group is the Hereford Mappa Mundi, produced about 1300 on an unusually large sheet of parchment.

Al-Mu'izz's map was embroidered on silk because no other support was readily available, paper still being an uncommon medium in North Africa. Gabes, in the southern part of Ifriqiya, was known for its silk industry, unique in North Africa at this time according to the geographer Ibn Hawqal.[147] Al-Mu'izz's idea to commission a large map may have been generally inspired by the precedent of the *Ma'muniyya*, the Abbasid caliph al-Ma'mun's great world map on linen prepared at Baghdad by the leading mathematicians and geographers of the ninth century, but scientific accuracy seems not to have been al-Mu'izz's paramount concern, particularly since the background colour was blue with gold embroidery. Some idea of the effect is provided by the roughly contemporary Star Mantle of the Holy Roman Emperor Henry II (*r.*1002–1024), embroidered with coloured silks and gold thread on an originally purple ground. The Star Mantle, which shows Christ as ruler of the universe surrounded by representations of the heavenly bodies, bears an inscription showing that it was made for the emperor as a gift from Ismahel, duke of Apulia in southern Italy.[148] Like the Star Mantle, the Fatimid map was meant to project the Fatimid view of the world. At this very moment the Fatimid ruler was preparing for the dynasty's third – and final – attempt to conquer Egypt and other parts of the Muslim world. The unusual phrase 'longing for God's sanctuary' inscribed beneath the map would support such an interpretation.

It is difficult to reconcile these three splendid works of art and the fulsome descriptions in the texts with the rather modest examples of decorative art – ceramics, glasswares, metalwork – that have been discovered at North African sites occupied in the Fatimid period, such as Mahdiyya or Mansuriyya. Textiles are known to have been important manufactures in North Africa and the sources suggest that they continued to play a significant role in Fatimid times. Only a very few are known to have survived, such as a simple cotton tiraz that is embroidered in red and blue or black silk chain-stitch with the name of al-Mu'izz and dated 345/956–7, or more than a decade before the conquest of Egypt. Although discovered in Egypt, it must have been made at al-Mansuriyya in North Africa, although C. J. Lamm, who owned it before presenting it to the Museum of Islamic Art in Cairo, believed that on technical grounds it had been made in the Khurasanian city of Merv![149] Fatimid literary sources suggest that high-quality goods were made and given as gifts. For example, al-Mu'izz is said to have come up with the idea of a fountain pen which the court goldsmith made for him. 'We wish', he once said

to construct a pen with which one may write without dipping it into the inkwell. The ink must be inside the pen itself and when a person wishes to write, he fills it up and writes to his heart's content and when he wishes to stop, he empties out the ink and the pen is dry. The writer can put it under his armpit or wherever he likes, without its leaving any stains on him and without any ink dripping out.

Qadi al-Nu'man doubtfully asked whether it was possible to make such a thing, but a craftsman was given precise instructions and returned a few days later with an example made out of gold. As it leaked a bit, al-Mu'izz suggested a few improvements, so the craftsman took it away and brought it back a few days later. The pen could be 'rotated in the hand and inclined in all directions, without the ink running out'.[150]

Once the Fatimids had departed for Egypt, however, and left the province in the hands of their Zirid governors, such local production – whatever it may have been – must have declined, for the North African gifts to Egypt in this period were predominantly slaves, animals and raw materials – slave girls, Slav slave boys, black eunuchs, racehorses, lions, leopards, saluqi hounds, wax and saffron. The manufactured goods were modest, including silk cloth, cloth from Sousse and Sicily, turbans, beechwood spears, palm-frond crates and trunks. This list indicates the relative poverty of the products of that region.[151]

In general the quality of surviving goods is not very high and there is little evidence, beyond their find-site in places occupied during the Fatimid period, to assign these objects specifically to the Fatimids. Most of the pieces are unique or rare types, so it is difficult to establish comparisons by which to date them. Some of the pieces bear figural decoration, which is otherwise quite rare in the decorative arts of North Africa, and since figural decoration would become common in Fatimid period art in Egypt, the temptation has been to assign all of them indiscriminately to Fatimid patronage.

For example, in the ninth century, North African potters had produced various types and qualities of glazed polychrome pottery and these continued to be produced under Fatimid and Zirid rule in the tenth and eleventh centuries.[152] These included monochrome green lead-glazed earthenwares of a type produced since late antiquity, fine white pottery with manganese lines separating different colours of glaze, somewhat like later cuerda seca wares and pieces glazed in three colours (Fig. 30).[153] The geographer Ibn Hawqal noted

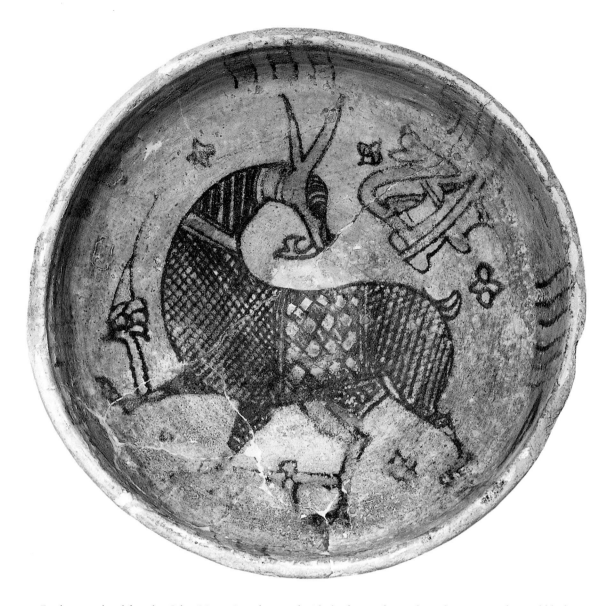

30 Earthenware bowl found at Sabra Mansuriyya decorated with the figure of a quadruped in green, ochre and black on a mustard-yellow ground under a transparent colourless glaze, diameter: 27 cm (10⅝ in.). Tunis, Bardo Museum

c.960 that in Tunis, 'they make there glazed pottery [*ghuḍār*] of beautiful colours and handsome earthenware [*khazaf*] like that acquired in Iraq',[154] but the comparison seems to be overstated, as few, if any, of the surviving local North African ceramics are comparable in quality to those actually produced in Iraq or in Egypt. A kiln site was found at Mansuriyya, but it is not known whether it operated in the Fatimid or Zirid period.[155] Furthermore, as ceramics were traded widely among the medieval Islamic lands, without technical analysis of the ceramic body it is impossible to say whether the more 'sophisticated' pieces discovered in the region were produced locally or imported.

The Fatimid caliphs had great reverence for books and book learning and they must have had extensive libraries even though virtually none of their books is known to have survived. On his flight from Syria to the Maghrib, the Mahdi had brought along with him 'the writings of his ancestors', but they were lost to Berber thieves.[156] His grandson al-Mansur was once found composing a book in the garden of one of his country estates and his son al-Muʿizz was also a bookworm: one day he requested a particular book, but the librarian could not find it, so he went himself into the library, opened one of the bookcases and started looking.[157] He spent the rest of the night browsing in the collection,

48

which apparently included the works of the ancient Arab poets, such as Labid and al-Farazdaq, the literature of Basra and Baghdad, such as Jahiz, Ibn Qutayba and the grammarian Khalil, as well as those of ancient authors such as Galen and Ptolemy, Plato and Aristotle.[158] Apart from the Blue Qur'an, it seems curious indeed that none of the medieval manuscripts preserved from Kairouan can be associated with the Fatimid period. Granted, at this time it had not yet become as common as it would be later to date manuscripts, but perhaps we do not yet have the right criteria to distinguish them.

It has often been argued that North African culture flourished until the eleventh century, when the bedouin depredations of the Banu Hilal and Banu Sulaym, who had been unleashed in retaliation for the break with Cairo, disrupted the infrastructure and spelled the cultural decline of the region,[159] but the modest nature of early Fatimid art would suggest that there had never been much of a florescence from which to decline. Despite some significant cultural activity in such isolated centres as Kairouan, North Africa had not been poised to become a centre of artistic creativity at the advent of the Fatimid caliphate and the North Africa rulers were evolving only slowly into enlightened patrons of the arts. The evidence suggests that the rulers had only limited means to realize their ambitions. Despite the bombastic poetry, the surviving architecture is ultimately quite simple, even parsimonious, in its construction and decoration, especially when compared with contemporary experiments in such regions as al-Andalus or Khurasan, where some of the most exciting features of Islamic architecture – intersecting arches, ribbed vaults and muqarnas, for example – were being developed at that very time. The almost total absence of examples of decorative arts, again when compared to what was happening in contemporary Andalus or Khurasan, suggests that the relative poverty of early Fatimid art is not merely an accident of survival but was a function of the scarcity of the local resources. Certainly there was plenty of money in the Fatimid treasury, but money wasn't enough to make up for the modest artistic life that North Africa's narrow coastal strip with its reduced agricultural basis could have supported on its own in the centuries before the Fatimids arrived. Goitein described medieval Tunisia as the 'hub of the Mediterranean' in the period from the ninth to the eleventh century, with a flourishing export of wool and woollen cloth noted by Ibn Hawqal and the spread of agricultural settlement in the Sahara encouraged by the introduction from Iran of the underground aqueduct, known as a qanat or foggara. Yet surviving artefacts are not nearly as splendid as such a description would suggest.[160]

Nevertheless, a few splendid works of art were created in this period, but they were the exceptions rather than the rule. The creation of Mansuriyya, the Blue Qur'an, the ivory box and the world map show that the germs of an original art and imperialist ideology were already in place. All it needed was lots of time, money, people and thriving artistic traditions. Ifriqiya could provide none of these, especially since the Fatimids were halfway out the door in anticipation of establishing themselves in the East. The period therefore can best be understood as a prelude to greater developments in Egypt.

This was, however, a period of enormous social change in North Africa, as Fatimid rule legitimated the hegemony of the Kutama over the other Berber peoples and cities of the Maghrib.[161] Simultaneously the Kutama Berbers were being integrated into the larger world of Arab-Islamic material culture. For example, according to Qadi al-Nu'man, the Mahdi was the first to command the Kutama to adorn themselves and don finery and so they abandoned the style of adornment to which they had previously been accustomed and dressed themselves in costly garments, ornamented their saddles and bridles, and paraded in splendid attire.[162] In this way, the period of Fatimid rule in North Africa may have had a greater effect on North Africa than it did on the Fatimid dynasty itself.

III

Architecture in Egypt from 969 to the 1060s

The period from the Fatimid conquest of Egypt in 969 to the middle of the eleventh century was not only a glorious one for Fatimid architecture but also the first truly brilliant period in Egyptian art and culture since the fall of the Ptolemies one thousand years earlier. Egypt may have produced significant works of art in the previous centuries of Roman, Byzantine and Islamic rule, but not since 30 BC had it been an intellectual and artistic capital. Even the huge concentration of military power there in the first century of Islam had not made it a cultural centre, and artistic innovation in the early Islamic period was entirely a product of Syria and Iraq.[1] Once the Fatimids were firmly in power, however, and ruling over an empire spanning most of North Africa, Arabia and occasionally the Levant, as well as subtly exerting their influence over a much larger area, their capital city of Cairo seems to have set the artistic taste of its time. During the Fatimid period it became one of the largest cities of the Mediterranean basin, with somewhere between 120,000 and 200,000 inhabitants, perhaps fewer than in contemporary Constantinople or Baghdad but far more than in contemporary Florence, Bologna, Genoa, Venice, Damascus, Córdoba or Seville.[2]

A series of grand congregational mosques with beautifully worked decoration in stucco and stone, magnificent palaces embellished with intricately carved woodwork, glittering lustre dishes decorated with naturalistic images of figures engaged in a variety of activities, inscribed and pictorial textiles woven of diaphanous linen, engraved metalwares, laboriously sculpted rock crystals and precious carved ivories all testify to the artistic pre-eminence of Egypt at this time. Figural decoration of humans engaged in a variety of

activities from dancing and music to hunting and wrestling seems to characterize many if not all of the arts of this period. Only manuscripts seem to be absent from this heady artistic mix, yet contemporary texts leave no doubt about the size and scope of the Fatimid libraries at their prime and indicate that this absence is due only to the accidents of survival or our inability to know what to look for.

To some extent this artistic florescence can be explained as a distinctive Egyptian phenomenon, as willing patrons with plenty of money allowed native artisans to realize their potential. The artistic flowering also had some roots in North Africa, as Fatimid patrons brought with them a taste for luxury and splendour, but the previous chapter demonstrated that earlier scholarship may have overstated this aspect of Fatimid patronage. In any event, Egyptian artisans and builders would have had little or no need or occasion to look abroad to North African ideas. Far more important, however, particularly for the decorative arts, were Mesopotamian, specifically Basran, artists, who were attracted to the Fatimid court not merely as a centre of lavish patronage but also as the home of the Ismaili mission.

Oddly enough, when the Fatimid general Jawhar entered Egypt on 6 July 969, he and his troops could have had little idea of what was in store during the coming decades. Back in North Africa the able and energetic al-Mu'izz had reached the apogee of his power, as his ineffectual Abbasid rivals had become mere pawns in the hands of the actual ruler of Baghdad, the Buyid Mu'izz al-Dawla (r.945–967) and his successors, who nominally professed another – but non-Ismaili – form of Shi'ism.[3] Meanwhile, al-Andalus,

31 Gold dinar of Abu Tamim Ma'add al-Mu'izz li-Din Allah struck at Misr in 358 AH /969 CE. London, British Museum

which had enjoyed a period of remarkable cultural splendour under the neo-Umayyad caliphs 'Abd al-Raḥman III and his son al-Ḥakam II (r.961–976), did not pose the threat of a serious attack from the west. The time was ripe, therefore, to expand the Fatimid state towards Egypt, Syria, the holy cities of Arabia and the Yemen. During the North African period, Fatimid missionaries had been active from Spain to Iran. Khurasan and Syria were already straining to throw off the Abbasid yoke and the Qarmatis of Bahrayn, erstwhile allies of the Fatimids but now their sworn enemies, were themselves poised to conquer Egypt, which was currently slipping through the hands of the impotent and incompetent rule of the Ikhshidids. Al-Mu'izz realized that he had to get to Egypt first.

Al-Mu'izz subordinated the Fatimid government and the entire resources of the realm to prepare for the conquest of Egypt and the expedition was meticulously and flawlessly planned.[4] Wells were dug along the route across Libya and depots established for supplies.[5] Accompanied by a huge army and a strong fleet and helped by an enormous war chest of perhaps 24 million dinars (nominally 93,500 kg of gold), al-Mu'izz's general Jawhar, who had already distinguished himself in campaigns in north-west Africa against the Umayyads and their proxies, arrived in Alexandria in April or May 969.[6] A delegation of notables arrived from Fustat to negotiate a peace treaty with the conquerors, who promised to establish order and security, implement justice, redress wrongs, improve the social and economic situation, protect the country from both the Qarmatis and the Byzantines and ensure complete religious tolerance.[7]

The general letter of safety written by Jawhar for the notables of Fustat is the most important document to have survived from this period. It is a political manifesto

explaining why Jawhar had waged war against his fellow Muslims. He claimed that his aim was to protect the Egyptians against an unnamed enemy (the Byzantines) and he promised improvements such as the restoration of internal security, the removal of illegal taxes and improvement in the levying of legal ones. Jawhar expressed the Fatimids' intention to build new mosques and refurbish old ones and he promised to pay the salaries of the muezzins, preachers and prayer-leaders who serviced them. In short, it was a persuasive document designed to appeal to wide sections of Egyptian society.[8]

Jawhar's promise to bring back good money, however, was nearly disastrous. The arrival of the Fatimid army in Egypt was commemorated in the striking of a fine gold coin (Fig. 31), for which purpose the mint appears to have travelled from North Africa, since it is entirely unlike contemporary Egyptian coins. The legend was inscribed in three concentric circles, the standard pattern for the Fatimid dinar. On the obverse was inscribed:

There is no god but God and Muhammad is the Messenger of God
'Ali is the most excellent of trustees and vizier to the best of messengers
God has sent him with the right way and the religion of truth, that he may render it victorious over all religion, whatever the opposition of the polytheists (Qur'an 9:33).

On the reverse, the text read:

In the name of God, this dinar was struck at Misr in the year three hundred and fifty eight
Al-Mu'izz li-Dīn Allah, commander of the believers
The Imam Ma'add requires belief in the Oneness of the Eternal God.

Instead of circulating, Jawhar's new coins immediately disappeared from the market because they were deemed too valuable for use as currency in comparison with the debased coinage that had been issued during the previous years of inflation.[9]

Arriving at the banks of the Nile at Giza in July, the Fatimid army simply crossed to Fustat, the capital city of Egypt since the Islamic conquest over three centuries earlier, and camped to the north east of the city in a largely agricultural site occupied only by a Coptic monastery, a small qaṣr or mansion and the stables and zoological park of the former Ikhshidid ruler. Jawhar initially named this encampment al-Manṣūriyya after

the Fatimid capital near Kairouan in Tunisia, but within a few years it would be renamed *al-Qāhira al-Mu'izziyya*, 'the (City of) al-Mu'izz's Victory', or more simply *al-Qāhira*, 'the Victorious', from which Cairo, its modern name, derives.[10]

It remains unclear exactly why or when the city received its new name, but it seems plausible to link it with al-Mu'izz's arrival in Egypt in 973. Stories linking the name to the astrological term *qāhir al-falak* for Mars have been shown to be patently false.[11] Ibn Hani al-Andalusi (*d.*973), al-Mu'izz's court poet at Mansuriyya in Ifriqiya, frequently used various forms of the Arabic root *q-h-r* in his work and the contemporary geographers Ibn Hawqal and al-Maqdisi called the city *al-Qāhira* in the following decades.[12] Nevertheless, the name is not attested in Fatimid numismatics until 394 (1003–4), when a unique coin was struck at *al-Qāhira al-maḥrūsa* (The Well-Guarded Victorious (City)). Such questions reveal a perennial problem in uncovering the history of Fatimid Cairo: as few sources are actually contemporary with the events they purport to depict, wishful retrospection often plays a powerful role in colouring interpretation of seemingly simple facts and events.

Jawhar, who had brilliantly played a leading role in the first act of the drama in which the Fatimids expected to conquer all the Islamic lands, had no interest in the arts or architecture, but he did need to build whatever was necessary to service his troops. Within the following decades, however, and particularly during the reign of al-Mu'izz's son and successor al-'Aziz (975–996), the Egyptian capital would rapidly emerge as a brilliant centre for the patronage of the arts and learning. As in North Africa, however, this transformation was the product not of a preconceived policy to encourage the arts but of a fortuitous combination of factors, including a much larger population, many talented artisans trained in a wide range of techniques that had been practised for centuries, great wealth generated by trade and the agricultural surplus of the Nile valley (as well as a much broader and deeper system of taxation) and the willingness of enlightened patrons to spend their wealth on material comforts. In short, the Fatimid seed found the Egyptian environment more fertile ground than it had North Africa.

Some idea of the wealth that would make this flowering of the arts possible can be determined by the lavish gift Jawhar sent to al-Mu'izz in North Africa after the army had arrived in Egypt. Along with a group of important prisoners, it included

99 dromedaries, 21 palanquins, each with coverings of gold brocade, gold girdles adorned with precious stones, 120 she-camels with ordinary brocade and Byzantine fine brocade, the reins embellished with silver, 500 thoroughbred Arabian camels, 56 saddle cloths, 48 beasts of burden consisting of a single she-mule and 47 horses, all equipped with decorated brocade saddle cloths, saddles adorned with gold or vermeil trappings, bridles of gold or silver, as well as two enormously long pieces of aloeswood.

The gift was brought down the Nile by boat to Alexandria, whence it was transported to Kairouan by land.[13] Like al-Mansur's earlier gifts to the Berber chiefs, it consisted primarily of livestock with associated textiles and trappings of precious metal. Apart from the textiles and trappings, there were no manufactured or crafted items in the gift, suggesting that workshops to produce these items had not yet been established in Egypt.

The Arts in Egypt before the Fatimids

Architectural, textile, ceramic, glass and epigraphic evidence all indicate that the artistic situation in Egypt on the eve of the Fatimid conquest had great potential, given the proper conditions, but it also suggests that in most of these fields that potential was still far from being realized. The city of Misr, or Fustat, had been founded by the first Muslim conquerors of Egypt in 642 near a Romano-Byzantine fortress known to the Arabs either as Babylon or Qasr al-Sham'a.[14] In the second half of the eighth century, the Abbasids had expanded the original settlement by building another district, known as al-'Askar ('the Army'), to its north east. A century later, the semi-independent Abbasid governor Ahmad ibn Tulun (*r.*868–884) had constructed a third district, known as al-Qita'i' ('the Allotments'), again to the north east of the original settlement. The continuing vitality of this metropolitan region over the first three centuries of Muslim rule in Egypt testifies to the site's natural advantages, which had already been known and exploited in antiquity.

Standing at the intersection of Africa and Asia, where the Muqattam escarpment on the east narrows the Nile valley before it opens into the broad and fertile delta, the site also controls the mouth of an ancient canal connecting the Nile with the Red Sea. Fustat was, therefore, not only generously supplied with the waters of the Nile and the agricultural surplus of Nile valley and delta farms but was also an intercontinental commercial hub, controlling east–west caravan traffic across North Africa

32 Fragment of an inscription in floriated kufic dated to 966, found in the nineteenth century in the wall of a house near the Mosque of Ibn Tulun

as well as maritime traffic between the Mediterranean, the Red Sea and Upper Egypt. Seaborne commerce became particularly important as the market economy in Latin Europe slowly revived in the tenth and eleventh century and Egypt began to develop direct ties with Italian entrepôts and indirect ones with the transalpine lands they served. At the same time political turmoil and economic problems in Iraq and southwest Iran led to the decline, if not collapse, of the Persian Gulf route to India, so that Egypt became the principal hinge between the Indian Ocean and the Mediterranean basins.[15]

Under the Umayyads and early Abbasids, Fustat had been only a provincial capital, but under the semi-independent Tulunids in the second half of the ninth century, Egypt became a significant, if still provincial, artistic centre. Egypt's artistic legacy from antiquity and the Greco-Roman and early Byzantine periods may have been extraordinary, but the Roman conquest of Egypt at the end of the first century BC had brought about a break with the artistic past which was only exacerbated by the Islamic conquest in the seventh century CE. This ancient centre of civilization once again became a province of a distant empire, its primary role being reduced to supplying the capital and its elites with crops, textiles and cash.

The earliest evidence for the visual arts in Islamic Egypt reflects this somewhat lowly status. The mosque erected by 'Amr ibn al-'As, the conqueror of Egypt, for example, was a nondescript functional structure with little or no artistic pretension, intended only to accommodate the Muslim male population for Friday noon worship in the most efficient way possible.[16] Although it

enjoyed enormous prestige and was repeatedly repaired, restored and embellished, the mosque never had great artistic significance. The far more ambitious mosque erected in the ninth century by Ahmad ibn Tulun was the centrepiece of his new urban district, which also included a palace, a hippodrome, offices and housing for his troops. Nevertheless, the mosque was less an original creation than a free Egyptian interpretation of the typical mosque erected by the patron's Abbasid overlords in Mesopotamia.[17] That artistic debt is particularly visible in the building's use of the hypostyle plan with multiple brick piers and carved stucco decoration, both features foreign to the Egyptian architectural tradition of erecting significant public and cultic buildings in stone.

After the fall of the Tulunids and the return of Egypt to the Abbasid fold in the early tenth century under its Ikhshidid governors, artistic production continued at much the same level. The founder of the dynasty, Muhammad ibn Tughj al-Ikhshid, seems to have had little interest in building, but Kafur, the Black eunuch who dominated the political history of the period, is credited with the construction of several sumptuous palaces, two mosques (one in Giza, the other on al-Muqattam), a hospital and some gardens, although no traces of his work have been identified.[18]

Apart from tombstones, the sole epigraphic document known to survive from the period is a fragmentary limestone plaque inscribed with a beautiful floriated kufic inscription, in which the individual letters of the inscription have leaves and tendrils growing from them and filling the empty spaces between the letters (Fig. 32). Max van Berchem, who first published the inscription over a hundred years ago, was unable to identify the text but dated it from the style of its script to sometime in the Fatimid period. Gaston Wiet later recognized the text as a fragment of the foundation deed for a well and conduit to supply the Seven Cisterns, a structure founded by the vizier Abu'l-Fadl Ja'far ibn al-Furat in 966, just a few years before Jawhar appeared with his armies in Giza.[19] Apart from the inscription's historical importance, it shows that a sophisticated form of floriated kufic – usually identified as a Fatimid 'invention' – had been established in Egypt well before their arrival in Egypt.[20]

The Founding of Cairo

Historical sources as well as simple logic suggest that the Fatimid caliph al-Mu'izz and his general Jawhar initially

viewed the conquest of Egypt merely as a means to the greater end of conquering the Muslim world, but later historians – particularly Egyptians – have tended to view the foundation of Cairo through the rose-coloured lenses of retrospection. Fustat had been an important node in the Ismaili network long before the Fatimid conquest of Egypt.[21] The Mahdi had passed through Fustat on his way to the Maghrib and Fatimid missionaries are known to have been active in Fustat long before Jawhar arrived in 969.[22] The director of the Egyptian mission had befriended and perhaps bribed many important Egyptian officials and the heads of local 'Alid families. While many Egyptians might have objected on doctrinal grounds to Fatimid rule, many others would have seen Jawhar's conquest as a deliverance from the chaos caused by the ineptitude of Ikhshidid rule. A series of low Nile floods had brought on the worst famine in living memory and the government collapsed under the incompetent administration of the eunuch Kafur, who was unable to keep the various factions from pulling the country apart.[23]

The aplomb and ostentation with which Jawhar marched his army – perhaps numbering as many as 100,000 men – through Fustat to camp to the north east of al-Qita'i' indicates that he had planned the operation carefully. Indeed, the account of Ibn Zulaq, one of the few contemporary sources, suggests that al-Mu'izz may already have selected the site in advance from his base in Tunisia.[24] In any event, Jawhar did not have much choice about where to settle his troops, for the spot he chose was the only sizeable piece of relatively vacant flat – and dry – ground still available on the right bank of the Nile (Fig. 33). Located on the same side of the river as Fustat, it had the further advantage of being at a tactful distance from its congregational mosque and the old government offices, which Jawhar could well have expected to be centres of anti-Fatimid resistance.[25] There is thus good reason to doubt the later stories told about al-Mu'izz's displeasure when, finally arriving in Egypt in 973, he saw that Jawhar had settled the Fatimid garrison on the plain rather than on the banks of the Nile or on the hills overlooking Fustat, so that his city 'might have shone over Misr.'[26] The site was perfectly good, as its later history would show.

Following early Islamic precedents, when a conqueror would establish a camp (usually called a *misr/amsār* in Arabic) for his army, Jawhar and his troops established a rectangular encampment, which medieval historians called a *qasr*, or fortress, measuring roughly a kilometre in either direction. Some medieval historians recount an amusing story about how Jawhar consulted astrologers to determine the most auspicious moment to begin work, but the fact that the same story had been told earlier about Alexander's foundation of Alexandria much reduces its evidential value.[27] Decades earlier, before the Mahdi set out with the Kutama army from Sijilmasa for Kairouan, astrologers are said to have warned him of an unfavourable conjunction of Mars and Virgo, but he set no store by it. He, like the later Fatimids, attached no importance to astrology.[28]

The orientation of the encampment along an axis about 20° east of north, which was to have major ramifications for the later urban history of Cairo, was dictated, it seems, not by astrological considerations but by the alignment of the Nile–Red Sea canal (*khalīj*), first laid out in Pharaonic times, against which the camp's north-west wall was built.[29] The enclosure wall itself is said to have been built of improbably large sun-dried bricks which measured about a cubit (approximately 50 centimetres) square and nearly two-thirds of a cubit (some 33 centimetres) thick; it was broad enough for two horsemen to ride abreast, according to an eyewitness who saw parts of it several centuries later.[30]

We have no idea how high this wall would have stood, but the staggering amount of labour involved in constructing a rampart about 4.5 kilometres long makes it ridiculous to imagine that such a task could have been completed, as some credulous medieval accounts state, during the first night of work. It is likely, however, that the Fatimid troops did work at night, at least initially, for the full moon of midmonth (they arrived on 17 Sha'ban) would have been more conducive to heavy labour than the full sun of midsummer. That the enclosing wall was the first thing Jawhar built in Egypt indicates just how vulnerable he must have felt, despite the ease with which he took the city.

The walls of the encampment lay on flat and open ground. Its north-west wall was protected by the canal and its south-east wall was protected by the proximity of the Muqattam escarpment. The south-west wall, however, was exposed to the potentially unruly population of Fustat. Still more vulnerable was the north-east side, which gave onto an extensive open plain and the routes leading to Palestine, Syria and Arabia. Defence was Jawhar's primary consideration, so the massive walls were initially breached by only a few gates, although more were added once security was assured. The first gates included the *Bāb al-Futūḥ* ('Gate of Conquests') and the *Bāb al-Naṣr* ('Gate of Victory') on the north, as well as a *Bāb Zuwayla* ('Gate of the Zuwayla or Zawila [regiment]') on the south. The martial names of the gates, particularly the two on the vulnerable

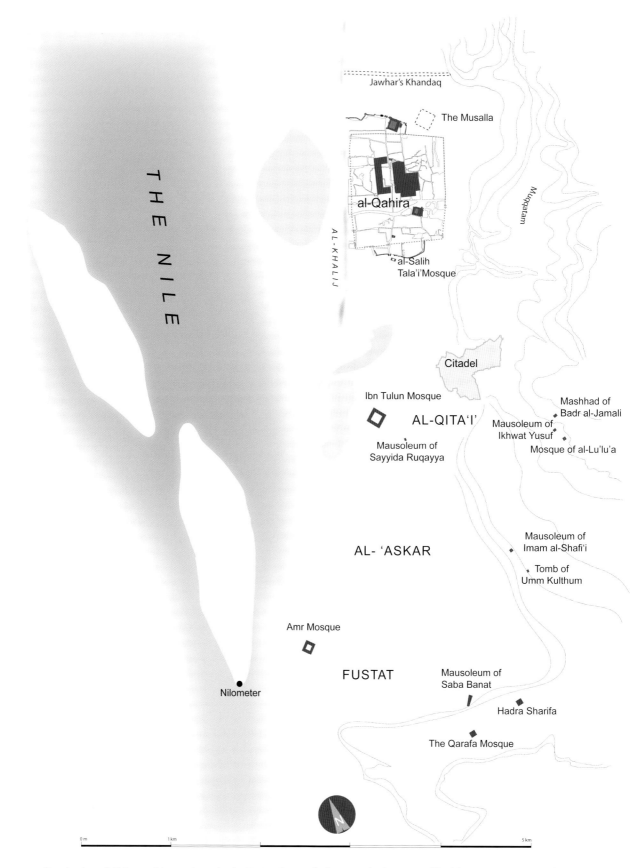

THE NILE

AL-KHALIJ

Jawhar's Khandaq

The Musalla

al-Qahira

Muqatam

al-Salih
Tala'i'Mosque

Citadel

Ibn Tulun Mosque

Mashhad of
Badr al-Jamali

AL-QITA'I'

Mausoleum of
Ikhwat Yusuf

Mosque of al-Lu'lu'a

Mausoleum of
Sayyida Ruqayya

Mausoleum of
Imam al-Shafi'i

AL-'ASKAR

Tomb of
Umm Kulthum

Amr Mosque

Mausoleum of
Saba Banat

FUSTAT

Nilometer

Hadra Sharifa

The Qarafa Mosque

0 m 1 km 5 km

N

33a Sketch plan of Cairo and its environs in the Fatimid period, showing the location of buildings mentioned in the text

north-east side, appear to express Jawhar's wishful thinking about current conditions, although they also echo the names of the gates of Mansuriyya in Tunisia. Their names lend further credence to Ibn Zulaq's report that Jawhar had initially named the new settlement *al-Manṣūriyya*.[31] That Jawhar's Mansuriyya was roughly square while the one in Tunisia was round suggests that shape was of no special significance. Although a circle encloses the greatest area in the shortest outline, it was probably easier – and faster – to lay out a large rectangle than an immense circle, and time was of the essence. The gates would be rebuilt and even renamed a century later (see Chapter 5), but they have continued to maintain their original names for over a millennium.

Jawhar's troops, whose primary responsibilities would have been building the walls and gates, immediately established their residences inside the camp. As in the early Islamic *amṣār*, each regiment was given its own area in which to settle and the regimental names eventually came to designate the area, as in the 'Barqiyya' district of the south-east corner of the settlement, which was settled by the regiment from Barqa. While the occupying army did some of the work, some of it must have been contracted to local residents, and some of the benefits of these and other public works projects must also have accrued to those who had suffered mightily from the famines and disruptions of the final years of Ikhshīdid rule.[32]

Almost immediately after settling in Egypt, Jawhar ordered the construction of an outdoor prayer-place, called a *muṣallā* in Arabic, beyond the Bab al-Nasr, one of the two northern gates. It was necessary to establish a musalla immediately since the Fatimid army had arrived in the middle of the month of Shaʿban, the month before Ramadan. This month of fasting culminates in the ʿId al-Fitr, or feast of the breaking of the fast, one of the two great holidays normally celebrated at a musalla rather than in a mosque. In fact, the celebration of the end of Ramadan that year revealed sharp differences of religious practice between the Fatimid army and the Egyptian populace they governed. The new rulers did not wait to actually see the new moon of Shawwal, but determined that the month of fasting had ended by calculation of its appearance after thirty days had elapsed since the beginning of the month. Meanwhile the largely Sunni Egyptians remained fasting and praying at the Mosque of ʿAmr in Fustat until they saw the crescent of the new moon the following night.[33] The new rulers also ordered a change in the number of prostrations a worshipper had to make in prayer, the performance of which was the worshipper's public acknowledgement of the caliph's divine authority.

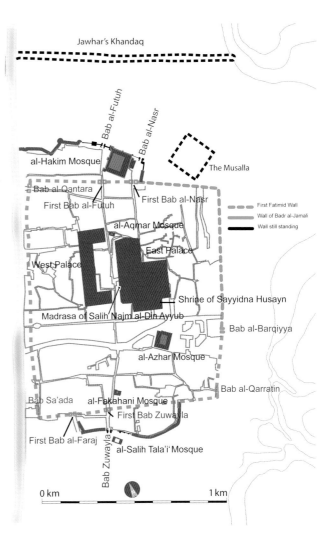

33b Detail of map shown in Fig. 33a

Meanwhile, the dynasty's ancestral title was affirmed at Abbasid expense by ruling that brothers and uncles, such as the Prophet's uncle ʿAbbas and eponymous ancestor of that dynasty, could not inherit except in the absence of direct descendants, such as the sons of ʿAli, and especially of female heirs, such as the Prophet's daughter Fatima.[34]

In line with the Fatimids' eastern strategy, in November 969, or only four months after the conquest of Egypt, Jawhar dispatched the main body of the Fatimid army to conquer Palestine and Syria. But Fatimid success there proved transitory and Fatimid control of the region was always tenuous.[35] In the summer of 971 the Qarmatis of Bahrayn defeated the Fatimid army at Damascus. Anticipating that the Qarmatis would next attack the Fatimids in Egypt, Jawhar ordered an immense dry moat (*khandaq*) dug beyond the north-western wall of the encampment, stretching from the

canal to the Muqattam cliffs, to further protect it. He also ordered a bridge built over the canal to provide his settlement with direct access to the Nile port of al-Maqs. The two iron-clad valves of a portal from the Ikhshidid polo-ground (*maydan al-Ikhshīd*) were erected to close the gate in the wall that led to the bridge. While the population might interpret their transfer to symbolize the transfer of power to the new Fatimid rulers of Egypt, surely the gates' primary function was practical, to defend the new Fatimid outpost from attack.[36]

Just as Jawhar had feared, the Qarmati commander, encouraged by his victory in Syria, chased the Fatimid army back to Egypt. The Qarmatis overran the eastern Delta and the towns on the coastal route from Palestine. In late December, Jawhar mustered an improvised army to successfully defend his encampment and the city beyond and the Qarmati commander and his army were forced to retreat.[37]

Once security was assured in Egypt and the residents of the encampment needed to go in different directions, additional gates were cut through the walls. Within a few decades one could enter the city through a total of eight gates spread out in all four walls. The multiplicity of gates suggests that security became less of a concern as free and easy movement between the Fatimid settlement and the surrounding districts became increasingly important. The gates included *Bāb al-Qanṭara* ('Gate of the Bridge'), *Bāb al-Barqiyya* ('Gate of the regiment from Barqa'), *Bāb al-Qarratīn* ('Gate of the Clover-Merchants'), *Bāb Saʿāda* ('Gate of Felicity') and *Bāb al-Faraj* ('Gate of Joy').[38] Their presence and numbers suggest that the Fatimid encampment was increasingly integrated in the urban agglomeration.

As the city grew over the centuries, all of these gates were eventually superseded and replaced and even the line of the wall itself was moved to accommodate the growth of the city. In the fifteenth century al-Maqrizi saw a fragment of a kufic inscription on the remains of what he identified as the original Bab al-Futuh. The urban historian ʿAli Pasha Mubarak (*d.*1893) saw another kufic inscription on the remains of the first Bab al-Qantara, which was demolished in 1878. As it would have been difficult, if not impossible, to form a legible inscription from sun-dried brick, let alone preserve it for centuries in Cairo, it is reasonable to conclude that the inscriptions, if not the portals themselves, were made of baked brick, or decorated with plaques of stucco or stone. Furthermore, although the text of the inscription al-Maqrizi saw is not preserved, these precious bits of evidence indicate that inscriptions in

Fatimid Egypt, as elsewhere in the contemporary Muslim world, were from the first integral to the exterior decoration of public buildings, such as gates and mosques.

In earlier centuries, the city of Fustat had not been walled because the natural defences of the site and, above all, the political situation made city walls unnecessary. Immediately after the Muslim conquest in the seventh century, the old Romano-Byzantine fortress had continued to provide some security for the residents, and in the ninth century Ibn Tulun, like his Abbasid suzerains, seems to have relied on the overwhelming number of his troops rather than military architecture to provide security. In North Africa, however, with its much smaller and more dispersed population, walled encampments and cities had been constructed since the advent of Islam, and the Fatimids had already constructed two, one at Mahdiyya on the coast and another at Mansuriyya near Kairouan.[39] The idea of a walled encampment is, therefore, a North African concept which Jawhar introduced to Egypt.

Later observers, projecting backwards from what Cairo eventually became, have imagined that Jawhar meant to build something more than what he actually did construct. Historians have repeatedly stated that the Fatimids intended Cairo to be a princely town to mark the birth of a dynasty and to affirm its authority. Specifically, Cairo would have been 'a royal refuge within whose secure enclosure an alien (and Shiʿi) caliph and his entourage could pursue their lives' and rule over a largely Sunni population.[40] Indeed, one recent study considers the walled city of Cairo a 'ritual city' constructed as a stage for the elaboration of Fatimid ceremonial.[41] Although the Fatimid walled city might eventually have come to serve as a ceremonial stage in the later part of the dynasty's two hundred years of rule in Egypt, when fancy-dress parades to mosques replaced military-dress parades to war, Cairo was certainly not created as a stage set. The historical sources are clear on one point: the walls were begun significantly before the mosque and even the palace, which seems to have been something of an afterthought. Given the Fatimids' experience in North Africa and their designs on the rest of the Muslim lands, the enormous initial effort of building a great defensive wall was a practical response to very real threats rather than a symbolic gesture to separate the rulers from the ruled. Cairo was founded to be a temporary way-station for the Fatimids' conquest of the entire Muslim lands. As at many other times in history, however, things did not turn out as planned.

Nor was Fatimid Cairo a forbidden city reserved exclusively for the members of the court. Later authors such as Ibn Duqmaq (*d.*790/1388) tell us that Jawhar built the palace for his master 'so that he and their friends and armies were separated from the general public',[42] but contemporary texts mention houses, merchants and traffic in the city. Granted, there were occasional edicts prohibiting traffic, but – like all laws attempting to regulate behaviour – these show what was already the norm. For example, the chronicler al-Musabbihi reports that in March–April 1005 merchants were prohibited from setting up shops near one of the palace gates and everyone was prohibited from passing by the palace, but the merchants complained bitterly and the edict was repealed.[43] Many, if not all, of the typical urban functions were present in Fatimid Cairo. The caliph al-'Aziz built the first bathhouses and his daughter Sitt al-Mulk built more.[44] Nasir-i Khusraw, who visited Cairo between August 1047 and April 1048, says that there were 20,000 shops in Cairo belonging to the ruler, as well as caravanserais and bathhouses. The ruler also owned another 8,000 buildings in both Cairo and Fustat which were rented by the month.[45] Perhaps the numbers are exaggerated, but the buildings surely were inhabited. Their residents were served by markets, of which the first was built in 975–6, and the bathhouses. Even in the middle of the twelfth century, when the Fatimid dynasty was teetering on the brink of collapse, houses in Cairo were bought, sold and bequeathed, according to documents from Cairo's Jewish community. In short, contemporary evidence does not indicate that Fatimid Cairo was a restricted royal city.

As in North Africa, the majority of the Egyptian population never converted to the Ismaili interpretation of Islam, but most seem to have accepted the rulers as valid caliphs with legitimate rights to lead the Muslim community, much as the Abbasids had ruled in Egypt before. The true Ismaili believers (*mu'minūn*) were a small segment of the population, who were simply Muslims (*muslimūn*). Membership in the Ismaili inner circle implied total devotion to the imam and his orders. Most believers attended regular prayer and instruction which gradually assumed greater importance.[46] At the beginning of the eleventh century the chief missionary began to give lectures, known as 'Sessions of Wisdom', for a number of separate audiences: the faithful, the servants of the state, the common people, the noblewomen of the palace and other women. True believers also paid for the privilege of receiving instruction in Ismaili doctrines at these sessions.[47]

The native Egyptian population was swelled by many immigrants. Maghribis – including soldiers from Berber and Black regiments, their families and others – came to Egypt between the early years of Fatimid rule and the mid-eleventh century when Fatimid relations with their erstwhile North African allies declined precipitously, eventually leading to total rupture with the region and its recognition of the caliph in Baghdad (see Chapter 7). Many eastern Ismailis, who may have regarded the Fatimid caliphate in the distant Maghrib with a certain detachment, now began to see Cairo as a destination for pilgrimage and as a centre of Ismaili doctrine and teaching, although sizeable Ismaili communities continued to flourish in Yemen, India, parts of Arabia, Iraq, Syria and Iran.[48] These migrations to Egypt from other parts of the Islamic lands undoubtedly contributed to the cosmopolitan character Fatimid architecture and art would take in its first century in Egypt.

Architecture

The new Fatimid rulers of Egypt and others necessarily commissioned many new buildings – mosques, palaces, houses, shops and libraries – in the capital and elsewhere, but the great majority of this construction has been lost. Two large congregational mosques survive in sufficiently good condition to understand their original state, but other early Fatimid buildings survive only in the texts collected by the Mamluk historian al-Maqrizi or in early Fatimid architectural fragments reused in later buildings in Cairo. This evidence – paltry though it is – reveals several notable developments in Egyptian architecture of this period, including the revival of stone masonry for public buildings, the use of monumental inscriptions on their exteriors and the development of new responses to an increasingly dense urban environment.

The Azhar Mosque

For nine months after the conquest of Egypt, the religious needs of both the Egyptians and the conquerors had been served by the congregational mosques of Fustat, except for the 'Id al-Fitr at the end of Ramadan, which had been celebrated in the new musalla. The Egyptian chief preacher, who was strongly opposed to the Fatimids, avoided giving the sermon in favour of the Fatimid caliph by delegating the responsibility to a deputy. In late March, after several months of delicate negotiations, the preacher returned from temporary retirement and finally pronounced the sermon in favour of the Fatimid caliph, who was still resident in Tunisia.

At the same time, the muezzins at the mosque of Ibn Tulun began adding the distinctive Shi'i formula ('Come to the best of works!') to the call to prayer and within a few weeks even the Mosque of 'Amr, the bastion of Sunni orthodoxy, resounded with the distinctive Shi'i formula.

These accommodations may not have been sufficient, for on 4 April 970, nine months after he had conquered Egypt, Jawhar ordered a new congregational mosque constructed in the middle of the Fatimid settlement; it was finished with remarkable speed in a little more than a year, for the first Friday prayer was held there on 22 June 971.[49] The building is now known as *al-Azhar* ('the most Radiant'), a name conventionally understood to be a reference to Fatima *al-Zahra'* ('the Splendid'), the Prophet's daughter and progenitrix of the Fatimid lineage, for both words share the Arabic root *z-h-r*, but it is unclear how early this name was used. One source states that the mosque at Mansuriyya in Tunisia was also called al-Azhar, opening up the intriguing possibility that both the Egyptian settlement and its mosque were modelled on North African originals. In any event, the name was certainly used by 1010, when an endowment deed refers to the mosque by its epithet.

The mosque is the oldest Fatimid structure in Egypt to survive, although it has been cloaked and lined with later constructions that totally obscure its Fatimid core. The veneration accorded the building in modern times has made archaeological investigation impractical if not impossible and the ill-conceived renovations following the devastating earthquake of October 1992 have further obscured any Fatimid remains under slabs of polished marble and coats of bright paint and gold leaf. An understanding of the original Fatimid mosque must rely, therefore, on a careful analysis of the extant – if altered – physical remains combined with a judicious interpretation of the often equivocal and obscure medieval texts.[50]

All scholars agree that the mosque was originally a broad rectangle measuring roughly 85 × 69 metres. Creswell, who measured the mosque, noted that it is oriented to a qibla reckoned 50° south of east (140°), which is for all intents and purposes identical to the qibla used at the Mosque of Ibn Tulun (141°). As at Mahdiyya, the prayer hall occupied roughly one-third of the mosque's area and consisted of five aisles, but unlike the Mahdiyya mosque, the Cairo mosque was wider than it was long and the aisles ran parallel to the qibla wall. The prayer hall is divided in half by an axial aisle with clerestory windows running from the court to the mihrab (Fig. 34), leaving arcades of nine arches on either side. The columns along the axial aisle are irregularly paired, suggesting that some rebuilding has gone on in this area of the mosque. A passage from al-Maqrizi has led some scholars to reconstruct domes in the rear corners of the prayer hall, but the absence of any physical evidence to support such structures argues strongly against this.[51]

On either side of the courtyard were narrow halls three bays deep with arcades running parallel to the mosque's qibla wall, an unusual arrangement, as it would have made more structural sense for them to run parallel to the mosque's side walls, as at the Mosque of Ibn Tulun. The short arcades running into the court façade would have made it inherently unstable and such instability may explain why this part of the mosque was rebuilt already in the later Fatimid period. Is this evidence of the builder's hasty work and unfamiliarity with mosque construction? Creswell somewhat hesitantly reconstructed the court façade, which has been rebuilt several times, as comprising an arcade supported on columns, but it may well have been supported on piers, as it is today. Although Creswell believed that there was no evidence to reconstruct an arcade along the wall of the court opposite the prayer hall, this arrangement is very ungainly, unknown in Egypt or elsewhere. It is much more likely that the entire courtyard would have been surrounded by arcades. The walls, both inside and out, were built of brick covered with plaster and the arcades were supported by marble columns and capitals taken from earlier buildings.[52] (The use of large quantities of spolia may help explain how Jawhar was able to build the mosque so quickly.) The upper portion of the mosque's interior brick walls as well as the upper arcades were decorated with plaster carved into lush vegetal designs outlined with bands of texts taken from the Qur'an written in floriated kufic script (Fig. 35).

Nothing is known of the mosque's exterior, since it has been entirely encased in later construction, but it is likely that the main (north-west) façade of the mosque had a projecting portal, based on the precedent of the first Fatimid mosque at al-Mahdiyya in Tunisia, as well as the example of the slightly later Mosque of al-Hakim in Cairo, both of which had elaborate portals projecting from the wall opposite the mihrab. This area of the Azhar mosque has been so rebuilt, however, that we cannot be sure. In the early fourteenth century the Mamluk amirs Aqbugha and Taybars built madrasas on either side of the portal, and in the late fifteenth century, the Mamluk sultan Qa'itbay erected a beautiful new portal surmounted by a minaret between them exactly on the spot where a Fatimid projecting portal might have stood and this remains the mosque's principal

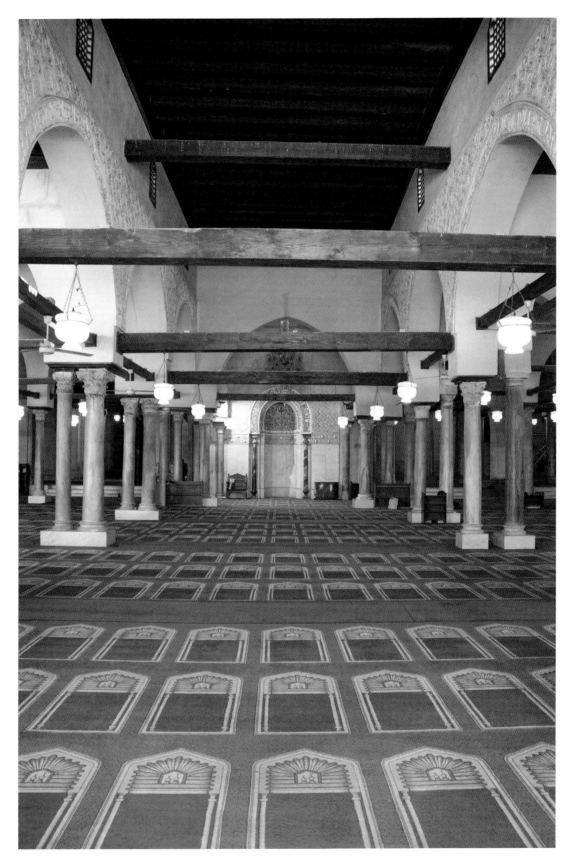

34 Cairo, al-Azhar mosque, general view of prayer hall looking towards mihrab, begun 970

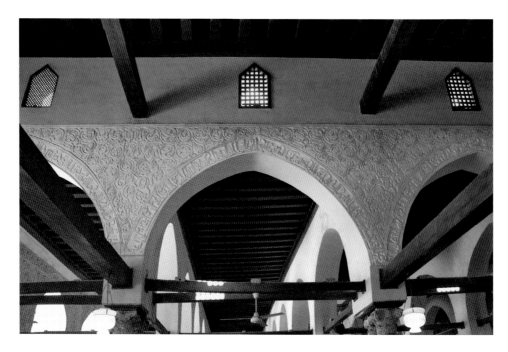

35 Cairo, al-Azhar mosque, carved stucco ornament in central aisle

entrance to this day. Like other early Fatimid mosques, this mosque would have had no tower because there was no need for one: following the Shiʿi practice, the call to prayer would have been given either from the portal itself or the mosque's roof.[53]

Apart from the absence of a minaret, the most prominent feature of all Abbasid mosques since the ninth century, and the possible presence of a monumental portal, which seems to have taken on a special significance for the Fatimids already in the North African period, Jawhar's mosque fits relatively well into the course of Islamic architecture in Egypt. Although it was a hypostyle building with spolia stone columns like the mosque of Mahdiyya in Tunisia (and equally the mosque of ʿAmr in Fustat), the walls were constructed of brick, not stone, and the decoration was worked in carved plaster, like the decoration of the mosques of ʿAmr and Ibn Tulun.[54] Besides the conjectured portal, all the features indicate that the builders of the Azhar mosque would have been Egyptians. Jawhar may have been willing to give his Maghribi troops the relatively unskilled jobs of building a massive mud-brick wall to surround the encampment and erecting their own houses, but he entrusted the construction and decoration of a mosque to a skilled corps of native Egyptians familiar with working such materials as baked brick, stone and carved plaster. In the same way he had entrusted the complicated fiscal administration of Egypt

to Egyptian specialists.[55] He probably conveyed whatever special instructions he had to the builders – for example, whether or not to build an elaborate portal or a minaret – verbally rather than by means of drawings or plans, which seem hardly to have been used at this date.[56] This process might serve to explain why the mosque is so different from its sources: its shape is neither long like the mosque at al-Mahdiyya nor square like that of Ibn Tulun.

The scattered locations of the carved stucco panels in the interior[57] and the discontinuity of the accompanying Qurʾanic texts indicate that the mosque's interior was once decorated with an elaborate programme of vegetal designs executed in carved plaster and outlined with Qurʾanic inscriptions (Fig. 36). Throughout much of the twentieth century these plaster panels were whitewashed, but they are now gaudily painted in colour and gold, which, although shocking to purists weaned on a diet of Creswell's photographs, may be closer to the original than the puritan white of recent centuries. We know from texts that the interior of the slightly later mosque of the Qarafa was painted in many colours and it would be fascinating to examine the stuccoes to see if they preserve any traces of original paint.[58] Most of the Azhar panels have disintegrated over the centuries and some of them were restored in a Fatimidizing style in the late nineteenth century, when some new Qurʾanic passages were inserted. Nevertheless it is possible to make an informed guess about the nature of the original inscriptions.

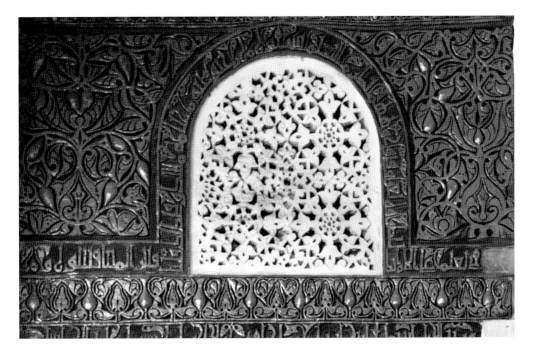

36 Cairo, al-Azhar mosque, carved stucco ornament near the interior south corner

Unlike the mosque of Ibn Tulun, where long passages taken from the Qur'an were carved in their entirety into wooden planks that decorated the interior arcades just below the ceiling, at al-Azhar particular verses seem to have been selected to make specific theological points. They were set in prominent bands that outlined the vegetal decoration. The verses surviving in the hood of the mihrab, for example, appropriately deal with prayer and man's relationship to God. Those surviving on the walls of the central aisle tell the story of Abraham and his father, while those on the qibla wall discuss the signs of God and the rewards of paradise.[59] Fragments of decoration on the outer walls, including more arabesque decoration and other Qur'anic texts, suggest that all the lateral arches of the prayer hall were once covered with vegetal decoration and inscriptions, although none of this has survived. Considering that what does survive would represent the merest fraction of what must have originally decorated the walls, it would be hazardous, if not downright foolish, to derive too much meaning or significance from the inscriptions that remain.[60]

If the surviving inscriptions are too fragmentary to allow the reconstruction of the mosque's iconographic programme, they do provide the first surviving evidence for the Fatimids' selective use of Qur'anic verses for monumental inscriptions, for no inscriptions survive from the earlier Fatimid mosque at Mahdiyya and the date and function of the white marble inscription from Mansuriyya is uncertain. The Fatimids are known, however, to have used such inscriptions in North Africa on objects, textiles and coins and their Aghlabid predecessors had a long tradition of using monumental epigraphy,[61] so it is possible that the Fatimids brought this taste with them to Egypt. Yet the story is not quite so simple: the Bir al-Watawit inscription (see Fig. 32) shows that Egypt too had a lively tradition of monumental epigraphy already before the Fatimids arrived. Nor were the Fatimids alone in adopting this practice: the contemporary Jurjir portal at Isfahan, Iran, is decorated with a Qur'anic verse appropriate to its Mu'tazilite foundation.[62] Thus, the use of selected Qur'anic verses for monumental inscriptions to make particular theological points was a widespread phenomenon in Islamic lands of the late tenth century and Fatimid builders can only be credited with participating in this trend, not inventing it.

After the Azhar mosque was completed and inaugurated in 972, it continued to be embellished and restored. The ceiling of the central aisle may have been raised during the reign of al-'Aziz, for this would explain the ungainly and inelegantly coupled columns and arches in this part of the mosque. In 1010 his successor, al-Hakim, established a charitable endowment in favour of the mosque and at the same time he presented the mosque with a massive pair of carved wooden doors made of Turkish pine (Fig. 37).[63] Each leaf, 3.25 metres

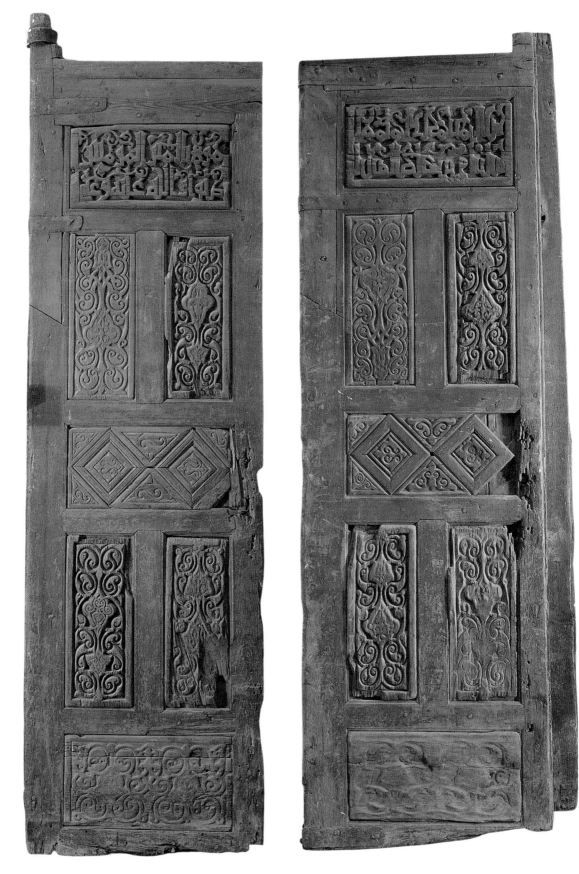

37 Pair of wooden doors ordered by al-Hakim for al-Azhar in 1010. Cairo, Museum of Islamic Art

high and 1 metre broad (11.5 × 3.3 feet), is composed of a mortised frame enclosing seven rectangular panels, three of which are placed horizontally enclosing and separating the four others, which are arranged vertically in pairs. The upper panel on each valve contains an inscription in two lines:

Our master the prince of believers	the imam al-Hakim bi-Amr Allah
Blessings of God on him and on	his pure ancestors and descendants.

As Max van Berchem noted over a century ago, the inscription presents incomplete versions of typical formulas, probably because the panels provided insufficient room for the full texts.[64] The rest of the panels are worked with symmetrical arabesque motifs carved in the Bevelled Style, which had been introduced from Iraq into Egypt during the Tulunid period. The lower panels (which are very worn) are decorated with a spiralling vine motif. The middle panels are themselves composed from six triangular pieces around two square panels placed on the diagonal.[65] The arabesque motifs and Bevelled Style fit nicely within the development of Egyptian woodwork from the Tulunid period and indicate that Egyptian woodworkers had no difficulty adapting their work for new patrons.[66]

As none of the Fatimid doorways to the Azhar mosque remains unaltered, with the possible exception of those on the south-west wall, it is impossible to say with certainty where or how this set of doors was originally placed – whether they were recessed within an opening or set flush with the wall. If recessed, they could not have fitted any of the side doors, which measure somewhat more than three metres in width. If they were mounted flush, they would have been too wide for any of the existing portals, although their imposing size and caliphal patronage might suggest that they were intended for the mosque's main entrance.[67]

The Palace

In January 973, about three and a half years after Jawhar had conquered Egypt, he began building a suitable palace to receive the imam-caliph al-Mu'izz. Although the sources are silent on his motivations, chronology would suggest that al-Mu'izz decided to transfer the seat of the imamate to Egypt only after his general had repulsed the Qarmati attack there and the caliph had realized that the conquest and pacification of Syria would be more difficult than he had previously imagined.[68] Meanwhile, in North Africa, preparations had to

be made for the imam-caliph's procession to Egypt. Suitable housing had to be built in Cairo, the contents of the palaces at Mansuriyya had to be packed up and everyone accompanying the monarch had to be provided with written authorizations and passes to be controlled at checkpoints along the way.[69] The displacement of an entire dynasty, including even the coffins of their ancestors, from Ifriqiya to Egypt was an extraordinary achievement unparalleled in Islamic history, and this logistical triumph underscores the Fatimids' mastery of administration even before they established themselves in Egypt.[70]

At Ajdabiya in Libya, a curious fortified reception hall was erected for the ceremonial use of the imam-caliph when he passed through, and other such structures may have been erected at other major stops, for example at Barqa.[71] At Ajdabiya, the monarch was housed in a grand but temporary marquee erected for the event, but he received the homage of the desert chiefs in the reception hall. When he arrived at Barqa, his chamberlain Jawdhar, whose memoirs provide much telling detail about the trip and court life, ordered his entourage to parade around the town with the maximum display of finery to impress those who had come from the east to meet their new ruler.[72] Such displays provided a tantalizing hint for the early development of the 'theatre state' that would eventually come to characterize Fatimid court life in Egypt.[73]

The Egyptian palace where the imam-caliph was to be received, located in the heart of the Fatimid enclosure on the eastern side of the north–south thoroughfare crossing the city, would eventually come to be known as the Great or Eastern Palace. It was complemented on the west by the Lesser or Western Palace, which was begun by al-Mu'izz's son and successor al-'Aziz (r.975–996) and extensively restored by his great-great-grandson al-Mustansir (r.1036–1094), who hoped to install the Abbasid caliph al-Qa'im (r.1031–1075) there as his permanent 'guest.'[74] The Fatimid caliphs continued to live in these palaces until the fall of the dynasty in 1171, when both were abandoned. Over the course of the following centuries, the buildings, the materials of which they were built and the valuable land on which they stood were all appropriated by Ayyubid and Mamluk sultans and amirs for their own charitable constructions, which remain to this day the heart of old Cairo.[75]

Virtually no part of the palace structures has survived the centuries, but some foundations discovered by archaeologists under later Ayyubid and Mamluk buildings in the centre of Cairo may belong to Fatimid struc-

tures,[76] as may some marble panels and wooden beams and doors removed and reused in other Cairene buildings. Eyewitness descriptions of the palace include the account of Nasir-i Khusraw, the Persian poet, philosopher and traveller who visited the city in 1047–8, and Hugh of Caesarea, the Crusader whose twelfth-century Latin report is contained in William of Tyre's *A History of the Deeds Done Beyond the Sea*. The major source, however, remains the fifteenth-century Mamluk historian al-Maqrizi, who collected what textual information he could from earlier Arabic sources about the palaces some two centuries after they had disappeared.[77] These range from contemporary Fatimid accounts to retrospective histories written during the Ayyubid period.

In the late nineteenth century Paul Ravaisse coordinated al-Maqrizi's reports with the map of the contemporary city (see Fig. 8). He determined that the Great, or Eastern, Palace measured approximately 425 by 275 metres (1400 by 900 feet) and was roughly shaped like a thick **L** (or a rectangle missing its upper right quarter) with a rectangular projection on the bottom; the Lesser, or Western, Palace was shaped like an elongated and squared **C**. The two palaces were separated by a great plaza or *maydān*, logically known as *Bayn al-qaṣrayn*, or 'Between the two palaces'. Although Ravaisse was unable to determine the internal articulation of the Great Eastern Palace, he hypothesized major axes separating three great internal courtyards, an arrangement that had less to do with textual evidence than with nineteenth-century Beaux-Arts design principles.[78]

Working from this jumble of evidence, most scholars have imagined the twin palaces in Cairo to have been massive constructions copying the twin palaces at Mahdiyya and al-Mansuriyya and occupying the centre of Fatimid Cairo from its foundation.[79] The chronology of the palaces in Cairo, however, shows that Jawhar did not plan this arrangement but that it evolved over time. Furthermore, even the Great Western Palace was enlarged and embellished to meet new needs, as for example in 979–80 when al-ʿAziz added the Great Hall (*iwān al-kabīr*).[80] Al-Hakim added the *Bāb al-Baḥr* (River Gate) on the north side of the palace's eastern façade and a century later the vizier al-Maʾmun al-Baṭaʾihi built three new pavilions nearby. Al-ʿAziz began the Lesser Western Palace as the *Qaṣr al-Baḥr* (Palace of the River) for his daughter, Sitt al-Mulk, but it was completed by al-Mustansir only in 1064.[81] The textual accounts taken with the evidence from other medieval Islamic palaces suggests that the Eastern Palace was not a single structure but a series of buildings including gates, pavilions, belvederes, a dynastic mausoleum,

kitchens and suites of rooms arranged around courtyards, all enclosed behind high walls.[82] Nasir-i Khusraw wrote:

> The sultan's palace is in the middle of Cairo and is encompassed by an open space so that no building abuts it. Engineers who have measured it have found it to be the size of Mayyafariqin. As the ground is open all around it, every night there are a thousand watchmen, five hundred mounted and five hundred on foot, who blow trumpets and beat drums at the time of evening prayer and then patrol until daybreak. Viewed from outside the city, the sultan's palace looks like a mountain because of all the different buildings and the great height. From inside the city, however, one can see nothing at all because the walls are so high. They say that twelve thousand hired servants work in this palace, in addition to the women and slave-girls, whose number no one knows. It is said, nonetheless, that there are thirty thousand individuals in the palace, which consists of twelve [separate] buildings. There are ten gates on the ground level, excluding the subterranean ones, each with a name: Bāb al-Dhahab, Bāb al-Bahr, Bāb al-Rih, Bāb al-Zahuma, Bāb al-Salām, Bāb al-Zabarjad, Bāb al-ʿId, Bāb al-Fotuh, Bāb al-Zallāqa and Bāb al-Sariyya[?]. There is also a subterranean entrance through which the sultan may pass on horseback. Outside the city he has built another palace connected to this palace by a passageway with a reinforced ceiling. The walls of this palace are of rocks hewn to look like one piece of stone and there are belvederes and tall porticoes. Inside the vestibule are platforms for the ministers of state; the servants are Blacks and Greeks.[83]

This evidence shows that the Great Palace of Cairo was less like the Umayyad palace at Mshatta or the Abbasid Balkuwara palace at Samarra, which were the products of single campaigns, and more like such urban palaces as the Citadel of Cairo, the Alhambra in Granada or Topkapı Saray in Istanbul, which evolved slowly over time.[84]

This evolution easily explains two otherwise unusual features of the Fatimid palaces. The first is the Eastern Palace's irregular outline. While the outline of the Western palace is relatively self contained, suggesting that it was planned at once, if built over time – the irregular outline of the Eastern palace betrays a history of accretions. According to both Nasir-i Khusraw and al-Maqrizi, the Great Palace was composed of ten individual palaces (*quṣūr*). Al-Maqrizi's list names the Qasr

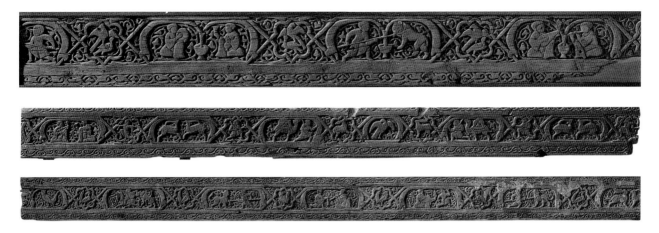

38 Carved wooden beams found in the Maristan of Qala'un and believed to come from the Fatimid Palace, eleventh century: a) 30 × 430 cm (11¾ in. × 14 ft 1 in.); b) 27 × 350 cm (10⅝ in. × 11 ft 6 in.); c) 18 × 418 cm (7 in. × 13 ft 9 in.). Cairo, Museum of Islamic Art, nos. 220a, 3471 and 12935

al-Nafaʻi, the Golden Palace, the Princes' Palace, the Victory Palace, the Tree Palace, Qasr al-Shawk, the Emerald Palace, the Breeze Palace, the Women's Palace and Qasr al-Jarr. These palaces themselves were comprised of rooms (qāʻa) and belvederes (manẓara).[85] A wall of finely-cut stone, according to Nasir-i Khusraw, enclosed the different complexes. The exterior walls were probably articulated, at least along the main façades, with blind arcades, for the façades of all later Fatimid and Ayyubid buildings in the vicinity, such as the Aqmar mosque (see Chapter 5) or the complex of al-Salih Najm al-Din Ayyub, have façades with blind arcades; this feature makes sense only when it is understood as a response to an aspect of the palace that had once stood in the middle of the city.

The second unusual feature of the Great Palace is its many gates. Al-Maqrizi gives the names of nine instead of Nasir-i Khusraw's ten. Whatever the actual number, palaces normally have few entrances, because every additional entrance decreases security for those inside. The many gates consistently enumerated by the sources, however, make sense if each is thought to have belonged to a particular and originally separate 'palace'. Thus the Emerald Gate would have led to the Emerald Palace and the Golden Gate to the Golden Palace. The gates were built of stone and were surmounted by belvederes from which the caliph could appear to the crowds assembled outside.[86]

Security could not have been all that tight, for on 8 March 1049, Nasir-i Khusraw managed to get himself admitted to see the hall in the palace where the caliph would host the banquet celebrating the end of Ramadan that evening. He had, he said to his friend the chamberlain, seen the courts of the Persian sultans, such as

Mahmud of Ghazna and his son Masʻud, who enjoyed great prosperity and luxury, and wanted to know how the Fatimid caliph's surroundings compared with these:

> As I entered the door to the hall, I saw constructions, galleries and porticos that would take too long to describe adequately. There were twelve square structures, built one next to the other, each more dazzling than the last. Each measured one hundred cubits square and one was a thing sixty cubits square with a dais placed the entire length of the building at a height of four ells, on three sides all of gold, with hunting and sporting scenes depicted thereon and also an inscription in marvellous calligraphy. All the carpets and pillows were of Byzantine brocade and būqalamūn, each woven exactly to the measurements of its place. There was an indescribable latticework balustrade of gold along the sides. Behind the dais and next to the wall were silver steps. The dais itself was such that . . . words do not suffice to describe it.[87]

The hunting and sporting scenes depicted on the dais or throne find their parallel in the wooden planks and panels that were found, reused, in the Maristan of Qala'un. This late thirteenth-century building is known to have incorporated parts of the Western Palace. The wooden panels were either the casings for ceiling beams or the coffers between them. Measuring approximately 20–30 centimetres wide and up to several metres long, the planks are typically carved with narrow foliate borders enclosing a frieze of alternating lobed octagons and hexagons formed by a continuous strapwork fillet (Fig. 38). Typically each octagon contains a single animal or human figure while each hexagon contains a

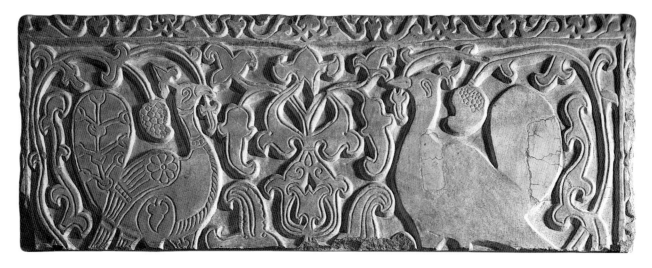

39 Marble panel carved in relief with confronted peacocks, found in the Mausoleum of Faraj b. Barquq and believed to come from the Fatimid Palace, eleventh century, 93 × 245 cm (3 × 8 ft). Cairo, Museum of Islamic Art, no. 21610

pair of figures, engaged in such courtly activities as music-making, dancing, hunting or drinking. Traces of colour indicate that the carving was once emphasized with paint. Other surviving panels are thought to have belonged to sets of wooden doors, such as the one found in the Hospital of Qala'un that is believed to have been recycled from the Western Palace.[88]

Several large (approx. 1 × 2.5 metres; 3.3 × 8.2 feet) marble panels carved in low relief were also discovered a century ago in the early fifteenth-century mosque of Sultan Faraj ibn Barquq (also built on the site of the Fatimid palace), where they had been reused as paving stones, their smooth sides uppermost (Fig. 39). More recently, other similar stones have been discovered during the course of restoration in the courtyard of the mosque-madrasa of Amir Sarghitmish (1356), which stands adjacent to the mosque of Ibn Tulun. Bearing symmetrical representations of peacocks, lions, etc., these panels are thought to have once decorated the walls of a Fatimid palace, but it is impossible to provide a more specific localization or date.[89] Unlike the wooden panels that once decorated the palace ceiling and upper walls, in which the figures occupy cartouches and panels created by the geometrical or arabesque interlaces on one or more levels, the figures on the stone panels inhabit the interstices of rather flat and unimaginative foliage scrolls in a manner seen in some late antique and early Islamic art. The quality of the design and execution is rather crude and unsophisticated, in sharp contrast to the naturalism often found in the wooden panels. In short, these stone panels are interesting more for their survival than for their inherent artistic quality.

Nevertheless, the stone panels and particularly the wooden friezes indicate unequivocally that the palaces of the Fatimids, like those of their contemporaries and predecessors elsewhere in the Islamic lands, were decorated with a range of secular images of musicians, dancers, hunters, birds and animals.

When the palace was looted in 1068–9, the royal throne – perhaps the dais described by Nasir-i Khusraw – was discovered by the looters. According to one eye-witness, it was cast from 110,000 *mithqals* (approx. 515 kilograms or 1135 pounds) of pure gold, an impressive but entirely plausible amount, considering that a century earlier al-Mu'izz had arrived in Egypt flaunting his North African gold. The bullion had been formed into ingots shaped like millstones, tied together through the hole in the middle and slung in pairs across the backs of camels.[90] In addition to its value in gold, the throne was studded with 1,560 precious stones of all kinds.[91] The looters wreaked terrible damage on the palace and its contents; nevertheless, it remained extraordinarily luxurious, to judge from the report of the Crusader Hugh of Caesarea who visited it a century later (see Chapter 5 below).

Fatimid sources confirm the visitor's accounts. For example, when the Byzantine emperor, Basil II, sent an ambassador to Egypt in 1001, al-Hakim wished to decorate the throne room with unusual furnishings to impress the visitor. He ordered a search in the furnishings storerooms and twenty-one sacks of textiles were found. Princess Rashida remembered that in 972–3 her father al-Mu'izz had brought these, along with other sacks, from Kairouan to Egypt. The whole of the throne

room was furnished with this fabric and all its walls covered with the hangings. Everything, floor and walls, was nothing but glittering gold. In the back of the throne room a gold shield called al-Asjada was suspended, adorned with all kinds of precious stones that illuminated its surroundings. When sunlight fell on it, 'eyes could not look at it without becoming tired and dazzled.'[92]

According to both Nasir-i Khusraw and al-Maqrizi, the palace also had subterranean passages, which seem to have been a *sine qua non* of medieval Islamic palaces, but it is difficult to understand how our sources would have known about such private parts of the palace.[93] Recent but unsubstantiated reports claim that the tunnels have been found, which purportedly connected the congregational mosque to the palace so that the Ismaili imam-caliph was able to 'move within the city without being seen.'[94]

Already in the time of al-Mu'izz, the palace combined the functions of a royal treasure house with that of a royal necropolis, for the southern part of the palace contained the tombs of the first Fatimid caliphs, whose remains al-Mu'izz had brought from North Africa for interment in Egypt.[95] By the middle of the eleventh century, when the palace was looted, this building – 'The Saffron (Anointed) Tomb' – alone was furnished with fifty thousand dinars' worth of chandeliers, incense burners, censers and ornamental objects.[96] The funerary associations of the palace only increased after 1149 when the head of al-Husayn, the Prophet's grandson, was brought to Cairo (see Chapter 6). With the interment of al-Husayn's head, the Saffron Tomb became the nucleus of the structure that would eventually become one of the landmarks of Cairo, the Mosque of Sayyidna al-Husayn.

Housing

The Fatimid city contained not only the ruler's palaces but also houses and gardens. Nasir-i Khusraw, the visitor to Cairo in the middle of the eleventh century, describes Cairo as having gardens and orchards, with 'pleasure parks built even on the roofs' of the houses. All the houses were freestanding, he wrote, so that none of the walls abutted. Whenever an owner needed to open the walls of his house to add on he could do it without detriment to any neighbour. One typical house in the city proper, on a lot of some 60 square metres or 650 square feet (20 × 12 ells) was four stories tall, with three stories rented out. These houses, he wrote, 'are so magnificent and fine that you would think they were

made of jewels, not of plaster, tile and stone.'[97] (The situation has changed mightily since his time.) He said that, in contrast, the district of Old Cairo (i.e. Fustat) was built on a hill and resembled a mountain because the houses were so tall. There were some houses with seven stories and others with even fourteen. On top of one seven-story house, he heard from a reliable source, there was a roof-garden where the tenant raised a calf, which was used to turn a waterwheel to lift water from a well below to irrigate orange trees, bananas, flowers and herbs planted on the roof.[98] Even today, some residents of Cairo are said to purchase calves and carry them to their roofs, where they raise them on fodder they bring up until the animals are big enough to slaughter.

None of this has survived, although archaeologists have excavated several residential areas in the older areas of the city, approximately where al-'Askar and al-Qita'i' conjoined, that continued to be used into the Fatimid period, although many if not all of the structures had been constructed at an earlier date.[99] The most elaborate houses, which were excavated after 1912 by Ali Bey Bahgat, had rectangular or square courtyards with a triple-arched scheme on one side in front of a T-shaped reception room with smaller rooms in the corners, but there is no evidence that they supported superstructures like those mentioned by the Persian traveller.[100] A possibly-Fatimid residential structure is the *qā'a* of al-Dardir, all that remains of an early palace rebuilt in Ottoman times, located a short distance south of the Azhar mosque. The oldest part consists of a central square space with a sunken floor flanked by two great tunnel-vaulted iwans (or liwans), each over 11 metres high, a room type well known in Mamluk times as a *qā'a*.[101] Creswell ascribed the structure to the (late) Fatimid period on the basis of its keel-arched niches and the form of the flat pendentives, which he compared to those which the caliph al-Zahir (*r*.1021–1036) added to the al-Aqsa mosque in Jerusalem. Other scholars, however, have suggested, on the basis of its great arched iwans – a feature of eastern (i.e. Iraqi or Persian) Islamic architecture that is thought not to have been introduced to Egypt before the Ayyubid period – that it dates as late as the fifteenth century, although the most recent discussion cautiously places it in the twelfth century.[102]

The Geniza documents, the discarded records of the Palestinian synagogue in Fustat, many of which date to the Fatimid period, provide more detailed information about the residential architecture of the urban agglomeration in this period, although none of the deeds of sale or other documents can be correlated to existing

remains.[103] Most of the descriptions concern properties in Old Cairo, where the majority of the Jewish population lived, but other properties were located elsewhere in the city and even in other countries. Although most houses differed markedly one from the other, they all seem to have had a court with a fountain or well, at least one large social room on the ground or upper floors and numerous dependent smaller rooms.

The Cemetery

Among the most distinctive features of the urban agglomeration in the medieval period was the enormous cemetery that stretched south of Cairo and east of Fustat. We have seen that the bodies of the most important male members of the Fatimid line had been and continued to be buried in the palace itself, but the rest of the capital's population – and lesser members of the Fatimid family – were buried in the great Qarafa cemetery, which had numerous mosques, palaces, mausolea and waterworks until the district was deliberately destroyed in November 1168 to prevent it being taken by the Crusaders.[104] Following the instructions of the Prophet Muhammad, who strongly disapproved of monumental tombs, most of the graves in the cemetery were undoubtedly simple affairs marked by a flat vertical headstone inscribed with an appropriate Qur'anic verse and the name and death date of a particular individual.[105] As early as the ninth century, however, the graves of some particularly important individuals began to be marked with commemorative structures, perhaps a simple domed cube built of brick and covered with plaster.[106]

In 976, only a year after the death of al-Muʿizz, his widow and daughter began construction of a congregational mosque, pleasure pavilion, pool and bathhouse in the midst of the Qarafa cemetery. This range of structures indicates that the women of the Fatimid court were anxious to integrate themselves into the great variety of funerary activities that must have developed in Egypt during the first centuries of Islamic rule. Well before the Fatimid conquest, the cemeteries of Egypt seem to have been the locus of popular, and particularly female, piety; it is likely that Fatimid propagandists had prepared the way for the conquest by proselytizing among the people, especially women, for whom visiting the tombs of their deceased relatives seems to have been an important activity.[107] Of the Fatimid constructions in the cemetery, only a fragmentary inscription has survived,[108] although excavations in the area have revealed the foundations of a funerary complex of the early

Fatimid period, if not the royal complex itself.[109] According to historical sources, Durzan, mother of the caliph al-ʿAziz, ordered a large mosque, built on the site of the earlier Masjid al-Qubba (Mosque of the Dome), which was said to have been built 'in the style' of the Azhar mosque itself. It had extraordinary carved and painted decoration on the interior, the work of 'painters from Basra and of the Banu'l-Muʿallim' (see Chapter 4 below).[110] The mosque appears to have been a favourite gathering place for the Egyptian élite. They would gather in its courtyard on Friday evenings during the summer to talk, eat, celebrate and sleep by the light of the moon; in the winter they would gather for the same purposes around the minbar. The prominence of the assembled company, along with the vast quantities of food and drink provided, also encouraged the general populace to attend these gatherings. Other celebrations were held during the four 'nights of light', on the eves of the new moons marking the beginning and the full moons of the middle of the months of Rajab and Shaʿban. These appear to have been joyful occasions, celebrated with the lighting of thousands of candles and great bonfires.[111]

The powerful women of the Fatimid court seem to have adopted Egyptian funerary practices in defiance of established Ismaili male practice, because the men, at least in Kairouan, had disapproved of visits to the cemeteries and of loud mourning for the dead – all customs that the North Africans, like the Egyptians, held dear in defiance of the Prophet's instructions about proper conduct. Abu ʿAbd Allah, the early Fatimid missionary, had already asked the Shiʿi theologians of Kairouan about the permissibility of loud mourning and based the Ismaili rejection of the practice on Qur'an 9:40: 'Do not

40 Cairo, group of mausolea known as the Saba Banat, 1012. Photograph taken in the early twentieth century by K. A. C. Creswell

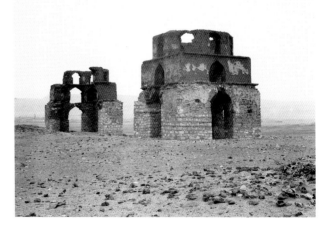

be mournful! God is with us!' Later on, it is reported that one of al-Mu'izz's nephews requested permission to have female mourners appear at the burial of his son. The application was denied. 'Let him mourn with his slaves and servants [at home], if he wishes!' the imam-caliph replied.[112]

Soon, however, even the caliphs themselves were building structures in the cemetery. Al-Hakim, for example, who was not known for his adherence to convention, built the set of six domed structures known as the *Qibāb al-Saba'* (The Seven Domes) or the *Saba' Banāt* (Seven Maidens) in October–November 1012. They were constructed over the graves of six members of the Banu Maghribi family whom the caliph had ordered decapitated two and a half years earlier in June 1010.[113] These buildings are simple domed cubes: a square stone base with openings on each of the four sides is surmounted by a brick superstructure, itself consisting of three separate parts: (1) a square zone of transition containing four squinches, (2) an octagonal drum and (3) the dome (destroyed) (Fig. 40). These rather simple structures covered in plaster represent the type of domed tomb that became popular in various regions of the Muslim world in the tenth century, particularly in northern Iran and Egypt. At one time it was hypothesized that the rise of Shi'ism, which venerated the descendants of the Prophet, may have led in this period to the proliferation of tombs among the common folk, but the specific role of Shi'ism may have been somewhat overstated.[114]

The domed cube was not the only type of mausoleum erected in the early Fatimid period. The nearby building known today as the Hadra Sharifa is an early eleventh-century Fatimid funerary complex.[115] Measuring about twenty by thirty metres, the rectangular complex consists of a series of vestibules and chambers at one end, a large open courtyard in the middle and a three-room mausoleum at the other end. The whole is roughly built of small brick-like stones quarried from the nearby Muqattam hill (Fig. 41). The largely ruined mausoleum once had a central dome flanked by smaller rooms covered with vaults or flat wooden roofs. In each room there were cenotaphs over the graves of the deceased and stucco mihrabs in the qibla wall. The elaborate entrance indicates that interior privacy was desired; the large courtyard could accommodate a range of functions and the mihrabs indicate that people expected to pray there. Creswell originally assigned this building to the late Fatimid period although scholars now prefer an earlier date. Some confusion arises because this type of structure would continue to be built over the course of the

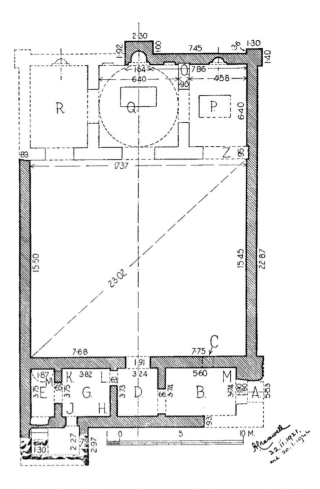

41 Cairo, plan of the mausoleum complex known as the Hadra Sharifa, early eleventh century. After Creswell, *Muslim Architecture of Egypt*, I, fig. 127

Fatimid period, suggesting that the activities practised in them – whatever they may have been – continued to be current throughout the period. Further confusion arises from the nomenclature: some sources call this type of structure a *mashhad* or 'martyrium', although not all *mashhad*s were so complex.[116]

An even more unusual structure of the period is the Lu'lu'a ('Pearl') Mosque, which has no specifically funerary associations except through its location in the north-eastern part of the Qarafa cemetery (Fig. 42). In 1015–16, the imam-caliph al-Hakim ordered the restoration of the Lu'lu'a Mosque in the Qarafa cemetery. The structure is unlike anything else of the period: built from and vaulted with rough-cut stone quarried from the adjacent Muqattam hill as well as with baked brick, it comprises a tower of three superposed vaulted rooms measuring approximately 3 × 5 metres (10 × 16 feet) in plan. Each room once contained a mihrab flanked by small windows, but in later centuries the ground around the building was quarried for stone. Standing precari-

42 Cairo, Mosque of al-Lu'lu'a, 1015–16 (restored)

ously on a promontory, the fragile building fell into nearly total ruin following a disastrous rainstorm in 1919. It remained in this condition for nearly a century until it was imaginatively reconstructed in gleaming white limestone under the auspices of the Bohra community, whose leaders trace their descent from the Fatimid caliphs. According to Ibn al-Zayyat's medieval pilgrimage guide, the mosque was celebrated for the granting of prayers said there.[117] The idea of three small rooms with three mihrabs invites comparison with the Hadra Sharifa and other shrines, but their superposition is unique. Why build such a small and tall structure unless either land was scarce – which it does not appear to have been – or the site was of particular sanctity?

The Mosque of al-Hakim

Following the fall from favour of al-Mu'izz's eldest son Tamim, who had retired to a life of poetry in February 969 before the conquest of Egypt, the imam-caliph al-

Mu'izz had intended that his middle son, 'Abd Allah, succeed him. Having made it to Egypt and helped in the defence of the city, however, the heir-apparent fell ill and died in February 975. The imam-caliph himself followed his son at the end of December, dying from pestilence at the age of forty-four. Born in North Africa, al-Mu'izz had brought his dynasty to extraordinary success in Egypt, although he reigned there only two and a half years and was able neither to make the promised pilgrimage to Mecca nor to enter Baghdad in triumph. He had already designated his third son, Nizar, as his successor, ushering in a subdued beginning to a new age.[118]

Nizar, who took the regnal name *al-'Azīz bi'llāh*, 'Mighty by God', publicly announced his succession by riding out to offer the prayer for the Feast of the Sacrifice under the *mizalla*, a parasol shaped like a bejewelled shield suspended from the point of a lance held by a courtier. While al-Mu'izz is not known to have used it, al-'Aziz's elder brother 'Abd Allah had paraded under a parasol following the defeat of the Qarmati,[119] and it seems likely that the Fatimid *mizalla* was synonymous with and ultimately derived from the *shamsa* or *shamsiyya* ('sun') parasol used earlier by the Abbasid caliphs as a symbol of authority.[120]

The reign of al-'Aziz (975–996) was marked by peace, political stability and a well-functioning economy. The caliph consolidated Fatimid authority and contributed much toward creating an imperial style of rule. Indeed, compared to the economic chaos that had prevailed less than a decade earlier, the transformation was nothing short of miraculous. The fiscal regime was comprehensively reformed, enriching the treasury and broadening the base of the dynasty's support. The most conspicuous sign of this prosperity was the luxury of the court.[121] The temporary camp that Jawhar had erected was transformed by a continuous building programme into a splendid capital city: the young imam-caliph and his family – his mother and his sister Sitt al-Mulk – built many religious and secular structures, including mosques, palaces and aqueducts.[122] This physical imprint on the landscape of the capital 'confronted the inhabitants with permanent and visible symbols of the regime's might and authority', as did the splendid public celebrations of festivals which al-'Aziz instituted.[123] Al-'Aziz's propensity for grandeur was matched by his proclivity for extravagance. It is said, for example, that ten thousand slave girls and eunuchs were employed at court.[124] While this number may be a blatant exaggeration, it does give some idea of the ostentatious display of wealth that characterized his reign.

The stability and prosperity that characterized life in the capital during the two decades of al-'Aziz's rule, however, did not necessarily transfer to the provinces of Ifriqiya and Syria, where events continued to flux dramatically. Following this caliph's death in 996, conflict broke out between the Kutama Berbers and the Turkish troops which he had begun incorporating into his army. The Kutama had been with the Fatimids since the very beginning and they resented the increased power of other groups, particularly the Turks, who came from the opposite quarter of the globe.[125] Power was handed over to al-'Aziz's eleven-year-old son Abu 'Ali al-Mansur, who took the regnal name *al-Ḥākim bi-Amr Allāh* ('He Who Rules by God's Command'), under the guidance of the Ismaili qadi and the Kutama chief Ibn 'Ammar. Ibn 'Ammar's favouritism towards the Kutama sparked off serious clashes with the Turks in which he was defeated and succeeded by the caliph's tutor Barjawan, a 'white' eunuch – perhaps a Sicilian or a Slav.[126] Barjawan proved to be a competent administrator of state, but his accumulation of power to himself was deeply resented by the young caliph who had him executed in 1000 – an early example of the tumult and violence that would characterize al-Hakim's reign and eventually lead to his demise.

Meanwhile the young caliph promulgated a series of stringent ordinances to reform public behaviour. These ordinances affected dietary laws, the freedom of non-Muslims and their right to worship as well as the situation of women. For example, in early 1003 the caliph ordered construction of the new Rashida Mosque on the site of one of Fustat's Jacobite churches and several Jewish and Christian cemeteries. The brick mosque was completed within two years and used for congregational prayer for a few years until 1010–11, when it was torn down, apparently because it was not properly aligned to Mecca.[127] The orientation was recalculated and the mosque rebuilt in stone three years later.[128] Perhaps the most consequential of the caliph's measures was the caliph's mysterious decision in 1009 to order the destruction of the Church of the Holy Sepulchre – the church erected in the fourth century by the Byzantine emperor Constantine over the purported burial place of Christ in Jerusalem. While the destruction was not complete and the church was soon rebuilt with the blessing of al-Hakim's successor al-Zahir, the report circulated widely in the Latin West and became one of the causes of the First Crusade, which captured Jerusalem in 1099.

Al-Hakim's eccentricities and shifting edicts have led a number of modern scholars to puzzle over his behav-

iour, although no consensus of opinion has emerged.[129] His actions were, however, a source of encouragement to a small group, eventually known as the Druze, as they were followers of Muhammad al-Darazi, who believed al-Hakim to be the incarnation of divinity. But no popular rebellion erupted even though the caliph's behaviour became increasingly ascetic and unpredictable. The situation deteriorated in 1019–20 as relations between the population and the Black, Maghribi and Turkish troops worsened. On the night of 13 February 1021 al-Hakim mysteriously disappeared; his influential older sister Sitt al-Mulk is reported to have played a pivotal role in his disappearance and the succession of his son Abu'l-Hasan 'Ali as the caliph al-Zahir.[130]

The great architectural monument of al-Hakim's reign is the mosque just inside the Gate of Conquests (Bab al-Futuh) in Cairo's northern wall that now bears his name. Nothing about this statement is actually correct: the mosque was begun in 990 by the caliph's father al-'Aziz – or (according to one report) the all-powerful vizier Ya'qub ibn Killis, who more or less governed Egypt until his death in 991. The mosque was originally located outside the city walls and was known simply as 'the Congregational Mosque Outside Bab al-Futuh' before getting the epithet *Jāmi' al-Anwar* ('the Bright Congregational Mosque'), a name chosen undoubtedly to rhyme with al-Azhar ('The Radiant, Splendid').[131] Work progressed sufficiently for the caliph al-'Aziz to lead prayers in the new mosque by December of that year and again in 993, but the building was hardly complete, for a few years after the caliph's death in 996 it was estimated that some forty thousand dinars, a very large sum indeed, was needed to complete construction. The carved stone towers at either end of the main façade, which are inscribed with the date 393 (1002–3), as well as the carved stone central portal, which once bore such an inscription,[132] indicate that the entire main façade was the work of al-Hakim. In 1010–11, however, the controversial caliph ordered the towers encased in huge square stone bastions. On 6 Ramadan 403/21 March 1013, more than two decades after the mosque had been conceived and after an additional outlay of five thousand dinars for furnishing with mats, lamps, chains, etc., the building was finally inaugurated by the caliph. The minbar, which no longer exists, carried another inscription stating that the caliph al-Hakim had ordered it in 403/1013 for 'the mosque built outside the Bab al-Futuh', indicating that its name was invented well after it was built and furnished.[133]

The mosque – whatever its name – had a long and unusually chequered history after its construction. It

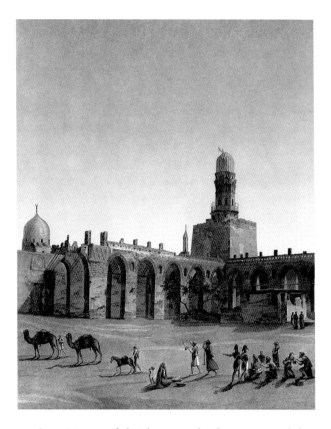

43 Cairo, Mosque of al-Hakim, completed 1013, as recorded in 1798 during the Napoleonic expedition to Egypt. Published as 'View of an ancient mosque located near Bab al-Nasr' in the *Description d'Egypte, État Moderne* (Paris, 1809–), vol. 1, pl. 28

was often visited by the Fatimid caliphs during their ceremonial progressions to the various mosques of the capital city, especially during the month of Ramadan.[134] Al-Hakim's son and successor, al-Zahir (*r.*1020–1035), added a large *ziyāda*, or area for ablutions, to the south side of the mosque. The mosque was built directly north of the Gate of Conquests and the city wall, so the *ziyāda* had to have been built where the wall had stood. In other words, the northern city wall, which had been built of mud-brick, must have fallen into disrepair within fifty years of its construction, another indication of the peace and prosperity early eleventh-century Cairo enjoyed.[135] Between 1087 and 1092, however, during the reign of al-Mustansir, the situation changed dramatically as the vizier Badr al-Jamali, fearing a Turkish invasion, rebuilt the northern wall of the city in stone and enclosed the mosque in a great salient, making it part of the city's defences. In the twelfth century, Frankish Crusaders were imprisoned in the mosque's *ziyāda* and horses were even stabled there. After the fall of the Fatimid dynasty, the Ayyubid leader Saladin eliminated Friday prayer at al-Azhar and the mosque of al-Hakim

became the principal mosque of Cairo, since Shafi'i doctrine, which the Ayyubids followed, prohibited congregational prayer in more than one mosque in any given urban entity. The mosque was restored in the early Mamluk period and the upper parts of the two towers on the façade were given Mamluk-style 'pepper-pot' finials. The mosque was eventually abandoned, however, and after the French occupation in 1798, it was turned into a fortress (Fig. 43). In the nineteenth century various types of craftsmen used it for workshops until 1880, when the Arab Museum was erected first in what remained of the prayer hall and later in a building erected in the court. During the Nasser period, a boys' school was erected in the mosque's courtyard and the mosque itself was in a rather sorry state (Fig. 44). In 1980 the buildings were cleared from the exterior and interior and the derelict mosque was garishly restored under the patronage of the Bohra community (Fig. 45).

The mosque measures approximately 120 × 113 metres (394 × 370 feet), or nearly two and a half times the size of al-Azhar, and is oriented 42° south of east (132°). Its outer walls are built of rough-cut stone and there were once thirteen entrances leading either to the arcades surrounding the courtyard or to the prayer hall itself. Of these, those in the middle of each side were built of finely-dressed stone and projected from the outer wall, but the largest and finest one in the centre of the northwest wall (opposite the mihrab) was the main entrance (Fig. 46). The twin towers, which are still partly visible within the massive salients built around them, are similar in size but different in shape: the northern tower is cylindrical and rests on a square base, while the western tower has a tapered octagonal shaft. Both have lost their original tops and there is no way of knowing exactly how tall they once stood.

In contrast to the exterior, the interior of the mosque was built of brick, with brick piers and arcades faced with plaster (Fig. 47). The prayer hall is five bays deep and has a higher and wider axial aisle leading to a domed bay over the mihrab. There were also domed bays in the rear corners of the prayer hall, a feature said to have existed at al-Azhar but for which there is no monumental evidence. The lateral halls are three bays deep and that opposite the prayer hall is two bays deep. The interior of the mosque, to judge from the present remains, was rather plain except for a magnificent band of Qur'anic inscriptions carved in the plaster just under the roof (Fig. 48), plaster window grilles, carved wooden tie-beams and the lamps, mats and hangings that al-Hakim provided to complete the building.

44 Cairo, Mosque of al-Hakim, completed 1013, before restoration

45 Cairo, Mosque of al-Hakim, courtyard, after restoration

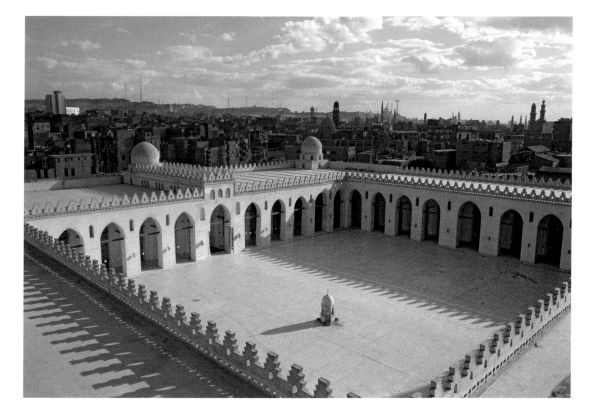

46 Cairo, Mosque of al-Hakim, main portal after restoration

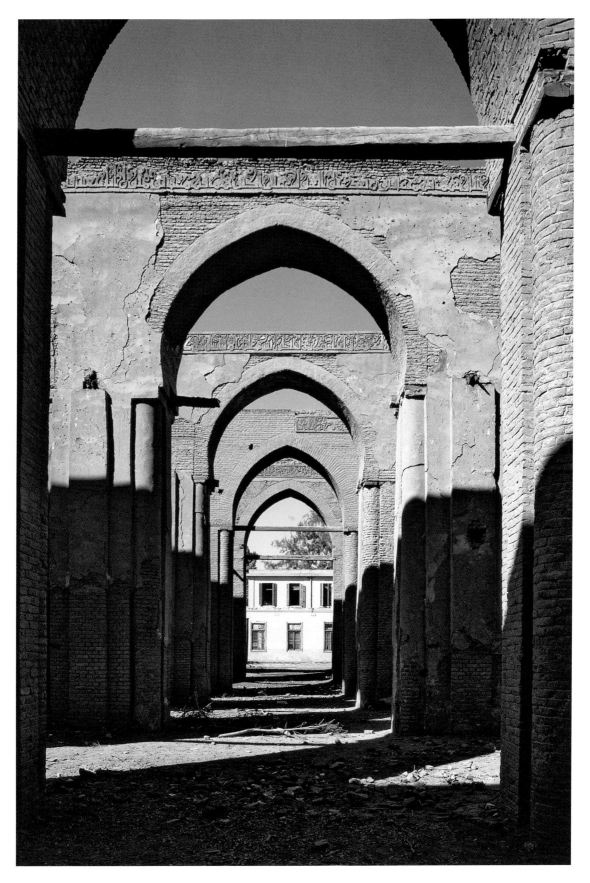

47 Cairo, Mosque of al-Hakim, arcades and inscriptions before restoration

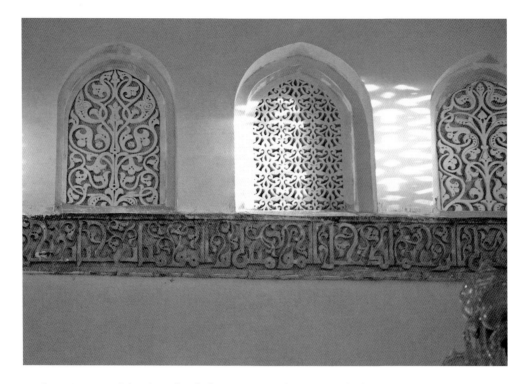

48 Cairo, Mosque of al-Hakim, detail of inscription in dome over mihrab

The mosque presents several problems which remain difficult to resolve. Why did the Fatimids, so soon after the construction of al-Azhar, feel it necessary to construct such a large mosque outside the Fatimid city walls, in a place as far away as possible from the old centre of population in Fustat? If they simply needed more space for a larger congregation, why did they not simply enlarge al-Azhar, which already stood in the centre of the Fatimid city? If it was so important to build this mosque, why was construction halted for so long after al-ʿAziz died? Why did al-Hakim build two elaborate stone towers – the first on any Fatimid mosque – and then have them hidden behind great stone bastions?

Over the past half-century, scholars have responded to these questions with several different answers, ranging from population pressure to symbolic appropriation of the city, but no single hypothesis is entirely convincing.[136] Owing to the fragmentary nature of the monumental and historical evidence and the complete restoration of the structure, we may never be able to satisfactorily explain this odd building completed by an eccentric ruler.

Whatever the motives for its construction, the building is a precious document for the evolution of Fatimid art and architecture at the end of the tenth century and beginning of the eleventh. The idea of placing a very large mosque outside the city walls in 990 shows that within two decades of the Fatimids' arrival in Egypt they had assured their own security, so that Jawhar's hastily-erected mud-brick walls were no longer needed – and may no longer have existed – as a protection against external threats. This supposition is confirmed by the construction of the mosque's *ziyāda* over the emplacement of the wall a few decades later. Nasir-i Khusraw, who visited the city in the middle of the eleventh century, mentions no wall around the city, just around the palace. Security would again become a concern, however, in the latter part of the century when Badr al-Jamali used stone to rebuild the northern wall of the city to protect it from Seljuq attack. This meant enclosing the mosque within the embrace of the new wall.

Although most of the interior of the building has been destroyed and rebuilt, the major techniques of construction and decoration used in the mosque are more generically Egyptian than specifically Fatimid. The technique of brick rendered, or covered, with plaster had already been used at al-Azhar, but al-Azhar's system of stone columns and capitals was replaced by one using brick piers in the Egyptian tradition of the Mosque of Ibn Tulun. Perhaps the hundreds of antique marble columns and capitals that were available to Jawhar in the early 970s for al-Azhar were no longer available two decades later.[137] The Mosque of al-Hakim, two and a half times larger than al-Azhar, would have

needed many more columns of even larger size to support its roof. Likewise, the exuberant vegetal decoration in carved stucco found between the inscriptions at al-Azhar gave way to a more restrained and purely epigraphic decoration on the interior of the Hakim mosque, accented with a bit of Bevelled-Style ornament, another Tulunid quotation.[138]

It is on the exterior of the mosque, however, particularly on the towers and central portal of the north-west façade, which dates from the earlier phase of construction, that there is much that is new and different. Creswell suggested many years ago that the twin-towered façade flanking a central portal was a holdover from the mosque of Mahdiyya, but al-Hakim's Egyptian builders could hardly have known of this mosque in Tunisia in an era before photographs and drawings, so it is more likely that they would have adopted the idea of a projecting portal from the nearby mosque of al-Azhar. But what of the twin towers? Creswell believed that the corner bastions of the mosque at Mahdiyya had once supported towers, so he traced their origins there. We now know that the bastions at Mahdiyya were cisterns and that al-Azhar did not have two towers. Why then did al-Hakim decide to erect them and why are they not identical?

Twenty-five years ago I studied the mosque's inscriptions and found that they do not easily reveal what purpose these towers served, being relatively well-known selections from the Qur'an such as 11:73 containing the phrase 'People of the House', which the Shi'a interpret as referring to the family of 'Ali, or the Light Verse (24:35), as well as the typical formulas recording the names and titles of the builder.[139] I did note, however, how unusual such towers were in contemporary Islamic architecture and suggested that they should not be understood as minarets erected for the call to prayer but as symbolic references to the towers gracing the mosques of Mecca and Medina, the holy cities of Arabia. At the time, I suggested that al-Hakim was led to make that reference because of his interest in the holy cities, but I did not know then that in 390/1000, just a few years before al-Hakim's work on the mosque, the caliph had ordered the construction of three sanctuaries to the south of Cairo. They were intended to contain the remains of the Prophet and the first two caliphs which were to be removed surreptitiously from their graves in Medina in order to attract pilgrims to Egypt. This audacious feat was prevented when the Medinans discovered the plot and the tombs, which were called either *masjid* (mosque) or *mashhad* (martyrium) and which stood on a high foundation, came to

be associated with lesser local figures.[140] In this context, the intended symbolism of the façade of the new mosque would have proved inappropriate and the controversial caliph might have had them encased in stone because it would have been impious to dismantle any part of a mosque dedicated to the worship of God.[141]

Although my interpretation was based on a close reading of the mosque's inscriptions and its forms, it largely ignored the building's decoration, for the epigraphic bands that surround the windows, encircle the tower shafts and decorate the portal are enclosed in beautiful bands of arabesques and geometric interlaces carved into the stone blocks (Fig. 49).[142] The harmonious floriated kufic inscriptions are the product of a long Egyptian development, for which evidence can be found, for example, in the pre-Fatimid Bir al-Watawit inscription (see Fig. 32), but the elegant geometric interlaces and arabesque bands between and around the inscriptions are quite unlike anything found in the earlier Islamic art of Egypt. Creswell aptly characterized the decoration on the portal as 'extraordinary', describing it as 'arabesque worked, so to speak, into the skeleton of a Classical entablature.'[143] He compared this decoration to other 'curious' Classical survivals, all of which are significantly later in date, such as the Bab al-Nasr in Cairo, the Dar al-Fuqara' portal at Damascus and the 'amazing' Jami' al-Tuti (Madrasa al-Shu'aybiya) at Aleppo. Creswell followed Ernst Herzfeld in seeing these not as the product of a 'renaissance of the antique' but as 'an uninterrupted antique tradition.'[144] He suggested that the western tower and the portal of the Mosque of al-Hakim were the work of one builder, the northern tower the work of another.[145]

Despite the millennial tradition of elegant masonry in Egypt and the ready availability of the raw material there, there had been little, if any, new stone construction during the first centuries of Islamic rule in Egypt. Apart from spolia, the principal use of stone was to make the thousands of inscribed tombstones that have been found in the cemeteries of Cairo and Aswan, but the rather workmanlike techniques used for carving flat tombstones could not have provided the reservoir of craft tradition in the absence of major architectural patronage.[146] The arrival of the Fatimids, a dynasty intent on impressing their mark on Egypt instead of a series of governors keen to build themselves fancy – but transitory – palaces, surely opened the way for large-scale public architecture, but there was more to it than that. The tentative appearance of dressed and decorated stone masonry at the Hakim Mosque – the towers and portal are finely worked while the rest of the façade is

49 Cairo, Mosque of al-Hakim, detail of arabesque decoration and inscription on north side of main portal before resortation

rough-cut – was to be followed by a series of increasingly sophisticated buildings in stone, such that by the end of the Fatimid period, stone had become the preferred medium for the façades of all public buildings. It is possible that the builders of Coptic churches in Egypt preserved a reservoir of masonry techniques, but our knowledge of these buildings is limited and their decoration is quite unlike the arabesque motifs of the Hakim mosque.[147] It is unlikely that the techniques had been lying dormant among Egyptian artisans waiting for some benevolent patronage to bring them out of dormancy, so the new use of stone must have come from somewhere else.

Stone is known to have been used as a building material in tenth-century Spain, North Africa and Syria. The style of the Egyptian ornament is very different from that used in Spain and the ideological differences between the neo-Umayyads and the Fatimids – let alone the great distances involved – make such a connection extremely unlikely. Stone masonry was also used extensively in North Africa. The close historical and ideological ties between North Africa and Egypt in the tenth century would make it the most probable source for the revival of stone masonry in Egypt, but for the fact that Fatimid Egyptian ornament in stone, which itself of course depends on a stone-working tradition, is entirely unlike that used in contemporary North Africa. It is unlikely that masons would have moved from North

Africa to Egypt during the reigns of al-ʿAziz and al-Hakim when they had not come earlier.

As Creswell and others have already noted, fine stone buildings, such as the minaret of the Great Mosque of Aleppo, were being erected in late eleventh-century Syria, but the origins of this building tradition are quite unknown, for no Islamic buildings survive there from the tenth century or early eleventh. That does not mean, however, that none was built, nor does it take account of the building activities of Christians in the region. In short, greater Syria seems to be the most likely source for the introduction of this new technique and style to Egypt. Jerusalem was known as a centre of stone masonry – the Madrasa al-Shuʿaybiya in Aleppo, for example, is signed by a builder from that city. In the late tenth century, Fatimid advances in Palestine and Syria might have attracted artisans to the bustling metropolitan centre of Cairo, much as they would a century later, and so the revival of stone masonry in Egypt may be linked to the emigration of Syrian artisans who brought with them a taste for the antique. It is also possible that these artisans were members of the Syrian Ismaili community who were finally attracted to settle in Cairo by the establishment of the Fatimid state there.

In any event, close examination of the Mosque of al-Hakim shows that it is not what it purports to be at all: it was not begun by al-Hakim, but by his father; it was not

based on the mosque at Mahdiyya, but on al-Azhar; its stone masonry has little to do with North Africa and much to do with Syria. Its virtual reconstruction in recent years means that its original purpose and meaning may never be entirely clear; all we can do is explore and reveal its peculiarities and inconsistencies in an attempt to come closer to understanding its origins and history.

Jerusalem

Once established in Egypt, the Fatimids expanded rapidly into Syria, conquering Palestine and then Damascus without encountering any particular resistance, except from the Bedouin tribes who regularly harassed the cities. Fatimid authority in Syria, however, was enforced only when their troops occupied the region, but once they departed, the local amirs did as they pleased. The Byzantines took advantage of this anarchy and extended their influence along the Phoenician coast from the north, taking the Orontes valley and establishing a 'duchy' at Antioch. Fatimid sights were undoubtedly focused not on Syria itself but on faraway Baghdad in Iraq, but this was not to be the case except for a brief moment in 1058–9, when the Fatimid caliph's name was invoked for several months in the Friday sermon in the Abbasid capital. This development, however, was not the product of Fatimid military might but the unforeseen result of an extraordinarily complicated struggle for power among various warring factions in Abbasid Mesopotamia (see Chapter 5, below).

The tenuousness of the Fatimid presence in Syria meant that they left few major constructions there. It is likely that buildings continued to be built in such major cities as Damascus or Ramla, but nothing is known of them. Salamya, the ancestral home of the Fatimid line, would have been a natural objective and the Fatimid commander who seized the town around 1009 constructed a mausoleum over the tomb of the Ismaili imam 'Abd Allah (the Younger) and the inscription at the tomb was restored some four decades later.[148]

Literary and historical sources indicate that the Fatimids and other patrons built extensively in Jerusalem during the first half of the eleventh century. As elsewhere in the region, it has been very difficult to determine exactly what they built, for all Fatimid-era constructions were substantially transformed after the Crusaders took the city in 1099. It is often said that the impetus for the Crusades was the caliph al-Hakim's destruction of the Holy Sepulchre in 1009, but Byzantine Christians, who were much closer to and far more involved in Jerusalem, did not take the destruction as

seriously as did Christians from western Europe. It is even unclear how much was actually 'destroyed.' The Holy Sepulchre had already been severely damaged by fire in 938 and pillage in 966.[149] There is no doubt that the building was looted in the Fatimid period, yet as substantial portions of the earlier church remain, the destruction cannot have been quite as complete as contemporary chronicles would suggest. Furthermore, the destruction of the Holy Sepulchre was followed by major earthquakes in 1016 and 1034 or 1035, which also resulted in the partial collapse of the Dome of the Rock, the major Muslim monument in the city. At this time other transformations show how the city contracted: al-Hakim's successor, the caliph al-Zahir, shortened the southern city wall to approximately its present extent, essentially returning the line of the walls to their layout in the Roman period.[150]

Historians have also been unable to provide a satisfactory reason why al-Hakim destroyed the Holy Sepulchre. Fatimid–Byzantine relations, for example, were not particularly bad in the early eleventh century. Muslims venerated Jesus as a prophet and may even have built a small mosque inside the Holy Sepulchre itself as early as the tenth century. An inscription once carved on the walls of the building suggests that this mosque was still extant – or even renewed – in the eleventh century, when al-Zahir gave the Byzantine emperor permission to reconstruct the Holy Sepulchre after 1033.[151] Al-Zahir's successor al-Mustansir (r.1036–1094) even allowed Amalfitan merchants to build or sponsor a monastery, a church, a hospital and two hostels (one for men and another for women) near the Holy Sepulchre.[152] It is therefore difficult to establish a coherent picture of the city in this period, except to say that for Muslims, this was the time when the focus of popular piety shifted from the biblical prophets to the Prophet of Islam and the great structures the Umayyads had erected three centuries earlier were reinterpreted as commemorative monuments to Muhammad.[153]

For example, following the earthquake of 1016, the caliph al-Zahir ordered the Dome of the Rock to be restored in 1022–3, according to three inscriptions carved on wooden beams placed at cardinal points inside the narrow gallery at the base of the dome.[154] In 1027–8 the repairs were sufficiently far along to allow the restoration of the mosaics on the interior of the drum, according to a mosaic inscription (Fig. 50) in a particularly archaic script: '. . . and the restoration of this glass mosaic [billawr] in the year 418.' The presence of the word 'and' at the beginning of the inscription implies that it was preceded by some text, although it has not

50 Jerusalem, Dome of the Rock, mosaic inscription in drum recording restoration in 1028

survived and the panel containing this inscription has no room for more words.

Much ink has been spilled over the extent of the Fatimid restorations to the Dome of the Rock, which certainly include the decorative diaper band in the drum below the windows in the north quadrant where the inscription appears.[155] Beyond that, opinions are based on stylistic analysis. The French scholar Henri Stern believed that all the drum mosaics were the work of al-Zahir's craftsmen, while the Swiss scholar Marguerite van Berchem thought the drum mosaics to have been Umayyad in conception with many later restorations and repairs, continuing well into the twentieth century.[156] She identified Fatimid period work by comparing some of the drum mosaics to the 'triumphal arch' at the end of the central aisle of the Aqsa mosque. The most recent study of the building by Oleg Grabar deems them largely Umayyad with 'restorations of high technical quality . . . accomplished in Fatimid times'.[157] Considering how many times the mosaics have been repaired and restored over the centuries, it is probably impossible now to separate the Fatimid work from that done in other periods. Still, one can say with certainty that significant work was done and that during al-Zahir's reign there was a corps of craftsmen in Jerusalem able to restore damaged mosaics not only at the Dome of the Rock but also at the Aqsa mosque.

At the Aqsa Mosque the 'triumphal arch' (Fig. 51) is decorated with a large mosaic panel with two grandiose vegetal devices on a golden background, with a thick ornamental band of frets below and a long inscription above in kufic script. The vegetal designs are clearly related to the decorative vocabulary found in the Dome of the Rock, but they are scaled out of proportion and lack the exuberance of the model. The reason is explained by the inscription, which reads:

> In the name of God, the Merciful, the Compassionate. Glory to the One who took his servant for a journey by night from the Masjid al-Haram to the Masjid al-Aqsa whose precincts We have blessed (Q 17:1). Has renovated its construction, our lord 'Ali Abu al-Hasan, the imam al-Zahir li-I'zaz Din Allah, Commander of the Faithful, son of al-Hakim bi-Amr Allah, Commander of the Faithful, may the blessing of God be on him, on his pure ancestors and on his noble descendants. By the hand of 'Ali ibn 'Abd al-Rahman, may God reward him. Supervised by Abu'l-Qasim al-Sharif al-Hasan al-Husayni . . . may God help him.[158]

Although the inscription has not preserved its date, another mosaic inscription recorded in the twelfth century stated that the redecoration of the dome behind the arch had been completed in October 1035.[159] These then are Umayyad-style mosaics done in the eleventh century when the design of the Aqsa mosque was entirely reconfigured and reduced in size from its earlier state, either as the result of destruction in an earthquake or following a reassessment of the city's population.[160]

Fatimid activities in Jerusalem were not limited to restoration and repair, however, for it is during this period that, as a result of Fatimid policies, a new image of the city emerged from several pan-Islamic developments that combined with purely local ones.[161] Although tenth-century authors had indicated that various other localities on the Haram al-Sharif were already associated with the *mi'rāj*, Muhammad's miraculous ascent to heaven referred to in Chapter 17 of the Qur'an, this inscription is the earliest evidence that specifically identifies Jerusalem's congregational mosque with the *masjid al-aqṣā*, 'the furthest mosque' mentioned in Qur'an. It is, therefore, to the early Fatimid period that this identification, now universally accepted by Muslims and non-Muslims alike, must be ascribed.

Just as mosaicists in Umayyad Jerusalem are believed to have moved from the Dome of the Rock to the Church of the Nativity in Bethlehem (whose early eighth-

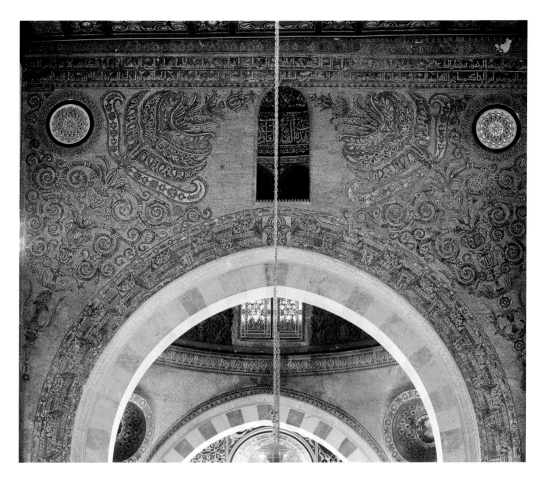

51 Jerusalem, Aqsa Mosque, 'triumphal arch' as restored under al-Zahir in the 1030s

century mosaics no longer survive) and then to the Great Mosque of Damascus, regardless of the purposes to which their work would be put,[162] the Fatimid mosaics in Jerusalem should be understood in the wider context of all restoration work in Jerusalem, including the Holy Sepulchre and other churches, during this same period. Mosaicists in the Fatimid period, just like those centuries earlier, are as likely to have undertaken work wherever it was available and wherever they would be paid well.

Fatimid patrons were responsible for the renovation of many aspects of the Haram al-Sharif, although again their exact nature remains a subject of lively scholarly debate.[163] The Persian traveller Nasir-i Khusraw, who has left us such an important description of Cairo, visited Jerusalem in the spring of 1047 and described a particularly splendid gate on the west side of the Haram, which probably corresponds to the present Bab al-Silsila. After the southern gates to the Haram were closed in the Fatimid reconfiguration of the city, the new gate would have been the main link with the city on the west. This monumental gate had two domes with 'wings' – probably rooms on either side – and was decorated with colourful mosaics and a formal inscription bearing the names and titles of the Fatimid caliph. The two valves of the doors were made of wood plated with gilded brass. Within the Haram itself, the set of six stairways leading up to the central platform on which the Dome of the Rock stands are first mentioned by Nasir-i Khusraw, although one on the west had already been constructed, according to an inscription, in the middle of the tenth century.[164]

Upper Egypt

Elsewhere, architecture in the Fatimid provinces was not always directed by the tastes and styles of the capital. For example, Aswan and Upper Egypt developed a style of building quite different from what was going on in Cairo, to judge from the ruins of an impressive medieval cemetery at Aswan with many mudbrick tombs and domed mausolea standing over

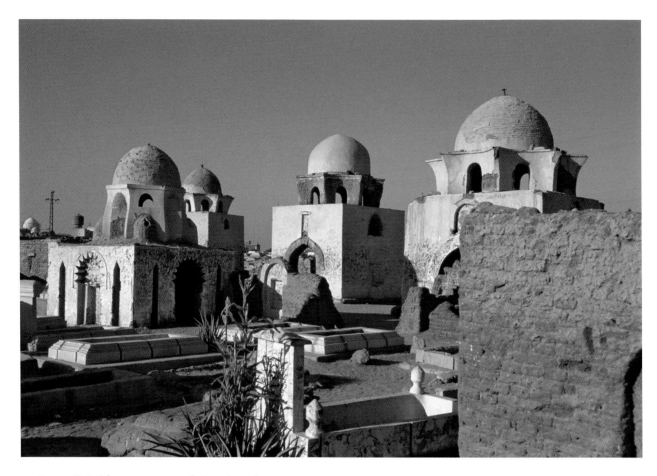

52 Aswan, Fatimid cemetery, general view, eleventh century

the graves of the deceased (Figs 52, 53). The domed mausolea have a particularly wide variation in their zones of transition, the part of the building between the cubic base and the actual dome. These range from simple stone lintels bridging each corner to bizarre elaborations of an ordinary squinch. The buildings also have a drum – octagonal prisms with flat or concave sides and often horn-like projections at the corners – inserted between the zones of transition and the dome itself.

Virtually every one of these tombs would have contained one or more dated tombstones which could have allowed scholars to date the structures. However, in December 1887, a rare tropical downpour nearly destroyed the Aswan cemetery and well-meaning local notables removed the stones for preservation, unfortunately taking no notice of what they found where. Years later, when scholars attempted to make sense of what was left, they had to rely on stylistic evidence to date the structures, because they could not associate a particular gravestone with a building. The majority of the tombstones are believed to date from the ninth century, but

the majority of the mausolea are thought to date between the eleventh century and the thirteenth, squarely in the Fatimid period.[165]

Many of the distinctive features of the mausolea – complex zones of transition with acroteria-like protrusions that resemble muqarnas elements seen from the outside – also appear in the lanterns of a group of largely undated minarets built along the Nile in Upper Egypt at Aswan, Shellal and Luxor (Fig. 54).[166] An additional tower of similar appearance is attached to the mosque at Edfu (Fig. 55), but Hasan al-Hawary, who noticed the first three, and Creswell, who added two more, inexplicably did not include it in the group.[167] Apart from the tower at Isna, which was built by a high Fatimid official in 1082 (see Chapter 5), none of the towers is dated, although Creswell placed them in the later part of the eleventh century and related them to the patronage of the vizier Badr al-Jamali. They were initially thought to symbolize his reassertion of Fatimid power over the region, but my later research suggested that although the eleventh-century date was correct,

84

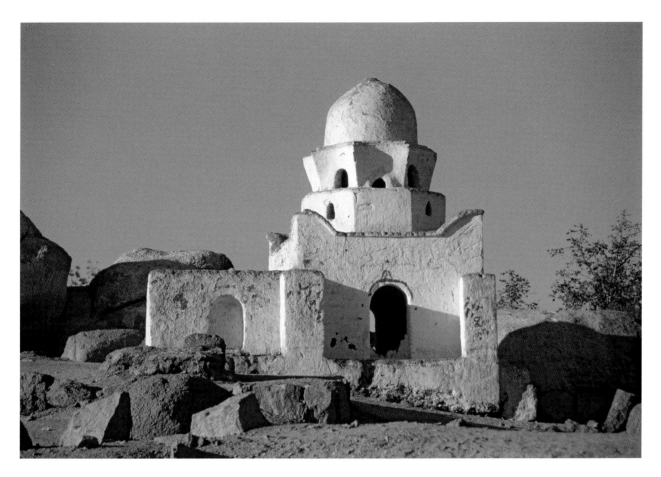

53 Aswan, mausoleum, eleventh century

their attribution to a Fatimid patron was not. Whatever their intended meaning, they were technically and stylistically the work of local patrons inspired by architectural ideas then current across the Red Sea in the Hijaz, a region with which Upper Egypt was closely linked by the pilgrimage route to Mecca, which at that time went from the Nile to either Qus or Aswan and across the desert to the ports of Qusayr and ʿAydhab respectively.[168]

Unfortunately, none of the Hijazi parallels, which were described in some detail by medieval travellers such as Ibn Jubayr, has survived, but their reflections have survived in such structures as the minaret of the Maʿruf Mosque at Shibam in the Yemen.[169] It seems likely that these mausolea and towers do not reflect the metropolitan style of Fatimid Cairo, but rather a distinctively non-metropolitan provincial style with closer affiliations to Arabia. Such buildings are therefore distinctly not Fatimid at all, but vernacular buildings of the Fatimid period.

Conclusion

Architecture in Egypt during the first century of Fatimid rule was focused on the construction of a new capital and all that it required, including walls, mosques, palaces and residences for the new inhabitants. Although the Fatimid rulers had arrived with large numbers of supporters from North Africa, there is little evidence for any transfer of specifically North African techniques and motifs during this period, and early Fatimid architecture seems to grow directly from earlier Egyptian precedents. This stands in sharp contrast to the period of Tulunid rule in the late ninth century, when Mesopotamian artisans appear to have introduced the fashionable Bevelled Style of Iraq to Egypt. Rather, it appears that Egyptian builders in the Fatimid period were encouraged by their new-found prosperity and their new rulers' patronage to develop and expand upon techniques already known in Egypt, whether in the use of brick piers to support enormous hypostyle mosques or carved stucco decoration. It is only in the carved

54 Luxor, Mosque of Abu'l-Hajjaj, eleventh century

stone decoration of the mosque of al-Hakim that the presence of foreign – probably Syrian – artisans can be discerned, although our knowledge of Syrian architecture of this period is minimal. Fatimid patrons appear to have been more interested in projecting splendour than polemic and – apart from a preference for monumental portals and an aversion to the single Abbasid-style minaret – it is difficult to discern any ideological component in their architecture.

Fatimid building efforts were concentrated in the capital city, but buildings were erected and repaired elsewhere in the realm. Evidence from Palestine and Upper Egypt indicates that local traditions were respected and preserved. While Fatimid rulers may have paid for the renovations to the Dome of the Rock or the al-Aqsa mosque, one does not get a sense that these renovations were done in a specifically Fatimid style.

Mosaics, for example, were associated with Jerusalem, not with the Fatimids, and there is no evidence that Fatimid patrons ever thought of using mosaics in Egypt. One might contrast this approach to that of the Ottomans, who refurbished the Dome of the Rock in the sixteenth century by removing the exterior mosaics and replacing them with distinctly Ottoman underglaze and cuerda seca tiles.[170] Similarly, in Upper Egypt, Fatimid period builders erected tower minarets even though they were not part of the architectural repertory of the metropolis. While some might interpret these structures as signs that the region was not under close Fatimid control, one might also see them as evidence that the Fatimid rulers of Cairo had more important things to worry about than the styles of architecture used in the provinces.

IV

The Decorative Arts from 969 to the 1060s

Literally thousands of objects or fragments in a wide variety of media – ranging from metal, glass, stone, rock crystal, ivory, wood and textiles to paper – many of them distinguished by a particularly lively use of figural imagery, have been attributed to the Fatimid period in Egypt on the basis of their style, inscriptions or archaeological context. These attributions are apparently confirmed by the accounts of such travellers and geographers as Nasir-i Khusraw, who mentions several crafts practised in Egypt, and by the Geniza documents, which enumerate and describe many of the material goods owned by Cairo's Jewish community in the Fatimid period. Perhaps most enticing are the descriptions of the fabulous goods which the hungry troops looted from the caliphal treasuries in 1068, most of which have vanished forever.[1] Together, these disparate sources provide an unusually rich perspective on the visual arts during the period of Fatimid rule. Indeed, it is probably not until the reigns of the Ilkhanids and Timurids in Iran in the fourteenth and fifteenth centuries that such complete assemblages of the different arts have survived.[2] Nevertheless, the essential nature of Fatimid-period art remains elusive.

Style has been the most common method of dating extant works to the period, but it is also the least reliable, for to be successful, the use of stylistic criteria must be founded on the existence of securely dated examples with which undated ones can be compared. In contrast, inscriptions are normally very reliable for dating and localizing objects, but inscribed works are far less common than uninscribed ones and only certain types of objects made for certain segments of society were inscribed with historical information. Indeed, inscrip-

tions have sometimes been added to genuine or spurious objects to give them authenticity. A leaf with a painting of a human figure now in the Keir Collection (Fig. 56), for example, was identified many years ago by Gaston Wiet as containing a poem of the Umayyad poet Kuthaiyir (*d.*723) of the tribe of Khuza'a, possibly collected by Abu Ayyub Sulayman ibn Muhammad ibn Abu Ayyub al-Harrani.[3] Wiet dated the piece to the Fatimid period based on details of the figure's costume. Ernst Grube hypothesized that this leaf was the frontispiece to a manuscript that would have had two such images facing each other.[4] Nevertheless, the offset image of an upside-down face under the feet of the figure shows that the painting had been folded in half while the paint was still wet, an impossibility had the page been bound in a codex, so the image had to have been made after the page was removed from a book. In sum, either the text or the painting may be genuine.

A third source of information, excavations – legal and clandestine – have been carried out at Fustat and other sites for many years, but scientific excavation is a relatively recent phenomenon and archaeologists are rarely able to excavate when and where they like. Consequently the extraordinarily detailed view archaeology is able to present is often focused on relatively peripheral areas and questions. It is far easier to excavate an abandoned site in the provinces or even the garbage dumps of Fustat, for example, than to dig under the ruins of the Fatimid palaces and mosques in the heart of Cairo. Nevertheless, archaeology and its associated scientific techniques for the examination of works of art are presenting surprising results that challenge the received wisdom.[5]

Facing page: earthenware bowl with figure of an eagle, detail of Fig. 62

56 Leaf from a manuscript with painting of an enthroned human figure. 20.7 × 12.4 cm (8⅛ × 4⅞ in.). Ham, Surrey, Keir Collection I. 7

Egyptian Arts before the Fatimids

Surviving examples of decorative art from the Tulunid period are far more sober than the texts would indicate, but they show nonetheless that when Egypt did not have to send its wealth abroad as tribute, traditional crafts – and not only artists producing extravagant luxuries – could flourish. For millennia Egyptian weavers had transformed flax into fine linen textiles. As linen was difficult to dye, these white textiles were often decorated with tapestry-woven figural designs in brightly coloured wool or imported silk, and weavers continued to produce similar cloths in Islamic times.[6] Likewise, Egyptian potters continued to use Nile valley clays to produce variations on classical and Coptic shapes, although following the Islamic conquest potters began to cover their wares with glaze, a Parthian (i.e. Iranian) technique that had been introduced to Egypt from Syria, as well as with stamping and moulding, another Iranian technique.[7]

Glass had been made in Egypt since the second millennium BCE, but the technique of blowing glass was introduced only in the Graeco-Roman period, when Egyptian glassblowers produced some very sophisticated pieces in the cameo and gold-glass techniques, both involving two layers of glass. In the former, an outer layer of a different colour was partially cut away to reveal designs on the inner layer; in the latter, a design in gold leaf was sandwiched between two transparent layers of glass. Egyptians also mastered the technique of decorating glass with wheel-cut designs and the same technique was also applied to small objects and phials of rock crystal, a material imported from East Africa, although the city of Basra in southern Iraq became famed as a centre for working rock crystal sometime after its foundation in the seventh century.[8]

From the second half of the eighth century, Egyptian glassmakers had also begun to decorate some glass vessels with stained or lustre designs, in which the surface of the glass object was first painted with a suspension of finely powdered oxides of copper or silver and then gently fired in a reducing (i.e. oxygen-poor) kiln to fuse the metal to the surface. After polishing, the surface of the vessel revealed lustrous effects in brown, yellow, green or red.[9] The discovery of this process was a major technical breakthrough because it allowed artists to freely decorate the surface of the glass with a brush. While the use of lustre decoration on glass declined over the years, in the ninth century potters in Abbasid Iraq adapted it for use on ceramics and it became the most important technique for decorating luxury wares, which were exported far and wide. The technique seems to have remained something of a trade secret; lustre designs were widely admired but not reproduced successfully outside Iraq. The origins of lustre are disputed, but as the earliest dated pieces come from Syria, it seems likely that it was a Syrian technique adopted by Egyptian glassmakers. Although some scholars argued that Tulunid potters produced lustrewares in Egypt, current opinion indicates that no lustrewares were produced in Egypt before the Fatimid period.[10] Moreover, as lustre painting is found only on those Abbasid ceramics with the Basran clay body, it has been argued that Iraqi lustre production was centred on the city of Basra.[11] It seems likely, therefore, that the arrival of the Fatimids in Egypt encouraged Ismaili sympathizers to emigrate from southern Iraq to Cairo; Iraqi lustre-potters and workers of rock crystal would have brought their skills to Egypt at that time.

Pre-Fatimid Egyptian works may be interesting and attractive, but they largely imitate the Abbasid work

produced in the metropolitan centres in Mesopotamia, whether in the use of arabesque, or geometricized vegetal ornament and the Bevelled, or 'Samarra', style of three-dimensional ornament or the nature of tiraz inscriptions. Even experts are often unable to distinguish provincial Egyptian products from their Mesopotamian models. Some objects usually identified as Egyptian are distinguished by the transformation of the abstract designs of the Abbasid models into birds or other representations, suggesting that Egyptian artisans, unlike Muslim craftsmen elsewhere, showed a decided predilection for representation, but this conclusion is by no means sure.

Textiles

The production of textiles had long been important in Egypt, as it was throughout the medieval Islamic lands. Since prehistoric times, flax (*Linum usitatissimum*) had been one of the major agricultural products of Egypt valued not only for its fibres but also for its seeds which were pressed to produce (linseed) oil, typically used for lighting. Nevertheless, grain had been the major crop of Egypt in Pharaonic, Roman and Byzantine times. In Islamic times, however, the caliphs and their governors made flax the main cash crop of Egypt and the major industry of medieval Egypt became the manufacture of linen textiles. This short-sighted policy ultimately led to food shortages and epidemics, which contemporary authors blamed on the Nile's failure to flood the fields rather than on their rulers' mercenary policies.[12]

The extraordinary importance of textiles in the medieval Egyptian economy is amply demonstrated by the Geniza documents, where fibres, dyes, mordants and finished textiles figure prominently in trade documents, lists of furnishings and bequests. Textiles were equally important at the Fatimid court, where, as in all contemporary Islamic courts, sumptuous fabrics decorated rooms, were made into tents, clothed the caliphs and their courtiers and were given out as seasonal presents. The members of the Fatimid dynasty had already demonstrated a particular interest in textiles in the Maghrib or even earlier, when they posed as merchants to conceal their proselytizing activities. The first Fatimid caliphs in North Africa donned special outfits for important occasions and gave textiles as signs of royal favour. Even before their conquest of Egypt, the Fatimids ordered Egyptian tiraz textiles – presumably from the private factories – inscribed with their names and titles, to judge from a few pieces that have sur-

vived.[13] Once in Egypt, the far greater resources available only encouraged the taste for fine textiles, and the passages in al-Maqrizi's *Khiṭaṭ* describing the royal storehouse of textiles (*khizānat al-kiswāt*), quite apart from those concerning the separate storehouses of carpets and tents, are the longest among his description of the parts of the Fatimid palace.[14]

According to one of these texts, the Fatimid caliphal treasuries held stores of tents and upholstery and furnishing fabrics of unimaginable luxury and splendour. One tent was said to have been decorated with a picture of every beast in the world; it took 150 workers nine years and cost 30,000 dinars to make. There were elephant saddle-cloths of red fabric embroidered everywhere with gold except at the bottom where the elephants' thighs protruded. The accompanying howdahs had matched sets of cushions, pillows, carpets, seats, curtains and spreads of silk brocade. The fabrics were decorated with designs of elephants, wild beasts, horses, peacocks, birds and even humans in all manner of striking and wonderful forms and shapes.

Courtiers collected such fabrics as well. For example, when Abu al-Futuh Barjuwan, one of al-'Aziz's administrators, was killed on al-Hakim's orders in 1000, he left a hundred kerchiefs of coloured thin linen, wrapped as turbans around a hundred *shāshī* caps, a thousand pairs of trousers of linen voile and a thousand silk waistbands, as well as tailored garments of high quality. When the caliph ordered Husayn ibn Jawhar, for whom a crystal ewer was made, killed in 1009, his legacy included seven thousand quilted wraps.[15] Neither man needed so much cloth and clothing for his personal use, but the fabrics and garments represented wealth and were signs of prestige that could be distributed in turn to clients as signs of favour.

Despite the great variety of terminology found in the sources, most of the textiles that have actually survived from the period are of one specific type: lengths of plain white linen cloth decorated at one end with inscriptions and sometimes ornamental bands, which have been tapestry-woven in either wool or silk. Recent excavations at Fustat have produced a more nuanced picture of contemporary fabrics, but the great majority of pieces are undyed. While some pieces were made with yarn dyed blue with indigo (Fig. 57), coloured decoration was normally added in another fibre and technique.[16] These textiles were woven in state or private factories and inscribed with the name of the ruler and the date.[17] They were given seasonally to courtiers, who used them as turbans or made them up into clothing. Most pieces have been recovered from the clandestine excavation of

57 Turban fragment of blue linen with yellow silk tapestry inscribed with the name of the caliph al-ʿAziz. Woven at Tinnis in 377 or 399 (987–90), 19.3 × 17.3 cm (7½ × 6¾ in.). Athens, Benaki Museum 14997

58 Linen with tapestry-woven repeated decoration of two birds flanking a pillar between single affronted hares, made at the private factory of Tuna in 406 (1015–16) for al-Hakim, 17 × 23 cm (6¾ × 9 in.). Washington, DC, Textile Museum 73.573

59 Linen with tapestry-woven decoration of two lines of text flanking a central band with medallions containing a running jackal or dog and a fluttering bird. 20.7 × 39.5 cm (8⅛ × 15½ in.). Washington, DC, Textile Museum 73.543

graves, where they had been used as burial shrouds and preserved by the arid Egyptian climate. Grave-robbers generally kept the inscribed and decorated bands, discarding lengths of irreparably soiled or damaged or plain fabric as they were of little commercial value. Thus, the surviving sample is badly skewed, presenting a very lopsided picture of Fatimid textile production.[18]

The wealth of historical information provided by the dated inscriptions has made it relatively easy to understand the development of Fatimid tiraz, although differences in quality and among production sites – there were tiraz factories in Misr (i.e. Fustat) and in Damietta, Shata, Bura, Tuna, Tinnis and Dabqu in the Nile Delta – remain to be worked out. In the first period (969–1020), comprising the reigns of al-Muʿizz, al-ʿAziz and al-Hakim, tapestry-woven borders of kufic script enclose foliate designs and hexagonal or oval medallions enclosing affronted or addorsed animals or birds (Fig. 58). At first the decorative bands are few and narrow, but they gradually increase in number and breadth. More subtle miniature designs, with well-drawn small and elegant birds and palmettes, appear in the latter half of this period during the reign of al-Hakim. Following his death and continuing right through to the end of al-Mustansir's reign, techniques became finer and more

varied within the same general schema of medallion bands between kufic borders (Fig. 59). Textiles from the mid-eleventh century have graceful calligraphy with symmetrical and clear small letters, sometimes a tall curve in the final letters and elaborate interlacing with vines and palmettes.[19]

Nasir-i Khusraw provides a splendid description of how these and other textiles were used when he visited Cairo in 1048. For the ceremony of the opening of the canal, he mentioned, for example, that 'ten thousand horses with gold saddles and bridles and jewel-studded reins stand at rest, all of them with saddle-cloths of *Rumi* (Byzantine?/Byzantine-style?) brocade and *būqalamūn* specially woven so that they are neither cut

nor sewn (i.e. loom-lengths woven to shape). In the borders of the cloth are woven inscriptions bearing the name of the Sultan of Egypt.'[20] Although no such Fatimid textiles are known to survive, the description is remarkably like the so-called Shroud of St Josse, a roughly contemporary silk compound weave from north-eastern Iran that can be reconstructed as a saddle-cloth.[21]

Ceramics

The ceramic arts of Egypt enjoyed a period of unprecedented achievement in the late tenth and early eleventh century, as Egyptian potters produced fine glazed earthenware bowls and plates which they often decorated with lively figural motifs. Indeed, ceramics are often considered to be the principal decorative art of the period and Fatimid lustre painted ceramics occupy a particularly prominent place in virtually every collection of Islamic art.[22]

Overglaze lustre painting, in which metallic oxides are applied in a medium to the surface of the fired piece, which is then refired in a reducing (i.e. oxygen-poor, or smoky) kiln to leave a very thin residue of shiny metal on the ceramic surface after the medium is polished away, is an expensive and time-consuming technique. The oxides of copper and silver used to make the designs are expensive, as are the special kiln and the extra fuel needed to fire them. The technique is acknowledged to be one of the least controllable in ceramics and it is often difficult to obtain any lustre effects even in the best of circumstances, because the reducing atmosphere of the second firing can not only affect the different oxides in unpredictable ways but also transform the glazes themselves, reducing the lead and tin used as fluxes and turning what were intended to be white glazes speckled grey.[23] All of these factors contribute to making lustrewares the most expensive type of pottery produced in medieval Egypt.

Lustrewares were therefore comparatively rare among the many types of pottery that were produced in the Fatimid period. Like other Islamic pottery produced before the sixteenth century, Fatimid ceramics are largely known through material retrieved from archaeological contexts, such as rubbish dumps, wells and occupation sites. Virtually all of the ceramics found in these contexts were broken and discarded rather than abandoned when whole. The enormous quantity of ceramic material found in the rubbish dumps at Fustat, reflecting over a millennium of continuous habitation

in Cairo, consists therefore largely of sherds, which – apart from those overglaze painted in lustre – have been largely ignored by scholars and collectors.[24] Whereas public museums and private collectors normally exhibit only complete – or restored – pieces from other times and places, they regularly display sherds of Fatimid lustre pottery, because the lively figural scenes often found on them make them particularly attractive. The scenes have also engendered lively speculation about their possible meaning.

The Fatimid ceramics found in museums, however, do not figure among the types of objects the Fatimid rulers are known to have collected, so it would seem safe to assume that the Fatimid caliphs themselves did not regard contemporary ceramics wares as particularly valuable, preferring – like their contemporaries in Abbasid Baghdad – Chinese porcelains and stonewares (ṣīnī) including storage jars and footed basins, and Chinese sherds – ranging from Tang splashware to carved white stoneware – have been found in the Fustat excavations.[25]

Ceramics appear to have been a craft primarily patronized by the bourgeoisie, who would have bought examples in the markets of Cairo and other cities.[26] Nasir-i Khusraw, for example, appears to be describing lustre pottery when he wrote that 'in Old Cairo they make all types of pottery (sufālina), so fine and translucent that one can see one's hand behind it when held up to the light. From this pottery they make cups, bowls, plates and so forth and paint them to resemble the būqalamūn so that different colours show depending on how the article is held.'[27] Nevertheless, Geniza inventories and trousseau lists, which reflect the actual owning habits of the (Jewish) bourgeoisie, do not list ceramic vessels, but this absence may be explained because such lists normally included only durable goods, not fragile ceramics.[28] There is, therefore, a certain inherent incongruity in the study of Fatimid ceramics, for an essentially non-court art has been taken as the most characteristic art of a period, which is itself defined by its court. In short, a considerable degree of ambiguity remains about the function and status of ceramics during the Fatimid period in Egypt.[29]

Oddly enough, however, the only two pieces of Fatimid-era pottery dated by inscription are associated with the Fatimid court. A fragment of a plate-rim in the Benaki Museum in Athens (Fig. 60) is inscribed '(the work of) Muslim ibn al-Dahhān to please . . . al-Ḥassan Iqbāl al-Ḥākimī', the latter being an otherwise unknown figure whose epithet indicates that he was a courtier of

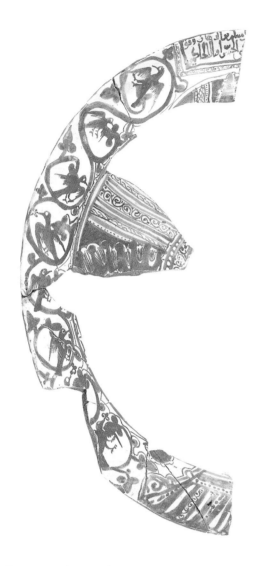

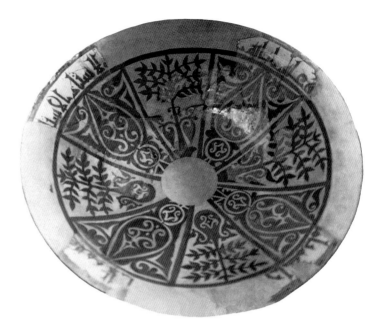

61 Earthenware dish decorated in lustre for the Commander-in-Chief Ghabn between 1011 and 1013. Diameter: 50 cm (19⅝ in.). Cairo, Museum of Islamic Art

60 Fragments of an earthenware plate decorated in lustre by Muslim ibn al-Dahhan between 996 and 1021 for al-Hasan Iqbal al-Hakimi. Maximum diameter: 38 cm (15 in.). Athens, Benaki Museum, 11122

the Fatimid caliph al-Hakim, who ruled from 996 to 1021.[30] The script is an otherwise unremarkable *naskh*, except that it once again demonstrates that so-called 'cursive' scripts were used in the Fatimid period. In addition to the vegetal scroll on the rim which encloses small birds, the fragments show that the well of the dish may have displayed the heraldic figure of an eagle painted with panache in olive green lustre.

Fragments of a large plate in Cairo (Fig. 61) bear a very different lustre design of a 'palmette tree' in the field and a carefully-written Arabic inscription around the rim, '*Power and thriving to the master of masters, Commander-in-Chief Ghabn, servant of the Commander of the Believers, al-Ḥākim bi-Amr Allāh, (May God's*

blessings rest) upon him and his (pure) ancestors.'[31] As Ghabn served in this position only from 9 November 1011 to his death in November 1013, the plate can be dated to this short period. Furthermore, the wording and the careful kufic script of the inscription on the Cairo fragments indicate that it was an official commission, not a casual piece made for sale on the market. The differences between these two contemporary pieces, which bear two different styles of decoration intended for people in similar high positions, indicate that a range of styles was practised at any one moment. Style, which has commonly been used to study the development of Fatimid ceramics, may not therefore be the best criterion for understanding them and – in the absence of inscriptions or other documentary information – archaeological and technical analysis may prove to be a more fruitful approach.[32]

The inscription on the Benaki piece identifies the potter (or decorator) Muslim ibn Dahhan and his name – or part of it – is found on about twenty complete or fragmentary pieces scattered in various museum collections.[33] One bowl in the Metropolitan Museum in New York (Fig. 62) is decorated with the figure of a heraldic eagle drawn with great verve in yellowish green lustre. Signed 'Muslim' on the tail-feathers, it appears to be remarkably similar to what the Benaki plate might have been like when complete (Fig. 63). The signature of Muslim is not unique; other Fatimid pieces are 'signed',

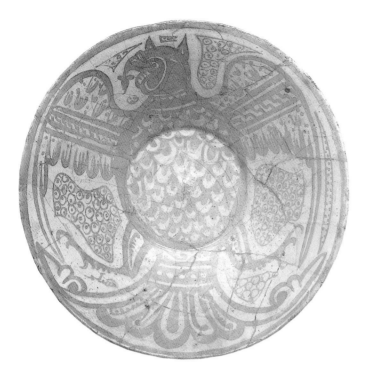

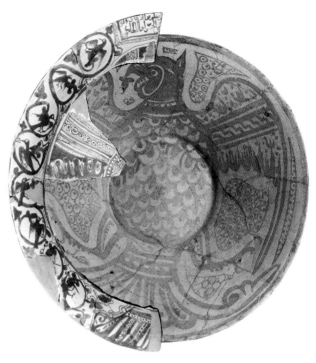

62 Earthenware bowl with figure of an eagle, signed on the tail by Muslim. Diameter: 25.4 cm (10 in.). New York, Metropolitan Museum of Art, 63.178.1. Gift of Mr. and Mrs. Charles Wilkinson

63 Benaki fragment superimposed on Metropolitan Museum of Art bowl

usually on the underside of the foot, but it is unclear whether other names are truly individual signatures or workshop trademarks.[34] As the name 'Muslim' appears on pieces painted not only in very different styles, but also with levels of skill ranging from the inept to the expert, it has also been suggested that the name represents that of a workshop.[35]

The free and relaxed style of figural representation characteristic of Fatimid lustre ceramics immediately distinguishes them from the more abstract and formalized designs on Abbasid lustrewares from Iraq. Nearly forty years ago, Oleg Grabar ingeniously proposed that this new style of representation had resulted from the dispersal of the Fatimid treasuries in the second half of the eleventh century, but Muslim's signed works show that figural representation was an integral feature of Fatimid lustre ceramics from the beginning. Some of these representations seem to develop types found in earlier Abbasid lustrewares, while others seem to derive from Hellenistic and eastern Christian traditions of representation and draughtsmanship which apparently continued to be practised in Egypt.[36] The variety of representation is extraordinary – traditional subjects like animals, hunters, musicians, dancers, entertainers and rulers, as well as new subjects like wrestling, cockfights

(see Fig. 5), rope dancing or duels.[37] The sensitivity and elegance of the drawing (Fig. 64) is quite amazing, often surpassing the quality of drawing seen on contemporary paper fragments (see below).

Several decades ago, Richard Ettinghausen proposed that representations on ceramics could be used to reconstruct the lost art of Fatimid wall painting, which is known largely from texts.[38] While there may have been some shared modes of representation

64 Typical earthenware sherd painted in lustre with the face of a man on an opaque white glaze, 10.5 × 6.2 cm (4⅛ × 2½ in.), Egypt, eleventh century. Kuwait, Sabah Collection LNS21C

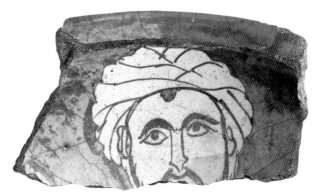

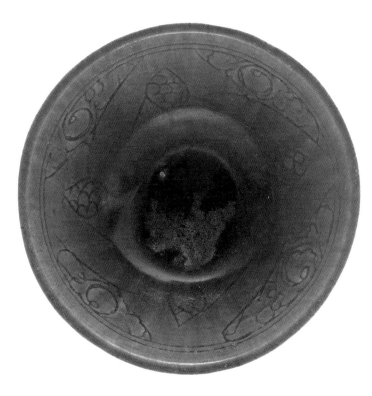

65 Fritware bowl with incised decoration covered in a transparent cobalt blue glaze, so-called FFS (Fustat Fatimid Sgraffito), eleventh century, height: 8 cm (3⅛ in.), diameter: 19 cm (7½ in.). Kuwait, Tareq Rajab Collection CER1780TSR

decorated with patterns, aphorisms and even amusing representations.[41] Substantial technical skill was needed to produce these apparently simple daily wares, for the disk of soft clay was carved with the design and partially dried before being inserted in the neck of a jug as it was being thrown on a potter's wheel.

The most important other type of early Fatimid pottery was an earthenware covered with a fine white slip, decorated with incised vegetal and geometric designs and then glazed in a variety of colours, ranging from colourless to pale green, turquoise, cobalt blue, honey-brown or purple (Fig. 65). Typical shapes include small and medium bowls as well as vases and jars. The technique is known to some specialists as FFS (for Fustat Fatimid Sgraffiato), because wasters (mis-fired pieces discarded at the kiln) have been found in the Fustat excavations. Archaeologists have determined that these incised wares were introduced after lustre reappeared in the last quarter of the tenth century and that they continued to be manufactured until the end of the Fatimid period in the twelfth century.[42] This type of pottery was clearly inspired by Chinese prototypes and the discovery of such pieces in even the proletarian quarters of Fustat indicates the prosperity of life in the Egyptian capital under the early Fatimids.

As neither the lustre nor the incised ceramics has anything in common with earlier Maghribi ceramics, it is safe to conclude that North African potters did not move to Egypt with the Fatimid rulers and that the sources of Fatimid ceramics must lie elsewhere.[43] Recent research suggests that lustreware was a very specialized and restricted craft. As the so-called Tulunid lustrewares of the ninth century are indistinguishable from those known to have been made in Iraq, it is now thought that they were all imports. Lustre production in Egypt seems to have begun only around 975, when it is thought that Iraqi potters emigrated to Egypt, possibly from the port city of Basra, now believed to have been a major pottery centre.[44] Some of these Basran potters may have emigrated to Egypt after the Fatimids established their capital there, suggesting once again that these may have been Ismaili craftsmen attracted to Egypt because of their beliefs. Basra, it should be recalled, was the region from which Ismaili power had originally sprung.[45] Whatever these craftsmen's origins were, their work is characterized by the increased use of ground quartz in the ceramic body, a process that would lead to the development of a stone-paste, or fritted, ceramic body in the later Fatimid period.[46]

between media, in an era before the widespread use of drawings on paper, there would have been few means by which artisans would have been able to transfer them from one medium to another.[39] It seems more likely that in this period each craft was separate from the other: representations on ceramics were distinct from representations on walls and neither was dependent on the other. Scholars have also seen expression and individuality – qualities normally missing in Islamic art – in these scenes of what appear to be daily life, although what some have perceived as 'realism', others have called 'classicism'. In any event, it is quite unclear how the contemporary audience viewed these ceramics or used them – except with pleasure!

Lustre ceramics were, however, only one of the several types of pottery produced in Fatimid Egypt. Lustrewares were even imitated in provincial centres with coarser and cheaper techniques.[40] The vast majority of contemporary pottery was, as in any pre-modern period in the region, unglazed earthenware used for storing water and other purposes. Unglazed water jars usually had pierced filters in the neck to prevent insects and floating detritus from entering the body of the jar when it was dipped in water and filled; these filters were often

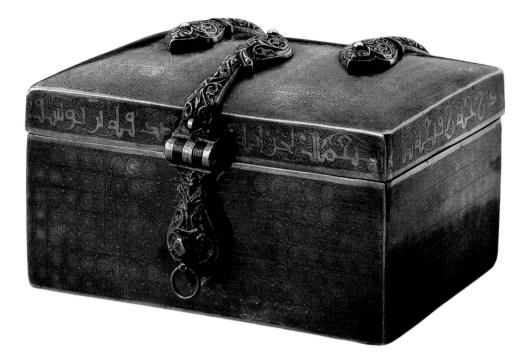

66 Silver spice-box made for Sadaqa ibn Yusuf between 1044 and 1047. León, Real Colegiata de San Isidoro

Metalwares

Many different types of metalwares, ranging from the enormous cast bronze statue of a griffon in Pisa[47] to small gold earrings,[48] have been attributed to Fatimid patronage on the basis of style, but the only metal object ever attributed to Fatimid Egypt on the basis of an inscription is a very small (7.5 × 12.4 × 7.9 centimetres; 3 × 4⅞ × 3⅛ inches) rectangular casket – perhaps a spice-box – now in León, Spain, made of silver decorated in gilt and niello and decorated with a fine pattern of spirals (Fig. 66).[49] Around the lid is inscribed the text '*made for the cabinet of Ṣadaqa ibn Yūsuf, perfect happiness and complete good fortune and continuous glory and perpetual power and elevated authority and high rank to the owner.*' Another inscription under the hasp on the front may bear the signature of a certain 'Uthman. The patron of the box has been identified as Abu Mansur Sadaqa ibn Yusuf al-Falahi, who was a vizier of the caliph al-Mustansir between 1044 and 1047. An Iraqi Jew who converted to Islam, Sadaqa ibn Yusuf was appointed vizier at the request of his predecessor al-Jirjira'i and shared power with Abu Sa'd al-Tustari, counsellor to al-Mustansir's powerful mother. Their reciprocal animosity led first to al-Tustari's murder in 1047 and then to Sadaqa's imprisonment and execution the same year. The inscription states that the box was made for Sadaqa's *khizāna*, which was thought to mean his 'treasury'. For the Jews of

Cairo in the Fatimid period, however, the word often meant 'cabinet' or 'cupboard', a locked repository where one kept valuables, such as spices.[50] This then would have been a very elegant spice-box.

If the identification of this piece is correct, it creates a host of problems, for it is quite unlike most examples of metalwork attributed to the Fatimid period, about which there is still much uncertainty.[51] The box is made of silver, most other surviving pieces are of cast brass; the box is inscribed, most other pieces are anepigraphic; the box is decorated with a fine pattern of spirals arranged geometrically in rows, most other pieces are decorated with animate or foliate motifs; and the stilted style of kufic script of the inscription – which is set against a ground of minute spirals as well as a gently bending vine – is unlike any other known from the period. Perhaps the box can be understood better with other works from the period in precious metal (see below), but none of these has survived.

A typical example of Fatimid metalware, for example, is a silvered cast-iron mirror with engraved decoration in the Benaki Museum, Athens (Fig. 67). It has been attributed to the Fatimid period on the basis of its style, particularly that of its kufic inscription.[52] The type, a circular disk of metal with a pierced knob in the centre of one side from which it could have been suspended, is well known from later periods, but this is the sole example dated to the eleventh or twelfth century. The

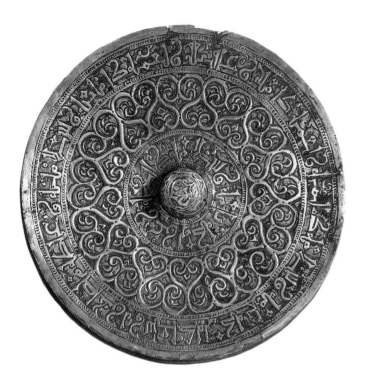

67 Hammered silver back for a cast iron mirror, eleventh century, diameter: 18 cm (7 in.). Athens, Benaki Museum, 13770

ments from the Cairo Geniza, but they lack inscriptions that would make a Fatimid attribution compulsory.[55]

A hoard of bronze and copper objects dating to the eleventh century was recently discovered during excavation at Caesarea in Palestine. Consisting of candelabra, candlesticks, boxes, braziers, ladles and buckets, as well as a variety of fragments, the pieces were often decorated with stylized kufic inscriptions offering blessings and good wishes on the owner.[56] One of the Caesarea pieces is remarkably like a short but large cylindrical copper box in Berlin (Fig. 70).[57] Acquired in Cairo by Friedrich Sarre, the box stands on three short feet and has two hinges and a clasp. The surface is engraved with a strapwork interlace enclosed within a kufic inscription offering blessings on the (anonymous) owner. Another similar piece is said to be housed in the treasury of the cathedral of Bari.[58] In short, a comprehensive picture of Fatimid metalwork still remains to be delineated.

68 Cast brass figure of a lion, presumably intended as a fountain head, eleventh century, height: 21 cm (8 in.), length: 20 cm (7¾ in.). Cairo, Museum of Islamic Art, 4305

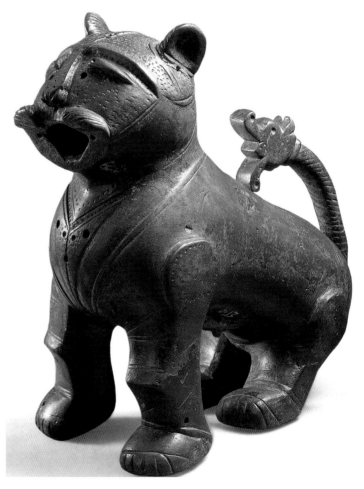

text – repeated good wishes – provides no more specific dating information, but the poor quality of the script, whether due to the craftsman's illiteracy or the hardness of the material he was working, would indicate that it had little if anything in common with the box from León.

Attributions of other metalwares to the Fatimid period have been based on the presence of some motif, such as a rabbit/hare or a particular type of surface decoration, which is comparable to that found on works in other media attributed – often on stylistic grounds as well – to the Fatimid period. Perhaps the most distinctive pieces attributed to the period are a group of anthropomorphic fountain heads, such as a well-known lion in the Museum of Islamic Art in Cairo (Fig. 68), but far more common – and prosaic – are the cast-brass lamps and lampstands, ewers and buckets that continue the metalworking traditions of late antiquity at a somewhat lower level of quality.[53] A bucket in London, for example, is made from a copper alloy and has a cylindrical body with a bail handle (Fig. 69). It is incised with a benedictory inscription and some geometric decoration on and below the hammered rim. Several other comparable examples are known.[54] Such utilitarian objects correspond perfectly to the range of domestic metal utensils – lamps, lampstands, braziers, censers, basins, ewers, buckets, dippers, cups, etc. – mentioned in the docu-

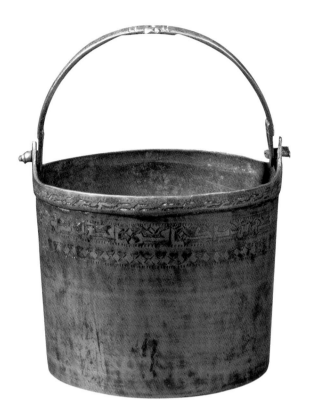

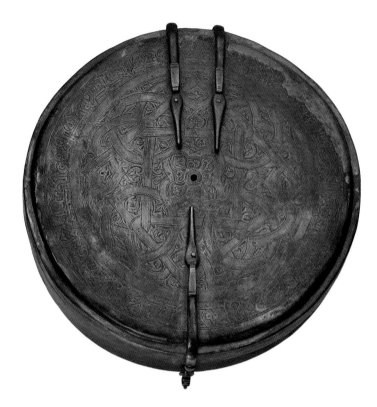

69 Cast copper-alloy bucket with bail handle, height: 15.8 cm (6¼ in.), diameter: 17.3 cm (6¾ in.) London, Victoria & Albert Museum, м. 25-1923

70 Flat cylindrical copper-alloy box on three feet, eleventh century, height: 11 cm (4⅓ in.), diameter: 29.5 cm (11⅝ in.). Berlin, Museum für Islamische Kunst, I 3679

Precious Metals: Coins

Already in North Africa, the Fatimids had introduced a distinctive new type of coinage, which they continued to produce after the move to Egypt. Fatimid coinage, like other Islamic coinage, has usually been studied for its historical importance because coins give important information about who ruled when and where. The choice of Qur'anic quotations and legends, moreover, sheds light on particular beliefs. For example, from 386/996 during the reign of al-Hakim to the end of the dynasty, all coins carried the legend *'Ali walī Allāh*, which for Ismailis attests to 'Ali's role as God's friend and guardian (*walī*) of His earthly community in a way similar to Muhammad's position as God's messenger; Sunnis might take it to mean simply that 'Ali was God's friend.[59]

Die-cutters in North Africa working first for al-Mansur and then for al-Mu'izz had already transformed the typical design of the Islamic coin by increasing the number of concentric borders and eliminating the field. During the reign of al-Mu'izz, presumably after the conquest of Egypt, the central blank disk was replaced by a central dot. This new coinage had symbolic and eco-

nomic importance, since al-Mu'izz had coins struck to celebrate his conquest of Egypt (above, Chapter 3), but no sources provide the slightest hint about what significance, if any, these changes were meant to have. From 1048 onward, the coins of al-Mustansir purposely imitate those of his predecessor al-Mu'izz. Both rulers shared the same name (*ism*) and patronymic (*kunya*), so only the regnal title was different. Perhaps al-Mustansir, facing increased economic pressures, was attempting to ride on the reputation of his predecessor's coins for purity and fineness. Nevertheless, despite their declining economic fortunes, the Fatimids preserved the metallurgical standard of their coinage remarkably well.

Precious Metals: Jewellery and Curios

Not all the gold and silver available in the Fatimid period was minted into coins, but all precious metal vessels (apart from the silver box for Sadaqa ibn Yusuf) were probably melted down for their bullion during some crisis. Texts describe some of the objects that have not been preserved. The Persian traveller Nasir-i

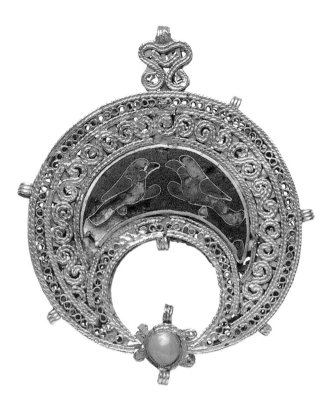

71 Gold pendant fabricated from wire and strips of sheet gold, set with cloisonné; enamel and turquoise, eleventh century, height: 4.5 cm (1¾ in.), width: 3.5 cm (1⅜ in.). New York, Metropolitan Museum of Art, 30.95.97. Bequest of Theodore M. Davis, 1915

cious stones and enamels. For example, when the caliphal treasuries were looted, several gem-studded gold curios were found including a peacock studded with precious gemstones, whose eyes were of ruby, its feathers of glass enamel inlaid with gold, emulating the colours of peacock feathers; also there was a gold rooster similar to the peacock, with a split crest – the largest rooster crest ever known – studded with all kinds of large pearls and precious stones, whose eyes were of ruby; and there was a gazelle that looked, in colour and shape, like a real gazelle. It was similar to both the peacock and rooster, in being studded with large pearls and precious stones. The gazelle's belly was the only white spot on its body – just like the colour of real gazelles and it was closely set with magnificent large pearls.[62]

Like the silver lamps described by Nasir-i Khusraw, however, such precious metal objects were melted down for coin in times of crisis and their stones removed and reset.

Our knowledge of Fatimid work in precious metal, apart from the one box, is therefore based on chance finds of jewellery or archaeological investigation in the ruins of Fustat and other sites occupied in the period.[63] As interesting as these pieces are, they tend to be relatively modest in design and execution and give only the faintest impression of the splendid works made by court goldsmiths.[64]

The main centre of jewellery production is believed to have been in Egypt, but comparable objects were probably produced in Palestine, Syria and Tunisia, where pieces have also been found.[65] Associated materials found with the jewellery, particularly coins, have helped to establish a relative chronology of these objects. They suggest that by the middle of the eleventh century the decorative use of granulation, an ancient technique in which tiny spherical grains of gold are mounted on fine gold wires, gave way to filigree, in which either plain or twisted wire was made into decorative configurations (Fig. 71).[66] Gold work was embellished with pearls, turquoises and cloisonné enamels, a Byzantine technique that must have been adopted by Muslim craftsmen, for several pieces bear accurate Arabic inscriptions.[67] According to texts, the Fatimid treasuries contained objects of *mīnā*, several of which were either *majrūd* (simple) or *mujrā bi'l-dhahab* (inlaid with gold). The description of the technique seems to refer to enamel and cloisonné, but apart from the earring and the problematic Innsbruck plate, no Islamic examples of enamel are known from the medieval period.[68]

Khusraw mentioned several. He particularly admired a set of silver lamps in the Dome of the Rock in Jerusalem. The lamps, a gift of the Fatimid caliph, presumably al-Zahir, were inscribed around the bottom with the patron's name written in gold.[60] At the mosque of Amr in Fustat, Nasir also saw an enormous silver polycandelon or lamp-holder so large that the workmen had to remove the doors before it could fit through the doorway of the mosque. The lamp was 24 cubits (12 metres or 36 feet) in circumference (roughly 3 metres or 12 feet in diameter) with sixteen branches, each of which was one and a half cubits (approximately 75 centimetres or 24 inches) long. It held more than seven hundred glass lamps which were lit on holiday evenings. The total weight was said to be 25 quintars (over 1 metric ton, or 2,500 pounds) of silver.[61] None of these creations has survived, but their memory reveals the important public role that the vanished art of luxury metalwork played during the Fatimid period.

Contemporary texts, whether court annals or Geniza documents, also mention numerous curios, as well as pieces of jewellery such as earrings, pendants, beads, bracelets, anklets and rings, made of gold, silver, pre-

Rock Crystal and Glass

Among the wonders the looters discovered in the Fatimid treasuries were objects carved from rock crystal and other hardstones. For example, Nasir al-Dawla, who had once been governor of Damascus, acquired a large storage jar of rock crystal decorated with images carved in high relief and having a capacity of seventeen *ratls* (8 litres/2 gallons), as well as a somewhat larger jar of smooth rock crystal, a white jasper chamberpot and jasper carafes.[69] Although these particular objects have not survived, nearly two hundred rock crystal objects dating from medieval Islamic times are known to exist, many in European church treasuries, and they include at least three that were commissioned by the Fatimid caliphs or their close associates in the late tenth century and the first half of the eleventh.[70]

Perhaps the most famous is a rock crystal ewer in the treasury of San Marco, Venice. Measuring about 12.5 centimetres/5 inches in diameter, this spectacular vessel bears a dedicatory inscription to the caliph al-'Aziz (Fig. 72). Cut from a block of flawless crystal, it has a pear-shaped body with thin walls, a short cylindrical neck with two mouldings and a prominent lip. The footring, below another moulding, is hidden by the later European gold mount. The handle is cut from the same piece of crystal as the body, pierced and surmounted by the figure of an ibex. The body is decorated with an inscription as well as a central stylized foliate motif, flanked by confronted seated lions.[71]

Another ewer in Florence bears an inscription referring to the *qā'id al-quwwād*, a title born only by the Fatimid general Husayn ibn Jawhar from 1000 to 1008 (Fig. 73).[72] In December 1998, nearly a millennium after it was made, this ewer was accidentally dropped when it was being returned to its case after being photographed. It fell to the marble floor, striking one of its fracture planes and smashed into nearly 200 pieces.[73] The third item, a crescent-shaped ornament about 19 centimetres, or 8 inches, in diameter in Nuremberg, is simply inscribed with the name of the caliph al-Zahir (Fig. 74). On the basis of these three pieces, several dozen other examples of carved rock crystal, ranging from comparable ewers to mace-heads, phials and gaming pieces, have been attributed to Fatimid Egypt.[74]

The amount of skill and labour required to make such exquisite objects cannot be underestimated. To make a crystal ewer, for example, a block of rock crystal (a macrocrystalline form of SiO_2, hardness 7 on Moh's scale) was first roughly shaped to size. A cavity was then laboriously hollowed out in the block using first drills and then wires and abrasives. The exterior of the vessel was then roughly shaped before the decoration was carved and the whole polished to a flawless finish. The precision of the work is quite incredible: the thickness of the wall of a related, but uninscribed, ewer in the Victoria and Albert Museum, for example, ranges from 1.7 to 2 millimetres (.07–.08 inches)![75] Such work was, therefore, the product of a long craft tradition.

That such pieces were made in Fatimid Egypt is confirmed by Nasir-i Khusraw, who saw extremely fine crystals, 'which the master craftsmen carve most beautifully', in the Lamp Market adjacent to the Mosque of 'Amr in Fustat. One may conclude, therefore, that although some pieces were inscribed with court names, the craft was not confined to, or even necessarily associated with, the court, although the rarity and expense of the raw material, quite apart from the skill involved to work it, meant that crystal would not have been used for everyday items. The raw material had to be imported, Nasir said, from the Maghrib, although even finer and more translucent crystal was found near the Red Sea.[76] A few rock crystal items have been excavated in Egypt and attributed to the ninth or tenth centuries, but most earlier examples have been attributed to Iraq, where it is thought the pre-Islamic (i.e. Sasanian) tradition of hardstone carving continued under Abbasid patronage. In any event, the Fatimid ewers are so much more sophisticated than earlier crystal objects that they can hardly be compared.

The objects themselves give little or no hint of their intended function. The number of items enumerated in texts indicate the Fatimid rulers' unusual fondness for rock crystal tablewares – jugs, basins, ewers, goblets, carafes, jars and lidded and unlidded bowls. According to al-Qazwini (*c*.1203–1283), the Persian physician and polymath, admittedly a late and somewhat distant source, drinking from rock-crystal vessels ensured that the drinker would never suffer thirst and vessels of rock crystal became popular among rulers.[77] While some of the rock-crystal vessels attributed to the Fatimid period, such as these ewers or the cups and chalice associated with the emperor Henry II,[78] could have been used for pouring and drinking liquids, others, such as a lamp-shaped vessel in the Hermitage, could not have served such a purpose.

There is no firm evidence that crystal was worked in Egypt before the reign of al-'Aziz and even in the early eleventh century, the great polymath al-Biruni (973–1048) still associated the technique with Basra in Iraq, where rock crystal was imported from the 'Isles of Zanj' (East Africa) and the Laccadive and Maldive islands in

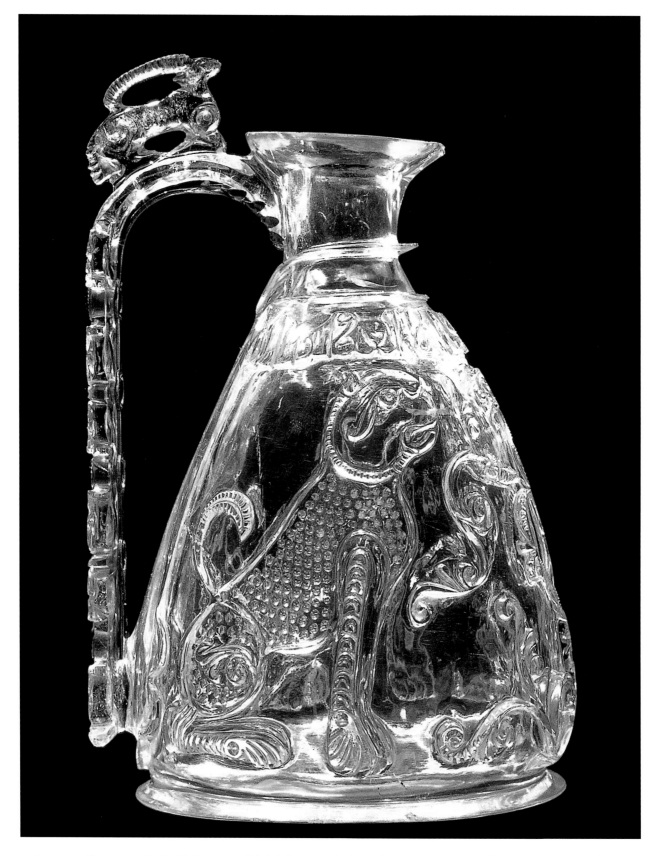

72 Rock crystal ewer inscribed with the name of al-Aziz (*r*.975–996), sixteenth-century European gold and enamel mount, height: 18 cm (7 in.), diameter: 12.5 cm (5 in.). Venice, Treasury of San Marco, no. 80

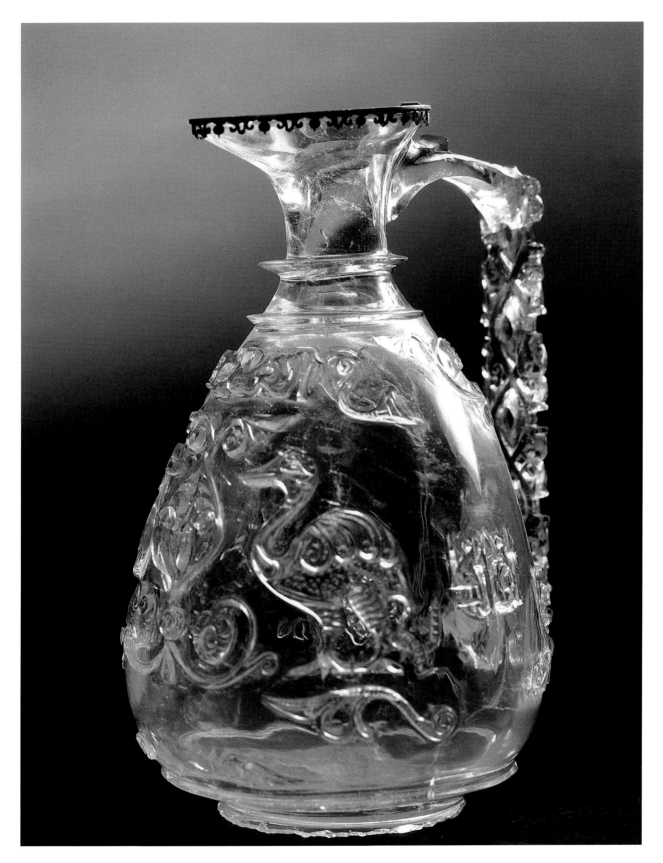

73 Rock crystal ewer made for the Qa'id al-Quwwad [Husayn ibn Jawhar] between 1000 and 1008, height: 15.6 cm (6⅛ in.), diameter: 7.7 cm (3 in.). Florence, Palazzo Pitti, inv. no. 1917

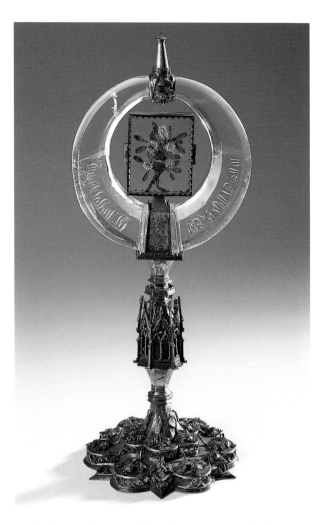

74 Rock-crystal crescent-shaped ornament inscribed with the name of al-Zahir (r.1021–1036), fourteenth-century European mount, diameter: 19 cm (7½ in.), thickness: 4.3 cm (1¾ in.). Nuremberg, Germanisches Museum, KG 695

the Indian Ocean to be worked by local craftsmen. Rock crystal of inferior quality, he said, was also imported to Basra from Kashmir and made into vases, beakers, gaming pieces and beads.[79] It is quite possible, therefore, that the major centre of the craft in the Abbasid period had been Basra, but that it – like the production of lustre ceramics – moved to Egypt in the early Fatimid period as craftsmen migrated, attracted not only by the wealth and patronage of the caliphal court, but also by their Ismaili beliefs.

Carved rock crystal is often associated – rightly or wrongly – with glass, whether because the materials present a similar appearance or because they can be decorated with similar techniques. Our knowledge of contemporary Fatimid glass is equally – if not more – problematic. Several extraordinary relief-cut or cameo glass ewers are so similar in size, shape and decoration

to the crystal ewers that some scholars have attributed them to Fatimid Egypt. Yet they are said to have been found in Iran and their shape is thought to imitate metal vessels of pre-Islamic and early Islamic Iran, so despite their similarities most recent opinion attributes these exquisite cut glass ewers to West Asia, i.e. greater Iran.[80]

Other glass objects often attributed to Fatimid Egypt are the group of relief-cut drinking glasses known as Hedwig Beakers from their association with St Hedwig of Silesia (d.1243). Made of colourless or smoky topaz glass and ranging from 8.3 to 14.6 centimetres (3¼–5¾ inches) in height, they have been slant-cut with designs of lions, eagles and other animals as well as vegetal and geometric motifs. Because of their relief-cut designs, the Hedwig Beakers have often been compared to Fatimid carved rock crystals, but other scholars have suggested that these objects were made in Byzantium, southern Italy, Central Europe or even Russia.[81] In the absence of conclusive evidence, the jury is still out, although a Mediterranean origin, if not a specifically Fatimid one, seems assured.

Perhaps the most intriguing piece of glass associated with the Fatimids, an opaque turquoise coloured bowl in the Treasury of San Marco, was not made in Egypt (Fig. 75).[82] The wide bowl, which is mounted in a later metal setting, is decorated with five relief-carved panels, each containing the figure of a running hare. Under the foot the word *Khurāsān* is carved in relief in kufic letters, perhaps because the province of Khurasan was known as the source of the finest turquoise. The bowl is generally believed to have been made somewhere in the eastern Islamic lands, perhaps in Khurasan itself and it is said that it was presented to the Signoria of Venice by the Turkoman ruler Uzun Hasan in the late fifteenth century. It is certainly much older than that and may indeed be the very bowl known to have been brought to Medina by some pilgrims from north-eastern Iran, which was stolen from them during a riot in 1022. It then passed into the hands of Sadid al-Dawla ʿAli ibn Ahmad ibn al-Dayf, the Fatimid governor of Syria. He is known to have been put to death by the intrigues of Sitt al-Mulk, at which time the bowl may have found its way into the treasury of the caliph al-Zahir, although how it passed from there to Uzun Hasan is not known.

Rock crystal items, whether carved or plain, were far more precious than glass ones, but less expensive versions of crystal objects were made of *muḥkam*, a material understood to mean transparent glass, sometimes colourless but also tinted emerald green or ruby red and often decorated with wheel-cut designs.[83] This 'sophisticated' or luxury glassware, which was used by the court, should be contrasted with the mass of blown

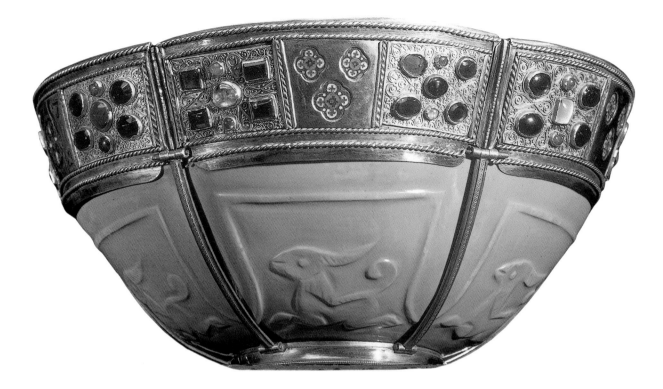

75 Opaque turquoise glass bowl. Iran, tenth century, with later European mount, height: 6 cm (2⅜ in.), diameter: 18.6 cm (7⅓ in.). Venice, Treasury of San Marco, no. 140

glass vessels that were used widely in all the medieval Islamic lands, for the invention of glass-blowing in Syria–Palestine during the first century BC had made reasonably priced glass available to most sections of society. Excavations at Fatimid-period sites in North Africa, Egypt and Syria have produced hundreds, if not thousands, of glass vessels and fragments made and decorated in a variety of techniques. Fustat, for example, is known to have been a centre for glass manufacturing from its foundation into the Fatimid period, but the complex nature and long duration of its occupation has made it difficult to establish the chronology of production. Excavation at one site in Fustat has provided thousands of fragments of undecorated blown-glass lamps that can safely be attributed to the period.[84]

Characterizing Fatimid era glass production at any particular site is all the more difficult as glass was shipped across long distances as commercial cargo. A shipwreck found at Serçe Limanı off the southwest coast of Turkey in 1975, for example, was full of glass cullet (broken glass intended for recycling) that shows what types of glass were available c.1025 in the eastern Mediterranean region.[85] Many of the fragmentary pieces are so similar to the glass vessels accidentally discovered in the 1920s at Sabra-Mansuriyya in Tunisia that it is

now thought that many of the Tunisian pieces were made in Syria or Palestine.[86]

In addition to plain blown glass, the only two types that can safely be attributed to the Fatimid period are stained (or lustre-painted) glass and glass coin weights, but moulded, cut, impressed and applied glass have also been convincingly attributed to the period using technical and stylistic criteria.[87] For example, one of the finest examples of the stained technique is a relatively large bowl or beaker in New York (Fig. 76). It has a flat base and straight flaring walls which are decorated in three colours of lustre with a design of alternating narrow and round panels, each containing a vegetal motif, the whole surmounted by an inscription that has not yet been deciphered. Although vessels of similar shape and size are known from Iraq, certain features of the design suggest that it be attributed to Fatimid Egypt c.1000.[88]

Woodwork

Among all the arts of the Fatimid period, carved and/or joined woodwork provides the surest chronology because so many examples are dated or associated with dated structures, whether palaces, mosques or churches,

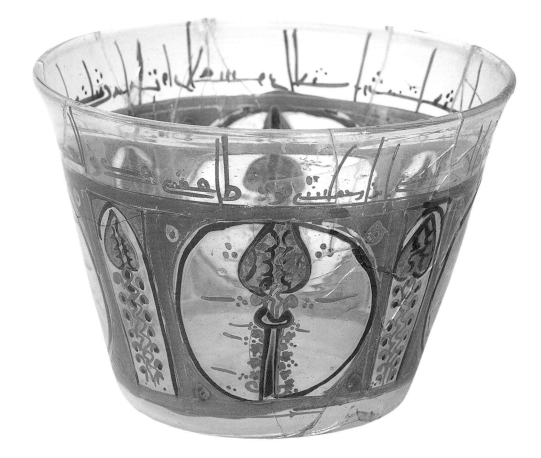

76 Colourless glass bowl with lustre ('stained') decoration in several colours, late tenth–early eleventh century, height: 10.7 cm (4¼ in.), diameter: 15.3 cm (6 in). Metropolitan Museum of Art, 1974.74

and some pieces from secure architectural contexts have already been discussed with them in Chapter 3.[89] As is to be expected, the earliest examples continue the traditions of pre-Fatimid ornament, particularly the local Tulunid variant of the Bevelled Style that had been brought from Abbasid Mesopotamia, although Egyptians seem to have enjoyed transforming the abstracted vegetal forms of the model into representational and figural motifs. On a well-known plaque in Paris, for example the leaves of the Bevelled Style ornament have been transformed into a duck.[90] The earliest datable example of Fatimid woodwork are the carved beams in the dome in front of the mihrab in the mosque of al-Hakim (990–1003). They display a series of typical Bevelled Style leaves shaped like the pulvins of Ionic capitals, that is a pair of spirals linked by a swelling middle section, laid at an angle.[91] Such spiral pulvin motifs are also found on the pair of doors ordered by al-Hakim for al-Azhar (see Fig. 37), presumably in 1010 when he ordered an endowment for the mosque. The individual panels have fleshy and symmetrical compositions of large-scale Bevelled Style leaves with no apparent background, although some of the central motifs support finer and more delicately carved elements.

Over the course of the next decades, however, the style of woodwork appears to have changed significantly, assuming that the beams associated with the Western Palace (see Fig. 38) were made at this time. In contrast to earlier woodwork, which had been based on the Bevelled Style associated with Samarra, the woodwork from the Western Palace shows a clear differentiation between figure and ground, with figures, usually enclosed in lobed strapwork cartouches displayed on a scrolling ground. Most of the panels in this new style have figures of birds, animals and people engaged in a variety of activities. While it could be argued that this new style was associated with secular, rather than religious, architecture, the appearance of this style in contemporary Coptic buildings, such as the Dayr al-Banat, or 'Convent of the Daughters', in Fustat would argue against that view.[92] This style of woodwork – with and without figures – would continue to be used well into the twelfth century (see Chapter 6).

Ivory

One of the finest luxury arts associated with the Fatimid era is carved ivory, based on a group of spectacular carved ivory plaques in the museums of Berlin (Fig. 77), Paris and Florence. Islamic ivories and particularly Fatimid ones, were studied extensively by Ernst Kühnel, who identified nearly 60 ivories from medieval Egypt.[93] He established two groups: the first included figural plaques in Berlin, Paris and Florence; the second a series of smaller pieces. After dating the plaques to the beginning of the eleventh century on stylistic grounds, he was then able to argue for the same date for the smaller pieces. Anna Contadini has recently argued for an expansion of the corpus to include carved ivory objects found at Fustat as well as ivory pieces for playing chess, backgammon, draughts and dice and the ivory writing boxes that are mentioned in the sources. She believes that Egyptian craftsmen continuously carved elephant ivory from the eighth and ninth century to the seventeenth, using the offcuts from the larger and more expensive items to make simpler and cheaper objects.[94]

The panels in the European museums measure approximately 5.8 centimetres (2 inches) in width and are carved with consummate skill and assurance. They are generally ascribed to mid eleventh-century Egypt because their subject matter – scenes of hunting and merrymaking – is uncannily similar to that decorating the woodwork associated with the Western Palace (see above, Chapter 3). The themes on the panels are connected with the princely life – drinking, musicians, dancers – as well as agricultural and hunting scenes; all of these have parallels in the carved wooden panels from the Fatimid palace. The tiny figures, which are acutely observed with particular attention given to their clothing and textile patterns, frolic on a slightly recessed and pierced ground of regular vine scrolls which give added depth to the composition. Two of them are remarkably like sculptures of the Labours of the Month on the portal of San Marco in Venice, a rare instance of this iconography in Islamic art.[95]

Close examination of some ivories shows traces of gilding and painting, although earlier cleaning has often removed this evidence. The Berlin, Paris and Florence plaques differ from the Fatimid palace beams in their use of openwork carving, a rare technique not found on the beams. It is generally believed that the four Berlin and three Paris plaques, which have the same dimensions, come from the same 'set', while the six Florence plaques show subtle differences in detail and scale.[96] Scholars have long believed that all the panels once formed part of the decoration of one or more pieces of furniture, such as a chest, a door or a wall panel, and such a hypothesis is strengthened by the discovery of ivory panels at the early Abbasid site of Humayma in Jordan, which are believed to have decorated a throne.[97] The Florence plaques largely preserve their original dimensions, but the Berlin plaques have been cut and reassembled as a frame at least since the nineteenth century, and the Paris plaques are only fragments. The lower horizontal plaque of the Berlin frame is more abraded, especially in the centre, than the lateral or upper pieces, for such projecting features as the details of the textile patterns and the figures' noses have largely worn away.

Eva Hoffman has recently proposed that the Berlin and Paris plaques are the remains of a luxury bookcover.[98] Several features argue against this ingenious hypothesis. No Fatimid book of such dimensions or appropriate to such an iconography is known to have survived. Furthermore, the delicacy of the openwork carving is quite inappropriate to a book cover, that part of a book that would have been most subject to abrasion. Had the panels been used as a book cover, one would have expected that the outer edges of the frame would have been worn more than elsewhere. The uneven wear of the lower Berlin panel, in contrast, shows that someone or something repeatedly rubbed against this panel – but not the others – suggesting that it might have once been inserted into a piece of furniture. How would these covers have been attached to a book? Moreover, all Muslim societies tended to view the contents of the book as more important than its cover. Al-Maqrizi's descriptions of the Fatimid treasury of books, for example, enumerates titles but not bindings.[99] While some later patrons in Iran and Central Asia commissioned beautiful tooled and stamped leather covers for their books, few – if any – were figural before the technique of varnished painting developed in the fifteenth century. The identification of the exquisite panels as belonging to a bookcover, therefore, remains highly problematic. Even the attribution of the panels to Fatimid Egypt has also been questioned and a Sicilian or South Italian provenance proposed.[100] Wherever they were made, this particular set of ivory panels is more likely to have decorated some frame, casket, throne or piece of furniture.

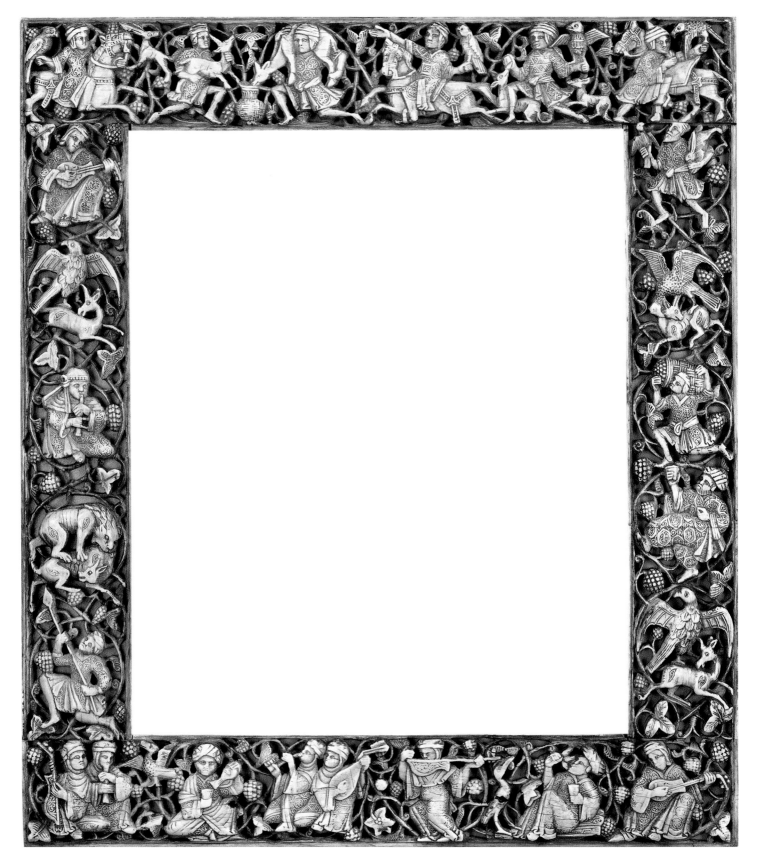

77 Four ivory plaques with figural scenes assembled into a frame, eleventh century, overall dimensions 40.6 × 36.1 cm (16 × 14¼ in.). Berlin, Museum für Islamische Kunst, I 6375

Books and Paintings

As in virtually all times and places in the medieval Islamic lands, books and book learning were of great importance in Fatimid Egypt, but paradoxically not a single manuscript from this time and place is known to survive. The Fatimid caliphs in the Maghrib, especially al-Mansur and al-Muʻizz, had already shown great interest in books and their successors in Egypt followed suit. For example, it is said that in 993–4 the caliph al-ʻAziz was able to produce from his personal library thirty copies of al-Khalil ibn Ahmad's lexicographical masterpiece *Kitāb al-ʻayn*, including one by the hand of the author himself, as well as twenty copies of al-Tabari's multi-volume *History*, including an autograph copy and one hundred copies of the *Jamhara* of Ibn Durayd.[101] Such numbers are not as incredible as they may seem, for Muslim scholars had already developed an ingenious method of dictating texts to facilitate their copying and distribution.[102]

The period of Fatimid rule in Egypt coincides with the explosion of books and book-learning in the Muslim lands that resulted from the triumph of paper over papyrus and parchment, the two ancient writing materials used widely in the first centuries of Islam. In 956 the historian al-Masʻudi had noted that papyrus manufacture was not completely defunct in Egypt, but Ibn Hawqal, who visited Egypt a few years later, made no reference to the use of papyrus as a writing material, although he did mention the papyrus plant. Egyptians still used papyrus in preparing amulets and for medical treatment, but by the late tenth century it had been decisively replaced by paper, the writing material invented a thousand years earlier in China.[103]

The Fatimid caliphs, like their rivals in Baghdad and Córdoba, established several major institutions of learning in Cairo, apparently modelled on those that had long been established in Baghdad.[104] In addition to the caliphs' personal collections of books, the *Dār al-ʻIlm* (House of Knowledge), sometimes also known as the *Dār al-Ḥikma* (House of Wisdom), located in the palace in Cairo, contained a library and reading room and served as a meeting-place for scholars of hadith, jurists, grammarians, doctors, astronomers, logicians and mathematicians. During the reign of al-Hakim, its annual budget totalled 207 dinars, of which the largest single expense, 90 dinars or 43 per cent, was on paper for the copyists. (To give some idea of the value of this sum, a lower middle-class family could survive on 24 dinars a year; meanwhile the caliphs, we have seen, were commissioning tents for 30,000 dinars!) The next

largest expense, 48 dinars or 23 per cent, was for the librarian's salary, with lesser amounts for the attendant's wages (15 dinars), wages for the keeper of paper, ink and pens (12 dinars) and for repairing books (12 dinars); floor mats and drinking water (10 dinars each); felt carpets and blankets for winter (5 and 4 dinars respectively) and repairing the curtains (1 dinar).[105] Considering the caliph's other expenditures, this support for this institution seems remarkably modest, and the annual budget clearly had nothing to do with the acquisition of books, for when a new library catalogue was prepared in 1045, the library was said to contain 6,500 volumes on various subjects. Presumably this was a public library, like contemporary palace libraries already established in Baghdad and Córdoba.[106]

In 1012–13, at the same time that al-Hakim ordered the new silver chandelier for the Mosque of ʻAmr in Fustat, he also commanded that 1298 manuscripts of the Qurʼan in both bound volumes and chests be taken from the Fatimid palace to the mosque. Among them were some written entirely in gold.[107] When the Fatimid palace was looted a half century later, one storeroom yielded 18,000 volumes on the 'ancient sciences' and another contained 2,400 boxed manuscripts of the Qurʼan written in 'apportioned scripts', that is, the kind that had been developed by Ibn Muqla at Baghdad in the early tenth century and Ibn al-Bawwab *c.*1000. An eyewitness saw twenty-five camels laden with books valued at 100,000 dinars headed to the house of the vizier Abuʼl-Faraj Muhammad ibn Jaʻfar ibn al-Muʻizz al-Maghribī, who had taken them in lieu of the 5,000 dinars salary he was owed. A month later, the same books were looted from the vizier's house and dispersed.[108]

Not only is this text interesting for the numbers of books it mentions, but also because it should put to rest the idea that the Fatimids did not participate in the evolution of the rounded scripts that would change the course of Arabic writing so profoundly.[109] Certainly the Fatimids continued to write their monumental inscriptions in the older, angular scripts, but there is no reason to believe that they eschewed the rounded hands for their manuscripts and correspondence, although few of these have survived. The two earliest documents preserved from the monastery of St Catherine's are decrees by al-Zahir of 415/1024. An old photograph (Fig. 78) shows five lines of the text written a fluid secretarial script known as *tawqiʻ*.[110] Furthermore, fragments of a religious text discovered in an eleventh-century context in the French excavation of the Qarafa cemetery are also copied in a typical eleventh-century rounded hand.[111]

Qur'an, also in Dublin (Fig. 79). Measuring only 9.3 × 7.7 centimetres ($3^3/_4$ × 3 inches!) and having 175 folios of firm paper, the text is written with 25 lines to the page in a 'small, regular, old *naskh* script', a style of writing that is more properly classified as the typical 'broken' cursive of the era.[114] The first and last pages are fully illuminated in gold and blue. Folio 175a has a colophon praising God, Muhammad his messenger and his (Muhammad's) pure (*ṭāhirīn*) family. It states that 'the humble servant . . . finished copying it on Monday, 21 Rajab 428 [10 May 1037]'.[115]

Although the colophon provides a date during al-Mustansir's long reign, it gives no indication of where the manuscript was copied. The invocation of God's blessings on Muhammad's *pure* family suggests that the calligrapher was an Ismaili, for the Fatimids used this epithet conspicuously in their inscriptions. Contadini has noted similarities between the decoration of the manuscript and other arts of Fatimid Egypt, so it is quite possible that this manuscript was made there, although such stylistic comparisons can be notoriously unreliable. Whatever its place of production, its size and quality suggest that it was made neither for the court

Considering the Fatimid interest in books and the great numbers of them they collected, it seems quite implausible that not one single manuscript is known to have survived from these collections before their partial dispersal in the middle of the eleventh century. It is likely that, among those hundreds or thousands of manuscripts dating from the tenth and eleventh centuries and preserved into modern times, some were once in the Fatimid royal libraries or were produced in Egypt when it was under Fatimid rule, but identification of such volumes will come only slowly.[112] It is possible, for example, that a well-known manuscript like the copy of the Qur'an transcribed by Ibn al-Bawwab in 391/1000–1 now in the Chester Beatty Library in Dublin was once in the Fatimid library. The Fatimid caliphs are known to have owned copies of the master calligrapher's work and the earliest owner's mark on the Dublin manuscript is by a certain Khushraqmakhan Gujrati in 1741.[113] Another possibility is a very small copy of the

nor for public use in a mosque but for private reading. It would, therefore, be an example of Fatimid-era art and might confirm that various styles of script were used concurrently in the Fatimid period, depending on the medium, the function and the patronage.

When al-Hakim ordered his father's administrator Barjawan killed in the year 1000, he is said to have left 'many illustrated and other books, as well as song books' among his possessions and al-Yazuri, vizier to al-Mustansir from 1050 to 1058, was said to be 'especially fond of an illustrated book or anything like a picture or gilding.'[116] Over the years, clandestine scientific excavations at Fustat and other sites have produced thousands of fragments of paper – some of them illustrated with simple pictures – in levels dated between the tenth and twelfth centuries. They have led some scholars to try to reconstruct the lost art of Fatimid painting in general and book illustration in particular.[117] These drawings, however, provide little or no evidence for the art of book-illustration, because few if any of them bear both text and pictures, which would indicate that they once formed part of a book. When they do, only equivocal conclusions can be drawn, for none is dated and many raise troubling questions about authenticity.

One drawing (Fig. 80), for example, a well-known fragment in New York, bears an almost calligraphic drawing of a lion on one side. The drawing is accompanied by a few lines of text identified as a discourse on wild animals by the early Jewish convert to Islam, Ka'b al-Ahbar (d.652–653). The presence of this text would suggest that the drawing came from an early Islamic book about animals. The drawing's style, however, suggests a twelfth-century date, which would lead to the conclusion that this drawing came from a copy of an early text illustrated at a later date. The reverse of the same sheet, however, bears a drawing of a hare accompanied by a text irrelevant to that on the front of the sheet, so it is difficult – indeed impossible – to imagine how this page could once have formed part of a book by Ka'b al-Ahbar let alone by any other author.[118] Another painting in the Keir Collection (see Fig. 56) purports to be the frontispiece to a collection of poems by a well-known Umayyad poet, but similar historical and technical problems raise doubts about the authenticity of this painting and several other related drawings.[119] For example, a meticulously executed drawing of two warriors in Cairo (Fig. 81), which has been reproduced countless times and used as evidence for Fatimid costume and weaponry, bears a truncated inscription, *'izz wa-iqbāl li'l-qā'id Abī Manṣ[ūr]* (Power and good fortune to the commander Abu Mansur), presumably

80 Drawing of a lion, ink and colour on paper, eleventh century, 15.3 × 12 cm (6 × 4¾ in.). New York, Metropolitan Museum of Art, 54.108.3

referring to a specific individual of the early eleventh century.[120] The inscription, which oddly truncates the most important part of the inscription, namely the dedicatee's name, contrasts disconcertingly with the meticulous care with which the drawing has been planned and executed. Furthermore, the slight damage affects only unimportant portions of the design. If the drawing is genuine, what exactly would its purpose have been? It is certainly not an illustration for a book, nor was it a preliminary design for something to be executed in another medium, because the level of finish – despite the truncated inscription – is too high.

One of the most impressive drawings to survive is a somewhat larger (28 × 18 centimetres) sheet in the Israel Museum bearing a representation of a nude and tattooed woman carrying a lute (Fig. 82).[121] The drawing, on yellowish paper, was first done in red ink and then gone over in black, with touches of white and crimson, a technique that can be traced back to Classical times.

81 Drawing of two warriors, ink on paper, 14 × 14 cm (5½ × 5½ in.). Cairo, Museum of Islamic Art, no. 13703

Some scholars have suggested that this image of a dancing girl is a specific representation of a famous courtesan in Fatimid Egypt, while others have suggested that it is a generic representation of Venus playing the lute. As there is no text around or on the back of the image, it seems unlikely that the page was taken from a book, nor does it look like a preparatory study for something else, so its purpose remains a matter of speculation.

Ernst Grube, who has studied these fragments more than anyone else, has interpreted many of the drawings and paintings that cannot be specifically identified as coming from books as preparatory studies for painters working on manuscripts or even pottery, ivory boxes, glass vessels, wooden panels and the like. Other drawings are thought to have served the textile weaver or embroiderer, the book-binder and metal-worker for the creation of his designs.[122] From the broader perspective, however, there is no evidence at all that wall-painters, potters, metalworkers, glass-blowers or most weavers worked in this way at this date. Furthermore, the evidence from the art itself shows that artisans normally worked directly in their chosen medium without recourse to paper drawings and patterns. In short, the drawings said to have been discovered in the rubbish-heaps of Fustat raise more questions than they answer.

The same can be said for several dozen block-printed amulets (Fig. 83), a few of which date from the Fatimid period. Most of them were found in the nineteenth century in rubbish-mounds in Fayyum, eventually making their way into European and American libraries and museums. Long ignored, they have recently been restudied and provide evidence of an important stage in the history of printing in the Islamic lands.[123] Two examples were discovered in controlled excavations at Fustat in levels that have been dated 950–1050,[124] but it is unclear how many of the other examples should be

dated to this early period. One excavated example shows that the image on the block was printed twice on the same sheet of paper, presumably in anticipation of cutting them apart for separate sale. As on many of the block-printed amulets, some of the text is written in a more intricate display script (here the letters are reserved against the printed ground) of the prayer. The ends of the letters are elegantly floriated. The technology of printing was also used in the Fatimid period for decorating cotton textiles (see Chapter 6 below).

Representation in Fatimid Art

One of the most remarkable features of the decorative arts in the first century of Fatimid art in Egypt is the prevalence of figural representations in virtually all media, from ceramics, metalware, textiles, carved ivory, carved crystal and goldwork to the problematic works on paper. Even architectural decoration included figural representation, as can be seen on the carved wooden beams and panels from the Western Palace. Although figural decoration is not known to have been used in any specifically Islamic religious contexts, such as mosques or shrines, the widespread popularity of figural representation cut across levels of patronage, from the royal to the popular, from the Muslim to the Christian.

Well over a century ago, H. Lavoix first drew attention to a text quoted by al-Maqrizi concerning a contest between painters that had been organized by the Fatimid vizier Yazuri sometime before his execution in 1058 and this incident was further cited by T. W. Arnold in his seminal book *Painting in Islam* (1928). The actual text is not by al-Maqrizi, as Arnold and others believed, but from the lost work of al-Qudaʿi, a Shafiʿi jurist who had served as deputy qadi under the Fatimids before his own death in 1062.[125] As Gaston Wiet noted, the larger context is a description of the mosque of the Qarafa (which has already been discussed in Chapter 3).[126]

> And the Mosque of the Qarafa was decorated with paintings in blue, vermillion, verdigris and other colours and, in certain places, painted a uniform colour. The ceilings were entirely painted in polychrome and the intrados and extrados of the arcades resting on the columns were covered with paintings of all colours. This decoration is the work of the painters of Basra and of the Banu Muʿallim, of whom Kutami and Nazuk were the masters. Opposite the seventh door [of the mosque] one can see

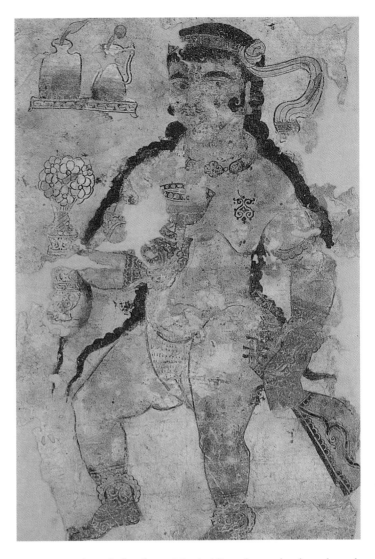

82 Drawing of a nude female musician holding a lute and a glass, eleventh century, ink and colour on paper. 28 × 18 cm (11 × 7 in). Jerusalem, Israel Museum, M 165-4-65

> on the intrados of one of the arches, a painting representing a *shadhirwān* [stepped fountain], with decoration in black, white, red, green, blue and yellow. When one stands under the keystone of the arch and raises one's head towards this decoration, one might imagine that the painted steps were like a muqarnas made of wood. But if one stood under one of the flanks of the arch, where the semicircle ends and when, keeping to the beginning of the arch, one raises the head to look at it again, one sees that it was an optical illusion and that the surface was quite flat without any relief. That is the epitome of the painter's art. This arch was the work of the Banu Muʿallim; other artists came to imitate it, but none was successful.[127]

83 Block-printed amulet, tenth–eleventh century, ink on paper, 14.1 × 7 cm (5½ × 2¾ in). Cambridge University Library Michaelides (charta) E31

And this case is similar to that of al-Qasir and Ibn 'Aziz in the time of Yazuri, the chief minister Hasan b. 'Ali b. 'Abd al-Rahman, for he often used to provoke them against one another, since he was especially fond of an illustrated book or anything like a picture or gilding. Thus he invited Ibn 'Aziz from Iraq and aroused his evil passions, for he had sent for him to contend with al-Qasir, because al-Qasir demanded extravagant wages and had an exaggerated opinion of his own work – and it really merited so high an estimate, for in painting he was as great as Ibn Muqla was as a calligrapher, while Ibn 'Aziz was like al-Bawwab. I [i.e. al-Quda'i] have already given a detailed account of the matter in the book I have written on the subject – namely the classes of painters – entitled, *The Light of the Lamps and the Amuser of Company in Respect to the Annals of Artists*. Now Yazuri had introduced al-Qasir and Ibn 'Aziz into his assembly. Then Ibn 'Aziz said, 'I will paint a figure in such a way that when the spectator sees it, he will think that it is coming out of the wall.' Whereupon al-Qasir said, 'But I will paint it in such a way that when the spectator looks at it, he will think that it is going into the wall.' Then [everyone present] cried out,

'This is more amazing (than the proposal of Ibn 'Aziz).' Then Yazuri bade them do what they had promised to do: so they each designed a picture of a dancing girl, in painted niches opposite one another – the one looking as though she were going into the wall and the other as though she were coming out. Al-Qasir painted a dancing-girl in a white dress in a niche coloured black, as though she were going into the painted niche and Ibn 'Aziz painted a dancing-girl in a red dress in a niche that was coloured yellow, as though she were coming out of the niche. And Yazuri expressed his approval of this and bestowed robes of honour on both of them and gave them much gold.[128]

This passage is significant for a host of reasons: in addition to describing a contest between artists, it also describes the *trompe l'oeil* decoration in the mosque of the Qarafa; it once again provides evidence for the role of Iraqi, specifically Basran, artists in Fatimid Egypt; it contains an early reference to muqarnas decoration, which had its first known appearance in Egyptian architecture several decades later at the Mashhad al-Juyushi (see Chapter 5); and finally, it provides evidence for the presence of illustrated books in eleventh-century Egypt as well as books about painters.

The flowering of figural representation during the early Fatimid period is something of an anomaly in the larger development of Islamic art and it serves to explain much of its attraction for contemporary Western audiences who are drawn through habit to an appreciation of representational art. Although some carved tenth- and eleventh-century ivories and textiles from the Iberian peninsula employ figural motifs (and are equally popular), the general trend in the decoration of Islamic art in the tenth and eleventh centuries was away from representation towards abstraction, whether in the form of pure geometry or in the arabesque, that is geometricized vegetal ornament. Both of these types of decoration would become increasingly popular in Islamic and specifically Egyptian art of the following centuries, although figural motifs would remain popular on some Syrian and Iranian ceramics of the twelfth century and later, and figural motifs would remain an important aspect of Persian and Persianate traditions, most notably in book illustration, which developed only in the early fourteenth century. The unusual presence of figural motifs in Fatimid and Persian art led some early scholars to hypothesize that the Shi'a had a predilection for representational art, an idea that seems particularly silly today.

Richard Ettinghausen, looking at the great variety of figural representations in Fatimid art – and he cast his net rather widely in defining it – was able to differentiate between various 'schools' of painting, including the 'Perso-Iraqian', 'Hellenistic', 'realistic' and 'popular'.[129] Although he believed that these various styles coexisted, he found that the old and indigenous art of Coptic Egypt played little or no role, at least in the art of the court of higher Islamic society.[130] In contrast, Ernst Grube, while acknowledging the impact of Mesopotamian styles, saw the continuation of an Egyptian tradition of representation that went back through Coptic art to late Antiquity and even to the art of Dynastic Egypt, although he neglected to explain exactly how – or why – such imagery might have been maintained.[131] Taking a different tack, Oleg Grabar attempted to explain the popularity of figural art in Fatimid Egypt by giving it a social dimension, ascribing it to the sudden impact of upper-class royal imagery on the urban art of the bourgeoisie following the dispersal of the Fatimid treasuries, but we have seen that this attractive and ingenious explanation cannot hold true, because figural art was already present in Egypt long before the treasuries were dispersed.[132] Egyptians apparently liked representational art before the Fatimids arrived on the scene; the arrival of Mesopotamian artists only intensified that taste, which was realized in various media, ranging from walls to ceramics, textiles and even books. Finally, before connecting this interesting anecdote with a lost art of manuscript illustration in the Fatimid period, we should remember that the artists of the Basra school were not celebrated for their manuscript illustrations, but for their *trompe l'oeil* murals.[133]

The continuation of older traditions of representation, whether Mesopotamian or Hellenistic-Egyptian, does not mean that older meanings came along with the images, and it remains difficult, if not impossible, to suggest what images of royal pastimes or animals in vine-scrolls were meant to convey, apart from generalized messages of goodwill and blessing. It seems therefore quite impossible, given the little we know, to propose whether these images were meant to be 'realistic' or 'narrative' in content. In any event, in the second century of Fatimid rule in Egypt, interest in representation seems to wane. If anything, the dispersal of the treasuries spelled the decline of the taste for representation, for the taste for pure arabesque and geometry reigned supreme by the later Fatimid period, as it would everywhere else in the Islamic lands.

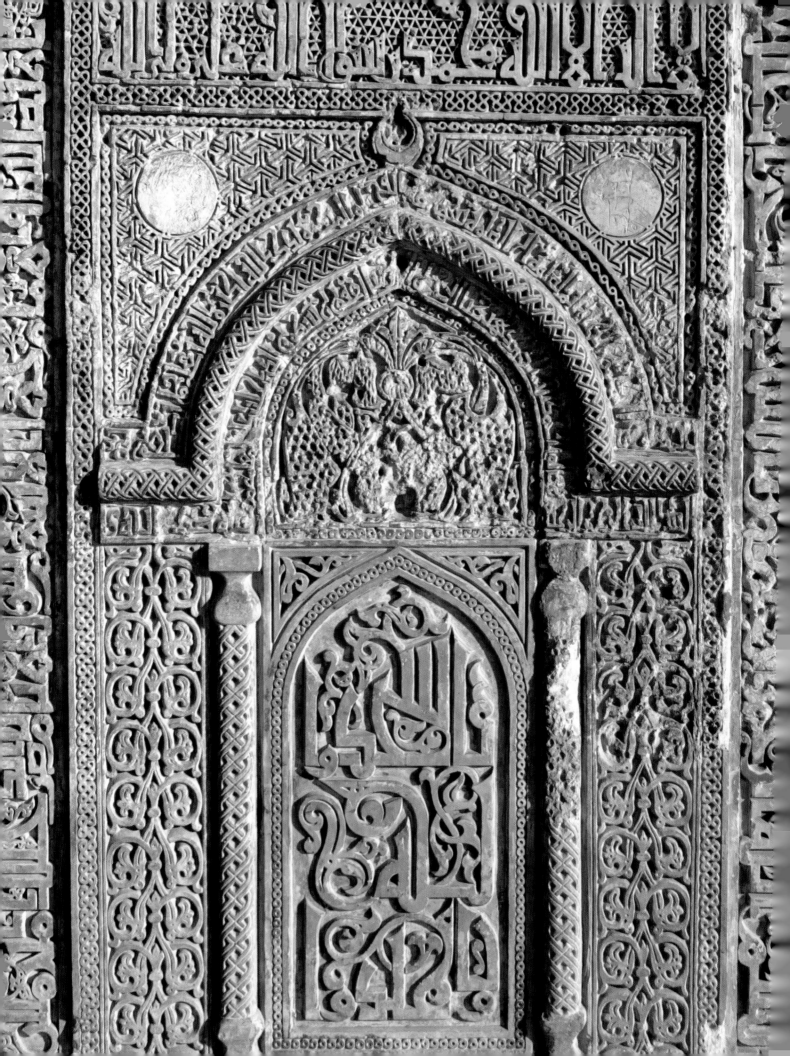

V

Architecture from the 1060s to 1171

The third period of Fatimid art began with the crisis in the middle of al-Mustansir's long reign (1036-1094) when fighting among the various factions of the army forced the caliph to summon Badr al-Jamali, a Fatimid governor in Syria, to come to Cairo, become vizier and restore caliphal authority. When al-Mustansir had acceded to the throne, the Fatimid empire extended from North Africa and Sicily to Mecca and central Syria and the *da wa* organization was active and successful in Iraq and Iran. In the 1040s the Zirids of North Africa had been the first region to spin loose from the Fatimid orbit, as economic failure and the shift of trade routes promoted a precipitous decline in the region's prosperity, while distance from the capital encouraged xenophobic Maliki attacks on the remaining Ismaili supporters. After the Zirid prince al-Mu'izz temporarily renounced Fatimid suzerainty in 1041, al-Mustansir's vizier al-Yazuri encouraged the Arab tribe of Hilal to resettle in the Maghrib, thereby wreaking unprecedented devastation on the region. To the east, although al-Mustansir's supporters briefly enjoyed the unexpected success of hearing his name invoked in the Friday sermons proclaimed in Baghdad, the Abbasid capital, from the end of 1058 to the beginning of 1060, this triumph was short-lived. Indeed, by the time Badr was summoned, the Fatimid empire had been shorn of all its possessions outside Egypt except for a few localities in Syria and Palestine.

Badr restored law and order and was able to repel invasions from the east, particularly the Seljuq Turks, but the caliph and his successors paid a heavy price, for Badr and later viziers became military dictators over the country. After Badr's death, al-Mustansir tried

unsuccessfully to regain power from Badr's own son and successor al-Afdal but the shift in power from caliph to military vizier was permanent. To complicate matters even further, in 1099 European Crusaders took Jerusalem and occupied much of the Levantine coast. There they would remain, a sharp thorn in the Fatimid flank, for many years. Over the course of the following century, until the end of the dynasty in 1171, the Fatimid caliphs devolved into relatively weak figures unable to respond to a host of internal and external enemies, whether Fatimid pretenders or European invaders.

In addition to decreasing opportunities for patronage of the arts, the reduced size of the realm during this turbulent period also limited the resources available to the caliphs and new classes of patrons focused their efforts on new types of projects and different forms of decorative art. The military viziers, for example, became important patrons, but they were usually unwilling or unable to dip deep enough into their own well-lined pockets to fund the large-scale projects the caliphs had commissioned in the past. At this stage of our knowledge, there seems to be no inherent stylistic distinction between the arts ordered by caliphs and that by viziers or other patrons. Nevertheless, there seem to be several simultaneous strands of stylistic development despite the reduced size of the realm. Cairo continued to be the centre of patronage and artistic innovation, but important projects were also undertaken in frontier regions such as Syria and Upper Egypt, where it was necessary to project the image of Fatimid authority, even if the reality was less convincing.

Some artistic developments of the period appear to be specific to Egypt. For example, the high technical

quality and intensity of epigraphic and ornamental motifs carved in stone and stucco on some late Fatimid buildings suggests that Fatimid patrons and builders were exploring new ways of increasing the symbolic meaning of their structures, but the elucidation of these meanings – whatever they might have been – remains a matter of lively scholarly speculation. At the same time artistic and cultural ideas, such as the mausoleum, the minaret, the muqarnas, cursive scripts or geometric interlace patterns, which had become popular or developed elsewhere in the Islamic lands, particularly in Syria, Iraq and Iran, were introduced to or popularized in Egypt. During this period, for example, tombs and shrines were erected in Egypt over the gravesites – or purported gravesites – of several members of the Prophet's family. Scholars such as Oleg Grabar and Caroline Williams have argued that these constructions reflect particularly Fatimid and Shi'i practices of veneration,[1] but other scholars have demonstrated that such practices had been followed by Sunni and Shi'a alike in Egypt and elsewhere for a century or more.[2] Conversely, it has been argued that cursive scripts and geometric interlace patterns were developed in Sunni milieux as counterweights to the kufic script and vegetal arabesques initially favoured by Fatimid patrons of the arts,[3] but, as this book shows, it is equally clear that these motifs and modes of decoration had no doctrinal associations.

Despite the reduced circumstances of the Fatimid court, artisans and patrons continued to be attracted – or to escape – to cosmopolitan Cairo, which in this period took on the dense urban character it would maintain to the present day, fostering the exchange and interplay of artistic traditions. Egyptian artisans of the later Fatimid period certainly built on and expanded the indigenous traditions of mosque design, stucco carving and ceramic technology, yet they were also aware of new and foreign ideas with which they experimented to enrich their own artistic traditions.

The Historical Setting

Factional strife among the various elements in the Fatimid army – African Blacks, Berbers, Daylamis and Turks – came to a head in 1062 when these groups began to engage in open warfare near Cairo. Barely a year after al-Basasiri had invoked the Fatimid caliph's name in Baghdad, Nasir al-Dawla, commander of the victorious Turkish battalions in the Fatimid army – who remained staunchly Sunni – went so far as to invoke the name of the Abbasid caliph of Baghdad in the khutba pronounced in the mosques of Alexandria and other localities in Lower Egypt. Meanwhile, in Cairo, a succession of individuals briefly occupied the posts of vizier and chief qadi, making it difficult, if not impossible, for the central administration to control the provinces. Local warlords withheld the taxes they owed the central government, so it was unable to pay the troops who might have been expected to keep the warlords under control. Following their victory in 1062, the Turks emerged as the strongest group in the Fatimid army, demanding and receiving a disproportionately large share of the state's dwindling resources.[4]

The remorseless plundering of the country by the various factions brought agriculture to a standstill. Despite the regularity of the annual Nile flood in this period, a series of shortages and famines, exacerbated by the cultivation of flax rather than wheat, led to the outbreak of civil war and a complete breakdown of law and order.[5] As the provinces fell out of central control, more land was left uncultivated and famine ravaged the country. The troops meanwhile demanded that the caliph pay them for services rendered; when he refused, they first seized the tax and custom-house revenues and then – beginning in December 1068 – began looting the caliph's great palace in Cairo, first for military supplies and then for his personal treasures (see below, Chapter 6).

The destruction was not limited to the caliph's treasuries in Cairo alone. Much of the city of Fustat was abandoned during the eighteen years of epidemics and famines (1054–72) and many of the abandoned buildings were dismantled and the materials transported to other parts of the city for reuse. Archaeologists have been able to excavate some areas of the ruins of Fustat and discover much valuable information about urbanism and material culture in the pre-Fatimid and Fatimid periods.[6] The Cairenes' use of the site for a dump in later times has, however, has tended to complicate the archaeological record. Just as it was once suggested that the dispersal of the treasuries had a crucial impact on the course of representation in Fatimid art, it is particularly tempting to imagine that this period of widespread social turmoil had a decisive effect on the course of Fatimid art in the following century. The smaller scale of production in this period was surely brought about from reduced resources; yet the absence of well-documented examples (apart from architecture, textiles and ceramics) makes it hazardous to draw sweeping conclusions. As our knowledge gets increasingly refined, however, it may become easier to do so.

The troubles lasted until the winter of 1073–4, when al-Mustansir secretly asked Badr al-Jamali to come to Egypt and put an end to the civil war. An Armenian by birth, Badr had been the slave of the Syrian amir Jamal al-Dawla ibn 'Ammar (hence his *nisba*, or epithet, *Jamālī*) and had made a great name for himself in Syria, having served twice as Fatimid governor of Damascus and most recently as commander of the Fatimid garrison at Acre, which had fought successfully against the invading troops of the Seljuk sultan Malikshah (r.1073–1092). Given the title of *amīr al-juyūsh* (commander of the armies) and assisted by his private Armenian corps, Badr was able to achieve peace in Egypt by dividing and conquering the different factions. Badr instituted new tax policies that paved the way for the economic revival of Egypt and re-established security that allowed Ismaili adherents, whether at home or abroad, to refill the royal coffers with their contributions. He also received important help from the merchant community who desperately wanted order restored so that they could resume trading. It is likely that Badr's policies increased the regime's income by fifty percent, from two million to over three million dinars.[7] Badr also pursued a deliberate policy of adding soldiers, often Armenians like himself, to his own regiments so that they owed him personal loyalty. Some were Muslims, while others were certainly Christians, and once word got back that there were openings for Armenians in Cairo, great numbers of Armenian soliders, tradesmen, clergy and their families apparently moved to Egypt, where they often rose to important and even commanding positions.[8]

Badr and his lieutenants travelled from Cairo to Upper Egypt, restoring Fatimid authority as far as the frontier at Aswan and re-securing the pilgrimage (and commercial) route linking the upper Nile valley to the Red Sea coast, whence it went by sea either to Mecca or to Yemen and eventually India. In Syria, however, Badr was less successful, as Damascus and all but a few towns along the southern coast fell into the hands of the Seljuq Turks by 1076. Badr repeatedly but unsuccessfully attempted to regain territory lost to the Seljuqs in central Syria and to the Artuqids in the north. He successfully repelled the Seljuq invasion of Egypt commanded by the Turkish general Atsiz in 1077 as well as others in 1078–9, 1085–6 and 1089–90. In 1091, the head of al-Husayn, the Prophet's grandson and progenitor of the Fatimid line, was miraculously discovered in Ascalon, the last frontier city retained by the Fatimids after they had lost most of Syria and Palestine to the Seljuqs, in an effort to re-establish Fatimid authority in the region.

For all this work, however, Badr exacted a hefty price: in addition to his role as commander of the army, he became the military dictator of the country, controlling the administration as vizier and controlling the judiciary as the chief qadi, as well as controlling the Fatimid propaganda as chief missionary following the death of the great al-Mu'ayyad fi'l-Din Shirazi in 1077.[9] To cement his position, he also arranged for his daughter to marry the caliph al-Mustansir's younger son Ahmad. Unlike earlier Fatimid viziers, who had all been civilians, or the viziers to the Buyid amirs and Seljuq sultans in the east, who were, like Badr's contemporary Nizam al-Mulk, drawn from the ranks of scholars and the bureaucracy, Badr was strictly a military man.[10] The caliph retained his theoretical superiority as head of the realm but lost it in practice to the vizier, and this effective transfer of power was to be a permanent feature of later Fatimid politics.[11] Badr threw himself into practical and symbolic construction, refortifying the Fatimid capital and building mosques and shrines in the provinces on which his names and titles were prominently displayed. His patronage of architecture takes on added importance since the two decades of his government are otherwise 'the worst documented of the whole Fatimid age'.[12]

After Badr's death in March–April 1094 at a very advanced age – he was probably over eighty – the caliph al-Mustansir (who was himself about sixty-five) unsuccessfully tried to recoup the powers he had lost to his vizier. The caliph failed, for the majority of Badr's officers rallied behind his twenty-eight-year-old son Abu'l-Qasim Shahanshah ('King of kings' in Persian) and nominated him to be the new vizier, who modestly took the title of *al-Afḍal* ('the Best'). Following al-Mustansir's own death in December of that same year – after a reign of sixty lunar years, the longest in Islamic history – al-Afdal broke with Fatimid precedent and himself nominated the nineteen-year-old prince Ahmad, al-Mustansir's young and more tractable son – as well as al-Afdal's brother-in-law – to the throne rather than al-Mustansir's eldest son, Nizar, who was al-Mustansir's choice, or another son 'Abd Allah who had also been waiting patiently in the wings for his elderly father to die. For nearly two centuries the Fatimids had faced no major succession crisis, as the imamate passed from father to the son designated as his heir. This was usually, but not necessarily, the eldest, for indeed Isma'il, the progenitor of the Fatimid line, had been the second eldest son of the Imam Ja'far al-Sadiq. Sometimes older sons were passed over, as in the case of al-Mu'izz's son Tamim, because he was unable (or unwilling) to produce a male heir.[13]

Taking the regnal name *al-Musta'lī bi'llāh* ('He who is Elevated by God'; *r.*1094–1101), the new caliph was recognized by the Fatimid army (which was, of course, controlled by al-Afdal), the court notables and the propagandists. The dispossessed Nizar, the original heir-designate to the Fatimid throne, fled to Alexandria in early 1095, where he was recognized as the rightful caliph *al-Muṣṭafā li-Dīn Allāh* ('The Chosen of God's Religion'). Nizar then raised his own army against al-Afdal and advanced to the vicinity of Cairo. Towards the end of 1095, however, Alexandria was besieged by al-Afdal and Nizar was captured, brought to Cairo and executed there. The Ismailis were thereby split into two rival factions, the Musta'lis, who were recognized in Cairo, Egypt, Yemen and western India, and the Nizaris, who were recognized in Iran and Iraq and eventually in Syria. The Nizari Ismailis, who today recognize the Aga Khan as their spiritual leader, continue to accept the validity of his nomination.[14]

Al-Afdal, who served as vizier from 1094 until his assassination in 1121, became as powerful over the new caliph al-Musta'li as his father had been over the old, but despite Badr al-Jamali's best efforts, the once glorious Fatimid empire was now reduced almost entirely to Egypt, and even that lacked its former wealth and grandeur. Neither al-Afdal nor the Fatimid state were, therefore, in a position to confront the gravest threat facing Syria and Palestine – the First Crusade, which arrived in the Near East in 1099. The Crusaders, after defeating an army led by al-Afdal near Ascalon, took Jerusalem and established a kingdom that would outlast the Fatimids.

Al-Musta'li died prematurely two years later and al-Afdal placed the caliph's five-year-old son on the throne as *al-Āmir bi-Aḥkām Allāh* ('The Master of God's Laws'), although the Nizaris quite naturally rejected this claim. The vizier even had a special riding saddle made with a tiny seat in front of his own, so that he could parade with the infant caliph in public.[15] The greater part of Palestine as well as the Syrian coastal towns fell into Crusader hands and in 1117 Egypt was even briefly invaded by King Baldwin I of Jerusalem, although he himself died from an accident during the campaign. Meanwhile, public ceremonies and feasts multiplied in direct ratio to the number of cities that had fallen into the hands of the Franks. A cluster of court-sponsored ceremonies began in the month of Ramadan, continued through the Festival of the Sacrifice on 10 Dhu'l-Hijja and the specifically Shi'i festival of Ghadir Khumm (when the Prophet had designated 'Ali as his successor) eight days later and ended with the solemn observance of 'Ashura on 10 Muharram, commemorating Husayn's martyrdom at Karbala in 680. Taking place north of the Great Palace on the Festival Gate Plaza, these celebrations had little specifically Shi'i content, but were public and popular entertainments characterized by fancy clothes and fanfares accompanied by prayers and the distribution of food, clothing and gold.[16] In contrast to the practical works of civil and religious architecture his father had erected, al-Afdal spent his money building pleasure pavilions for himself in Cairo and Fustat. In 1121 the caliph al-Amir, now grown to a young man of twenty-five, instigated the assassination of al-Afdal, confiscating his extensive properties. It took two months of concerted labour to transfer the vizier's precious objects, jewels and textiles to the palace.

Al-Amir took charge of the deteriorating Fatimid state and chose as his new vizier al-Ma'mun al-Bata'ihi, who had been closely associated with al-Afdal. Al-Ma'mun served in this position until his own execution in 1125, after he had aroused the caliph's suspicion that he was angling for his own job. During his short tenure, al-Ma'mun began construction of an observatory and ordered the restoration of seven *mashhad*s near Cairo, probably in an attempt to vindicate the claims of the ruling imam against the powerful Nizari schismatics.[17] Nevertheless, these schismatics remained a force to be reckoned with and in 1130 the caliph al-Amir himself was assassinated, by Nizari agents probably because he had made numerous attempts to refute the claims to the imamate by the partisans of his uncle Nizar and his descendants) or as a result of court intrigues.[18]

Al-Amir's assassination itself led to another succession crisis which further split the Musta'li Ismailis into the partisans of al-Tayyib, a son purportedly born to al-Amir a few months before his death and those of al-Amir's cousin Abu'l-Maymun 'Abd al-Majid, a grandson of al-Mustansir who was the eldest member of the Fatimid family, at the time a man in his late fifties.[19] 'Abd al-Majid ruled as regent and concealed the existence of al-Tayyib, who then disappeared from history. Only the Yemeni branch of the Fatimid movement, which was firmly controlled by the aged Sulayhid queen Arwa, declared in favour of the infant al-Tayyib and his descendants, and Yemen consequently ceased to recognize the legitimacy of the Fatimid government in Egypt. The Bohra community of Ismailis belongs to the Tayyibi line.

The Egyptian army then installed al-Afdal's son Abu 'Ali Ahmad, who was known as Kutayfat, as vizier. Kutayfat then imprisoned the regent 'Abd al-Majid and suddenly proclaimed the sovereignty of the twelfth

Imam of the Twelver Shi'a, perhaps in an attempt to resolve the succession crisis in the absence of legitimate claimants. In 1131, however, Kutayfat was himself overthrown and killed and 'Abd al-Majid was released from prison. He initially ruled again as regent, but in February 1132 he was proclaimed caliph and imam, assuming the title of *al-Ḥāfiẓ li-Dīn Allāh* ('The Guardian of God's Religion'). The court recognized that his succession to the imamate was highly irregular, for according to Fatimid doctrine the current imam had to specifically designate his successor. Contemporaries attempted to legitimize this irregular succession by likening it to the Prophet Muhammad's designation of his cousin 'Ali as his successor at Ghadir Khumm, but the Ismaili community continued to subdivide into rival and hostile factions, who wasted their limited resources on fighting internal feuds rather than external enemies.

In 1149 al-Hafiz was succeeded by his son Isma'il, who took the title *al-Ẓāfir bi-A'dā' Allāh* ('The Victorious over God's Enemies'); in 1154 he was succeeded in turn by his five-year-old son Abu'l-Qasim 'Isa, who took the title *al-Fā'iz bi-Naṣr Allāh* ('The Triumphant in God's Victory'), but by then the dynasty was in its death throes and patronage of the arts was not high on the agenda. Tala'i' ibn Ruzzik, a governor in Upper Egypt, became vizier and tried to maintain order, but Ascalon, the last Fatimid foothold in Syria, fell to the Crusader king Baldwin III after a siege of seven months.[20] Just before the city fell, the head of al-Husayn, which Badr al-Jamali had miraculously discovered there sixty years earlier when the city was threatened by the Seljuqs, was transferred to Cairo and interred in the dynastic mausoleum in the palace. When the caliph al-Fa'iz died childless in 1160, Tala'i' put a nine-year-old grandson of al-Hafiz on the throne as *al-'Āḍid li-Dīn Allāh* ('The Support of God's Religion'). Even viewed against the chaos of the late Fatimid period, al-'Adid's reign was extraordinarily turbulent and confused. A series of short-lived viziers, who intrigued against each other, held power, such as it was, for the Franks had resumed their invasions and established a virtual protectorate over Egypt.

One of the deposed Fatimid viziers encouraged the ruler of Syria, Nur al-Din b. Zangi (r.1147–1174), a staunch supporter of Sunnism, to help him regain the Fatimid vizierate. Nur al-Din dispatched his general Shirkuh and Shirkuh's nephew Salah al-Din ibn Ayyub (known in the West as Saladin) to help the vizier, which they did – although they then had him arrested and killed. In 1169 the caliph al-'Adid was obliged to appoint Shirkuh vizier, but when Shirkuh soon died, his nephew

Saladin succeeded him and began to restore Egypt to Sunnism. On 7 Muharram 567/10 September 1171, the first Friday of the year, Saladin ordered the *khuṭba* in Cairo to be proclaimed in the name of the reigning Abbasid caliph and a few days later the caliph al-'Adid died, barely twenty-one years old. The once-glorious Fatimid state had come to an ignominious end in Egypt 262 years after it had appeared in North Africa, although far-flung Ismaili communities survive and indeed flourish to the present day.

Military Architecture

The troubled political history of this period as well as the reduced resources of the state meant that there was neither the means nor the necessity to embark on the great construction projects, such as building cities, large congregational mosques and palaces, that had been such an important feature of the earlier period. In any event, most of these early buildings continued to be used and maintained, which meant that there was no need to build more. Instead, attention was focused either on the construction of essential public works projects to guarantee safety, such as the rebuilding of the walls and gates of Cairo, or on the building and restoration of small mosques and shrines, which are best understood as attempts to bolster popular support for the doddering regime. Prestigious buildings such as the Azhar mosque were renovated to the greatest effect at the least expense. Egyptian traditions of building were once again reinvigorated in this period by the arrival of foreign workmen and ideas, this time from northern Syria and upper Mesopotamia. The steady loss of territory meant that Fatimid architecture in this period contracted to become largely an Egyptian and increasingly a Cairene phenomenon, with little of the confident universal appeal – if not response – that had marked its earliest phase.

Badr al-Jamali's first challenge was to refurbish Cairo's defences. For the first time in a century, the Fatimid capital actually faced the threat of foreign invaders, for the Seljuq Turks had established themselves in Syria at the expense of the Fatimids and were steadily pushing south with the idea of putting an end to their Shi'i rivals in Egypt. As it turned out, the Seljuqs never made it to Cairo and neither Badr nor his Sunni enemies had any idea that the Seljuq threat would simply evaporate in the face of the European Crusaders, who suddenly appeared out of nowhere in 1099 and established four principalities in the Levant, including a kingdom in Jerusalem that did actually invade Egypt.

Badr's new set of defences moved the central sections of the northern wall sufficiently to the north so that the mosque of al-Hakim and the area to its west were brought inside the walls; on the south, the central gate was moved an equivalent distance south, suggesting that an important district had also grown up around whatever remained of the original Bab Zuwayla (see Fig. 33).[22] An inscription discovered in the middle of the twentieth century also records the construction in Muharram 480/April–May 1087 of the gate known as the Bab al-Tawfiq or Bab al-Barqiyya, a modest gate on the east side of the enclosure which was itself discovered by archaeologists in 1998.[23] Badr's efforts, therefore, affected the entire enclosure, not just parts of it.

Badr al-Jamali's new gates and walls (Fig. 84) were built of stone, not the rough brick-like masonry used for the exterior walls of the Mosque of al-Hakim or for the Sabaʿ Banat, but large, beautifully dressed limestone ashlars laid carefully in courses. Many of the stones bear hieroglyphic inscriptions indicating that Badr drew his materials liberally from the ruins of some or several ancient sites, perhaps Memphis, Giza and/or Heliopolis. Some Roman or Byzantine sites must also have been raided for materials, because the lower courses of the

84 Cairo, North Wall, exterior looking west towards Great Salient

In the century since Jawhar had established Cairo's first defences, the massive mud-brick walls and gates seem to have fallen into serious disrepair, for after he had eliminated the threat of a Qarmatian invasion, the land north of the city was open for development. Although this area did not immediately become a major district of the urban agglomeration, the caliphs al-ʿAziz and al-Hakim had built the largest mosque in the entire city to the north of the original Bab al-Futuh, indicating that the region outside the wall was safe for settlement. As we have seen, the mosque's *ziyāda* was constructed on land previously occupied by the walls and gate itself, so in the first half of the eleventh century access to al-Qahira must have been unimpeded, another indication that scholars have overstated the isolation of the Fatimid city.[21]

85 Cairo, Bab al-Futuh, detail of constructio showing ends of column shafts laid horizontally in masonry

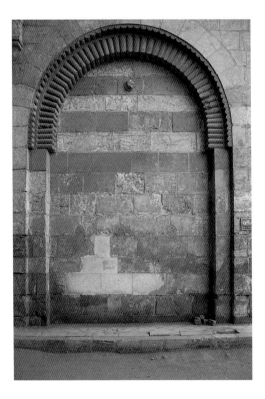

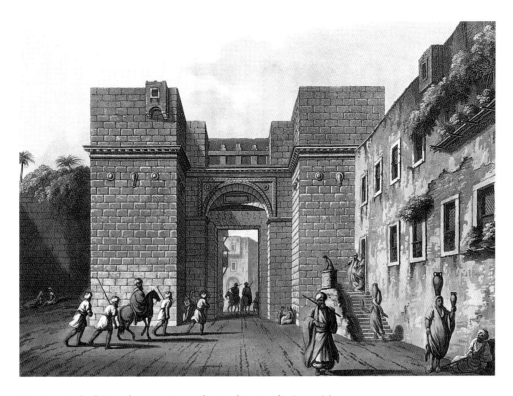

86 Cairo, Bab al-Nasr, begun 1087, as depicted in 1802 by Louis Meyer

gates were reinforced with rows of column shafts laid perpendicular to the ashlar facing, to knit it to the rubble core, thereby making it better able to withstand mining and the force of battering rams (Fig. 85). The ends of the shafts appear as circles on the face of the masonry. The stonework is uniformly superb: although the three large gates have more decoration, the curtain walls and towers were built with equal attention to detail.

In addition to the Bab al-Barqiyya inscription, another inscription next to the gate known as the Bab al-Nasr states that the Bab al-'Izz (Gate of Glory, for so it was named) was begun in April–May 1087, as was the Bab al-Iqbal (Gate of Prosperity), as the gate now known as the Bab al-Futuh was then called. In contrast, the new Bab Zuwayla on the south was begun about five years later in 1092, suggesting that, like Jawhar a century earlier, Badr was more concerned with a threat from the north and east than one from the south and west.[24] Despite Badr's attempts to rename the gates, the northern gates have retained their first Fatimid names; Bab Zuwayla on the south, however, came to be known from Ottoman times as Bab al-Mitwalli, a name it commonly retains today.[25]

Bab al-Nasr consists of two great square towers flanking a fine arched gateway (Fig. 86) leading to a pas-sageway roofed with an intersecting vault. The whole measures just over 24 metres (78 feet) across. The bottom two-thirds of the towers are solid masonry of rubble faced with ashlar; the upper third contains rooms and passages for the gate's defenders that are reached by a spiral staircase – Creswell called it 'perhaps the finest ever built for a military purpose' – enclosed in another masonry tower behind. At the base, the dressed stone facing of the two main towers is bonded to the rubble core with columns placed perpendicular to the ashlar face. The exterior faces of each tower are decorated with representations of one kite-shaped and two round shields, which may have had some general apotropaic or even some specifically Fatimid significance (Fig. 87).[26]

From Bab al-Nasr a great curtain wall with square and round-fronted towers reached by a passage within the wall extends several hundred metres to the west towards the Bab al-Futuh (see Fig. 84). A great salient, or bend in the wall, goes around the northern tower of the Mosque of al-Hakim, which was thereby integrated in the northern defences of the city. The exterior of the wall is quite plain except for a 59-metre long recessed band (Fig. 88) that begins just to the east of the Bab al-Futuh. It is splendidly inscribed with the long text detailing the foundation of the wall and its gates:

87 Cairo, Bab al-Nasr, begun 1087, detail of kite-shaped shield

88 Cairo, inscription from North Wall near Bab al-Futuh, 1087

Basmala. Q 2:256. By the power of God, the Powerful and Strong, Islam is protected; by it do fortresses and walls arise. This gate of glory (*Bāb al-ʿIzz*) and the wall that protects the well-guarded Cairo of al-Muʿizz (*al-Muʿizziyya al-Qāhira al-maḥrūsa*) – may God protect it – were raised by the slave of our sovereign and master, the imam al-Mustansir bi'llah, Prince of the Believers – may God's blessings be upon him, his ancestors, the pure imams and his noble descendants – the most noble lord, the commander-in-chief, sword of Islam, defender of the imam, the guardian of the judges of Muslims and the director of the missionaries of the believers, Abu Najm Badr al-Mustansiri – may God support the true religion through him and grant enjoyment to the Prince of the Believers by prolonging his [Badr's] life, may He make his power endure and elevate his speech! Because it is by the excellence of his administration that God has strengthened the state and its subjects and his integrity unites the élite and the general populace. [He began this] seeking God's reward and approval and asking for His generosity and benefi-cence, to safeguard the throne of the caliphate and praying to God that he may surround him with His favour. The work was begun in Muharram of the year 480 [April–May 1087].[27]

Badr's text, which is complimented by the framed inscription carved into the stones over the Bab al-Nasr (Fig. 89), was carved in a beautiful floriated kufic script with a beaded edge on plaques of marble fastened to the wall with bronze pins, which may once have been gilded to add to the decorative effect. The text, which must

89 Cairo, Bab al-Nasr, inscription over portal

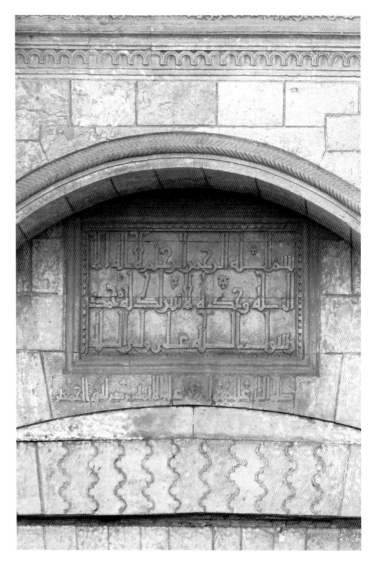

have been drawn up in the Fatimid chancery, was carefully composed, learned and witty, stressing themes such as glory and protection, echoing the Qur'anic excerpt and containing many plays on such Arabic roots as 'izz and nasha'a. Although the epigraphic style is entirely within the Egyptian canon and the content specific to Badr and the current political situation in Egypt, the idea and placement of Badr's inscription appears to have been inspired by similar inscriptions surviving on the walls of Diyarbekir, which were themselves inspired by now lost inscriptions on the walls of Edessa (Ruha) or Baghdad.[28]

The Bab al-Futuh itself (Fig. 90), just beyond the Mosque of al-Hakim, consists of two solid towers defending a great archway set back between them, but rather than the cross-vault of the Bab al-Nasr, the passageway behind the towers is covered with a dome resting on spherical-triangular pendentives. The smallest of Badr's three great gates, it measures only 22.85 metres (75 feet) across and it is constructed with stone courses averaging 52 centimetres (20 inches) in height. The towers, moreover, are oblong with rounded fronts and decorated with three blind arched panels. The arch connecting the towers is decorated with a latticework of squares, each filled with a simple but crisply carved motif – flowers, hexagrams, stars and crosses (Fig. 91). The flat faces of the brackets above the arch are decorated with beautiful arabesque ornament, typical of earlier Fatimid work at the Hakim mosque and fanciful – and unusual – bull's heads on the ends (Fig. 92). There are rooms in the upper portions of the towers.[29] On the inside wall, to the right of the gate, is an arched window curiously decorated with three tiers of muqarnas carved in the ashlars above the arch (Fig. 93). These carved niche-like elements are far more sophisticated than the plaster muqarnas constituting the cornice on the tower of the contemporary Mashhad al-Juyushi (see Fig. 98) and anticipate by several decades those on the stone façade of the Aqmar Mosque of 1125 (see Fig. 105). They demonstrate that several different types of muqarnas arrived in Egypt by several different routes at roughly the same time.[30]

Bab Zuwayla on the south (Fig. 94) is quite similar to Bab al-Futuh, with two oblong and round-fronted towers, solid for two-thirds of their height, enclosing a great arched gateway, the whole measuring about 25 metres (82 feet) across. The courses of excellent masonry average 54 centimetres (21 inches) in height and column shafts were also used to bind the stone facing to the rubble core. The late eleventh-century street level was about 3 metres/10 feet below the present

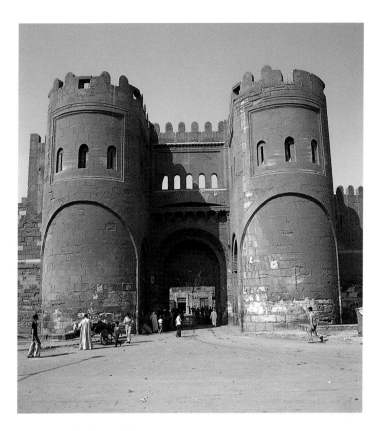

90 Cairo, Bab al-Futuh, begun 1087

grade level, as at the mosque of al-Salih Tala'i' across the street, so the portal would have appeared even more imposing than it does now. As at Bab al-Futuh on the north, Bab Zuwayla itself leads to a passageway covered with a shallow dome resting on spherical-triangular pendentives. The central voussoirs of the dome are cut, remarkably, in a spiral, a marvellous feat of medieval stereotomy (Fig. 95). The chambers that once existed in the upper story are now occupied by the bases of the twin minarets of the adjacent mosque of al-Mu'ayyad Shaykh, added to the structure in the fifteenth century.[31] The thirteenth-century historian Ibn Muyassar wrote of this gate that it did not have a bent entrance (bāshūra) like the gates of fortresses, but that originally it had a great granite glacis before it to make it difficult to attack.[32]

These three gates and the associated walls are of supreme importance as one of the few surviving examples of the military architecture of the Islamic world before the Crusades. Although earlier Fatimid builders had used stone, the fortifications are quite unlike anything done before in Egypt or even in North Africa. They reveal many similarities, however, with the military and religious architecture of northern Syria, eastern Anatolia and Armenia, which is reasonable

91 Cairo, Bab al-Futuh, detail of decoration on arch

92 Cairo, Bab al-Futuh, detail of brackets

93 Cairo, Bab al-Futuh, muqarnas hood over a window on the interior face

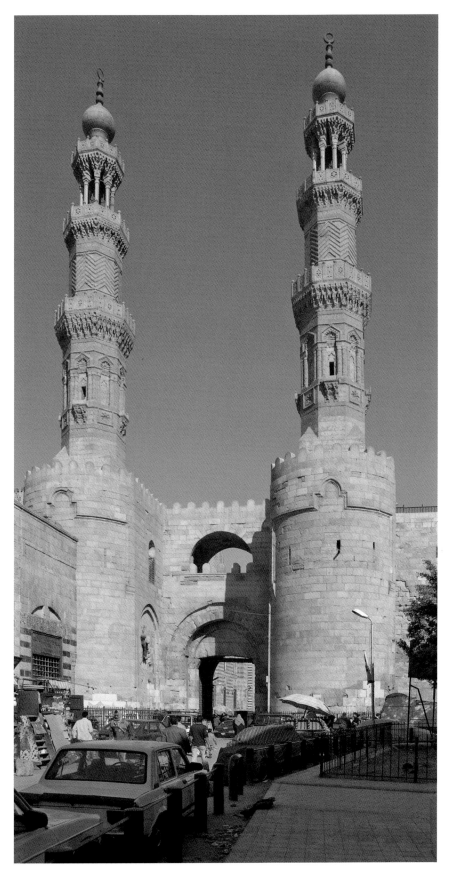

94 Cairo, Bab Zuwayla, begun 1092

95 Cairo, Bab Zuwayla interior of vault showing spiral cut stones

considering that Badr was an Armenian who had served in Syria before coming to Cairo with his own troops. Badr's own ethnic origins surely had little to do with the nature of the stonemasonry, but he must have hired workmen from these regions who were experienced in the task at hand. Cairo's new walls and gates most closely parallel the fortifications of Diyarbakır in south-western Turkey, but similar techniques are found at many other sites. For example, both square and round towers defend the walls of Ani, the Armenian capital founded in the tenth century.[33] Spherical-triangular pendentives, which were previously unknown in Egyptian architecture, were popular in Armenian architecture, as was the semicircular arch and the arcuated lintel. The use of column shafts to knit the facing to the core is a construction technique found earlier at Caesarea in Palestine. Creswell found that the only 'typically Fatimid' detail in the fortifications is the arabesque decoration on the brackets and slabs of the Bab al-Futuh (see Fig. 92), although even the bull's-heads on the brackets are similar to those at the (slightly later) Great Mosque at Diyarbakır, once again

suggesting the activities of foreign workmen in virtually every facet of the design.[34]

The walls and gates of Cairo are thus eloquent testimony of the presence of new corps of workmen in Fatimid Egypt following Badr al-Jamali's accession to the vizierate. According to the Mamluk historian al-Maqrizi, three brothers were brought from Urfa (Edessa) to Cairo. Each one of these *muhandis* (engineers) was responsible for building one of the gates.[35] While the builders' origins in the region around Urfa seem undeniable, to judge from the evidence of the gates and walls themselves, the story of the three brothers sounds suspiciously like a tale told by local guides to gullible tourists to explain why the three gates were slightly different from each other. There is, however, a more practical explanation for their differences: in an era before the widespread use of paper and drawings, as well as standardized designs and materials, there was simply no reason for all the gates to be identical and each one would have been designed and built to its own specifications, including the height of the courses and the type of vault used.[36]

128

Palaces

Despite the ransacking of the Great Palace by the Turkish troops, the caliphs continued to live there for another hundred years and the wide-eyed description of it by the Crusader Hugh Grenier of Caesarea, who saw it in the middle of the twelfth century, shows that it had lost none of its magnificence:

> The palace of that monarch is unique and, after a fashion, quite unfamiliar to our world. . . . On arriving at the palace, we were led through narrow passages entirely without light, preceded by a numerous and noisy throng of attendants armed with swords. At each entrance we found bands of armed Ethiopians . . .
>
> After passing the first and second guards, we were conducted into a large and spacious court open to the sky which freely admitted the sun's rays. There, supported by columns of marble covered with designs in relief were promenades with fretted and gilded ceilings and pavements of various coloured stones. Throughout the entire circuit royal magnificence prevailed. So elegant was both material and workmanship that involuntarily the eyes of all who saw it were ravished by the rare beauty and never wearied of the sight. There were marble fishpools filled with limpid waters; there were birds of many kinds
>
> From this court the chief eunuch led us still further on, where we saw buildings which surpassed in elegance those recently seen, just as the latter had seemed more splendid than common and ordinary structures. Here was an amazing variety of animals such as the playful hand of the painter or the imagination of the poet loves to picture, or such as the mind sees in the visions of the night – creatures such as are often found in the countries of the East and the South but which are never seen and rarely heard of in the West[37]

The increasing power of the viziers, however, meant that their palaces became more important than before. Ibn Killis, the vizier to the caliph al-'Aziz, had erected a mansion in the south-west quarter of al-Qahira that became the official residence of subsequent viziers.[38] As Badr al-Jamali did not wish to occupy this residence, he built a new one called al-Muzaffar in the Barjawan quarter to the north of the Western Palace. The house eventually became a guest-house after his son and successor al-Afdal built an immense new vizieral palace on a prominent site in the north-eastern quadrant of al-Qahira between the North Wall and the Festival Square, which was overlooked by the Great Palace. Al-Afdal eventually built yet another palace on the banks of the Nile to the south of Fustat which became the effective seat of power during the remaining years of his reign. Under his successor al-Ma'mun al-Bata'ihi, however, the locus of power reverted to the vizieral and royal palaces in al-Qahira, while al-Afdal's riparian palace became a pleasure pavilion for the caliphs. Nothing of the vizieral palace survives, but texts tell us that it consisted of many halls arranged around a central garden court with an adjacent bath.[39] Al-Afdal also built at least four pleasure-pavilions, most of them in the countryside to the north of Cairo. In the late tenth and early eleventh centuries the Fatimid caliphs themselves had built several pavilions along the canal or on the shores of the seasonal ponds near Cairo, but al-Afdal was the first Fatimid vizier to do so.[40] His successors also ordered other structures built in and around Cairo – a mint, a caravanserai, a mill and an observatory – but little is known about them apart from their names and locations.[41]

Religious Architecture

Building congregational mosques was a less pressing need in the second century of Fatimid rule in Egypt. There were already several large mosques – whether Fatimid or pre-Fatimid – in use in Cairo and Fustat and the famines and destruction of Fustat in the mid-eleventh century could only have reduced the population. Nevertheless, several viziers and at least one caliph are known to have constructed relatively modest mosques in the capital or in provincial cities. For example, Badr al-Jamali himself ordered a mosque constructed on Roda Island adjacent to the Nilometer, the early Islamic device for measuring the height of the annual Nile flood.[42] The plan of the mosque next to the Nilometer was recorded during the French expedition of 1798, as were the three inscriptions of Badr al-Jamali embedded in its walls.[43] This building was destroyed in an explosion around 1830, but as Badr's structure had already been demolished and rebuilt by the Mamluk sultan al-Mu'ayyad Shaykh in 1420, the mosque seen by the French expedition had little, if anything, to do with the Fatimid-era mosque that once stood on the site.

More often patrons in these troubled times ordered only some conspicuous portion of a congregational mosque, such as a minbar or a minaret, or a furnishing,

96 Carved wooden inscription from the lintel of a minbar in the congregational mosque, Asyut. Cairo Museum of Islamic Art

such as a mihrab or minbar, that would advertise their piety to the congregation. Badr al-Jamali is known to have passed through Asyut around 1077 during his campaign through Upper Egypt to re-establish the authority of the Fatimid caliph and a fragment of a wooden inscription bearing the name of al-Mustansir survives from the Asyut congregational mosque (Fig. 96). It is tempting to imagine that the inscription dates from this trip.

> Basmala. And the end is best for the righteous [Q 7:128 or 28:83] Our sovereign and lord, al-Mustansir bi'llah, Prince of Believers – may God's blessings be upon him and [on his] pure [ancestors] may He give victory to his armies and to his partisans, may He make his adversaries and enemies perish, may He protect Islam and the Muslims by making his reign last and by prolonging his life.... for the noble woman.

According to the Mamluk historian Ibn Duqmaq, the mosque had a remarkable minbar decorated with turned wood and little marquetry panels, and this fragment may come from the minbar ordered to commemorate this visit.[44] Although Jean David-Weill considered the vigorous floriated kufic characters to have 'an attractive sobriety', they are clearly provincial work, lacking the sophisticated epigraphic qualities that would characterize Badr's inscriptions of a decade later on the capital's walls and gates. The letters are cramped and the last few words are broken off and their reading is quite uncertain. Unlike the later inscriptions, where Badr's names and titles exceed those of the imam-caliph he ostensibly served, the vizier is not mentioned in this inscription, although the brief Qur'anic quotation would have been most appropriate in a situation in which order had been restored and malefactors punished.

A few years later, in 1081–2, a high Fatimid official, Fakhr al-Mulk Sa'd al-Dawla Sartakin, erected a tower next to the mosque at Isna (Fig. 97), a town further up the Nile. The base is a square brick prism (crowned with four little acroteria-like elements at the top corners)

supporting a tapering cylindrical shaft. The shaft itself is crowned by a three-story lantern like that on the tower at Shallal and reminiscent of the typical form of an Aswan mausoleum A marble plaque is beautifully inscribed with a long text specifying the patron's titles, who is identified as the sword (ḥusām) of the Commander of the Believers. Otherwise the ruling caliph is neither mentioned nor named, a grievous sin of omission, which may indicate his tenuous authority in this region so far from the capital. The inscription is also remarkable because it is the first surviving example of the word mi'dhana ('place from which the call to prayer is given') in Egyptian epigraphy and it thereby makes the intended function of this tower perfectly clear.[45] While one might object to a mosque tower as a symbol of

97 Isna, Minaret, 1081–2.

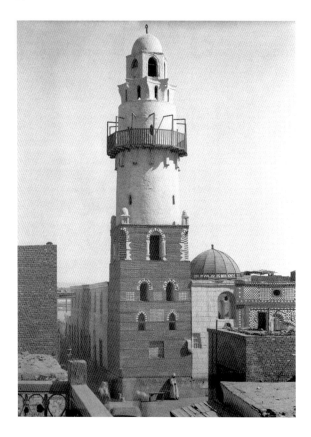

Abbasid Sunnism, a tower specifically intended as the locus of the call to prayer was becoming increasingly acceptable in the architecture of the later Fatimid period. This development, however, may be a function of Isna's distance – both geographically and politically – from the Fatimid capital.

Perhaps the most notable aspect of architectural patronage during this period was the construction and restoration of shrines honouring major and minor Shi'i saints, for these became increasingly important during the latter half of the Fatimid period. Although the Prophet Muhammad had disapproved of the memorialization of the dead, as early as the ninth century Sunni and Shi'a alike in Egypt and elsewhere had venerated the burial places of people considered particularly holy, whether through their descent or their deeds.[46] While several shrines and mausolea were constructed in the first century of Fatimid rule in Egypt, after Badr al-Jamali's restoration of Fatimid power in the second half of the eleventh century, the discovery and monumentalization of Shi'i shrines took on a new purpose, as the rulers sought to manipulate popular piety through the veneration of saints. Some of these buildings are exceedingly fine and have prominent inscriptions stating that they were constructed or restored by prominent patrons, such as viziers or members of the court, while others are anonymous constructions of varying levels of quality.[47]

The Mashhad al-Juyushi

Badr al-Jamali is perhaps best known for constructing an intriguing yet remarkably inaccessible structure on top of the Muqattam overlooking Cairo and its cemeteries in 1085, two years before he began work on the city's defences (Fig. 98). Called a *mashhad* (a word usually understood to mean 'martyrium' or 'memorial') in the foundation inscription on a marble plaque inserted in the wall over the portal, the building's popular name ultimately derives from one of Badr's titles, *amīr al-juyūsh* (commander of the armies).[48] Despite its prominence, the building is one of the few extant medieval structures in Cairo that is not mentioned by al-Maqrizi, and the thirteenth-century historian Ibn Muyassar misattributed it to Badr's son al-Afdal, suggesting that neither had ever actually seen the building close enough to read the inscription over the door that names its patron.[49]

The compact and small structure – it is only about 20 metres long – consists of several distinct parts joined rather uneasily together: an entrance flanked by a room containing a cistern and another containing a stair and surmounted by a tower, a small courtyard flanked by vaulted rooms and a sanctuary of six vaulted bays, of which the one over the mihrab is covered with a high dome (Fig. 99). A corridor leads from the courtyard to a small domed annexe attached to the north side of the sanctuary; scholars have continued to argue whether it

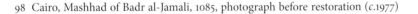

98 Cairo, Mashhad of Badr al-Jamali, 1085, photograph before restoration (*c.*1977)

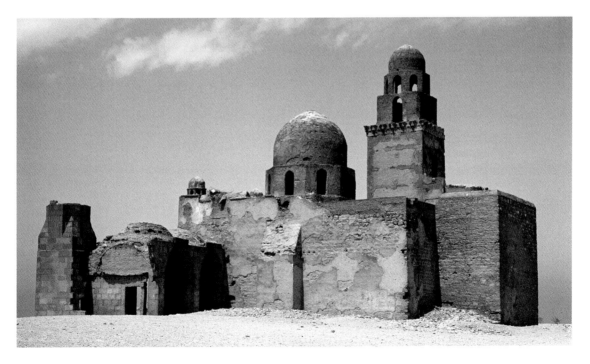

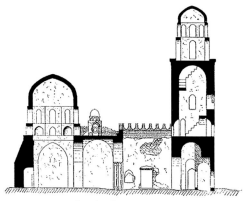

Section A-B

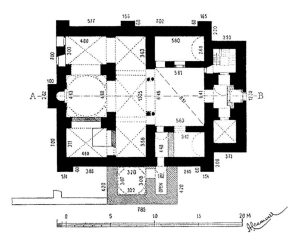

99 Cairo, Mashhad of Badr al-Jamali plan. After Creswell, *Muslim Architecture of Egypt*, I, fig. 79

is integral with the original structure or a later addition, but most now judge it to be an addition. The tower has a square shaft crowned by two tiers (there may have once been three) of brick and stucco muqarnas elements, which then supports a three-story lantern which itself resembles the typical domed mausoleum of the Fatimid period (see Fig. 53).[50] These linear muqarnas – that is, muqarnas used as a cornice – are the first known in Egypt, although linear muqarnas had been used earlier elsewhere, for example on the octagonal stone minaret of the Minuchihr Mosque (1073) at Ani in eastern Turkey.[51] They also appear slightly later on the minaret of the congregational mosque at Aleppo (1094), where the sophistication of the work suggests that they had been used in earlier decades on Syrian buildings that have not survived.[52] Muqarnas are not, however, used anywhere else in the Mashhad al-Juyushi and the dome is supported on plain squinches, not on muqarnas or muqarnas-like elements, which were apparently introduced into Upper Egyptian architecture through the Hijaz.[53]

In addition, several small domed aedicules stand on the roof of the Mashhad al-Juyushi; each contains a small mihrab. The rooms, measuring 80 centimetres (2.5 feet) square, are only 2.90 metres (9.5 feet) high. Two survived into modern times, but when the building was restored in the 1990s, three more were added to make a total of five, one atop each buttress. Much ink has been spilled over what these aedicules are, for they are too small for actual prayer. Farid Shafe'i suggested that they were sentry-boxes for guards posted on the roof,[54] but perhaps they were *mi'dhana*s to shelter the muezzin when he gave the call to prayer from the roof of the structure.

The lower walls of the building are constructed of roughly-shaped blocks of stone set in a thick bed of mortar, while the vaults, dome, drum and squinches are of dark red brick, as is the upper part of the tower, which is additionally bonded with palm trunks. The whole is covered with a layer of plain plaster. The interior of the building is now quite plain, except for an exquisite stucco mihrab (Fig. 100), a beautiful inscribed band of stucco around the base of the dome and a carved stucco medallion in its centre. (The painted ornament, which was removed during the recent restoration, dated to the Ottoman period.) The marvellously inventive spandrels of the mihrab are decorated with a loosely spiralling vine, with neither beginning nor end, fitted exactly into the allotted space. The stems terminate in palmette leaves, each of which is filled with a distinct geometric pattern, most of them based on hexagonal grids. The motifs are loosely derived from the type of ornament seen at the Hakim mosque, but are distinguished from earlier work not only by the flatness of the execution but also by the inversion of the relationship between geometric and vegetal ornament. In earlier examples, geometric frames enclose vegetal motifs, while here the vegetation encloses geometric motifs. The inscription band around the base of the dome is set against a similarly patterned ground of interlocking hexagonal motifs.[55] The inventiveness and high quality of the decoration – muqarnas, mihrab and stucco inscriptions – contrasts sharply with the simplicity of the architectural massing and construction.

The marble inscription plaque over the doorway first quotes two passages from the Qur'an (72:18 and 9:108) concerning the founding of places of worship (*masjid*), then continues that 'the construction of this blessed *mashhad* was ordered by the amir al-Juyush, the servant of al-Mustansir bi'llah, in Muharram 478 [April–May 1085].' Although Badr al-Jamali is not mentioned by name in this inscription, his epithets are twice as long

as those of the reigning imam and the text exhorts God to 'suppress his [i.e. Badr's] enemies and those envious of him as he seeks His good pleasure.'[56] The inscriptions around the mihrab again quote from the Qur'an, stating that 'Blessed be He who, if He pleaseth, will make for thee a better provision than this which they speak of, namely, gardens through which rivers flow: and He will provide thee palaces' (Q 25:10) followed by several verses (Q 24:36–38) dealing with the construction of buildings for religious purposes. This inscription finishes with Qur'an 9:129: 'If they turn back, say "God is my support: there is no God but He. On Him do I trust; and He is the Lord of the magnificent throne."' The base of the dome is decorated with the opening verses of the Victory (*Fath*) chapter (48:1–5):

> Lo! We have given thee a manifest Victory, that God may forgive thee of thy sin that which is past and that which is to come and may perfect His favour to thee and may guide thee on the right path. And that God may help thee with a powerful help. It is He Who sent down the Sechina into the hearts of the believers, that they might add faith unto their faith. To God belong the forces of the heavens and the earth; and God is the Knowing, the Wise. That He may admit the men and women who believe to gardens beneath which rivers flow.

The medallion in the apex of the dome is decorated with a hexagram of intertwined Muhammads and 'Alis surrounded by Qur'an 35:41:[57]

> Lo! God graspeth the heavens and the earth that they deviate not and if they were to deviate there is not one that could grasp them after Him.

The only clues to the building's meaning are its location, forms and inscriptions. The building is prominent but inaccessible; it overlooks but is not actually part of the cemetery. Its plan is an elaborated version of a shrine type, exemplified by the earlier Hadra Sharifa (see Fig. 41) or the later Mausoleum of Sayyida Ruqayya, rather than a mosque, although some scholars have seen parallels between its plan and that of contemporary Coptic churches.[58] Arguing against its role as a shrine, however, is the absence of any Fatimid burial in the building. Despite their differences, the simple massing and construction and the beauty and sophistication of the mihrab are almost entirely within the Fatimid Egyptian tradition. Even the tower is related to contemporary towers in Upper Egypt, although its square shaft is quite unlike the cylindrical shaft of the tower at Isna (see Fig. 97). The only discordant elements are the muqarnas

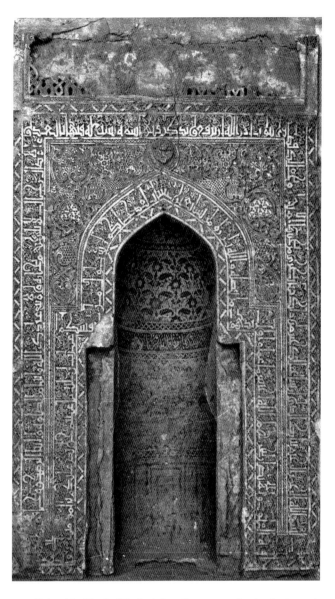

100 Cairo, Mashhad of Badr al-Jamali, stucco mihrab, photograph before restoration (*c.*1977)

cornice, which is quite foreign to Egypt and suggests some contact with points further east and north, whether Syria or Armenia, and the geometric filler-motifs in the stucco decoration, which are somewhat like the filler-motifs used in northern Mesopotamian decoration, whether contemporary Qur'an illumination or later metalwork.

Even the mosque tower, anathema to the Fatimids in the first century of their rule, was becoming increasingly acceptable for buildings erected in their realm, if not by the Fatimid caliphs themselves. Given the popularity of towers as symbols of Islam elsewhere in the Muslim lands, particularly in Syria and the lands controlled by the Seljuqs, the increasing frequency of towers in later

the Seljuqs, the increasing frequency of towers in later Fatimid architecture should not come as too much of a surprise. The Fatimids were no longer strong enough culturally to offer a viable alternative, particularly as the population of Egypt increasingly rejected Ismailism. Yet it may be significant that the builder has hedged his bets, providing not only a tower but also several shelters for the muezzin on the roof. Nowhere is the purpose of the tower specified by inscription. In contrast to contemporary Christendom, Islamic societies lacked the institutions to keep meanings firmly associated with architectural forms, so precise meanings tended to revert rather quickly to a general level of acceptability. That said, it is noteworthy that the only mosque erected by a caliph in this period, the mosque of al-Aqmar (1125), did not originally have a tower.

At least a century earlier, Fatimid builders had selected Qur'anic inscriptions to specify meaning at al-Azhar and later at the mosque of al-Hakim. The content and placement of the Qur'anic inscriptions in this building suggest that they were deliberately chosen to make some specific theological point, although scholars have differed about exactly what this point might be. The inscriptions emphasize the idea of building mosques for prayer and the rewards of paradise, but scholars have interpreted the inscriptions and hence the building in very different ways. While Shafe'i interpreted the building as a watchtower disguised as a mosque, most others have understood it as a structure built to commemorate the military triumphs of its founder.[59] Such an interpretation would seem to accord well with the prominent, if inaccessible, location and the martial tone of the foundation inscription over the door, if not with the normal meaning of the term *mashhad* as a funerary shrine.[60] Yusuf Raġib, however, disagreed, suggesting that a *mashhad* did not have to be a shrine but could be understood as any place of pilgrimage or assembly, which might (or might not) include a burial; he concluded that this building was simply a mosque. He drew his examples from northern Syria (whence the patron had come), but also argued that these terms were also used somewhat interchangeably in Egypt.[61] This explanation in turn presents its own problems, as it begs the question of why Badr would have chosen to build a mosque of such unusual form in such an inaccessible place. Where would the congregation have come from? In short, unless some new contemporary source for this building is found (and this period is one of the worst documented in Fatimid history), the building's original meaning will remain a matter of lively speculation.

Al-Husayn's Shrine and Minbar at Ascalon

Ascalon ('Asqalan in Arabic and Ashquelon in Modern Hebrew) was the only city in southern Palestine set right on the sea. Owing its prosperity to its prime location and fertile hinterland, the city was important in the Fatimid period, to judge from several inscriptions preserved there.[62] According to some Islamic traditions, the head of al-Husayn, the Prophet's grandson and progenitor of the Fatimid line, had been sent as a trophy in 680 from Karbala in Iraq to the Umayyad caliph al-Yazid I (r.680–683) in Damascus. We hear next of the head in 1091–2, when it was fortuitously discovered buried at Ascalon, whence it had supposedly been carried and Badr al-Jamali building a *mashhad* to house it. The head had no known connection with Ascalon, but interest in the head seems to have been a syncretistic revival of pre-existing Syrian popular cults of venerating saints' heads, notably that of John the Baptist, whose head is still venerated in the Great Mosque of Damascus, combined with the need for generating some popular support for Fatimid authority in the region.[63] At the very end of the Fatimid period, just before the Fatimids finally lost the city to the Crusaders, the head was transferred from Ascalon to Cairo, where it continues to be venerated in the Mosque of Sayyidna Husayn there.

Apart from the record of a now lost inscription,[64] all that remains of the Ascalon shrine is a magnificent wooden minbar (Fig. 101), which was itself transferred to the Shrine of the Patriarchs at Hebron sometime in the medieval period, perhaps in the late twelfth century when the head was moved to Cairo. Although the fragmentary inscription from Asyut discussed above suggests that a minbar had been ordered there during al-Mustansir's reign, the minbar from Ascalon is one of the earliest wooden minbars to survive anywhere and a masterpiece of Fatimid woodwork. The presence of the minbar, moreover, unequivocally indicates that the shrine of al-Husayn at Ascalon, unlike the Mashhad al-Juyushi and other Fatimid period shrines in Egypt, was a congregational mosque, for its primary function was to serve as the pulpit from which the Friday sermon would have been pronounced.

The minbar, like most others from the central Islamic lands, is a triangular wooden structure with a flight of steps leading up to a raised seat. A pair of elaborately decorated doors, framed and surmounted by an elaborate inscription and a gilded muqarnas cornice, controls access to the stairs. The stairs are flanked by spoolwork (*mashrabiyya*) railings, themselves enclosed by inscribed frames, leading to a platform protected by a canopy

supported by an elaborate muqarnas cornice and covered by a dome. The minbar is notable for the beautiful geometric design on its sides (Fig. 102), which is divided above the base into two panels – a narrow vertical panel beneath the platform and a triangular field under the railing – by a vertical scrollwork band between two plain fillets. Both panels are decorated with a large-scale strapwork pattern based on a hexagonal lattice of zigzag lines enclosing two sizes of hexagons, hexagrams (six-pointed stars) and bow-tie shapes where they intersect. As the 45° rise of the steps is less than the 60° angles governing the hexagonal design, the edge of the stair cuts across the field design somewhat uneasily. The individual panels of the flanks are themselves richly carved with delicate arabesques, often combined with interlaced star-patterns, but vine motifs, which are typically found in Egyptian woodcarving, are absent.[65] The complex geometry, composed of hundreds of individual elements carefully fitted together with tongue-and-groove joints, also differs from Egyptian woodwork of the eleventh century, as craftsmen there preferred to make rectangular panels which they enclosed in rectangular mortised frames or large beams which were decorated with medallions. The *mashrabiyya* grilles under the handrails, composed of a 90° lattice of turned elements, are the earliest dated example of a technique that would become extraordinarily popular throughout the region. Although the gilded muqarnas cornice over the door was probably added during some later restoration, the two tiers of larger muqarnas elements over the platform are probably contemporary, for they are quite similar in form – if different in material – to those on the tower of the Mashhad al-Juyushi in Cairo.

The long inscription over the minbar's door and on its balustrades records the miraculous manifestation, triumphal exaltation and magnificent installation of the head in a new *mashhad,* and the construction of this shrine registered Badr's intention to turn the frontier-post of Ascalon into a rallying point for beleaguered Fatimid ambitions in Syria.[66] According to the long text, God caused

> the appearance of the head of . . . al-Husayn . . . in a certain place in Ascalon where the oppressors, may God curse them, had concealed it, in order to cause the obliteration of his light which He, may He be exalted, promised as a sign for its appearance.

God granted that the head would appear to Badr al-Jamali and singled him out to be favoured with its veneration and with the dignity of its sacred shrine. And he resolved upon the construction of this pulpit

101 Minbar ordered by Badr al-Jamali in 1081 for the Shrine of al-Husayn at Ascalon, later moved to Hebron, Shrine of the Patriarchs

especially for the venerable martyrion which he had founded and wherein he had buried this head, in a most noble place so that it should be a qibla for the amir and for the prayer of those wishing to have their prayers accepted and an intercessor for those who seek its mediation and for the visitors. He built the martyrion from its foundation to its top and he acquired for it properties the income of which he tied up inalienably for its maintenance, its custodians and for its guardians, for the present time and for the future, until God inherits the earth and whatever is on it, for He is the best of all inheritors. He [Badr] spent on all this from that which God graciously benefited him with, namely his legitimate fortune and the purest of all his possessions, for the sake of pleas-

102 Badr al-Jamali's minbar from Ascalon, detail of side panels

ing God and seeking His reward and pursuing His approval[67]

In other words, the appearance of Husayn's head was a divine miracle, one of a string in which God had honoured the family of 'Ali and consequently the Fatimid caliphs. However, Badr, the servant to the Fatimid caliph, gets all the credit and paid all the cost of erecting the new shrine and minbar from his own personal fortune, marking another turning point in the diminution of caliphal patronage of the arts. Rather than turning to Egyptian craftsmen to build his shrine and minbar, Badr must have turned to local Syrian or Palestinian ones, who already possessed the ability to produce high-quality woodwork with complicated geometric designs. Although no earlier Syrian examples of this technique are known, absence of evidence is not evidence of absence. In short, this minbar is of the utmost importance for it is quite unlike earlier Fatimid woodwork and prefigures the fine woodwork with geometric decoration of the late Fatimid, Zangid and Ayyubid periods, the latter closely associated with the city of Aleppo.[68]

In Rabi' II, 482/June 1089, just before his death, Badr al-Jamali ordered the restoration of the mausoleum of Sayyida Nafisa, the first 'Alid to be buried in Egypt. Her grave, established around 210/825, had undergone many restorations over the course of the centuries, but Badr's was apparently the first official renovation of the build-

ing, according to a now-lost inscription that must have been written after Badr's son al-Afdal Shahanshah succeeded his father to the vizierate.[69] The present mausoleum dates from the late nineteenth century and the only remaining Fatimid element is a magnificent wooden mihrab, which will be discussed in Chapter 6.

Mihrab of al-Afdal in the Mosque of Ibn Tulun

Al-Afdal was perhaps more famous for his pleasures than his piety, but he himself did order several works of religious architecture, including a mosque at Giza, a large minaret for the Mosque of Amr in Fustat and on the Jarf hill overlooking Cairo, and the Elephant Mosque (*jāmi' al-fiyala*), which got its name from the rounded shape of its nine domes, supposedly resembling the backs of elephants (Arabic *fīl/fiyala*).[70] The Elephant Mosque was the initial site of an enormous astronomical instrument that al-Afdal ordered prepared for an observatory begun after 1119.[71] An inscription dated 482/1089 in the names of al-Mustansir and al-Afdal recorded the construction of a portal (*bāb*) for the Mausoleum of Sayyida Nafisa (762–824), who was a great-granddaughter of Hasan, the Prophet's grandson. She had been born in Medina but moved to live in the Egyptian capital. Married to a son of the sixth Shi'i imam Ja'far al-Sadiq, she bore him two children, a son al-Qasim and a daughter Umm Kulthum. Nafisa was

known for her piety and immense knowledge of prophetic traditions, which she transmitted to the Imam al-Shafi'i among others. After her death, she was buried in a grave she had dug herself in the floor of her house and her gravesite subsequently became a focus of popular veneration. The shrine was subsequently restored by al-Hafiz in 532/1138 and perhaps again in 541/1147 when the wooden mihrab was ordered.[72]

Of all al-Afdal's works, however, only two small examples have survived. The first is a magnificently large and prominently sited plaster mihrab for the Mosque of Ibn Tulun (Fig. 103). The mosque, which had been built in the late ninth century, continued to be used throughout the Fatimid period. Jawhar had attended Friday prayer there soon after the Fatimid conquest,[73] and towards the end of the Fatimid period, according to Ibn al-Tuwayr (d.617/1220), the historian of the late Fatimid court, when the caliph passed by on his way to celebrate the opening of the canal, an acrobat performed tricks on a long rope strung up between the top of the tower and the street.[74] The function of the mosque's tower may have been a matter of contention for the Fatimids in the eleventh century. Nasir-i Khusraw reports, somewhat fantastically, that the descendants of Ibn Tulun had sold the mosque to the caliph al-Hakim for 30,000 dinars. When the descendants began to tear down the tower, the caliph is said to have inquired what they were doing, since he had already bought the mosque from them. They replied that they had sold him the mosque, not the tower, so the caliph was forced to pay them another 5,000 dinars for it.[75] The story has been compared to a well-known Arabic folk tale, 'Juha and the Nail', and is unlikely to be true, since no other source reports it. Nevertheless, that such stories were circulated in mid-eleventh-century Egypt suggests that the Fatimids may have been uneasy with this very prominent and distinctive tower as a part of a mosque.[76]

Whatever the Fatimids' feelings towards Ibn Tulun's tower, the mosque continued to be a place of congregational prayer, undoubtedly because it was located between Fustat and Cairo. According to an inscription dated 1077 over the north-east door of the outer wall, Badr al-Jamali ordered the restoration of 'this door and that which surrounds it, after the fire had destroyed the innovations (mā abda'ihi) that the heretics (māriqūn) had left there'. This must refer to some damage the mosque suffered during the period of troubles, although van Berchem did not think that this restoration amounted to much since al-Maqrizi does not mention it.[77] Almost two decades later, immediately after Badr's

son al-Afdal acceded to the vizierate, he ordered a magnificent stucco mihrab for the mosque. Measuring 3.15 metres (10 feet 4 inches) high and prominently located on one of the piers in front and to the left of the main mihrab, it is testimony to the new vizier's exalted position but limited charity, for by erecting this mihrab he could make a public statement without going to the great expense of building and endowing an entire mosque.

The mihrab comprises a rectangular frame with an upside-down U-shaped band enclosing two horizontal bands above an arched frame, which itself encloses a smaller arch. The large inscription around the exterior specifies the patron's titles; the borders of the inner arch contain Qur'anic inscriptions (35:34 and 29:45). The historical inscription is not dated, but as it is written in the names of both al-Mustansir and al-Afdal, it must date to the brief period when both were in power, the middle of 487H (the second half of 1094). A small inscription across the top appears to be historical in content and the innermost arch contains a (restored) inscription in very large kufic letters.

The mihrab of al-Afdal has been celebrated as a great example of Fatimid stuccowork, but the crowding of the letters at the corners, especially at the top, suggests that the designer was simply not up to the task: a more accomplished designer would not have turned the corner so inelegantly or crowded letters in this way. He did so, however, for a specific reason, for he wanted to place the names of the major players prominently: the caliph's name and titles begin at the top right, while the vizier's begin at the top of the left side. We can imagine that the artisan was handed the text of an inscription, presumably written out on paper in the chancellery, which he then tried to fit as best he could into the space allowed by the preconceived design. A more accomplished artisan at a later date would have designed the mihrab on paper, worked out the problems and then executed it in plaster.

Al-Afdal's mihrab differs from the plaster mihrab erected by his father at the Mashhad al-Juyushi less than a decade earlier not only in execution but also in design. In contrast to the deep semicircular niche at the mashhad, al-Afdal's mihrab is flat, presumably because its location on a pier precluded carving out a deep niche. But the differences go even further: in contrast to the simple framed niche of his father's example, al-Afdal's mihrab consists of nested frames and arches, a scheme quite unlike earlier – and even later – Egyptian mihrabs. The straight carving is quite different from the extensive stucco work in the mosque of Ibn Tulun.

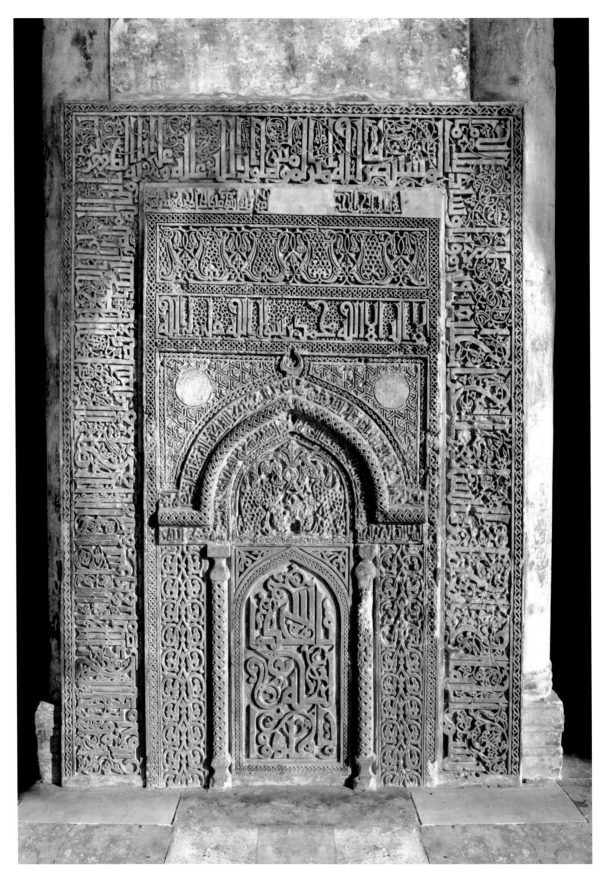

103 Cairo, Mosque of Ibn Tulun, mihrab ordered by al-Afdal in 1094

Indeed, Creswell compared it not to Egyptian examples, but to a series of flat plaster Persian mihrabs, such as the late tenth-century example in the mosque at Nayin, and his comparison remains as valid today as when he first made it fifty years ago.[78]

Some of the small geometric patterns used as filler motifs in the horizontal bands are already found on the Juyushi mihrab and dome inscription, but other features such as the little holes at the ends of the letters are more characteristic of contemporary Iranian epigraphy. Still other features, such as the Y-fret motifs filling the spandrels of the arches, also point further east. Exact parallels are difficult to find because so few works of art have survived from contemporary Syria, Armenia and Mesopotamia, but to my knowledge the Y-fret first appears as a filler motif on some of the decorative pages at the beginning of the copy of the Qur'an penned by Ibn al-Bawwab at Baghdad in 1000.[79] This same pattern is later found on Mosul metalwork of the twelfth and thirteenth centuries. This combination of features in design and execution of this mihrab suggests that it must have been the product of some sort of team effort, combining both native Egyptian and foreign expertise, perhaps from Iran.

104 Cairo, Mashhad of Umm Kulthum, mihrab, 1122

The Aqmar Mosque, 1125

The vizier al-Afdal was assassinated on the orders of the caliph al-Amir, who tried thereby to re-establish the power of the caliphs over the viziers. Al-Amir's choice to replace him was al-Ma'mun al-Bata'ihi, who had been chief of staff for the former vizier. The elevation of al-Ma'mun to the vizierate marks a dramatic increase in the amount of information available about the Fatimid state, as more chronicles and other kinds of sources survive whole or in part. For example, al-Ma'mun's son, Ibn al-Ma'mun (d.588/1192), himself wrote a four-volume history that later historians relied on heavily.[80] Before his imprisonment in 1125 and eventual execution, al-Ma'mun is said to have built many congregational and smaller mosques in several localities in Upper and Lower Egypt, as well as various constructions in Cairo itself, but it is unclear whether the number represents an absolute increase or simply an increase in the quality and quantity of information.[81]

In 516/1122 al-Ma'mun ordered his agent to restore seven masjids, of which the first was that of Sayyida Zaynab, a daughter of 'Ali b. Abi Talib by a wife other than Fatima, and the last that of Kulthum, a great-granddaughter of Imam Ja'far al-Sadiq. The buildings were restored and a marble plaque was placed in each

with its name and the date of restoration. Of these works, only the beautiful and unusual mihrab in Mashhad of Umm Kulthum remains (Fig. 104). It has a fluted shell hood of ten alternately angular and rounded ribs that emanate from a central boss. The recess wall is covered with a rather primitive strapwork pattern of two rows of eight-pointed stars and crosses, the stars are inscribed either 'Muhammad' or 'and 'Ali'.[82] Although Creswell linked several features of this mihrab to North Africa, the unusual profile of alternating rounded and angular ribs is more closely tied to monuments from Northern Syria and Mesopotamia, such as at Aleppo and Dunaysir.

The diminutive al-Aqmar Mosque is the only other extant structure commissioned by al-Ma'mun. Built on a small plot (roughly 24 × 38 metres; 79 × 123 feet) north of the Great Eastern Palace facing the main north–south street of al-Qahira, the building was begun in 1122 and completed in 1125. The prime location, which had previously been the site of a royal pavilion (and a storage place for fodder), as well as the prominence of the name of the imam (and his father) in the dedicatory inscriptions on the façade, indicate that such a building could not have been erected without the caliph's expressed approval.

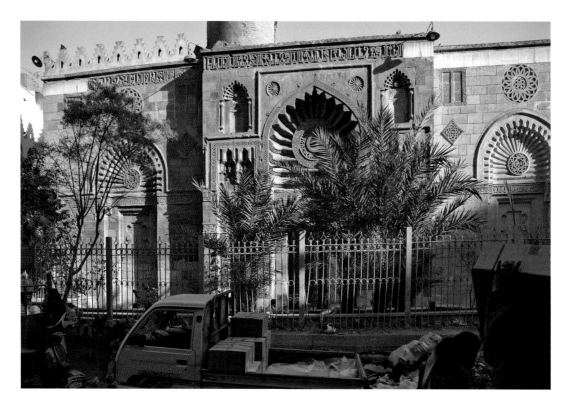

105 Aqmar Mosque, view of façade, 1125

The slightly projecting entrance (Fig. 105) leads to a small courtyard surrounded by arcades of three arches on each side (Fig. 106). On the qibla side of the court, the arcades create a small prayer hall three bays deep; elsewhere they are but one bay deep. To the left of the prayer hall are two small closets and a small room that projects beyond the line of the exterior wall. The court arcades are outlined with inscriptions carved in the plaster; only fragments of them remained before the building's recent – and total – restoration.

The interior arrangement of the mosque is exactly what one might expect for the smallest possible hypostyle mosque with a courtyard built in the Fatimid period, where every element has been reduced to absolute minimum. The exterior of the building, however, particularly the north and west façades, is quite unusual: instead of being oriented to the interior of the mosque, the façades are oriented to the adjacent streets, creating spaces between the lines of the outer and inner walls which have been filled with small rooms and a staircase to the roof (Fig. 107). The small room to the left of the prayer hall projects 2.5 metres from the line of the wall, but the masonry is quite different, being composed of alternating courses of brick and stone, and must have been the result of a later addi-

tion or renovation. The mosque was later given a minaret, but the walls of the ground floor do not provide enough support to indicate that one was intended in the original plan.

The mosque's main façade, perhaps the most beautiful ensemble of Fatimid stonework to survive, was originally a symmetrical composition arranged around a salient entrance about 7 metres (23 feet) wide and set forward about 70 centimetres (2.3 feet) from the line of the façade. Two magnificent foundation inscriptions cross the façade (Fig. 108); the text includes Qur'an 24:36–37, dealing with those who raise temples to God and commemorate His name therein, and prominently mentions the names of the vizier, the caliph and his father.[83] The upper text is written in an elegant, occasionally floriated kufic script, while the lower text has shorter letters inscribed against a gently scrolling vine that fills the spaces between the ascending letters. The central doorway (Fig. 109) has an elaborately arched hood with ribs radiating from a splendid pierced stone medallion, containing the intertwined names of Muhammad and 'Ali surrounded by Qur'an 33:33, the verse referring to the 'People of the House', which the Shi'a believe is a specific reference to the descendants of 'Ali.

140

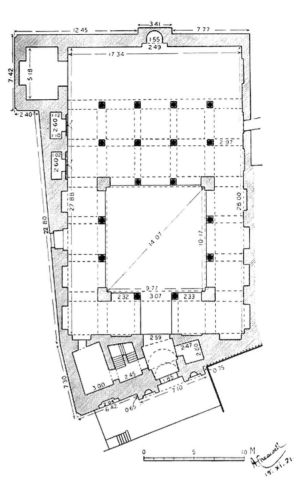

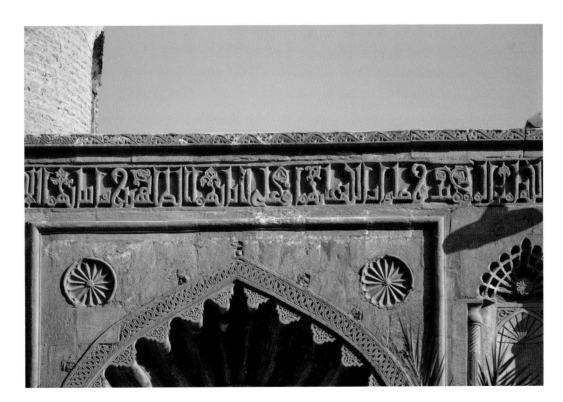

106 (ABOVE LEFT)
Aqmar Mosque,
view of interior
court

107 (ABOVE RIGHT)
Aqmar Mosque,
plan, 1125, after
Creswell, *Muslim
Architecture of
Egypt*, I, fig. 141

108 (LEFT)
Aqmar Mosque,
inscription on
façade before
restoration

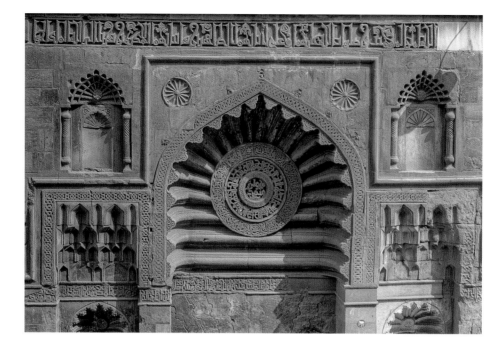

109 Aqmar Mosque, detail of portal before restoration

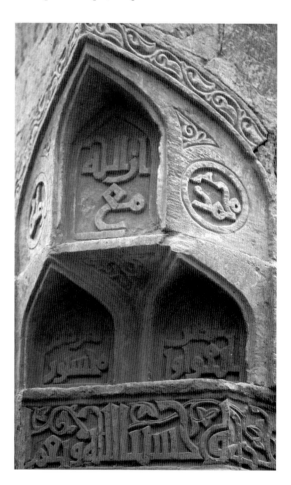

110 Aqmar Mosque, muqarnas corbel on north corner

The doorway is flanked on either side by superposed niches and muqarnas hoods carved in the stone. Until quite recently the right side of the façade was hidden by a house and had to be imagined, but during the recent renovations the house was removed and the right side reconstructed as a mirror image of the left.[84] Each side now contains a slightly recessed panel capped by a ribbed arch, with the arched panel flanked by small panels of fine stonework. These include two squares poised on a corner, two rectangular panels (one containing the representation of an arched niche with a hanging lamp, the other a door) and a central circular panel which is now filled with a medallion modelled on one that survived on the north-east wall. The latter is otherwise undecorated except for an elegant chamfered treatment of the north corner and the remains of the inscription and cresting along the top. A simple door, now blocked, in this wall once led to the middle bay of the court arcade.

Many of the individual motifs and techniques of carving stone can be traced to the decoration on the portal and towers of the nearby Mosque of al-Hakim, but the prominent use of muqarnas on the façade of this building is novel and appears to be yet another Syrian import. Although muqarnas decoration is mentioned as early as the vizierate of Yazuri, the first examples to survive in Cairo date from the vizierate of Badr al-Jamali: a muqarnas cornice separates the stories of the

tower attached to his *mashhad* on the Muqattam (see Fig. 98), but their use there as a separating element is quite different from their use as filler motifs and transitional elements on the Aqmar façade.[85] These ones are much closer in conception to, but far more elaborate than, the few tiers of muqarnas elements curiously carved in the blocks over a small window in the North Wall near the Bab al-Futuh (see Fig. 93).[86] At the north corner of the Aqmar mosque, another composition of two tiers of muqarnas neatly crowns the chamfered corner of the building (Fig. 110). The individual cells are wittily inscribed with an elegantly written text from Qur'an 16:128, 'For God is with those who restrain themselves and those who do good', with the names of Muhammad and 'Ali in the spandrels on either side. (The text was probably chosen for its punning value, as the word *muḥsinūn*, 'those who do good', stems from the same root as the names Hasan and Husayn.) At this state of our knowledge, however, it is impossible to say exactly how these early examples of Egyptian muqarnas are related. The chamfered corner would become a typical motif in later Cairene architecture.

This small mosque is notable for two other features. First, its double alignment to the qibla and to the street is the first surviving example of a practice that would come to characterize most religious architecture in Cairo, as an increasingly dense urban environment put space at a premium and forced builders to wedge buildings into irregular plots bounded by streets and other buildings while maintaining their interior orientation towards Mecca. Second, the building's richly decorated façade is unusual and demands explanation.

On a strictly formal level this façade can be understood as the continuation and refinement of a decorative tradition established in the first Fatimid mosque at Mahdiyya and continued in the Azhar and Hakim mosques of Cairo, in which a more-or-less decorated portal, itself ultimately derived from a Roman triumphal arch, projects from the mosque's principal façade. The façade of the Aqmar mosque, therefore, much like its interior, can be seen as a distillation or concentrated essence of the ideal Fatimid mosque, in which all the essential elements – prayer hall, courtyard and façade – have been compressed and refined to create this rich decorative composition.

The building's façade can also be understood as a response to its physical context, for it was constructed on a prominent site immediately to the north of the Fatimid palace. The mosque's designer probably intended that its façade should reflect or respond in some way to the external articulation of the palace itself, which

is, of course, entirely lost to us today. Working backwards from the Aqmar mosque, one might imagine that the exterior walls of the palace – or particularly its gates – were themselves decorated with blind arcades and inscriptions which the mosque's façade would have mirrored or complemented. Were the palace to have been decorated in this manner, it would also explain the widespread use of blind arcades and inscription bands on the façades of the Ayyubid and early Mamluk charitable foundations that increasingly replaced the Fatimid palaces in the heart of Cairo after the dynasty's fall.

The elaborate exterior decoration of the Aqmar mosque has also been interpreted in several symbolic ways. At the simplest level, the façade has been explained as a projection of the mosque's interior on to the street, a gigantic qibla wall, as it were, articulated by the blind arcades that suggest the multiple mihrabs found in several shrines of the Fatimid period, such as the undated mausoleum of Ikhwat Yusuf in the Qarafa cemetery, usually dated to *c*.1145 (Fig. 111).[87] There is no evidence, however, that this mosque ever had more than one mihrab inside and the significance of multiple mihrabs in Fatimid shrines remains to be explained. Furthermore, the façade does not point in the direction of Mecca, which would make it inappropriate as a focus of worship.

The façade has also been interpreted as a highly charged image in the context of Fatimid Ismailism, where each element – niche, radiating rib, muqarnas, lamp and door – would have had a specific esoteric meaning in Ismaili thought. Thus the arrangement of three main niches would represent 'Ali, Hasan and Husayn, while the entire composition of seven recesses would recall the first seven imams of the Ismaili line.[88] Although such an interpretation is certainly possible, there is nothing to demand that the building be interpreted in this way, and the Qur'anic inscriptions on the façade, which deal with mosques and the descendants of Adam, seem quite at odds with such a specific symbolic interpretation. Another interpretation places the façade in the context of the elaboration of Fatimid ceremonial under the caliph al-Amir, in which the building was meant to celebrate the return of the city and its palace to splendour.[89] Again, such an explanation is possible, but certainly not necessary. Like all great works of art and architecture, the building somewhat smugly withstands all our best efforts to unravel its secrets.

Quite simply, there is nothing at all to prevent us from interpreting this marvellous building in almost any way we please, and at the same time nothing in the building

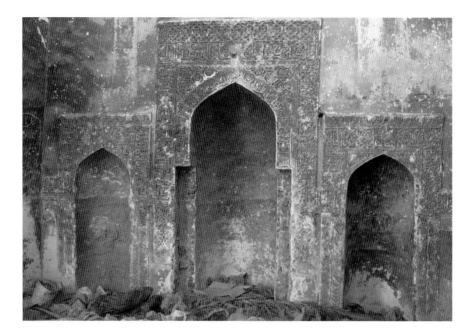

111 Cairo, Mausoleum of Ikhwat Yusuf, triple mihrab

requires the primacy of one explanation over another. If we are to accept the premise that the building was meant to have a deep symbolic meaning, then we must first establish either that Fatimid builders and patrons had long been familiar with the practice of giving their buildings symbolic meaning, a principle not supported by the earlier evidence, or that the patron or designer of this particular building came up with the idea himself. This supposition is entirely possible, for indeed processions became much more elaborate in this period, although the sources are mute about any specific role this building might have played in such activities.[90] Whatever the specific meanings the patron and builders may have assigned to the mosque, there was no societal mechanism – whether in Fatimid Egypt or in the Islamic lands in general – for maintaining such meanings over any substantial period, and succeeding generations, particularly of Sunnis, saw nothing particularly Ismaili or sectarian about this façade. Like much Islamic religious art from other times and places, therefore, the façade of the Aqmar mosque is ambiguous to us today. It may have been designed with some specific meaning in mind, but we have been left free to read into it as much – or as little – as we like.

The original mihrab in the Aqmar mosque no longer survives, but during the recent restoration it was reconstructed in marble, following the design of the wooden mihrab (Fig. 112) presented in the same year by the caliph al-Amir to the Azhar mosque and that is now in the Islamic Museum.[91] The mihrab itself is a massive

hunk of wood hollowed from a single log. A long inscription, once painted, is carved in six lines on a wooden panel attached to the top of the mihrab:

In the name of God the Merciful, the Compassionate. Be you watchful over the prayers and the middle prayer; and do you stand obedient to God [Q 2:239]. For such prayers are a timed prescription for the Believers [end of Q 4:103]. This blessed mihrab for the noble Azhar congregational mosque (*jāmi'*) in the Cairo of al-Mu'izz is among the things that was ordered by our master and lord al-Mansur Abi 'Ali, the Imam al-Amir bi-Ahkam Allah, Commander of the Believers, may God's blessings be upon him, his pure ancestors and his noble descendants, son of the Imam al-Musta'li bi'llah, Commander of the Believers, son of the Imam al-Mustansir bi'llah, Commander of the Believers, may God's benedictions be on them all and on their ancestors, the pure imams, the sons of the rightly-directed guides and complete peace until the Day of Judgment. In the months of the year 519. Praise be to the One God![92]

The letters in the first five lines are much more crowded than the last line that bears the date and the superfluous phrase 'Praise be to the One God!' These features suggest that the designer did not plan out the text carefully before carving. He squeezed in the letters of the first line and found himself with too much extra space at the end. The monolithic mihrab is surrounded by

144

four rectangular panels (the lower ones have been restored) bearing shallow carved arabesque decoration set into a mortised frame, itself lightly carved in the Bevelled Style with a gently scrolling vine and leaves.

Although the Aqmar mosque and the Azhar mihrab are exact contemporaries, the wooden mihrab appears decidedly old-fashioned, being closer in proportion to the earlier mihrabs at the Mashhad al-Juyushi or even al-Azhar than to the semicircular or keel-arched fluted hoods of contemporary shrines. Furthermore, the decoration of its frames is entirely different from the geometric patterns that decorate other twelfth-century mihrabs, with its shallow Bevelled-Style carving and vegetal motifs. The inscription panel appears to have once been set into a rectangular wooden frame, which would have made it significantly larger than the mihrab assemblage below it. The top rail of the mihrab frame is gently rounded, as if it had once been fitted into a slightly arched niche. Historians are silent about this mihrab and the circumstances under which it was given to al-Azhar. Rather than date it in its entirety to the twelfth century, it may very well be a venerated relic given to the mosque and commemorated in an inscription in an attempt to publicize the ruling caliph's lineage.[93]

Such an interpretation is supported by the remains of an inscription that once ran around the portal of the mosque of Sidi 'Abd Allah al-Sharif (formerly known first as the Fath and then the Abu'l-Ma'ati mosque) at Damietta, which was renovated on the order of the caliph al-Amir in 1127. The inscription, carved in floriated kufic on six wooden beams of unequal length measuring 23.8 metres (78 feet) long and 23 centimetres (9 inches) high, is somewhat the worse for wear and is now in the Islamic Museum (Fig. 113).[94]

(1) In the name of God, the Merciful the Compassionate. Only he shall inhabit God's places of worship who believes in God and the Last Day and who performs the prayer, (2) and pays the alms and fears none but God alone, it may be that those will be among the guided [Q 9:18]. Ordered the restoration of this (3) blessed mosque the Imam of the Period and the Age – may peace be upon his mention – our (4) lord and master al-Mansur Abu 'Ali al-Amir bi ahkam Allah, (5) Commander of the Believers – may God's blessings be upon him and upon his most pure and rightly-guided ancestors and upon his most magnanimous (6) descendants – eternal blessings until the Day of Judgment in the month of Rajab 521 [July–August 1127].[95]

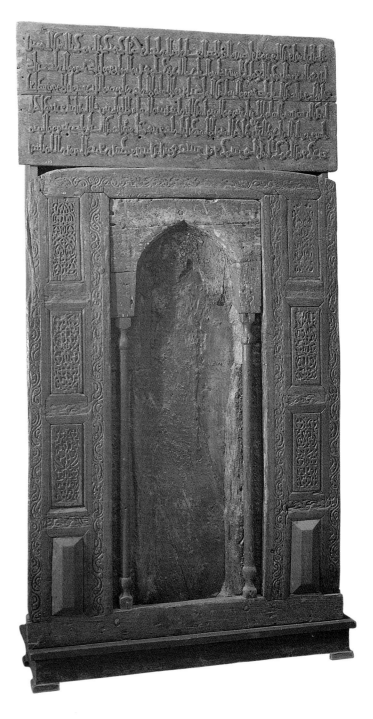

112 Wooden mihrab presented by al-Amir in 1125 to al-Azhar, inscription panel measures 122 × 54 cm (48 × 21¼ in.). Cairo, Museum of Islamic Art, inv. nos 420 and 422

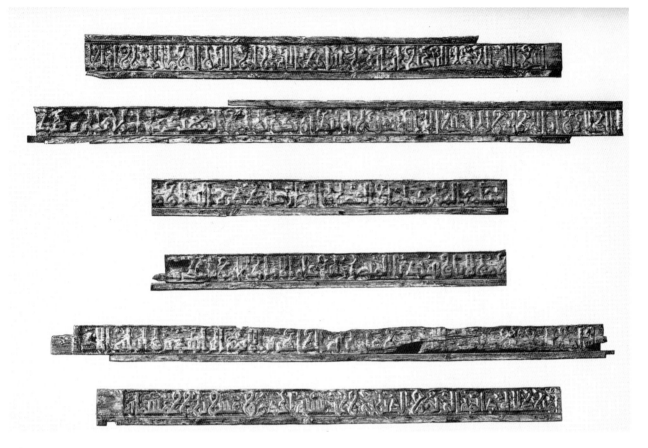

113 Wooden beams from the mosque of Sidi ʿAbd Allah al-Sharif, Damietta. Cairo, Museum of Islamic Art, inv. no. 2389

These two inscriptions, unlike many late Fatimid inscriptions, state that the caliph al-Amir himself ordered the work without the assistance of a vizier. In the first, al-Amir asserted the legitimacy of his claims to the imamate through his descent from al-Mustansir and al-Mustaʿli. In this inscription he makes reference to current political events: the otherwise-unknown epithet 'Imam of the Period and the Age', with its frankly Shiʿi tone, may have been a Nizari title that al-Amir attempted to turn to his own advantage. Over a century ago, van Berchem noted that the other unusual eulogy, 'may peace be upon his mention,' had Nizari resonances and concluded that it was not by chance that these phrases were found at Damietta, which was, like Alexandria, a prosperous maritime city tied to Syria, whence blew 'a wind of revolt against the Fatimids.'[96]

Mausoleum of Sayyida Ruqayya

The Mausoleum of Sayyida Ruqayya (Fig. 114), another daughter of b. Abi Talib Imam ʿAli by a wife other than Fatima, bears witness to the increasing political turmoil in this period. Despite his efforts to claim legitimacy, the caliph al-Amir was assassinated two years later, presumably by Nizari partisans. After another succession crisis, he was eventually succeeded by his cousin ʿAbd al-Majid, the oldest surviving member of the Fatimid family and a grandson of the caliph al-Mustansir, who took the regnal name al-Hafiz (1130–1146) after having served for some time as regent for al-Amir's posthumous son.

According to an inscription painted around the interior of the dome (Fig. 115), the mausoleum of Sayyida Ruqayya is dated to Dhu'l-Qaʿda 527/September 1133.[97] Located in the same enclosure as the tombs of Sayyida ʿAtika and Muhammad al-Jaʿfari (Fig. 116), which were built about ten years earlier, and one of the largest and most impressive of the mausolea surviving from the Fatimid period, the building is hardly mentioned in the sources.[98] It comprises a central domed square room flanked by two rectangular chambers, each with stucco mihrabs and covered with flat wooden roofs, all preceded by a portico with three arches sheltering two mihrabs flanking the entrance into the central room (Fig. 117). The portico was restored in the early twenti-

146

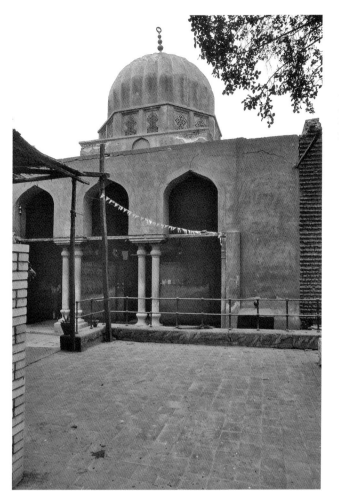

114 (LEFT) Mausoleum
of Sayyida Ruqayya,
1133

115 (BELOW)
Mausoleum of Sayyida
Ruqayya, painted
inscription on the
interior of dome

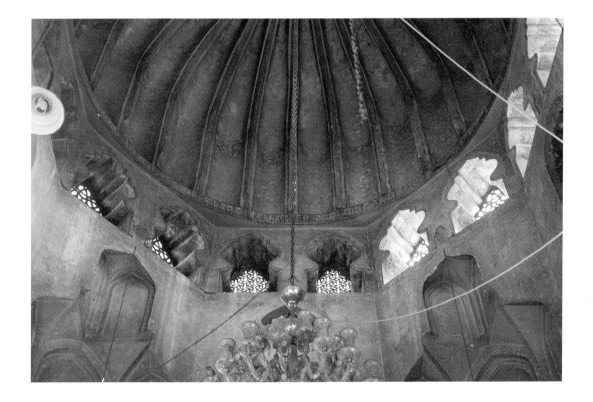

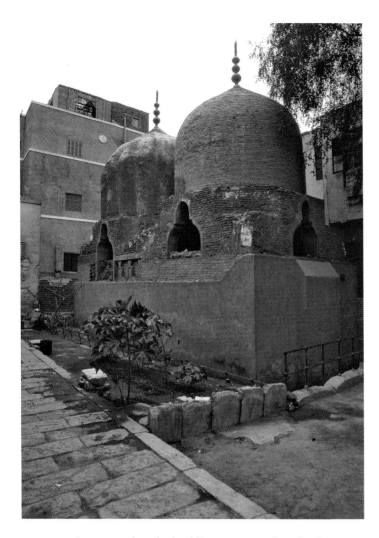

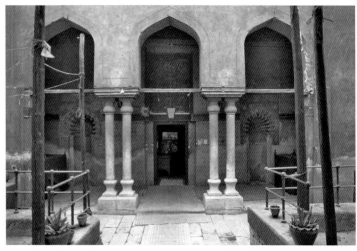

117 (ABOVE) Mausoleum of Sayyida Ruqayya, portico

116 (LEFT) Mausoleums of Sayyida Atika and Muhammad al-Ja'fari

eth century, but the building may once have had a court-yard, to judge from the evident similarities in plan to the earlier Hadra Sharifa (compare Fig. 41). The dome, which has twenty-four ribs expressed on the exterior as flutes, rests on an octagonal drum with elaborate windows in each face, itself resting on a zone of transition composed of simple muqarnas in the pendentives and Y-shaped supports in the windows. Creswell went to great pains to show that these Egyptian muqarnas developed entirely at variance with the contemporary muqarnas squinch in Iranian architecture, but this assertion seems quite silly in retrospect. It is far more likely that both Egyptian and Iranian muqarnas of the twelfth century reflect a common source, perhaps one in Iraq.

The glory of the shrine of Sayyida Ruqayya is its prin-cipal mihrab, which is a masterpiece of Egyptian stucco decoration (Fig. 118). It comprises a niche covered with a conch with sixteen ribs radiating from a central boss containing the name Muhammad, written seven times to form a star around the name 'Ali. The ribs radiate to

form a keel-shaped arch with concentric rows of seven-teen, eighteen and finally nine muqarnas-like flat niches. The spandrels of the frame contain arabesque ornament around blank bosses; the whole composition is crowned with a beautifully knotted kufic inscription (Q 33:33, which mentions the 'people of the house') and a particularly elaborate strapwork cornice in which grooved and flat bands intertwine. Apart from the arch, all of the decoration is rather flat. The smaller mihrabs in the side rooms and in the vestibule are similar but less elaborate, having, for example, only one or two tiers of muqarnas respectively.

It has long been noted that the muqarnas-like decoration of the niche developed from the arched decoration of the Aqmar façade. Nevertheless, the interpretation of muqarnas is quite bizarre, as if the principle of how the cells should be logically subdivided and related was not completely understood. No patron is specified in the long Qur'anic inscription painted on the interior of the dome that concludes with the date 527/1133, but an inscription on the splendid wooden cenotaph that stands under the dome (now hidden behind a garish metal screen) indicates that the patron-age came from the highest level. It states that 'this tomb was ordered in 533 (1139) by the widow of al-Amir through the services of the Qadi Maknun, servant of al-Hafiz by the hand of the excellent Abu Turab Haydara ibn Abi'l-Fath.'[99]

While it is possible that this was just another example of female patronage in the cemetery, there may be more to the building than first meets the eye.

Al-Maqrizi tells the story that a certain Abu Turab al-Suwwal brought al-Tayyib, the posthumous infant son of al-Amir, to the vicinity of the 'mosque' of Ruqayya in a basket of reeds in which were cooked leeks and onions and carrots, with the baby in swaddling clothes under the food. Hidden from al-Hafiz, the child was suckled by a wet nurse until he grew up and began to be called Kufayfa, 'little basket'. After the death of Abu Turab, however, the child was denounced to al-Hafiz, who had him murdered.[100] Caroline Williams concluded that the Qur'anic inscriptions, which remind the believer that it is God who creates and disposes and which mention wicked women, 'take on a poignant quality in this context'. She suggested that the shadowy figure of Ruqayya would have been chosen as a pretext for a structure of special significance for Tayyibi Ismailis, who usually state that the true imam was smuggled out of Egypt to the Yemen.

Al-Hafiz renovates al-Azhar

Caliphal patronage of architecture is clearer in the work al-Hafiz ordered at al-Azhar, although its meaning is more obscure. According to al-Maqrizi, the new caliph installed a small maqsura alongside the west door in the front of the Azhar mosque; the historian said that it was known as the Maqsura of Fatima and it can be identified with the domed pavilion in front of the central entrance from the courtyard to the prayer hall.[101] Although the maqsura had been known for centuries in Islamic architecture, it is traditionally understood as a sort of royal box, normally a screened enclosure adjacent to the mihrab in which the caliph or ruler could pray without fear of harm.[102] The Fatimids are not known to have used maqsuras in their mosques; this one conforms neither to the traditional placement nor function and its purpose remains enigmatic.

This project should be understood as part of a larger undertaking to reconstruct the porticoes encircling the courtyard of the mosque (Fig. 119). The new façade lining the courtyard consisted of marble columns sustaining keel-shaped arches supporting a wall decorated with a row of arched recesses alternating with roundels, the whole surmounted by an elaborate geometric cornice. The project served to give the mosque, now some 160 years old, a new look by concealing the lowness of the roof of the original prayer hall and hiding the piers of the original court façades. By the early twentieth century, the court façades as restored by al-Hafiz had again been restored, but Creswell was able to reconstruct their twelfth-century disposition from nine-

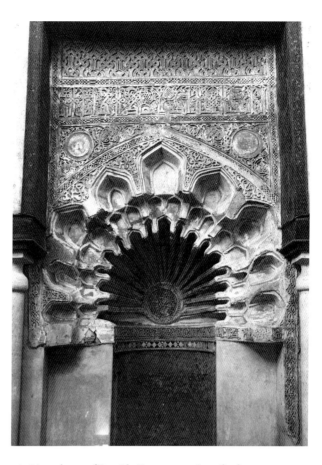

118 Mausoleum of Sayyida Ruqayya, main mihrab

teenth-century photographs.[103] Columns spaced about 4 metres (13 feet) apart supported an arcade of keel arches. Above each column is a blind keel-arched panel with a fluted hood resting on colonnettes; between each panel is a sunken roundel with eight alternating pear- and lozenge-shaped lobes.

The focus of this restoration was a small domed bay, the maqsura noted by al-Maqrizi, in the centre of the court façade on the qibla side of the mosque in front of the aisle leading to the mihrab. Seen from the courtyard, this bay – which still exists (unlike the rest of this project which was already renovated in the nineteenth century) – was differentiated by the bundled columns supporting the arches and a raised and more elaborate cornice, which may have served to (partially) conceal the slightly bulbous and pointed dome behind. Columns and piers support four keel-shaped arches (quite different in profile from the early Fatimid arches on the inner side) which in turn support first a zone of transition with tall squinches alternating with windows and then a slightly pointed brick dome. The windows are fitted with pierced stucco grilles that are fitted with panes of coloured

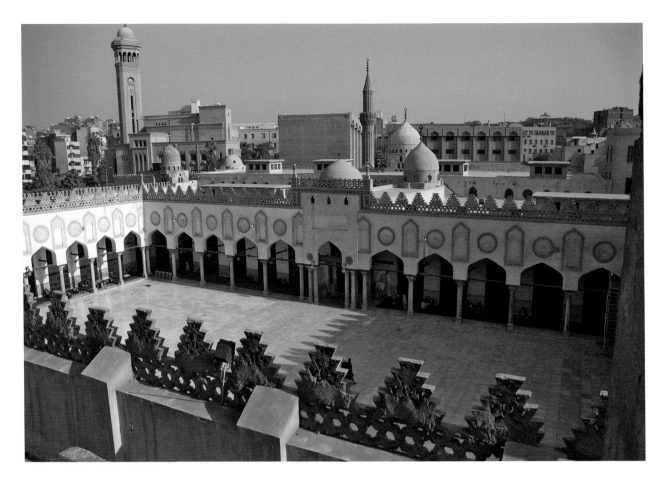

119 Cairo, al-Azhar Mosque, general view of court with maqsura of al-Hafiz (1130–49) in centre

glass, the first use of the technique known in Egyptian architecture. The interior (Fig. 120) is lavishly decorated with carved stucco: Qur'anic inscriptions in kufic script outline (1) the four arches, (2) the square base of the zone of transition, (3) the arches of the zone of transition and (4) the octagonal band at the top of the zone of transition. A fifth band on the interior of the dome outlines an arcade of six ogee arches resting on pilasters. The space above them is filled by a six-pointed star.

The inscriptions are of interest for their content and design. Inscription 1) begins with the *basmala* at the apex of the north-western arch and continues

> Surely the godfearing shall be in a station secure
> among gardens and fountains, robed in silk
> and brocade, set face to face.
> Even so; and We shall espouse them to wide-eyed
> houris, therein calling for every fruit, secure.
> They shall not taste therein of death, save the first
> death,

> And He shall guard them against the
> chastisement of Hell – a bounty from thy Lord;
> that is the mighty triumph.
> Now We have made it easy by thy tongue, that
> haply they may remember.
> So be on the watch; they too are on the watch.
> (Q 44:51–59)
> *Basmala.* [that God] may recompense them for
> their fairest works and give them increase of
> His bounty: and God provides whomsoever He
> will, without reckoning. (Q 24:38)

The inscription around the base of the zone of transition (2) is the familiar Throne Verse (Q 2:255). It begins at the south-east (qibla) wall in the south (right) corner and continues around all four walls. The quality of the inscription is generally finer than the lower one, suggesting that the lower inscription may have been restored at some point, but the inscription ends with some crowded words, indicating that the artisan did not plan out his work accordingly. A further indication of a lack of

150

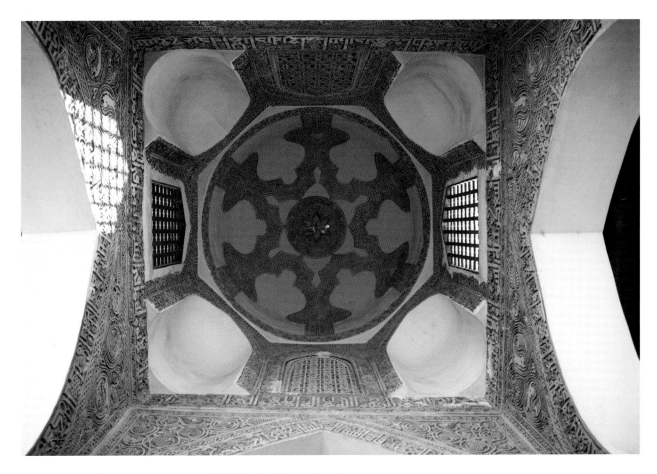

120 Cairo, al-Azhar Mosque, maqsura of al-Hafiz, looking up into dome

planning may be that both inscriptions do not begin in the same place. The upper inscriptions, which are also Qur'anic texts, are all but invisible from the ground.[104]

Considering that the squinches of the contemporary dome covering the mausoleum of Sayyida Ruqayya were decorated with muqarnas, it is odd that the interior of this bay at al-Azhar was not similarly decorated, for the designer and patron surely intended the effect to be as sumptuous as possible. Instead the interior was decorated with elaborate carved stucco on the spandrels of the arches and the interior of the zone of transition and in the dome. Except in the dome, each element is outlined with bands of Qur'anic inscriptions and the interstices are filled with arabesque or geometric ornament; in the dome a similar inscribed band twists and turns to form an arcade of six arches running round the base of the dome, with the apex filled with a six-pointed star. Compared to the contemporary stucco decoration in the Mausoleum of Sayyida Ruqayya, however, the quality of the carving is rather flat and unimaginative.

We have no idea what purpose such a dome might have been built to serve. Despite its slightly bulbous profile, Creswell likened it to North African examples, such as the congregational mosques of Kairouan, Sousse, Tunis and Sfax, where a dome stands at the court end of the aisle leading to the mihrab. It is odd, however, that such a form should first appear in Fatimid architecture in the middle of the twelfth century without any earlier Fatimid examples, considering that all the North African examples Creswell cited date from the tenth century or earlier. The time for the Fatimids to have adopted North African forms and motifs had long passed. It is quite possible that this pavilion was intended to provide a locus for some regular event, such as the repeater who made what happened within the mosque accessible to those who were praying in the court, or for some specific celebration, such as the festival of Ghadir Khumm, when the Prophet nominated 'Ali as his successor, for such celebrations became more elaborate during al-Hafiz's reign, presumably to legitimize his irregular accession to the imamate.[105] Unfor-

151

tunately, the decoration on the interior of the pavilion does not support this hypothesis, the Qur'anic inscriptions being generalized sentiments about God's majesty, paradise and the necessity of prayer. The vegetal scrolls and six-pointed stars are no more than decorative fill, so its specific purpose remains enigmatic.

Creswell reluctantly compared the elaborate cresting in front of the pavilion to a *pishiṭāq*, the rectangular frame surrounding an arch used in Persian architecture, for he was eager to show that Egyptian Islamic architecture had absolutely nothing to do with Persia.[106] The connection with Persian architecture may still be valid, however, for the most important aspect of al-Hafiz's renovation of al-Azhar is not the addition of a single pavilion but rather the concept of lining the entire court façade of a mosque. By building this courtyard façade, the caliph was able to give the building a new and contemporary look without having the great expense of building a new mosque from scratch. Creswell also noted that the upper part of the façade serves to conceal the lowness of the original sanctuary's roof, which is only about seven metres high, or over two metres below the cresting.[107] Iranian patrons of the Buyid period had done much the same thing at the mosques of Nayin and at Isfahan, when they gave Abbasid congregational mosques an entirely new look by adding a colonnade of decorated piers along the court façades. It is quite unlikely, however, that the Cairo mosque owes anything to Iranian architecture; rather, in both cases patrons found identical solutions to get the most value for their money.

The absence of muqarnas in this prestigious construction remains something of a mystery. The type of decoration in stone or plaster that architectural historians today lump together as 'muqarnas' seems to have had several different associations in the Fatimid period. Muqarnas squinches and vaults were found only on commemorative and funerary architecture, while cornices and niche-hoods were appropriate on mosques.[108] Whatever the reason for these associations, muqarnas appears to have been inappropriate at al-Azhar.

It is often claimed that the Fatimid devotion to Shi'ism prevented the establishment of madrasas in Egypt until the fall of the dynasty. Yet, Alexandria, because of its location on the Mediterranean coast, had a particularly important population of Maghribis, not only Muslims, but Jews and Christians as well. The Muslims among them were particularly devoted to the Maliki school of law, which was popular in the Maghrib. Towards the end of the eleventh century, the distinguished Maliki jurist al-Turtushi settled in

Alexandria, where he set up an institution for the teaching of Maliki law and wrote a manual of government for the Fatimid vizier al-Ma'mun al-Bata'ihi. At the beginning of the twelfth century, the post of the qadi of Alexandria was occupied by the Banu Hadid, a Maliki family from Toledo, who established a madrasa for the teaching of Maliki law in 1134–5. In the twelfth century, the Fatimid viziers Ridwan ibn Walakshi and Ibn al-Sallar established in Alexandria two colleges of law that would contribute to the revival of Sunnism in Egypt even before the end of the Fatimid period.[109] Unfortunately we know nothing about the design or plan of these structures.

Mosque of al-Salih Tala'i'

In 1149 al-Hafiz was succeeded by his son who took the title al-Zafir. Five years later in Muharram 549/April 1154 the young caliph was assassinated by his favourite companion, Nasr, the son of the vizier al-'Abbas, and succeeded in turn by his five-year-old son al-Fa'iz. In the ensuing chaos, the women of the palace summoned Tala'i' ibn Ruzzik, a Twelver Shi'i who had his power base in Upper Egypt, to restore order. Al-'Abbas, the vizier, was forced to leave Cairo with his son, along with a convoy of 100 war horses, 200 mules and 400 camels laden with treasures taken from the caliphal palace in Cairo. Tala'i' arrived in Cairo dressed in black and brandishing black standards instead of the traditional Fatimid white. Chroniclers took this as a portent of the imminent fall of the dynasty and a return to Abbasid rule. Yet al-Salih Tala'i' ruled until 1161 and the dynasty would survive him for a decade. He was the first Fatimid vizier to bear the *laqab*, or title, *al-mālik al-ṣāliḥ*, constructed with *al-mālik* (king), following the example of his contemporary Nur al-Din in Damascus but probably chosen in memory of the Buyids, who were Twelver Shi'is like himself. As vizier, Tala'i' restored the economy and fought the Crusaders as best he could, even proposing an alliance with Nur al-Din in Damascus. Tala'i' was praised for his knowledge of Arabic and his intellectual circle. In 1160 when the eleven-year-old al-Fa'iz died childless, Tala'i' installed a nine-year-old grandson of al-Hafiz – his father, al-Hafiz's son, had been killed on the day of his brother al-Fa'iz's enthronement – on the throne as al-'Adid li-Din Allah. The vizier married his daughter to the imam so that his grandson might become caliph, but one of al-'Adid's aunts instigated the vizier's assassination on 19 Ramadan 556/11 September 1161.[110]

The congregational mosque constructed by al-Salih Tala'i' ibn Ruzzik directly outside Bab Zuwayla was built in 1160 during the death-throes of the Fatimid state.[111] Apart from the Fakahani mosque – a remnant of the Afkhar mosque constructed by al-Zafir – of which only fragments of Fatimid-era woodwork on two sets of doors (Fig. 121) remain, it is the last significant work of architecture done under Fatimid rule in Egypt.[112] It was erected just outside Bab Zuwayla and the patron supposedly confided to his son on his deathbed that he regretted constructing the mosque since it could have offered an advance position to an assailant against Cairo.[113] Like the Aqmar mosque, it is a hypostyle structure with a prayer-hall three bays deep preceded by a courtyard flanked by arcades (Fig. 122). Unlike the Aqmar mosque, the building is much larger and largely freestanding. It is set on a rectangular footprint measuring approximately 29 × 54 metres (95 × 175 feet) and raised several metres above the ground by a high basement occupied by a series of vaulted shops (Fig. 123) which were rented out to provide money to keep up the mosque. Steps led from the street up to the mosque's three entrances, but as the ground level has risen at least 2 metres (7 feet) over the centuries, the stairways have become more like bridges.

The principal façade of the mosque is also unusual because it consists of an open loggia of five arches flanked by two suites of three rooms, one of which projects from either corner of the mosque. Not too much should be made of this arrangement, since most of the mosque, apart from the prayer-hall, was rebuilt by the Comité de Conservation. Staircases on either side of the principal entrance lead to the roof and perhaps once led to a minaret: the walls on either side of the entrance have been reinforced to support something, although the earliest evidence for a tower there dates from the Mamluk period. The courtyard contained a large cistern filled either by rainwater or by a waterwheel when the Nile was in flood. The prayer hall (Fig. 124) had a minbar, indicating that the mosque was intended for Friday worship, but the present minbar itself dates from after 1302, when part of the mosque collapsed in an earthquake. The mosque has been rebuilt several times in the medieval and modern periods, with more or less fidelity to the original Fatimid plan. The structural instability may indicate that the original design was somewhat experimental.

In any event, the repeated reconstructions have provided much fuel for speculation about the form of the original mosque and what we see today is largely a product of the efforts by the Comité.[114] As the patron

121 Cairo, Fakahani Mosque, doors showing Fatimid-era woodwork

had erected a mosque in Qus four years earlier in 550/1156, it is possible that some of the Cairo mosque's unusual features, such as the *malqaf* (wind-catcher) in the qibla wall to the right of the mihrab to cool the seat of the minbar, may be explained by the plan of the earlier building.[115] Other features, however, follow nicely on trends in the architecture of metropolitan Cairo over the past two centuries: the prayer hall is supported on reused marble columns and capitals and the arches are outlined with kufic inscriptions carved in the

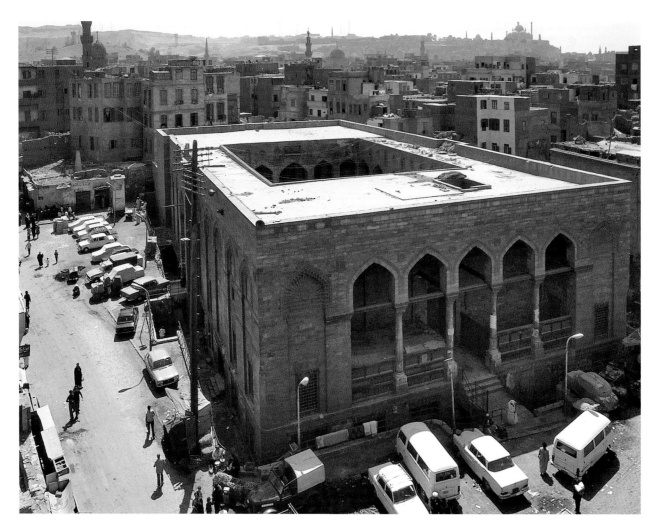

122 Mosque of al-Salih Tala'i', general view

plaster. On the exterior, two long bands of kufic inscriptions envelop the façade.[116] The muqarnas-like decoration of the niches on the façade is paralleled on the interior by the great fluted saucers of stucco ornament in the spandrels of the arcades. In short, there is little in this building to suggest that it is the last gasp of Fatimid architecture and that nothing like it would be built for centuries. The Ayyubids, who were to restore Egypt to Sunnism of the Shafi'i *madhhab*, believed that an urban agglomeration should be served by only one congregational mosque, so they restricted Friday prayer to the mosque of al-Hakim and did not build additional congregational mosques in the city.

According to al-Maqrizi, who based his account on that of the historian Ibn 'Abd al-Zahir, Tala'i' ibn Ruzzik built this mosque in 1154 in order to inter the head of al-Husayn, which was brought from Ascalon when the Crusaders threatened the town. According to this account, the caliph would not authorize this plan, saying that his ancestor's head could be interred only in the palace. A long and prominent inscription encircling the façade of the mosque of al-Salih Tala'i', however, states that the mosque was built in 1160, seven years after the head of Husayn reached Cairo.[117] Although the original function of the portico and corner rooms has never been explained, al-Maqrizi's story is not to be trusted. The building does not appear to have been designed to house or display a relic such as the head of al-Husayn and in any event, the space outside the southern gate of the city would have been an unlikely place to house it. After the fall of Ascalon, the relic was actually interred in the Fatimid palace, and the much restored and rebuilt mosque and shrine of Sayyidna al-Husayn, which was

154

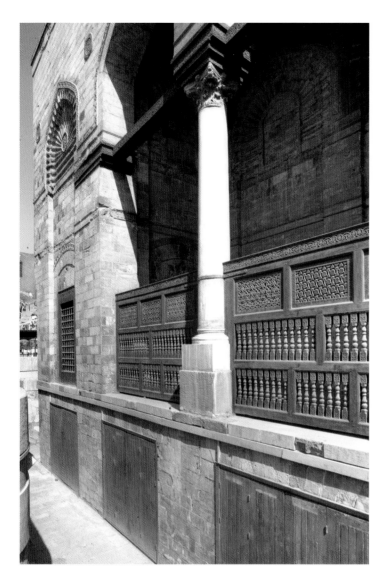

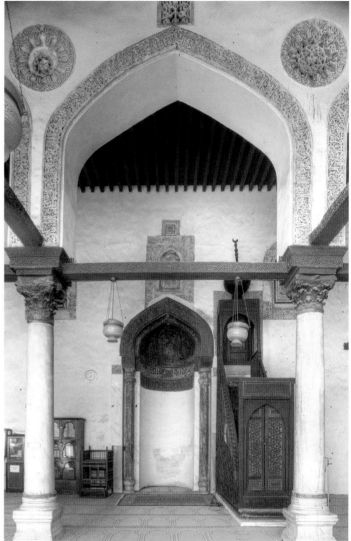

123 Cairo, Mosque of al-Salih Tala'i', view of shops

124 Cairo, Mosque of al-Salih Tala'i', prayer hall

built where the Fatimid palace once stood, still commemorates the relic.[118]

Like the Aqmar mosque, the designer of the Mosque of al-Salih responded to the increasing pressures of the urban environment by building it over a basement of shops. Unlike the Aqmar mosque, however, the designer was able to construct a building that was free-standing on at least three, if not all four, sides. Creswell, however, believed that

the most important innovation of this mosque was its use of a panelled façade with a window in each panel, for this device was adopted in several foundations of the Ayyubid and early Mamluk periods built on the site of the great Fatimid palace.[119] As we have already seen, however, it is far more likely that the exterior articulation of Tala'i's mosque, just like the earlier Aqmar mosque, itself reflected the architectural articulation of the palace itself.

VI

The Decorative Arts from the 1060s to 1171

While some arts, such as ceramics, textiles and carved wood, continued to be important throughout the later Fatimid period, the production of other arts seems to have stopped or declined. The diminished resources of the state and the economic uncertainty meant that patronage of certain crafts declined or changed. For example, carved rock crystals, which had figured so prominently among the arts of the early Fatimid period in Egypt, do not seem to have been produced in the second century of their rule there, for none of the surviving examples bears any indication that it was carved at this time. Similarly, although woodworkers certainly continued to carve and join wood into decorative architectural fittings, the production of carved ivory – which in the earlier period is closely related to wood-carving – seems to have ceased as well, for no surviving ivories demand to be dated to the later period on the basis of similarities to carved woodwork. The production of lustre ceramics, which had been one of the high points of the earlier period, appears to have ceased entirely as practitioners of this expensive craft sought to make their fortunes elsewhere. Nevertheless, we should always remember that absence of evidence is not necessarily evidence of absence and new discoveries will surely refine our knowledge of the arts of this period.

The Dispersal of the Fatimid Treasures

The major event for the decorative arts in this period was the looting of the palace treasures in the late 1060s. The story began when the troops demanded that the caliph al-Mustansir pay them for services rendered; when he refused, they first seized the tax and customhouse revenues and then – from December 1068 – began looting the caliph's great palace in Cairo, first for military supplies and then for his personal treasures. Despite the incredible riches they found, it seems, however, that the looters only reached the outer (*al-dākhila*) storerooms; the inner (*al-barrāniyya*) stores remained intact.[1] As the goods were brought out from the palace, functionaries recorded who took what against what he was owed in wages. Although the original records are lost, the extravagant descriptions of these fabulous treasures appear in various later works, most based on a 'Book of Gifts and Rarities' composed by an anonymous eleventh-century Egyptian.[2] Even allowing for a certain degree of exaggeration, the goods found in the palace were extraordinary, ranging from huge rock crystal jars filled with precious jewels to intricate curios and rare books.

The Fatimid treasures appear quite incredible to us today – and indeed they were then – but they were probably no more splendid than those collected by the Abbasid caliphs of Baghdad in their prime, who were as rich as, if not richer than, the Fatimids. A taste for luxury and excess was neither exclusively Fatimid nor exclusively Egyptian, although no comparable enumeration of the Abbasid treasures has survived.[3] On a broader historical scale, the Fatimid treasures can profitably be compared to the extraordinary jewels, curios and relics amassed by other Islamic rulers in later times, whether by the Ottoman sultans, the Qajar and Pahlavi rulers of Iran, or the Mughal emperors of India.[4]

As always, and at all levels of Islamic society, textiles were a major source of wealth and status and the

Facing page: Linen cloak with tapestry woven decoration, detail of Fig. 127

Fatimid treasuries included lengths of fabrics, both heavy and light, with embroidered and gold decoration, as well as garments, tents, parasols, flags and curtains. Among the animal trappings were five thousand saddles decorated with gold and silver, each worth anywhere between one and seven thousand dinars, this at a time when a middle-class family could survive on two dinars a month! Other items were made of silver and gold inlaid with enamel and studded with emeralds, turquoises and pearls. Books included manuscripts of the Qur'an penned by the master calligraphers Ibn Muqla and Ibn al-Bawwab, written in gold outlined with lapis lazuli, as well as multiple copies of the standard works of Islamic literature and learning.

The jewel treasury contained seven *mudd*s (a unit of volume equivalent to 2.5 litres) of emeralds, worth at least 300,000 dinars, a string of pearls itself worth about 80,000 dinars, a cap studded with precious stones worth 130,000 dinars and a spinel weighing 23 mithqals (over 100 grams). Bowls and drinking cups made of hard-stones such as bezoar and white jasper were engraved with the names of the caliphs who had drunk from them. Among the thirty-six thousand objects of solid glass and smooth rock crystal, there was one enormous rock crystal jar carved with images which had a capacity of 17 ratls (about 4 gallons). There were also chess and backgammon sets made of gemstones and hardstones, porcelain and other kinds of storage jars filled with perfumes including camphor, ambergris, musk and aloeswood. The curios included penboxes of exotic woods adorned with precious stones, sets of nesting trays made of gold and silver and silver cups inlaid with gold, as well the golden figurines of birds and animals studded with gemstones and pearls discussed already in Chapter 4.

Virtually none of this has survived intact. Some of the gemstones may still be around, recut and reset to meet later tastes, but there is no way of tracing their provenance. The looters took everything at deep discount from its actual value. For example, a string of pearls worth 80,000 dinars was taken for 2,000.[5] Nevertheless, some Turkish troops ignored many precious items from the treasuries and simply 'went their way.'[6] What then became of the treasures? Many of the rare and precious items must have been sold in the markets of Cairo, but the grave economic crisis would not have encouraged the bourgeoisie, such as it was, to spend money on the trappings of a nouveau-riche lifestyle.[7] It is also thought that some of the Fatimid royal objects, such as the rock-crystal ewers now housed in European church treasuries, must have been acquired at this time, but no chain of provenance links the objects to this source. Most of the royal objects were undoubtedly broken up, melted down and sold for their component parts.

As for the books, one eyewitness reported that

during the first third of Muharram 461 (1068), I saw twenty-five camel loads of books taken [from the palace] to the house of the vizier Abu'l-Faraj Muhammad ibn Ja'far al-Maghribi. I asked and was told that the vizier and Khatir ibn al-Muwaffaq fi'l-Din had taken them contractually from the palace treasuries in payment for sums due to them and their respective functionaries. The vizier's share of the balance due his mamluks and servants was only five thousand dinars; however, an expert on books said that they were worth over one hundred thousand dinars. The following month, all was plundered from his house when Nasr al-Dawla ibn Hamdan was forced to flee Fustat. Still other books from the library of the Dar-al-'Ilm in Cairo went to 'Imad al-Dawla Abu'l-Fadl ibn al-Muhtarraq in Alexandria. After he was killed, the books eventually passed to the Maghrib. Still other books fell into the hands of the Luwata tribe – either by purchase or force – when in the same year they moved down the Nile to Alexandria. These precious books – which had no equals anywhere in the beauty of the writing and binding – were taken by slaves and their wives who made sandals from the bindings. The pages were burned on the pretext that they came from the caliph's palace and contained improper sectarian ideas. Still other books were dumped in the Nile, destroyed, or carried off to other lands. Those which were not burned were covered by the wind-blown sands, forming the small hills still known today in the region as the 'Hills of Books.'[8]

Just as the caliph's collection of sculpted curios puts the lie to a supposedly 'Islamic' abhorrence of figural representation, the ghastly treatment these books received shows that not all sectors of Islamic society revered the written word the way they were supposed to. Indeed, al-Maqrizi's chilling account seems constructed to show just how barbaric these ruffians were. Nevertheless, such wholesale destruction, if it is true, may go far to explain the nearly total absence of manuscripts, whether sacred or secular, attributable to Fatimid Egypt.

Despite the extensive looting, the Fatimid caliphs were by no means destitute for the second century of their rule in Egypt, for as noted the looters never reached the inner storerooms. When Tala'i' ibn Ruzzik forced the vizier al-'Abbas to leave Cairo in 1154, he fled

to Syria with all the currency and movable treasures he could carry from the caliph's palace. The loot was loaded on a hundred horses, two hundred mules and four hundred camels. According to the Damascene historian Ibn al-Qalanisi, crusaders in Palestine captured al-ʿAbbas and his son, along with their goods. They killed the former vizier and sent his son back to Talaʾiʿ in Cairo; he handed him over to the palace women, who put him to death. The Fatimid royal treasures al-ʿAbbas had taken seem to have passed from Crusaders in the Holy Land eventually to western European churches and monasteries.[9]

Coins

Despite the diminished resources of the state in this period, Fatimid coinage preserved its standard remarkably well over the years. Paul Walker hypothesized that the natural temptation towards debasing the coinage in times of economic crisis was held in check by Fatimid religious policy and tradition, for control of the mint fell under the domain of the qadi, who was charged with fulfilling the obligations mandated in religious law.[10] Fatimid coins remain remarkably consistent in style as well, although there are some slight peculiarities: in 482 (1089–90) some coins struck in the name of al-Mustansir go back to an older Fatimid style with a large field and two borders, of which the inner one is blank.[11] Under al-Mustaʿli and al-Amir there was a return to the concentric design, but the inner empty border gets progressively narrower to become a double fillet separating the two lines of text in the border. In 518 (1124–5), coins were struck in al-Amir's name at *al-Muʿizziyya al-Qāhira* (Fig. 125). This is the first time the name Cairo appears on a coin, although *al-Muʿizziyya* alone had been used quite a bit earlier. The die-cutting, however, is bad and maladroit.[12] Eventually, under al-Zafir, the double fillet evolved to simply separate the single line of text in the border from the larger field.[13]

Perhaps the most interesting development in this period is the deliberate imitation of late Fatimid gold dinars by Latin Crusaders after their conquest of Jerusalem in 1099 (see Fig. 149) The Crusaders, whose previous experience minting coins in Europe had been limited to silver, began striking imitations of Fatimid gold coins soon after their arrival in the Levant. Unlike Fatimid coins, which remained remarkably pure, the Crusader imitations were debased and they presumably drove the finer Fatimid coins out of circulation, as people following Gresham's Law tended to hoard the good

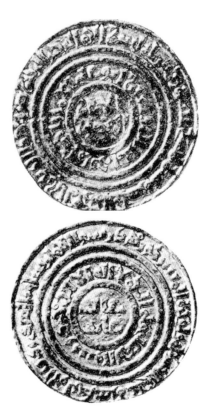

125 Dinar of al-Amir struck at al Muʿizziyya al-Qahira in 518/1124–5 New York, American Numismatic Society, 1002.1.1020

coins.[14] It is tempting to imagine that the slight changes in the appearance of Fatimid coins in the twelfth century were the results of attempts by the Fatimids to distinguish their coins from their rivals' imitations.

Textiles

Textiles, apart from coins, provide the largest number of consistently dated objects through which to trace developments in Fatimid art, for production seems to have continued apace, as the rulers continued to parade around the city wearing spectacular outfits surrounded by courtiers to whom they had given lengths of embroidered cloth. Although many of these textiles must have been extraordinary, their generally fragmentary state of preservation means that it takes a great leap of imagination to conjure up their original appearance. On technical grounds textile production during the second century of Fatimid rule in Egypt seems to fall into two periods: a first period from *c*.1095 to *c*.1130 and a second one from *c*.1130 to the end of the dynasty. Despite eco-

126 Linen cloak with tapestry woven decoration in silk and gold thread with the name of the caliph al-Musta'li. Damietta, 1096-7, 310 × 152 cm (10 ft 2 in × 5 ft). Apt, cathedral collection

nomic troubles, tiraz textiles continued to be produced in seemingly great quantities and the decorative bands worked in tapestry became increasingly elaborate in design, even if their semantic content became more formulaic and eventually meaningless.

Perhaps the most famous – and complete – example of a Fatimid textile is the so-called Veil of Saint Anne, dating from the very end of the eleventh century and now in the Cathedral of Apt, Provence (Fig. 126).[15] The only other relatively complete piece is the so-called 'Shroud of Cadouin', preserved in a Cistercian monastery in Perigord.[16] The Veil of Saint Anne, which measures 3.1 × 1.52 metres, is woven in cream-coloured linen tabby and decorated with three parallel bands tapestry-woven in coloured silk and gold, one along either side and a central band between them. The side bands, which are 16.5 centimetres wide, themselves consist of three parallel bands separated by narrow bands of plain weave. Of these three, the central one is decorated with a band of alternately circular and polygonal medallions, decorated respectively with a quadruped or two birds.

The bands contain several inscriptions that need to be read together to pinpoint its date of manufacture. The border bands bear blue inscriptions written on a gold ground and state 'this is what was made in the private tiraz of Damietta in the year ??9.' The most elaborate decoration is found on the central band, which is decorated with a line of interlacing circles that join three circular medallions of decreasing size descending from a decorated collar band, of which only a few traces remain. The medallion, also partly destroyed, contained two facing figures surrounded by an incomplete kufic inscription that mentions 'the imam Abu'l-Qasim al-

Musta'li bi'llah, Prince of the Believers, may God's benedictions be upon him and on his pure and most honorable ancestors . . .' The middle medallion (Fig. 127), which is the best preserved, contains a pair of addorsed sphinxes on either side of a central motif formed by their tails and wings transformed into leaves. The kufic inscription continues '. . . and on his very honourable descendants. The very illustrious lord, al-Afdal, sword of the imam, splendour of Islam . . .' The bottom medallion is poorly preserved, but an additional title of al-Afdal, 'noble of humans', is still visible. As the only year ending in the digit nine during which both the caliph al-Musta'li and al-Afdal were in power was 489, equivalent to 1096–7, the textile can be dated to that year. Although later venerated as a relic of the Virgin's mother, the piece was intended to be made into the type of overgarment or mantle known as an *abā'*, with the central band containing the medallions falling down the back, but in this case the loom-length was never cut or sewn. Poorly restored in the 1930s, the cloth was reconserved at the end of the twentieth century and exhibited in Paris in 1998.[17]

The focus of the decoration of the Veil of Saint Anne would have been the collar band, which is largely destroyed, but two small fragments of a technically similar textile in the Bouvier Collection shows what it might have once been like.[18] Measuring only 32 × 37 centimetres (12½ × 14½ inches), the larger fragment (Fig. 128) contains a circular medallion with a gold ground, surrounded by a circular border that twists at the top and extends horizontally to end in split palmettes, themselves decorated with small medallions containing a single bird. An extraordinarily beautiful depiction of a mounted archer fills the large medallion; the white horse is dappled with black spots and caparisoned in gold; the archer wears a green turban and matching robe decorated with arabesque scrolls. The smaller fragment (19 × 20 centimetres; 7½ × 8 inches), which presumably comes from one of the side bands, is inscribed with four lines of kufic characters separated by a band of medallions filled with paired birds, rosettes or bowls of fruit. The texts, which would have run in bands down the front and sides, consist entirely of prayers and benedictions, although the names of the caliph and his vizier – for surely this would have also been a court commission – have not been preserved.

Other fragmentary textiles that date from the first quarter of the twelfth century often have broad bands of plaited ornament with animals or arabesques in the interstices between the interlaces. While most have kufic or kufesque inscriptions, several pieces have epi-

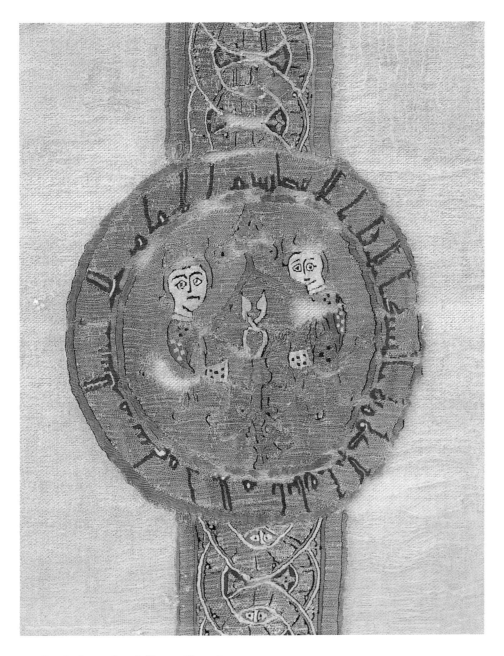

127 Detail of central medallion on Fig. 126

graphic borders with cursive script, once again showing that ideology and script had nothing to do with each other in this period.[19] A piece in the Benaki Museum, for example, has a debased cursive inscription that reads, perhaps, *naṣr min Allāh*, 'Victory from God' (Fig. 129).[20] From the second quarter of the twelfth century to the end of the Fatimid period, the braided decoration increases in complexity and the bands increase in width to cover the entire fabric. While earlier textiles had been woven with silk thread wrapped with gold, many later textiles have a bright yellow ground, pre-

sumably to give the effect of cloth-of-gold without the expense.[21]

Although tapestry-woven tiraz are the best known, other types of textiles were produced in this period, including embroidered, knitted and block-printed fabrics, some even printed with gold.[22] In addition to their use as clothing and signs of favour and prestige, textiles were used for furnishing spaces and creating them in the form of tents. The late Fatimid historian Ibn al-Tuwayr (1130–1220) described a particular tent, called *al-Faraḥ*, meaning 'joy'. Manufactured over the course

161

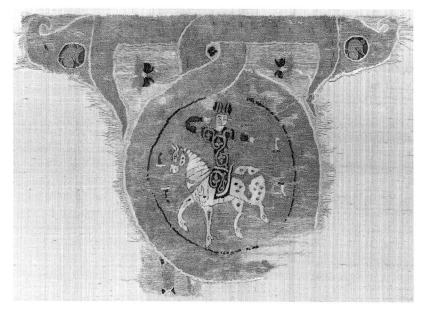

128 (ABOVE) Fragment of a linen cloak with tapestry woven decoration in silk and gold thread depicting a cavalier, 32 × 37 cm (12½ × 14½ in). Peseux, J.-F. Bouvier Collection, JFB M92

129 (RIGHT) Fragment of a silk and linen textile with a stylised inscription and an interlace design enclosing hares and birds. Egypt, twelfth century, height: 25 cm (10 in.). Athens, Benaki Museum, inv. no. 15178

of nine years during the vizierate of al-Afdal, it was said to have been made of 1.4 million [*sic*] cubits [of fabric] and comprised four vestibules (*dihlīz*) and four halls (*qaʿa*) in addition to the main one. The centre pole reached a height of 50 cubits [approximately 25 metres or 75 feet]. When it was finally erected, several people were injured and two died, earning it the nickname, *al-qatūl*, or 'The Killer'.[23] The arrangement of four halls and four vestibules around a central space suggests that this tent was arranged like the *hasht bihisht* ('Eight Paradises') palace plan of later Islamic times, in which a central hall was surrounded by four axial porches and four domed rooms.[24] The tent was lined with hangings and spread with carpets; the centre pole was wrapped in coloured brocade from top to bottom. Within the tent, in front of the royal throne, which was set up inside next to the pole, gold trays were arranged holding figurines of humans, elephants, giraffes, lions and other beasts made of gold, silver and amber ornamented with pearls, sapphires and other stones.[25] Even as the late Fatimid caliphs diminished in power and wealth, they and their viziers were still able to maintain some of their old habits of ostentatious display.[26]

Woodwork

Once again, woodwork provides one of the best indices for the development of art in the Fatimid period because of the large numbers of dated and/or datable objects that have survived. These were made not only for the Muslim community but also for Christians – and Jews as well – for one of the earliest ensembles from this period may be the Haikal screen from the chapel of St George in the church of St Barbara in Fustat (Fig. 130).[27] The screen, now in the Coptic Museum, consists of a mortised frame some 2.68 metres wide and 2.18 metres high containing 35 large and small rectangular panels arranged around an arched recess enclosing a pair of doors decorated with an additional eight rectangular panels. The spandrels of the arch are also carved and the three original panels across the top are pierced. The panels on the screen itself are arranged horizontally in eight staggered rows, while those on the door are arranged vertically in two rows, one on each valve, much like the closet doors from the al-Aqmar mosque. All of the larger panels, whether horizontal or vertical, have symmetrical compositions, while the smaller panels were made in symmetrical pairs.

Unlike earlier woodwork for Islamic religious contexts, all the compositions on the screen include con-

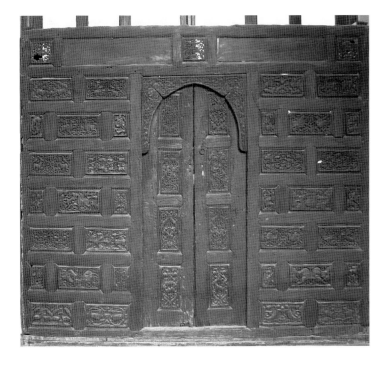

130 Wooden screen from church of St Barbara, Old Cairo. Coptic Museum, Cairo

131 Minbar ordered by al-Afdal, St Catherine's Monastery, Sinai (the stand is visible to its left)

fronted or addorsed pairs of real and imaginary animals, birds and humans engaged in various activities and arranged symmetrically against a scrolling arabesque ground. Unlike the woodwork from the Hakim and Azhar mosques, however, there is a clear differentiation between figure and ground, and the vines are delineated by a narrow medial groove. Edmond Pauty dated the screen to the late tenth century before the reign of al-Hakim,[28] while the Swedish scholar C. J. Lamm provisionally dated it to 1004–5 or after 1020, since al-Hakim began persecuting Christians in 1007–8 and continued this policy until two months before his death. He imagined that this work could hardly have been accomplished during the latter part of al-Hakim's reign.[29] These dates seems far too early, however, as the church, built perhaps as early as the seventh century, was likely reconstructed between 1072 and 1075 to house the relics of Saint Barbara, at which point a new screen was probably needed.[30]

Furthermore, the Coptic screen is comparable in style and technique to a minbar made for the mosque at St Catherine's Monastery, Sinai, in November 1106 (Fig. 131).[31] While the screen has no inscription to date it, the minbar is known to have been ordered by al-Afdal fifteen years after his father had ordered the minbar for the shrine of al-Husayn at Ascalon. First published

some seventy years ago by Lamm, it has hardly been seen in the intervening years, presumably because the monks do not wish to call attention to its presence. To judge from the few existing photographs, it is a triangular structure with six steps leading to the raised seat. The sides are decorated with rectangular panels arranged in a grid corresponding to the minbar's steps, with triangular panels under the rails. The alternating wide and narrow panels under the raised seat are set in an ashlar pattern, as on the Coptic screen. The rails are decorated with mashrabiyya spoolwork and the door at the front is crowned by the inscription plaque decorated with six lines of floriated kufic script.

According to another undated inscription on a wooden stand (kursī) near the minbar, an amir of the caliph al-Amir, Abu Mansur Anushtakin al-Amiri, also ordered several works at Sinai, presumably around the same time that al-Afdal ordered the minbar.[32] The stand, a truncated pyramid supported on four feet, is girdled by two bands of foliated inscriptions separated by spoolwork ornament.[33] These works included not only this and at least two other stands (the plural karāsī indicates there must have been at least three) and a chandelier, but also several buildings. These comprised a congregational mosque (jāmi') in the monastery, as well as three additional places of prayer (masājid). The

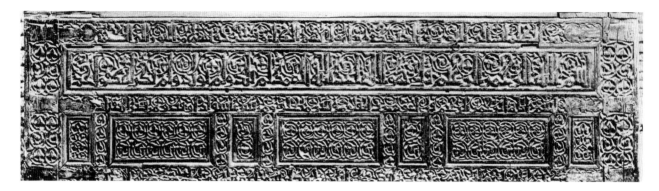

132 Cairo, Mausoleum of Sayyida Ruqayya, wooden cenotaph, 1139

first was a mosque at Munajat Musa, where Moses spoke with God (presumably the present Jabal Musa), another was a congregational mosque (*jāmiʿ*) above the mountain of the Monastery of Faran (perhaps the present Jabal al-Muharra) and a third was below New Faran (the oasis of Firan). In addition Anushtakin ordered a lighthouse (*manāra*) constructed on the coast, probably to mark a useful if poor anchorage where the Wadi Firan enters the sea.[34] Assuming that the congregational mosque in the monastery had to have been built before al-Afdal ordered a minbar for it, Anushtakin's work came first and was then followed by al-Afdal's.

These Fatimid activities in Sinai are confirmed by eight decrees dating from a few decades later in the middle of the twelfth century that are preserved at the monastery.[35] Apart from the eleventh-century one already discussed (see Fig. 78), these rare documents are among the earliest preserved diplomatic records from anywhere in the Islamic lands. The documents, apart from confirming the court's interest in the region, normally concerned redress requested by the monks for grievances committed against them, usually by some local agents who tried unjustly to seize the monastery's revenues. Meanwhile, al-Afdal's and Anushtakin's involvement reflects a deliberate policy of islamization in southern Sinai, which had remained Christian far longer than the north.[36]

The form and decoration of al-Afdal's minbar for St Catherine's mosque show what different resources were available to the son only fifteen years after his father had ordered the minbar for al-Husayn's shrine at Ascalon. The minbar for St Catherine's is distinctly retardataire, with symmetrical Bevelled Style arabesques in each panel. The new style of interlaced geometric patterns comparable to those on Badr's minbar are found only on the inside of the backrest and sides of the seat. One may conclude that in contrast to the Ascalon minbar,

which is of the highest quality Syrian workmanship, the Sinai minbar and kursi were both typically Egyptian work that was sent to Sinai. The centre of political power may have remained in Egypt, but Syrian craftsmen were far more innovative in their work.

The mihrab ordered for the Azhar mosque by the caliph al-Amir in 1125–6 and now in the Islamic Museum has already been discussed in the context of the Aqmar mosque (see Chapter 5), for it was used as a model for its restored mihrab. The actual niche, which has the appearance of a venerated relic, is flanked on either side by four rectangular panels (the lower ones have been restored) with carved symmetrical arabesque panels typical of the period set into a mortised frame. Similar panels are also found on a closet door from the Aqmar mosque, constructed in the same year. At the back of the prayer hall on the left-hand side were two shallow closets, presumably for books, closed by panelled doors. The remains of a few of the original rectangular panels, decorated with symmetrical arabesques, were incorporated in the present mortised frame; two other panels are also preserved in the Islamic Museum.[37]

A more metropolitan example of contemporary woodwork is the splendid wooden cenotaph (*tābūt*) of Sayyida Ruqayya, dated by inscription to 1139, which stands on a brick substructure under the main dome of her purported mausoleum in Cairo (Fig. 132). Measuring 2.85 metres × 1.75 metres × 47 centimetres (9.35 × 5.75 × 1.5 feet), the cenotaph is divided into five registers by three horizontal bands mortised into vertical bands of arabesque at each end. All but the fourth register from the top are decorated with elaborate kufic inscriptions against a scrolling ground; the fourth band is composed of alternating narrow vertical and broad horizontal panels separated by vertical stiles and decorated with somewhat monotonous symmetrical arabesques of

overlapping scrolling vines.[38] The vertical stiles are equally decorated with tight vine scrolls, giving the cenotaph a particularly ornate appearance. The text of the inscription indicates that this tomb was ordered in 1139, or six years after the construction of the mausoleum, by the widow of the caliph al-Amir through the services of the Qadi Maknun, servant of Caliph al-Hafiz by the hand of the 'excellent' Abu Turab Haidara ibn Abi'l-Fath.[39]

An ensemble consisting of a pair of doors, a door-soffit and a magnificent mihrab from the Mausoleum of Sayyida Nafisa in Cairo, now in the Museum of Islamic Art, dates from a few years later (1146–1147). The mausoleum, which honoured a great-granddaughter of al-Hasan, the Prophet's grandson, and the first 'Alid to be buried in Egypt, had been built in 1089–1090 during the caliphate of al-Mustansir, and was restored a half-century later by the caliph al-Hafiz (see Chapter 5 above). The pair of doors measures 2.24 × 1.20 metres, or 7.34 × 3.9 feet. Each valve has four identical rectangular panels with finely carved arabesque decoration held in a mortised frame with plain wooden rails and stiles.[40] The panels are similar to those found at the Aqmar mosque. The door-soffit consists of a frame containing two similar panels.

In sharp contrast, the magnificent mihrab made for the shrine itself (Fig. 133) is decorated with elaborate geometric ornament of a type previously unknown in Egypt. The mihrab, perhaps made of sycamore and teak, consists of a semi-domed niche with a slightly elongated and pointed arch set in a rectangular frame measuring 1.92 metres × 77 centimetres, or 6.3 × 2.5 feet.[41] The frame is a tongue-and-groove assemblage of polygons based on a hexagonal (60°) system, in which relatively broad and grooved strapwork bands create interstices of small stars, kites and T-shapes, all carved with arabesque designs.

Some of the arabesques are noticeably finer than others and might be replacements, although many missing pieces have been restored with plain strips. A six-pointed star in the centre of the panel above the niche is complemented by half-stars along the lateral edges of the frame, showing that the design was perfectly coordinated to the space available. Some of the unusual quality of the design derives from the balance established between the strapwork and the background, for the strapwork bands are separated from each other by a distance equal to their width. The resulting relatively narrow interstices therefore do not dominate the design, as they did on the minbar Badr al-Jamali ordered for the shrine at Ascalon (see Fig. 101).

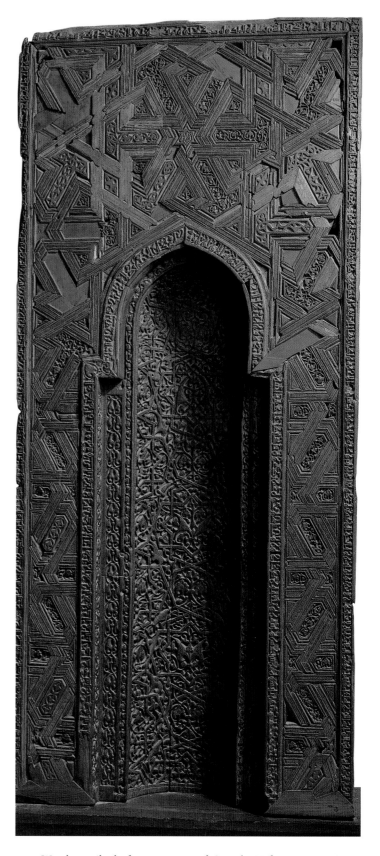

133 Wooden mihrab from mosque of Sayyida Nafisa, 1138–45 Cairo, Museum of Islamic Art, inv. no. 421

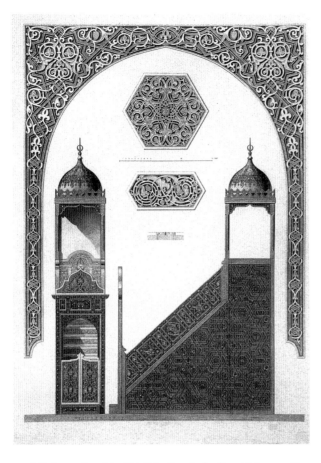

134 Minbar ordered by Tala'i' b. Ruzzik for 'Amri Mosque, Qus in 1155

Perhaps the finest piece of late Fatimid woodwork is the minbar ordered by the vizier Tala'i' b. Ruzzik in 1155–1156 for the 'Amri Mosque at Qus (Fig. 134).[44] The minbar, without the canopy, measures some 3.80 metres deep, 1.15 metres, wide and 2.70 metres high (12.5 feet deep, 4.9 feet wide and 8.9 feet high). The flanks are covered with a continuous network design based on a 60° grid of parallel bands that produce regular and elongated hexagons, hexagrams and bow-ties, as well as V-shapes and diamonds. The network bands, which are carefully grooved, are arranged in pairs as on the mihrab of Sayyida Nafisa, but the balance between the geometric network and the interstitial panels has been altered to give prominence to the individual panels, which are carved with a marvellously inventive range of strapwork designs. These often consist of pearl bands intersecting with vegetal arabesques, but others are purely vegetal. On several of the panels, the meandering profile of the pearl band is exactly like that found earlier on woodwork from Damascus, suggesting not only that this minbar was not provincial work, but that woodworkers (or woodwork) must have moved relatively easily between such centres as Damascus and Cairo in the late Fatimid period. Once again the designers had the unenviable task of reconciling the 60° grid of the decoration with the different slope of the staircase, but they did so with better results. Perhaps the finest and most inventive carving is found, not unexpectedly, on the minbar's backrest (Fig. 135), traditionally the locus of the most important designs and decoration, where strapwork and arabesque designs are seamlessly integrated into an almost architectural composition.[45]

Equally splendid in design and execution is the final example of Fatimid woodwork, the cenotaph of Husayn in Cairo (Fig. 136).[46] Although not dated in the inscription, it must have been ordered while the Fatimid dynasty was still in power, for it is unlikely that the Sunni leader Saladin or his successors would have ordered a cenotaph honouring the progenitor of the Fatimid line, whose demise they had orchestrated. The work is signed by a certain ('Ubayd) Ibn Ma'ali, who also signed the cenotaph of Imam al-Shafi'i (dated 1178), founder of the Sunni Shafi'i madhhab. Ibn Ma'ali is assumed to be the brother of the Aleppan craftsman Salman, who worked on the splendid minbar, now destroyed, that Nur al-Din ordered for Aqsa Mosque in Jerusalem, again confirming the movement of woodworkers between Syria and Egypt in this period.[47] Caroline Williams saw a subtle Shi'i message in the choice of Qur'anic texts inscribed on the cenotaph in kufic

In contrast, the interior of the niche is decorated with a carved rendering of a lacy strapwork pattern comprising a narrow pearled band forming large octagons alternating with eight-pointed stars. The whole is intertwined with a vine scroll. Like the earlier mihrab for al-Azhar, the niche itself appears to have been carved from a single piece of wood, but the strapwork design, although entirely different in effect from the joinery decorating the surround, seems perfectly in keeping with it. A Qur'anic inscription in kufic script runs around both the exterior and interior edges of the frame.[42] The mihrab of Sayyida Ruqayya is, therefore, a transitional piece between the Syrian style strapwork of Badr al-Jamali's minbar for Ascalon and the emerging geometric style. It would appear to have been made by Egyptian woodworkers who were becoming increasingly aware of and competent in the new style of decoration being developed in Syria. Nevertheless, comparison of these late Fatimid examples with the finest examples of contemporary woodwork, whether made in Aleppo or Cairo, shows not only how strapwork designs were all the rage but also how modest the Fatimid achievement was.[43]

script as well as in the design of the central panel, which is unusually based on a seven-pointed star. This unusual choice would, she argued, have made a subtle reference to Fatimid theology, which accorded the number seven unusual prominence. She reasonably concluded, therefore, that the cenotaph probably dates to 1154 when the head of al-Husayn was re-interred in Cairo. If this is true, it would underscore once again how artisans in this period – whatever their own confessional affiliation – were willing to work for whatever patrons were available in whatever style they requested, as long as they were paid.

Ceramics and Glass

We have already seen in Chapter 4 that the overwhelming majority of Fatimid ceramics are undated and the two that can be precisely dated were made in the early eleventh century. Archaeological findings – and common sense – would indicate that ceramics continued to be made throughout the Fatimid period, but dating them with any sort of precision has been difficult, if not impossible. Scholars have been resigned to give rough but unsatisfactory dates such as 'eleventh–twelfth century', which theoretically might encompass the very

135 Backrest of the minbar from Qus

different artistic situations during the reigns of al-Hakim and al-Hafiz. Such dates tell us nothing about how the ceramic arts developed in the Fatimid period. Typical tools of art history, such as stylistic analysis,

136 Cenotaph of al-Husayn, Cairo

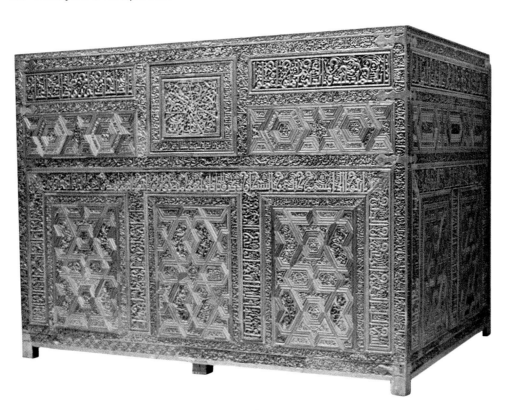

have been no more help providing convincing dates, for it seems futile to arrange a group of dishes according to a perceived development of their imagery or decorative motifs without first having some fixed points from which to hang the series.

Similarly, it has been difficult to characterize later Fatimid glass, as all of the dated finds come from the earlier period.[48] Nevertheless, even in the absence of dated pieces it is possible to look at what came before and what comes after to see that a transition must have occurred between the earlier technique of lustre or 'stained' glass and the enamelling that would become popular during the Ayyubid period. The last phase of stained glass can be dated to the eleventh and twelfth centuries and gilding – perhaps inspired by Byzantine glass – and enamelling were established by the end of the twelfth century.

It has long been noted that the major technical development in Fatimid-period ceramics was the presence of ground quartz in the body to create a kind of ceramic commonly known as 'fritware' or more correctly 'stonepaste'. In the finest of these wares, large quantities of ground quartz and/or a glassy material (frit) were mixed with small amounts of fine clay to create a hard white body that could be turned on a wheel, moulded into shapes, carved and incised, and decorated in a variety of techniques ranging from underglaze painting to overglaze decoration with lustre. All scholars familiar with Fatimid-era ceramics have noted that Egyptian lustrewares display a wide range of bodies, ranging from the relatively soft and friable earthenwares presumably made from Nile clay to the hard bodies comparable to the finest fritwares of twelfth-century Syria and Iran.[49]

One way to explain this variation has been to credit Fatimid-era potters with a great deal of experimentation, as they played around with different formulas for making pots. The simplest explanation would be that potters at the beginning of the period began by making pure earthenwares and gradually increased the percentages of ground stone in their mix, finally making full-fledged stonepaste wares at the end. Unfortunately, there is no evidence to support such a simplistic line of development. Petrographic analysis, in which very thin slices of ceramic are examined under high-powered microscopes, of Fatimid-era lustrewares has shown instead that they fall roughly into four groups, each of which flourished for approximately fifty-year periods between *c*.975 and *c*.1175. In the century that concerns us here, from *c*.1075 to *c*.1175, it appears that two types of lustrewares were produced along with underglaze-painted and monochrome glazed incised (or relief) wares.[50]

The most notable technical change occurred *c*.1075, when potters began painting all-clay bodies with lustre. Stonepaste virtually disappeared, except for incised wares. This change of technique was accompanied by a switch from the traditional Nile clay mixture to a highly calcareous (or chalky) clay. When fired, this produced a hard pinkish-red body with visible inclusions of carbonate. Furthermore, the potters no longer used the traditional glaze opacified with tin; instead they began using a clear lead-alkali glaze. For effective decoration, the pinkish-red body needed to be covered with a white surface and this was provided by a thin layer of calcium silicate or 'Wollastonite-slip'. The white seems not to have been applied to the surface by dipping or painting, the way a slip is traditionally applied; rather, it is thought that the high levels (15–20 per cent) of lime in the body caused salts to effloresce on the surface of the unfired vessel to give the appearance (and function) of a light-coloured slip.[51]

Taken together, these technical changes seem to reflect a sharp decline in the fortunes of Egyptian potters beginning around 1075. The materials they used were less expensive or required less labour to process. The severity of the changes seems to parallel the social and economic crises of the times, and since lustre-decorated pottery begins to appear at about this time in Syria, Iran and Spain, it is thought that some potters must have left Egypt at this time to seek their fortunes in these regions.[52] Although Badr al-Jamali and his successor viziers were able to somewhat restore the fortunes of the Fatimid state, the economic climate was not particularly favourable for potters. Fewer Egyptians, it would seem, were willing to spend their liquid assets on fine pottery, although one must imagine that the market for everyday (i.e. unglazed) wares remained relatively constant.

A second transition can be seen *c*.1125 in the transition from what Robert Mason has called Fustat Lustre Group Three to Fustat Lustre Group Four. This change is not as marked as earlier transitions, but the wares show increased dependence on Syrian potters, whose activities burgeoned in the twelfth century. Following *c*.1175, roughly equivalent to the end of the Fatimid dynasty, Egyptian potters virtually abandoned the production of lustrewares, although underglaze-painted and possibly incised-wares continued to be made. Underglaze-painted wares, which often displayed designs similar to those that formerly appeared on lustrewares, became an increasingly larger part of the total production, indicating that lustre-potters were switching to wares that they could produce more cheaply

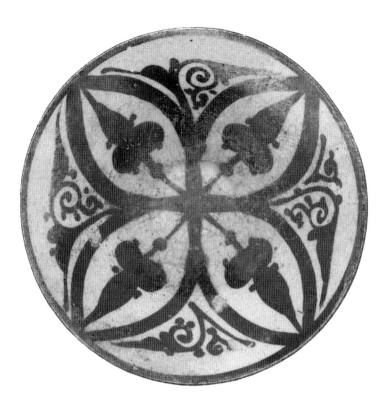

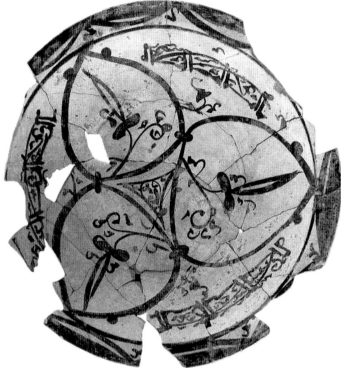

137 Ceramic bowl overglaze-painted in reddish lustre, Egypt, twelfth century, height: 6.3 cm (2½ in.), diameter: 21.3 cm (8⅜ in.). Washington, DC, Freer Gallery of Art, 1966.26

138 Underglaze-painted bowl excavated at Tell Acharneh in Syria, diameter: 33 cm (13 in.)

because they did not require the expensive materials or second firing in a special kiln.[53]

An example of late Fatimid lustreware is provided by a small (diameter 21.3 centimetres/8.5 inches) bowl with a slightly recurved rim and splayed foot in the Freer Gallery of Art (Fig. 137).[54] Painted in reddish-brown lustre, the bowl is decorated on the interior with a large quatrefoil motif with each lobe enhanced by a trilobed leaf. The spaces between the petals are embellished with scrolling tendrils and split palmettes. The trilobed motif and extra fine spirals are all characteristic motifs of Fustat Lustre Group Three, which dates c.1075–c.1125.[55]

A bowl recently excavated at Tell Acharneh, a Bronze- and Iron-Age site located on the Orontes River in the Ghab valley, 35 km south west of Hama in Syria, which was briefly occupied as a Crusader castle in the early twelfth century, exemplifies the typical late Fatimid Wollastonite-slip underglaze-painted ware (Fig. 138).[56] Measuring approximately 33 centimetres in diameter, the segmental bowl has a slightly sloping everted rim. Decorated in black under a transparent glaze, the bowl's material and decoration are typical of Egyptian production during the period 1125–1175, with hastily drawn designs based on the earlier lustre repertoire.

A third type of late-Fatimid ceramic is exemplified by an unusually large (height 42.8 centimetres / 16.8 inches) incised-ware jar with a green glaze in Kuwait (Fig. 139).[57] As already noted, most late Fatimid-era potters abandoned the stonepaste body except for incised wares, of which this is a particularly fine example. Constructed of several sections (base, shoulder, neck) that were formed separately and then luted together, the jar is incised around the shoulder with a benedictory inscription carved in thuluth script against palmette scrollwork and between scrolled bands. The 'less than perfectly rendered inscription' reads 'glory and wealth and good fortune and . . . and well-being [?] and long life to the owner.' The lead-fluxed glaze is coloured green with copper and falls down the body in streaked drips. Contemporary and later Syrian wares would have been covered with an alkaline glaze where copper would have produced a turquoise colour. Assuming that the attribution to the Fatimid period is correct, the presence of the thuluth inscription should again put to rest the erroneous notion that Fatimid-era artisans did not use rounded scripts.

If one can generalize from these three types of pottery and compare them to the pottery produced in the first

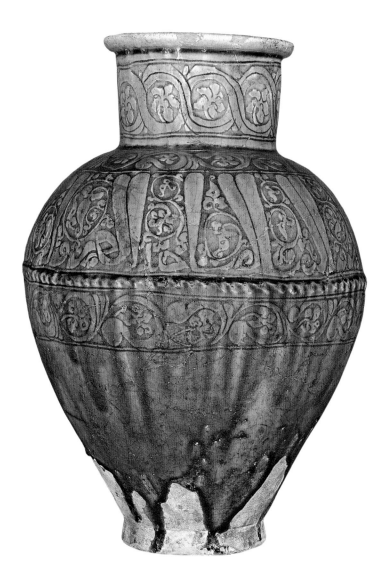

Metalware

Fatimid metalware in general has been difficult to characterize; in the absence of securely dated or dateable pieces, late Fatimid metalware remains particularly difficult to describe. James Allan has ingeniously suggested that late Fatimid vessels can be characterized by a preference for concave forms, as for example on a series of cast bowls with everted rims.[59] The finest example, in the Benaki Museum, Athens, measures 11.5 centimetres high and 26 centimetres in diameter. It is decorated on the flat rim with a kufic inscription broken into four sections by a scrolling stem set against a punched ground. On the inside, the upper band of decoration consists of four sections of a corrupt kufic inscription between rosettes, each section separated from the adjacent one by strapwork or palmettes. A narrower lower band displays a scrolling stem against a punched ground. The inscriptions appear to offer anonymous good wishes to the owner. Similar bowls are found in the Benaki Museum (Fig. 140) and the Keir Collection. Working from the bowls, Allan suggested that both concave-sided candlesticks and albarellos could trace their forms to Fatimid-era metalwork and ultimately to late Antique and Byzantine prototypes.[60] There can be no question that metalsmiths continued to produce vessels and other useful items in this period, but in the absence of inscribed and dated pieces, it seems that only the discovery of a datable hoard like that discovered at Caesarea will definitively establish the nature of late Fatimid metalwork.

Books

At his death in 1121, the powerful Fatimid vizier al-Afdal left a library of half a million books; the caliph al-Amir moved them to the palace and then endowed many of them for public circulation. The late Fatimid historian Ibn al-Tuwayr reports that the library contained over 200,000 bound volumes on such subjects as *fiqh* (jurisprudence), hadith, theology, grammar, lexicography, history, biography, astronomy and chemistry.[61] According to the historian Ibn Abi Tayyi, when the Fatimid dynasty fell to Salah al-Din in 1171, the caliph's library contained twelve hundred copies of al-Tabari's *History*, along with an estimated 1.6 million other books, many of which Salah al-Din sold. In apparent confirmation of these incredible numbers, Ibn Abi Tayyi claims that at least 100,000 volumes were transferred to the new Sunni madrasa established by al-Qadi al-Fadil, while the rest were sold over the next decade.

139 Fritware jar with incised decoration covered with a transparent copper-green glaze, Kuwait, Egypt, twelfth century, height: 42.8 cm (16⅞ in.), diameter: 30 cm (11¾ in.). Kuwait, Sabah Collection, LNS 350

century of Fatimid rule in Egypt, one notices that figural decoration seems to have been abandoned in favour of purely vegetal-arabesque or epigraphic motifs, such as seen on these three pieces. This evolution would appear to be the exact opposite of what had once been proposed, namely that the dispersal of royal goods from the palace treasuries in the 1060s inspired the bourgeoisie to adopt figural motifs in their art.[58] Instead, one may suggest that figural motifs were more characteristic of the ceramics produced in the early Fatimid period; they became increasingly rare with the passage of time.

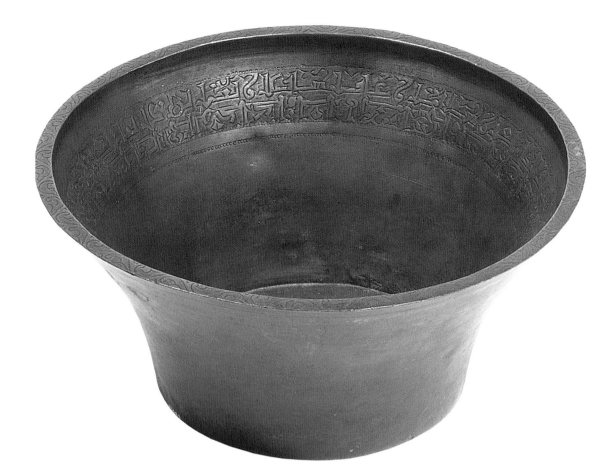

140 Cast copper alloy bowl with concave body, Egypt, twelfth century, diameter: 25.6 cm (10 in.). Athens, Benaki Museum, inv. no. 13093

Just as only one manuscript is known to have survived from the four hundred thousand volumes in al-Hakam's library in Spain, only two manuscripts from the extensive Fatimid royal libraries are known to have survived. The first, now divided between the National Library in Cairo (Fig. 141) and the library of the Asiatic Society of Bengal in Calcutta, is a unique copy of Abu ʿAli al-Hajari's *al-Taʿlīqāt waʾl-nawādir*. The second, now in the Public Library of Rabat, Morocco, is an auto-graph copy by the noted grammarian Ishaq al-Najayrami of his genealogical work, *Kitāb hadhf min nasab Quraysh ʿan Muʾarrij b. ʿAmr al-Sadūsi* ('Abridge-ment of the genealogy of the Quraysh by Muʾarraj b. ʿAmr al-Sadusi').[62] The first manuscript was written for the library of the vizier al-Afdal, but a few years later, the book was incorporated into the library of al-Faʾiz. The second manuscript bears an inscription stating that it was *liʾl-hizāna al-saʿīda al-Ẓāfiriyya*, that is 'for the library of the Fatimid caliph al-Zafir', father of al-Faʾiz. The manuscript was, however, copied before 966 in

Baghdad, so it is therefore not technically a Fatimid manuscript. Nevertheless, both manuscripts indicate that the libraries of the later Fatimid period contained manuscripts written in the cursive scripts that had become standard – except in the western Islamic lands – in the period after *c*.1000.

Paintings

Neither of these manuscripts is illustrated and an under-standing of painting in the late Fatimid period poses the same problems as does that of the earlier period: dating and authenticity. In the absence of dated manuscripts with illustrations, it seems rather futile to assemble corpora of images of questionable date, let alone authenticity, to illustrate a single track of development of Fatimid painting.[63] Perhaps the only example of painting that can be dated with some degree of certainty to the second century of Fatimid rule in Egypt is a group

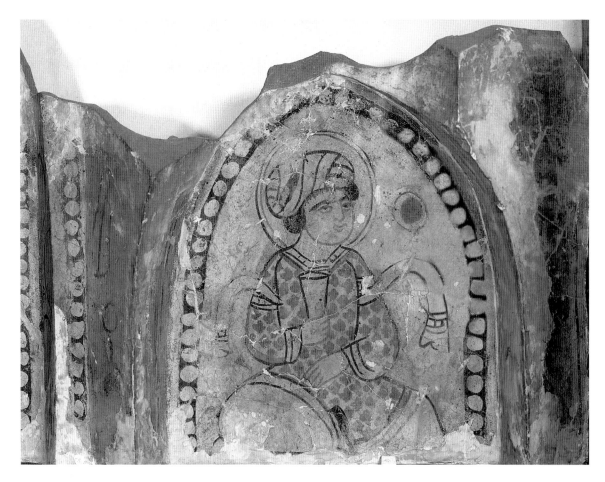

of painted plaster fragments from the Bath of Abu Suʿud (Fig. 142).[64] Now in Cairo's Museum of Islamic Art, the fragments were discovered in the ruins of a bath in a district of Cairo destroyed when the area was intentionally set ablaze in 1168. While the paintings cannot, therefore, be later than the mid-twelfth century, scholars have dated the fragments as early as the ninth century, a date based on their 'pure Abbasid style' almost 'identical to that used by the ninth-century painters of Samarra.'[65] The fragments consist of several muqarnas elements outlined with pearl bands and filled with rather simple symmetrical arabesques of twining vines, confronted birds, or figures of a seated drinker and dancing girl. While the style of the paintings may indeed resemble that of Samarra, it is an incontrovertible fact that they are painted on muqarnas, an architectural element that first appeared in Central Asia in the last quarter of the tenth century and that did not arrive in Egypt until the middle of the eleventh (see above, Chapter 5).[66] It is possible that the bath in which

the muqarnas was found might date from the Tulunid period, but it is unlikely that any Tulunid period decoration could have survived for two centuries in such an atmosphere of constant heat and humidity. It is far more probable that the bath would have been redecorated several times over in the course of the centuries and these plaster muqarnas would therefore represent a late – if not the last – stage in the bath's history.

The persistence of a style of painting associated with ninth-century Iraq into the late eleventh or even twelfth century in Egypt indicates that the history of Fatimid painting – whatever it might be – is far more complex and nuanced than previously imagined. It cannot be characterized by any single style or line of development and it is likely that different styles or techniques were favoured in different social and economic milieux. The popular setting of a bathhouse could have not been more different from the royal setting of a palace, so there is no reason to expect that they should share the same style of painting.

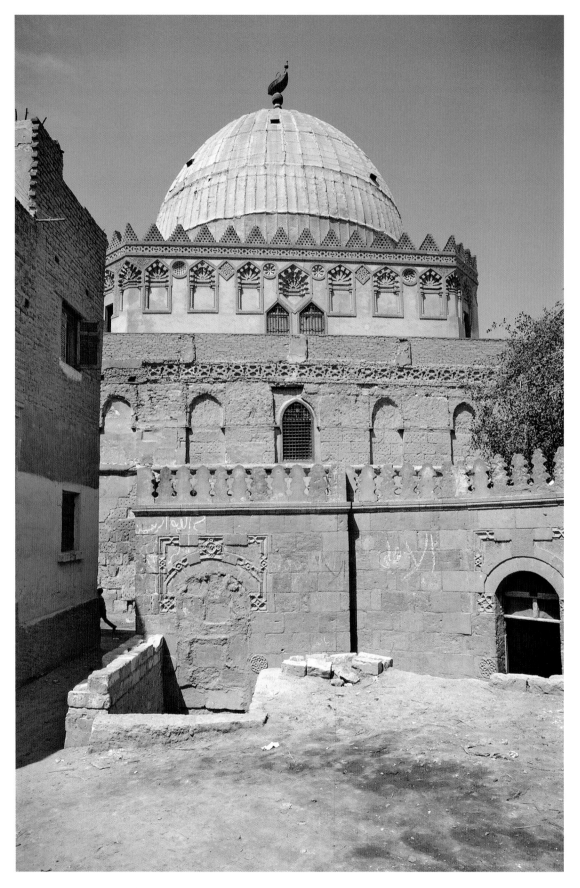

143 Cairo, Mausoleum of Imam Shafiʻi, 1211

VII

The Legacies of Fatimid Art

When the caliph al-Fa'iz died childless in 1160, the powerful vizier Tala'i' installed a grandson of al-Hafiz as the next caliph and arranged for his own daughter to marry him. However, Tala'i' himself was assassinated in 1161 on the instigation of an aunt of the former caliph al-'Adid but was succeeded by his son, Ruzzik. Although Tala'i' had been able to direct several successful military campaigns against the Crusaders, the Fatimid state was in a precarious position, for following the fall of Ascalon in 1153, the Fatimids had lost all their Syrian territories, allowing the Crusaders to threaten the Delta and the Egyptian capital from their strongholds on the Syrian coast.

Meanwhile, a strong counterthrust to Crusader power had been developing in the Syrian hinterland, first at Aleppo and then at Damascus, under the staunch Sunni leadership of Nur al-Din Zangi, who recognized the suzerainty of the Abbasid caliph in Baghdad. In Cairo, the palace clique, which had already arranged Tala'i''s assassination a year and a half earlier, arranged as well for his son's assassination in 1163 and installed Shawar, the tractable governor of Upper Egypt, as vizier. When the caliph soon became unhappy with his new vizier, Shawar refused to go peacefully and called on Nur al-Din to help him regain his office. Nur al-Din, who like the Crusaders already had his eye on Egypt, could not resist the opportunity and in 1164 dispatched an army of his own soldiers led by Shirkuh, one of Nur al-Din's Kurdish amirs, to reinstall Shawar and encircle the Crusader lands. Shirkuh took along his young nephew Salah al-Din (Saladin) b. Ayyub, who would bring the Fatimid dynasty to an end in 1171 and champion resurgent Sunnism.

Once Shawar was back in power, he proved to be a fickle ally to Nur al-Din, reneging on his agreement to turn over a substantial portion of Egypt's revenues and allying himself instead with Amalric, King of Jerusalem. Despite the Fatimids' precarious state, they could still put on a show: an embassy from Amalric to the Egyptian caliph was received in a vast hall divided in two by a great curtain of silk and gold, decorated with a pattern of beasts, birds and figures. Shawar prostrated himself three times before the hanging, which was then raised to reveal the veiled and gloved caliph, a dark-skinned and plump youth whose beard was just beginning to grow, seated on a golden throne encrusted with jewels.[1]

The wily Shawar tried to play both of his enemies against each other. Amalric's army eventually threatened to take Cairo, so in November 1168 Shawar ordered Fustat burned to prevent the Crusaders from occupying it. The extent of the damage has been disputed, but it does appear to have spelled the end of several districts. Shawar then sought the aid of the Syrians, who, in 1169, lured him into a trap and had him killed. Shirkuh was then installed as vizier to the Fatimid caliph but he died suddenly two months later and in March 1169 his nephew took over as commander and vizier.

Salah al-Din, as a staunchly Sunni Kurd in service to an Ismaili caliph, was in a delicate position. Over the course of the next two years he manoeuvred to sharply reduce the Shi'i character of the state and augment its Sunni character. The call to prayer now omitted the distinctly Shi'i phrases that had been used for two centuries and for the first time in centuries the Friday khutba invoked the names of the early caliphs and eventually even the name of the Abbasid caliph ruling in Baghdad.

Abbasid black banners replaced the white banners of the Ismailis, whose activities were curtailed within and outside the palace, which remained under close supervision. The imam-caliph al-Adid, who was not yet twenty-one, was known to be sick and eventually died of natural causes on 13 September 1171, ending two-and-a-half centuries of Fatimid rule.[2]

Salah al-Din initially governed for his overlord Nur al-Din in Damascus, but in the wake of the latter's death in 1174, Salah al-Din proclaimed himself sultan, thereby founding the Ayyubid dynasty which would rule Egypt and Syria until the Mongol invasions nearly a century later.[3] In addition to the Crusaders and his overlords in Syria and Palestine, Salah al-Din had to deal with the remains of the Fatimid state in Cairo and its considerable assets. Sources state that 18,000 men, women and eunuchs were turned out of the palace, of which 252 were males of the caliph's family. They were initially interned in the Dar al-Muzaffar in Harat Barjawan, north of the Western Palace, and later in the new Ayyubid citadel. The two sexes were allegedly separated so that the Fatimid line might become extinct, but this could not have been too successful, as some members of the line apparently survived until the reign of the Mamluk sultan Baybars in the middle of the thirteenth century.[4]

The once-splendid royal palace itself held no interest to the new ruler, who continued to live in the vizier's mansion as he had done before. Eventually Salah al-Din moved the centre of power from the heart of the Fatimid city when he constructed a massive new citadel on a hilltop overlooking it; the citadel was linked to the remaining populated districts by massive new defensive walls.[5] The citadel's position showed how it was designed not only to protect the city from invaders but also to control it, should the population prove unruly. Salah al-Din offered his high-ranking commanders separate portions of the old Fatimid palaces, which were in turn broken up into smaller and smaller units. Over time these fell into disrepair and were replaced with new buildings, although as we have seen, materials scavenged from the palace were reused whenever possible well into the Mamluk period.[6] Of the embarrassing mass of riches remaining in the palace, Salah al-Din proceeded to sell whatever he or his agents could. It reportedly took his agents ten years to dispose of everything.[7]

> From the Palace so many dinars and dirhems were taken, at a random estimate, so much gold and silver ware, jewels, copper, vases, furniture, cloths and weapons which constitute wealth such as Chosroes never equalled, no imagination conceived, nor the Mamluks ever attained. Indeed, no one could assess it save He who can count men on the Day of Judgment.[8]

Salah al-Din also prepared some of the spoils as a gift for Nur al-Din in Damascus, which included

> five copies of the Qur'an, one being of thirty parts with covers of blue satin and held together by golden clasps with gold locks bearing gold inscriptions, another of ten parts and covered with pistachio-coloured brocade and a third of leather with a gold lock and written in the hand of Ibn al-Bawwab; three balas rubies, one weighing twenty-two *mithqal*s, another twelve and a third ten-and-a-half; six emeralds, one weighing three *mithqal*s; one red (oriental) ruby weighing seven *mithqal*s; one blue (sapphire) stone weighing six *mithqal*s; one hundred jewelled necklaces weighing 857 *mithqal*s; fifty vessels of balm ointment; twenty pieces of crystal; fourteen checkered earthenware drinking bowls and dishes; a ewer and basin of jade; a gilt wine cup with a handle containing two pearls and in the centre a sapphire; plates, drinking bowls and dishes, all of Chinese porcelain and numbering forty pieces; two large blocks of aloeswood; amber including one piece weighing thirty *ratl*s and another twenty; one hundred satin garments; twenty four gold-embroidered black carpets; twenty-four garments of white figured silk; a gold-embroidered pepper-coloured set of clothes; another splendid set, yellow coloured and gold embroidered; a magnificent blue set, also gold embroidered; a splendid set with red and white thread; a pistachio-coloured set with gold thread; and many clothes as well, the value of it all amounting to 225,000 dinars. The messengers departed with these gifts, but learned on the way of the death of Nur al-Din, whereupon they turned back, losing some of the treasures.[9]

In short, Salah al-Din couldn't even give all this stuff away.

Cairo

The legacy of the Fatimids was, of course, strongest in Cairo itself, whose very name recalls their foundation, although Egyptians continued to use the popular name 'Misr'/'Masr' to refer not only to Egypt but also to its capital city.[10] The architectural remains of Fatimid Cairo

– incorporated whole or in part – shaped the development of first the Ayyubid and then the Mamluk city and continue to provide the underlying structure of Cairo's historical district.

Following the fire of 1168, which appears to have destroyed much of the eastern part of Fustat, the settlement at the end of the Fatimid period included, apart from the Fatimid city itself, a suburb known as al-Husayniyya to its north and another, Harat Bab Zuwayla, to its south. Cemeteries were located outside the walls to the north and south, and the lands to the west between al-Qahira and the Nile were occupied by gardens and pavilions, as were the areas around the Birkat al-Fil and the Birkat Qarun to the south east and al-Roda island in the Nile. While only part of Fustat was ruined, most of the districts of al-'Askar and al-Qita'i' to its north east were destroyed.[11]

Salah al-Din and his successors attempted to enclose the twin cities of al-Qahira and Fustat within one massive wall linked to the new citadel constructed on the Muqattam spur. The wall, which excluded some ruinous areas, was designed to protect the urban agglomeration from Frankish invasions and serve as a guideline for restoration within.[12] Although the Fatimid city itself was never as restricted in population as some later historians would have it, there can be no question that the character of the city changed as Saladin's amirs and their retainers took possession of the Fatimid palaces and transformed them for their own use. Several travellers, including Ibn Jubayr, 'Abd al-Latif al-Baghdadi and Ibn Sa'id al-Maghribi, left accounts of their visits to the city during the Ayyubid period. They universally report on the ruin of several neighbourhoods, with abandoned and collapsed buildings almost everywhere.[13]

Development seems to have occurred in other areas of the city, particularly along the Darb al-Ahmar, the road south of Bab Zuwayla leading to the citadel. This was the district where the vizier Tala'i' had been the first to build a mosque and its importance could only have grown as it stood between the old Fatimid city and the new centre of power on the citadel.[14]

Under the Ayyubids, who not only restored Sunnism – and specifically the Shafi'i school of law – as the state religion but expanded the role of madrasas, which had already been introduced in Fatimid times, a fundamental shift in religious policy took place. The Shafi'is, who had been predominant in Egypt since the ninth century when the founder, the Imam al-Shafi'i, lived in Egypt, allowed for only one congregational mosque in each town, assuming that it could hold the entire community.

In pre-Fatimid times, the 'towns' of Fustat, al-Qita'i' and al-Qarafa had been regarded as juristically separate and had their own congregational mosques and even the Shafi'is could have regarded the new Fatimid mosque in al-Qahira (al-Azhar) as serving a new and separate 'town'. As the number of congregational mosques multiplied under the Fatimids, however, the Friday sermon came to be pronounced in many mosques, which Shafi'is could hardly have identified as serving independent towns. The Mosque of al-Hakim, for example, was built outside and to the north of al-Qahira; nobody could have thought it to serve a separate population centre. Under the Ayyubids, Shafi'i law was re-established and the Friday sermon terminated at several mosques, including al-Azhar, since the 'town' was already served by the larger Mosque of al-Hakim. The Friday sermon was only reinstated at al-Azhar by the Mamluk sultan Baybars I in the middle of the thirteenth century when he sought to break the monopoly of the Shafi'i ulema.[15]

To promulgate Sunni teaching and counter whatever Ismaili doctrines remained in Egypt, the Ayyubids founded many madrasas, some in pre-existing structures and others in purpose-built ones.[16] Perhaps the most important was that near the grave of the Imam al-Shafi'i, which was founded by Salah al-Din himself in 1176 and completed three years later.[17] While nothing of the madrasa is known to survive, the present domed structure (Fig. 143) over the tomb was founded by the Ayyubid sultan al-Kamil in 1211 although it has been repeatedly restored over the centuries.[18] Measuring a little over 15 metres square (49 feet) internally and about 20.5 metres (67 feet) externally, the massive walls now support wooden pendentives and a double-shelled lead-covered wooden dome dating from the eighteenth century, but the thickness of the walls indicates that a dome – perhaps of masonry – was contemplated from the start. The exterior walls are decorated with blind arcades of fluted keel-arched niches flanked by engaged colonettes that recall the decoration of the mosque of al-Salih Tala'i'. One may imagine therefore that local builders continued to work as they always had, for any patron with deep pockets. While Fatimid theology may have been suspect, nobody seems to have thought that fluted keel-arched niches were specifically associated with the dynasty that had first used them. In short, contemporaries must not have seen anything particularly 'Fatimid' about their architecture.

The walls mark out a space that remains the largest mortuary chamber in Egypt. Covering this enormous space would have posed a major challenge to Ayyubid

144 Cairo, Mausoleum of Imam Shafi'i, cenotaph by 'Ubayd ibn Ma'ali, 1178

builders, who had no knowledge of how to do vaulting on such a scale. As far as we know, there were no great domed spaces in Fatimid architecture, although it is possible that the Fatimid royal necropolis was covered by a wooden dome or that wooden vaults covered some of the palaces' larger spaces. The closest parallel was – and remains – the Dome of the Rock in Jerusalem, whose wooden dome measures an uncannily-close 20.44 metres in diameter, only 6 centimetres (or 2 inches) less than the base of Shafi'i's dome. A great cursive inscription around the base of the Jerusalem dome states that Saladin himself ordered its 'renovation and gilding' in 1189–90,[19] so it is possible that the design of the mausoleum of Shafi'i was dependent in some way on the Dome of the Rock and meant to associate Salah al-Din's reinstitution of the Shafi'i madhhab in Egypt with his reinstitution of Islamic rule in Jerusalem.

The magnificent teakwood cenotaph over the grave of al-Shafi'i (Fig. 144) was crafted in 1178 by 'Ubayd, 'known as ibn Ma'ali', the same woodworker who had made the cenotaph for the head of Husayn a decade or so earlier when Egypt was still ruled – at least nominally – by the Fatimids. The cenotaph consists of a lower box-like base with a slightly smaller gable-shaped cover. The faces are decorated with a geometrical network based on a hexagonal grid with fine arabesque panels in the interstices. Inscriptions in kufic script run along the edge of each face and on the top of the qibla-facing side, while at the summit of the gabled part is an inscription in naskh stating who had made the cenotaph when. Not only is the design of the cenotaph largely a continuation of earlier Fatimid styles, but the kufic inscriptions prove that the kufic script continued to be used into Ayyubid

times and was not specifically identified with the Fatimids. Kufic inscriptions, this time in stucco, were also present on the madrasa founded by Sultan al-Kamil in 1225[20] and – with fluted keel-arched panels – on the Mausoleum of the Abbasid caliphs (before 1242).[21]

Virtually all of these buildings follow Fatimid precedent in using stone, or at least a stone veneer over a rubble core, for exterior construction, while interiors continued to be decorated with plaster, often carved and presumably painted as well. Whereas stone had been widely used in pre-Islamic Egypt, brick was preferred in early Islamic times before the rise of the Fatimids. Although the first Fatimid builders in Egypt continued to use brick, by the end of the tenth century the transition had begun on the façade of the Mosque of al-Hakim and by the end of the Fatimid period stone facings had become the preferred medium for monumental and high-prestige exteriors. Stone would remain the preferred medium for high-prestige construction in Egypt until modern times.

The only other major building to survive in part from the Ayyubid period is the double madrasa and tomb complex that sultan Salih Najm al-Din Ayyub ordered built between 1242 and 1244 on a site previously occupied by the Great Eastern Palace.[22] Although the interior is largely ruined (apart from the mausoleum), Creswell was able to reconstruct its plan as two blocks, each comprising a rectangular court with two iwans, united behind a panelled façade facing the street and centred on a magnificent portal crowned with a minaret (Fig. 145). This building appears to be the first major Ayyubid construction on the street known as Bayn al-Qasrayn, 'Between the Two Palaces'. The iwan – a vaulted room open at one end to a court – was a new architectural feature introduced by the Ayyubids, although the Fatimid palace did have a large room called iwan (we have no idea how it was roofed). In contrast, the decoration of the façade with blind keel-shaped arches along with the ribbed hood of the central arch is indebted to Fatimid precedents, presumably the façade of the Great Western Palace which had once stood on the site. Even more important, however, for the later development of Islamic architecture in Cairo is the way the builders followed the precedent of the Fatimid Aqmar mosque, which had been erected over a century earlier, by aligning the building's façade to the street while simultaneously aligning the interior to the direction of Mecca. This double orientation would characterize much of the Islamic architecture of Cairo over the next three centuries, as builders had to cope with the demands of an increasingly dense urban environment.

It remains one of the most notable legacies of Fatimid architecture in Egypt.[23]

The minaret over the portal of al-Salih's madrasa may have been the first minaret erected on the main street of Cairo – apart from the two enigmatic towers on al-Hakim's mosque, although an inscription records that a few years earlier, in 1237, a minaret had been erected on the Bab al-Ahdar, a very late Fatimid portal to the shrine of Sayyidna al-Husayn which stands on the site of the former Fatimid dynastic mausoleum.[24] The upper parts of both minarets have fallen and been replaced, but they both had square lower shafts decorated with three long and narrow fluted keel-arch panels, a design quite different from the mid-eleventh-century towers discussed earlier. Although some patrons in the later Fatimid period constructed towers, it seems likely that the restoration of Sunnism to Egypt brought about a small boom in minaret construction as patrons sought to grace their buildings with very visible signs of Islam. The proliferation of minarets in Ayyubid and particularly Mamluk Cairo may, therefore, be seen as a reaction to their relative paucity in Fatimid times.

Although details of Fatimid era architecture were regularly imitated in Ayyubid architecture, it was not until the early Mamluk period that a Fatimid-era building was copied for the first – and apparently only – time. The Mosque of Baybars I al-Bunduqdari, erected in the middle of the thirteenth century to the north of the city in the Husayniyya district, combines the general plan of the nearby Mosque of al-Hakim and its projecting portals with the dome of the mausoleum of Imam al-Shafi'i.[25] From that time on, as the architecture of the Mamluk period developed its own character and momentum, it is difficult to discern any specific quotations of Fatimid-era architecture until the early twentieth century. The handsome limestone façade of the Coptic Museum (1910) is quoted entirely from the façade of the Aqmar mosque (Fig. 146) with a few discreet modifications, such as the substitution of Coptic Christian motifs for the specifically Islamic inscriptions in the roundels. Presumably Marcus Simaika Pasha, the director of the Museum, chose the Aqmar façade as a model because he believed that the Coptic community had prospered under Fatimid rule.

More recently, the Dawoodi Bohra community of Ismailis, who until the twentieth century lived mostly in Gujarat, have been energetically restoring and rebuilding the Fatimid architectural heritage of Cairo. They first restored the Mosque of al-Hakim in the late 1970s and subsequently worked on the Aqmar mosque, the mashhad of al-Juyushi and the Lu'lu'a mosque as well

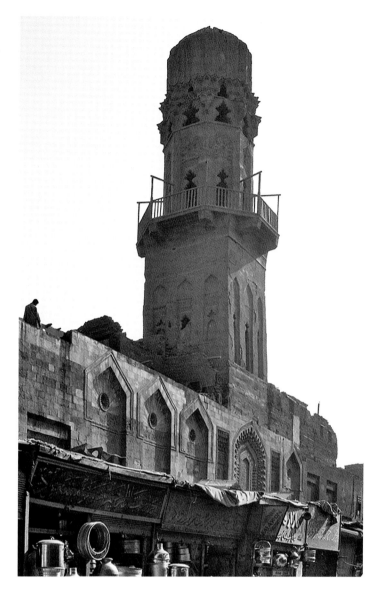

145 Cairo, Madrasa of Salih Najm al-Din Ayyub, 1242

as many of the smaller shrines.[26] The nature and extent of their activities has provoked criticism, as shabby old buildings have been reconstructed with stone and concrete and revetted with shiny marble and gleaming paint. Members of the Bohra community have also built new mosques in a Fatimid style or using Fatimid elements in such locations as Dubai, Surat and Houston. According to its website, the Fatimid Mosque (al-Masjid al-Fatemi) at the Sayfiyya University in Surat was built by the fifty-first dā'ī to replicate most of the Fatimid mosques of Cairo.[27] The Dawoodi Bohra mosque in Houston, Texas, is loosely based on the (restored) mashhad of al-Juyushi (Fig. 147). Even more recently, the pavilion housing the new Citadel View Restaurant (Fig. 148) in the Azhar Park project in Cairo, which was

179

146 Cairo, Coptic Museum, 1910

147 Houston, Texas, Dawoodi Bohra Mosque

148 Cairo, Azhar Park, Citadel View Restaurant designed by Rami el-Dahan and Soheir Farid

designed by the Egyptian architects Rami el-Dahan and Soheir Farid and funded by the Aga Khan Trust for Culture, was also inspired by Fatimid architecture.[28] In this way, contemporary Ismailis have succeeded in a way their ancestors never did in creating an identifiable Fatimid style of architecture.[29]

Much of what we know about Fatimid Cairo depends on the works of the great Mamluk historian Taqi al-Din Abu'l-'Abbas Ahmad b. 'Ali al-Maqrizi (1364–1442), who wrote three books – a history, a topographical work and a biographical work – that deal with the Fatimids either *in toto* (the history) or in large part.[30] His compendia often quote large portions of earlier texts that are known only through his works and provide invaluable information about the Fatimid city and its buildings. His contemporaries and later authors noted the lavish attention al-Maqrizi paid to the history and architecture of the Fatimids, his evident sympathy for them and his acceptance of their 'Alid genealogical claims, and reported that – at least early in his life – he believed that he was a descendant of al-Mu'izz through his eldest son Tamim, who was passed over in favour of the second son, the future caliph al-'Aziz.[31] Paul Walker has shown how al-Maqrizi discovered, in the course of his research, that his family's genealogical claims could not have been true (since Tamim was unable or unwill-

ing to produce an heir), but continued to learn more and more about their doctrine, not from malicious detractors nor from the writings of renegades like the Druzes but from their own esoteric writings. Although al-Maqrizi ultimately lost his early enthusiasm for Ismaili doctrine, he never lost his enthusiasm for individual members of the dynasty or for the way they had created and transformed the architectural space of his native city. Al-Maqrizi remains a unique figure in the historiography of medieval Egypt – and of the Islamic world in general – for the way in which he understood that the history of space, like that of individuals and of events, could provide a prism through which to view a society.[32]

Egyptian Islamic Art

Despite the brilliance of their textiles, ceramics, carved ivories, carved rock crystals and woodwork, the decorative arts of the Fatimid period had a considerably weaker impact on the decorative arts of later Islamic times than did its architecture. We have already seen that the economic problems of the twelfth century seem to have encouraged lustre potters to leave Egypt for greener pastures elsewhere since few people were willing to pay the added costs for these luxury wares,

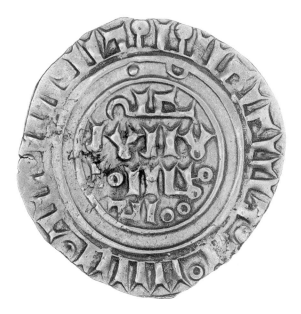

149 Crusader Besant with imitation kufic inscription

and one may imagine that similar problems faced artisans in other media. Egyptians continued to need common unglazed and glazed crockery and we know that less-expensive carved and underglaze-painted wares continued to be produced in Cairo. Ayyubid-era ceramics from Egypt are no match for the finest Fatimid wares, but recent discoveries suggest that some potters in Egypt continued to produce lustrewares of very modest quality.[33] Apart from the wonderful lustre ceramics they produced in the early part of the period, the major contribution of Fatimid potters was their emigration. Just as Basra potters in the tenth century had brought the techniques of making a stone-paste body and overglaze decorating with lustre to Egypt, Egyptian potters in the eleventh and twelfth centuries were responsible for introducing these same techniques to Syria, Iran and perhaps to North Africa and the Iberian peninsula as well.[34]

Whereas metalwork attributed to the Fatimid period largely comprises cast copper alloy pieces decorated with a variety of surface techniques such as engraving, chasing and punching, luxury metalwork of the Ayyubid period is very different. Much of it is made of hammered sheet and the finest is decorated with designs engraved and then inlaid in silver, copper and gold.[35] The technique of inlay had been developed in the eastern Islamic lands during the twelfth century and brought west thanks to the movement of artisans in the lands then under Seljuq rule. Ayyubid metalwork, like Ayyubid power, traces its roots to northern Syria and the Jazira,

particularly the city of Mosul. Nevertheless, James Allan has convincingly demonstrated that certain aspects of Ayyubid metalwork, particularly concave profiles, may continue Egyptian shapes of the Fatimid period.[36]

The decoration of Ayyubid inlaid metalwork had little to do with earlier Fatimid art. The figural style derives from an entirely different – although not yet surely identified – source.[37] Allan's suggestion that stellar decoration in Ayyubid and Mamluk metalwork is a direct and meaningful continuation of stellar symbolism from the Fatimid period is much more problematic.[38] Strapwork star motifs certainly appear in many forms of Fatimid art, although rarely – if ever – on metalwork. Seven-pointed stars may have occasionally been intended in the past to convey a subtle Ismaili message, but six- and eight-pointed stars appear equally if not more frequently in Fatimid art.[39] It is unlikely that the number of points on a star would have mattered much to the vast majority of the population that did not espouse Ismaili beliefs and no mechanisms for maintaining such symbolic meanings have yet been identified in Fatimid or post-Fatimid societies. Conversely, it has also been suggested that all strapwork patterns in Islamic art had a Sunni, particularly 'Ashari, association, an opinion that now seems equally misguided.[40] To paraphrase Sigmund Freud, sometimes a star is simply a star.

Because Fatimid coinage retained its quality up to the very end of the dynasty, the Ayyubids like the Crusaders (Fig. 149) initially copied Fatimid gold coinage, although at a slightly lower standard of fineness. The type

of dinars the Ayyubids struck at Alexandria, al-Qahira and Fustat had three circular legends around a short central inscription bearing the name of the caliph or the sultan. As time progressed, however, and as gold became increasingly scarce, the weight of these coins diminished greatly in order to preserve the purity of the coin. Later Ayyubid die-cutters replaced the kufic script adopted from Fatimid models with a legible naskh and decreased the number of circular legends on gold coins. In addition to gold, the Ayyubids minted silver dirhams in Damascus for the first time in a century. These silver coins had new and distinctive designs, such as a square within the circular flan or an eight-petalled interlaced rosette, that differentiated them sharply from earlier – and more valuable – coins.[41]

As I have noted, it is extremely difficult to characterize the nature of glass production in the late Fatimid period, but Egyptian glassmakers may have continued to produce stained glass into the twelfth century, as seen for example on a small bowl said to have been found in the Fayyum.[42] Decoration of deeply coloured glass with trails and marvering, another older technique, also continued into the twelfth and thirteenth centuries, but the major development of the Ayyubid period was clear glass with enamelled and gilded decoration, often figural in nature. The technique first appears on a beaker made in the late twelfth century for the Zangid ruler of Mosul.[43] It is possible that the technique, which would become extremely popular and important in Mamluk Egypt, first appeared during the later Fatimid period in Syria, but there is no evidence that it was practised in Egypt during that time. Its origins should be sought either in the Seljuk east along with enamelled ceramics or in Byzantium.[44]

Only a very small number of Ayyubid textiles have been identified and these are either silk on linen embroideries or lampas silks.[45] Texts appear to show that the Ayyubid sultans continued to present inscribed textiles to their courtiers, but surviving examples of them have yet to be identified. Unlike the late Fatimid textiles, the embroidered linen fabrics attributed to this period are entirely non-epigraphic. Some of the changes may be due to shifts in production, for important centres of textile production on the Mediterranean coast of Egypt, such as Tinnis, were destroyed in 1227 by al-Malik al-Kamil for fear of Frankish attack.[46] Nevertheless, many other centres in less vulnerable regions continued to produce in the Ayyubid period.[47] Perhaps the most interesting textile from the period is a lampas woven of green and cream-coloured silk, now dispersed among many collections around the world (Fig. 150).

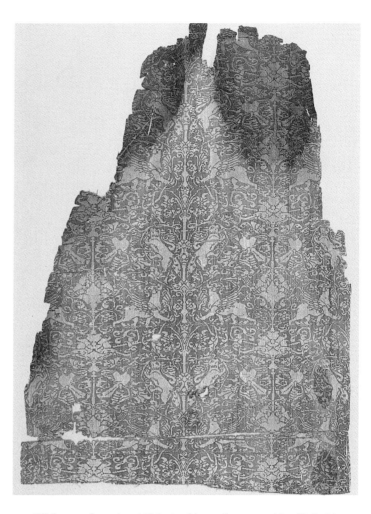

150 Silk lampas from Ayyubid Syria, thirteenth century. New York, Metropolitan Museum of Art 1947.15

The design presents a field of parallel vertical stems, with pairs of griffons and foxes flanking one stem, and flying birds flanking the other, the whole unified by a tracery of fine scrolling vines bearing leaves and palmettes.[48] Nothing could be more different in design or technique from the tapestry-woven tiraz bands known from Fatimid Egypt and this textile is usually attributed to twelfth- or thirteenth-century Syria.

Although the Fatimids had extensive libraries that included many beautiful and rare books, it is still impossible to assess the impact of Fatimid-era books on later production, whether in calligraphy, decoration or illustration. The new, more fluid scripts, which had been developed in tenth-century Baghdad, were avidly collected and presumably imitated in Egypt during the Fatimid period, although no examples are known to survive. Although some books must have been illustrated in this period, paper was neither cheap nor common enough to be used as an intermediary medium

between one technique and another, so it is unlikely that the painted images commonly found on eleventh-century lustre ceramics, for example, can be used to reconstruct the lost art of book illustration. Our knowledge of manuscript production under the Ayyubids is equally fragmentary.[49] When relatively large numbers of illuminated and illustrated books do begin to be made in Egypt in the thirteenth century, they generally belong to a broader phenomenon taking place throughout the central Islamic lands and are specifically inspired by Iraqi prototypes.[50]

North Africa

Fatimid architecture and art is generally thought to have had a more direct and greater impact on the architecture and arts of North Africa under the Zirids (*r.*972–1148) and Hammadids (*r.*1015–1152), two Berber dynasties that ruled in the region, for these two lines of governors were directly dependent on the Fatimids. When the fourth Fatimid caliph al-Mu'izz left Ifriqiya for Egypt in 973, he appointed the Sanhaja Berber Buluggin b. Ziri, whose father had already served the Fatimids as governor of Ashir in the central Maghrib, to be viceroy of the entire region. In the early eleventh century Buluggin's grandson Badis entrusted the western part of his realm to his uncle, Hammad b. Buluggin. Buluggin's brother Zawi, meanwhile, took up service in Spain, eventually founding a Taifa kingdom in Granada, so that in the early eleventh century different members of the Zirid family were ruling much of the Maghrib into the Iberian peninsula. The great medieval historian Ibn Khaldun saw the Zirids as vigorous newcomers who had supplanted the decadent and demoralized regime of the Fatimids; a more nuanced view shows them to be a lesser power in the shadow of a greater ambition, as the Fatimids departed in pursuit of a higher goal and their lieutenants were left to make their own way in the west.[51]

In 1041 Badis's son al-Mu'izz rebelled against his Fatimid overlords, giving his allegiance to the Abbasid caliphs of Baghdad. Although al-Mu'izz later reverted to the Fatimids, in the following years the Bedouin tribe of the Banu Hilal, which had long been settled in Lower Egypt, began migrating to the Maghrib.[52] Al-Mu'izz, not recognizing the extent of the problem, even attempted to diffuse the situation by marrying one of his daughters to a tribal chief, but anarchy and insecurity spread as one town fell after another. The Bedouin captured Kairouan on 1 November 1057 and forced the Zirids to

evacuate for al-Mahdiyya on the Ifriqiyan coast, and the old capital would never regain its former glory. Similarly, the Hammadids evacuated Qal'at Bani Hammad, their capital near Msila in the central Maghrib, for Bijaya (Bougie) on the Algerian coast. In the following years both the Zirids and the Hammadids attempted to reinvent themselves as Mediterranean naval powers, but in 1087 Mahdiyya was successfully attacked by the Pisans and Genoese. Meanwhile, the Normans – who had begun the conquest of Sicily in 1061 and completed it thirty years later – attacked the town in 1123, to be followed by the Hammadids in 1134. The Zirids signed a peace treaty with the Normans in 1140–1, who finally seized the town in 1148, marking the end of the Zirid dynasty. The Hammadids themselves faced the growing power of the Almoravids from the west, who finally put an end to the dynasty in 1152.[53]

Historians since Ibn Khaldun have decried the depredations of the nomadic invaders, who he famously compared to spreading locusts, claiming that they caused the brilliant urban culture of the Maghrib to decline irrevocably. According to this view, the initial Arab invaders of North Africa had been absorbed into the urban Berber population, bringing the benefits of Islam and Arab culture with them; the rude Hilalian nomads in contrast were little concerned with religion, urban culture and art and were only re-converted to Islam by the strength of religious institutions already existing in the Maghrib.[54] Recent scholarship, however, has seen the entire story of the invasion in an entirely new light, for the destruction the nomads wreaked may have been grossly overstated in the mythologized accounts of later city dwellers seeking to explain the cultural situation in the Maghrib.[55]

It is very difficult to assess how the Hilalian invasions actually affected the artistic situation in the Maghrib, for the artistic climate during the Aghlabid, Fatimid and early Zirid periods may well have been overstated. The monumental and archaeological record, already discussed in Chapter 2, suggests that artistic activities were already concentrated in a small number of cities, such as Kairouan or Sousse, and that the level of artistic achievement may not have been as high as some wishful thinkers have imagined. It has often been asserted, for example, that potters in ninth-century Ifriqiya already produced lustre pottery following Abbasid models, but petrographic analysis of the lustre tiles in the Great Mosque of Kairouan has demonstrated convincingly that all were imported from Iraq.[56] While individual lustre objects certainly arrived earlier, the technique of overglaze decoration in lustre did not appear in North

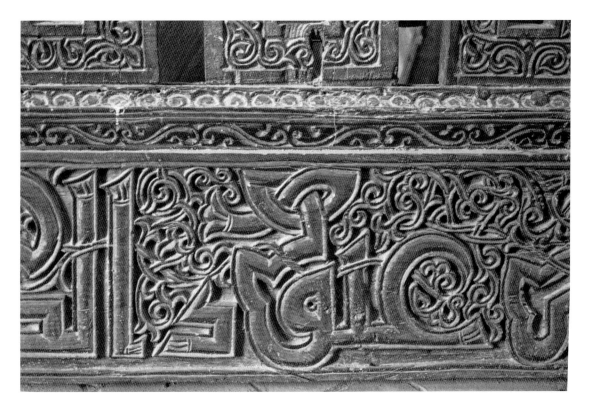

151 Kairouan, Great Mosque, Zirid wooden maqsura, detail of inscription, c.1036

Africa until the Fatimid potters left Egypt in the late eleventh century. While some craftsmen, particularly calligraphers and woodworkers, are known to have produced works of reasonably high quality, others, such as builders or potters, never achieved the technical or artistic quality of their colleagues elsewhere in the Islamic lands. Furthermore, only one example of each type – whether metalware, manuscript or maqsura – survives from the Zirid period, so it is impossible to discern trends. In contrast to contemporary developments in Iraq, Iran, Egypt, Syria or Spain, one senses that the artistic potential in North Africa was limited whether before or after the invasion of the Banu Hilal. This impression may change, however, should the long-unpublished excavations at the Zirid palaces of Sabra-Mansuriyya in Tunisia become better known.

Perhaps the finest work of Zirid art is the maqsura that al-Mu'izz b. Badis (1016–1062) ordered for the Great Mosque of Kairouan. It comprises a room-sized (8 × 6 metres /26 × 19 feet) rectangular enclosure 2.8 metres/9 feet high to the right of the mihrab and minbar. It is decorated with rectangular panels of turned spoolwork set within frames decorated with Bevelled-Style ornament, the whole surmounted by a frieze of Bevelled Style panels above which runs a band of kufic script on a scrolling vegetal ground (Fig. 151).[57] The inscription states that Abu Tamim al-Mu'izz b. Badis b. al-Mansur (his name is given without any accompanying title) ordered the maqsura through the agency of the secretary Zimam al-Dawla ('reins of the state') Abu'l-Qasim b. Abi 'Abbud. It also offers blessings on the Prophet and on his family. Although the maqsura is undated, al-Mu'izz is known to have presided over a gathering in the maqsura of the mosque in October–November 1036, but we cannot be sure that this maqsura had been erected by this time. The modest statement of blessing on the Prophet's family suggests that it was erected before the rupture with Cairo.[58] Samuel Flury suggested that the idea of erecting a maqsura had been inspired by the art of the Seljuqs rather than by the Fatimids of Cairo – who are not known to have used maqsuras (at least of this type), suggesting to him a date c.1050.[59] It is unspecified, however, how these 'influences' would have travelled from Seljuq Iraq to Ifriqiya and the earlier date seems preferable.

Although it shows some general similarities to early Fatimid woodwork, such as the use of Bevelled-Style panels on al-Hakim's doors for al-Azhar (see Fig. 37), the

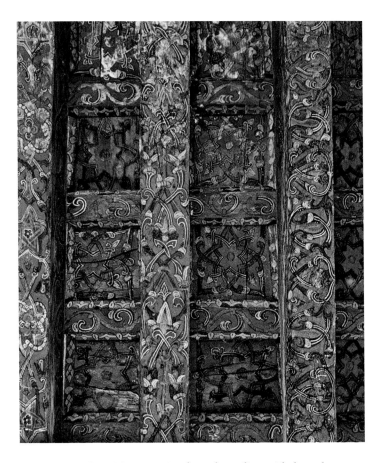

152 Kairouan, Great Mosque, painted wooden ceiling, mid-eleventh century

general effect of the Kairouan maqsura is quite different. The inscription – and indeed the entire ensemble – is far busier, for the letters have knotted stems and cusped and knotted tails, all outlined with a narrow bead and set against exuberant grooved foliage. Whereas the artist of the Azhar doors established a contrast between the densely-carved panels and the plain mortised frame, in the Kairouan maqsura everything is covered with lush ornament. Although spoolwork is found on the slightly-later minbar from Ascalon, it was also used significantly earlier on the minbar that Buluggin b. Ziri, his great-grandfather, had ordered for the Andalusians' Mosque in Fez. While the spoolwork decoration is not nearly as evolved as on the Kairouan maqsura, it too is set within frames carved with vegetal ornament.[60] This generally exuberant decoration also recalls that on the ninth-century minbar in Kairouan. In short, the general effect suggests that the Kairouan maqsura is the product of a local tradition of woodwork rather than the result of any continuing contact with Fatimid Egypt.

During the course of restoration work in the Great Mosque of Kairouan in 1935, painted ceilings were dis-covered that have been attributed to restoration work carried out by Mu'izz b. Badis in the mosque (Fig. 152).[61] Brightly painted in several colours with scrolling vegetal arabesques on a red ground, the designs on the ceiling have been generally, but not specifically, compared to examples produced in the central and eastern Islamic lands. Close inspection and more recent discoveries, however, reveal them to be closer to western Islamic examples, such as the painted and carved beams from the Great Mosque of Córdoba, than to beams from mosques in Egypt or Syria.[62]

The so-called Nurse's Qur'an, another notable example of Zirid art, also appears to have nothing to do with contemporary Fatimid art. The manuscript is a very large (45 × 30 centimetres; 17.7 × 11.8 inches) multi-volume copy of the Qur'an transcribed on approxi-mately 3,500 leaves of parchment by a certain 'Ali b. Ahmad al-Warrāq (the bookseller or copyist) (Fig. 153). In addition to copying five lines of a very distinctive broken cursive script on each page, he also vowelled, marked, gilded and bound this manuscript under the supervision of Durra, the (female) secretary. According to its colophon, it was then endowed to the Great Mosque of Kairouan by Fatima, the former nurse of the Zirid prince al-Mu'izz b. Badis in Ramadan 410/January 1020.[63] The script, which is a dramatic form of the broken cursive developed in the tenth century in the eastern Islamic lands, is characterized by its great size and unusually strong contrasts between the thick and thin strokes. As no Fatimid manuscripts of the Qur'an, apart from the Blue Qur'an (see Fig. 25), have yet been identified, it is difficult to place this unique manuscript in a broader context. Nevertheless, the continued use of parchment at a time when paper had become standard for copying manuscripts of the Qur'an in the eastern Islamic lands gives some indication of the artistic isola-tion of the Maghrib in the years before the Hilalian inva-sion. This tendency would only be exacerbated in the following decades as Maghribi calligraphers continued to prefer parchment to paper and developed their own distinctive regional scripts.

A large hanging lamp with pierced decoration, signed the work of Muhammad b. 'Ali al-Qaysi al-Ṣaffār (the metalworker), was also made for al-Mu'izz (Fig. 154).[64] The lamp originally comprised a cast suspension hook and plate, several cast openwork plaques which would have been fitted together to make three bands by which the basin was suspended from the plate, and finally the lamp itself, a large hammered brass basin pierced with hundreds of tiny holes which would have let out the light from a glass lamp suspended within. When com-

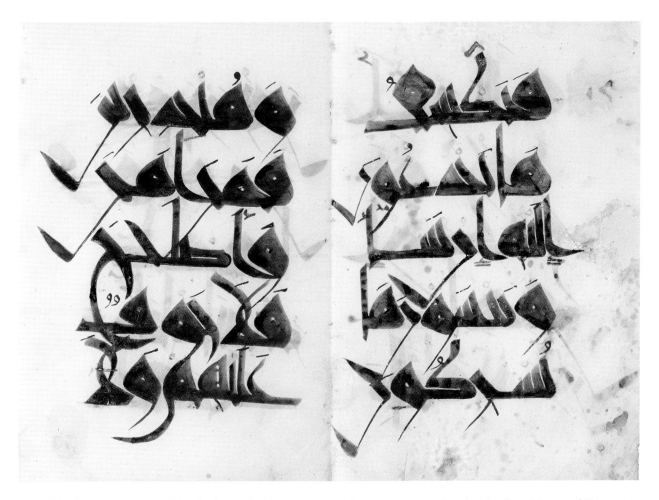

153 Bifolio from a manuscript of the Qur'an, with discontinuous text from Q 6:41–48, endowed to the Great Mosque of Kairouan in 1012, ink on parchment

plete, it would have measured 1.18 metres (approx. 4 feet) high. The plaques are decorated with an extremely sophisticated arabesque design in which the positive and negative elements alternate. The basin of the lamp is decorated with three inscriptions, created by piercing the background, that offer good wishes, presumably to the owner, and name the artisan and patron. The absence of religious inscriptions led Georges Marçais to propose that the lamp was made, not for the mosque in which it was found, but for the palace in Sabra-Mansuriyya.[65] This conclusion seems logical, as one might expect a lamp made specifically for a mosque to bear a Qur'anic rather than a benedictory inscription.

The site of Sabra-Mansuriyya has been excavated repeatedly since the 1920s producing quantities of architectural elements, including stucco fragments, mosaic pavements and glazed ceramic tiles, as well as large quantities of glazed ceramic vessels decorated with vegetal, geometric and figural designs. Apart from the

finds published by Marçais and Poinssot long before Tunisian independence, none of them has been adequately published. Two marble plaques bearing an inscription dated 1045–6 appear to have been made for one of the gates of the city (Fig. 155). They were later reused at Kairouan's Tunis gate, for they state that this is the 'City of the Glory of Islam', the name that appears on dinars struck by Mu'izz b. Badis in the middle of the eleventh century.[66]

In contrast, the Hammadid capital at the Qal'at Bani Hammad in central Algeria has been the subject of scientific excavation and publication for nearly a century, although the finds tend to raise as many questions as they solve. Built on the slopes of Mt Takarbust, the site was identified by Méquesse in 1886 and soon investigated by Blanchet and Robert. It was excavated by the general de Beylié in 1908, again by Lucien Golvin from 1951 to 1962. After Algerian independence Rachid Bourouiba continued work there.[67] The site's strategic

154 (RIGHT) Brass lamp made for al-Muʿizz ibn Badis, mid-eleventh century. After Marçais, *Objets Kairouanis*

155 (FAR RIGHT) Kairouan, inscription from Bab Tunis, 1045–6. After Houdas and Basset, *Épigraphie tunisienne*, pl. IX

N.° IX.

QAïROUÁN

value had long been apparent, since researchers found Roman ruins there as well.

Hammad, the grandson of Ziri (founder of Ashir), chose the Qalʿa or 'fortress' to replace his grandfather's capital and thereby not only dominate the Zanata Berbers of the adjacent plain but also put sufficient distance between himself and his relatives in Kairouan. Although the town was founded in the early eleventh century, its brief apogee came in the period between the Hilalian invasions and the decision by al-Mansur (r.1098–1105) to open an outlet to the sea at Bijaya. Refugees fled Kairouan for the relative safety of the remote outpost, but by the middle of the twelfth century, fears of an Almohad attack from the west led to the site's abandonment, although the Almohads briefly maintained a small garrison there. According to some sources, the town had several mosques, caravanserais and other public buildings, but despite the temporary influx of population in the second half of the eleventh century, it seems never to have attained the status of a true city, a self-perpetuating central place where goods and services are exchanged.

The Qalʿa is composed of a series of more or less independent constructions separated from each other and surrounded by an enclosing wall, an organization similar to that of other western Islamic palace complexes, most notably the Alhambra of Granada.[68] The foundations of several major structures have survived, including the congregational mosque with its tall (20 metres) square minaret of stone (Fig. 156) and four palaces, of which the largest, the Qasr al-Mulk/Qasr al-Bahr, had an enormous artificial pool at its centre (Fig. 157). Others included the adjacent Qasr al-Salam (Peace) and Qasr al-Kawkab (Constellation), as well as the Qasr al-Manar (Palace of the Tower), which overlooked the whole city. The palaces' terraced gardens overlooked a large pool, as at the neo-Umayyad palace suburb of Madinat al-Zahra'.[69] Although scholars have repeatedly likened aspects of the Qalʿa's architecture to Fatimid Egypt because of the Zirid-Fatimid connection, most of the affinities are to buildings in the western Islamic lands: the square rooms surrounded by rampant barrel vaults in the Qasr al-Manar, for example, foreshadow the great Almohad minarets of the late twelfth

157 (ABOVE) Qal'at Bani Hammad, plan of the Qasr al-Bahr palace

156 (LEFT) Qal'at Bani Hammad, minaret of congregational mosque

century, as does the square shaft of the minaret itself, which also follows north-west African and Iberian prototypes, particularly Abd al-Rahman III's minaret for the Great Mosque of Córdoba. Lobed interlaced arches – interlaced arches were already found at Ashir (see Fig. 22) – point to the decorative vocabulary of neo-Umayyad Córdoba rather than Fatimid Egypt, where they are unknown. The use of large pools as the central feature of palaces follows either the Fatimid palace at Sabra-Mansuriyya or Madinat al-Zahra more than anything in Cairo, as does the use of long narrow rooms around rectangular courtyards and the inverted T-plan of major reception rooms. Vaulting seems to have been a technical challenge for North African builders, so rooms remained relatively narrow and often covered with flat timber ceilings. A few partially glazed ceramic elements in the shape of grooved square shafts have been identified as a proto-muqarnas and a few actual plaster muqarnas elements were discovered at the Qal'a; they have all been said to show close affinities with Fatimid Egypt even though they look nothing like Fatimid muqarnas and the earliest surviving ceilings of plaster muqarnas are found in Fez, surely not a Fatimid outpost under the Almoravids. A few glazed cross tiles with lustre decoration have been found combined with

turquoise-glazed stars to create a star-and-cross pattern.[70] While excavators claimed that polychrome lustre wasters are said to have been found at the site, the evidence is moot and the tiles may have been imported from some other centre of lustre production – the way they are 'stretched out' with turquoise-glazed tiles supports this hypothesis. Polychrome lustre is an early Abbasid technique that was abandoned by potters before they left Basra for Egypt and entirely unknown by potters in Fatimid Egypt. In short, the major source for Hammadid visual culture continued to be nearby al-Andalus; the few similarities to the arts of Fatimid Egypt are either rare or coincidental.

Sicily

Another region whose art is said to have close ties with Fatimid Egypt is Sicily. The island, which was only completely conquered by Muslims from Ifriqiya at the beginning of the tenth century, fell into the hands of the Fatimids along with the rest of the Aghlabid realm. Despite the Shi'i beliefs of the new masters, the Muslim population of Sicily largely remained loyal to the caliph in Baghdad, forcing the Fatimid governors to rule with

an iron hand. The Kalbid family, who had been a mainstay of Fatimid political and religious policy in Ifriqiya, became hereditary governors of the island. The Kalbids had to face not only the hostility of the island's Sunni Muslims but also the designs of the emperor Otto I from the north and the Byzantines from the east. Once the Fatimids had left Ifriqiya for Egypt, the governors of the island, while maintaining cordial relations with Cairo, became increasingly autonomous and blithely ignored Christian threats. In 1004 the Muslims suffered their first setback in over a century from the Byzantines and Venetians at Bari; in the following year they were defeated again by the Pisans at Reggio. Al-Mu'izz b. Badis, the Zirid governor of Ifriqiya, eventually sent a large military contingent to secure the island, but the Kalbid governor then sought the help of the Byzantines, who defeated the Zirids but subsequently withdrew to the mainland, leaving the Zirid 'Abd Allah b. Mu'izz to defeat and kill his opponent. The ensuing struggles between various local rulers resulted in a period of anarchy; exploiting the situation, the Norman count Roger d'Hauteville came to the aid of the qa'id of Syracuse in 1061 and began the Norman conquest of the island, which was completed in 1091. Not content with ruling only Sicily, the Normans expanded not only into Calabria and Apulia in southern Italy but along the North African coast as well. They occupied the coast between Tripoli and Bijaya, starting in 1135, and were checked only by the advance of the Almohads from the west in 1153.[71] A period of instability following the death of William II in 1189 led the Hohenstaufen ruler Henry VI to claim the crown of Sicily in 1194, less than a quarter century after the fall of the Fatimids in Egypt.[72]

The Normans (r.1061–1194) were parvenus. Roger II crowned himself king of Sicily on Christmas Day 1130, but he inherited no trappings of monarchy. All had to be created *ex novo* and he and his ministers exhibited an eclectic taste, looking at monarchies past, from the Capetian kings of France and the emperors of Byzantium to the Fatimid rulers of Egypt.[73] Roger II is known to have sent gifts to al-Hafiz in Egypt, but there remains no record of what the gifts exchanged between the monarchs were. Al-Hafiz is known to have sent Roger a ceremonial parasol (*mizalla*), which the Berber historian Ibn Hammad (c.1220) said resembled a 'shield on top of a lance, strongly made and shining to behold'.[74]

Although historical sources state that the Muslims, especially the Kalbid governors, had erected many religious and civil structures during the centuries when they actually ruled Sicily, paradoxically virtually nothing survives from that time. The period of Norman rule, however, is characterized by a blending of Muslim, Byzantine and Latin cultures epitomized in such buildings as Roger's Cappella Palatina (1131–40) in Palermo, which combines a Byzantine style apse with a Latin basilica roofed with a wooden muqarnas ceiling (Fig. 158).[75] Several royal pavilions also survive from the Norman period. They were conceived in an Islamic style as pleasure palaces with attached chapels and baths situated within an extensive royal park. The buildings, which were considered until the eleventh century to be Kalbid structures, show striking similarities in plan to those adopted in Ifriqiya and the central Maghrib.[76] They are characterized by T-plan reception rooms, blocks that project from the body of the structure and the use of large expanses of water to reflect the principal façade, all features found in contemporary or earlier North African palaces. Set within a large hunting preserve, which had already been established under the Kalbids, the palaces were conceived primarily as residential structures, although the economic reality of the surrounding park should not be overshadowed. Each residence was surrounded by agricultural installations, such as citrus orchards, date-palm groves and olive groves. In this respect they are more reminiscent of the *munya* tradition of Islamic Spain than they are of the Fatimid palaces of Cairo.[77]

Many 'Islamic' features in Norman art and architecture are traditionally identified with Egypt. Roger is said to have imported aspects of palace architecture and decoration from Fatimid Egypt. Roger and his two successors built palaces, such as the Royal Palace, la Favara, l'Uscibene, la Ziza and la Cuba, that are quite unlike any earlier structures yet discovered in Sicily. It has long been recognized that they share some features, however, with Ifriqiyan palaces of the Fatimids and their Zirid and Hammadid successors, although their relationship to contemporary Egyptian palaces is less clear, primarily because the Egyptian evidence is so fragmentary. Jeremy Johns noted parallels between the Arabic inscriptions that decorated the Royal Palace in Palermo (which called on Roger's courtiers to treat the building as an analogue of the Ka'ba at Mecca) and Fatimid panegyrics, which treated the caliph's palace in the same terms. He compared the painted depictions of a seated ruler from the ceiling of the Cappella Palatina in Palermo with the seated figure from al-Mahdiyya (see Fig. 19) and is sure that the iconography, style and technique of the ceiling paintings indicate that it was largely the work of an atelier of artists imported from Fatimid Egypt.[78] Similarly, the coronation mantle of Roger II (Fig. 159), which, according to an inscription embroi-

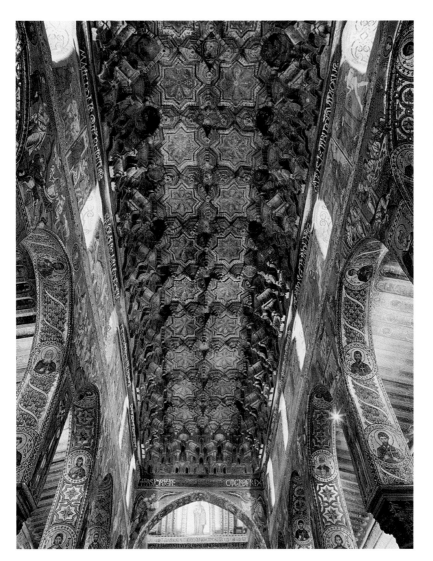

158 (LEFT)
Palermo, Capella
Palatina, painted
muqarnas ceiling, 1130s

159 (BELOW)
Coronation mantle of
Roger II. Gold and silk
embroidery on silk
with pearls, gold with
cloisonné enamel and
precious stones,
Palermo, 1133–4,
height: 146 cm (57½
in.), width: 345 cm (11ft
4 in.). Vienna,
Kunsthistorisches
Museum, SK Inv. No.
XIII 14

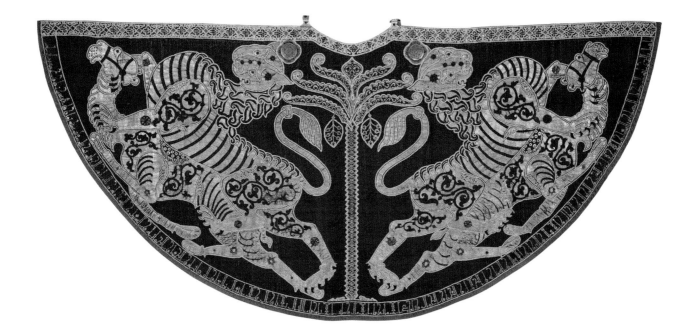

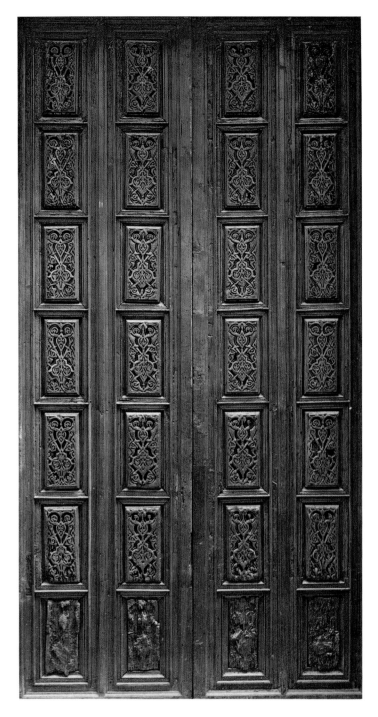

160 Palermo, Santa Maria dell'Ammiraglio, wooden doors with Fatimid-style panels, twelfth century

Many features in these works may, in fact, be more dependent on the arts of the Islamic west. For example, although the painted decoration on the muqarnas ceiling over the Cappella Palatina is regularly compared to Fatimid painting from Egypt, no comparable muqarnas ceiling like it is known from Egypt, although a remarkably similar – albeit unpainted – one was erected over a similarly rectangular space built only a few years earlier at the Qarawiyyin Mosque in Fez.[79] Similarly, the elaborate marble pavement on the floor of the Cappella Palatina is technically comparable to contemporary Roman Cosmati and Byzantine work, but its angular geometric design is based on a pattern common in Almoravid Córdoba and is quite unlike anything known from Fatimid Egypt.[80] The cultural affinities of Roger's coronation mantle are more difficult to establish. As a garment and in its iconography it too is quite unlike anything known from Fatimid Egypt, although its technique of underside couched embroidery is equally unlike contemporary textiles known from the western Mediterranean.[81] The protean nature of all these examples is epitomized by the Pisa Griffon, a bronze figure of a large winged quadruped that has been in Pisa since the Middle Ages. It has been variously attributed by serious art historians to eleventh-century Spain, Fatimid North Africa, Fatimid Egypt and northeastern Iran.[82]

Perhaps the closest artistic connections between Sicily and Fatimid Egypt can be seen in woodwork. The twenty-eight rectangular panels in the wooden doors from George of Antioch's twelfth-century church of Santa Maria dell'Ammiraglio in Palermo (Fig. 160) are said to have been carved by craftsmen 'trained in the Fatimid school'.[83] While there can be no question that the door panels are extremely similar to Fatimid work – particularly the doors to the Shrine of Sayyida Nafisa[84] – is there any reason to think that they could not have been imported to Sicily from Egypt sometime after they were made? In comparison, the carved wooden door jambs from the adjacent Casa Martorana are distinctly less fine in execution, with carving on only a single plane, and might well have been local imitations of Egyptian work.[85] A wooden panel with strapwork geometric designs in the National Gallery of Sicily, probably the soffit from a portal in the Palazzo Reale, has also been compared to Fatimid work, although its strapwork ornament and polygonal panels are more like contemporary geometric pavements and Almoravid woodwork.[86] In short, although there certainly were connections between Sicily and Fatimid Egypt, Ifriqiya and al-Andalus appear to have played a stronger role in the development of the dis-

dered on the hem, was made in the royal workshop at Palermo in 1133–4, has long been cited as an important example of Fatimid inspiration. Measuring over 3 metres/9 feet in diameter, it is a huge semicircle of red silk embroidered with gold thread, pearls and cloisonné plaques in a design showing a central palm tree separating scenes of a lion attacking a camel.

tinct Norman style. Accidents of history, including the destruction of virtually all representational art from medieval al-Andalus, make it difficult to provide parallels for some aspects of Norman Sicilian decoration, such as figural ceiling paintings, but absence of evidence is again not evidence of absence and it is quite possible that North African and Andalusian palaces were once decorated with figural images.

Although modern scholars have drawn connections between Sicily and Egypt, contemporary writers were more likely to see Sicily as an outpost of al-Andalus. For example, the traveller Ibn Jubayr, writing at the end of the twelfth century, called Sicily 'daughter of al-Andalus'.[87] Roger II often looked west for cultural and political reasons: he had the Andalusian sage Abu'l-Salt Umayya (1068–1134) install a hydraulic clock at the royal palace[88] and invited the *sharīf* Abu 'Abd Allah al-Idrisi (1100–1165) to Palermo to construct a world map and write a commentary on it. Al-Idrisi's invitation was also intended to further Roger's own political objectives, which included the conquest of North Africa and the establishment of Norman hegemony over the western Mediterranean basin, for the scholar was not a geographer and had little knowledge of cartography. His impressive genealogy, however, which went via the Idrisids of Fez back to the Prophet Muhammad as well as to the former rulers of Málaga, made him welcome in Roger's court as a potential puppet ruler.[89]

Christian Europe

The portable arts of the Fatimid period were collected in the Middle Ages throughout Christian Europe from Constantinople to the Latin West. Despite their obvious attractiveness and the value European owners attached to these items, few if any European artisans attempted to emulate their techniques or styles. Perhaps the closest relationships were established with the Byzantines of Constantinople, for over the course of the two-and-a-half centuries of their rule in North Africa and Egypt, the Fatimids had long and varied relationships with them. They often fought each other for control of liminal regions such as Sicily and northern Syria, occasionally paid tribute and regularly exchanged embassies and gifts.[90] Fatimid court ceremonial shows surprising similarities to Byzantine ceremonial and the Fatimid treasuries were full of real or purported *rūmī* (i.e. Byzantine) goods, including silk textiles and gold and silver vessels either enamelled or inlaid with gems.[91] Kufic inscriptions in what we might call a Fatimid style

appear on several works of Middle Byzantine decorative art, painting and architecture, but the tenth-century dates usually ascribed to these works suggest that the Byzantine appropriation must have taken place before the Fatimids established their power in Egypt. In short, middle Byzantine art seems to have existed in a universe parallel to that in which Fatimid art existed.[92] While the Byzantines may have received Fatimid gifts with delight, they had little or no reason to emulate them.

Some of the newly emerging Italian city states established commercial relationships with Fatimid Egypt. A document dated 976 mentions that the Amalfitan nobleman Lupino di Rini made a voyage *ad Babiloniam* and at the end of the century 107 or 160 *Rum* (i.e. European) merchants resident in a *funduq* known as the Dar Manak were suspected of setting part of the Egyptian fleet ablaze and were massacred by an Egyptian mob. The Fatimids had great need of European timber and iron while the Amalfitan merchants could find much to buy in Egyptian markets, including spices (pepper, cinnamon, ginger), alum, dyes, flax and odoriferous woods. Over the course of the eleventh century Genoese, Venetian and Pisan merchants also came to Egypt, although most of the documentary evidence concerns the twelfth century when some Italian cities became increasingly involved with the Crusader states in the Levant.[93]

Italian mercantile activities in Egypt are confirmed by the discovery of Fatimid-era ceramics in Italy, either as fragmentary pieces found in excavations or as *bacini*, complete pottery vessels inserted as decoration in the walls of medieval buildings. The date of construction therefore provides a *terminus ante quem* for the date of the ceramics themselves. Although two fragmentary Fatimid ceramics of the early eleventh century bear inscriptions linking them to court patronage (see Figs 60 and 61), most ceramics are thought to have been made for sale in the markets of Cairo, where Italian merchants would have been able to buy them. *Bacini* have been found at a variety of Italian sites, including Amalfi, Ravello, Salerno, Rome, Lucca, Pisa, Genoa, Venice and Bologna, as well as on the islands of Sardinia and Sicily, a distribution closely keyed to the mercantile centres trading in Egypt and the Levant. To judge from the surviving *bacini*, Italian merchants imported ceramics of varying qualities not only from Egypt, but also from Syria, Ifriqiya and the western Maghrib as well.[94] The use of these imported ceramics as decoration for prestigious buildings indicates that these wares were precious and expensive curios that were eventually given to the churches.

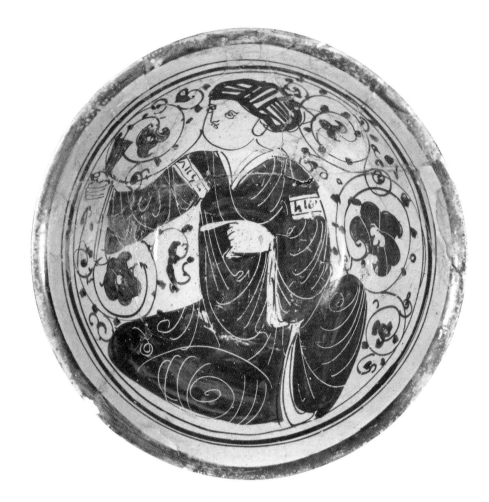

161 Ceramic bowl depicting a seated figure drinking inserted as decoration in the wall of the
Church of San Sisto, Pisa. Egypt, last quarter of eleventh century?

One of the finest surviving examples is a bowl once embedded in the walls of the church of San Sisto at Pisa (Fig. 161). Decorated in a deep brown lustre, the bowl is filled with a painting of a turbaned seated figure wearing robes with tiraz bands on the sleeves and holding a cup. Measuring 22.5 centimetres in diameter, it has the typical deep rounded profile of Egyptian ceramics of the late eleventh or early twelfth century.[95] The brown lustre of the body has been scratched to delineate the folds of the cloth; the background is filled with a loosely scrolling arabesque, both features that the finest Egyptian potters would take with them to Syria and make characteristic of the so-called Tell Minis wares.

In addition to complete lustre and underglaze-painted ceramics, fragments of underglaze-painted pottery from Egypt or Syria were used as mosaic tesserae in several churches in and around Ravello, presumably to take advantage of their startling turquoise

blue glaze after the pieces had been accidentally broken in transit or use.[96] It would be several centuries before Italian potters would be able to emulate the brilliant glazes, let alone the stonepaste bodies, of the ceramics imported from the Islamic lands.

Although *bacini* – presumably representing an urban art acquired by merchants travelling abroad – may represent the numerically largest category of Fatimid art in Italy, church treasures comprising Fatimid court items were more highly valued. These textiles, carved rock crystals, glasses, ivories and metalwares were usually valued not for their pedigree but for their precious materials – even the linen cloth was woven with gold – and fine workmanship.[97] Unlike the ceramics, which would have been easy for merchants to acquire, none of these royal objects has a clear provenance.

Some, such as the Fatimid tiraz in Apt known as the Veil of Saint Anne (see Fig. 126), appear to have been acquired directly during the Crusades, for both Isoard,

the bishop of Apt and Raimbaud de Simiane, the lord of Apt, participated in the First Crusade, although there is no documentary evidence to prove that these men acquired the textile in the Levant. It is less likely, but possible, that it was given as a gift by an Egyptian embassy to the Crusaders at Antioch in late 1097 or given to Frankish ambassadors who came to Cairo in 1098.[98] Similarly the 'Sacro Catino' in the cathedral of San Lorenzo in Genoa – a flat, hexagonal bowl of transparent green glass – is said to have been presented to the cathedral by Guglielmo Embrico, commander of the Genoese during the First Crusade. It may be identified with the brilliant green 'vase' William of Tyre saw in the mosque of Caesarea around 1100; it was acquired by the Genoese, who gullibly believed it to be made of emerald.[99]

Crusaders were less respectful of metalwares that could easily be melted down and refashioned. Ibn al-Jawzi (*d.*1200) said that Crusaders at the Dome of the Rock stripped the building of forty-odd silver candelabra, each of them worth 360,000 dirhams. They also took a silver lamp weighing forty Syrian *ratl*s as well as twenty-odd gold lamps.[100] Latin sources, however, mention only eight huge silver lamps that were taken from the Dome of the Rock and it is likely that all the gold and silver objects, like similar royal objects from the Fatimid treasuries, were melted down for coin.[101]

Many of the Fatimid royal objects in European church treasuries are thought to have been acquired after the dispersal of the Fatimid treasuries in the 1060s. According to the *Book of Gifts and Rarities*, 'wealthy merchants transported some [of the precious items] to other cities and to all countries, [where] they became beautiful adornments and treasures for their kings and also ornaments and objects of pride for their kingdoms.'[102] It is possible, therefore, that some of the precious items, such as the rock crystals the looters discovered, were sold on the market and eventually made their way to Europe. For example, al-Maqrizi reports that two vessels of superb rock crystal – one was a carafe and the other a bowl or pot – bearing the name of al-'Aziz b'illah were later seen by someone in Tripoli.[103] It is tempting to identify the ewer in San Marco (see Fig. 72) with the carafe in question, but the report states that the carafe held about 3 litres, while the San Marco ewer holds much less. It is possible, of course, that the writer was exaggerating the size.[104] Similarly, a Fatimid rock crystal ewer that came from the treasury of the Abbey of St Denis and is now in the Louvre (Fig. 162) is probably to be identified with the *lagena* (flagon) that Count Thibaut acquired from

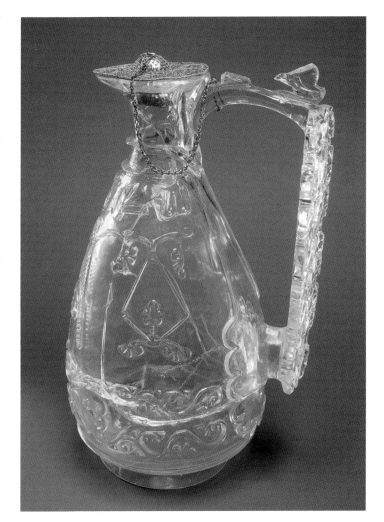

162 Rock crystal ewer formerly in the Abbey of St Denis. Egypt, eleventh century, height: 24 cm (9½ in.), diameter: 13.5 cm (5¼ in.). Paris, Louvre MR 333

the King of Sicily (i.e. Roger II) and gave 'in its case' to Abbot Suger (*d.*1151). Although Suger did not mention the material from which the flagon was made, he mentioned it with other vessels of carved hardstone, suggesting that it too was made of stone. That the vessel was presented in its case suggested to Avinoam Shalem that it could have been one of the rock-crystal vessels in the Fatimid treasury, which al-Maqrizi states had their own cases of bamboo, although the word *lagena* points to a much larger vessel that held several gallons.[105] Jeremy Johns believes that the ewer was a gift to Roger II from the Fatimid caliph al-Hafiz (*r.*1130–1149), although no documentary evidence supports this claim.[106] If this is the same vessel, then its golden lid would have been made in mid-century Sicily in the local style.[107]

Other pieces either passed through Venice or ended up in that city. For example, the crescent of al-Zahir now

163 Drawings of woodwork from the Moristan Hospital [mis-attributed to the thirteenth century]. After A. C. T. E. Prisse d'Avennnes, *L'Art arabe* (1877), pl. LXXXIII (compare to Fig. 38)

in Nuremburg (see Fig. 74), which may have originally been mounted on a spear carried during Fatimid processions, was in Venice no later than 1350 when it was mounted on a reliquary. Scholars think that it may have reached the city a century or so earlier from Constantinople, from which it might have been taken as spoils of the Fourth Crusade in 1204, when the Crusaders decided to attack the Byzantine capital instead of the Holy Land.[108] But it is unknown how it would have gotten to Constantinople in the first place, although it is possible that some of the merchants present at the Fatimid liquidation sale sold their wares in Constantinople as well.

As the looters in eleventh-century Cairo never made it to the inner treasuries, many splendid items remained in the Fatimid palace for another century, when they were dispersed either before or after the fall of the dynasty. The antepenultimate Fatimid vizier al-'Abbas fled Cairo in 1154 with all the treasures he could carry from the palace; he is known to have been captured in Palestine and the booty passed to the Crusaders, who presumably took some of it to Europe. But there was still lots left for Salah al-Din to dispose of. For example, he acquired a huge ruby called *al-ḥāfir* (the hoof) from the Fatimid treasury. It had been sewn onto a silk cloth, surrounded by green emerald baguettes and was hung on the forehead of the

caliph's horse during royal processions. The stone is known to have been given to William II of Sicily in 1179, but it is not known how it reached him. William later gave it to the Almohad ruler Abu Ya'qub Yusuf (r.1163–1184), after which it was no longer heard of.[109]

In sum, then, Europeans collected Fatimid objects for their intrinsic or artistic value but rarely if ever tried to emulate or copy them. In this way, although Fatimid works of art were better preserved in Europe than they were in Egypt, they ultimately had much less of an impact there, for their provenance became immaterial as new histories were created for them linking them to the Christian past. It was only with the development in the nineteenth century of an interest in what is now termed Islamic art and the publication of some key texts that the Fatimid provenance of these objects became significant.

Conclusions

The recognition of a distinct Fatimid style of art and architecture was the product of two developments in the nineteenth century: first, an increasing interest in all the arts of the Islamic lands, and second, the publication of several key texts.[110] Fatimid-era buildings, including the mosque of al-Hakim and two of Cairo's Fatimid gates,

had been published in some of the volumes of the *Description d'Égypte*, beginning in 1809.[111] In 1877 A. C. T. E. Prisse d'Avennes included several works of Fatimid art in his book *L'Art arabe d'après les monuments du Kaire*, among them a view of the courtyard of the al-Azhar mosque (Fig. 164) – which he dated between the ninth and the eighteenth centuries – the Mosque of al-Salih Tala'i' (Fig. 165), the Fatimid minbar from Qus (see Fig. 134) and six carved wooden panels from the Maristan of Qala'un (Fig. 163), which he logically, but incorrectly, dated to the thirteenth century.[112]

A more systematic approach developed at the end of the century in the works of the Comité de Conservation des Monuments de l'Art Arabe, which held its first meeting in February 1882,[113] and in the writings of such scholars as Stanley Lane-Poole and Max van Berchem, who were able to connect what they saw in front of their eyes in Egypt with what they had read in the Arabic and Persian sources. A complete, if defective, edition of al-Maqrizi's *Khitat* had been published at Bulaq in two volumes in 1853, and in 1895 the orientalist Urbain Bouriant began publication of a French translation.[114] In 1881, the French orientalist Charles Schéfer had published an edition and translation of the travels of Persian Ismaili Nasir-i Khusraw, who – unlike al-Maqrizi – had seen Fatimid Cairo first-hand.[115] Lane-Poole was prob-

164 Courtyard of al-Azhar as drawn by Prisse d'Avennnes, *L'Art arabe* (1877), pl. IV

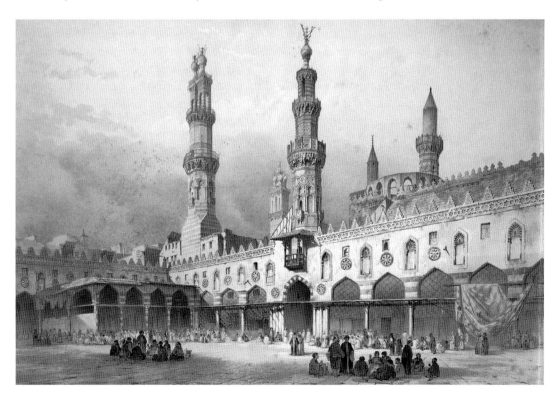

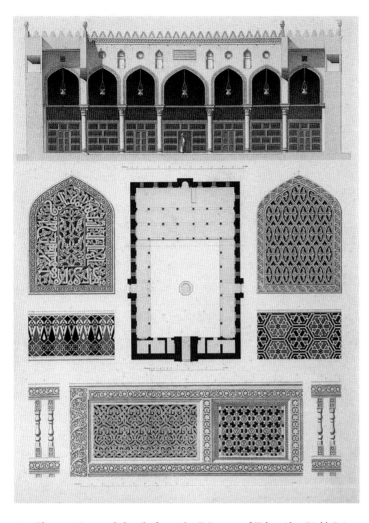

165 Plan, section and details from the 'Mosque of Telay Abu Rizk', Prisse d'Avennnes, *L'Art arabe* (1877), pl. v

ably the first European scholar writing about 'Saracenic' art to have access to both texts and he concluded that Fatimid art provided the missing link between the art of Northern Mesopotamia (i.e. Mosul) and that of the Mamluks.[116] To support his point, he discussed the woodwork from the mausoleum of 'Sitta Rukeyya', although he accepted Prisse's Mamluk date for the 'Moristan' panels.[117] Lane-Poole may have been the first to identify as Fatimid the ceramic sherds decorated with a gold or copper lustre he found in the rubbish mounds of Fustat after 'high winds' disturbed the site. He surmised that they had probably been made before the destruction of Fustat in 1168 and compared them to the iridescent pottery described by Nasir-i Khusraw.[118] Citing al-Maqrizi, he described the luxurious fabrics of the 'Fātimy Khalifs', who were 'fond of display beyond the dreams of even Oriental potentates'. The chief weavers, he surmised, must have been Copts, for only

they would have introduced figures of animals and portraits into their works. Unable to illustrate an actual Fatimid textile, he cited what he called the 'Mantle of Nürnberg' (i.e. Roger's Mantle) in Vienna of 1133 as an example of 'Fātimy-inspired' Sicilian work.[119]

From a modern scientific perspective, Lane-Poole's views may appear quaintly antiquated, but they reflect a burgeoning interest in the field that is epitomized in the work of his contemporary, the Swiss scholar Max van Berchem (1863–1921). In contrast to Lane-Poole, van Berchem's work remains as fresh today as when it was first written. After receiving his Ph.D. in 1886 from Leipzig for a thesis on early Islamic taxation, he travelled to Cairo and published his first article two years later on the curious building known as the Mashhad al-Juyushi. Following in the footsteps of the Danish scholar A.F. Mehren, who had written on the funerary monuments of Cairo but was unable to decipher the kufic inscription over the portal, van Berchem finally read the inscription and placed the building in its appropriate historical context.[120] This first foray was followed by several more articles on Fatimid-era buildings, as well as his monumental *Corpus Inscriptionum Arabicarum*, which presented Fatimid buildings as well as inscribed works of decorative art in chronological order.[121] In this way it can be said that van Berchem began not only the serious study of Fatimid architecture and art but also modern study of Islamic art (which he termed *archéologie arabe*). This book, with its focus on history and inscriptions, can be understood therefore as an attempt to apply van Berchem's method systematically to the entire corpus of Fatimid art and architecture.

Although many individual pieces of Fatimid art were published in the first half of the twentieth century, further interest in the architecture and arts of the Fatimid period was spurred not only by the publication in 1952 of the first volume of K. A. C. Creswell's brick-by-brick study of the Muslim architecture of Egypt,[122] but also by the millenary of Cairo in 1969, when scholars such as Oleg Grabar attempted to explain the novel characteristics of Fatimid art in terms of its history.[123] More recently, the first travelling exhibition of Fatimid art was organized to commemorate the bicentennial of Napoleon's expedition to Egypt in 1798. The exhibition, which was seen in Paris and Vienna, was accompanied by an international symposium which brought together dozens of scholars concerned with various approaches to the study of the material culture of the Fatimid period.[124]

In conclusion, Fatimid art presents us with curious paradoxes. It stands somewhat uneasily between the

universal aspirations of early Islamic times and the frankly regional divisions that emerged in the eleventh and twelfth centuries. Although the Fatimids eventually ended up being just an Egyptian power, their claim to rule was based not on the region they ruled, but on who they were. Fatimid art encompasses the architecture and decorative arts produced during the two hundred and sixty-two tumultuous years when the dynasty ruled more or less ably over North Africa, Egypt and Syria. This period is usually considered relatively brief, perhaps because it is often broken up into its North African and Egyptian phases, but the Fatimids were actually in power for five years more than the Mamluks (1260–1517, the longest Islamic 'dynasty' in Egypt – and they were hardly a dynasty). Fatimid art, however, cannot truly be considered a dynastic style in the sense associated with later Islamic times, such as the Mamluks or Ottomans, because there is no evidence that the Fatimids consciously directed artistic production from the top. Beautiful and problematic, Fatimid art played an essential role in the history of Islamic art and architecture in Egypt, but it plays a relatively small role in the larger and broader history of Islamic art, for only a very few of its media, techniques and themes would be developed and expanded by others in later centuries elsewhere. The major exception is, of course, lustre pottery, where Fatimid Egypt provided the springboard for later developments, in Syria, Iran and Spain.

In the long term perhaps the most important contribution of the Fatimids was their founding of Cairo and the creation of a metropolitan style of art focused in the Egyptian capital. Although the Fatimids never succeeded in making Egypt, let alone its capital, into a centre of their Ismaili teachings, they were able to transform Egypt's emerging and provincial Islamic culture to make it *the* centre of Arab-Islamic civilization for centuries to come. The Fatimids, more than anyone else before, attracted talented people from near and far, to make it one of, if not the, largest urban centres of the Mediterranean world, a position it retains to this day. As the eastern Islamic lands became increasingly centres of Persian and Turkish culture in the years after *c*.1000, Cairo not only replaced Damascus and Baghdad, the capitals of the Umayyad and Abbasid caliphates, but also eventually superseded them.

APPENDIX

The Fatimid Caliphs 297–567 AH 909–1171 CE

297/909	Abū Muḥammad ʿAbd Allāh b. al-Ḥusayn **al-Mahdī**
322/934	Abū'l-Qāsim Muḥammad b. al-Mahdī, **al-Qāʾim** bi-Amr Allāh
334/946	Abū Ṭāhir Ismāʿīl b. al-Qāʾim, **al-Manṣūr** bi'llāh
341/953	Abū Tamīm Maʿadd b. al-Manṣūr, **al-Muʿizz** li-Dīn Allāh
365/975	Abū Manṣūr Nizār b. al-Muʿizz, **al-ʿAzīz** bi'llāh
386/996	Abū ʿAlī al-Manṣūr b. al-ʿAzīz, **al-Ḥākim** bi-Amr Allāh
411/1021	Abū'l-Ḥasan ʿAlī b. al-Ḥākim, **al-Ẓāhir** li-Iʿzāz Dīn Allāh
427/1036	Abū Tamīm Maʿadd b. al-Ẓāhir, **al-Mustanṣir** bi'llāh
487/1094	Nizār al-Muṣṭafā li-Dīn Allāh (to Nizari Ismailis
487/1094	Abū'l-Qāsim Aḥmad b. al-Mustanṣir, **al-Mustaʿlī** bi'llāh
495/1101	Abū ʿAlī al-Manṣūr b. al-Mustaʿlī, **al-Āmir** bi-Aḥkam Allāh
524/1130	interregnum
525/1131	Abū'l-Maymūn ʿAbd al-Majīd b. Muḥammad **al-Ḥāfiẓ** li-dīn Allāh; al-Ṭayyib b. al-Āmir (to Tayyibi Ismailis in Yemen and India)
544/1149	Abū'l-Manṣūr Ismāʿīl b. al-Ḥāfiẓ **al-Ẓāfir** bi-Aʿdāʾ Allāh
549/1154	Abū'l-Qāsim ʿĪsā b. al-Ẓāfir, **al-Fāʾiz** bi-Naṣr Allāh
555/1160	Abū Muḥammad ʿAbdallah b. Yūsuf, **al-ʿĀḍid** li-Dīn Allāh
567/1171	Salaḥ al-Dīn b. Ayyūb assumes power

Notes

PREFACE

1 Jonathan Max Bloom, 'Meaning in Early Fatimid Architecture: Islamic Art in North Africa and Egypt in the Fourth Century A.H. (Tenth Century A.D.)' (Ph. D. diss., Harvard University, 1980).

2 Jonathan M. Bloom, 'The Mosque of al-Hakim in Cairo', *Muqarnas*, 1 (1983), pp. 15–36; Jonathan M. Bloom, 'The Origins of Fatimid Art', *Muqarnas*, 3 (1985), pp. 20–38; Jonathan M. Bloom, 'The Mosque of the Qarafa in Cairo', *Muqarnas*, 4 (1987), pp. 7–20.

3 Jonathan M. Bloom, 'al-Ma'mun's Blue Koran?', *Revue des études islamiques*, 54 (1986), pp. 61–5; Jonathan M. Bloom, 'The Blue Koran: An Early Fatimid Kufic Manuscript from the Maghrib', in François Déroche, ed., *Les Manuscrits du moyen-orient: essais de codicologie et paléographie* (Istanbul and Paris, 1989), pp. 95–9; Jonathan Bloom, *Minaret: Symbol of Islam* (Oxford, 1989).

4 Jane Turner, ed., *The Dictionary of Art* (London, 1996); Sheila S. Blair and Jonathan M. Bloom, *The Art and Architecture of Islam, 1250–1800* (London and New Haven, CT, 1994).

5 Jonathan M. Bloom, 'The Fatimids (909–1171), their Ideology and their Art', in *Islamische Textilkunst des Mittelalters: Aktuelle Probleme* (Riggisberg, 1997), pp. 15–26.

1 AN INTRODUCTION TO FATIMID HISTORY
 AND FATIMID ART

1 For an outline of Fatimid history and its sources, see Paul E. Walker, *Exploring an Islamic Empire: Fatimid History and Its Sources* (London, 2002), pp. 17–90, and his 'The Isma'īlī Da'wa and the Fāṭimid caliphate', in Carl Petry, ed., *The Cambridge History of Egypt, I: Islamic Egypt 640–1517* (Cambridge, 1998), pp. 120–50. I am reminded of an Egyptian colleague who came to do research at Harvard's Aga Khan Program for Islamic Architecture in the early 1980s. He said that he didn't understand why I spent so much time writing about Shi'is, since 'Egypt had always been a Sunni country!'

2 Philip Mayerson, 'The Role of Flax in Roman and Fatimid Egypt', *Journal of Near Eastern Studies*, 56 (1997), pp. 201–17.

3 See, for example, Ernst J. Grube, 'Realism or Formalism: Notes on Some Fatimid Lustre-Painted Ceramic Vessels', in Renato Traini, ed., *Studi in Onori di Francesco Gabrieli nel suo Ottantesimo Compleanno* (Rome, 1984), pp. 423–32, and Eva Baer, 'Fatimid Art at the Crossroads: A Turning Point in the Artistic Concept of Islam?', in Marianne Barrucand, ed., *L'Égypte Fatimide: son art et son histoire* (Paris, 1999), pp. 386–94.

4 Michael Brett and Elizabeth Fentress, *The Berbers* (Oxford, 1996).

5 For an overview of Buyid art, see Jonathan M. Bloom, 'Fact and Fantasy in Buyid Art', in Barbara Finster, Christa Fragner and Herta Hafenrichter, eds, *Kunst und Kunsthandwerke im frühen Islam, 2. Bamberger Symposium der islamischen Kunst 25.-27. July 1996* (=*Oriente Moderno*, NS, 22 (2004)).

6 Robert Hillenbrand, ed., *The Art of the Saljūqs in Iran and Anatolia: Proceedings of a Symposium Held in Edinburgh in 1982* (Costa Mesa, CA, 1994).

7 Jonathan M. Bloom, *Paper Before Print: The History and Impact of Paper in the Islamic World* (New Haven, CT, 2001).

8 For a superb introduction to Fatimid history and its sources, see Walker, *Exploring*.

9 Taqī al-Dīn Aḥmad al-Maqrīzī, *al-Mawā'iz wa'l-i'tibār bi-dhikr al-khiṭaṭ wa'l-athār (Exhortations and instructions on the districts and antiquities)*, (Cairo, 1853); new critical edition with indices, Taqī al-Dīn Aḥmad b. 'Alī

b. 'Abd al-Qādir al-Maqrīzī, *al-Mawā'iz wa'l-i'tibār fī-dikr al-ḫitaṭ wal-aṭār (Exhortations and instructions on the districts and antiquities)*, ed. Ayman Fu'ād Sayyid (London, 1422–1405 / 2003–4). As this wonderful new edition appeared only after much of this book was complete, I have retained references only to the Bulaq edition of 1853.

10 Taqī al-Dīn Aḥmad al-Maqrīzī, *Itti'āz al-ḥunafā' bi-akhbār al-a'imma al-Fāṭimiyyīn al-khulafā'*, ed. Jamāl al-Dīn al-Shayyāl and Muḥammad Ḥ. M. Aḥmad (Cairo, 1967–73).

11 al-Qāḍī al-Rashīd ibn al-Zubayr, *Kitāb al-dhakhā'ir wa'l-tuḥaf*, ed. M. Ḥamīdullāh (Kuwait, 1959); English trans., Ghāda al-Ḥijjāwī al- Qaddūmī, as *Book of Gifts and Rarities. Kitāb al-hadāyā wa al-tuḥaf*, foreword by Oleg Grabar and Annemarie Schimmel (Cambridge, MA, 1996).

12 al-Muqaddasī, *Aḥsan al-taqāsīm fī ma'rifat al-aqālīm*, ed. M. J. de Goeje (Leiden, 1906); al-Muqaddasī, *Aḥsan at-taqāsīm fī ma'rifat al-aqālīm (La Meillure répartition pour la connaissances des provinces)*, tr. André Miquel (Damascus, 1963); al-Muqaddasī, *The Best Divisions for Knowledge of the Regions (Aḥsan al-taqāsīm fī ma'rifat al-aqālīm)*, tr. Basil Collins (Reading, 1994).

13 Nāṣir-i Khusraw, *Sefer nameh: relation du voyage de Nassiri Khosrau*, ed. and tr. Ch. Schefer (Paris, 1881); English trans., W. M. Thackston, Jr, as *Naser-e Khosraw's Book of Travels (Safarnama)* (New York, 1986).

14 S. D. Goitein, *A Mediterranean Society* (Berkeley and Los Angeles, CA, 1967–94).

15 See, for example, Goitein, *Mediterranean Society*, vol. 4: *Daily Life*; S. D. Goitein, 'The Main Industries of the Mediterranean Area as Reflected in the Record of the Cairo Geniza', *Journal of the Economic and Social History of the Orient*, 4 (1961), pp. 168–97; Yedida K. Stillman, 'The Importance of the Cairo Geniza Manuscripts for the History of Medieval Female Attire', *International Journal of Middle East Studies*, 7 (1976), pp. 579–89.

16 Robert Irwin, *Dangerous Knowledge: Orientalism and its Discontents* (Woodstock, NY, 2006), p. 145.

17 F. Wüstenfeld, 'Geschichte der Faṭimiden Chalifen nach den Arabischen Quellen', *Sitzungsberichte der Königl. Gesellschaft der Wissenschaften, Histor.-Philolog. Classe* XXVI.3, XXVII. 1, XXVIII, 3 (1880–1), pp. 1–97, 3–130, 1–124.

18 Walker, *Exploring*, pp. 189ff. But al-Maqrizi seems to have had some access to Ismaili sources as well, according to Paul E. Walker, 'al-Maqrīzī and the Fatimids', *Mamluk Studies Review*, 7 (2003), pp. 83–97.

19 P. Ravaisse, 'Essai sur l'histoire et sur la topographie du Caire d'après Maḳrîzî', *Memoires de la mission archéologique française au Caire*, 1 (1889), pp. 409–79; P. Ravaisse, 'Essai sur l'histoire et sur la topographie du Caire d'après Maḳrîzî', *Memoire de la mission archéologique française au Caire*, 3 (1890), pp. 1–114.

20 Max van Berchem, 'Une Mosquée de temps des Fatimites au Caire: Notice sur le Gâmi' el Goyûshî', *Mémoires de l'Institut Égyptien*, 2 (1889), pp. 605–19.

21 Gaston Wiet, 'Un Dessin du XIe siècle', *Bulletin de l'Institut Égyptien*, 19 (1936–1907), pp. 223–7; Gaston Wiet, 'Une Peinture du XIIe siècle', *Bulletin de l'Institut d'Egypte*, 26 (1944), pp. 109–18.

22 Martin S. Briggs, *Muhammadan Architecture in Egypt and Palestine* (New York, 1924; repr., 1974), p. 69.

23 Stanley Lane-Poole, *The Art of the Saracens in Egypt* (London, 1886; repr. Beirut, n.d.), pp. 232–4.

24 Bloom, *Paper Before Print*, p. 74.

25 Stephen Vernoit, 'The Rise of Islamic Archaeology', *Muqarnas*, 14 (1997), p. 5.

26 Władysław B. Kubiak, *Al-Fustat: Its Foundation and Early Urban Development* (Cairo, 1987), pp. 29–30; Donald Malcolm Reid, 'Cultural Imperialism and Nationalism: The Struggle to Define and Control the Heritage of Arab Art in Egypt', *International Journal of Middle East Studies*, 24 (1992), p. 67.

27 See, for example, Władysław Kubiak and George T. Scanlon, *Fustat Expedition Final Report, Vol. 2: Fustat-C* (Winona Lake, IN, 1989), with substantial bibliography to date.

28 The best general overview is still Georges Marçais, *Architecture musulmane d'occident* (Paris, 1954); Lucien Golvin, *Recherches archéologiques à la Qal'a des Banû Hammâd* (Paris, 1965), for example, presents work done in the 1950s, which was continued by Rached Bourouiba, *La Qal'a des Bani Hammad* (Algiers, 1975).

29 Helen Philon, *Early Islamic Ceramics: Ninth to Late Twelfth Centuries* (London, 1980).

30 For the first approach, see Anna Contadini, *Fatimid Art at the Victoria and Albert Museum* (London, 1998). For the second, see *Trésors fatimides du Caire* (Paris, 1998) and Wilfried Seipel, ed., *Schätze der Kalifen: Islamische Kunst zur Fatimidenzeit* (Vienna, 1998).

31 Richard Ettinghausen, 'Painting in the Fatimid Period: A Reconstruction', *Ars Islamica*, 9 (1942), pp. 112–24; Grube, 'Realism or Formalism; Lamm, 'Fatimid Woodwork; Kahle, 'Die Schätze der Fatimiden'; Irene A. Bierman, *Writing Signs: The Fatimid Public Text* (Berkeley, CA, 1998).

32 Konstantin Aleksandrovich Inostrantsev, *La Sortie solennelle des califes Fatimides* (St Petersburg, 1905); Marius Canard, 'Le Cérémonial Fatimide et le cérémonial Byzantin: essai de comparaison', *Byzantion*, 21 (1951), pp. 355–420; Marius Canard, 'La Procession du nouvel an chez les Fatimides', *Annales de l'institut d'études orientales*, 10 (1952), pp. 364–95; Paula Sanders, *Ritual, Politics and the City in Fatimid Cairo* (Albany, NY, 1994).

33 For the history of Cairo, see, for example, Janet L. Abu-Lughod, *Cairo: 1001 Years of the City Victorious* (Princeton, 1971); André Raymond, *Cairo*, tr. Willard Wood (Cambridge, MA, 2000); André Raymond, ed., *Cairo, an Illustrated History*, tr. Jane Brenton and Barbara Mellor (New York, 2001). For Fatimid Cairo, see the exhaustive work of Ayman Fu'ad Sayyid, *La Capitale de l'Égypte jusqu'à l'époque Fatimide: al-Qāhira et al-Fusṭāṭ, essai de*

reconstitution topographique (Beirut, 1998), which is based on a deep and thorough reading of the Arabic sources.

34 Bloom, 'Mosque of al-Hakim'; Ja'far us Sadiq M. Saifuddin, *Al Aqmar: A Living Testimony to the Fatemiyeen* (London, 2000); Ja'far us Sadiq M. Saifuddin, *Al Juyushi: A Vision of the Fatemiyeen* (London, 2002); Caroline Williams, 'The Cult of 'Alid Saints in the Fatimid Monuments of Cairo. Part I: The Mosque of al-Aqmar', *Muqarnas*, 1 (1983), pp. 37–52; Caroline Williams, 'The Cult of 'Alid Saints in the Fatimid Monuments of Cairo. Part II: The Mausolea', *Muqarnas*, 3 (1985), pp. 39–60; Doris Behrens-Abouseif, 'The Façade of the Aqmar Mosque in the Context of Fatimid Ceremonial', *Muqarnas*, 9 (1992), pp. 29–38; Irene A. Bierman, 'Inscribing the City: Fatimid Cairo', *Riggisberger Berichte*, 5 (1997), pp. 105–14; *Islamische Textilkunst des Mittelalters: Aktuelle Probleme* (Riggisberg, 1997).

35 Bibliographically-minded readers will find an extraordinary amount of information in Ernst J. Grube and Jeremy Johns, *The Painted Ceilings of the Cappella Palatina*, Supplement to *Islamic Art* (Genoa and New York, 2005), especially §VI, pp. 358–417, an often annotated bibliography of several hundred titles on art and architecture in this period.

36 Richard Ettinghausen, Oleg Grabar and Marilyn Jenkins-Madina, *Islamic Art and Architecture 650–1250* (New Haven and London, 2001), pp. v–vi.

37 Ettinghausen, Grabar and Jenkins-Madina, *Islamic Art and Architecture 650–1250*, p. viii.

38 Blair and Bloom, *The Art and Architecture of Islam*.

II FATIMID ART IN NORTH AFRICA

1 Perhaps the most accessible synthesis of this period for the non-specialist is Walker, 'The Ismā'īlī Da'wa', which manages to steer a judicious course between concision and precision.

2 Farhad Daftary, *The Ismā'īlīs: Their History and Doctrines* (Cambridge, 1990, 2nd ed., 2007); Heinz Halm, *The Empire of the Mahdi: The Rise of the Fatimids*, tr. Michael Bonner (Leiden, 1996).

3 Michael Brett, *The Rise of the Fatimids: The World of the Mediterranean and the Middle East in the Fourth Century of the Hijra, Tenth Century CE* (Leiden, 2001).

4 Heinz Halm, 'Les Fatimides à Salamya', *Revue des Études Islamiques*, 54 (1986), pp. 133–49.

5 Walker, 'Ismā'īlī Da'wa', pp. 122–5.

6 Halm, *Empire*, pp. 5–14.

7 Ibid., p. 50.

8 Ibid., pp. 53–4.

9 Ibid., p. 82.

10 http://www.amnumsoc.org/collections/abbasid.html

11 Halm, *Empire*, p. 82.

12 Sheila S. Blair, *The Monumental Inscriptions from Early Islamic Iran and Transoxiana* (Leiden, 1992).

13 Brett and Fentress, *The Berbers*, p. 63.

14 Halm, *Empire*, pp. 20–43.

15 Walker, *Exploring an Islamic Empire*, p. 25.

16 This supposition is confirmed by the increased number of Egyptian tombstones bearing specifically Ismaili formulas that commemorated deaths in the early tenth century. One may imagine that the deceased had espoused Ismaili beliefs several decades before their deaths, in other words, sometime during the late 9th century. See Bloom, 'Mosque of the Qarafa.'

17 Farhad Daftary, *A Short History of the Ismailis: Traditions of a Muslim Community* (Edinburgh, 1998), pp. 68–9.

18 Halm, *Empire*, p. 138.

19 Ibid., p. 160.

20 Ibid., p. 161.

21 Brett, *Rise*, p. 139.

22 Halm, *Empire*, p. 147.

23 On the role of textiles in the medieval Islamic world, see Patricia L. Baker, *Islamic Textiles* (London, 1995), Maurice Lombard, *Les Textiles dans le monde musulman VIIe–XIIe siècle* (Paris, La Haye, New York, 1978) and Goitein, *A Mediterranean Society*.

24 Halm, *Empire*, p. 147.

25 Bloom, *Minaret*, Ch. 6.

26 K. A. C. Creswell, *Early Muslim Architecture* (Oxford, 1940), vol. 2, pp. 208–26, 308–20; Marçais, *Architecture musulmane*, pp. 1–61; Lucien Golvin, *Essai sur l'architecture religieuse musulmane* (Paris, 1970).

27 Creswell, *Early Muslim Architecture*, vol. 2, pp. 53, 246, 271–6, 321–6.

28 G. Marçais, 'Raḳḳāda', in *The Encyclopaedia of Islam*, ed. H. A. R. Gibb et al. (new ed., Leiden, 1960), vol. 8, pp. 414–15.

29 Brett, *Rise*, pp. 153–4.

30 *De Carthage à Kairouan: 2000 ans d'art et d'histoire en Tunisie* (Paris, 1982), pp. 232–73.

31 Ettinghausen, Grabar and Jenkins-Madina, *Islamic Art and Architecture, 650–1250*, p. 94.

32 Georges Marçais, *Les Faïences à reflets métalliques de la grande mosquée de Kairouan* (Paris, 1928); Jean Soustiel, *La Céramique islamique: le guide du connaisseur* (Fribourg, 1985), pp. 153–8; O. Bobin et al., 'Where Did the Lustre Tiles of the Sidi Oqba Mosque (AD 836–63) in Kairouan Come From?', *Archaeometry*, 45 (2003), pp. 569–77; Robert B.J. Mason, *Shine Like the Sun: Lustre-Painted and Associated Pottery from the Medieval Middle East* (Costa Mesa, CA, 2004), p. 226.

33 Halm, *Empire*, p. 214.

34 Walker, 'Ismā'īlī Da'wa', pp. 129–30.

35 Ibid., p. 130.

36 Walker, *Exploring*, pp. 23–5.

37 Brett, *Rise*, p. 143.

38 Jacob Lassner, *The Shaping of 'Abbāsid Rule* (Princeton, NJ, 1980).

39 Halm, *Empire*, pp. 236–8.

40 Brett, *Rise*, p. 164.

41 Halm, *Empire*, p. 215.

42 Alexandre Lézine, *Mahdiya: recherches d'archéologie Islamique* (Paris, 1965), pp. 24–38; Halm, *Empire*, p.216.

43 Lézine, *Mahdiya*, pp. 49–53.

44 Brett, *Rise*, p. 142.

45 Lézine, *Mahdiya*, pp. 65–136.

46 Ettinghausen, Grabar and Jenkins-Madina, *Islamic Art and Architecture, 650–1250*, p. 188.

47 Halm, *Empire*, pp. 220–1.

48 Alexandre Lézine, 'Notes d'archéologie ifriqiyenne IV: Mahdiya – quelques precisions sur la 'ville' des premiers Fatimides', *Revue des études islamiques*, 35 (1967), pp. 82–101.

49 Bloom, *Minaret*.

50 Derek Hill and Lucien Golvin, *Islamic Architecture in North Africa* (London, 1976), fig. 126.

51 G. Kircher, 'Die Moschee des Muḥammad b. Hairūn ("Drei-Tore-Moschee") in Qairawān/Tunesien. Erster Bericht', *Mitteilungen des Deutschen Archäologischen Instituts Abteilung Kairo*, 26 (1970), pp. 141–68.

52 Ibn 'Idharī al-Marrākushī, *Kitāb al-bayān al-Maghrib (Histoire de l'Afrique du nord et de l'Espagne Musumane)*, ed. G.S. Colin and É. Lévi-Provençal (Leiden, 1948), vol. 1, p. 159; Jonathan M. Bloom, 'The Origins of Fatimid Art', *Muqarnas*, 3 (1985), p. 21.

53 Sheila S. Blair, 'Floriated Kufic and the Fatimids', in Barrucand, ed., *L'Égypte Fatimide*, p. 111 and ill. 5; Georges Marçais and Lucien Golvin, *La Grande Mosquée de Sfax* (Tunis, 1960), pp. 16–17.

54 Marçais, *Architecture musulmane*, pp. 87–8.

55 Ibid., p. 79; Halm, *Empire*, p. 218.

56 Turner, ed., *Dictionary of Art*, s.v. 'Islamic art II, 9 (ii) b: Tiles in the Western Islamic Lands.'

57 *De Carthage à Kairouan*, p. 216, no. 287; Marçais, *Architecture musulmane*, p. 117.

58 Marçais, *Architecture musulmane*, p. 28, 34b.

59 Ibn 'Idharī, *Kitāb al-bayān al-Maghrib*, vol. 1, p. 184.

60 See, for example, my youthful opinion in Bloom, *Meaning in Early Fatimid Architecture*, pp. 29–31, a view which was uncritically adopted by Paula A. Sanders, 'The Court Ceremonial of the Fāṭimid Caliphate in Egypt' (Ph.D. diss., Princeton University, 1984) and then by Jeremy Johns, *Arabic Administration in Norman Sicily: The Royal Dīwān* (Cambridge, 2002), p. 152, who saw a reference to this purported practice in the Norman court in Sicily.

61 Brett, *Rise*, p. 165.

62 Ibid., p. 257.

63 The full translation of the poem is given in Bloom, 'The Origins of Fatimid Art', p. 24.

64 Halm, *Empire*, p. 219; Abū'l-Qāsim Ibn Ḥawqal, *Kitāb ṣūrat al-arḍ*, ed. J. H. Kramers (2nd ed., Leiden, 1967), p. 73.

65 Brett, *Rise*, pp. 146ff.

66 Halm, *Empire*, p. 256.

67 Brett, *Rise*, pp. 159–60.

68 Ibid., p. 163.

69 Lucien Golvin, 'Le Palais de Zîrî à Achîr (dixième siècle J.C.)', *Ars Orientalis*, 6 (1966), pp. 47–76.

70 Brett, *Rise*, p. 185.

71 Golvin, 'Le Palais de Zîrî'.

72 Robert Hillenbrand, *Islamic Architecture: Form, Function and Meaning* (Edinburgh, 1994), pp. 437–9.

73 Brett, *Rise*, pp. 149–51.

74 Ibid., p. 245; Mohamed Talbi, 'Tahart', *EI2*, vol. 10, pp. 99–101.

75 Marguerite van Berchem, 'Le Palais de Sedrata dans le désert saharien', in *Studies in Islamic Art and Architecture in Honour of Professor K. A. C. Creswell* (Cairo, 1965), p. 8.

76 *De Carthage à Kairouan*, no. 236.

77 S.M. Stern, 'Abū Yazīd al-Nukkārī', *EI2*, vol. 1, pp. 163–4.

78 F. Dachraoui, 'al-Manṣūr bi'llāh', *EI2*, vol. 6, p. 434.

79 Halm, *Empire*, p. 326.

80 Blair, *Monumental Inscriptions*, no. 6.

81 Halm, *Empire*, p. 326.

82 Ibid., p. 327.

83 Ibid., p. 328.

84 Walker, *Exploring*, pp. 28–9.

85 Brett, *Rise*, p. 169.

86 Ibid., p. 170.

87 Halm, *Empire*, p. 324.

88 Bloom, 'Origins', pp. 27–8.

89 Sheila S. Blair, 'Tiraz', in Turner, ed., *Dictionary of Art*, vol. 30, pp. 20–3; R. B. Serjeant, *Islamic Textiles: Material for a History to the Mongol Conquest* (Beirut, 1972), Ch. 18.

90 Bloom, 'Origins', p. 26, and, for Maghribi textile production, Serjeant, *Islamic Textiles*, pp. 177–90.

91 Bloom, 'Origins', p. 27.

92 Toby Falk, ed., *Treasures of Islam* (London, 1985), p. 364, no. 411.

93 Walker, *Exploring*, p. 95.

94 Falk, *Treasures*, p. 370, no. 439.

95 Ibid., p. 370, no. 440.

96 J. Ferrugia de Candia, 'Monnaies fatimites du Musée du Bardo', *Revue tunisienne*, NS, 7 (1936), pp. 336, 354–60.

97 Ferrugia de Candia, 'Monnaies', no. 32; Falk, *Treasures*, p. 370, no. 441.

98 Walker, *Exploring*, pp. 94–9.

99 Brett, *Rise*, pp. 254–5.

100 Bierman, *Writing Signs*, pp. 62–3.

101 Brett, *Rise*, p. 175.

102 al-Muqaddasī, *Aḥsan al-taqāsīm*, p. 226; al-Muqaddasī, *Best Divisions*, p. 187. Might his 'Valley of the Fullers' refer to present-day Kasserine, the site of the important World War II battle?

103 Halm, *Empire*, p. 346.

104 Brett, *Rise*, p. 318.

105 Heinz Halm, 'Nachrichten zu Bauten der Aġlabiden und Fatimiden in Libyen und Tunesien', *Die Welt des Orients*, 23 (1992), pp. 129–57.

106 Halm, *Empire*, p. 345.

107 Ibid., p. 361.

108 Ibid., pp. 343–4; M. Solignac, 'Recherches sur les installations hydrauliques de Kairouan et des steppes tunisiennes du VIIe au XIe siècle (J.-C.)', *Annales de l'institut détudes orientales* (1952–3), p. 270.

109 Faouzi Mahfoudh, Samir Baccouch and Bechir Yazidi, *L'Histoire de l'eau et des installations hydrauliques dans le bassin de Kairouan*, unpublished PDF paper (Tunis, 2004), pp. 33–4, http://www.iwmi.cgiar.org/assessment/FILES/word/ProjectDocuments/Merguellil/Histoire%20eau%20Kairouan.pd.

110 Solignac, 'Recherches, p. 272; Mahfoudh, Baccouch and Yazidi, *L'Histoire de l'eau*, pp. 33–6.

111 See, for example, Michel Terrasse, 'Recherches archéologiques d'époque islamique en Afrique du nord', *Comptes rendus de l'académie des inscriptions et belles-lettres* (1976), pp. 590–611. A joint Tunisian–French research project at the site has begun in 2003 under the supervision of Professor Marianne Barrucand of the Université de Paris IV-Sorbonne.

112 Slimane Mostfa Zbiss, 'Mahdia et Ṣabra-Manṣoûriya: nouveaux documents d'art fatimite d'occident', *Journal Asiatique*, 244 (1956), pp. 79–93; Terrasse, 'Recherches archéologiques.'

113 *De Carthage à Kairouan*, p. 216, no. 286.

114 Ḥasan Ḥusnī 'Abd al-Wahhāb, *Mujmal tārīkh al-adab al-Tūnisī min fajr al-fatḥ al-'arabī li-Ifriqiya ilā al-'aṣr al-ḥāḍir* (Tunis, 1968), p. 97.

115 Solignac, 'Recherches.'

116 Abou-Obeïd El-Bekri, *Description de l'Afrique septentrionale*, tr. Mac Guckin de Slane (Paris, 1965), p. 60.

117 For some tangible evidence of this rivalry, see the wooden panels from the minbar, or pulpit, made for the Mosque of the Andalusians in Fez, which were made in Córdoba to replace similar panels presumably invoking the name of the Fatimid caliph. Jerrilynn D. Dodds, ed., *Al-Andalus: The Art of Islamic Spain* (New York, 1992), no. 41 by J. M. Bloom.

118 D. Fairchild Ruggles, *Gardens, Landscape and Vision in the Palaces of Islamic Spain* (University Park, PA, 2000), p. 87.

119 Ruggles, *Gardens*, p. 87.

120 Ibid., pp. 53–4.

121 Halm, *Empire*, p. 284.

122 Ruggles, *Gardens*, p. 67.

123 Halm, *Empire*, p. 169.

124 Ruggles, *Gardens*, p. 57.

125 Ibid., p. 60.

126 Halm, *Empire*, p. 237.

127 Ibid., p. 238.

128 Marius Canard, 'Le Cérémonial fatimide'.

129 Abū 'Alī Manṣūr al-'Azīzī al-Jawdharī, *Sīrat al-ustādh Jawdhar*, ed. Muḥammad Kāmil Ḥusayn and Muḥammad 'Abd al-Hādī Sha'īra (Cairo, 1954), p. 61; French trans., Marius Canard, *Vie de l'Ustadh Jawdhar* (Algiers, 1957), p. 89.

130 Brett, *Rise*, p. 242.

131 F. Dachraoui, 'al-Mu'izz li-Dīn Allāh', *EI2*, vol. 7, pp. 485–9.

132 François Déroche, *The Abbasid Tradition: Qur'ans of the Eighth to the Tenth Centuries AD*, vol. 1 of Julian Raby, ed., *The Nasser D. Khalili Collection of Islamic Art* (London, 1992), p. 92.

133 Marcus Fraser and Will Kwiatkowski, *Ink and Gold: Islamic Calligraphy* (Berlin and London, 2006), pp. 44–8.

134 Blair and Bloom, *The Art and Architecture of Islam*, pp. 116–17.

135 Déroche, *Abbasid Tradition*, p. 146; Bloom, *Paper Before Print*, p. 107; Sheila S. Blair, *Islamic Calligraphy* (Edinburgh, 2006), p. 153.

136 Bloom, 'The Blue Qur'an: An Early Fatimid Kufic Manuscript from the Maghrib', in Déroche, ed., *Les Manuscrits du moyen-orient*, pp. 95–9.

137 Blair, *Islamic Calligraphy*, pp. 125–7.

138 Turner, *Dictionary of Art*, vol. 9, p. 664, s.v. 'Early Christian and Byzantine Art, VII, 8: Textiles (ii) Dyes'; Alexander P. Kashdan, ed., *The Oxford Dictionary of Byzantium* (New York, 1991), s.v. 'Purple.'

139 Bloom, 'Al-Ma'mun's Blue Qur'an?'; Jonathan M. Bloom, 'The Early Fatimid Blue Qur'an Manuscript', *Graeco-Arabica*, 4 (1991), pp. 171–8; Jonathan M. Bloom, 'The Early Fatimid Blue Qur'an Manuscript', in François Deroche, ed., *Les Manuscrits du moyen-orient: essais de codicologie et paléographie* (Istanbul and Paris, 1989), pp. 95–9. It is odd indeed that no other Fatimid manuscripts of the Qur'an have been identified, apart from the 'Nurse's Qur'an' (Fig. 153). For other views on the date of the Blue Qur'an, see Déroche, *Abbasid Tradition* and *The Qur'an and Calligraphy: A Selection of Fine Manuscript Material* (London, 1995), pp. 7–15. For writing in gold in general, see Turner, *DoA*, s.v. 'Chrysography.'

140 Madrid, Museo Arqueológico Nacional, no. 887. *The Arts of Islam* (London, 1976), p. 151, no. 145, with bibliography but erroneous description.

141 Anna Contadini, 'Fatimid Ivories Within a Mediterranean Context', *Journal of the David Collection*, 2 (2005), p. 228.

142 A selection of the Spanish ivories is published in Dodds, *Al-Andalus*; the complete corpus can be found in Ernst Kühnel, *Die Islamischen Elfenbeinskulpturen, VIII.-XIII. Jahrhundert* (Berlin, 1971). For Byzantine ivories, see Anthony Cutler, *The Hand of the Master: Craftsmanship, Ivory and Society in Byzantium* (Ninth-Eleventh

Centuries) (Princeton, NJ, 1994) and Turner, *DoA*, 9, pp. 649–52, s.v. 'Early Christian and Byzantine art, VII, 5 (iii) Ivories and steatites, ninth century-1453.'

143 Anthony Cutler, *The Craft of Ivory: Sources, Techniques and Uses in the Mediterranean World: A.D. 200–1400* (Washington, DC, 1985).

144 R. H. Pinder-Wilson and C. N. L. Brooke, 'The Reliquary of St. Petroc and the Ivories of Norman Sicily', *Archaeologia*, 104 (1973), pp. 261–305.

145 al-Maqrīzī, *Khiṭaṭ*, vol. 1, p. 417, lines 12ff; Étienne Combe, Jean Sauvaget and Gaston Wiet, *Répertoire chronologique d'épigraphie arabe* (Cairo, 1931), vol. 4, p. 186, no. 1564, with bibliography.

146 Gerald R. Tibbetts, 'The Balkhī School of Geographers', in J. B. Harley and David Woodward, eds, 'Cartography', in *The Traditional Islamic and South Asian Societies*', vol. 2 of *The History of Cartography* (Chicago, 1992), vol. 2, pp. 108–36.

147 Serjeant, *Islamic Textiles*, p. 180.

148 It is one of three silk mantles associated with the emperor and his wife Kunigunde and now in the Cathedral of Bamberg. See Peter Lasko, *Ars Sacra 800–1200* (New Haven and London, 1994), pp. 131–2.

149 Carl Johan Lamm, *Cotton in Medieval Textiles of the Near East* (Paris, 1937), pp. 96–9; M.A. Marzouk, 'The Earliest Fatimid Textile (Tiraz al Mansuriya)', *Bulletin of the Faculty of Arts, Alexandria University*, 11 (1957), pp. 37–56, Two pieces of linen tapestry-woven in wool with the name of al-Mu'izz are known: one in the Textile Museum, Washington, DC, with the date 355, and the other in the Benaki Museum, Athens, with the date 357. These are both ascribed to Egypt and suggest that the Egyptian ruler Kafur was already on friendly terms with the Fatimid ruler. See Ernst Kühnel and Louisa Bellinger, *Catalogue of Dated Tiraz Fabrics: Umayyad, Abbasid, Fatimid* (Washington, DC, 1952), pp. 54–5, and Etienne Combe, 'Tissus fatimides du Musée Benaki', *Mémoires de l'institut français d'archéologie orientale au Caire*, 68 (1935), pl. 1.

150 Halm, *Empire*, pp. 370–1.

151 al-Qaddūmī, tr., *Book of Gifts and Rarities*, §79.

152 Ernst J. Grube, 'Fatimid Pottery', in Ernst J. Grube, *Cobalt and Lustre: The First Centuries of Islamic Pottery* (London, 1994), p. 138.

153 Soustiel, *La Céramique islamique*, p. 156.

154 Ibn Hawqāl, *Kitāb ṣūrat al-arḍ*, p. 73.

155 Marilyn Jenkins, 'Western Islamic Influences on Fāṭimid Egyptian Iconography', *Kunst des Orients*, 10 (1976), p. 97.

156 Halm, *Empire*, p. 368.

157 Ibid., p. 366.

158 Ibid., p. 369.

159 Georges Marçais, *La Berbérie musulmane et l'orient au moyen age* (Paris, 1946).

160 S. D. F. Goitein, *Studies in Islamic History and Institutions* (Leiden, 1966), pp. 308–28; Brett, *Rise*, p. 253.

161 Halm, *Empire*, pp. 148–9.

162 Ibid., p. 149.

III ARCHITECTURE IN EGYPT FROM 969 TO THE 1060S

1 Kubiak, *Al-Fustat*.

2 André Raymond estimates the population of Fustat, which covered approximately 300 hectares (720 acres, or 1.15 square miles), at about 120,00, in the Fatimid period, while Thierry Bianquis estimated 175,000. Cairo itself might have had about 40,000 inhabitants, although Bianquis estimated a population of 75,000. The walls of Florence comprised only 97 hectares c.1200; those of Bologna 120 hectares; the walls of Genoa enclosed 52 hectares in 1160. The population of Venice was probably under 100,000 at the end of the twelfth century. Damascus covered only 120 hectares at the time of the Crusades. Córdoba's population is estimated at 90,000 around 1000, while Seville's is estimated at 52,000 in 118 hectares. See Raymond, *Cairo*, p. 62. See Colin McEvedy's estimates at http://scholar.chem.nyu.edu/tekpages/urbanpop.html.

3 Cl. Cahen, 'Buwayhids or Būyids', *EI2*, vol. 1, pp. 1350–7.

4 Brett, *Rise*, p. 266.

5 Ibid., p. 318.

6 The figure is given by Walker, 'Ismā'īlī Da'wa', p. 137.

7 F. Dachraoui, 'al-Mu'izz li-Dīn Allāh', *EI2*, vol. 7, pp. 485–9.

8 Yaacov Lev, *State and Society in Fatimid Egypt* (Leiden, 1991), pp. 15–16.

9 Brett, *Rise*, pp. 304, 306–7.

10 Walker, 'Ismā'īlī Da'wa', p. 141; Walker, *Exploring an Islamic Empire*, p. 26.

11 Paul Kunitzsch, 'Zur Namengebung Kairos (al-Qāhir= Mars?)', *Der Islam*, 52 (1975), pp. 209–25.

12 Marius Canard, 'L'Imperialisme des Fatimides et leur propagande', *Annales de l'institut d'études orientales*, 6 (1942–7), pp. 156–93.

13 al-Qaddūmī, *Book of Gifts and Rarities*, §77.

14 For the development of Fustat, see Kubiak, *Al-Fustat*.

15 R. Stephen Humphreys, 'Egypt in the World System of the Later Middle Ages', in Petry, ed., *The Cambridge History of Egypt*, vol. 1, pp. 448–9.

16 Creswell, *Early Muslim Architecture*, vol. 1, *passim*; Creswell, *Early Muslim Architecture*, vol. 2, pp. 171–96.

17 Creswell, *Early Muslim Architecture*, vol. 2, pp. 327–59.

18 A. S. Ehrenkreutz, 'Kafur', *EI2*, vol. 4, pp. 418–19.

19 Gaston Wiet, *Matériaux pour un corpus inscriptionum Arabicarum I: Egypte 2* (Cairo, 1929–30), pp. 91–101.

20 Blair, 'Floriated Kufic'.

21 Halm, *Empire of the Mahdi*, p. 43.

22 Bloom, 'Mosque of the Qarafa', pp. 7–20.

23 Thierry Bianquis, 'Autonymous Egypt from Ibn Ṭūlūn to Kāfūr, 868–969', in Petry, ed., *The Cambridge History of Egypt*, vol. 1, p. 117.

24 Quoted in al-Maqrīzī, *Ittiʿāẓ al-ḥunafā'*, vol. 1, pp. 112–13.

25 Thierry Bianquis, 'La prise de pouvoir par les Fatimides en Égypte', *Annales islamologiques*, 11 (1972), pp. 49–108. Peter Sheehan recently suggested to me that a road presumably leading towards Palestine and Syria, might have run parallel to the east side of the canal in pre-Fatimid times. The road, if it lay some 500 m away from the canal, would explain the location of the first Fatimid gates.

26 al-Maqrīzī, *Ittiʿāẓ*, vol. 1, pp. 112–13. This anecdote is probably a later interpolation into Ibn Zulaq's contemporary account reported by al-Maqrīzī.

27 K. A. C. Creswell, *The Muslim Architecture of Egypt* (Oxford, 1952–9), vol. 1, pp. 22–3.

28 Halm, *Empire*, p. 143.

29 Orthogonal lines generated from this axis point to *c.*117°, which marks not only the winter sunrise but also the qibla favoured by the Companions of the Prophet who first settled in Egypt. See David A. King, 'The Orientation of Medieval Islamic Religious Architecture and Cities', *Journal for the History of Astronomy*, 26 (1995), pp. 265–6.

30 al-Maqrīzī, *Khiṭaṭ*, vol. 1, p. 377, lines 31–5. These bricks would have been staggeringly large and heavy. Mud-bricks are normally thought to have been one-quarter the size, although unusually large bricks are recorded at Baghdad and Samarra. See Marcus Milwright, 'Fixtures and Fittings: The Role of Decoration in Abbasid Palace Design', in Chase F. Robinson, ed., *A Medieval Islamic City Reconsidered: An Interdisciplinary Approach to Samarra* (Oxford, 2001), p. 85, n. 28.

31 al-Maqrīzī, *Ittiʿāẓ*, vol. 1, p. 111; Walker, 'Ismaili Daʿwa', p. 139; Halm, *Empire*, pp. 415–16.

32 Brett, *Rise*, p. 307.

33 al-Maqrīzī, *Ittiʿāẓ*, vol. 1, p. 116; Bianquis, 'Prise de Pouvoir', p. 81; Halm, *Empire*, p. 415.

34 Brett, *Rise*, p. 305.

35 For the Fatimids in Syria, see Thierry Bianquis, *Damas et la Syrie sous la domination Fatimide 359–468 H/969–1076, essai d'interprétation de chroniques Arabes médiévales* (Damascus, 1986–9).

36 On the reuse of gates in Islamic architecture, see Creswell, *Muslim Architecture of Egypt*, vol. 1, p. 32.

37 Brett, *Rise*, pp. 314–15.

38 For the location of the gates see Creswell, *Muslim Architecture*, vol. 1, pp. 23ff. Nāṣir-i Khusraw mentions only five gates in 1047–8 and he says 'there is no wall, but the buildings are even stronger and higher than ramparts and every house and building is itself a fortress.' Thackston, *Safarnama*, p. 46.

39 Jonathan M. Bloom, 'Walled Cities in Islamic North Africa and Egypt with Particular Reference to the Fatimids (909–1171)', in James D. Tracy, ed., *City Walls: The Urban Enceinte in Global Perspective* (Cambridge, 2000), vol. 4, pp. 219–46.

40 Abu-Lughod, *Cairo*, pp. 14, 19.

41 Sanders, *Ritual, Politics and the City*.

42 Ibid., p. 42.

43 al-Maqrīzī, *Ittiʿāẓ*, vol. 2, p. 57; al-Maqrīzī, *Khiṭaṭ*, vol. 2, p. 28.

44 Lev, *State and Society*, p. 5, quoting al-Maqrīzī.

45 Thackston, *Safarnāma*, p. 45.

46 Walker, 'Ismāʿīlī Daʿwa', pp. 139–40.

47 Brett, *Rise*, p. 37.

48 Walker, 'Ismāʿīlī Daʿwa', p. 142.

49 al-Maqrīzī, *Khiṭaṭ*, vol. 2, p. 273.

50 In addition to Creswell, *Muslim Architecture of Egypt*, Chapter 4, see Bloom, *Meaning in Early Fatimid Architecture*, pp. 94ff and, particularly for the history of the mosque in the post-Fatimid period, Nasser Rabbat, 'Al-Azhar Mosque: An Architectural Chronicle of Cairo's History', *Muqarnas*, 13 (1996), pp. 45–67.

51 Rabbat, 'Al-Azhar Mosque', pp. 51–2.

52 Marianne Barrucand, 'Les chapiteaux de remploi de la mosquée al-Azhar et l'émergence d'un type de chapiteau médiévale en Égypte', *Annales islamologiques*, 36 (2002), pp. 37–75.

53 Rabbat, 'Al-Azhar Mosque', p. 50, argues for the existence of a Fatimid-era minaret by quoting a remark in Ibn ʿAbd al-Zahir's chronicle of *c.*1280 that the 'minaret of al-Azhar was increased in height during the time of the late judge Sadr al-Din', whom he identifies as a confidant of the Mamluk sultan al-Zahir Baybars. It is likely that this individual erected a tower for the mosque, but it is by no means certain that the structure he modified was a tower. Rabbat states that as none of the Ayyubid rulers could have built the original minaret, the original must have been a tower erected in the Fatimid period. While it is possible that a tower was added to the mosque in the late Fatimid period (the mosque of al-Salih Talaʾiʿ, for example, seems to have had some sort of structure on its roof), it takes a great leap of faith to imagine that a tower must have been part of the mosque's original plan. It is possible, for example, that someone had built something like a 'staircase minaret' on the mosque's roof.

54 Creswell, *Early Muslim Architecture*, vol. 2.

55 Halm, *Empire*, p. 415.

56 Bloom, *Paper Before Print*, Chapter 5.

57 The panels are located around the hood of the mihrab, along the central aisle, in the window frames of two bays on the original qibla wall, along the north-east wall of the prayer hall, along the south-west wall and at either end of the arcade between the prayer hall and the court.

58 Bloom, 'Mosque of the Qarafa'.

59 Bloom, *Meaning*, Appendix A.

60 I examined the content and meaning of these inscriptions in Bloom, *Meaning*, pp. 117–24. At that time, I suggested that the Qur'anic references to paradise com-

bined with the vegetal decoration were an attempt to represent in the mosque the paradise that awaited believers. In retrospect, I now think that my youthful attempt to elucidate the iconography of the decoration was somewhat enthusiastic.

61 See, for example, the Mosque of Bu Fatata at Sousse or the Mosque of the Three Doors at Kairouan, discussed by Kircher, 'Die Moschee des Muḥammad b. Hairūn', pp. 141–68. These inscriptions antedate by a century Irene Bierman's idea in *Writing Signs* of the Fatimid 'public text'.

62 Blair, *Monumental Inscriptions*, no. 14.

63 J. David-Weill, *Les Bois à épigraphes jusqu'à l'époque Mamlouke* (Cairo, 1931), vol. 1, pp. 16–18; Wiet, *Matériaux pour un corpus inscriptionum arabicarum I: Egypte 2*, p. 108ff.

64 Max van Berchem, *Matériaux pour un corpus inscriptionum arabicarum I: Egypte 1* (Cairo, 1894–1903), no. 453.

65 Lamm, 'Fatimid Woodwork', pp. 68–9.

66 Ibid.

67 See the measured plan in Creswell, *Muslim Architecture of Egypt*, fig. 20.

68 F. Dachraoui, 'al-Muʿizz li-Dīn Allāh', *EI2*, vol. 7, pp. 485–9. Rabbat, 'Al-Azhar Mosque', p. 65, n. 39, argues that Jawhar had begun constructing the palace long before, but the pace of construction had slackened in the interim. It is unlikely that Jawhar built a palace before his overlord had decided to move. There is some textual confusion: the word *qaṣr* found in the texts refers not only to the palace but also to the entire settlement itself. See Bloom, *Meaning*, pp. 75–8.

69 Brett, *Rise*, p. 318.

70 Ibid., p. 325.

71 Hugh Blake, Antony Hutt and David Whitehouse, 'Ajdabiyah and the Earliest Fatimid Architecture', *Society for Libyan Studies, Annual Report*, 2 (1971), pp. 9–10.

72 Brett, *Rise*, pp. 324–5.

73 Brett, *Rise*, p. 327; Sanders, *Ritual, Politics and the City*.

74 Al-Maqrīzī, *Khiṭaṭ*, vol. 1, p. 457.

75 Sayyid, *Capitale*, pp. 209–326.

76 Among the most recent discoveries, see Nairy Hampikian and Monique Cyran, 'Recent Discoveries Concerning the Fatimid Palaces Uncovered During the Conservation Works on Parts of al-Ṣāliḥiyya Complex', in Barrucand, ed., *L'Égypte Fatimide*, pp. 649–63. In the early twentieth century, Max Herz Pasha identified part of the Hospital of Qalaʿun as the great *qāʿa* of Sitt al-Mulk. See Max Herz, *Die Baugruppe des Sultans Qalaun in Kairo* (Hamburg, 1919) and Sayyid, *Capitale*, pp. 307–11.

77 al-Maqrīzī, *Khiṭaṭ*, vol. 1, pp. 383–464.

78 Ravaisse, 'Essai'.

79 Sayyid, 'Grand palais'.

80 al-Maqrīzī, *Khiṭaṭ*, vol. 1, p. 388.

81 Sayyid, *Capitale*, pp. 215, 300.

82 Hillenbrand, *Islamic Architecture*, pp. 77–462; Gülru Necipoğlu, ed., *Pre-Modern Islamic Palaces* (1993).

83 Thackston, *Safarnāma*, pp. 45–6.

84 Oleg Grabar, *The Alhambra* (Cambridge, MA, 1978); Gülru Necipoğlu, *Architecture, Ceremonial and Power: The Topkapı Palace in the Fifteenth and Sixteenth Centuries* (Cambridge, MA, 1991).

85 al-Maqrīzī, *Khiṭaṭ*, vol. 1, p. 384.

86 Sayyid, 'Grand palais', p. 123, quoting al-Maqrīzī, *Khiṭaṭ*, vol. 1, p. 362.

87 Thackston, *Safarnama*, p. 57.

88 E. Pauty, *Les Bois sculptés jusqu'à l'époque Ayyoubide* (Cairo, 1931), p. 51 and pl. LX, also illustrated in Sayyid, 'Grand palais', p. 121. See also Viktoria Meinecke-Berg, 'Materialien zu fatimidischen Holzdekorationen in Kairo I: Holzdecken aus dem Fatimidischen Westpalast in Kairo', *Mitteilungen des deutschen archäologischen Instituts: Abteilung Kairo*, 47 (1991), pp. 227–33, and Michael Meinecke, 'Materialien zu fatimidischen Holzdekorationen in Kairo II: Die Holzpaneele der Moschee des Aḥmad Bāy Kuḥya', *Mitteilungen des deutschen archäologischen Instituts: Abteilung Kairo*, 47 (1991), pp. 235–42.

89 *Trésors*, no. 12.

90 Brett, *Rise*, p. 336.

91 Al-Qaddūmī, tr. *Book of Gifts*, §410.

92 Al-Qaddūmī, tr. *Book of Gifts*, §410; al-Maqrīzī, *Ittiʿāẓ*, vol. 2, pp. 39–40.

93 Sayyid, *Capitale*, pp. 215–17.

94 Irene A. Bierman, 'Art and Architecture in the Medieval Period', in Petry, ed., *The Cambridge History of Egypt*, vol. 1, p. 352.

95 Thomas Leisten, 'Dynastic Tomb or Private Mausolea: Observations on the Concept of Funerary Structures of the Fāṭimid and ʿAbbāsid Caliphs', in Barrucand, ed., *L'Égypte fatimide*, pp. 465–79.

96 Al-Qaddūmī, tr. *Book of Gifts*, §406.

97 Thackston, *Safarnama*, p. 47.

98 Ibid., p. 52.

99 Creswell, *Muslim Architecture of Egypt*, vol. 1, pp. 119–28; Kubiak and Scanlon, *Fustat Expedition Final Report*, vol. 2, pp. 11–31; Goitein, *A Mediterranean Society*, vol. 4, p. 54.

100 Creswell, *Muslim Architecture of Egypt*, vol. 1, pp. 127–8.

101 M.M. Amin and Laila A. Ibrahim, *Architectural Terms in Mamluk Documents (648–923H) (1250–1517) (al-Muṣṭalaḥāt al-miʿmāriyya fī-al-wathāʾiq al-malūkiyya)* (Cairo, 1990), p. 87, s.v. (in Arabic). In the Geniza documents, the word seems to have had a somewhat different meaning, for which see Goitein, *Mediterranean Society*, vol. 4, p. 63.

102 Creswell, *Muslim Architecture of Egypt*, vol. 1, pp. 261–3; Bernard O'Kane, 'Domestic and Religious Architecture in Cairo: Mutual Influences', in Doris Behrens-Abouseif, *The Cairo Heritage: Essays in Honor of Laila Ali*

Ibrahim (Cairo, 2000), p. 152; Nicholas Warner, *The Monuments of Historic Cairo: A Map and Descriptive Catalogue* (Cairo, 2005), p. 159, no. 466.

103 Goitein, *Mediterranean Society*, vol. 4, pp. 49–82.

104 Christopher S. Taylor, *In the Vicinity of the Righteous: Ziyāra and the Veneration of Muslim Saints in Late Medieval Egypt* (Leiden, 1999), pp. 15–20.

105 H. Hawary and H. Rached, *Les Stèles funéraires* (Cairo, 1932–8); Gaston Wiet, *Les Stèles funéraires* (Cairo, 1936–42).

106 Oleg Grabar, 'The Earliest Islamic Commemorative Structures', *Ars Orientalis*, 6 (1966), pp. 7–46.

107 Bloom, 'Mosque of the Qarafa'. For an alternative (and rather dyspeptic) view, see Yūsuf Rāġib, 'La Mosquée d'al-Qarāfa et Jonathan M. Bloom', *Arabica*, 41 (1994), pp. 419–21.

108 Yūsuf Rāġib, 'Deux monuments funéraires d'al-Qarāfa al-Kubrā', *Annales Islamologiques*, 12 (1974), pp. 67–83.

109 The excavators' identification of the graves as the Fatimid royal cemetery seems open to doubt. See Roland-Pierre Gayraud, 'Le Qarāfa al-Kubrā, dernière demeure des Fatimids', in Barrucand, ed., *L'Égypte Fatimide*, pp. 443–64.

110 The text was first discussed in English by T. W. Arnold, *Painting in Islam* (Oxford, 1928), pp. 21–2.

111 Taylor, *Vicinity*, p. 24.

112 Halm, *Empire*, p. 244.

113 Yūsuf Rāġib, 'Sur un groupe de mausolées du cimitière du Caire', *Revue des études islamiques*, 40 (1972), pp. 189–95.

114 Grabar, 'Earliest Islamic Commemorative Structures'; Christopher S. Taylor, 'Reevaluating the Shi'i Role in the Development of Monumental Funerary Architecture: The Case of Egypt', *Muqarnas*, 9 (1992), pp. 1–10; Thomas Leisten, *Architektur für Tote : Bestattung in architektonischem Kontext in den Kernlandern der islamischen Welt zwischen 3./9. und 6./12. Jahrhundert* (Berlin, 1998).

115 Creswell, *Muslim Architecture of Egypt*, vol. 1, pp. 224–6; Rāġib, 'Deux Monuments'; Abd el-Ra'uf Ali Yusuf, 'A Rock-Crystal Specimen in the Museum of Islamic Art and the Seven Fatimid Domes in the Qarāfa al-Kubrā in Cairo', in Barrucand, ed., *L'Égypte*, pp. 311–18.

116 Taylor, *Vicinity*, p. 30.

117 Creswell, *Muslim Architecture of Egypt*, pp. 113–15.

118 Brett, *Rise*, pp. 319, 329.

119 Sanders, *Ritual, Politics and the City*, p. 25.

120 C. E. Bosworth, 'Miẓalla', *EI2*, vol. 7, pp. 191–2.

121 Brett, *Rise*, pp. 331–3.

122 Bloom, 'Mosque of the Qarafa'; Brett, *Rise*, p. 334.

123 Sanders, *Ritual, Politics and the City*.

124 Lev, *State and Society*, p. 22.

125 Walker, *Exploring*, p. 44.

126 For Barjawan, see B. Lewis, 'Bardjawān', *EI2*, vol. 1, pp. 1041–2.

127 The al-Azhar and Hakim mosques are aligned to 140° and 132° respectively, quite different from the orienta-tion of the mosque of Ibn Tulun (151°). Al-Hakim is known to have brought the noted astronomer Ibn Yunus (*d*.1009) to Cairo, who determined that the correct qibla was actually 127°. Does this reconstruction signal the adoption of Ibn Yunus's measurements? See King, 'The Orientation of Medieval Islamic Religious Architecture and Cities', p. 264.

128 Sayyid, *Capitale*, p. 352; Sanders, *Ritual, Politics and the City*, pp. 54–5.

129 Walker, *Exploring*, p. 48.

130 Lev, *State and Society*, pp. 25–37; Walker, 'Ismā'īlī Da'wa', p. 152.

131 Sayyid suggests, following al-Maqrīzī, that the mosque was originally known as the Khuṭba Mosque. See his *Capitale*, p. 335.

132 Creswell, *Muslim Architecture of Egypt*, vol. 1, p. 64, quoting Ibn 'Abd al-Zāhir.

133 Sayyid, *Capitale*, p. 335.

134 Sanders, *Ritual, Politics and the City*, pp. 48ff.

135 Bernard O'Kane, 'The Ziyada of the Mosque of al-Hakim and the Development of the Ziyada in Islamic Architecture', in Barrucand, ed., *L'Égypte Fatimide*, pp. 141–58.

136 In addition to my own article 'Mosque of al-Hakim', see the extensive treatment in Creswell, *Muslim Architecture of Egypt*, and Doris Behrens-Abouseif, *Islamic Architecture in Cairo, an Introduction* (Leiden, 1989), pp. 63–5.

137 Creswell's reconstruction (*Muslim Architecture of Egypt*, 1, fig. 21) suggests that nearly 200 columns and an equal number of capitals were needed.

138 Sanders, *Ritual, Politics and the City*, pp. 58–60, using information provided by my article on 'Mosque of al-Hakim' and access to Irene Bierman's then unpublished book *Writing Signs*, disagreed with my suggestion that the extensive quotations of Qur'anic text on the interior were modelled on those found inside the Mosque of Ibn Tulun. She was able to discern that the inscriptional programme inside the mosque had a specifically Ismaili content. I remain to be convinced.

139 Bloom, 'Mosque of al-Hakim', appendix.

140 Sayyid, *Capitale*, pp. 356–61.

141 Bloom, 'Mosque of al-Hakim'

142 Samuel Flury, *Die Ornamente der Hakim- Under Ashar-Moschee* (Heidelburg, 1912).

143 Creswell, *Muslim Architecture of Egypt*, vol. 1, p. 69.

144 Ibid.

145 Necipoğlu has proposed that the Fatimids and the Umayyads of Spain did not use geometric strapwork ornament, which she believes was developed in Baghdad, because it had specifically Sunni associations, but this cannot be the case here. See Gülru Necipoğlu, *The Topkapi Scroll – Geometry and Ornament in Islamic Architecture* (Santa Monica, CA, 1995), Chapter 6.

146 Bloom, 'Mosque of the Qarafa'; Hawary and Rached, *Stèles funéraires,* vols. 1 and 3; Wiet, *Stèles funéraires,* vols. 2 and 4–10.

147 Lucy-Anne Hunt, 'Coptic art I. Architecture', in Turner, ed., *Dictionary of Art*, pp. 819–21; Peter Grossmann, *Christliche Architektur in Ägypten* (Leiden, 2002).

148 Heinz Halm, 'Fatimides à Salamya.'

149 Turner, *Dictionary of Art*, vol. 7, p. 490.

150 Oleg Grabar, *The Shape of the Holy. Early Islamic Jerusalem* (Princeton, NJ, 1996), p. 139.

151 Van Berchem, *Matériaux, Jerusalem: ville*, no. 24, vol. 2.

152 Grabar, *Shape of the Holy*, p. 144.

153 Jonathan M. Bloom, 'Jerusalem in Medieval Islamic Literature', in Nitza Rosovsky, ed., *City of the Great King: Jerusalem from David to the Present* (Cambridge, MA, 1996), pp. 205–17.

154 Van Berchem, *Matériaux, Jerusalem: Haram*, nos. 220–2.

155 See Saïd Nuseibeh and Oleg Grabar, *The Dome of the Rock* (New York, 1996), pp. 132–3, where the slight change in pattern is clearly visible in the photographs. Note, however, that the photographs are mislabelled.

156 Henri Stern, 'Recherches sur la Mosquée al-Aqsa et ses mosaïques', *Ars Orientalis*, 5 (1963), pp. 27–47; Creswell, *Early Muslim Architecture*, vol. 1, pp. 300–8.

157 Grabar, *Shape of the Holy*, p. 82.

158 Combe, Sauvaget and Wiet, *Répertoire chronologique d'épigraphie arabe*, no. 2410.

159 Van Berchem, *Matériaux Jerusalem*, no. 275; Grabar, *Shape of the Holy*, pp. 148–51.

160 Grabar, *Shape of the Holy*, p. 149.

161 Ibid., p. 161.

162 Sheila S. Blair, 'What is the Date of the Dome of the Rock?', in Julian Raby and Jeremy Johns, eds, *Bayt al-Maqdis: 'Abd al-Malik's Jerusalem, Part One* (Oxford, 1992), pp. 59–88.

163 Grabar, for example, believes that they were responsible for the renovation of the southern accesses to the upper platform of the Haram. See Grabar, *Shape of the Holy*, p. 158.

164 Combe, Sauvaget and Wiet, *Répertoire*, no. 1458; Thackston, *Safarnāma*, p. 33.

165 Jonathan M. Bloom, 'The Introduction of the Muqarnas into Egypt', *Muqarnas*, 5 (1988), pp. 21–8.

166 Jonathan M. Bloom, 'Five Fatimid Minarets in Upper Egypt', *Journal of the Society of Architectural Historians*, 43 (1984), pp. 162–7.

167 Hasan Muhammad Effendi al-Hawari, 'Trois minarets Fatimides à la frontière Nubienne', *Bulletin de l'institut d'Égypte*, 17 (1934–5), pp. 141–153. Creswell, *Muslim Architecture of Egypt*, pp. 146–55. The unpublished tower at Edfu has a tapering octagonal shaft culminating in a balcony that supports a tapering cylindrical shaft, a crown of muqarnas-like elements and a small domed lantern. I thank Alison Gascoigne for bringing this structure to my attention.

168 Bloom, 'Five Fatimid Minarets.'

169 Ibid.

170 Sylvia Auld and Robert Hillenbrand, eds, *Ottoman Jerusalem, the Living City: 1517–1917* (London, 2000), chs 26, 27.

IV THE DECORATIVE ARTS FROM 969 TO THE 1060s

1 Avinoam Shalem, *Islam Christianized: Islamic Portable Objects in the Medieval Church Treasuries of the Latin West* (Frankfurt am Main, 1997), pp. 56–66.

2 Linda Komaroff and Stefano Carboni, eds, *The Legacy of Genghis Khan: Courtly Art and Culture in Western Asia, 1256–1353* (New Haven, CT, 2002); Thomas W. Lentz and Glenn D. Lowry, *Timur and the Princely Vision* (Los Angeles, CA, 1989).

3 Wiet, 'Une Peinture du XIIe siècle'.

4 B. W. Robinson, *Islamic Painting and the Arts of the Book* (London, 1976), pp. 33–5.

5 See, for example, the reports of Professor George Scanlon's excavations at Fustat, many of which can be found in the pages of the *Journal of the American Research Center in Egypt*, or the continuing work by such scholars as Nairy Hampikian and Roland-Pierre Gayraud.

6 Sheila S. Blair and Jonathan M. Bloom, 'Islamic art VI, 2 (i) (a) Fabrics, before c.1250: Egypt', in Turner, ed., *Dictionary of Art*.

7 George Scanlon, 'Islamic art V, 2 (iv) Ceramics, before c.1250, Egypt', in Turner, ed., *Dictionary of Art*.

8 Ralph Pinder-Wilson, 'Islamic Art VIII, 13. Rock crystal', in Turner, ed., *Dictionary of Art*.

9 David Whitehouse, 'Islamic art, VIII, 5 (i): Glass: seventh– eleventh centuries', in Turner, ed., *Dictionary of Art*.

10 Rudolph Schnyder, 'Tulunidische Lüsterfayence', *Ars Orientalis*, 5 (1963), pp. 49–78; Robert B. Mason and Edward J. Keall, 'Petrography of Islamic Pottery from Fustat', *Journal of the American Research Center in Egypt*, 27 (1990), pp. 165–84; Robert B. Mason, 'Medieval Egyptian Lustre-Painted and Associated Wares: Typology in a Multidisciplinary Study', *Journal of the American Research Center in Egypt*, 34 (1997), pp. 201–42.

11 Oliver Watson, *Ceramics from Islamic Lands* (London, 2004), p. 38.

12 Mayerson, 'The Role of Flax'.

13 Combe, 'Tissus Fatimides', pl. 1; Kühnel and Bellinger, *Catalogue of Dated Tiraz Fabrics*, pp. 54–5.

14 al-Maqrīzī, *Khiṭaṭ*, vol. 1, pp. 409–13.

15 al-Qaddūmī, *Book of Gifts*, p. 218.

16 *Tissus d'Égypte: collection Bouvier* (Paris, 1994), pp. 198–200.

17 Contadini, *Fatimid Art*, pp. 39–70.

18 Jochen A. Sokoly, 'Between Life and Death: The Funerary Context of Tiraz Textiles', in *Islamische Textilkunst*

des Mittelalters: Aktuelle Probleme (Riggisberg, 1997), pp. 71–8.

19 Sheila S. Blair and Jonathan M. Bloom, 'Islamic art VI, 2 (i) (a): Fabrics, before c.1250: Egypt', in Turner, ed., *Dictionary of Art*; Kühnel and Bellinger, *Catalogue of Dated Tiraz Fabrics*.

20 Thackston, *Safarnama*, p. 48.

21 M. Bernus, H. Marchal and G. Vial, 'Le suaire de Saint-Josse', *Bulletin de liaison du centre international d'études des textiles anciens*, 33 (1971), pp. 1–57.

22 Oliver Watson, 'Fritware: Fatimid Egypt or Saljuq Iran?', in Barrucand, ed., *L'Égypte fatimide*, pp. 299–307.

23 Alan Caiger-Smith, *Lustre Pottery: Technique, Tradition and Innovation in Islam and the Western World* (London, 1985), pp. 21–50.

24 Watson, *Ceramics*, p. 18.

25 Kubiak and Scanlon, *Fustat Expedition Final Report*, p. 47.

26 al-Qaddūmī, *Book of Gifts*, §§384, 385.

27 Nasir-i Khusraw, *Safarnāma*, ed. Dabīr Siyāqī; Thackston, *Safarnama*, p. 54.

28 Goitein, *A Mediterranean Society*, vol. 4, p. 106.

29 In the 1998 exhibition in Paris and Vienna (Seipel, *Schätze*), for example, some of the lustre ceramics (cat. nos. 53–61) were exhibited as courtly art, while others (136–53) were exhibited as everyday wares.

30 Philon, *Early Islamic Ceramics*, p. 198.

31 Ḥasan Maḥmūd Ḥasan al-Bāshā, 'Tabaq min al-khazaf bi-ism Ghabn mawla al-Ḥakim bi-Amr Allah (A ceramic dish with the name of Ghabn, client of al-Hakim)', *Bulletin of the Faculty of Arts, Cairo University* 18 (1965), pp. 71–85; Marilyn Jenkins, 'Early Medieval Islamic Pottery: The Eleventh Century Reconsidered', *Muqarnas*, 9 (1992), pp. 56–66.

32 Marie-Odile Rousset, 'La Céramique des XIe et XIIe siècles en Égypte et au Bilād al-Shām. État de la question', in Barrucand, ed., *L'Égypte Fatimide*, pp. 249–64.

33 Marilyn Jenkins, 'Muslim: An Early Fatimid Ceramicist', *Bulletin of the Metropolitan Museum of Art*, 26 (1968), pp. 359–69.

34 Contadini, *Fatimid Art*, pp. 81–2.

35 Watson, *Ceramics*, p. 280.

36 Grube, 'Fatimid Pottery'.

37 Baer, 'Fatimid Art at the Crossroads', pp. 386–94.

38 Ettinghausen, 'Painting in the Fatimid Period'.

39 Bloom, *Paper Before Print*, pp. 162–78.

40 Jenkins, 'Early Medieval Pottery'.

41 Watson, *Ceramics*, pp. 132–3.

42 George T. Scanlon, 'Fustat Fatimid Sgraffiato: Less Than Lustre', in Barrucand, ed., *L'Égypte Fatimide*, pp. 265–84.

43 Grube, 'Fatimid Pottery', p. 138.

44 Mason, 'Medieval Egyptian Wares.'

45 Halm, *The Empire of the Mahdi*, pp. 9–11.

46 Robert Mason and M. S. Tite suggest that Iraqi potters developed fritware when they experienced difficulty in procuring fine clay in Egypt. See 'The Beginnings of Islamic Stonepaste Technology', *Archaeometry*, 36 (1994), pp. 77–91.

47 Anna Contadini, Richard Camber and Peter Northover, 'Beasts That Roared: The Pisa Griffin and the New York Lion', in Warwick Ball and Leonard Harrow, eds, *Cairo to Kabul: Afghan and Islamic Studies Presented to Ralph Pinder-Wilson* (London, 2002), pp. 65–83; Giovanni Curatola, *Eredità dell'Islam* (Venice, 1993), p. 43; Dodds, ed., *Al-Andalus*, p. 15; Marilyn Jenkins, 'New Evidence for the Possible Provenance and Fate of the So-Called Pisa Griffon', *Islamic Archaeological Studies*, 1 (1978), pp. 79–85.

48 Marilyn Jenkins, 'Fāṭimid Jewelry, its Subtypes and Influences', *Ars Orientalis*, 18 (1988), pp. 39–58.

49 *The Art of Medieval Spain A.D. 500–1200* (New York, 1993), no. 47.

50 Goitein, *Mediterranean Society*, vol. 4, p. 131.

51 J. W. Allan, 'Islamic art IV. Base metals, before c.1100: Egypt', in Turner, ed., *Dictionary of Art*, vol. 16, p. 369; Eva Baer, *Metalwork in Medieval Islamic Art* (Albany, NY, 1983), p. 295; Geza Fehérvári, *Islamic Metalwork of the Eighth Century to the Fifteenth Century in the Keir Collection* (London, 1976), pp. 39–45.

52 Seipel, *Schätze*, no. 72.

53 Rachel Ward, *Islamic Metalwork* (New York, 1993), pp. 62–6.

54 Contadini, *Fatimid Art*, pp. 113–14.

55 Goitein, *Mediterranean Society*, vol. 4, pp. 132–50.

56 Myriam Rosen-Ayalon, *Islamic Art and Archaeology of Palestine* (Walnut Creek, CA, 2006), p. 76.

57 Museum für Islamische Kunst Berlin, *Katalog 1971* (Berlin, 1971), no. 307; *Trésors*, no. 53.

58 *Trésors*, p. 125.

59 Walker, *Exploring an Islamic Empire*, p. 96.

60 Thackston, *Safarnama*, p. 32.

61 Ibid., p. 53.

62 al-Qaddūmī, tr. *Book of Gifts*, p. 238.

63 Georges Marçais and Louis Poinssot, *Objets Kairouanais IXe au XIIIe siècle* (Tunis, 1948), pp. 467–93.

64 A generous selection of Fatimid-era jewellery was displayed at the 1998 exhibition in Vienna; see Seipel, *Schätze*, pp. 119–30.

65 Rosen-Ayalon, *Islamic Art*, p. 77; Marçais and Poinssot, *Objets Kairouanais*.

66 Rachel Ward, 'Islamic art § VIII, 9 Jewelry'; Marilyn Jenkins, 'Fāṭimid Jewellery, Its Subtypes and Influences', *Ars Orientalis*, 18 (1988), pp. 39–58; Marilyn Jenkins and Manuel Keene, *Islamic Jewelry in the Metropolitan Museum of Art* (New York, 1982), pp. 80–8; M. Keene and M. Jenkins, 'Djawhar', *EI2*, supplement, pp. 254–5.

67 Valérie Gonzalez, 'Pratique d'une technique d'art Byzantine chez les Fatimides: l'émaillerie sur métal', in Barrucand, ed., *L'Égypte Fatimide*, pp. 197–217.

68 Kahle, 'Schätze'; Scott Redford, 'How Islamic is It? The Innsbruck Plate and its Setting', *Muqarnas*, 7 (1990), pp. 119–32.

69 al-Qaddūmī, *Book of Gifts*, p. 238.

70 Shalem, *Islam Christianized*; Contadini, *Fatimid Art*, pp. 16–35; Yusuf, 'Rock-Crystal'.

71 Were the Venice ewer a perfect cone 12.5 centimetres in diameter and 18 centimetres high, it would hold just over a litre (or one US quart), but it is not. Shalem (p. 61) imagines that it could hold almost half again as much.

72 D. S. Rice, 'A Datable Islamic Rock Crystal', *Oriental Art*, 2 (1956), pp. 85–93.

73 I thank Anna Contadini for providing me with this information.

74 Yusuf, 'Rock-Crystal'; Shalem, *Islam Christianized*, pp. 56–8, 177–226.

75 Contadini, *Fatimid Art*, pp. 25–7.

76 Thackston, tr., *Safarnama*, p. 53.

77 Shalem, *Islam Christianized*, p. 57.

78 Ibid., pp. 203–5.

79 Contadini, *Fatimid Art*, pp. 17–18.

80 Stefano Carboni and David Whitehouse, *Glass of the Sultans* (New York, 2001), no. 90.

81 Shalem, *Islam Christianized*, pp. 113–15; Carboni and Whitehouse, *Glass*, pp. 160–1.

82 Avinoam Shalem, 'New Evidence for the History of the Turquoise Glass Bowl in the Treasury of San Marco', *Persica*, 15 (1995), pp. 65–8; Shalem, *Islam Christianized*, pp. 63–6; Carboni and Whitehouse, *Glass*, no. 83.

83 Shalem, *Islam Christianized*, pp. 58–60.

84 Danièle Foy, 'Lampes de verre Fatimides à Fostat: le mobilier des fouilles de Istabl 'Antar', in Barrucand, ed., *L'Égypte Fatimide*, pp. 179–96.

85 The material still awaits full publication. A brief description is provided by Carboni and Whitehouse, *Glass*, pp. 20–1, with reference to Berta Lledó, 'Mold Siblings in the Eleventh-Century Cullet from Serçe Limani', *Journal of Glass Studies*, 39 (1997), pp. 43–55, and Frederick H. van Doorninck, 'The Serçe Limanı Shipwreck: An Eleventh-Century Cargo of Fatimid Glassware Cullet for Byzantine Glassmakers', in *I. Uluslararasi Anadolu Cam Sanati Sempozyumu, 26–27 Nisan 1988/First International Anatolian Glass Symposium, April 26th-27th, 1988* (Istanbul, 1990), pp. 58–63.

86 Jens Kröger, 'Fusṭāṭ and Nishapur. Questions About Fatimid Cut Glass', in Barrucand, ed., *L'Égypte Fatimide*, p. 225.

87 Stefano Carboni, 'Glass Production in the Fatimid Lands and Beyond', in Barrucand, ed., *L'Égypte Fat-imide*, pp. 169–78.

88 Carboni and Whitehouse, *Glass*, no. 108.

89 E. Pauty, *Les Bois sculptés d'églises Coptes (époque Fatimide)* (Cairo, 1930); David-Weill, *Les Bois à épigraphes*; Pauty, *Les Bois sculptés*; Lamm, 'Fatimid Woodwork'.

90 Elise Anglade, *Catalogue des boiseries de la section Islamique, Musée du Louvre* (Paris, 1988), p. 30, no. 15.

91 Flury, *Ornamente*, pl. 1.

92 Marilyn Jenkins, 'An Eleventh-Century Woodcarving from a Cairo Nunnery', in Richard Ettinghausen, ed., *Islamic Art in The Metropolitan Museum of Art* (New York, 1972), pp. 227–40.

93 Ernst Kühnel, *Die Islamischen Elfenbeinskulpturen VIII–XIII Jahrhunderts* (Berlin, 1971), nos. 88–130.

94 Contadini, 'Fatimid Ivories', pp. 227–8.

95 D. S. Rice, 'The Seasons and Labours of the Months', *Ars Orientalis*, 1 (1954), pp. 1–39.

96 Contadini, 'Fatimid Ivories', p. 231.

97 Ralph Pinder-Wilson, 'Ivory Working in the Umayyad and Abbasid Periods', *Journal of the David Collection*, 2 (2005), fig. 1; Rebecca M. Foote, 'Abbasid Qasr (F103) and the Carved Ivory Panels', *Annual of the Department of Antiquities of Jordan*, 47 (2003), pp. 55–64.

98 Eva R. Hoffman, 'A Fatimid Book Cover: Framing and Re-Framing Cultural Identity in the Medieval Mediterranean World', in Barrucand, ed., *L'Égypte Fatimide*, pp. 403–19.

99 al-Maqrīzī, *Khiṭaṭ*, vol. 1, pp. 408–9; Gulnar Bosch, John Carswell and Guy Petherbridge, *Islamic Bindings and Bookmaking* (Chicago, 1981); Duncan Haldane, *Islamic Bookbindings in the Victoria and Albert Museum* (London, 1983).

100 Seipel, *Schätze*, no. 245, where they are attributed to south Italy or Sicily in the eleventh or twelfth century.

101 Paul E. Walker, 'Fatimid Institutions of Learning', *Journal of the American Research Center in Egypt*, 34 (1997), p. 195.

102 Bloom, *Paper Before Print*, pp. 110–16.

103 Ibid.

104 Walker, 'Fatimid Institutions'.

105 D. Sourdel, 'Dār al-'Ilm', *EI2*, vol. 2, p. 127.

106 Youssef Eche, *Les Bibliothèques Arabes publiques et semi-publiques en Mésopotamie, en Syrie et en Égypte au moyen age* (Damascus, 1967).

107 al-Maqrīzī, *Khiṭaṭ*, vol. 2, p. 250.

108 Walker, 'Fatimid Institutions', p. 195; al-Maqrīzī, *Khiṭaṭ*, vol. 1, p. 409.

109 Blair, *Islamic Calligraphy*, pp. 175–6.

110 Marcus Simaika Pasha and 'Abd al-Masiḥ Effendi, *Catalogue of the Coptic and Arabic Manuscripts in the Coptic Museum, the Principal Churches of Cairo and Alexandria and the Monasteries of Egypt* (Cairo, 1939), pl. xxxiii; Blair, *Islamic Calligraphy*, p. 205.

111 Roland-Pierre Gayraud, 'La Nécropole des Fatimides à Fostat', *Dossiers d'archéologie*, 233 (1998), p. 38.

112 Ayman Fu'ad Sayyid, 'L'art du livre', *Dossiers d'archéologie*, 233 (1998), pp. 80–3.

113 D. S. Rice, *The Unique Ibn al-Bawwāb Manuscript in the Chester Beatty Library* (Dublin, 1955), p. 11.

114 Blair, *Islamic Calligraphy*, pp. 195–202.

115 Is. 1430. See Arthur J. Arberry, *The Qur'an Illuminated: A Handlist of Qur'ans in the Chester Beatty Library* (Dublin, 1967). This identification was first proposed by Contadini, *Fatimid Art*, pp. 10–11. Elaine Wright generously provided me with study photographs of this intriguing manuscript.

116 al-Qaddūmī, tr., *Book of Gifts*, p. 218; al-Maqrīzī, *Khiṭaṭ*, vol. 2, p. 318.

117 Ettinghausen, 'Painting in the Fatimid Period'. The fullest treatment of these fragments published so far is that by Ernst J. Grube in a volume of his collected articles, *Studies in Islamic Painting* (London, 1995).

118 As dealers have been known to 'embellish' or 'improve' some genuine medieval pages and drawings to increase their worth on the art market by providing them with identifying texts or illustrations, it would be hazardous to use this leaf as evidence for early book illustration. For the leaf illustrated with a lion see the most recent description by Stefano Carboni in *Trésors*, p. 99.

119 Ernst J. Grube, 'Fostat Fragments', in B. W. Robinson, ed., *Islamic Painting and the Arts of the Book* (London, 1976), p. 33; Wiet, 'Une Peinture'. These works all appeared on the art market in the 1930s and 1940s, at the same time as did a group of Persian silks purporting to date from the 'Buyid' period. These textiles, which have been shown to be modern forgeries, were initially authenticated by unsuspecting scholars who identified the dated texts and poetry that had been inscribed on them in much the same way that these drawings have been inscribed with texts. See Sheila S. Blair, Jonathan M. Bloom and Anne E. Wardwell, 'Reevaluating the Date of the "Buyid" Silks by Epigraphic and Radiocarbon Analysis', *Ars Orientalis*, 22 (1992), pp. 1–42.

120 Seipel, *Schätze*, no. 27.

121 Jerusalem, Israel Museum, M 165-4-65. Rachel Milstein and N. Brosch, *Islamic Painting in the Israel Museum* (Jerusalem, 1984), p. 23.

122 Grube, 'Fustat Fragments', pp. 26–7.

123 Karl R. Schaefer, *Enigmatic Charms: Medieval Arabic Block Printed Amulets in American and European Libraries and Museums* (Leiden, 2006), pp. 27ff.

124 Kubiak and Scanlon, *Fustat*, pp. 69–70.

125 Walker, *Exploring*, p. 145.

126 Gaston Wiet, 'L'Exposition d'art persan à Londres', *Syria*, 13 (1932), p. 201.

127 Al-Maqrīzī, *Khiṭaṭ*, p. 318; Wiet, 'L'Exposition', p. 201.

128 Al-Maqrīzī, *Khiṭaṭ*, vol. 2, p. 318; H. Lavoix, 'Les Arts Musulmans', *Gazette des beaux-arts*, 12 (1875), pp. 97–113; Arnold, *Painting in Islam*, p. 22.

129 Ettinghausen, 'Painting'.

130 Ibid.

131 Ernst J. Grube, 'Studies in the Survival and Continuity of Pre-Muslim Traditions in Egyptian Islamic Art', *Journal of the American Research Center in Egypt*, 1 (1962), pp. 75–97; Grube, 'Fatimid Pottery'.

132 Oleg Grabar, 'Imperial and Urban Art in Islam: The Subject Matter of Fāṭimid Art', in *Colloque internationale sur l'histoire du Caire* (Gräfenheinichen, 1972), pp. 173–90.

133 Wiet, 'L'Exposition', p. 203.

V ARCHITECTURE FROM THE 1060S TO 1171

1 Grabar, 'The Earliest Islamic Commemorative Structures'; Williams, 'The Cult of 'Alid Saints, parts I and II'.

2 Taylor, 'Reevaluating the Shi'i Role'.

3 Yasser Tabbaa, *The Transformation of Islamic Art During the Sunni Revival* (Seattle and London, 2001); Necipoğlu, *The Topkapi Scroll*.

4 Lev, *State and Society in Fatimid Egypt*, p. 44.

5 Daftary, *Short History*, pp. 105–6; Lev, *State and Society*, p. 45.

6 See, for example, the many archaeological reports by George Scanlon *et al.* in the *Journal of the American Research Center in Egypt*.

7 Lev, *State and Society*, pp. 45–6; Walker, *Exploring*, p. 69.

8 Walker, *Exploring*, p. 67.

9 Lev, *State and Society*, p. 46; Walker, *Exploring*, p. 67.

10 Walker, *Exploring*, p. 68.

11 C. H. Becker, 'Badr al-Djamālī', *EI2*, vol. 1, pp. 869–70.

12 Walker, *Exploring*, p. 69.

13 Walker, 'al-Maqrīzī and the Fatimids', pp. 83–97.

14 Lev, *State and Society*, p. 48; Daftary, *Short History*, pp. 106–8; Walker, *Exploring*, pp. 71–3.

15 Walker, *Exploring*, p. 73.

16 Sanders, *Ritual, Politics and the City*, pp. 127–9.

17 Williams, 'Cult I', p. 48; D. M. Dunlop, 'al-Baṭā'iḥī', *EI2*, vol. 1, pp. 1091–2.

18 Daftary, *Short History*, p. 109.

19 A. M. Magued, 'al-Ḥāfiẓ', *EI2*, vol. 3, pp. 54-55.

20 Contadini, *Fatimid Art*, p. 73.

21 Bernard O'Kane, 'The Ziyada of the Mosque of al-Hakim'; Sayyid, *Capitale*, p. 382.

22 Sayyid, *Capitale*, pp. 352–6.

23 Gaston Wiet, 'Une Nouvelle Inscription Fatimide au Caire', *Journal Asiatique*, 249 (1961), pp. 13–20; Sayyid, *Capitale*, p. 418.

24 Creswell, *Muslim Architecture of Egypt*, vol. 1, pp. 164–5.

25 Ibid., vol. 1, p. 205.

26 Creswell (ibid., vol. 1, pp. 166–76) was the first to discuss these shields, suggesting that the kite-shaped ones were of 'Norman' inspiration. Behrens-Abouseif, *Islamic Architecture in Cairo*, p. 68, suggested they were 'symbolic of the walls as being the shields of the city', while Avinoam Shalem, 'A Note on the Shield-Shaped Ornamental Bosses on the Façade of Bāb al-Nasr in Cairo', *Ars Orientalis*, 26 (1996), pp. 55–64, implies that they

may have been related to some celebrated shields kept in the Fatimid treasuries.

27 Van Berchem, *Matériaux*, vol. 1, p. 62; Combe, Sauvaget and Wiet, *Répertoire*, no. 2762; Creswell, *Muslim Architecture of Egypt*, vol. 1, p. 164.

28 S. Blair, 'Floriated Kufic', p. 115; S. Blair, 'Decoration of City Walls', pp. 509–10. According to early travellers, al-Ruha once had impressive walls and gates. See E. Honigmann (C. E. Bosworth), 'Ruha', *EI2*, vol. 7, pp. 589–91. For the suggestion that the walls of Diyarbekir were themselves inspired by Baghdad, see Estelle J. Whelan, *The Public Figure: Political Iconography in Medieval Mesopotamia* (London, 2006).

29 Creswell, *Muslim Architecture of Egypt*, vol. 1, pp. 176–81.

30 Bloom, 'Introduction of the Muqarnas'.

31 Doris Behrens-Abouseif, *The Minarets of Cairo* (Cairo, 1985), p. 116.

32 Sayyid, *Capitale*, p. 426.

33 Tommaso Breccia Fratadocchi, 'Notes on Armenian Military Architecture', *A.A.R.P Environmental Design: Journal of the Islamic Environmental Design Research Centre*, 1–2 (1999), pp. 66–71.

34 Creswell, *Muslim Architecture of Egypt*, vol. 1, p. 219.

35 al-Maqrīzī, *Khiṭaṭ*, vol. 1, p. 381; Creswell, *Muslim Architecture of Egypt*, vol. 1, p. 162.

36 Bloom, *Paper Before Print*.

37 William Archbishop of Tyre, *A History of Deeds Done Beyond the Sea*, tr. Emily Atwater Babcock and A. C. Krey (New York, 1943), pp. 319–20.

38 Sayyid, *Capitale*, pp. 330–3.

39 Ibid., pp. 431–2, 462–9.

40 Ibid., pp. 477–82.

41 Ibid., pp. 507–13.

42 Creswell, *Muslim Architecture of Egypt*, vol. 1, pp. 217–19.

43 Combe, Sauvaget and Wiet, *Répertoire*, vol. 7, pp. 265–9.

44 David-Weill, *Les Bois à épigraphes*, pp. 3–4.

45 Gaston Wiet, 'Nouvelles Inscriptions Fatimides', *Bulletin de l'Institut de Egypte*, 24 (1941–2), pp. 145–55; Combe, Sauvaget and Wiet, *Répertoire*, vol. 11, p. 263, no. 2733a.

46 Taylor, 'Reevaluating the Shi'i Role'.

47 Williams, 'Cult II'.

48 Creswell, *Muslim Architecture of Egypt*, vol. 1, pp. 155–60; Shāfe'i, 'The Mashhad al-Juyūshī: Archaeological Notes and Studies', in *Studies in Islamic Art and Architecture in Honour of Professor K. A. C. Creswell*, pp. 237–52; Grabar, 'The Earliest Islamic Commemorative Structures', pp. 27–8; Williams, 'Cult I', pp. 39–40; Yusuf Rāġib, 'Un Oratoire Fatimide au sommet du Muqaṭṭam', *Studia Islamica*, 65 (1987), pp. 51–67; Barbara Finster, 'On Masjid al-Juyūshī on the Muqaṭṭam', *Archéologie Islamique*, 10 (2000), pp. 65–78; Saifuddin, *Al Juyushi*.

49 Sayyid, *Capitale*, pp. 433–4.

50 Creswell, *Muslim Architecture of Egypt*, vol. 1, p. 159, n. 2.

51 T. A. Sinclair, *Eastern Turkey: An Architectural and Archaeological Survey* (London, 1987–90), vol. 1, p. 374.

52 Terry Allen, *Ayyubid Architecture* (Occidental, CA, 1996), Ch. 2, www.sonic.net/~tallen/palmtree/ayyarch.

53 Bloom, 'Introduction of the Muqarnas'.

54 Shāfe'i, 'Mashhad al-Juyūshī', p. 246.

55 See the photo in Saifuddin, *Al-Juyushi*, p. 101.

56 Van Berchem, 'Une Mosquée de temps des fatimites'; Saifuddin, *Al Juyushi*, p. 104, has slightly corrected van Berchem's reading, substituting 'suppress' (*kabata*) for 'deceive' (*kayada*).

57 Yusuf Rāġib has noted that Max van Berchem mistakenly noted the number of one chapter; the mistake has been repeated by every scholar since. See Rāġib, 'Oratoire Fatimide', pp. 58–60.

58 Janine Sourdel-Thomine and Bertold Spuler, *Die Kunst des Islam* (Berlin, 1973), p. 249; Finster, 'Masjid al-Juyushi'.

59 Shāfe'i, 'Mashhad al-Juyūshī'; Grabar, 'Earliest Islamic Commemorative Structures'; Williams, 'Cult I'.

60 Josef W. Meri, *The Cult of Saints Among Muslims and Jews in Medieval Syria* (Oxford, 2002).

61 Rāġib, 'Oratoire Fatimide'. The author, despite his enormous erudition, seems unaware of a contemporary kufic inscription dated 481/1088 from Salamiyya, the Fatimid ancestral home in Syria, specifically mentioning the erection of a *mashhad* specifically over a tomb. See J. H. Kramers and F. Daftary, 'Salamiyya', *EI2*, vol. 7, pp. 921–3. For the use of the terms in Egypt, see Sayyid, *Capitale*, p. 359.

62 Moshe Sharon, *Corpus Inscriptionum Arabicarum Palaestinae* (Leiden, 1997), pp. 130ff.

63 Max van Berchem, 'La Chaire de la mosquée d'Hébron et le martyrion de la tête de Husain à Ascalon', in *Festschrift Eduard Sachau* (Berlin, 1915), pp. 298–310. For the cult of saints in Syria and particularly the cult of Husayn, see Meri, *Cult of Saints*, pp. 191–5.

64 Sharon, *Corpus*, p. 159, no. 9.

65 Lamm, 'Fatimid Woodwork', pp. 76–7.

66 Van Berchem, 'La Chaire de la mosquée d'Hébron'; Gaston Wiet, 'Notes d'épigraphie Syro-Musulmane', *Syria*, 5 (1924), pp. 217–32; Williams, 'Cult I', pp. 41–2; Sharon, *Corpus*, pp. 155–9.

67 Sharon, *Corpus*, pp. 157–8.

68 Jonathan M. Bloom, 'Woodwork in Syria, Palestine and Egypt during the Twelfth and Thirteenth Centuries', in Sylvia Auld and Robert Hillenbrand, eds, *Ayyubid Jerusalem* (London, forthcoming).

69 Sayyid, *Capitale*, pp. 441–7.

70 Sayyid, *Capitale*, pp. 469–82. On the nine-dome mosque in Islamic architecture, see Bernard O'Kane, 'The Origin, Development and Meaning of the Nine-Bay

Plan in Islamic Architecture', in Abbas Daneshvari, ed., *A Survey of Persian Art, Vol. 18: From the End of the Sasanian Empire to the Present: Studies in Honor of Arthur Upham Pope* (Costa Mesa, CA, 2005), pp. 189–244.

71 Sayyid, *Capitale*, pp. 473–6.

72 Ibid., pp. 441–7.

73 al-Maqrīzī, *Ittiʿāẓ*, vol. 1, pp. 120–1.

74 al-Maqrīzī, *Khiṭaṭ*, vol. 1, p. 477.

75 Thackston, *Safarnama*, p. 68.

76 Behrens-Abouseif, *The Minarets of Cairo*, p. 52.

77 Van Berchem, *Matériaux Egypt I*, no. 11; Combe, Sauvaget and Wiet, *Répertoire*, p. 2807; Creswell, *Early Muslim Architecture*, vol. 2, p. 336 and pl. 97b; Sayyid, *Capitale*, pp. 382, 444.

78 Creswell, *Muslim Architecture of Egypt*, vol. 1, pp. 221–2. For the mihrab at Nayin, see Ettinghausen, Grabar and Jenkins-Madina, *Islamic Art 650–1250*, fig. 159.

79 Rice, *The Unique Ibn al-Bawwāb Manuscript*.

80 Walker, *Exploring*, pp. 76, 147.

81 Sayyid, *Capitale*, pp. 507–37.

82 Creswell, *Muslim Architecture of Egypt*, vol. 1, pp. 239–41; Williams, 'Cult I', p. 41.

83 Bloom, *Minaret*, p. 142.

84 Saifuddin, *Al Aqmar*, pp. 89–109.

85 Bloom, 'Introduction of the Muqarnas'.

86 Mentioned but not illustrated by Creswell, these muqarnas are illustrated in Saifuddin, *Al-Aqmar*, p. 49.

87 Robert Hillenbrand, *Islamic Art and Architecture* (London, 1999), pp. 77–8. For the Mausoleum of Ikhwat Yusuf, see Williams, 'Cult II', pp. 48–9.

88 Williams, 'Cult I'; Saifuddin, *Al-Aqmar*.

89 Behrens-Abouseif, 'The Façade of the Aqmar Mosque'.

90 Sanders, *Ritual, Politics and the City*.

91 David-Weill, *Bois à épigraphes*, vol. 1, pp. 5–6; Saifuddin, *Al-Aqmar*, p. 82.

92 The inscription was originally published by Paul Ravaisse, 'Sur trois mihrabs en bois sculpté', *Mémoires de l'Institut Egyptien*, 2 (1889), p. 630. For the complete bibliography to 1931, see David-Weill, *Bois à épigraphes*, pp. 5–6, no. 422. The Koranic quotations are misidentified by Williams, 'Cult I', p. 49.

93 Combe, Sauvaget and Wiet, *Répertoire*, no. 3013.

94 David-Weill, *Bois à épigraphes*, p. 51, no. 4389 and pl. XIII.

95 Van Berchem, *Matériaux Egypt I*, p. 709, no. 521; Williams, 'Cult I', pp. 49–50.

96 Van Berchem, *Matériaux Egypt I*, p. 712.

97 Wiet, *Matériaux I: Egypte 2*, no. 590; Combe, Sauvaget and Wiet, *Répertoire*, no. 3054.

98 Creswell, *Muslim Architecture of Egypt*, vol. 1, pp. 247–51; Williams, 'Cult II', pp. 42–7.

99 Combe, Sauvaget and Wiet, *Répertoire*, vol. 8, pp. 212–13, no. 3092.

100 Williams, 'Cult II', p. 47.

101 Al-Maqrīzī, *Khiṭaṭ*, vol. 1, p. 275.

102 J. Pedersen, 'Masdjid', *EI2*, vol. 6, p. 661; Jonathan M. Bloom, 'Maqṣūra', in Turner, ed., *Dictionary of Art*, vol. 20, pp. 368–70.

103 Creswell, *Muslim Architecture of Egypt*, vol. 1, pp. 254–5.

104 From photographs (e.g. Creswell, *Muslim Architecture of Egypt*, vol. 1 pls 91a and b), I have been able to identify Q 36 on band 3, Q 7:54 on band 4 and Q 62.3 on band 5.

105 Sanders, *Ritual, Politics and the City*, pp. 125, 130–2.

106 Creswell, *Muslim Architecture of Egypt*, vol. 1, p. 257.

107 Ibid., vol. 1, p. 255.

108 Bloom, 'Introduction of the Muqarnas'.

109 Lev, *State and Society*, p. 140; Walker, 'The Ismāʿīlī Daʿwa', vol. 1, p. 168.

110 Thierry Bianquis, 'Ṭalāʾiʿ b. Ruzzīk', *EI2*, vol. 10, pp. 149–51.

111 Creswell, *Muslim Architecture of Egypt*, vol. 1, pp. 275–88; Behrens-Abouseif, *Islamic Architecture in Cairo*, pp. 76–7.

112 Sayyid, *Capitale*, pp. 544–7.

113 Bianquis, 'Ṭalāʾiʿ b. Ruzzīk', p. 51.

114 In addition to the history of the Comité's works given by Creswell, *Muslim Architecture of Egypt*, vol. 1, pp. 275–8, see also Nairy Hampikian, 'Medievalization of the Old City as an Ingredient of Cairo's Modernization: Case Study of Bab Zuwayla', in Nezar Alsayyad, Irene A. Bierman and Nasser Rabbat, eds, *Making Cairo Medieval* (Lanham, MD, 2005), pp. 201–34.

115 Jean Claude Garcin, 'Remarques sur un plan topographique de la grande mosquée du Qûs', *Annales Islamologiques*, 9 (1970), pp. 97–108.

116 Creswell, *Muslim Architecture of Egypt*, vol. 1, pp. 287–8.

117 Williams, 'Cult II', p. 53.

118 Creswell, *Muslim Architecture of Egypt*, vol. 1, pp. 271–3.

119 Ibid., vol. 1, pp. 287–8.

VI THE DECORATIVE ARTS FROM THE 1060S TO 1171

1 Walker, 'Fatimid Institutions of Learning', p. 195, quoting al-Maqrīzī.

2 al-Qaddūmī, tr., *Book of Gifts*.

3 Nevertheless, see the many scattered references to Abbasid treasures in al-Qaddūmī, *Book of Gifts*.

4 Cengiz Köseoğlu, *The Topkapı Saray Museum: The Treasury*, tr. and ed. J.M. Rogers (Boston, MA, 1987); A. D. Tushingham and V. B. Meen, *Jawāhirāt-i sulṭānīyi Irān* (Tehran, 1967); Stephen Markel, 'Fit for an Emperor: Inscribed Works of Decorative Art Acquired by the Great Mughals', *Orientations*, 21 (1990), pp. 22–36.

5 al-Qaddūmī, *Book of Gifts*, §378.

6 Ibid., §414.

7 Grabar, 'Imperial and Urban Art in Islam: The Subject Matter of Fāṭimid Art'.

8 al-Maqrīzī, *Khiṭaṭ*, vol. 1, p. 408.

9 Th. Bianquis, 'Ṭalā'i' b. Ruzzik', vol. 10, p. 150.

10 Walker, *Exploring an Islamic Empire*, p. 98.

11 George C. Miles, *Fāṭimid Coins in the Collections of the University Museum, Philadelphia and the American Numismatic Society* (New York, 1951), no. 377.

12 Miles, *Fāṭimid Coins*, no. 476.

13 Ibid., pls v and vi.

14 Andrew S. Ehrenkreutz, 'Arabic Dinars Struck by the Crusaders', *Journal of the Economic and Social History of the Orient*, 7 (1964), pp. 167–82.

15 *Trésors*, no. 209.

16 J. Francez, *Un Pseudo-linceul du Christ* (Paris, 1935).

17 Georges Marçais and Gaston Wiet, 'Le «Voile de Sainte Anne» d'Apt', *Monuments et mémoires publiés par l'Académie des Inscriptions et Belles-Lettres*, 34 (1934), p. 185; Georgette Cornu, 'Les Tissus d'apparat fatimides, parmi les plus somptueux le «voile de Sainte Anne» d'Apt', in Barrucand, ed., *L'Égypte Fatimide*, pp. 331–7.

18 *Tissus d'Égypte*, pp. 225–9, nos 134 and 135.

19 Ibid., p. 247 no. 148.

20 A similar piece was published by Karel Otavsky and Muḥammad 'Abbās Muḥammad Salīm, *Mittelalterliche Textilien I: Ägypten, Persien und Mesopotamien, Spanien und Nordafrika* (Riggisberg, 1995), no. 50.

21 *Tissus d'Égypte*, p. 259, no. 158.

22 E.g. Cairo, Mus. Islam. A., 10836. See 'Islamic art, vi, 2 (i) (a): Fabrics, before c. 1250: Egypt', in Turner, ed., *Dictionary of Art*; *Tissus d'Égypte*, pp. 260ff.

23 al-Maqrīzī, *Khiṭaṭ*, vol. 2, p. 386.

24 Blair and Bloom, *Art and Architecture of Islam*, pp. 52, 196, *et seq.*

25 Al-Maqrīzī, *Khiṭaṭ*, vol. 1, p. 419.

26 Sanders, *Ritual, Politics and the City*, pp. 105–6.

27 Pauty, *Bois sculptés Coptes*, pp. 13–25; Lamm, 'Fatimid Woodwork', pp. 64–8.

28 Pauty, *Bois sculptés Coptes*, p. 25.

29 Lamm, 'Fatimid Woodwork', pp. 65–6.

30 www.touregypt.net/featurestories/barbara.htm

31 Combe, Sauvaget and Wiet, *Répertoire*, no. 2912; Lamm, 'Fatimid Woodwork', p. 78.

32 Jean-Michel Moulton, 'La Présence Chrétienne au Sinaï à l'époque Fatimide', in Barrucand, ed., *L'Égypte Fatimide*, p. 621.

33 Lamm, 'Fatimid Woodwork', pp. 77–8.

34 Combe, Sauvaget and Wiet, *Répertoire*, no. 2913; E. Honigmann (C. E. Bosworth), 'Ṭūr', *EI2*, vol. 10, pp. 663–5.

35 S.M. Stern, *Fāṭimid Decrees: Original Documents from the Fatimid Chancery* (London, 1964), nos. 3–10.

36 Moulton, 'Présence', p. 622.

37 Creswell, *Muslim Architecture of Egypt*, vol. 1, p. 244 and pl. 84e. Sixteen comparable panels, except with paired

38 Ibid., vol. 1, p. 251.

39 Wiet, *Matériaux*, vol. 1, pp. 197–203; Combe, Sauvaget and Wiet, *Répertoire*, vol. 8, pp. 212–13.

40 *Trésors*, no. 91.

41 David-Weill, *Les Bois à épigraphes*, no. 421.

42 Creswell, *Muslim Architecture of Egypt*, vol. 1, pp. 257–8; *Trésors*, p. 150, no. 90.

43 Bloom, 'Woodwork'; Jonathan M. Bloom et al., *The Minbar from the Kutubiyya Mosque* (New York, 1998).

44 Achille Constant Théodore Emile Prisse d'Avennes, *Arabic Art After Monuments of Cairo*, tr. Juanita Steichen (Paris, 2001), pp. 94–101; Edmond Pauty, 'Le Minbar de Qoūs', in *Mélanges Maspero III (Mémoires publiés par les membres de l'Institut Français d'Archéologie Orientale au Caire, LXVIII)* (Cairo, 1940), pp. 41–8; Jean-Claude Garcin, *Un Centre Musulman de la haute-Égypte médiévale: Qūṣ* (Cairo, 1976), p. 87.

45 For the symbolic importance of the backrest, see my discussion of five panels from a minbar made for the Andalusians Mosque in Fez in Dodds, ed., *Al-Andalus*, no. 41, as well as Bloom et al., *Minbar*.

46 Caroline Williams, 'The Qur'anic Inscriptions on the *Tabut* of al-Husayn in Cairo', *Islamic Art*, 2 (1987), pp. 3–14.

47 Sylvia Auld, 'The *Minbar* of al-Aqsa: Form and Function', in Robert Hillenbrand, ed., *Iconography in Islamic Art* (London, 2005), pp. 42–60; Bloom, 'Woodwork', cat. no. 17.

48 Carboni, 'Glass Production'; Ayala Lester, Yael D. Arnon and Rachel Rolak, 'The Fatimid Hoard from Caesarea: A Preliminary Report', in Barrucand, ed., *L'Égypte Fatimide*, pp. 242–5.

49 Oliver Watson, 'Fritware', p. 301.

50 Mason, 'Medieval Egyptian Wares'.

51 Mason, *Shine Like the Sun*, pp. 71–2.

52 Ibid., p. 161.

53 Ibid.

54 Esin Atıl, *Art of the Arab World* (Washington, DC, 1975), no. 18.

55 Mason, *Shine Like the Sun*, pp. 254–5.

56 I thank Dr Robert Mason of the Royal Ontario Museum for sharing information about this bowl.

57 Watson, *Ceramics from Islamic Lands*, p. 285; Esin Atıl, *Islamic Art and Patronage: Treasures from Kuwait* (New York, 1990), p. 120.

58 Grabar, 'Imperial and Urban Art'.

59 J. W. Allan, 'Concave or Convex? The Sources of Jazīran Metalwork in the Thirteenth Century', in Julian Raby, ed., *The Art of Syria and the Jazīra 1100–1250* (Oxford, 1985), pp. 127–40.

60 Allan, 'Concave or Convex', p. 133.

61 Walker, 'Fatimid Institutions', p. 196.

62 E. Lévi-Provençal, 'Un Manuscrit de la bibliothèque du calife al-Ḥakam II', *Hespéris*, 18 (1934), pp. 198–200; Sayyid, 'L'Art du livre'; Blair, *Islamic Calligraphy*, p. 176.

63 For a virtually complete catalogue of the so-called 'Fustat Fragments', see Grube, *Studies in Islamic Painting*, pp. 70–80, 518–19.

64 Sourdel-Thomine and Spuler, *Die Kunst des Islam*, p. 262 and pls XXIVa and b.

65 Grube, *Studies*, pp. 67–8, with full bibliography; Grube and Johns, *The Painted Ceilings of the Cappella Palatina*, p. 29 n. 41 and pp. 31–2 no. 67.

66 Bloom, 'The Introduction of the Muqarnas Into Egypt'.

VII THE LEGACIES OF FATIMID ART

1 G. Wiet, 'al-'Adid li-Dīn Allāh', *EI2*, vol. 1, pp. 196–7.

2 Walker, *Exploring an Islamic Empire*, pp. 84–7.

3 Clifford Edmund Bosworth, *The New Islamic Dynasties: A Chronological and Genealogical Manual* (Edinburgh, 1996), no. 30.

4 Neil D. MacKenzie, *Ayyubid Cairo: A Topographical Study* (Cairo, 1992), p. 30, quoting Casanova.

5 Creswell, *Muslim Architecture of Egypt*, vol. 2, pp. 2–6; Nasser O. Rabbat, *The Citadel of Cairo: A New Interpretation of Royal Mamluk Architecture* (Leiden, 1995), p. 16.

6 Walker, *Exploring*, pp. 89–90; Hampikian and Cyran, 'Recent Discoveries'.

7 Walker, *Exploring*, p. 89.

8 R. J. C. Broadhurst, tr., *A History of the Ayyūbid Sultans of Egypt, Translated from the Arabic of al-Maqrīzī with Introduction and Notes* (Boston, MA, 1980), pp. 39–40.

9 Broadhurst, *Ayyūbid Sultans*, p. 48.

10 A. J. Wensinck et al., 'Miṣr', *EI2*, vol. 7, pp. 146–86.

11 MacKenzie, *Ayyubid Cairo*, p. 18.

12 Ibid., p. 27.

13 Ibid., pp. 30–2.

14 Ibid., pp. 41–5.

15 Ibid., pp. 105–8; Jonathan M. Bloom, 'The Mosque of Baybars al-Bunduqdārī in Cairo', *Annales Islamologiques*, 18 (1982), pp. 45–78.

16 MacKenzie, *Ayyubid Cairo*, pp. 108–29.

17 Gaston Wiet, 'Les inscriptions du mausolée de Shāfi'ī', *Bulletin de l'Institut d'Égypte*, 15 (1933), p. 170 and pl. 1; Combe, Sauvaget and Wiet, *Répertoire chronologique d'épigraphie Arabe*, vol. 9, pp. 95–6; Creswell, *Muslim Architecture of Egypt*, vol. 2, p. 65.

18 Creswell, *Muslim Architecture of Egypt*, pp. 64–76.

19 Berchem, *Matériaux*, vol. 2, p. 225.

20 Creswell, *Muslim Architecture of Egypt*, vol. 2, pp. 80–3 and pl. 28b.

21 Ibid., pp. 88–94 and pls. 30–2.

22 Ibid., pp. 4–103.

23 Christel Kessler, 'Funerary Architecture Within the City', in *Colloque internationale sur l'histoire du Caire*, pp. 257–68.

24 Creswell, *Muslim Architecture of Egypt*, pp. 83–4; MacKenzie, *Ayyubid Cairo*, pp. 112–13.

25 Bloom, 'Mosque of Baybars'.

26 Paula Sanders, 'Bohra Architecture and the Restoration of Fatimid Culture', in Barrucand, ed., *L'Égypte Fatimide*, pp. 159–65; Saifuddin, *al Aqmar*; Saifuddin, *al-Juyushi*.

27 http://www.jameasaifiyah.edu.

28 http://www.alazharpark.com/historical.html.

29 Sanders, 'Bohra Architecture', p. 164.

30 Walker, 'al-Maqrīzī'.

31 Ibid., p. 87.

32 Sabri Jarrar, 'al-Maqrizi's Reinvention of Egyptian Historiography through Architectural History', in Doris Behrens-Abouseif, *The Cairo Heritage: Essays in Honor of Laila Ali Ibrahim* (Cairo, 2000), pp. 31–54.

33 Abd al-Ra'uf Ali Yusuf, 'Egyptian Lustre-Painted Pottery from the Ayyubid and Mamluk Periods', in Behrens-Abouseif, *The Cairo Heritage*, pp. 263–74.

34 Mason, *Shine Like the Sun*, Chs 5, 6.

35 Anabelle Collinet, 'Le Métal Ayyoubide', in *L'Orient de Saladin: l'art des Ayyoubides* (Paris, 2001), pp. 127–30.

36 Allan, 'Concave or Convex?'.

37 Eva Baer, *Ayyubid Metalwork with Christian Images* (Leiden, 1989).

38 James W. Allan, '"My Father is a Sun and I Am the Star": Fatimid Symbols in Ayyubid and Mamluk Metalwork', *Journal of the David Collection*, 1 (2003), pp. 25–47.

39 The Ismaili Centre on Cromwell Road in London is, however, full of seven-pointed stars, including a seven-sided pool.

40 Necipoğlu, *The Topkapi Scroll*, Ch. 6. But see George Saliba's trenchant review, 'Artisans and Mathematicians in Medieval Islam', *Journal of the American Oriental Society*, 119 (1999), pp. 637–45.

41 Cécile Bresc, 'Les Monnaies des Ayyoubides', in *L'Orient de Saladin, l'art des Ayyoubides* (Paris, 2001).

42 Carboni and Whitehouse, *Glass of the Sultans*, cat. no. 109.

43 *L'Orient de Saladin*, no. 198.

44 *The Treasury of San Marco Venice* (New York, 1984), no. 21; David Whitehouse, 'Byzantine Gilded Glass', in Rachel Ward, ed., *Gilded and Enamelled Glass from the Middle East: Origins, Innovations* (London, 1998), pp. 4–7; Carboni and Whitehouse, *Glass*, pp. 204–5.

45 *Tissus d'Égypte*, nos. 178–80, *L'Orient de Saladin*, nos. 45–50.

46 Serjeant, *Islamic Textiles*, pp. 146–7.

47 Ibid., p. 152.

48 Otavsky and Salīm, *Mittelalterliche Textilien*, pp. 141–3, no. 83; *L'Orient de Saladin*, no. 45.

49 See, for example, the (Syrian and Mesopotamian) manuscripts included in *L'Orient de Saladin*, nos. 215–19.

50 Bloom, *Paper Before Print*, pp. 178ff.

51 Brett, *Rise*, p. 353.

52 H. R. Idris, 'Hilāl', *EI2*, vol. 3, pp. 385–7; Michael Brett, 'The Way of the Nomad', *Bulletin of the School of Oriental and African Studies*, 58 (1995), pp. 251–69.

53 Bosworth, *New Islamic Dynasties*, nos. 5, 6 and 13; M. Talbi, 'al-Mahdiyya', *EI2*, vol. 5, pp. 1246–7.

54 Idris, 'Hilāl'.

55 The traditional view is found in M. Talbi, 'Ifrīkiya', *EI2*, vol. 3, pp. 1047–50. A more nuanced view is provided by Brett, 'Nomad'.

56 Ettinghausen, Grabar and Jenkins-Madina, *Islamic Art and Architecture*, p. 69; O. Bobin et al., 'Lustre Tiles'.

57 B. Roy and P. Poinssot, *Inscriptions Arabes de Kairouan* (Paris, 1950–8), no. 6; Paul Sebag, *The Great Mosque of Kairouan*, tr. Richard Howard (New York, 1965), p. 105; Ettinghausen, Grabar and Jenkins-Madina, *Islamic Art and Architecture*, p. 274.

58 B. Roy stated that the presence of the name of the secretary Abu'l-Qasim in the inscription means it cannot be later than the Hilalian invasion of Ifriqiya in 1050–5. See Roy and Poinssot, *Inscriptions Arabes de Kairouan*, p. 21.

59 Francesco Gabrieli et al., *Maghreb médiéval: l'apogée de la civilisation Islamique dans l'occident Arabe*, tr. Marguerite Pozzoli (Aix-en-Provence, 1991), p. 258.

60 Dodds, ed., *Al-Andalus*, no. 41.

61 Georges Marçais, *Coupoles et plafonds de la Grande Mosquée de Kairouan* (Tunis, 1925) Sebag, *Kairouan*, pp. 50–1; Ettinghausen, Grabar and Jenkins-Madina, *Islamic Art and Architecture*, pp. 245–7 and fig. 450.

62 Sheila S. Blair and Jonathan M. Bloom, *Cosmophilia: Islamic Art from the David Collection, Copenhagen* (Chestnut Hill, MA, 2006), no. 94.

63 Roy and Poinssot, *Inscriptions Arabes de Kairouan*, nos 9b, 9c; Blair, *Islamic Calligraphy*, pp. 155–6; Fraser and Kwiatkowski, *Ink and Gold*, no. 15.

64 Marçais and Poinssot, *Objets Kairouanais*, vol. 2, pp. 411–33.

65 Ibid., vol. 2, p. 424.

66 Roy and Poinssot, *Inscriptions Arabes de Kairouan*, no. 42.

67 Golvin, *Recherches archéologiques*; Bourouiba, *La Qal'a des Bani Hammad*; L. Golvin, 'Ḳalat Banī Ḥammād', *EI2*, vol. 4, pp. 478–81.

68 L. Golvin, 'Les Plafonds a muqarnas de la Qal'a des Banū Ḥammād et leur influence possible sur l'art de la Sicile a la période Normande', *Revue de l'occident Musulman et de la Méditerranée*, 17 (1974), p. 64.

69 Ruggles, *Gardens, Landscape and Vision*, p. 162.

70 Ettinghausen, Grabar and Jenkins-Madina, *Islamic Art and Architecture*, fig. 451.

71 U. Rizzitano, 'Kalbids', *EI2*, vol. 4, pp. 496–7; R. Traini, 'Ṣiḳilliya', *EI2*, vol. 9, pp. 582–9.

72 Barry Unsworth has recently painted an evocative portrait of this period in his novel *The Ruby in Her Navel: A Novel of Love and Intrigue in the Twelfth Century* (New York, 2006).

73 Jeremy Johns, 'The Norman Kings of Sicily and the Fatimid Caliphate', in Marjorie Chibnall, ed., 'Proceedings of the Battle Conference and of the XI Colloquio medievale of the Officina di Studi Medievali 1992', *Anglo-Norman Studies*, 15 (1993), pp. 133–59.

74 Johns, *Arabic Administration in Norman Sicily: The Royal Dīwān* (Cambridge, 2002), p. 265.

75 Giuseppe Bellafiore, *Architettura delle età islamica e normanni in Sicilia* (Palermo, 1990); William Tronzo, *The Cultures of His Kingdom: Roger II and the Cappella Palatina in Palermo* (Princeton, 1997).

76 Sibylle Mazot, 'L'Architecture d'influence nord-Africaine à Palerme', in Barrucand, ed., *L'Égypte Fatimide*, p. 666.

77 Mazot, 'L'Architecture', p. 667.

78 Johns, *Arabic Administration*, p. 266, Grube and Johns, *The Painted Ceilings of the Cappella Palatina*.

79 Henri Terrasse, *La Mosquée al-Qaraouiyin à Fès* (Paris, 1968), pl. 28.

80 Jonathan M. Bloom, 'Almoravid Geometrical Designs in the Pavement of the Cappella Palatina in Palermo', in Bernard O'Kane, *The Iconography of Islamic Art: Studies in Honour of Robert Hillenbrand* (Edinburgh, 2005), pp. 61–80.

81 For the Fatimid connections, see Tronzo, *Cultures*, pp. 142–3. For selection of contemporary textiles from the Iberian peninsula, see Dodds, *Al-Andalus*.

82 For the Spanish attribution, see Dodds, *Al-Andalus*, no. 15; for the North African attribution, see Ettinghausen, Grabar and Jenkins-Madina, *Islamic Art and Architecture*, p. 210. The Iranian attribution, which has not been widely accepted, was proposed by A.S. Melikian-Chirvani, 'Le Griffon Iranien de Pise: matériaux pour un corpus de l'argenterie et du bronze Iraniens, III', *Kunst des Orients*, 5 (1968), pp. 68–86.

83 Johns, *Arabic Administration*, p. 267; Francesco Gabrieli and Umberto Scerrato, *Gli Arabi in Italia: Cultura, Contatti e Tradizioni* (Milan, 1979; repr., 1989), figs. 114–16 and 197–8.

84 Creswell, *Muslim Architecture of Egypt*, pls 92a–c.

85 Gabrieli and Scerrato, *Arabi*, fig. 197.

86 Gabrieli and Scerrato, *Arabi*, fig. 196; Bloom, *Minbar*.

87 R. Traini, 'Ṣiḳilliya', *EI2*, vol. 9, pp. 582–9.

88 He was born at Denia and probably studied at Seville before making his way to the Fatimid court in Egypt, where he worked for al-Afdal. He eventually fell out of favour and returned to Spain via al-Mahdiyya, where he was so well received that he remained there for the rest of his life. He is reported to have played the lute very well and introduced Andalusi music into Tunisia. Mercè Comes, 'Umayya b. 'Abd al-'Aziz, Abu'l-Ṣalt', *EI2*, vol. 10, pp. 836–7.

89 Bloom, 'Geometrical Designs'.

90 Alexander P. Kashdan, ed., *The Oxford Dictionary of Byzantium* (New York, 1991), p. 780, s.v. 'Fatimids'.

91 Canard, 'Le Cérémonial Fatimide'; Sanders, *Ritual, Politics and the City*; Priscilla Soucek, 'Byzantium and the Islamic East', in Helen C. Evans and William D. Wixom, eds, *The Glory of Byzantium: Art and Culture of the Middle Byzantine Era A. D. 843–1261* (New York, 1997), p. 407.

92 Anthony Cutler, 'The Parallel Universes of Arab and Byzantine Art (with Special Reference to the Fatimid Era)', in Barrucand, ed., *L'Égypte Fatimide*, pp. 635–48.

93 Goitein, *A Mediterranean Society*, vol. 1, pp. 42ff, Michel Balard, 'Notes sur le commerce entre l'Italie et l'Égypt sous les Fatimides', in Barrucand, ed., *L'Égypte Fatimide*, pp. 628–33, Deborah Howard, *Venice and the East* (New Haven and London, 2000); Rosamond E. Mack, *Bazaar to Piazza: Islamic Trade and Italian Art, 1300–1600* (Berkeley, Los Angeles and London, 2002).

94 Cristina Tonghini, 'Fatimid Ceramics from Italy: The Archaeological Evidence', in Barrucand, ed., *L'Égypte Fatimide*, pp. 286–97.

95 Mason, *Shine Like the Sun*, p. 85, compare Fustat Lustre-painted Group Three with PSA 03.

96 Gabrieli and Scerrato, *Arabi*, pp. 382–3; Tonghini, 'Fatimid Ceramics', p. 289.

97 Shalem, *Islam Christianized*, pp. 146–7.

98 Marçais and Wiet, 'Le «Voile de Sainte Anne»'; Georgette Cornu, 'Les Tissus d'apparat Fatimides, parmi les plus somptueux le «voile de Sainte Anne» d'Apt', in Barrucand, ed., *L'Égypte Fatimide*, pp. 331–7.

99 Shalem, *Islam Christianized*, pp. 73–4.

100 Carole Hillenbrand, *The Crusades: Islamic Perspectives* (Edinburgh, 1999), p. 65.

101 Shalem, *Islam Christianized*, p. 75.

102 Al-Qaddūmī, *Book of Gifts*, p. 230.

103 Al-Maqrīzī, *Khiṭaṭ*, vol. 1, p. 414.

104 Shalem, *Islam Christianized*, pp. 60–1. But see Chapter 4, n. 71 above, where I recalculate the volume the ewer could hold.

105 Blaise de Montesquiou-Fezensac and Danielle Gaborit-Chopin, *Le Trésor de Saint-Denis* (Paris, 1977), pp. 44–5 and pls 26–7. There are beautiful photographs of the ewer at http://www.insecula.com/oeuvre/O0002615.html.

106 Johns, *Arabic Administration*, pp. 266–7, n. 48.

107 Shalem, *Islam Christianized*, pp. 61–2.

108 Ibid., pp. 76–8.

109 Ibid., p. 47.

110 Stephen Vernoit, 'Islamic Art and Architecture: An Overview of Scholarship and Collecting, c. 1850-c. 1950', in Stephen Vernoit, *Discovering Islamic Art* (London, 2000), pp. 1–61.

111 *Description de l'Égypte, publiée par les ordres de Napoléon Bonaparte* (Köln, 1994): Mosque of al-Hakim (called 'an old mosque near Bab al-Nasr') (EM I, pls 28 and 27, 1 and 2), Bab al-Nasr (EM I, pl. 46) and Bab al-Futuh (pl. 47); inscription at Nilometre by al-Mustansir (EM II, pl. b); Fatimid coins (EM II, pl. k) as well as some views of Fatimid buildings at Aswan, Isna and Luxor.

112 Prisse d'Avennes, *Arabic Art After Monuments of Cairo*.

113 At the first meeting, M. Franz Bey gave a report to the committee about the condition of the Bab-el-Metwalli (Bab Zuwayla). The reports of the Comité are available at http://www.islamic-art.org. Paula Sanders is preparing a monograph on restoration activities in nineteenth-century Cairo. In anticipation of her book, see the various essays in Alsayyad, Bierman and Rabbat, *Making Cairo Medieval*.

114 Al-Maqrīzī, *Khiṭaṭ*; al-Maqrīzī, *Description topographique et historique de l'Égypte*, tr. U. Bouriant and P. Casanova (Paris and Cairo, 1895–1900).

115 Nāṣir-i Khusraw, *Sefer Nameh*, ed. Schefer.

116 Lane-Poole, *Art of the Saracens*, pp. 163–4.

117 Ibid., p. 121, ns 123–6.

118 Ibid., pp. 232–4.

119 Ibid., p. 241.

120 Van Berchem, 'Une Mosquée de temps des Fatimites'.

121 Max van Berchem, 'Notes d'archéologie Arabe: monuments et inscriptions Fatimites', *Journal Asiatique*, 17 (1891), pp. 411–95; Max van Berchem, 'Notes d'archéologie Arabe II: monuments et inscriptions Fatimites', *Journal Asiatique*, 18 (1891), pp. 46–86; Max van Berchem, 'Notes d'archéologie Arabe: monuments et inscriptions Fatimites', *Journal Asiatique*, 18 (1891), pp. 46–86; Max van Berchem, 'Notes d'archéologie Arabe: monuments et inscriptions Fatimites', *Journal Asiatique*, 19 (1892), pp. 377–406; van Berchem, *Matériaux pour un corpus inscriptionum Arabicarum I: Egypte 1*.

122 Creswell, *Muslim Architecture of Egypt*.

123 *Abḥāth al-nadwat al-dawliyya li-tārīkh al-Qāhira* (Cairo, 1970); Andrée Assabgui et al., *Colloque internationale sur l'histoire du Caire* (Gräfenheinichen, 1972).

124 *Trésors*; Seipel, ed., *Schätze*; Barrucand, ed., *L'Égypte Fatimide*.

Bibliography

'Abd al-Wahhāb, Ḥasan Ḥusnī. *Mujmal tārīkh al-adab al-Tūnisī min fajr al-fatḥ al- 'arabī li-Ifriqiya ilā al- 'aṣr al-hāḍir*. Tunis, 1968.

Abḥāth al-nadwat al-dawliyya li-tārīkh al-Qāhira. Cairo, 1970.

Abu-Lughod, Janet L. *Cairo: 1001 Years of the City Victorious*. Princeton, NJ, 1971.

Allan, James W. 'Concave or Convex? The Sources of Jazīran Metalwork in the Thirteenth Century', in Julian Raby, ed., *The Art of Syria and the Jazīra 1100–1250*. Oxford, 1985, pp. 127–40.

——. '"My Father is a Sun and I am the Star"': Fatimid Symbols in Ayyubid and Mamluk Metalwork', *Journal of the David Collection*, 1 (2003), pp. 25–47.

Allen, Terry. *Ayyubid Architecture*. Electronic publication on the internet. Occidental, CA, 1996. www.sonic.net/~tallen/palmtree/ayyarch.

Alsayyad, Nezar, Irene A. Bierman and Nasser Rabbat. *Making Cairo Medieval*. Lanham, 2005.

Amin, M. M. and Laila A. Ibrahim. *Architectural Terms in Mamluk Documents (648–923H) (1250–1517) (al-Muṣṭalaḥāt al-mi'māriyya fī-al-wathā'iq al-mamlūkiyya)*. Cairo, 1990.

Anglade, Elise. *Catalogue des boiseries de la section islamique, Musée du Louvre*. Paris, 1988.

Arberry, Arthur J. *The Koran Illuminated: A Handlist of Korans in the Chester Beatty Library*. Dublin, 1967.

Arnold, T. W. *Painting in Islam*. Oxford, 1928.

The Art of Medieval Spain A.D. 500–1200. New York, 1993.

The Arts of Islam. London, 1976.

Assabgui, Andrée, Ahmed Beheiry, Evine Hashem, Magdi Wahba and Nadia Younes, eds, *Colloque internationale sur l'histoire du Caire*. Gräfenheinichen, 1972.

Atıl, Esin. *Art of the Arab World*. Washington, DC, 1975.

——. *Islamic Art and Patronage: Treasures from Kuwait*. New York, 1990.

Auld, Sylvia. 'The *Minbar* of al-Aqsa: Form and Function', in Robert Hillenbrand, ed., *Iconography in Islamic Art*. London, 2005.

Auld, Sylvia and Robert Hillenbrand, eds, *Ottoman Jerusalem, the Living City: 1517–1917*. London, 2000.

Baer, Eva. *Ayyubid Metalwork with Christian Images*. Leiden, 1989.

——. 'Fatimid Art at the Crossroads: A Turning Point in the Artistic Concept of Islam?', in Barrucand, ed., *L'Égypte Fatimide*, pp. 386–94.

——. *Metalwork in Medieval Islamic Art*. Albany, NY, 1983.

Baker, Patricia L. *Islamic Textiles*. London, 1995.

Balard, Michel. 'Notes sur le commerce entre l'Italie et l'Égypt sous les Fatimides', in Barrucand, ed., *L'Égypte Fatimide*, pp. 628–33.

Barrucand, Marianne, ed. *L'Égypte Fatimide: son art et son histoire*. Actes du colloque organisé à Paris les 28, 29 et 30 mai 1998. Paris, 1999.

——. 'Les chapiteaux de remploi de la mosquée al-Azhar et l'émergence d'un type de chapiteau médiévale en Égypte', *Annales Islamologiques*, 36 (2002), pp. 37–75.

al-Bāshā, Ḥasan Maḥmūd Ḥasan. 'Tabaq min al-khazaf bi-ism Ghabn mawla al-Ḥakim bi-Amr Allah (A ceramic dish with the name of Ghabn, client of al-Hakim)', *Bulletin of the Faculty of Arts, Cairo University*, 18 (1965), pp. 71–85.

Behrens-Abouseif, Doris. 'The Façade of the Aqmar Mosque in the Context of Fatimid Ceremonial', *Muqarnas*, 9 (1992), pp. 29–38.

——. *Islamic Architecture in Cairo, an Introduction*. Supplements to *Muqarnas*. Leiden, 1989.

——. *The Minarets of Cairo*. Cairo, 1985.

El-Bekri, Abou-Obeïd. *Description de l'Afrique sept-entrionale*, tr. MacGuckin de Slane. Paris, 1911–13; repr. 1965.

Bellafiore, Giuseppe. *Architettura delle età islamica e normanni in Sicilia.* Palermo, 1990.

Berchem, Marguerite van. 'Le Palais de Sedrata dans le désert Saharien', in *Studies in Islamic Art and Architecture in Honour of Professor K. A. C. Creswell.* Cairo, 1965, pp. 8–29.

Berchem, Max van. 'La Chaire de la Mosquée d'Hébron et le martyrion de la tête de Husain à Ascalon', in *Festschrift Eduard Sachau.* Berlin, 1915, pp. 298–310.

——. *Matériaux pour un Corpus Inscriptionum Arabicarum I: Égypte 1.* Cairo, 1894–1903.

——. *Matériaux pour un Corpus Inscriptionum Arabicarum II: Syrie du Sud: Jerusalem.* Cairo, 1920–7.

——. 'Une mosquée de temps des fatimites au Caire: Notice sur le Gâmi' el Goyûshi', *Mémoires de l'Institut Égyptien*, 2 (1889), pp. 605–19.

——. 'Notes d'archéologie Arabe: monuments et inscriptions Fatimites (1)', *Journal Asiatique*, 17 (1891), pp. 411–95.

——. 'Notes d'archéologie Arabe (1): monuments et inscriptions Fatimites (suite)', *Journal Asiatique*, 18 (1891), pp. 46–86.

——. 'Notes d'archéologie Arabe (II): monuments et inscriptions Fatimites', *Journal Asiatique*, 19 (1892), pp. 377–407.

Bernus, M., H. Marchal and G. Vial. 'Le Suaire de Saint-Josse', *Bulletin de liaison du centre international d'études des textiles anciens*, 33 (1971), pp. 1–57.

Bianquis, Thierry. 'Autonomous Egypt from Ibn Ṭūlūn to Kāfūr, 868–969', in Carl Petry, ed., *The Cambridge History of Egypt, I: Islamic Egypt 640–1517.* Cambridge, 1998, pp. 86–119.

——. *Damas et la Syrie sous la domination Fatimide 359–468 H/969–1076, essai d'interprétation de chroniques Arabes médiévales.* Damascus, 1986–9.

——. 'La prise de pouvoir par les Fatimides en Égypte', *Annales Islamologiques*, 11 (1972), pp. 49–108.

Bierman, Irene A. 'Art and Architecture in the Medieval Period', in Petry, ed., *The Cambridge History of Egypt*, vol. 1, pp. 339–74.

——. 'Inscribing the City: Fatimid Cairo', in *Islamische Textilkunst des Mittelalters: Aktuelle Probleme. Riggisberger Berichte*, 5 (1997). Riggisberg, 1997, pp. 105–14.

——. *Writing Signs: The Fatimid Public Text.* Berkeley, CA, 1998.

Blair, Sheila S. 'Decoration of City Walls in the Medieval Islamic World: The Epigraphic Message', in James D. Tracy, ed., *City Walls in Early Modern History.* Cambridge, 2000, pp. 488–529.

——. 'Floriated Kufic and the Fatimids', in Barrucand, ed., *L'Égypte Fatimide*, pp. 107–16.

——. *Islamic Calligraphy.* Edinburgh, 2006.

——. *The Monumental Inscriptions from Early Islamic Iran and Transoxiana.* Supplements to *Muqarnas.* Leiden, 1992.

——. 'What is the Date of the Dome of the Rock?', in Julian Raby and Jeremy Johns, eds, *Bayt al-Maqdis: 'Abd al-Malik's Jerusalem, Part One.* Oxford, 1992, pp. 59–88.

Blair, Sheila S. and Jonathan M. Bloom. *The Art and Architecture of Islam, 1250–1800.* London and New Haven, CT, 1994.

——. *Cosmophilia: Islamic Art from the David Collection, Copenhagen.* Chestnut Hill, MA, 2006.

Blair, Sheila S., Jonathan M. Bloom and Anne E. Wardwell. 'Reevaluating the Date of the "Buyid" Silks by Epigraphic and Radiocarbon Analysis', *Ars Orientalis*, 22 (1992), pp. 1–42.

Blake, Hugh, Antony Hutt and David Whitehouse. 'Ajdabiyah and the Earliest Fatimid Architecture', *Society for Libyan Studies, Annual Report*, 2 (1971), pp. 9–10.

Bloom, Jonathan M. 'Almoravid Geometrical Designs in the Pavement of the Cappella Palatina in Palermo', in Bernard O'Kane, ed., *The Iconography of Islamic Art: Studies in Honour of Robert Hillenbrand.* Edinburgh, 2005, pp. 61–80.

——. 'The Blue Koran: An Early Fatimid Kufic Manuscript from the Maghrib', in François Déroche, ed., *Les Manuscrits du moyen-orient: essais de codicologie et paléographie.* Istanbul and Paris, 1989, pp. 95–9.

——. 'The Early Fatimid Blue Koran Manuscript', *Graeco-Arabica*, 4 (1991), pp. 171–8.

——. 'Fact and Fantasy in Buyid Art', in Barbara Finster, Christa Fragner and Herta Hafenrichter, eds. *Kunst und Kunsthandwerke im Frühen Islam, 2. Bamberger Symposium der Islamischen Kunst 25.–27. July 1996, Oriente Moderno*, NS, 22 (2004).

——. 'The Fatimids (909–1171): Their Ideology and their Art', in *Islamische Textilkunst des Mittelalters: Aktuelle Probleme. Riggisberger Berichte*, 5 (1997). Riggisberg, 1997, pp. 15–26.

——. 'Five Fatimid Minarets in Upper Egypt', *Journal of the Society of Architectural Historians*, 43 (1984), pp. 162–7.

——. 'The Introduction of the Muqarnas Into Egypt', *Muqarnas*, 5 (1988), pp. 21–8.

——. 'Jerusalem in Medieval Islamic Literature', in Nitza Rosovsky, ed., *City of the Great King: Jerusalem from David to the Present.* Cambridge, MA, 1996, pp. 205–17.

——. 'Al-Ma'mun's Blue Koran?', *Revue des études Islamiques*, 54 (1986), pp. 61–5.

——. 'Meaning in Early Fatimid Architecture: Islamic Art in North Africa and Egypt in the Fourth Century A. H. (Tenth Century A. D.)'. Ph. D. dissertation, Harvard University, 1980.

——. *Minaret: Symbol of Islam.* Oxford, 1989.

——. 'The Mosque of al-Hakim in Cairo', *Muqarnas*, 1 (1983), pp. 15–36.

——. 'The Mosque of Baybars al-Bunduqdārī in Cairo', *Annales Islamologiques*, 18 (1982), pp. 45–78.

——. 'The Mosque of the Qarafa in Cairo', *Muqarnas*, 4 (1987), pp. 7–20.

——. 'The Origins of Fatimid Art', *Muqarnas*, 3 (1985), pp. 20–38.

——. *Paper Before Print: The History and Impact of Paper in the Islamic World.* New Haven, CT, 2001.

——. 'Walled Cities in Islamic North Africa and Egypt with Particular Reference to the Fatimids (909–1171)', in James D. Tracy, ed., *City Walls: The Urban Enceinte in Global Perspective.* Cambridge, 2000, vol. 4, pp. 219–46.

'——. 'Woodwork in Syria, Palestine, and Egypt During the Twelfth and Thirteenth Centuries', in Sylvia Auld and Robert Hillenbrand, eds, *Ayyubid Jerusalem.* London, forthcoming.

Bloom, Jonathan M., Ahmed Toufiq, Stefano Carboni, Jack Soultanian, Antoine M. Wilmering, Mark D. Minor, Andrew Zawacki and El Mostafa Hbibi. *The Minbar from the Kutubiyya Mosque.* New York, 1998.

Bobin, O., M. Schvoerer, C. Ney, M. Rammah, A. Daoulatli, B. Pannequin and R. P. Gayraud. 'Where Did the Lustre Tiles of the Sidi Oqba Mosque (AD 836–63) in Kairouan Come From?', *Archaeometry*, 45 (2003), pp. 569–77.

Bosch, Gulnar, John Carswell and Guy Petherbridge. *Islamic Bindings and Bookmaking.* Chicago, 1981.

Bosworth, Clifford Edmund. *The New Islamic Dynasties: A Chronological and Genealogical Manual.* Edinburgh, 1996.

Bourouiba, Rached. *La Qal'a des Bani Hammad.* Algiers, 1975.

Bresc, Cécile. 'Les Monnaies des Ayyoubides', in *L'Orient de Saladin*, pp. 31–44.

Brett, Michael. *The Rise of the Fatimids: The World of the Mediterranean and the Middle East in the Fourth Century fo the Higra, Tenth Century CE.* Leiden, 2001.

——. 'The Way of the Nomad', *Bulletin of the School of Oriental and African Studies*, 58 (1995), pp. 251–69.

Brett, Michael and Elizabeth Fentress. *The Berbers.* Oxford, 1996.

Briggs, Martin S. *Muhammadan Architecture in Egypt and Palestine.* 1924, repr., New York, 1974.

Broadhurst, R. J. C., tr. *A History of the Ayyūbid Sultans of Egypt, Translated from the Arabic of al-Maqrīzī with Introduction and Notes.* Boston, MA, 1980.

Caiger-Smith, Alan. *Lustre Pottery: Technique, Tradition and Innovation in Islam and the Western World.* London, 1985.

Canard, Marius. 'Le Cérémonial Fatimide et le cérémonial Byzantin: essai de comparaison', *Byzantion*, 21 (1951), pp. 355–420.

——. 'L'Imperialisme des Fatimides et leur propagande', *Annales de l'Institut d'Etudes Orientales*, 6 (1942–7), pp. 156–93.

——. 'La Procession du nouvel an ches les Fatimides', *Annales de l'Institut d'Etudes Orientales*, 10 (1952), pp. 364–95.

Carboni, Stefano. 'Glass Production in the Fatimid Lands and Beyond', in Barrucand, ed., *L'Égypte Fatimide*, pp. 169–78.

Carboni, Stefano and David Whitehouse. *Glass of the Sultans.* New York, 2001.

Collinet, Anabelle. 'Le Métal Ayyoubide', in *L'Orient de Saladin*, pp. 127–30.

Combe, Etienne. 'Tissus Fatimides du Musée Benaki', *Mémoires de l'Institut Français d'Archéologie Orientale au Caire*, 68 (1935), pp. 259–72.

Combe, Étienne, Jean Sauvaget and Gaston Wiet. *Répertoire chronologique d'épigraphie arabe.* Cairo, 1931.

Contadini, Anna. *Fatimid Art at the Victoria and Albert Museum.* London, 1998.

——. 'Fatimid Ivories within a Mediterranean Context', *Journal of the David Collection*, 2 (2004), pp. 227–47.

Contadini, Anna, Richard Camber and Peter Northover. 'Beasts That Roared: The Pisa Griffin and the New York Lion', in Warwick Ball and Leonard Harrow, eds, *Cairo to Kabul: Aftghan and Islamic Studies Presented to Ralph Pinder-Wilson.* London, 2002, pp. 65–83.

Cornu, Georgette. 'Les Tissus d'apparat Fatimides, parmi les plus somptueux le «voile de Sainte Anne» d'Apt', in Barrucand, ed., *L'Égypte Fatimide*, pp. 331–7.

Cortese, Delia and Simonetta Calderini. *Women and the Fatimids in the World of Islam.* Edinburgh, 2006.

Creswell, K.A.C. *Early Muslim Architecture*, vol. 1. 2nd ed., Oxford, 1969.

——. *Early Muslim Architecture*, vol. 2. Oxford, 1940.

——. *The Muslim Architecture of Egypt.* Oxford, 1952–9.

Curatola, Giovanni. *Eredità dell'Islam.* Venice, 1993.

Cutler, Anthony. *The Craft of Ivory: Sources, Techniques, and Uses in the Mediterranean World: A.D. 200–1400.* Washington, DC, 1985.

——. *The Hand of the Master: Craftsmanship, Ivory and Society in Byzantium (Ninth-Eleventh Centuries).* Princeton, NJ, 1994.

——. 'The Parallel Universes of Arab and Byzantine Art (with Special Reference to the Fatimid Era)', in Barrucand, ed., *L'Égypte Fatimide*, pp. 635–48.

Daftary, Farhad. *The Ismā'īlīs: Their History and Doctrines.* Cambridge, 1990; second edition 2007.

——. *A Short History of the Ismailis: Traditions of a Muslim Community.* Edinburgh, 1998.

David-Weill, J. *Les Bois à épigraphes jusqu'à l'époque Mamlouke.* Cairo, 1931.

De Carthage à Kairouan: 2000 ans d'art et d'histoire en Tunisie. Paris, 1982.

Description de l'Égypte, publiée par les ordres de Napoléon Bonaparte, part. repr. Cologne, 1994.

Déroche, François. *The Abbasid Tradition: Qur'ans of the Eighth to the Tenth Centuries AD*, vol. 1 of Julian Raby, ed., *The Nasser D. Khalili Collection of Islamic Art*. London, 1992.

Dodds, Jerrilynn D., ed. *Al-Andalus: The Art of Islamic Spain*. New York, 1992.

Doorninck, Frederick H. van. 'The Serçe Limanı Shipwreck: An Eleventh-Century Cargo of Fatimid Glassware Cullet for Byzantine Glassmakers', in *I. Uluslararasi Anadolu Cam Sanati Sempozyumu, 26–27 Nisan 1988/First International Anatolian Glass Symposium, April 26th–27th, 1988*. Istanbul, 1990, pp. 58–63.

Eche, Youssef. *Les Bibliothèques arabes publiques et semi-publiques en Mésopotamie, en Syrie et en Égypte au moyen age*. Damascus, 1967.

Ehrenkreutz, Andrew S. 'Arabic Dinars Struck by the Crusaders', *Journal of the Economic and Social History of the Orient*, 7 (1964), pp. 167–82.

The Encyclopaedia of Islam, New Edition, ed. H. A. R. Gibb et al. Leiden, 1960–2004.

Ettinghausen, Richard. 'Painting in the Fatimid Period: A Reconstruction', *Ars Islamica*, 9 (1942), pp. 112–24.

Ettinghausen, Richard, Oleg Grabar and Marilyn Jenkins-Madina. *Islamic Art and Architecture 650–1250*. New Haven and London, 2001.

Falk, Toby, ed. *Treasures of Islam*. London, 1985.

Fehérvári, Geza. *Islamic Metalwork of the Eighth Century to the Fifteenth Century in the Keir Collection*. London, 1976.

Ferrugia de Candia, J. 'Monnaies Fatimites du Musée du Bardo', *Revue Tunisienne*, NS, 7 (1936), pp. 333–71.

Finster, Barbara. 'On Masjid al-Juyūshī on the Muqaṭṭam', *Archéologie Islamique*, 10 (2000), pp. 65–78.

Flury, Samuel. *Die Ornamente der Hakim- Under Ashar-Moschee*. Heidelburg, 1912.

Foote, Rebecca M. 'Abbasid Qasr (F103) and the Carved Ivory Panels', *Annual of the Department of Antiquities of Jordan*, 47 (2003), pp. 55–64.

Foy, Danièle. 'Lampes de verre Fatimides à Fostat: le mobilier des fouilles de Istabl Antar', in Barrucand, ed., *L'Égypte Fatimide*, pp. 179–96.

Francez, J. *Un Pseudo-linceul du Christ*. Paris, 1935.

Fraser, Marcus and Will Kwiatkowski. *Ink and Gold: Islamic Calligraphy*. Berlin and London, 2006.

Fratadocchi, Tommaso Breccia. 'Notes on Armenian Military Architecture', *A.A.R.P Environmental Design: Journal of the Islamic Environmental Design Research Centre*, 1–2 (1999), pp. 66–71.

Gabrieli, Francesco, Gioia Chiauzzi, Clelia Sarnelli Cerqua, Lucien Golvin and Pierre Guichard. *Maghreb médiéval: l'apogée de la civilisation islamique dans l'occident arabe*, tr. Marguerite Pozzoli. Aix-en-Provence, 1991.

Gabrieli, Francesco and Umberto Scerrato. *Gli Arabi in Italia: Cultura, Contatti e Tradizioni*. Milan, 1979.

Garcin, Jean Claude. *Un Centre Musulman de la haute-Égypte médiévale: Qūṣ*. Cairo, 1976.

——. 'Remarques sur un plan topographique de la grande mosquée du Qûṣ', *Annales Islamologiques*, 9 (1970), pp. 97–108.

Gayraud, Roland-Pierre. 'La Nécropole des Fatimides à Fostat', *Dossiers d'archéologie*, 233 (1998), pp. 34–41.

——. 'Le Qarāfa al-Kubrā, dernière demeure des Fatimids', in Barrucand, ed., *L'Égypte Fatimide*, pp. 443–64.

Goitein, S. D. F. 'The Main Industries of the Mediterranean Area as Reflected in the Record of the Cairo Geniza', *Journal of the Economic and Social History of the Orient*, 4 (1961), pp. 168–97.

——. *A Mediterranean Society*. Berkeley and Los Angeles, CA, 1967–94.

——. *Studies in Islamic History and Institutions*. Leiden, 1966.

Golvin, Lucien. *Essai sur l'architecture religieuse musulmane*. Paris, 1970.

——. 'Le Palais de Zîrî à Achîr (Dixième siècle J. C.)', *Ars Orientalis*, 6 (1966), pp. 47–76.

——. 'Les Plafonds à muqarnas de la Qal'a des Banū Ḥammād et leur influence possible sur l'art de la Sicile a la période normànde', *Revue de l'occident Musulman et de la Méditerranée*, 17 (1974), pp. 63–9.

——. *Recherches archéologiques à la Qal'a des Banû Hammâd*. Paris, 1965.

Gonzalez, Valérie. 'Pratique d'une technique d'art Byzantine chez les Fatimides: l'émaillerie sur métal', in Barrucand, ed., *L'Égypte Fatimide*, pp. 197–217.

Grabar, Oleg. *The Alhambra*. Cambridge, MA, 1978.

——. 'The Earliest Islamic Commemorative Structures', *Ars Orientalis*, 6 (1966), pp. 7–46.

——. 'Imperial and Urban Art in Islam: The Subject Matter of Fāṭimid Art', in *Colloque Internationale sur l'histoire du Caire*. Gräfenheinichen, 1972, pp. 173–90.

——. *The Shape of the Holy Early Islamic Jerusalem*. Princeton, NJ, 1996.

Grossmann, Peter. *Christliche Architektur in Ägypten*. Leiden, 2002.

Grube, Ernst J. 'Fatimid Pottery', in Julian Raby and Ernst J. Grube, eds, *Cobalt and Lustre: The First Centuries of Islamic Pottery*. London, 1994, pp. 137–46.'

——. 'Fostat Fragments', in B. W. Robinson, ed., *Islamic Painting and the Arts of the Book*. London, 1976, pp. 23–66.

——. 'Realism or Formalism: Notes on Some Fatimid Lustre-Painted Ceramic Vessels', in Renato Traini, ed., *Studi in Ornori di Francesco Gabrieli nel Suo Ottantesimo Compleanno*. Rome, 1984, pp. 423–32.

——. *Studies in Islamic Painting*. London, 1995.

——. 'Studies in the Survival and Continuity of Pre-Muslim Traditions in Egyptian Islamic Art', *Journal of the American Research Center in Egypt*, 1 (1962), pp. 75–97.

Grube, Ernst J. and Jeremy Johns. *The Painted Ceilings of the Cappella Palatina*. Supplement to *Islamic Art*. Genova and New York, 2005.

Haldane, Duncan. *Islamic Bookbindings in the Victoria and Albert Museum*. London, 1983.

Halm, Heinz. *The Empire of the Mahdi: The Rise of the Fatimids*, tr. Michael Bonner. Leiden, 1996.

——. 'Les Fatimides à Salamya', *Revue des études Islamiques*, 54 (1986), pp. 133–49.

——. 'Nachrichten zu Bauten der Aġlabiden und Fatimiden in Libyen und Tunesien', *Die Welt des Orients*, 23 (1992), pp. 129–57.

Hampikian, Nairy. 'Medievalization of the Old City as an Ingredient of Cairo's Modernization: Case Study of Bab Zuwayla', in Nezar Alsayyad, Irene A. Bierman and Nasser Rabbat, eds, *Making Cairo Medieval*. Lanham, 2005, pp. 201–34.

Hampikian, Nairy and Monique Cyran. 'Recent Discoveries Concerning the Fatimid Palaces Uncovered During the Conservation Works on Parts of al-Ṣāliḥiyya Complex', in Barrucand, ed., *L'Égypte Fatimide*, pp. 649–63.

al-Hawari, Hasan Muhammad Effendi. 'Trois minarets Fatimides à la frontière Nubienne', *Bulletin de l'Institut d'Égypte*, 17 (1934–5), pp. 141–53.

Hawary, H. and H. Rached. *Les Stèles funéraires*. Cairo, 1932–8.

Herz, Max. *Die Baugruppe des Sultans Qalaun in Kairo*. Hamburg, 1919.

Hill, Derek and Lucien Golvin. *Islamic Architecture in North Africa*. London, 1976.

Hillenbrand, Carole. *The Crusades: Islamic Perspectives*. Edinburgh, 1999.

Hillenbrand, Robert, ed. *The Art of the Saljūqs in Iran and Anatolia: Proceedings of a Symposium Held in Edinburgh in 1982*. Costa Mesa, CA, 1994.

——. *Islamic Architecture: Form, Function and Meaning*. Edinburgh, 1994.

——. *Islamic Art and Architecture*. London, 1999.

Hoffman, Eva R. 'A Fatimid Book Cover: Framing and Re-Framing Cultural Identity in the Medieval Mediterranean World', in Barrucand, ed., *L'Égypte Fatimide*, pp. 403–19.

Howard, Deborah. *Venice and the East*. New Haven, CT and London, 2000.

Humphreys, R. Stephen. 'Egypt in the World System of the Later Middle Ages', in Petry, ed., *The Cambridge History of Egypt*, vol. 1.

Ibn Ḥawqal, Abū'l-Qāsim. *Kitāb ṣūrat al-arḍ*, ed. J.H. Kramers. Leiden, 1938; 2nd ed. 1967.

Ibn 'Idhārī al-Marrākushī. *Kitāb al-bayān al-Maghrib (Histoire de l'Afrique du nord et de l'Espagne Musulmane)*, ed. G. S. Colin and É. Lévi-Provençal. Leiden, 1948–51.

Ibn al-Zubayr, al-Qāḍī al-Rashīd. *Kitāb al-dhakkā'ir wa'l-tuḥaf*, ed. M. Ḥamīdullāh. Kuwait, 1959.

Inostrantsev, Konstantin Aleksandrovich. *La Sortie solennelle des califes Fatimides*. St Petersburg, 1905.

Irwin, Robert. *Dangerous Knowledge: Orientalism and its Discontents*. Woodstock, 2006.

Jarrar, Sabri. 'Al-Maqrizi's Reinvention of Egyptian Historiography Through Architectural History', in Doris Behrens-Abouseif, *The Cairo Heritage: Essays in Honor of Laila Ali Ibrahim*. Cairo, 2000, pp. 31–54.

al-Jawdharī, Abū 'Alī Manṣūr al-'Azīzī. *Sīrat al-ustādh Jawdhar*, ed. Muḥammad Kāmil Ḥusayn and Muḥammad 'Abd al-Hādī Sha'īra. Cairo, 1954; French tr., M. Canard as *Vie de l 'ustadh Jaudhar*. Algiers, 1958.

Jenkins, Marilyn. 'Early Medieval Islamic Pottery: The Eleventh Century Reconsidered', *Muqarnas*, 9 (1992), pp. 56–66.

——. 'An Eleventh-Century Woodcarving from a Cairo Nunnery', in Richard Ettinghausen, ed., *Islamic Art in The Metropolitan Museum of Art*. New York, 1972, pp. 227–40.

——. 'Fāṭimid Jewelry, its Subtypes and Influences', *Ars Orientalis*, 18 (1988), pp. 39–58.

——. 'Muslim: An Early Fatimid Ceramicist', *Bulletin of the Metropolitan Museum of Art*, 26 (1968), pp. 359–69.

——. 'New Evidence for the Possible Provenance and Fate of the So-Called Pisa Griffon', *Islamic Archaeological Studies*, 1 (1978), pp. 79–85.

——. 'Western Islamic Influences on Fāṭimid Egyptian Iconography', *Kunst des Orients*, 10 (1976), pp. 91–107.

Jenkins, Marilyn and Manuel Keene. *Islamic Jewelry in the Metropolitan Museum of Art*. New York, 1982.

Johns, Jeremy. *Arabic Administration in Norman Sicily: The Royal Dīwān*. Cambridge, 2002.

——. 'The Norman Kings of Sicily and the Fatimid Caliphate', in Marjorie Chibnall, ed., 'Proceedings of the Battle Conference and of the XI Colloquio medievale of the Officina di Studi Medievali 1992', *Anglo-Norman Studies*, 15 (1993), pp. 133–59.

Kahle, Paul. 'Die Schätze der Fatimiden', *Zeitschrift der Deutschen Morgenländischen Gesellschaft*, 14 (1935), pp. 1–35.

Kashdan, Alexander P., ed. *The Oxford Dictionary of Byzantium*. New York, 1991.

Kessler, Christel. 'Funerary Architecture Within the City', in *Colloque internationale sur l'histoire du Caire*. Gräfenheinichen, 1972, pp. 257–68.

King, David A. 'The Orientation of Medieval Islamic Religious Architecture and Cities', *Journal for the History of Astronomy*, 26 (1995), pp. 253–74.

Kircher, G. 'Die Moschee des Muḥammad b. Hairūn (Drei-Tore-Moschee) in Qairawān/Tunesien. Erster Bericht,' *Mitteilungen des Deutschen Archäologischen Instituts Abteilung Kairo*, 26 (1970), pp. 141–68.

Knipp, David. 'Image, Presence and Ambivalence: The Byzantine Tradition of the Painted Ceiling in the Cappella Palatina, Palermo, *Byzas* 5 (2006), pp. 283–328.

——. 'The Torre Pisana in Palermo: A Maghribi Concept and its Byzantinization', in Andreas Speer and Lydia Wegener, eds., *Wissen über Grenzen: Arabisches Wissen und Laternisches Mittelalter; Miscellanea Meduvalia* 33 (2006), pp. 745–74.

Komaroff, Linda and Stefano Carboni, eds. *The Legacy of Genghis Khan: Courtly Art and Culture in Western Asia, 1256–1353.* New Haven, CT, 2002.

Köseoğlu, Cengiz. *The Topkapı Saray Museum: The Treasury*, tr. and ed. J. M. Rogers. Boston, MA, 1987.

Kröger, Jens. 'Fusṭāṭ and Nishapur: Questions About Fatimid Cut Glass', in Barrucand, ed., *L'Égypte Fatimide*, pp. 219–32.

Kubiak, Władysław B. *Al-Fustat: Its Foundation and Early Urban Development.* Cairo, 1987.

Kubiak, Władysław and George T. Scanlon. *Fustat Expedition Final Report, Vol. 2: Fustat-C.* Winona Lake, IN, 1989.

Kunitzsch, Paul. 'Zur Namengebung Kairos (al-Qāhir=Mars?)', *Der Islam*, 52 (1975), pp. 209–25.

Kühnel, Ernst. *Die Islamischen Elfenbeinskulpturen, VIII.–XIII. Jahrhundert.* Berlin, 1971.

Kühnel, Ernst, and Louisa Bellinger. *Catalogue of Dated Tiraz Fabrics: Umayyad, Abbasid, Fatimid.* Washington, DC, 1952.

Lamm, Carl Johan. 'Fatimid Woodwork, its Style and Chronology', *Bulletin de l'Institut d'Égypte*, 18 (1935), pp. 59–91.

——. *Cotton in Medieval Textiles of the Near East.* Paris, 1937.

Lane-Poole, Stanley. *The Art of the Saracens in Egypt.* London, 1886 (repr. Beirut, n.d.).

Lasko, Peter. *Ars Sacra 800–1200.* 2nd ed., New Haven, CT, and London, 1994.

Lassner, Jacob. *The Shaping of 'Abbāsid Rule.* Princeton, NJ, 1980.

Lavoix, H. 'Les Arts Musulmans', *Gazette des beaux-arts*, 12 (1875), pp. 97–113.

Leisten, Thomas. *Architektur für Tote: Bestattung in architektonischem Kontext in den Kernlandern der islamischen Welt zwischen 3./9. und 6./12. Jahrhundert.* Berlin, 1998.

——. 'Dynastic Tomb or Private Mausolea: Observations on the Concept of Funerary Structures of the Fāṭimid and 'Abbāsid Caliphs', in Barrucand, ed., *L'Égypte fatimide*, pp. 465–79.

Lentz, Thomas W. and Glenn D. Lowry. *Timur and the Princely Vision.* Los Angeles, CA, 1989.

Lester, Ayala, Yael D. Arnon and Rachel Rolak. 'The Fatimid Hoard from Caesarea: A Preliminary Report', in Barrucand, ed., *L'Égypte Fatimide*, pp. 233–48.

Lev, Yaacov. *State and Society in Fatimid Egypt.* Leiden, 1991.

Lévi-Provençal, E. 'Un Manuscrit de la bibliothèque du calife al-Ḥakam II', *Hespéris*, 18 (1934), pp. 198–200.

Lézine, Alexandre. *Mahdiya: recherches d'archéologie islamique.* Paris, 1965.

——. 'Notes d'archéologie ifriqiyenne IV: Mahdiya – quelques precisions sur la "ville" des premiers fatimides', *Revue des études Islamiques*, 35 (1967), pp. 82–101.

Lledó, Berta. 'Mold Siblings in the Eleventh-Century Cullet from Serçe Limani', *Journal of Glass Studies*, 39 (1997), pp. 43–55.

Lombard, Maurice. *Les Textiles dans le monde musulman VIIe–XIIe siècle.* Paris, La Haye and New York, 1978.

Mack, Rosamond E. *Bazaar to Piazza: Islamic Trade and Italian Art, 1300–1600.* Berkeley, Los Angeles and London, 2002.

MacKenzie, Neil D. *Ayyubid Cairo: A Topographical Study.* Cairo, 1992.

Mahfoudh, Faouzi, Samir Baccouch and Bechir Yazidi. *L'Histoire de l'eau et des installations hydrauliques dans le bassin de Kairouan.* Unpublished paper. Tunis, 2004. http://www.iwmi.cgiar.org/assessment/FILES/word/ProjectDocuments/Merguellil/Histoire%20eau%20Kairouan.pd.

al-Maqrīzī, *Description topographique et historique de l'Égypte*, tr. U. Bouriant and P. Casanova. Paris and Cairo, 1895–1900.

——. *Itti'āz al-ḥunafā' bi-akhbār al-a'imma al-Fāṭimiyyīn al-khulafā'*, ed. Jamāl al-Dīn al-Shayyāl and Muḥammad Ḥ. M. Aḥmad. Cairo, 1967–73.

——. Taqī al-Dīn Aḥmad b. 'Alī b. 'Abd al-Qādir. *al-Mawā'iẓ wa'l-i'tibār bi-dhikr al-khiṭaṭ wa'l-athār (Exhortations and instructions on the districts and antiquities).* Cairo, 1270/1853–4.

——. *al-Mawā'iẓ wa'l-i'tibār fī-ḏikr al-ḥiṭaṭ wal-aṯār (Exhortations and instructions on the districts and antiquities)*, ed. Ayman Fu'ād Sayyid. London, 1422–4/2003–4.

Marçais, Georges. *Architecture musulmane d'occident.* Paris, 1954.

——. *La Berbérie Musulmane et l'orient au moyen âge.* Paris, 1946.

——. *Coupoles et plafonds de la Grande mosquée de Kairouan.* Tunis, 1925.

——. *Les Faïences à reflets métalliques de la Grande mosquée de Kairouan.* Paris, 1928.

Marçais, Georges and Lucien Golvin. *La Grande mosquée de Sfax.* Tunis, 1960.

Marçais, Georges and Louis Poinssot. *Objets Kairouanais ixe au xiiie siècle.* Tunis, 1948.

Marçais, Georges and Gaston Wiet. 'Le «Voile de Sainte Anne» d'Apt', *Monuments et mémoires publiés par l'Académie des Inscriptions et Belles-Lettres,* 34 (1934), pp. 177–94.

Markel, Stephen. 'Fit for an Emperor: Inscribed Works of Decorative Art Acquired by the Great Mughals', *Orientations,* 21 (1990), pp. 22–36.

Marzouk, M.A. 'The Earliest Fatimid Textile (Tiraz al Mansuriya)', *Bulletin of the Faculty of Arts, Alexandria University,* 11 (1957), pp. 37–56.

Mason, R. B. and M. S. Tite. 'The Beginnings of Islamic Stonepaste Technology', *Archaeometry,* 36 (1994), pp. 77–91.

Mason, Robert B. 'Medieval Egyptian Lustre-Painted and Associated Wares: Typology in a Multidisciplinary Study', *Journal of the American Research Center in Egypt,* 34 (1997), pp. 201–42.

——. *Shine Like the Sun: Lustre-Painted and Associated Pottery from the Medieval Middle East.* Costa Mesa, CA, 2004.

Mason, Robert B. and Edward J. Keall. 'Petrography of Islamic Pottery from Fustat', *Journal of the American Research Center in Egypt,* 27 (1990), pp. 165–84.

Mayerson, Philip. 'The Role of Flax in Roman and Fatimid Egypt', *Journal of Near Eastern Studies,* 56 (1997), pp. 201–7.

Mazot, Sibylle. 'L'Architecture d'influence nord-africaine à Palerme', in Barrucand, ed., *L'Égypte Fatimide,* pp. 665–79.

Meinecke, Michael. 'Materialien zu fatimidischen Holzdekorationen in Kairo II: Die Holzpaneele der Moschee des Aḥmad Bāy Kuḥya', *Mitteilungen des deutschen archäologischen Instituts: Abteilung Kairo,* 47 (1991), pp. 235–42.

Meinecke-Berg, Viktoria. 'Materialien zu fatimidischen Holzdekorationen in Kairo I): Holzdecken aus dem fatimidischen Westpalast in Kairo', *Mitteilungen des deutschen archäologischen Instituts: Abteilung Kairo,* 47 (1991), pp. 227–33.

Melikian-Chirvani, A. S. 'Le Griffon Iranien de Pise: Matériaux pour un Corpus de l'Argenterie et du Bronze Iraniens, III', *Kunst des Orients,* 5 (1968), pp. 68–86.

Meri, Josef W. *The Cult of Saints Among Muslims and Jews in Medieval Syria.* Oxford, 2002.

Miles, George C. *Fāṭimid Coins in the Collections of the University Museum, Philadelphia, and the American Numismatic Society.* New York, 1951.

Milstein, Rachel and N. Brosch. *Islamic Painting in the Israel Museum.* Jerusalem, 1984.

Milwright, Marcus. 'Fixtures and Fittings: The Role of Decoration in Abbasid Palace Design', in Chase F. Robinson, ed., *A Medieval Islamic City Reconsidered: An Interdisciplinary Approach to Samarra.* Oxford, 2001, pp. 79–110.

Montesquiou-Fezensac, Blaise de and Danielle Gaborit-Chopin. *Le Trésor de Saint-Denis.* Paris, 1977.

Moulton, Jean-Michel. 'La Présence Chrétienne au Sinaï à l'époque Fatimide', in Barrucand, ed., *L'Égypte Fatimide,* pp. 613–24.

Mulder, Stephennie. 'The Mausoleum of Imam al-Shafi'i', *Muqurnas* 23 (2006), pp. 15–46.

al-Muqaddasī. *Aḥsan at-taqāsīm fī ma'rifat al-aqālīm (La meilleure répartition pour la connaissances des provinces),* tr. Andrē Miquel. Damascus, 1963.

——. *Aḥsan at-taqāsīm fī ma'rifat al-aqālīm (La meilleure répartition pour la connaissances des provinces),* ed. M. de Goeje. Leiden, 1906.

——. *The Best Divisions for Knowledge of the Regions (Aḥsan al-taqāsīm fī ma'rifat al-aqālim),* tr. Basil Collins. Reading, 1994.

Museum für Islamische Kunst Berlin. *Katalog 1971.* Berlin, 1971.

Nāṣir-i Khusraw. *Safarnāma,* ed. Muḥammad Dabīr Siyāqī. Tehran, n.d.; English trans.,

——. *Sefer Nameh: relation du voyage de Nassiri Khosrau,* ed. and tr. Ch. Schefer. Paris, 1881.

Necipoğlu, Gülru. *Architecture, Ceremonial, and Power: The Topkapı Palace in the Fifteenth and Sixteenth Centuries.* Cambridge, MA, 1991.

——. [ed.] *Pre-Modern Islamic Palaces. Ars Orientalis* (Entire Issue), 1993.

——. *The Topkapi Scroll – Geometry and Ornament in Islamic Architecture.* Santa Monica, CA, 1995.

Nicol, Norman Douglas. *A Corpus of Fāṭimid Coins.* Trieste, 2006.

Nuseibeh, Saïd, with essay by Oleg Grabar. *The Dome of the Rock.* New York, 1996.

O'Kane, Bernard. 'Domestic and Religious Architecture in Cairo: Mutual Influences', in Behrens-Abouseif, *The Cairo Heritage,* pp. 149–82.

——. 'The Origin, Development and Meaning of the Nine-Bay Plan in Islamic Architecture', in *A Survey of Persian Art,* vol. 18: *From the End of the Sasanian Empire to the Present, Studies in Honor of Arthur Upham Pope,* ed. Abbas Daneshvari. Costa Mesa, CA, 2005, pp. 189–244.

——. 'The Ziyada of the Mosque of al-Hakim and the Development of the Ziyada in Islamic Architecture', in Barrucand, ed., *L'Égypte Fatimide,* pp. 141–58.

L'Orient de Saladin: l'art des Ayyoubides. Paris, 2001.

Otavsky, Karel and Muḥammad 'Abbās Muḥammad Salīm. *Mittelalterliche Textilien I: Ägypten, Persien und Mesopotamien, Spanien und Nordafrika.* Riggisberg, 1995.

Pauty, Edmond. *Les Bois sculptés d'églises coptes (époque fatimide).* Cairo, 1930.

——. *Les Bois sculptés jusqu'à l'époque ayyoubide.* Cairo, 1931.

——. 'Le Minbar de Qoūs', in *Mélanges Maspero III* (*Mémoires publiés par les membres de l'Institut Français d'Archéologie Orientale au Caire*, 68). Cairo, 1940, pp. 41–8.

Philon, Helen. *Early Islamic Ceramics: Ninth to Late Twelfth Centuries.* London, 1980.

Pinder-Wilson, Ralph. 'Ivory Working in the Umayyad and Abbasid Periods', *Journal of the David Collection*, 2 (2005), pp. 13–23.

Pinder-Wilson, R. H. and C. N. L. Brooke. 'The Reliquary of St. Petroc and the Ivories of Norman Sicily', *Archaeologia*, 104 (1973), pp. 261–305.

Prisse d'Avennes, Achille Constant Théodore Emile. *Arabic Art After Monuments of Cairo*, tr. Juanita Steichen. Paris, 2001.

al-Qaddūmī, Ghāda al-Ḥijjāwī, tr. *Book of Gifts and Rarities. Kitāb al-Hadāyā wa al-Tuḥaf.* Cambridge, MA, 1996.

The Qur'an and Calligraphy: A Selection of Fine Manuscript Material. London, 1995.

Rabbat, Nasser O. *The Citadel of Cairo: A New Interpretation of Royal Mamluk Architecture.* Leiden, 1995.

____. 'Al-Azhar Mosque: An Architectural Chronicle of Cairo's History', *Muqarnas*, 13 (1996), pp. 45–67.

Rāġib, Yūsuf. 'Sur deux monuments funéraires d'al-Qarāfa al-Kubrā', *Annales Islamologiques*, 12 (1974), pp. 67–83.

——. 'La Mosquée d'al-Qarāfa et Jonathan M. Bloom', *Arabica*, 41 (1994), pp. 419–21.

——. 'Un Oratoire Fatimide au sommet du Muqaṭṭam', *Studia Islamica*, 65 (1987), pp. 51–67.

——. 'Sur un groupe de mausolées du cimitière du Caire', *Revue des Études Islamiques*, 40 (1972), pp. 189–95.

Ravaisse, Paul. 'Essai sur l'histoire et sur la topographie du Caire d'après Maḳrîzî', *Memoires de la mission archéologique française au Caire*, 1 (1889), pp. 409–79.

——. 'Essai sur l'histoire et sur la topographie du Caire d'après Maḳrîzî', *Memoires de la mission archéologique Française au Caire*, 3 (1890), pp. 1–114.

——. 'Sur trois mihrabs en bois sculpté', *Mémoires de l'Institut Egyptien*, 2 (1889), pp. 621–67.

Raymond, André, ed. *Cairo*, tr. Willard Wood. Cambridge, MA, 2000.

——. *Cairo, an Illustrated History*, tr. Jane Brenton and Barbara Mellor. New York, 2001.

Redford, Scott. 'How Islamic is It? The Innsbruck Plate and its Setting', *Muqarnas*, 7 (1990), pp. 119–32.

Reid, Donald Malcolm. 'Cultural Imperialism and Nationalism: The Struggle to Define and Control the Heritage of Arab Art in Egypt', *International Journal of Middle East Studies*, 24 (1992), pp. 57–76.

Rice, D. S. 'A Datable Islamic Rock Crystal', *Oriental Art*, NS, 2 (1956), pp. 85–93.

——. 'The Seasons and Labours of the Months', *Ars Orientalis*, 1 (1954), pp. 1–39.

——. *The Unique Ibn al-Bawwāb Manuscript in the Chester Beatty Library.* Dublin, 1955.

Robinson, B. W. *Islamic Painting and the Arts of the Book.* London, 1976.

Rosen-Ayalon, Myriam. *Islamic Art and Archaeology of Palestine.* Walnut Creek, CA, 2006.

Rousset, Marie-Odile. 'La Céramique des XIe et XIIe siècles en Égypte et au Bilād al-Shām. État de la question', in Barrucand, ed., *L'Égypte Fatimide*, pp. 249–64.

Roy, B. and P. Poinssot. *Inscriptions Arabes de Kairouan.* Paris, 1950–8.

Ruggles, D. Fairchild. *Gardens, Landscape and Vision in the Palaces of Islamic Spain.* University Park, PA, 2000.

Saifuddin, Ja'far us Sadiq M. *Al Aqmar: A Living Testimony to the Fatemiyeen.* London, 2000.

——. *Al Juyushi: A Vision of the Fatemiyeen.* London, 2002.

Saliba, George. 'Artisans and Mathematicians in Medieval Islam', *Journal of the American Oriental Society*, 119 (1999), pp. 637–45.

Sanders, Paula A. 'Bohra Architecture and the Restoration of Fatimid Culture', in Barrucand, ed., *L'Égypte Fatimide*, pp. 159–65.

——. 'The Court Ceremonial of the Fāṭimid Caliphate in Egypt', Ph.D. dissertation. Princeton University, 1984.

——. *Ritual, Politics, and the City in Fatimid Cairo.* Albany, NY, 1994.

Sayyid, Ayman Fu'ād. 'L'art du livre', *Dossiers d'archéologie*, 233 (1998), pp. 80–3.

——. *La Capitale de l'Égypte jusqu'à l'époque Fatimide: al-Qāhira et al-Fusṭāṭ, essai de reconstitution topo-graphique.* Beirut, 1998.

——. 'Le Grand palais Fatimide au Caire', in Barrucand, ed., *L'Égypte Fatimide*, pp. 117–26.

Scanlon, George T. 'Fustat Fatimid Sgraffiato: Less Than Lustre', in Barrucand, ed., *L'Égypte Fatimide*, pp. 265–84.

Schaefer, Karl R. *Enigmatic Charms: Medieval Arabic Block Printed Amulets in American and European Libraries and Museums.* Leiden, 2006.

Schnyder, Rudolph. 'Tulunidische Lüsterfayence', *Ars Orientalis*, 5 (1963), pp. 49–78.

Schorta, Regula. 'Zur Entwicklung der Lampastechnik', in *Islamische Textilkunst des Mittelalters: Aktuelle Probleme.* Riggisberg, 1997, pp. 173–80.

Sebag, Paul. *The Great Mosque of Kairouan*, tr. Richard Howard. New York, 1965.

Sed-Rajna, Gabrielle. *L'art juif.* Paris, 1975.

Seipel, Wilfried, ed. *Schätze der Kalifen: Islamische Kunst zur Fatimidenzeit.* Vienna, 1998.

Serjeant, R.B. *Islamic Textiles: Material for a History to the Mongol Conquest.* Beirut, 1972.

Shāfe'ī, Farīd. 'The Mashhad al-Juyūshī (Archeological Notes and Studies)', in *Studies in Islamic Art and Architecture in Honour of Professor K.A.C. Creswell.* Cairo, 1965, pp. 237–52.

Shalem, Avinoam. *Islam Christianized: Islamic Portable Objects in the Medieval Church Treasuries of the Latin West*. Frankfurt am Main, 1997.

——. 'New Evidence for the History of the Turquoise Glass Bowl in the Treasury of San Marco', *Persica*, 15 (1995), pp. 65–8.

——. 'A Note on the Shield-Shaped Ornamental Bosses on the Façade of Bāb al-Nasr in Cairo', *Ars Orientalis*, 26 (1996), pp. 55–64.

——. *The Oliphant: Islamic Objects in Historical Context*. Leiden, 2004.

Sharon, Moshe. *Corpus Inscriptionum Arabicarum Palaestinae*. Leiden, 1997.

Simaika Pasha, Marcus, and 'Abd al-Masiḥ Effendi. *Catalogue of the Coptic and Arabic Manuscripts in the Coptic Museum, the Principal Churches of Cairo and Alexandria and the Monasteries of Egypt*. Cairo, 1939.

Sinclair, T. A. *Eastern Turkey: An Architectural and Archaeological Survey*. London, 1987–90.

Sokoly, Jochen A. 'Between Life and Death: The Funerary Context of Tiraz Textiles', in *Islamische Textilkunst des Mittelalters: Aktuelle Probleme*. Riggisberg, 1997.

Solignac, M. 'Recherches sur les installations hydrauliques de Kairouan et des steppes Tunisiennes du VIIe au XIe siècle (J.-C.)', *Annales de l'institut d'études orientales* (1952–3), 10, pp. 5–273 and 11, pp. 60–170.

Soucek, Priscilla. 'Byzantium and the Islamic East', in Helen C. Evans and William D. Wixom, eds, *The Glory of Byzantium: Art and Culture of the Middle Byzantine Era A.D. 843–1261*. New York, 1997, pp. 403–11.

Sourdel-Thomine, Janine and Bertold Spuler. *Die Kunst des Islam*. Berlin, 1973.

Soustiel, Jean. *La Céramique islamique: le guide du connaisseur*. Fribourg, 1985.

Stern, Henri. 'Recherches sur la Mosquée al-Aqsa et ses mosaïques', *Ars Orientalis*, 5 (1963), pp. 27–47.

Stern, S. M. *Fāṭimid Decrees: Original Documents from the Fatimid Chancery*. London, 1964.

Stillman, Yedida K. 'The Importance of the Cairo Geniza Manuscripts for the History of Medieval Female Attire', *International Journal of Middle East Studies*, 7 (1976), pp. 579–89.

Tabbaa, Yasser. *The Transformation of Islamic Art During the Sunni Revival*. Seattle and London, 2001.

Taylor, Christopher S. *In the Vicinity of the Righteous: Ziyāra and the Veneration of Muslim Saints in Late Medieval Egypt*. Leiden, 1999.

——. 'Reevaluating the Shi'i Role in the Development of Monumental Funerary Architecture: The Case of Egypt', *Muqarnas*, 9 (1992), pp. 1–10.

Terrasse, Henri. *La Mosquée al-Qaraouiyin à Fès*. Paris, 1968.

Terrasse, Michel. 'Recherches archéologiques d'époque islamique en Afrique du Nord', *Comptes rendus de l'Académie des Inscriptions et Belles-Lettres* (1976), pp. 590–611.

Thackston, W. M., Jr., *Naser-e Khosraw's Book of Travels (Safarnama)*. New York, 1986.

Tibbetts, Gerald R. 'The Balkhī School of Geographers', in J. B. Harley and David Woodward, eds, *Cartography in the Traditional Islamic and South Asian Societies*, vol. 2 of *The History of Cartography*. Chicago, 1992, pp. 108–36.

Tissus d'Égypte: collection Bouvier. Paris, 1994.

Tonghini, Cristina. 'Fatimid Ceramics from Italy: The Archaeological Evidence', in Barrucand, ed., *L'Égypte Fatimide*, pp. 286–97.

The Treasury of San Marco Venice. New York, 1984.

Trésors Fatimides du Caire. Paris, 1998.

Tronzo, William. *The Cultures of His Kingdom: Roger II and the Cappella Palatina in Palermo*. Princeton, NJ, 1997.

Turner, Jane, ed. *The Dictionary of Art*. London, 1996.

Tushingham, A. D. and V. B. Meen. *Jawāhirāt-i sulṭānī-yi Iran*. Tehran, 1967.

Unsworth, Barry. *The Ruby in Her Navel: A Novel of Love and Intrigue in the Twelfth Century*. New York, 2006.

Vernoit, Stephen. 'Islamic Art and Architecture: An Overview of Scholarship and Collecting, c. 1850–c. 1950', in Stephen Vernoit, *Discovering Islamic Art*. London, 2000, pp. 1–61.

——. 'The Rise of Islamic Archaeology', *Muqarnas*, 14 (1997), pp. 1–10.

Walker, Paul E. *Exploring an Islamic Empire: Fatimid History and Its Sources*. London, 2002.

——. 'Fatimid Institutions of Learning', *Journal of the American Research Center in Egypt*, 34 (1997), pp. 179–200.

——. 'The Ismā'īlī Da'wa and the Fāṭimid Caliphate', in Carl Petry, ed., *The Cambridge History of Egypt, I: Islamic Egypt 640–151*. Cambridge, 1998, pp. 120–50.

——. 'Al-Maqrīzī and the Fatimids', *Mamluk Studies Review*, 7 (2003), pp. 83–97.

Ward, Rachel. *Islamic Metalwork*. New York, 1993.

Warner, Nicholas. *The Monuments of Historic Cairo: A Map and Descriptive Catalogue*. Cairo, 2005.

Watson, Oliver. *Ceramics from Islamic Lands*. London, 2004.

——. 'Fritware: Fatimid Egypt or Saljuq Iran?', in Barrucand, ed., *L'Égypte Fatimide*, pp. 299–307.

Whelan, Estelle J. *The Public Figure: Political Iconography in Medieval Mesopotamia*. London, 2006.

Whitehouse, David. 'Byzantine Gilded Glass', in Rachel Ward, ed., *Gilded and Enamelled Glass from the Middle East: Origins, Innovations*. London, 1998, pp. 4–7.

Wiet, Gaston. 'Un Dessin du XIe siècle', *Bulletin de l'institut Égyptien*, 19 (1936–1907), pp. 223–7.

——. 'Les Inscriptions du mausolée de Shāfi'ī', *Bulletin de l'Institut d'Égypte*, 15 (1933), pp. 167–85.

——. 'L'Exposition d'art Persan à Londres', *Syria*, 13 (1932), pp. 65–93, 196–212.

——. *Matériaux pour un corpus inscriptionum Arabicarum I: Égypte 2*. Cairo, 1929–30.

——. 'Notes d'épigraphie Syro-Musulmane', *Syria*, 5 (1924), pp. 216–53.

——. 'Une Nouvelle inscription Fatimide au Caire', *Journal Asiatique*, 249 (1961), pp. 13–20.

——. 'Nouvelles inscriptions Fatimides', *Bulletin de l'Institut de Égypte*, 24 (1941–2), pp. 145–55.

——. 'Une Peinture du xiie siècle', *Bulletin de l'Institut d'Égypte*, 26 (1944), pp. 109–18.

——. *Les Stèles funéraires*. Cairo, 1936–42.

William of Tyre. *A History of Deeds Done Beyond the Sea*, tr. Emily Atwater Babcock and A. C. Krey. New York, 1943.

Williams, Caroline. 'The Cult of 'Alid Saints in the Fatimid Monuments of Cairo. Part I: The Mosque of al-Aqmar', *Muqarnas*, 1 (1983), pp. 37–52.

——. 'The Cult of 'Alid Saints in the Fatimid Monuments of Cairo. Part II: The Mausolea', *Muqarnas*, 3 (1985), pp. 39–60.

——. 'The Qur'anic Inscriptions on the *Tabut* of al-Husayn in Cairo', *Islamic Art* 2 (1987), pp. 3–14.

Wüstenfeld, F. 'Geschichte der Faṭimiden Chalifen nach den Arabischen Quellen', *Sitzungsberichte der Königl. Gesellschaft der Wissenschaften, Histor.-Philolog. Classe* XXVI.3, XXVII.1, XXVIII, 3 (1880–1), pp. 1–97; 3–130; 1–124.

Yusuf, 'Abd al-Ra'uf 'Ali. 'Egyptian Luster-Painted Pottery from the Ayyubid and Mamluk Periods', in Behrens-Abouseif, *The Cairo Heritage*, pp. 263–74.

Abd el-Ra'uf Ali Yusuf. 'A Rock-Crystal Specimen in the Museum of Islamic Art and the Seven Fatimid Domes in the Qarāfa al-Kubrā in Cairo', in Marianne Barrucand, ed., *L'Égypte Fatimide: son art et son histoire*, Actes du colloque organisé à Paris les 28, 29 et 30 mai 1998. Paris, 1999, pp. 311–18.

Zbiss, Slimane Mostfa. 'Mahdia et Ṣabra-Manṣoûriya: nouveaux documents d'art fatimite d'occident', *Journal asiatique*, 244 (1956), pp. 79–93.

Photograph Credits

© V&A Images: endpapers, 6, 69; Drawn by Pieter Collet and Ian Whiteman: 2, 33a, 33b; Author photo: 3, 7, 9, 11, 13, 15, 16, 17, 34, 35, 36, 42, 44, 45, 46, 47, 48, 49, 52, 53, 54, 84, 85, 87, 88, 89, 91, 92, 93, 94, 95, 105, 106, 108, 110, 111, 114, 115, 116, 117, 119, 120, 121, 122, 143, 145, 146, 148, 156; © Trustees of the British Museum: 4, 31; A C Cooper: 5, 56; Photo courtesy of Cambridge University Library: 8, 83; © The al-Sabah Collection, Dar al-Athar al-Islamiyyah, Kuwait: 10, 64, 139; Werner Forman Archive: 19, 30; © Institute of Ismaili Studies Library: 23; Aga Khan Trust for Culture: 25; Nour Foundation: 26; © Photo archive National Archaeology Museum, Madrid: 27; Soprintendenza of Mantua: 28; © Bodleian Library, University of Oxford: 29; Photo Philippe Maillard: 37, 38, 39, 68, 81, 112, 133; Courtesy of the Creswell Archive, Ashmolean Museum, Oxford University: 40 (EA. CA 2530), 97 (EA. CA.3374), 118 (EA. CA.3907); © Said Nuseibeh: 50, 51; Photo by Alison Gascoigne: 55; © 2007 Benaki Museum, Athens: 57, 60, 67, 129, 140; Photography courtesy of Marilyn Jenkins-Madina: 61, 151; Photo © 1982 The Metropolitan Museum of Art: 62; Tareq Rajab Museum, Kuwait: 65; Photo © The Metropolitan Museum of Art: 66, 71; Bildarchiv Preußischer Kulturbesitz: 70, 77; By kind permission of the Procuratoria of San Marco, Venice: 72, 75; The Art Archive/ Palazzo Pitti Florence/Alfredo Dagli Orti: 73; Germanisches National Museum, Nuremberg: 74; Photo 2000 © The Metropolitan Museum of Art: 76, 150; © The Trustees of the Chester Beatty Library, Dublin: 79; Photo © 1998 The Metropolitan Museum of Art: 80; © Henri Stierlin: 86, 90; Photo by Caroline Williams: 98, 100, 136; Photo Sherif Sonbol, 2007: 103, 104, 109, 123, 124, 142; Photo P. Gromelle Orange: 126, 127; © Photo Bettina Jacot-Descombes: 128; Photo by George W. Allen: 131; Photo Comité: 132; Photo Robert Mason and Michel Fortin: 138; Photo Paula Sanders: 147; Photo courtesy of Sam Fogg, London: 153; © 1990 Photo Scala, Florence: 158; KHM, Vienna: 159; © Photo RMN: 162; The Art Archive/Bibliothèque des Arts Décoratifs Paris /Gianni Dagli Orti: 164

Index

Page numbers in *italic* refer to illustrations

al-ʿAbbas 158–9, 196
Abbasids, art of 4
ʿAbd Allah ('the Elder') 16
ʿAbd Allah ('the Younger') 16, 81
ʿAbd al-Rahman III 40–1, 52
Abu'l-ʿAbbas 17–18
Abu'l-Yusr al-Baghdadi 41
Abu ʿAbd Allah 17–19, 70–1
Abu ʿAli al-Hajari 171, *172*
Abu Jaʿfar Muhammad ibn Ahmad al-Baghdadi 41
Abu Yazid Makhlad 34, 35
al-ʿAdid 121, 152, 175–6
al-Afdal 119–20, 129, 139, 163
 buildings of 136–8
 library 170
Aga Khan xiv, xv, 9, 120, 181
Aghlabid dynasty 17–21
Alexandria, madrasas 152
Allan, James 170, 182
Amalric 175
al-Amir 120, 139, 146
 coins of 159, *159*
 mihrab for Azhar Mosque 144–5, *145*, 164
amulets 112–13, *114*
Anushtakin al-Amiri, Abu Mansur 163–4
Arnold, T. W. 113
Ascalon
 minbar 134–6, *135*, *136*
 shrine of al-Husayn 121, 134–6
Ashir, palace of Ziri 33–4, *33*
Aswan, Fatmid cemetery 83–4, *84*, *85*
Asyut, Mosque 130, *130*

Ayyubid period
 Cairo 74, 176, 177–9
 ceramics 181–2
 coins 182–3
 glassware 183
 metalware 182
 textiles 183, *183*
al-Aziz
 al-Azhar Mosque 63
 Cairo buildings 53, 59
 Lesser (Western) Palace 65, 66
 library of 109
 reign of 72–3

Badr al-Jamali 117, 119
 Cairo Mosques 129, 130
 Cairo's defences 121–8
 al-Husayn's shrine at Ascalon 134–6, *135*, *136*
 Mashhad al-Juyushi 131–4, *131*, *132*, *133*
Bahgat, Ali Bey 69
al-Bakri, Abu ʿUbayd 38, 39
Baldwin I 120
Banu Hilal 184
Berchem, Marguerite van 82
Berchem, Max van 10, 54, 65, 146, 197, 198
Bevelled Style 65, 85, 106, 145, 185
Bierman, Irene 37
Bohra 72, 74, 120, 179
books 48–9, 109–13, 158, 170–1, 183–4
 covers 107
 illustrated 111
Borj al-ʿArif 30, *30*
Bouriant, Urbain 197
Buyids 32
Byzantines 41–2, 193

Cairo
 Aqmar Mosque 139–46, *140, 141, 142*, 179
 archaeological excavations 10
 Ayyubid period 74, 176, 177–9
 al-Azhar Mosque 10, 59–65, *61, 62, 63, 64*, 78–9, 106,
 177, 185, *197*
 al-Amir mihrab 144–5, *145*, 164
 renovation by al-Hafiz 149–52, *150, 151*
 Azhar Park, Citadel View Restaurant 179–81, *181*
 Bab al-Futuh *122*, 123, 125, *125, 126*, 128
 Bab al-Nasr 123, *123, 124*
 Bab al-Tawfiq (Bab al-Barqiyya) 122
 Bab Zuwayla (Bab al-Mitwalli) 122, 123, 125, *127,
 128*
 bath of Abu Su'ud, painted decoration 172, *173*
 cenotaph of al-Husayn 166–7, *167*
 Coptic Museum 179, *180*
 defences 121–8
 Elephant Mosque 136
 Fakahani Mosque 153, *153*
 Fatimid legacy 176–81
 founding of 1, 53, 54–9
 gates 55–7, 58, 122–8
 Hadra Sharifa 71, *71*, 148
 housing 69–70
 library 109
 Lu'lu'a Mosque 71–2, *72*, 179
 madrasas 177
 madrasa of Salih Najm al-Din Ayyub 178–9, *179*
 Mamluk period 179
 Mashhad al-Juyushi 131–4, *131, 132, 133*, 179, 198
 Mashhad of Umm Kulthum 139, *139*
 mausoleum of Ikhwat Yusuf 143, *144*
 mausoleum of Imam Shafi'i *174*, 177–8, *178*
 mausoleum of Muhammad al-Ja'fari 146, *148*
 mausoleum of Sayyida Nafisa 136–7, 165–6, *165*
 mausoleum of Sayyida Ruqayya 146–9, *147, 148, 149*,
 164–5, *164*
 military architecture 121–8
 Mosque of Baybars I al-Bunduqdari 179
 Mosque of al-Hakim 3, 72–81, *74, 75, 76, 77, 78, 80*, 87,
 106, 122, 177, 179
 Mosque of Ibn Tulun 54, 60, 63, 137
 mihrab of al-Afdal 136–9, *138*
 Mosque near Nilometer 129
 Mosque of al-Salih Tala'i' 153–5, *154, 155*
 Mosque of Sayyidna al-Husayn 69
 palace 65–9, 129, 176
 beams 67, *67*, 106
 looted (1068) 118, 157–9
 plans of in Fatimid period *11, 56, 57*
 Qarafa cemetery 70–2, 144

 Qarafa Mosque 62, 113–14
 Saba Banat *70, 71*
 Saffron Tomb 69
 walls of 55, 58, 122, *122*, 123–5, *124*
Canard, Marius 12
Carthage 23, 35
cemeteries
 Aswan cemetery 83–4, *84, 85*
 Qarafa cemetery 70–1, 144
 see also mausolea; shrines
cenotaphs
 cenotaph from mausoleum of Sayyida Ruqayya 164–5,
 164
 cenotaph of al-Husayn 166–7, *167*
 cenotaph of al-Shafi'i 178, *178*
ceramics
 bacini 193–4, *194*
 earthenware *xviii*, 5, 47–8, *48*, 93–4, *94, 95, 96*, 168
 Fatimid style 93–6, 167–70
 figurative decoration *xviii*, 4, 5, 95, *95*, 170
 fritware (stonepaste) 6, *96*, 168, *170*
 incised ware 96, *96*, 168–9, *170*
 in Italy 193–4, *194*
 lustreware *xviii*, 5, 93, *94, 95, 96*, 157, 168–9, *169*, 181–2,
 184–5, 198
 North Africa 47–8, *48*, 184–5
 post-Fatimid period 181–2
 underglaze-painted 168–9, *169*, 194
Christian Europe, Fatimid influence 193–7
coins
 of al-Amir 159, *159*
 of Ayyubid period 182–3, *182*
 Fatimid 36–7, 99, 159
 of al-Mu'izz 36, *36*, 37, 52, *52*
 of Zikrawayh 17
Comité de Conservation des Monuments de l'Art Arabe
 197
Constantine VII, emperor 41
Contadini, Anna 107
Creswell, Keppel 12, 60, 69, 79, 84, 128, 148, 151–2,
 198
Crusaders 2, 81, 117, 120, 159, 175, 194–5
 coins *182*

Damietta, Mosque of Sidi 'Abd Allah al-Sharif 145–6,
 146
David-Weill, Jean 130
de Sacy, Silvestre 10
Diyarbakır 128
drawings 111–12, *111, 112, 113*
 see also paintings

Edfu, al-Umriya Mosque 84, *87*
Egypt
 Fatimid architecture 51, 59–87, 117–18, 121–55
 Fatimid invasion 51–3
 pre-Fatimid arts 53–4, 90–1
Ettinghausen, Richard 12, 95, 115

al-Fa'iz 121, 152, 175
Fatimid art
 dispersal of objects 157–9, 193–7
 dynastic style 7, 117–18
 figurative representation 4, 95, 113–15
 identifying 89
 in North Africa 47–9
 studies of 10–12, 197–9
Flury, Samuel 185
funerary practices 70–1
 see also cemeteries
Fustat (Old Cairo)
 abandoned 118
 church of St Barbara, wooden screen 162–3, *163*
 excavations 10
 glass production 105
 pre-Fatimid 53–4
 rubbish heaps 10, 93, 198

Geniza documents 9, 69–70, 89, 91, 100
Genoa, Sacro Catino 195
glassware
 Ayyubid period 183
 blown glass 104–5
 Fatimid objects 104–5, 168
 Hedwig Beakers 104
 lustre decoration 90, 105, *106*
 pre-Fatimid techniques 90
 Sacro Catino, Genoa 195
 turquoise glass bowl, Venice 104, *105*
Goitein, Solomon 9, 49
Grabar, Oleg 12, 82, 95, 115, 118, 198
Grube, Ernst 89, 112, 115

al-Hafiz ('Abd al-Majid) 120–1, 146, 190
 renovation of al-Azhar Mosque 149–52, *150*, *151*
al-Hakim
 al-Azhar Mosque 63–5, 106
 coins 99
 destruction of the Church of the Holy Sepulchre,
 Jerusalem 73, 81
 al-Hakim Mosque 72–81
 mausolea 71
 reign of 73, 163
Hammadids, North Africa 184, 187–9

al-Hawary, Hasan 84
Herzfeld, Ernst 79
Hoffman, Eva 107
Houston, Texas, Dawoodi Bohra Mosque 179, *180*
Hugh of Caesarea 66, 68, 129
al-Husayn
 cenotaph 166–7, *167*
 head of 69, 119, 121, 134–6, 154

Ibn Abi Tayyi 170
Ibn al-Athir 10
Ibn Duqmaq 59, 130
Ibn Hawqal 32, 47–8
Ibn 'Idhari 29
Ibn Jubayr 193
Ibn Khaldun 184
Ibn Killis 129
Ibn Ma'ali 166
Ibn al-Ma'mun 139
Ibn Muyassar 125, 131
Ibn Tulun, Ahmad 53, 58
Ibn al-Tuwayr 161, 170
Ifriqiya *see* North Africa
Inostrantsev, Konstantin 12
Isna, tower 130–1, *130*
Italy, Fatimid influence 193–4
ivory 157
 boxes 44–6, *44*, *45*
 carved plaques 107, *108*
 oliphant *4*

Jawdhar 35–6, 37, 41, 65
Jawhar 51, 52–3, 55–8, 62
Jenkins-Madina, Marilyn 12
Jerusalem
 Aqsa Mosque 69, 82, *83*
 Church of the Holy Sepulchre 73, 81
 Dome of the Rock 81–2, *82*, 87, 100, 178, 195
 Haram al-Sharif 83
Johns, Jeremy 190, 195

Kairouan
 Aghlabid dynasty 19, 23
 Great Mosque 20, *20*, 21, 26
 ceiling 186, *186*
 maqsura 185–6, *185*
 Nurse's Qur'an 186, *187*
 Mosque of the Three Doors 29, *29*
Kalbids, Sicily 190
kufic script, floriated 3, *3*, 30, 38, *39*, 54, *54*, 79
Kühnel, Ernst 107
Kutayfat 120–1

233

Lamm, Carl 163
Lane-Poole, Stanley 10, 197–8
Lavoix, H. 113
Lézine, Alexandre 26
Luxor, Mosque of Abu'l-Hajjaj 84, 86

Madinat al-Zahra' 40–1
al-Mahdi
 clothing of 19
 Mahdiyya 22–32
 in North Africa 18
 proclaimed leader 19–20
 in Syria 16–17
Mahdiyya
 comparison with Mansuriyya 41
 founding of 22, 23
 marble relief 30–1, 30
 mosaic pavement 31, 31
 Mosque 23, 25–9, 25, 27, 60
 palaces 30–2, 33
 post-Fatimid period 184
 Skifa al-Kahla 23, 24
Mamluk period, Cairo architecture 179
al-Ma'mun al-Bata'ihi 120, 129, 139
al-Mansur 34, 35–42
Mansuriyya
 ceramics 48, 48
 construction of 37–8
 palaces 38–40
 political position 40–2
manuscripts
 Abu 'Ali al-Hajari 171, 172
 illustrated 89, 90, 111–12
 see also books; Qur'an
maps, of the world 46–7, 46
al-Maqdisi (al-Muqaddasi) 9, 37, 38
al-Maqrizi 8–9, 10, 58, 66–7, 128, 149, 154, 181, 197
Marçais, Georges 187
Martin, F. R. 10
Mason, Robert 168
mausolea see Cairo, mausoleums
Mecca, looted by Qarmatis 32
Mehren, A. F. 198
metalware 97–8, 170, 195
 Ayyubid period 182
 brass lamp 186–7, 188
 brass lion 98, 98
 copper-alloy bowl 170, 171
 copper-alloy box 98, 99
 copper-alloy bucket 98, 99
 domestic objects 98
 jewellery 100, 100

silver lamps 100
silver mirror back 97–8, 98
silver spice-box 97, 97
 see also coins
mihrabs
 mihrab of al-Afdal 136–9, 138
 mihrab for Azhar Mosque 144–5, 145, 164
 mihrab of Sayyida Nafisa 165–6, 165
minarets 179
minbars
 'Amri Mosque, Qus 166, 166, 167
 Ascalon 134–6, 135, 136
 St Catherine's Monastery, Sinai 163, 163, 164
mosaics
 Jerusalem 81–2, 82, 83, 87
 Mahdiyya 31, 31
al-Mu'izz 35
 coins 36, 36, 37, 52, 52, 99
 decorative arts 42–9
 invasion of Egypt 51–3, 54–5
 Mansuriyya 38
 moves to Cairo 65, 69
 successor of 72
al-Mu'izz ibn Badis 184, 185, 190
al-Musta'li 119–20
al-Mustansir
 coins 99
 Jerusalem 81
 political crisis 117, 118–19, 157
 successor of 119–20
 Western Palace 65, 66

Nafisa, Sayyida 136–7, 165
al-Najayrami, Ishaq 171
Nasir-i Khusraw 9, 10, 66–7, 69, 78, 83, 92–3, 100, 101, 197
Nizari faction 119–20, 146
Normans
 North Africa 184
 Sicily 190–3
North Africa (Ifriqiya)
 Aghlabid dynasty 17–18
 Fatimid arrival in 17–21
 Fatimid art 47–9
 Fatimid rule 22–32, 49
 post-Fatimid period 184–9
al-Nu'man, Qadi 35, 38, 47, 49
Nur al-Din 121, 175

ornamentation, figurative 4, 95, 113–15

paintings 95–6, 171–3, 172
 see also drawings

Palermo
 Cappella Palatina 190, *191*, 192
 doors of Santa Maria dell'Ammiraglio 192, *192*
Palestinian Synagogue, Genizia documents *see* Geniza
 documents
paper, introduction of 7–8, 109
Pauty, Edmond 163
Pisa Griffon 192
pottery *see* ceramics
printing, block-printed amulets 112–13, *114*
Prisse d'Avennes, A. C. T. E., *L'Art arabe* 197, *197*, *198*

al-Qa'im 33–4, 36
Qal'at Bani Hammad, Algeria 187–9, *189*
Qala'un
 Hospital 68
 Maristan 67–8, *67*
Qarmatis 16, 32
al-Qazwini 101
Qur'an
 Blue Qur'an 42–4, *42*
 manuscripts 21, *21*, 43, *43*, 110, *110*
 Nurse's Qur'an 186, *187*
Qus, 'Amri Mosque, minbar 166, *166*, *167*

Rāġib, Yusuf 134
Ravaisse, Paul, plan of Cairo in Fatimid period 10, *11*,
 66
rock crystal 101–4, 157, 195–6
 crescent-shaped ornament 101, *104*, 195–6
 ewer formerly in the Abbey of St Denis, Egypt 195,
 195
 ewer inscribed with al-Aziz 101, *102*, 195
 ewer made for the Qa'id al-Quwwad 101, *103*
 pre-Fatimid techniques 90
Roger II, king of Sicily 190, 193
 coronation mantle 190–2, *191*
Ruqayya, Sayyida, mausoleum of 146–9, 164–5

Sabra-Mansuriyya 187
Sadaqa ibn Yusuf 97
Salah al-Din (Saladin) 121, 175–8, 196–7
Salamya 16–17, 18, 81
Salih Najm al-Din Ayyub, madrasa 178–9, *179*
Sbeitla, Arch of Antonius Pius 26, *28*
Scanlon, George 10
Schefer, Charles 197
Sedrata (Sadrata) 34
Sfax, Great Mosque *8*, 30
Shawar 175
'Shi'i century' 5–7
shrines
 al-Husayn's shrine, Ascalon 121, 134–6, *135*, *136*

Mashhad al-Juyushi 131–4, *131*, *132*, *133*, 179, 198
 see also cemeteries; mausolea
Shroud of St Josse 93
Sicily, Fatimid influence 189–93
silverware *see* metalware
Sinai
 Fatimid buildings 163–4
 St Catherine's Monastery, minbar 163, *163*, 164
Sousse
 Great Mosque 26, *28*
 Mosque of Bu Fatata 29
 ribat 26, *29*
Star Mantle of Henry II 47
Stern, Henri 82
stone masonry 80
Surat, Fatimid Mosque 179
Syria, Fatimid conquest 81

Tahart (Tiaret) 34
Tala'i' ibn Ruzzik 121, 152, 158–9, 166, 175
al-Tayyib 120, 149
textiles 3–4, 47, 91–3, 159–62
 Ayyubid period 183, *183*
 coronation mantle of Roger II 190–2, *191*, 198
 decorated 92, *92*, 160–1, *162*
 linen 90
 manufacture of 35–6
 Shroud of St Josse 93
 Star Mantle of Henry II 47
 as status symbol 19, 91, 157–8
 tents 161–2
 tiraz 35, 47, 92, *92*, 160–1, *160*, *161*
 Veil of Saint Anne 160, *160*, *161*, 194–5
towers 130–1, 133–4

Umayyads 4, 40
Upper Egypt, Fatimid architecture 83–5, 87

Venice, Fatimid objects 195–6

Walker, Paul E. 159, 181
wall paintings 95–6
Wiet, Gaston 10, 54, 89, 113
Williams, Caroline 118, 149, 166–7
woodwork 105–6, 162–7
 beams from Fatimid palace 67, *67*, 106, *107*
 cenotaph from mausoleum of Sayyida Ruqayya 164–5,
 164
 cenotaph of al-Husayn 166–7, *167*
 cenotaph of al-Shafi'i 178, *178*
 doors for al-Azhar Mosque 63–5, *64*, 106, 185–6
 doors of Fakahani Mosque 153, *153*
 doors of Santa Maria dell'Ammiraglio, Palermo 192, *192*

drawings of woodwork from the Hospital of Qala'un
 196
maqsura in Great Mosque, Kairouan 185, *185*
mihrab of Sayyida Nafisa 165–6, *165*
mihrab presented by al-Amir to Azhar Mosque
 144–5, *145*, 164
minbar at 'Amri Mosque, Qus 166, *166*, *167*
minbar at Ascalon 134–6, *135*, *136*
minbar at St Catherine's Monastery, Sinai 163, *163*,
 164
screen from church of St Barbara, Fustat 162–3,
 163

writing 109, *110*
 fountain pen 47
Wüstenfeld, Ferdinand 10

al-Zafir 121, 152
al-Zahir
 al-Hakim Mosque 74
 in Jerusalem 69, 81–2
 succession 73
Zikrawayh ibn Mihrawayh 17
Zirids, North Africa 184–5
Ziri ibn Manad 33

DATE DUE

MAR 0 2 2009			
GAYLORD			PRINTED IN U.S.A.

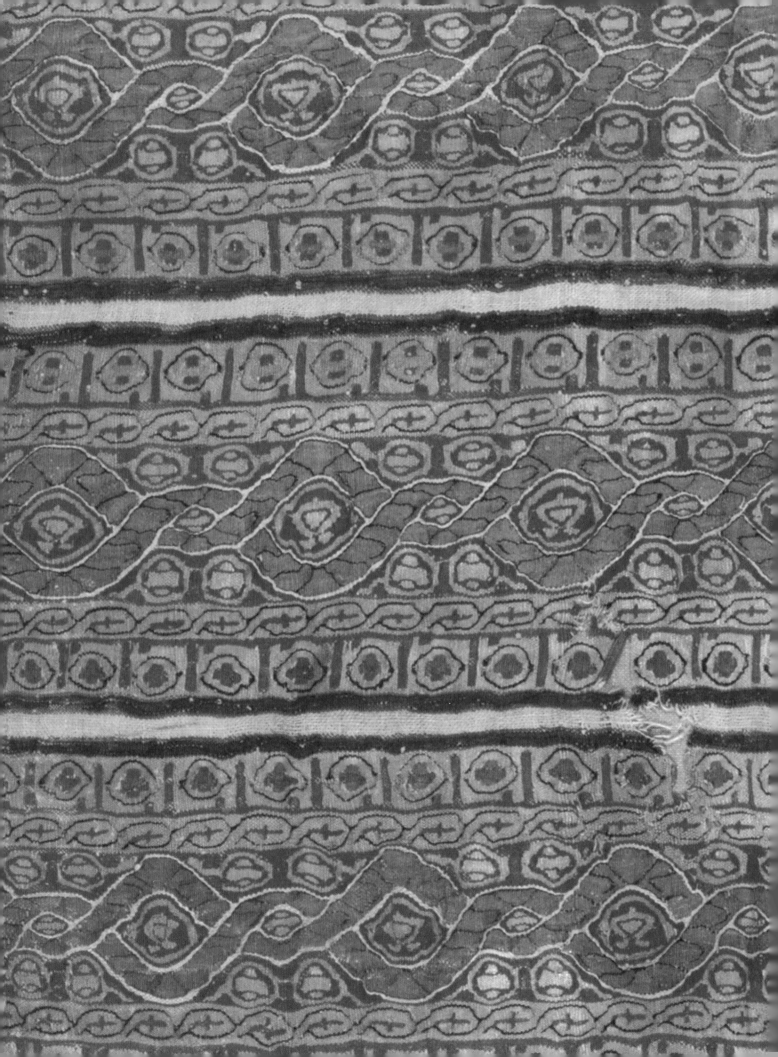